ILLUSIONS IN MOTION

Leonardo

Roger F. Malina
Executive Editor

Sean Cubitt
Editor-in-Chief

ILLUSIONS IN MOTION

MEDIA ARCHAEOLOGY OF THE MOVING PANORAMA AND RELATED SPECTACLES

ERKKI HUHTAMO

The MIT Press
Cambridge, Massachusetts
London, England

© 2013 Massachusetts Institute of Technology

MIT Press books may be purchased at special quantity discounts for business or sales promotional use. For information, please email special_sales@mitpress.mit. edu or write to Special Sales Department, The MIT Press, 55 Hayward Street, Cambridge, MA 02142.

This book was set in Palatino, Meta Pro, and Ziggurat and designed by Willem Henri Lucas and Jon Gacnik. Printed and bound in the United States of America.

Cover illustration: *L'Exposition Universelle de Paris 1900* (1900 Paris Universal Exposition), a moving panorama exhibited by Le Théatre Mécanique Morieux de Paris. Painted by Léon Van de Voorde, Ghent, Belgium, 1900. Jean-Paul Favand Collection. Courtesy of Pavillons de Bercy / Musée des Arts Forains.

Library of Congress Cataloging-in-Publication Data:
Huhtamo, Erkki.
Illusions in motion : media archaeology of the moving
 panorama and related spectacles / Erkki Huhtamo.
 pages cm — (Leonardo book series)
Includes bibliographical references and index.
ISBN 978-0-262-01851-7 (hardcover : alk. paper)
1. Panoramas. 2. Panoramas—Psychological aspects.
3. Mass media and culture. 4. Popular culture. I. Title.
ND2880.H84 2013
 ·1.7'4-dc23
 009892

5 4 3 2 1

So now, where everything seen or unseen, was new and strange, and the imagination was quite free to rove, the charm was more intense. We stood and gazed upon the moving panorama like persons in a trance.

—John Munro, *A Trip to Venus* (1897)

CONTENTS

SERIES FOREWORD

Leonardo/International Society for the Arts, Sciences, and Technology (ISAST)

Leonardo, the International Society for the Arts, Sciences, and Technology, and the affiliated French organization Association Leonardo have some very simple goals:

1. To document and make known the work of artists, researchers, and scholars interested in the ways that the contemporary arts interact with science and technology and
2. To create a forum and meeting places where artists, scientists, and engineers can meet, exchange ideas, and, where appropriate, collaborate.
3. To contribute, through the interaction of the arts and sciences, to the creation of the new culture that will be needed to transition to a sustainable planetary society

When the journal *Leonardo* was started some forty years ago, these creative disciplines existed in segregated institutional and social networks, a situation dramatized at that time by the "Two Cultures" debates initiated by C. P. Snow. Today we live in a different time of cross-disciplinary ferment, collaboration, and intellectual confrontation enabled by new hybrid organizations, new funding sponsors, and the shared tools of computers and the Internet. Above all, new generations of artist-researchers and researcher-artists are now at work individually and in collaborative teams bridging the art, science, and technology disciplines. For some of the hard problems in our society, we have no choice but to find new ways to couple the arts and sciences. Perhaps in our lifetime we will see the emergence of "new Leonardos," creative individuals or teams that will not only develop a meaningful art for our times but also drive new agendas in science and stimulate technological innovation that addresses today's human needs.

For more information on the activities of the Leonardo organizations and networks, please visit our Web sites at http://www.leonardo.info *and* http://www.olats.org.

Roger F. Malina
Executive Editor, Leonardo Publications

ISAST Governing Board of Directors:
Jeffrey Babcock, Nina Czegledy, Greg Harper (Chair), Gordon Knox, Melinda Klayman, Roger Malina, Meredith Tromble, Tami Spector, Darlene Tong

ACKNOWLEDGMENTS

My excavations of the moving panorama and related spectacles have greatly profited from my activities in various microworlds. The International Panorama Council (IPC) has been crucial. It connects "panoramaniacs" from all around the world—scholars, collectors, panorama proprietors, painters, creators of digital panoramas, media artists, and enthusiasts. The IPC has provided me valuable contacts, tips about sources, and, last but not least, possibilities to receive feedback from experts. Elements of my book project were read as papers at IPC's International Panorama Conferences at New York (Hunter College, 2004), The Hague (The Mesdag Panorama, 2006), Yale (Yale Center for British Art, 2007), and Dresden (The Panometer Dresden, 2008).

It is impossible to list all the IPC members who have helped me in one way or another. Ralph Hyde has been a source of constant encouragement. Not only has he shared his vast knowledge and archives with me; he has provided me a model of scholarly rigor. Ralph has read much of the manuscript, and made helpful suggestions. Suzanne Wray's contribution has been equally pivotal. It would be impossible to count all the pieces of evidence she has sent me over the years. Suzanne's—truly—countless emails have opened new lines of inquiry, and reminded me about how little we really know. Suzanne's comments have helped me to avoid embarrassing mistakes. Last but not least, she helped me to compile the list of the existing moving panoramas.

Whenever I have needed patents, I have been able to contact Marcel Just (Zurich, Switzerland). Peter Morelli, the driving force behind the restoration of the *Panorama of Bunyan's Pilgrim's Progress* (1850–1851), drove me all the way from New York City to Saco, Maine, to inspect this remarkable find, and helped me to compile the list of existing panoramas.[1] Ernst Storm, the director of the Mesdag Panorama (The Hague), has shown me how to keep panoramas alive in the twenty-first century. Andy "Andyrama" Newman has demonstrated the continuity of "discursive panoramas" by his collection of words ending in –orama. Panorama historians Gabriele Koller, Silvia Bordini, Russell Potter, and Mimi Colligan have supported in various ways; so has Sara Velas, the founder of the Velaslavasay Panorama (Los Angeles). The moving panorama her team recently produced, *The Grand Moving Mirror of California* (2010), means the resurrection of a lost medium.

Much of what I know about magic lanterns I have learned from members of the magic lantern societies of the Great Britain and the United States and Canada. Lester Smith has been an inspiration for years. Mike and Teresa Simkin (Birmingham) allowed me to excavate Mike's private Phantasmagoria Museum. Thomas Weynants, who runs an influential Web site on visual media archaeology, has provided me constant inspiration. The legendary collector William Barnes let me study the Poole family scrapbooks at his home. Terry and Debbie Borton, whose American Magic Lantern Theater is the only professional magic lantern troupe operating in the United States, have also supported and hosted me.

Of collectors whose private treasure troves I have excavated, I would particularly like to thank François Binetruy (Versailles), Jacqueline and Jonathan Gestetner (London), Richard Balzer (Boston), Jack Judson (San Antonio), and Jean-Paul Favand, whose Musée des Arts Forains (Paris) houses a veritable time capsule, the remains of the Morieux mechanical theater with its moving panoramas. Of curators of public collections, I would like to single out Frances Terpak (Getty Research Institute), Julie Anne Lambert (Bodleian Library), the late Fredric Woodbridge Wilson (Harvard Theater Collection), Laurent Mannoni

(Cinémathèque française, Musée du Cinéma), Donata Pesenti Campagnoni and Roberta Basano (The Turin Film Museum), Elisabeth Fairman and Scott Wilcox (Yale Center for British Art), Nicole Garnier (Musée Condé, Chantilly), and Robert Hauser (New Bedford Whaling Museum, New Bedford, Mass.). The staff at UCLA's Young Research Library and the Arts Library has been very helpful; particular thanks to Janine Henri.

Because my work fits uneasily within existing disciplines, I have learned much from researchers working at the fringes of academia. Laurent Mannoni, Ralph Hyde, Stephen Herbert, David Robinson, and Deac Rossell are such brilliant scholars. Of academic colleagues, I would like to thank Tom Gunning, Margaret Morse, Douglas Kahn, the late Anne Friedberg, John Fullerton, Vivien Sobschack, Yuri Tsivian, Oliver Grau, Sean Cubitt, Peter Lunenfeld, Soeren Pold, Hiroshi Yoshioka, Hannu Salmi, and Jussi Parikka. Gloria Cheng, my colleague at UCLA, who is not only a brilliant pianist, but also an outstanding copy editor, has read much of the manuscript, and helped me to improve it. I would also like to acknowledge the influence of David Wilson, whose extraordinary *Museum of Jurassic Technology* delves, among so many other things, into media archaeology. Meetings with David, as well as with Ricky Jay, the master magician and ephemera collector, have always been stimulating.

For help and inspiration, I would like also to thank, in no particular order, Seppo, Sinikka and Tuula Majavesi, Tarja and Brian Cockell, Ippu and Markku Kosonen, Perry Hoberman, Jeffrey Shaw, Tjebbe van Tijen, Budi N. D. Dharmawan, Ken Feingold, Paul deMarinis, Bernie Lubell, Michael Naimark, Doron Galili, Rafael Lozano-Hemmer, Toshio Iwai, Heidi Pfäffli, Tapio Onnela, and Päivi Kosonen. I would also like to acknowledge Gavin Bryars, whose extraordinary music has helped me to concentrate, and isolate myself from the noisescape of Los Angeles. The person who has contributed more than anyone else during the long gestation of this book is Professor Machiko Kusahara (Waseda University, Tokyo). With Machiko, I have traveled around the world, visited panoramas, and collected documents about them for the past twenty years. Machiko not only introduced me the richness of the Japanese culture; she has influenced my understanding of life and media in every imaginable way.

Travel and research enabling grants from UCLA's Academic Senate's Council on Research made some of the research trips possible. The chairs of the Department of Design | Media Arts during my tenure there, Victoria Vesna, Casey Reas, and Willem Henri Lucas, have all supported my research. Still, I have often paid for my travels from my own pocket, or combined my archival research with conference and festival visits. Except for three ten-week sabbatical leaves (one partial and two full), all the work was done either during my summer vacations, or periods of active teaching. I thank my students and colleagues at UCLA for their contributions and patience. Graduate student David Leonard helped me to prepare the illustrations. Willem Henri Lucas and Jon Gacnik, who designed the book, contributed to its final form in truly creative and essential ways.

When I presented my extensive manuscript to the MIT Press, it immediately received enthusiastic feedback from the Leonardo Book Series editor Sean Cubitt. Douglas Sery is the insightful editor who acquired my manuscript, while Katie Helke Dokshina has provided valuable support all the way. Michael Sims was my brilliant and insightful text editor. I am very grateful for the MIT Press for their vision and encouragement, especially at a moment when many publishers are unwilling to take risks with large and unconventional books.

Most of the material appears here for the first time. However, the book developed around "Peristrephic Pleasures, or The Origins of the Moving Panorama," in *Allegories of Communication: Intermedial Concerns from Cinema to the Digital*.[2] An early version of chapter 3 was published as "Penetrating the Peristrephic: An Unwritten Chapter in the History of the Panorama" in *Early Popular Visual*

Culture 6, no. 3 (Nov. 2008): 219–238, and part of chapter 5 as "Aeronautikon! or, the journey of the balloon panorama" in the same journal, vol. 7, no. 3 (Nov. 2009): 295–306. Material from chapter 8 was included as "Discursive Tug of War: On the Interconnections between Moving Panoramas and Magic Lantern Shows," in *The Panorama in the Old World and the New*, ed. Gabriele Koller (Amberg: Buero Wilhelm, Verlag Koch—Schmidt—Wilhelm GbR, 2010), pp. 34–44. I am grateful to the publishers for permissions to reprint material from these sources.

Finally, a word about Google Books. When I began this project a decade ago, traditional archival research was the way to go, and so I crisscrossed the world with my notepad, laptop computer, and digital camera. In 2005 I discovered Google Books, then called "Google Book Search," just as it was taking its first steps in cyberspace. It became an indispensable research tool for me. Four things make it useful for the media archaeologist: its scope and fast growth; its "anything goes" principle (the archive is not based on what our own time considers worth saving); the possibility of making searches *inside* documents; and open and free access to countless documents. This book became a test case for what one can do with such a resource, turning *Illusions in Motion* into a contribution to the emerging field of digital humanities.

As I am writing (in early 2012), the prospects of Google Books as an unique research tool have been jeopardized by commercial speculators selling on-demand copies of out-of-copyright books. They have found ways to block access to the same works on Google Books.[3] I am no longer able to access some of the sources I used. I would either have to buy a low-quality printout of the digital file, or to search for the book from the shelves of a library. In both cases the unique opportunity of making content-based searches inside the volume is lost. Academic institutions (from whose libraries many of the books in the Google Books database were scanned) should join forces to help keep Google Books open and accessible. Luckily, resources like the Internet Archive are gaining in strength, so there is hope.

NOTES

1. *The Grand Moving Panorama of Pilgrim's Progress* (Montclair, N.J.: Montclair Art Museum, 1999). The panorama was also known as *Bunyan's Tableaux*.

2. Ed. John Fullerton and Jan Olsson (Rome: John Libbey, 2004), pp. 215–248. Another early formulation was "Global Glimpses for Local Realities: The Moving Panorama, a Forgotten Mass Medium of the 19th Century," *Art Inquiry* (Poland), 4, no. 13 (2002): 193–223.

3. This is "copyfraud," according to Jason Mazzone, *Copyfraud and Other Abuses of Intellectual Property Law* (Stanford: Stanford University Press, 2011). Fortunately, other fast growing on-line archives, such as the Internet Archive (archive.org), are free of some of the problems Google Books is facing. I also find the interface of the Internet Archive's book search more advanced. There is hope for future media archaeologists! (April 2012).

ABBREVIATIONS

AAS	American Antiquarian Society (Worcester, Mass.)
AMLT	American Magic Lantern Theater (East Haddam, Conn.)
BDC	Bill Douglas Centre, University of Exeter (Exeter)
BL	British Library Collection (London)
CBA	Center for British Art (Yale)
EH	Erkki Huhtamo Collection (Los Angeles)
FB	François Binetruy Collection (Versailles)
GRI	Getty Research Institute (Los Angeles)
HL	Huntington Library (San Marino, Calif.)
HTC	Harvard Theater Collection, Harvard University (Harvard)
JJG	Jacqueline and Jonathan Gestetner Collection (London)
JJCB	John Johnson Collection, Bodleian Library (Oxford)
JWB	John and William Barnes Collection (London)
LM	Lester Smith Collection (London)
MAF	Jean Paul Favand's Musée des Arts Forains (Paris)
MG	Martin Gilbert Collection (Burton-on-Trent)
MHS	Minnesota Historical Society (St. Paul)
MIHS	Missouri Historical Society (St. Louis)
MSPM	Mike Simkin Phantasmagoria Museum (Birmingham)
NYPL	New York Public Library (New York City)
RB	Richard Balzer Collection (Boston)
RH	Ralph Hyde Collection (London)
SMC	Saco Museum Collection (Saco, Maine)
TW	Thomas Weynants Collection (Gent)
UCLASC	UCLA Special Collections, Young Research Library (Los Angeles)
VATC	Victoria & Albert Museum Theater Collection (London)
WM	New Bedford Whaling Museum (New Bedford, Mass.)
YBL	Beinecke Library Special Collections, Yale University (Yale)

PREFACE:

THE FORMATION OF A PANORAMANIAC

Why would anyone spend many years of his life writing a book like the one you have in front of your eyes? It all began in the 1980s. I was engaged in cinema studies and the cultural history of media and technology, but also had a keen interest in the most recent forms of audiovisual culture. It began to dawn on me that the history of cinema was part of something bigger, although its outlines were still fuzzy. My research on panoramas grew out of my broader interest in optical spectacles. One moment of revelation came at *Le Giornate del cinema muto* in Pordenone, Italy, where I saw early panoramic films shot by rotating the camera 360 degrees.[1] They had obviously been influenced by the panorama, a phenomenon that had existed for over a century before moving pictures on celluloid.[2]

Lecturing and curating sent me crisscrossing Europe, and gave me a chance to experience panoramas first-hand. Between screenings at the World Wide Video Festival (The Hague), I first climbed to the viewing platform of the Mesdag Panorama (1881), and was struck by the powerful sense of immersion.[3] During the 1991 Viper media art festival I went to the rotunda housing Édouard Castres's Bourbaki Panorama (1881) in Lucerne.[4] Its darkened interior contained a *faux terrain* that included a railway car on tracks as if leading into the painting.[5] In 2007, after the Ars Electronica jury had finished its work, I took a train from Linz to Salzburg to see Johann Michael Sattler's Panorama of Salzburg (1829), which had just been put on display in the relocated Museum Carolino Augusteum.[6]

The virtual reality craze that erupted around 1990 also inspired me to research links between current and earlier forms of artificial immersion.[7] It feels logical now that after visiting the Bourbaki Panorama, I went to the Swiss Museum of Transport and Communication to see Ernst A. Heiniger's Swissorama (1984–), a film-based 360-degree panoramic projection. At the headquarters of the IMAX Corporation in Mississauga I familiarized myself with large-screen projection technology, while my many trips to Japan revealed attractions like Galaxian, a hydraulic multiperson "game panorama" I tried at the Namco Wonder Eggs amusement park near Tokyo.[8] At the Futuroscope near Poitiers, France, I experienced

yet more panoramic attractions, including the astounding IMAX Magic Carpet.[9]

Lucky coincidences have often fanned my panoramic passions. I will restrain myself, and mention just a few examples. On a visit to the Conservatoire des Arts et Métiers in Paris in the late 1980s, I came across an unusual contrivance: ten moving picture cameras in a circle. It proved to be Raoul Grimoin-Sanson's unique camera system for the Cinéorama, an ambitious but ill-fated spectacle shown at the Universal Exposition of 1900.[10] An original program leaflet for Norman Bel Geddes's Futurama, an attraction at the 1939 New York World's Fair, found at a flea market, anticipated many similar discoveries at eBay, flea markets, and antique fairs around the world. This has resulted in a sizable collection of panorama-related documents and artifacts, which I have used to illustrate this book.

All these experiences are part of the "mental panorama" from which this book emerged, but most of them will be evoked only in passing through its pages. The focus will be the moving panorama, a once very widespread phenomenon that has fallen into nearly total oblivion. I first found out that such a thing had existed in the early 1990s. A decisive impulse was the huge exhibition *Sehsucht: Das Panorama als Massenunterhaltung des 19. Jahrhunderts* at the Kunst- und Austellungshalle der Bundesrepublik Deutschland (Bonn, Germany) in 1993.[11] It successfully pointed out intricate relationships between all kinds of things panoramic: circular panoramas, miniature toy panoramas, panoramic photographs—and moving panoramas.

Moving panoramas were discussed in the catalog by Ralph Hyde and Kevin Avery, but instead of satisfying my appetite, their essays whetted it. Here was a true "multimedia" phenomenon that had been almost completely forgotten. How was that possible? And so, while shooting my television series *The Archaeology of the Moving Image* (1996), I took the film crew to London to interview Hyde, who had organized the seminal *Panoramania!* exhibition (1988–1989), which I had sadly missed. Hyde patiently answered my questions, and showed me some rare documents from the collection of the Guildhall Library, where he was working as Keeper of Prints & Maps. Hyde introduced me to the seminal research by Dr. Scott B. Wilcox and Dr. Kevin Avery, which, ironically, remains largely unpublished. These three wise men provided the platform around which I began to build my own construct.

My own research began in earnest in 2000, after moving from Finland to Southern California. I lectured about moving panoramas for the first time (within an exposé of media archaeology) at the *Moving Images: Technologies, Transitions, Historiographies* conference at Stockholm University (Dec. 3–5, 2000). It resulted in an article in which I formulated the basic questions: What are moving panoramas? What was their nature as a medium, and their relationship with circular panoramas, dioramas, and magic lantern shows? How were they manifested discursively in journalism, literature, and pictorial traditions? What roles did they play in the cultural contexts in which they were exhibited and experienced?[12]

This book attempts to answer these questions (and many others) in a way that should appeal not only to panoramaniacs, but to anyone interested in broadening one's understanding of visual spectacles, and media culture in general. It will demonstrate a way of doing media studies I call *media archaeology*. Its "mission" can be hinted at by evoking the title of an iconoclastic film about early cinema: *Correction Please, or How We Got into Pictures*.[13] Media archaeology corrects our understanding of the past by excavating lacunas in shared knowledge. It reassesses existing media-historical narratives that are biased because of their ideological and historiographical presuppositions, or insufficient evidence.

Although methodological considerations have normally been hidden between the lines, the book is meant to be read as a kind of *discours de la mèthode*. It may seem like an anomaly in an era that has adopted Quick and Easy as its epithets. I find it alarming that even my academic colleagues tell me they no

longer read books! A huge and detailed volume goes against the grain, but for a reason. It is an argument against those who think that an understanding of anything can be founded on hastily scribbled blogs, text messages distributed to hordes of "friends," or haphazard cutting and pasting from Wikipedia or other online resources. More is needed to grasp the countless paths that link our contemporary culture(s) with those of the past. There are no shortcuts on the "information superhighway."

—Erkki Huhtamo, Los Angeles, June 16, 2012

NOTES

1. Such films were listed in film catalogs as "circular panoramas," "panoramas" or "panoramic views." Charles Musser, *Edison Motion Pictures, 1890–1900: An Annotated Filmography* (Gemona: Le Giornate del cinema muto/Smithsonian Institution Press, 1997), Film Title Index. The word *panning* expresses a discursive continuity.

2. At Pordenone I also witnessed an exhibition of panorama-related items from the private collection of the film historian David Robinson. *Il panorama da Robert Barker All'Omnimax: David Robinson Collection/The Panorama from Robert Barker to Omnimax* (Pordenone: Le giornate del cinema muto, 1–8 October 1988).

3. *The Magical Panorama: The Mesdag Panorama, an Experience in Space and Time*, ed. Yvonne van Eekelen (The Hague: Waanders Uitgevers/Panorama Mesdag, 1996).

4. Brigid Kämpfen-Klapproth, *Das Bourbaki-Panorama von Edouard Castres* (Lucerne: Stadt Luzern, 1980); Heinz Dieter Finck and Michael T. Ganz, *Bourbaki Panorama* (Zurich: Werd Verlag, 2000). The building and the painting were restored heavy-handedly in 1996–2003, wiping away the aura of the original.

5. During the WRO Festival in Wrocław, Poland, I visited the Raclawice Panorama (1894). Jan Poniatowski, *Panorama Raclawicka przewodnik* (Wrocław: Krajowa Agencja Wydawnicza, 1990).

6. As a bonus, it was surrounded by a selection of Hubert Sattler's superb cosmorama-paintings. *Das Salzburg-Panorama von Johann Michael Sattler*, vol. 1, *Das Werk und sein Schöpfer*, ed. Erich Marx und Peter Laub (Salzburg: Salzburger Museum Carolino Augusteum, 2005); *Kosmoramen von Hubert Sattler*, vol. 1, *Metropolen*, Red. Peter Laub (Salzburg: Salzburger Museum Carolino Augusteum, 2006, Salzburger Museumshefte 8).

7. I drew the connection in *Virtuaalimatkailijan käsikirja* ("The handbook of the Virtual Voyager"), ed. Erkki Huhtamo, a special issue of *Lähikuva* (Turku: The Finnish Society of Cinema Studies), nos. 2–3 (1991), pp. 5–6, and later in my *Virtuaalisuuden arkeologia: Virtuaalimatkailijan uusi käsikirja* ("An Archaeology of Virtuality: The New Handbook of the Virtual Voyager"), (Rovaniemi: The University of Lapland, Faculty of the Arts, 1995). I then called moving panoramas "roll panoramas" (p. 108).

8. My "Encapsulated Bodies in Motion: Simulators and the Quest for Total Immersion," in *Critical Issues in Electronic Media*, ed. Simon Penny (Albany: State University of New York Press, 1995), pp. 159–186.

9. Frédérique de Gravelaine, *Le Futuroscope: Le Parc européen de l'image, un lieu pour apprivoiser le futur*, ed. René Monory (Paris: Editions du Moniteur, 1992). Le Futuroscope was opened in 1987.

10. After the museum's years-long renovation, it has disappeared into storage.

11. *Sehsucht: Das Panorama als Massenunterhaltung des 19. Jahrhunderts*, ed. Marie-Louise von Plessen and Ulrich Giersch (Basel: Stroemfeld/Roter Stern, 1993).

12. "Peristrephic Pleasures," in *Allegories of Communication*, pp. 237–238.

13. By the film historian and theorist Noel Burch. "How We Got into Pictures: Notes Accompanying Correction Please," *Afterimage*, nos. 8–9 (Spring 1981), pp. 22–48.

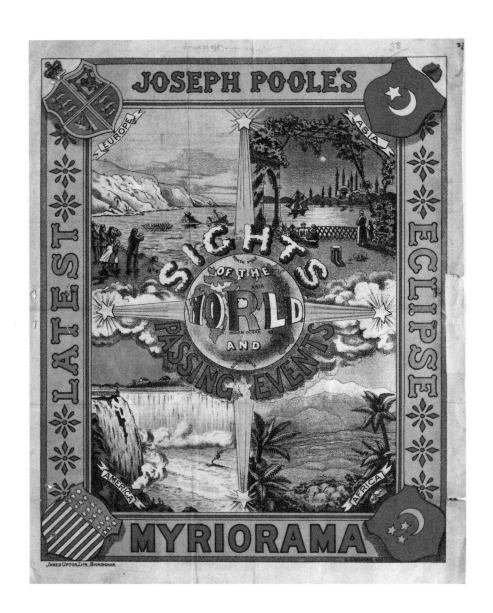

Cover of the booklet "Sights of the World and Passing
Events: Joseph Poole's Latest Eclipse Myriorama," printed in
Birmingham, UK, by James Upton, 1896. Author's collection.

ILLUSIONS
IN
MOTION

Plate 14

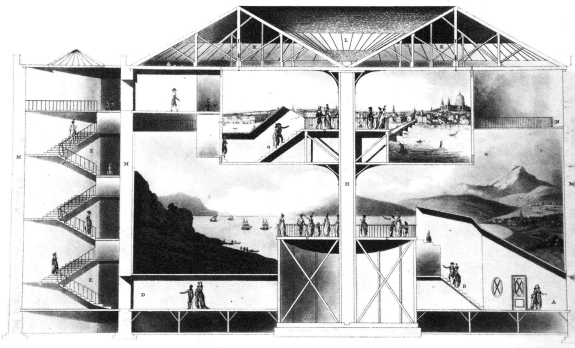

Section of the Rotonda, Leicester Square, in which is exhibited the **PANORAMA**.

Coupe de la Rotonde, dans laquelle est l'exhibition du **PANORAMA**, Leicester Square.

Publish'd May 15, 1801.

Rob.t Mitchell, Arc.t

Figure 1.1
"Section of the Rotonda, Leicester Square, in which is exhibited the PANORAMA." Aquatint, published May 15, 1801. From: Robert Mitchell, *Plans and Views in Perspective, with Descriptions, of Buildings erected in England and Scotland: And also an Essay, to elucidate the Grecian, Roman, and Gothic Architecture; accompanied with Designs* (London: J. Taylor, 1801). Author's collection.

1. INTRODUCTION:

MOVING PANORAMA —A MISSING MEDIUM

THE PANORAMA AND THINGS PANORAMIC

"How often has it been asked by unlettered simplicity,

what is the Panorama? And how often has lettered importance

been gratified in answering the question."

The Critical Review; or Annals of Literature (1794)[1]

To make sense of the moving panorama one must begin with an etymological excavation of the notion of panorama itself. The task is arduous, as a recent Google search I made demonstrated: 122,000,000 hits. The word is used to refer to almost anything—hotels, restaurants, tourist attractions, travel agencies, television programs, computer software, web design companies, and countless "overviews." It has been adopted by numerous languages, such as English, Polish, French, German, Italian, Spanish, Portuguese, Russian, Czech, and Indonesian (not to say anything about countless linguistic variants, such as the Finnish *panoraama*).

Those who routinely use this word may not realize that it was coined with a very specific cultural object in mind. As far as we know, it appeared in print for the first time on Saturday, May 18, 1791, in an advertisement promoting "the greatest IMPROVEMENT to the ART of PAINTING that has ever yet been discovered."[2] The reader found out that a "Panorama building" had been "erected on the Spacious Ground behind Mr. BARKER's House, No 28, Castle-street, Leicester square" (London). It housed a painting covering "ONE THOUSAND FOUR HUNDRED AND SEVENTY-NINE SQUARE-FEET," depicting "one of the best known Scenes in Europe; which, without any other deception than the simple art of the Pencil, appears the same as Nature in extent, and every other particular." Upon entering the premises, the visitor discovered a view of London "taken" from the

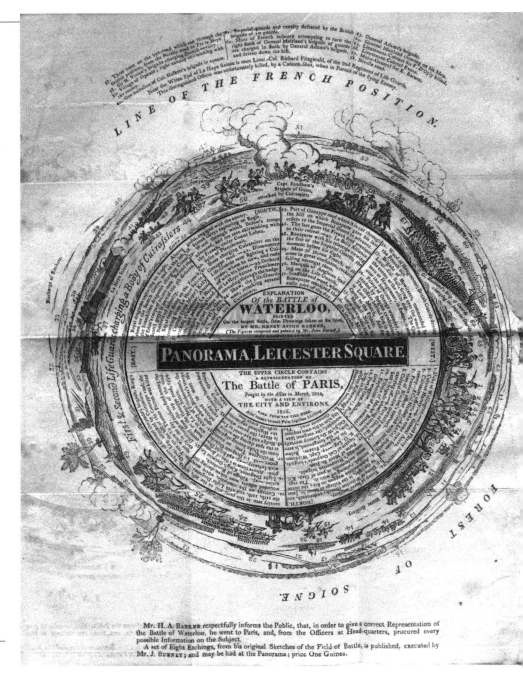

Figure 1.2
The key (above) and the title page (opposite) to the booklet of Barker's panorama of the Battle of Waterloo (Leicester Square, London), *Description of the field of battle, and disposition of the troops engaged in the action, fought on the 18th of June, 1815, near Waterloo; illustrative of the Representation of that great Event, in the Panorama, Leicester-Square* (London: J. Adlard, 1816). Author's collection.

DESCRIPTION
OF THE
FIELD OF BATTLE,
AND DISPOSITION OF THE
TROOPS engaged in the ACTION,
FOUGHT ON THE
18th of JUNE, 1815,
NEAR
WATERLOO;
ILLUSTRATIVE OF THE
Representation of that great Event,
IN THE
PANORAMA,
LEICESTER-SQUARE.

"Rivers of blood I see, and hills of slain,
"An Iliad rising out of one campaign."
Addison's Campaign, 11th and 12th lines.

PRICE SIXPENCE.

1816.

roof of the Albion Mills. The attraction was "opened for Inspection at ten o'Clock every Morning," and could be seen for one shilling—a considerable amount.

This "improvement to the art of painting" was the work of Robert Barker, an Irish-born painter from Edinburgh, who patented in 1787 *An Entire New Contrivance or Apparatus, which I Call La Nature à Coup d'Oeil, for the Purpose of Displaying Views of Nature at large by Oil Painting, Fresco, Water Colors, Crayons, or any other Mode of Painting or Drawing*.[3] An enormous painting of a single location was stretched horizontally along the inner wall of a cylindrical building, so that its ends merged seamlessly. By hiding the upper and lower margins, and controlling the light falling on the painting, it was turned from a representation into an illusory environment. When the visitors climbed onto the viewing platform at the center of the building, they were meant to feel, as Barker put it, "as if really on the very spot."

Contemporaries understood the novelty of this experience:

> No device, to which the art of delineation has given birth, has approached so nearly to the power of placing the scene itself in the presence of the spectator. It is not magic; but magic cannot more

effectually delude the eye, or induce a belief of the actual existence of the objects seen. There is a kind of infinitude in the form of a circle, which excludes beginning and ending; there is a kind of reality which arises from the spectator's ability to inspect every part in turn; and to revert to this incident, or the other, after having contemplated the bearings and effects of different parts of the circle.[4]

The new word was a combination of the Greek roots *pan* (all) and *horama* (view). It was coined between 1787 and 1891 to replace the French original ("view-at-a-glance").[5] This may have been influenced by political trends. French was the language of "modern tyrants." It was out of fashion because of the Revolution, while Hellenism was coming into favor. Greek neologisms were not beyond criticism either, as one writer sarcastically noted: "We soon expelled French denominations, for how could that frivolous language, or the sing song Italian, cope with the truly majestic appellations of Lyceum, Atheneum, Naumachia, Eidophusicon [sic], Eidouranion, Polygraphicon, Polyplasiasmos, Plocacosmos, Phantasmagoria, or Panorama? what melody! what descriptive signification! what Glossological enunciation! what Cardiphonian emphasis!"[6]

After exhibiting his first panoramas in temporary buildings, Barker opened the world's first permanent panorama in 1793 by the Leicester Square.[7] It housed two "circles" one above the other, to have "at all times a picture to exhibit whilst the other is painting."[8] As it often happens in the history of inventions, Barker's primacy was contested by the German theatrical scene painter Johann Adam Breysig (1766–1831). He may well have had similar ideas in mind, but he did not realize or publicize them until Barker and his son Henry Aston Barker were already in business; Breysig was doomed to play the second fiddle.[9]

The word spread like fire. The Theater Royal Haymarket presented *Songs, glees, &c. in the Thespian panorama; or, Three hours heart's ease* already in 1795.[10] A comedy named *Anna* had already stated that "*New* names, and hard ones too, affright the Fair, and *Panorama* makes th'unlearned Stare."[11] Foreign correspondents familiarized the word in other countries. A German reporter wrote in June 1794 about the impatience of the Londoners for the opening of Barker's latest panorama.[12] In New York, a panorama was exhibited as early as 1795, and the first permanent rotunda built in 1804. Paris got its first panorama in 1799, but the word had preceded it by years. By 1801 it was so familiar that it appeared in a grammar of the French language: "*Vous avez vu le Panorama; en êtes-vous content?*"[13] St. Petersburg experienced its first panoramas in 1803, when Johann Friedrich Tielker exhibited views of Rome, Berlin, and Riga.[14] The word was used, but the offerings had little to do with Barker's mighty spectacle.

By the turn of the century the word had "probably been introduced in every European language (if not through exhibitions of the paintings themselves, then through numerous references to them in magazine and newspaper articles)."[15] It soon found its way to book titles, referring to overviews of almost anything.[16] Edward Hazen's *The Panorama of Professions and Trades; or Every Man's Book* (1836) described what the title promised with the help of eighty-two engravings.[17]

Many written "panoramas" had neither illustrations nor connections with visual culture. Mary R. Sterndale's *The Panorama of Youth* (1807) was a book of fairytales, while J. Sharpe's *The Panorama of Wit* (1809) promised "at one view the choicest epigrams in the English language."[18] The shift from the visual to the textual was manifested perfectly by the title of the journal the *Literary Panorama* (1806).

The panorama appealed to the Romantic's desire to peek beyond the horizon, but cannot be sealed within Romanticism only.[19] The spectators's scopic-ambulatory mastery over the surrounding scenery resembled the position of the guard (but not of the inmates) in Jeremy Bentham's contemporaneous idea of the Panopticon.[20] Still, the panorama's spectators' visions were by no means unfettered; they were crafted by commercial and ideological concerns lurking behind the apparently limitless canvas. The panorama's emergence was intertwined with the onslaught of capitalism, imperialism, urbanism, and, in the long run, the emerging era of the masses.

The panorama may have been introduced as a new art form, but it was conceived to create a market for mediated realities and (seemingly) emancipated gazes. As such, it was an early manifestation of media culture in the making. Although it was not wired in the sense of broadcasting or the Internet, it was capable of teleporting its audience to another location, and dissolving the boundary between local existence and global vision. In an era when globetrotting for pleasure and organized mass tourism were taking their first timid steps, panoramas presented resplendent representations of exotic environments and current hotspots. Paris and Istanbul, as well as the battlefields of Waterloo and Gettysburg, were visited by spectators, who became "global citizens" *avant la lettre*.

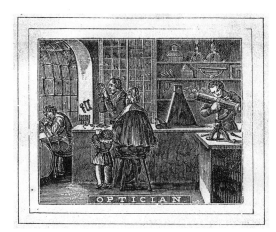

Figure 1.3 + 1.4
The title page of Edward Hazen's *The Panorama of Professions and Trades; or Every Man's Book* (Philadelphia: Uriah Hunt, 1837), and an engraving depicting an optician's shop (from same book). An upright peepshow box is seen on the desk; the selection of optical instruments on the shelves includes a camera obscura. Author's collection.

FROM A STATIONARY TO A MOBILE MEDIUM

We would . . . advise our readers not to neglect the present opportunity of witnessing the most magnificent spectacle which has ever been presented in the Province.

—*Hamilton Spectator*, May 15, 1850

Most circular panoramas conformed quite faithfully with Barker's patent description. Confusing matters, though, other visual forms were also designated as panoramas. These included paintings that were traditional in form, technique and content, but very large.[21] According to Altick, "That complete circularity soon ceased to be part of the popular definition of the new word was due to the panorama's affinity with another current fashion, that of large historical paintings. In practice, the distinction between the two was often blurred."[22] For example, in London commercial one-picture exhibitions had already begun in 1781, years before Barker put his first panorama on display.[23] There were also intermediate formats—huge paintings that covered a semicircle or three-quarters of a circle.[24] Promoting such exhibitions as panoramas adorned them with a new and fashionable label.

The public's fascination was echoed by the names of novelty toys and games. The Myrioramas, Panoramacopias, Panoraphoramas, Dominoramas, Cycloramas, or simply Panoramas had little in common with the huge panoramas. *The Panorama of Europe: A New Game*, published by J. & E. Wallis in 1815, was a board game. The players "visited" forty European cities (anticipating the travelogue format that was a favorite subject of moving panoramas).[25] The effusion of such toys accompanied the vicissitudes of panoramas throughout the nineteenth century, affecting in their own invisible ways how things panoramic were conceived.

There was also the moving panorama. Unlike toys, it enjoyed long-lasting popularity. Moving panoramas were by no means uniform, but their basic "apparatus" could be tentatively summarized as follows.[26] Instead of being surrounded by a stationary wrap-around painting, the spectators sat in an auditorium. A long roll painting was moved across a "window" (often with drawable curtains) by means of a mechanical cranking system. The presentation was accompanied by a lecturer, music, and occasionally sound and light effects. Other attractions,

BANVARD'S PANORAMA.---Figure 1.

Figure 1.5
The mechanism of John Banvard's panorama of the Mississippi. *Scientific American* 4, no. 13 (Dec. 16, 1848): 100. Author's collection.

such as musical acts or feats of *legerdemain*, could also be added. The duration varied, but by the mid-century a length of ninety minutes or more had become common.

The moving panoramas were inspired by the circular panorama, but their forms and cultural identities were quite different. The circular panorama was permanent. Most rotundas were in large cities, or erected at mass events like world's fairs. The short-lived panorama craze that captivated Japan around 1900 was not radically different: permanent rotundas were installed in cities like Tokyo and Osaka, and temporary ones at expositions.[27] The business depended on crowds. Painting a panorama was costly and labor-intensive, so the result had to be displayed for months or even for years to make a profit. After the interest eventually faded, the painting could be rolled up and displayed elsewhere.

For Walter Benjamin the circular panorama epitomized the triumphant urban modernity: "Announcing an upheaval in the relation of art to technology, panoramas are at the same time an expression of a new attitude toward life. The city dweller, whose political supremacy over the provinces is demonstrated many times in the course of the century, attempts to bring the countryside into town. In panoramas, the city opens out to landscape—as it will do later, in subtler fashion, for the flâneurs."[28] The panorama may indeed have mirrored the ambitions of the urban bourgeoisie, but one should not forget that the total number of panorama rotundas was limited. The word may have been on everyone's lips, but the vast majority of people never had an opportunity to experience a real one first-hand.

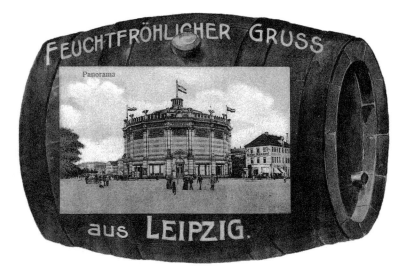

Figure 1.6
Postcard from Leipzig, Germany, showing a typical panorama rotunda inside a beer barrel, c. 1900. Author's collection.

The moving panorama was different: it was an itinerant medium. Although many were exhibited in cities, the showmen were on the move, also visiting the countryside and smaller communities. They exhibited in community halls, local opera houses, theaters, and churches. Successful moving panoramas toured for years. Their titles could be changed, scenes added, and even their subject matter "refreshed," as an anecdote by Charles Dickens demonstrates. Dickens had gone to see a show about "the intrepid navigators, M' Clintock and others." To his surprise, he found out that he had witnessed the *same* panorama already as a child:

> Faithful to the old loves of childhood, I repaired to the show; but pres-
> ently begun [sic] to rub my eyes. It seemed like an old dream coming
> back. The boat in the air, the wounded seal, and the navigators them-
> selves, in full uniform, treating with the Esquimaux—all this was
> familiar. But I rather resented the pointing out of the chief navigator
> "in the foreground" as the intrepid Sir Leopold, for he was the very
> one who had been pointed to as the intrepid Captain Back.[29]

The moving panorama may have appropriated its name and some of its features from the circular panorama, but as an itinerant medium it was also steeped into centuries-old traditions of ambulatory entertainment. It competed with theater troupes, blackface minstrels, automata, wax and dime museums, popular-scientific demonstrations, magicians, public lectures, medicine shows, dioramas, cosmoramas, and magic lantern shows.[30] This eclectic (w)underworld mediated the civilizing process, familiarizing city people and small-town audiences alike with current news and fashions. The cunning showmen assured their audiences that their shows were uplifting, moral, and suitable even for children and clergymen.

Returning to Benjamin's interpretation of the circular panorama, it could be claimed that the moving panorama's trajectories pointed to the *opposite* direction: away from urban centers and toward the periphery. But did the moving pan-orama simply extend the domination of the urban bourgeois worldview? It was, at least to an extent, a vehicle for homogenization. However, simply presuming that local audiences always took urban imports at face value would trivialize the matter. All moving panoramas were not emphatically urban products, and all spectators did not receive them in uniform ways. Their performances became sites where social attitudes and cultural identities were negotiated.

However, in spite of their differences, circular and moving panoramas were not diametrically opposed. They shared features and topics, and responded to similar desires. More than the subject matter, it was the "packaging" of the attraction, the constitution of the viewing apparatus, and its actuation in concrete exhibition practices that separated them. Circular panoramas empha-sized immersion into a place or event, while moving panoramas relied more on narration and combinations of different means of expression. The sensation of traveling virtually from place to place, or from topic to topic, was important for the latter, but seamless immersion was not the primary goal. To understand these spectacles, one must consider both their differences and their similarities.

Figure 1.7
"Grand Artistic and Historical Exhibition! The Myriopticon."
Printed by Samuel Bowles & Company, Springfield, Mass.,
c. 1866. This broadside was part of Milton Bradley's
The Myriopticon. A Historical Panorama of the Rebellion,
a miniature moving panorama for domestic use. In tongue-
in-cheek fashion, its text imitates the broadsides used
by professional showmen. Turned into a stock image, the
design of this broadside has been used many times ever
since, by Fluxus artists as well as by advertisers of Scotch
whisky. Author's collection.

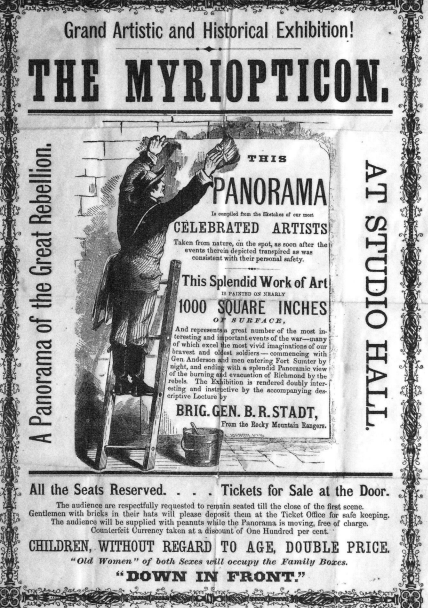

FROM THE SHADOW OF THE MIGHTY ROTUNDA

Most histories of the panorama mention the moving panorama, but relegate it to a secondary role. Instead of admitting that it had a significant cultural identity of its own, it is considered a minor spin-off.[31] Heinz Buddemeier's *Panorama, Diorama, Photographie* (1970) does not mention it at all.[32] Oettermann's authoritative *The Panorama: History of a Mass Medium* dedicates to it only about twenty-five of its 400 pages.[33] Silvia Bordini's *Storia del panorama* (350 pages) and Bernard Comment's *The Painted Panorama* (272 pages) are even more sparse: about four pages in each.[34] Comment admits that the moving panorama "brought about a radical shift in relation to the circular panorama, a shift that involved another logic," but he does not follow up his comment and elaborate on this logic.[35]

Why this silence that almost feels like a *damnatio memoriae*? It is worth noting that BUDDEMEIER, Oettermann, Bordini, and Comment all come from Continental Europe, where the circular panorama was the most visible and the most respected panoramic form. Moving panoramas were exhibited, but the major ones were British or American imports. They never attained as much attention in Continental Europe as on the British Isles, the United States, Australia, and New Zealand. Countless "diaphanoramas," "optical cabinets," "optical-mechanical theatres," "painterly room-travels" (*Malerische Zimmerreise*), "room panoramas," and even "moving panoramas" (*Beweglisches Panorama*) were exhibited by itinerant showmen at fairs and fairgrounds, but most were ephemeral small-scale attractions that have not received attention from scholars looking for "higher" cultural forms.[36]

Language may have been a factor. Circular panoramas did not originally use lecturers, whereas moving panoramas were associated with a showman. Expressions like "Banvard's Panorama" or "Burr's Seven Mile Mirror" were typical. The idiosyncratic ways in which John Banvard, Albert Smith, or Artemus Ward accompanied their panoramas were an essential part of their success. The linguistic, political, and economic borders that crisscrossed Europe caused extra costs; lecturers had to be hired, promotional material created, taxes paid, and permissions obtained. English speakers avoided much trouble by remaining in their own linguistic territory. American and British showmen routinely crossed the Atlantic, but some sailed all the way to Australia and New Zealand, finding appreciative audiences everywhere.

The field of art history has been broadening its focus from classical and modernist high art to hitherto neglected areas such as printed ephemera, art brut, comics and cartoons, advertising imagery, and popular visual media.[37] The circular panorama fits within this framework between academic painting and architecture, popular visual spectacles, and the emergent mass culture. Academic art historians can connect panorama paintings with forms they are familiar with, such as baroque church interiors, rococo wall paintings, large-scale history paintings, vedute, topographical prints, and pencil sketches in the tradition of

voyages pittoresques. Comment's, Bordini's, and, to a degree, Oettermann's books demonstrate that the circular panorama is a perfect subject for mildly revisionist art history—not too radically different, but not too conventional either.[38]

The early panorama painters had pretensions to the status of fine artist. They painted in oil, evoking the traditions of academic art.[39] Moving panorama painters favored distemper, a cheap water-based solution used by theatrical scene painters and fairground artists. Their products were hastily concocted ventures aimed at making a quick profit. Determining the correct ratio between cost, time, desired effect, and scope was crucial. This is how the prospective showman Wesley Tiffles, a.k.a. Professor Wesley, one of the characters of John Bell Bouton's delightful novel *Round the Block* (1864), planned to realize his Panorama of Africa:

> The canvas will be about four hundred feet long. One half of it will be a dead level of yellow paint, for desert; and the rest, perpendicular stripes of green paint, for jungle. A good artist, with a whitewash brush and two tubsful of paint, ought to do up the whole panorama in two days. The heads and tails of animated life, the two small lakes, and a few other objects of interest, such as the sun, the moon, birds flying in the air, &c., could be put in afterward by an artist of higher grade.[40]

Bouton has used his writer's license, but the issues are real. Many moving panoramas were closer to theatrical scenery or folk art than to academic history painting. It was the motion and the added attractions that compensated for the unrefined canvas. This may partly explain why moving panoramas are yet to be appreciated and analyzed by art historians.

It is not a surprise that the moving panorama has been mostly studied in the English-speaking world. Early scholars like Joseph Earl Arrington and John Francis McDermott laid the groundwork. Arrington published detailed articles about American showmen, while McDermott wrote a history of moving panoramas depicting the Mississippi.[41] Richard D. Altick covered the topic at some length in *The Shows of London* (1978), and so did Scott B. Wilcox (1976) and Kevin Avery (1995) in their dissertations and articles.[42] Ralph Hyde has also published seminal texts.[43] Recent signs of emerging interest include Mimi Colligan's *Canvas Documentaries* (2002), a history of panoramic entertainments in Australia and New Zealand, and Hudson John Powell's monograph of the Poole showman family (2002). Moving panoramas have also appeared in contexts ranging from orientalism and photography to representations of the Arctic.[44]

My own field, media studies, has paid scant attention to moving panoramas. Although scholars of early cinema have discussed developments that anticipated celluloid-based moving pictures, moving panoramas have rarely been included.[45] They are absent even from Laurent Mannoni's *Le grand art de la lumière et de l'ombre*, an extensive exploration of the "archaeology of cinema."[46] In the mid-1980s Charles Musser coined the concept "history of screen practice," explaining that it "presents cinema as a continuation and transformation of magic lantern traditions in which showmen displayed images on a screen, accompanying them

with voice, music, and sound effects."[47] But so did moving panorama showmen whom Musser does not mention, perhaps because they did not use projections, and the picture windows across which their moving paintings rolled do not qualify as screens.[48]

Giuliana Bruno's *Atlas of Emotion. Journeys in Art, Architecture, and Film* (2002) mentions moving panoramas only in passing, although they would have been relevant for the argument of the book.[49] Barbara Maria Stafford and Norman M. Klein acknowledge them briefly, and not without confusions.[50] Anne Friedberg's *Window Shopping* (1993) discusses circular panoramas and dioramas as tokens of emergent mobile spectatorship, associating them with the *flâneur* in the arcades of Paris, the *"flâneuse"* in department stores, and the visitors of the 1900 Universal Exposition on the *trottoir roulant*.[51] Friedberg demonstrates that the cinema chose another route, immobilizing the spectator's body, and emphasizing virtual movement on the screen instead. This was anticipated by the moving panorama by nearly a century, but Friedberg does not mention it.

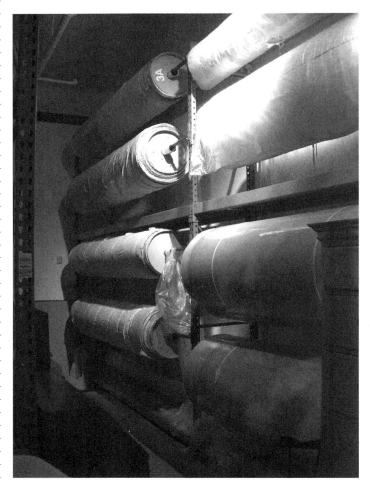

The moving panorama may have been neglected because it was later subsumed into screen-based media, while circular panoramas and dioramas retained their distinctive identities, becoming signposts for retroactive cultural theorizing by critics like Walter Benjamin and Dolf Sternberger, the author of the *Panorama of the 19th Century*.[52] For Sternberger, the panorama was nothing less than the key to "how the 19th century man

Figure 1.8
The rolls containing *Purrington and Russell's Original Panorama of a Whaling Voyage Round the World* (1848) in storage at the New Bedford Whaling Museum, New Bedford, Massachusetts. Photo: Erkki Huhtamo, May 2009. Courtesy of the New Bedford Whaling Museum, New Bedford, Massachusetts.

saw himself & his world & how he experienced history."[53] He found its echoes everywhere—in steam power, railway travel, the Western idea of the Orient, domestic lighting, etc.[54] His argument shifted (without acknowledging it) to the moving panorama, when he described Charles Darwin's grand "spectacle": "An endless panorama unrolls before us, and its name is: Evolution. One might almost think that this word itself indicated the long, unfolded picture."[55]

The moving panorama's apparatus, its relationships to other media, and its role(s) in the culture of its time can provide valuable windows for observing media in operation. Alison Griffiths's *Shivers Down Your Spine* (2008) demonstrates an acute awareness of the moving panorama's nature, and its connections with other cultural forms.[56] However, it is only one of the topics of her book. *Illusions in Motion* aims not only to fill in media-historical lacunas and correct mistakes caused by uncritical reliance on second-hand sources; it attempts to analyze the moving panorama in all its complexity, and to situate it within media culture in the making.

THE PAINTED, THE PERFORMED, AND THE DISCURSIVE PANORAMA

In an article about the forthcoming Universal Exposition of 1900, the *Brooklyn Eagle* mentioned that it was going to include "an old-fashioned [moving] panorama as one of the side shows," continuing: "This may revive a sort of exhibition that had seemingly passed from existence as absolutely as the froth of yestreen's beer. Yet it is not so long ago that the panorama was as well known as the stereopticon [magic lantern] show is known to-day [sic]."[57] The newspaper found it necessary to explain that canvases "were unrolled before our eyes, wrinkling and creaking, while the man at the crank pounded a bass drum behind the scene." "Dr. Judd," a former panorama showman, seconded this in 1904: "There is one branch in the history of the United States neglected by historians; they do not give any account of the old showmen and their shows that were perambulating the country in the early days."[58]

If the moving panorama was already a lost medium, how much more lost is it today? Hundreds, possibly thousands were painted, but only a handful have been preserved (see the appendix). Securing "miles" of canvas was expensive, so new panoramas were sometimes painted over earlier ones. Others were displayed until they literally fell into pieces, after which they were silently discarded, or cut into sections used as theatrical scenery or framed pictures.[59] John Banvard's panoramas of the Mississippi and the Holy Land may have been used as insulation material.[60] The "Panorama of Africa" in Bouton's *Round the Block* was cut into pieces and turned into window curtains—the only way it made any money.[61]

The surviving canvases are usually so brittle that rolling them will no longer be possible. Even opening the rolls is risky, because the paint may flake off and the canvas be torn. Producing a replica, either digitally or on canvas, is possible. Brown University has digitized its *Garibaldi Panorama* (c. 1860) and made it available on the Internet.[62] The Saco Museum in Maine has restored *The Moving Panorama of Pilgrim's Progress* (1851), miraculously recovered from its storage, and fabricated a full-size replica.[63] In Los Angeles, a team of panoramaniacs at the Velaslavasay Panorama (a cultural center housing a modern circular panorama) recently created *The Grand Moving Mirror of California* (2010), a free interpretation of a moving panorama exhibited in the 1850s by the showman L. Eaton Emerson. Although the panorama has long since disappeared, the lecture text that accompanied it survives.[64]

Initiatives like these open valuable windows to the realm of lost media, but their revelations can hardly be generalized. We cannot assume that *all* panoramas and their presentations were alike. Even determining what a certain panorama may have looked like can be an arduous task. Did it represent a continuous scene, or consist of a series of *tableaux*? Were the *tableaux* distinct, or did their edges dissolve into each other? Were narrative conventions, such as variations between "long shots" and "close-ups," used? Were parts of the canvas made translucent to allow dioramic light effects? Even such a basic issue as the height and the length of the roll can be difficult to determine. It would not be wise to trust showmen's hyperbolic claims about canvases that were several miles long.

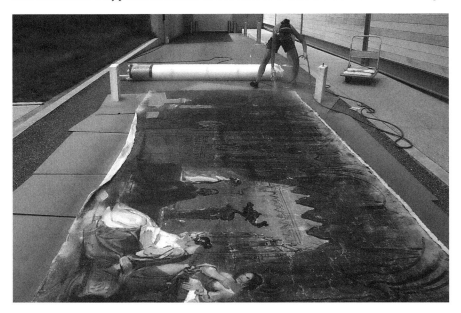

Figure 1.9
The rediscovered *Moving Panorama of Pilgrim's Progress* receiving treatment during conservation. The restored panorama was first exhibited in 2012. Photograph: Matthew Hamilton. Courtesy of Dyer Library / Saco Museum, Saco, Maine.

Crossing over from paintings to performances raises another set of questions. Were there features that remained constant? What kinds of variations existed? How did the shows develop over time? What roles did the lecturer, music, sounds, and visual effects play? How did audiences respond? How were moving panoramas related with other media forms? How were they assessed within different cultural environments? Performances were occasionally reviewed in the press, but rarely described by those who attended them.[65] Answers must be patched together from highly heterogeneous sources—show handbooks, pamphlets, panorama keys, broadsides, newspaper notices, reviews, illustrations, prints, journalism, fiction, poetry, panorama spoofs, toys, and ephemera.

Jeffrey Ruggles has made a useful distinction between the painted and the performed panorama that will be adopted here.[66] The former was the product of the painter, a roll of pictures. It turned into a performed panorama when it was unrolled in front of the spectators, who also listened to the lecturer, observed his gestures, enjoyed the music, and admired the special effects. All these issues influenced how the panorama was interpreted, and so did the mode of cranking: the painting metamorphosed depending on the speed with which it moved, the cranking direction, and the choice of rolling it continuously or intermittently. While gazing at the canvas, the spectators must also have been aware of other spectators, as well as issues such as the design and the temperature of the auditorium.[67] Such factors were elements of the moving panorama *apparatus* as a performative medium.[68]

But moving panoramas were not only painted and performed—they were also fantasized about, and evoked by words and illustrations. Some texts, including Nathaniel Hawthorne's short story "Main Street" (1849), used features of panoramic entertainments as their narrative backbones, while others referred to them metaphorically. Crowds, and even clouds, began moving like panoramas.[69] Moving panoramas were associated with anything from celestial mechanics to biblical prophecies: "As in a moving panorama, there passed before the prophet's vision the scenes of history. Earthly kingdoms were represented under the symbols of beasts."[70] According to the philosopher George Santayana, "matter, with all its vibrations felt in detail, forms one moving panorama with all the minds."[71]

A third term must therefore be added to Ruggles's distinction: the *discursive panorama*. It refers to the moving panorama as a figure of speech, writing, or visual representation. Panoramas of the imagination are no less interesting, or real, than the concrete ones. Their massive cultural presence demonstrates how the media penetrate minds and provide schemes for experience. Although the moving panorama as a spectacle disappeared long ago, it survives in discursive form. Both Henry Miller and Arthur C. Clarke used it as a metaphor.[72] It also surged from cultural memory in *Elvis' Search for God* (1998), when Jess Stearns described how the singer "felt a surge of emotion, as the moving panorama of the gilded years floated by for a moment."[73] In such discursive contexts the moving panorama can be interpreted as a *topos*—a persistent cultural formula that appears, disappears, and reappears, gaining ever-new meanings in the process.

TRACING THE TOPOI:
THE MEDIA ARCHAEOLOGICAL APPROACH

Sir Joshua Reynolds is said to have recommended the mechanical-optical spectacle known as Eidophusikon "as the best school to witness the powerful effects of nature" for girls practicing drawing.[74] In a similar anecdote, Jacques-Louis David, the well-known painter, visits Pierre Prévost's panorama with his students. After examining it for a few minutes, he exclaims: "Gentlemen, indeed, it is here one must come to study the nature."[75] Anecdotes like these tell us something about contemporary attitudes toward illusionistic spectacles, but they don't prove that any such events took place. They are best read as manifestations of an age-old topos about the painter's wondrous skills in imitating nature and, as a consequence, about the relationship between reality and its representation.

Examples about visual confusions between things that are real and things that are illusory can be found from many different eras and cultures.[76] Even animals are claimed to have mistaken panoramas for reality. A Newfoundland dog that was said to have accompanied a visitor to Barker's panorama of the *Grand Russian Fleet at Spithead* (1793) was said to have jumped over the hand-rail of the viewing platform to rescue the men struggling for their lives in the sea.[77] The same topos appeared a century later, in 1890, when it was reported that a cat being chased away from a cyclorama (circular panorama) building had tried to escape to a tree that proved to be just painted on the canvas.[78]

Topoi are building blocks of cultural traditions; they manifest both continuities and transformations in the transmission of ideas. Media-related topoi may serve various roles: as connectors to other cultural spheres; as commentaries and elaborations of media-cultural forms, themes, and fantasies; or as formulas deliberately used for profit or ideological indoctrination. Although some of their occurrences can be just local and personal (like poetic metaphors derived from tradition), recurrent topoi may symptomatically point to broader concerns and cultural patterns.

Researching the "life" of topoi is a task for media archaeology, an approach I have been involved in developing during the past two decades.[79] I see it as a way to penetrate beyond accepted historical narratives, uncovering omissions, gaps, and silences. The very topic of this book is a huge lacuna and therefore ideally suited for a media-archaeological investigation. All ways of doing media archaeology don't match each other neatly.[80] An influential "school," inspired by the work of Friedrich Kittler, emphasizes material factors as prime movers of media history. From inscriptions on writing surfaces, phonograph cylinders, or celluloid film to machine architectures, computer code, and digital archives, "Kittlerian" media-archaeologists trace the tightening grasp of the technological on the cultural.

Kittler's own *Optical Media* represents media history as a veritable "march of the machines."[81] Inventors are mentioned, but their creations seem controlled

by some external machinic logic rather than by human desires and needs. What Kittler provocatively calls "so-called humans" rarely appear in his writings that have been called "media studies without people."[82] This is logical, because Kittler's media history tells about the increasing mastery of smart machines over humans—a development the author's antihumanistic stance endorses. The digital revolution signals the end of (media) history, and ultimately, the end of the human being as we have known it.

The work of Michel Foucault has been a strong influence on Kittler and his followers, as well as on scholars of visual culture such as Jonathan Crary.[83] Like Foucault, both Kittler and Crary deal with the past, but mainly to use it as a canvas upon which to project theoretical formulations and schemes derived from the present. With good reason, they have often been criticized for their selective use of historical evidence.[84] All three have suggested macro-level historical "organisms," purporting to identify moments of discontinuity between them. Kittler wrote about the discourse networks ("notation systems") of 1800 and 1900, while Crary famously posited a perceptual transformation that supposedly took place in the early nineteenth century, epitomized by symptomatic optical instruments.[85] It could be argued that sources were selected to support such models, instead of allowing the full range of historical evidence to test and inform them.[86]

While I share with Kittler, Crary, and Foucault their interest in the discursive dimension of culture, my work differs from theirs in that it does not try to posit large-scale cultural formations and ruptures between them. It is more concerned with understanding how media spectacles function in and between local circumstances, giving rise to discursive "transfigurations." This book therefore advocates a different media archaeology, making a case for humans who concoct media spectacles with other humans in mind. Their interactions—collective and individual, conscious and unconscious—mold the media. The stance is closer to Anglo-American cultural studies, and is based on the assumption that although hard technological facts matter, the discourses that envelop them and mold their meanings play an even more decisive role. I endorse Carolyn Marvin's formulation:

> Media are not fixed objects: they have no natural edges. They are constructed complexes of habits, beliefs, and procedures embedded in elaborate cultural codes of communication. The history of media is never more or less than the history of their uses, which always lead us away from them to the social practices and conflicts they illuminate.[87]

Although this book stays close to its sources, it does not adhere to old-school positivism. Admittedly, it is necessary to uncover the object of study from the layers of historical residue under which it has been buried, but one should avoid the temptation to clean and polish it until it will sparkle in the unambiguous light of certainty. The moving panorama never had an unchanging and clearly delineated identity; giving it one a posteriori would be an act of falsification. At any moment, it was influenced by its surroundings and influenced them in its turn; its "identity" resided in this ever-changing tension and interplay. Rather

than as an ahistorical entity, a projection from the future, or an anticipation of things to come, the moving panorama is treated here as a complex and contradictory token of its time.

FROM OBLIVION TO RESURRECTION: A ROAD MAP

This book is best read from cover to cover, but each chapter forms a coherent whole and can be studied separately. Because one of the underlying premises of *Illusions in Motion* is that the moving panorama cannot be considered merely as an offshoot of the circular panorama, the book begins by exploring cultural forms that anticipated it (chapter 2). After an etymological discussion of the origins of the expression "moving panorama," it will review traditions of visual storytelling that flourished centuries before the moving panorama proper first appeared.

Of particular interest are picture scrolls used within these traditions. A good example is the Javanese *wayang bèbèr* that anticipated aspects of the moving panorama performance in an almost uncanny way. It presents a problem familiar for cultural anthropologists: it is difficult to judge where its influences came from, and whether it could have directly influenced Western moving panoramas. In the eighteenth century in the West picture rolls were used in three forms: as "software" in peepshow boxes, as moving landscape transparencies presented by a Frenchman named Carmontelle, and as "pocket-size" miniature panoramas. The issue of cultural transmission will haunt us again; to make sense of these traditions and their possible interconnections some speculation is unavoidable.

The moving panorama proper began to develop in England in the early nineteenth century. Two forms emerged side by side: the peristrephic panorama, and the moving scenery used on the theater stage. Peristrephic panoramas that will be discussed in chapter 3 have remained a white spot of panorama history until now. As this book reveals, they had an identity of their own as a transitory form between circular panoramas and later moving panoramas. Theatrical panoramas, the topic of chapter 4, were inspired by circular panoramas, but they were also a logical development from innovations in scenography and scene painting. Eidophusikon, an optical-mechanical spectacle created by the scenic artist Philippe Jacques de Loutherbourg, was particularly influential as a model for both stage designers and itinerant showmen.

Chapter 5 will focus on the Diorama, a spectacle that was both a challenge and an inspiration for moving panoramas. In its original form, as introduced by the French painters Charles-Marie Bouton and Louis-Jacques-Mandé Daguerre, it was a permanent urban institution, but transportable roadshow versions were soon produced by others, and dioramic features added to moving panoramas; some of them even came to be known with a hybridized title as moving dioramas. The Diorama could be characterized as one of the "known unknowns" of

the history of spectacles. Although its basic features are familiar, its complex relationship with the moving panorama and other media forms such as mechanical theaters and dissolving views (a type of magic lantern show) has received little attention.

The moving panorama reached its apogee in the 1850s with the raging "panoramania."[88] Chapter 6 discusses this phenomenon, including the developments that led to its formation. Chapter 7 is a case study dedicated to a central figure of the panoramania era, the British journalist and writer Albert Smith, who became a showman. *Albert Smith's Ascent of Mont Blanc* (1852–1858) was arguably the most successful moving panorama show of all times, performed for seven years in a row at the Egyptian Hall in London. Smith's career was at the same time typical and unusual. It provides a close-up of the media industry at its formative stage.

Although it may have reached its apogee, the moving panorama had a visible presence for the rest of the century. The basic question underlying chapter 8 sounds: what do we know about the microphysics of the moving panorama performance? Resorting to panorama parodies as one of its sources, it dissects the moving panorama apparatus and demonstrates how it was activated in concrete circumstances. The American Civil War provided a lucrative topic for touring panorama showmen, who began to feel the pressure of competitors, in particular of magic lantern shows with novelties such as dissolving views and photographic lantern slides. As chapter 9 will explain, fierce competition developed between them, leading to discursive battles, where slogans and announcements were used as weapons.

Chapter 10 will explore the vicissitudes of the moving panorama during its final decades. In the British Isles the scene was dominated by the touring exhibitions of the Hamilton and Poole family dynasties, while on the European Continent moving panorama canvases were incorporated in fairground shows featuring mechanical puppets, slide projections, and other forms. From the 1870s the moving panorama was influenced by the renewed popularity of the circular panorama. At international expositions its features were merged with large-scale immersive spectacles. Hugo d'Alési's Maréorama was the most ambitious of these hybrids. Its integral illusion separated Maréorama from the moving panoramas of the past and pointed toward specialty attractions of the future.

Chapter 11 revisits the history of the moving panorama on a higher level of abstraction by excavating the discursive panoramas imagined by novelists, poets, journalists, scientists, philosophers, and propagandists. Particularly during the latter half of the century the moving panorama was evoked in many different contexts, ranging from travel accounts to religious tracts and psychological explorations of the human mind. The proliferation of discursive panoramas demonstrates how material things are "transfigured" into cultural entities that drift away from their original impulses and attain different meanings and statuses. As a topos the moving panorama is still alive, having outlasted its concrete manifestations as a spectacle.

The conclusion (chapter 12) will open up a broader "panoramic" view and reflect on the moving panorama's role in the formation of media culture. What does it mean to say that we live in a media culture? What defines media culture

as a cultural, social, economic, and mental condition? When did such a condition first develop? The answers to such seemingly easy questions are anything but self-evident. The final speculations will necessarily be tentative, pointing toward future excavations.

Figure 1.10
The rotunda for the "Great Scottish National Panorama - Battle of Bannockburn," Glasgow. The panorama, painted by the Munich artist Philipp Ernst Fleischer, was exhibited in this building between 1888-1895. Part of in survives as wall murals in a conference room at Peebles Hotel Hydro (Peebles, Scotland). Undated tradecard, author's collection.

NOTES

1.	*The Critical Review; or Annals of Literature* (London: Printed for A. Hamilton), vol. 9 (1794), p. 477.

2.	*Oracle* (London), no. 624 (May 28, 1791). It was to be opened the following Monday, May 20. My find pushes back the assumed first appearance, June 11, 1791 (*Morning Chronicle*), suggested by Scott B. Wilcox, "Erfindung und Entwicklung des Panoramas in Grossbritannien," in *Sehsucht*, p. 35, n. 11. Richard D. Altick only says the word "came into use in 1791" in *The Shows of London* (Cambridge, Mass.: Belknap Press of Harvard University Press, 1978), p. 132. Stephan Oettermann's *The Panorama: History of a Mass Medium*, trans. Deborah Lucas Schneider (New York: Zone Books, 1997, orig. 1980) claims that the word "appears to have entered the English language sometime between 1787 and 1795, but most probably not before 1792" (p. 6). An advertisement in *The Times* (Jan. 10, 1792) is mentioned as the first occurrence (p. 101). Bernard Comment, *The Painted Panorama*, trans. Anne-Marie Glasheen (New York: Harry N. Abrams, 1999) mentions the *Times* in "January 1792" (p. 7).

3.	"Apparatus for Exhibiting Pictures," British patent no 1612, granted June 19, 1787. Facsimile in Laurent Mannoni, Donata Pesenti Campagnoni, and David Robinson, *Light and Movement: Incunabula of the Motion Picture 1420–1896* (Gemona: La Cineteca del Friuli/Le Giornate del Cinema Muto, 1995), pp. 157–158. For stories about how Barker got the idea, Altick, *The Shows of London*, p. 129. The inspiration is said to have come from the ray of light cast from above to his prison cell, where he had been locked up by his creditors. Panoramas were illuminated by natural light from above. *The Panorama Phenomenon: Mesdag Panorama 1881–1981*, ed. Evelyn J. Fruitema and Paul A. Zoetmulder (The Hague: Foundation for the Preservation of the Centenarian Mesdag Panorama, 1981), pp. 13–14.

4.	"Considerations on the Panorama View of Grand Cairo, composed by Mr. Barker from the Drawings of Mr. Salt, who accompanied Lord Valentia, now exhibiting in London," *The Literary Panorama, being a Review of Books, Magazine of Varieties, and Annual Register [etc.]*, vol. 7 (London: Cox, Son, and Beylis for C. Taylor, 1810), p. 448.

5.	According to Scott B. Wilcox, "friends of the proprietor provided him with a new title which was sufficiently striking to gain a permanent place in the English language." "Unlimiting the Bounds of painting," in Ralph Hyde, *Panoramania! The Art and Entertainment of the "All-Embracing" View* (London: Trefoil Publications in Association with Barbican Art Gallery, 1988), p. 20.

6.	Barnaby Banter, "Popular Progress of Recondite Learning," *The Literary panorama* (London: C. Taylor), vol. 1 (1807), p. 834. The writer added: "Not even yourself, Mr. Panorama, can explain the deep import of Kneph, Bubastis, Hermempthe."

7.	The building was designed by the architect Robert Mitchell. Its shell still exists, housing a Catholic church, Notre Dame de France. William H. Galperin is wrong when he writes that "Barker's Panorama, both the building in Leicester Square and the numerous representations displayed therein, have long since vanished." *The Return of the Visible in British Romanticism* (Baltimore: Johns Hopkins University Press, 1993), p. 36.

8.	From a review of Mitchell's book *Plans, and Views in Perspective, with Descriptions of Buildings erected in England and Scotland* (1801), in the *Monthly Mirror* (London: for the Proprietors by J. Wright), vol. 15 (1803), p. 100.

9.	Oettermann, *The Panorama*, pp. 191–196. Still in 1885, Arthur Pougin, *The Dictionnaire historique et pittoresque du théâtre et des arts qui s'y rattachent* (Paris: Librairie de Firmin-Didot et Cie, 1885, p. 577) claimed that the panorama "was imagined in the eighteenth century by a German, Professor Breysig from Danzig; in 1793, Robert Barker introduced it in Edinburgh, and the famous American Robert Fulton brought it to France in 1804" (author's translation). The information is generally incorrect.

10.	*Songs, glees, &c. in the Thespian panorama; or, Three hours heart's ease: As performed at the Theater-Royal, Hay-Market* (London: J. Barker, at the Dramatic Repository, 1795). I have not seen this source.

11.	*European Magazine, and London Review* 23 (March 1793): 231.

12.	"Aus einem Briefe vom Windsor, 18. Jun. 1794," *Neue Bibliothek der schönen Wissenschafen und der freyen Künste*, ed. C. F. Weisse (Leipzig: Dyck, 1794), vol. 53, pp. 377–378.

13.	Lewis Chambaud, *A Grammar of the French Tongue*, 13th ed. (London: A. Strahan, 1801), p. 250.

14.	*Monthly Magazine; or, British Register* (London: J. Adlard for Richard Phillips), vol. 17 (July 1, 1804), p. 593. About Tielker: Oettermann, *The Panorama*, pp. 201–203.

15.	Oettermann, *The Panorama*, p. 6.

16.	For example, James Smith, *The Panorama of Science and Art* (Liverpool: Nuttal, Fisher and Co., 1815).

17.	One of them depicts an optician's shop with instruments including a peepshow box. Edward Hazen, *The Panorama of Professions and Trades; or Every Man's Book* (Philadelphia: Uriah Hunt, 1838).

18.	[Mary R. Sterndale], *The Panorama of Youth, in Two Volumes* (London: J. Carpenter, 1807); J. Sharpe,

The Panorama of Wit: Exhibiting at one view the choicest epigrams in the English language (London: J. Sharpe, 1809).

19. Götz Grossklaus, *Natur— Raum: Von der Utopie zur Simulation* (Munich: iudicium, 1993), p. 68.

20. This parallel was noted by Nathaniel Hazeltine Carter on his visit to a panoptic prison (Bridewell) in Edinburgh in *Letters from Europe, Comprising the Journal of a Tour Through Ireland, England, Scotland, France, Italy, and Switzerland, in the Years 1825, '26, and '27*, vol. 1 (New York: G. & C. Carvill, 1827), p. 255; Anne Friedberg, *Window Shopping: Cinema and the Postmodern* (Berkeley: University of California Press, 1993), pp. 17–20.

21. Iris Cahn, "The Changing Landscape of Modernity: Early Film and America's 'Great Picture' Tradition," *Wide Angle* 18, no. 3 (July 1996): 85–94.

22. Altick, *The Shows of London*, p. 136.

23. Ibid., 105. The originator of the one-picture show was John Singleton Copley, "an American with a fully developed exploitative sense." He charged an entrance fee and sold engravings of the exhibited work.

24. Barker's first panorama, a view of Edinburgh, covered only a semi-circle. Robert Ker Porter's *The Storming of Seringapatam* (1801) and *The Siege of Acre* (1801) were half- or three-quarter circles. This was reflected in the design of their keys (Oettermann, *The Panorama*, pp. 115–116).

25. *Catalogue two hundred and eight* (London: Marlborough Rare Books, 2007), p. 35 (no. 75). Copies of the game in JJG and HL.

26. For an illustration of a typical moving panorama's mechanism, "Banvard's Panorama," *Scientific American* 4, no. 13 (New York, Dec. 16, 1848): 100.

27. A panorama of the battle of Vicksburg found its way from the United States to Japan, where it was presented in a wooden rotunda in Asakusa, Tokyo. Panoramas were also painted locally. Some were shown at shrines like the one in Narita near Tokyo, no doubt because of the crowds. Machiko Kusahara, "Panoramas in Japan," in *The Panorama Phenomenon*, ed. Tom Rombout (Den Haag: Panorama Mesdag, 2006), pp. 81–88.

28. Walter Benjamin, "Paris, the Capital of the Nineteenth Century (Exposé of 1935)," in *The Arcades Project*, trans. Howard Eiland and Kevin McLaughlin (Cambridge, Mass.: Belknap Press of Harvard University Press, 2002), p. 6.

29. Charles Dickens, "Moving (Dioramic) Experiences," *All the Year Round*, March 23, 1867, p. 305.

30. About itinerant occupations, Peter Burke, *Popular Culture in Early Modern Europe* (New York: New York University Press, 1978), pp. 91–115; Richardson Wright, *Hawkers & Walkers in Early America* (Philadelphia: J. B. Lippincott, 1927).

31. Alison Griffiths characterizes it as an "offshoot of the circular panorama" in *Shivers Down Your Spine: Cinema, Museums, and the Immersive View* (New York: Columbia University Press, 2008), p. 46.

32. Heinz Buddemeier, *Panorama, Diorama, Photographie; Entstehung und Wirkung neuer Medien im 19. Jahrhundert* (Munich: Wilhelm Fink Verlag, 1970). The moving panorama is also missing from Germain Bapst, *Essai sur l'histoire des panoramas et des dioramas* (Paris: Imprimerie nationale & Librairie G. Masson, 1891), and mentioned only in passing in Oliver Grau's *Virtual Art: From Illusion to Immersion* (trans. Gloria Custance; Cambridge, Mass.: MIT Press, 2003) although it covers the history of immersive imaging extensively.

33. In a review (1997) of the English translation of Oettermann's *The Panorama* Danielle Hughes stated: "The author's focus on the circular panorama limits his discussions of the moving panorama, a later important variation of the panoramas [sic] form. This also limits the discussion of work in the United States, since many of the major developments here were in moving panoramas." On-line: brickhaus.com/ amoore/magazine/hughes.html (last visited March 19, 2012).

34. Silvia Bordini, *Storia del panorama: la visione totale nella pittura del XIX secolo* (Roma: Officina Edizioni, 1984); Comment, *The Painted Panorama*.

35. Comment, *The Painted Panorama*, p. 65. Emmanuelle Michaux's *Du panorama pictural au cinéma circulaire: Origines et histoire d'un autre cinema 1785–1998* (Paris: L'Harmattan, 1999) says little about the moving panorama, and much of it is mistaken. Like Comment, Michaux considers the circular panorama the "real" panorama (p. 63).

36. Stephan Oettermann's privately produced compendium of broadsides and handbills contains many examples. *Ankündigungs-Zettel von Kunstreitern, Akrobaten, Tänzern, Taschenspielern, Feuerwerkern, Luftballons und dergleichen*, six volumes + Register & Katalog (Gerolzhofen: Spiegel & Co Verlag, 2003). One of about twenty hand-made copies in EH.

37. *The New Art History*, ed. A. L. Rees and F. Borzello (London: Camden Press, 1986), especially the intervention of Stephen Bann (pp. 19–31).

38. This impression was strengthened by several papers read by young American academic art historians at the conference "New perspectives on the Panorama," Yale Center for British Art, Yale University, March 30–31, 2007. One

of the presenters was Denise Blake Oleksijczuk, who has since published *The First Panoramas: Visions of British Imperialism* (Minneapolis: University of Minneapolis Press, 2011).

39. Circular panoramas ignited a debate about the nature of art. Wilcox in *Panoramania!*, pp. 24–25.

40. John Bell Bouton, *Round the Block: An American Novel* (New York: D. Appleton & Co, 1864), p. 158.

41. John Francis McDermott, *The Lost Panoramas of the Mississippi* (Chicago: University of Chicago Press, 1958); Altick, *The Shows of London*, ch. 15 (pp. 198–210). Arrington's articles include "The Story of Stockwell's Panorama," *Minnesota History* 33 (Autumn 1952): 284–290; "Leon D. Pomarede's Original Panorama of the Mississippi River," *Mississippi Historical Society Bulletin* 9, no. 3 (April 1953): 261–273; "Samuel A. Hudson's Panorama of the Ohio and Mississippi Rivers," *Ohio Historical Quarterly* 66, no. 4 (Oct. 1957): 355–374; "John Banvard's Moving Panorama of the Mississippi, Missouri, and Ohio Rivers," *Filson Club Historical Quarterly* 32, no. 3 (July 1958): 207–240; "William Burr's Moving Panorama of the Great Lakes, The Niagara, St. Lawrence and Saguenay Rivers," *Ontorio History* 51, no. 3 (1959): 141–162; "Otis A. Bullard's Moving Panorama of New York City," *New York Historical Society Quarterly* 44, no. 3 (July 1960): 308–355; "Lewis and Bartholomew's Mechanical Panorama of the Battle of Bunker Hill," *Old-Time New England* (Fall-Winter 1951–1952), pp. 1–17; Skirving's Moving Panorama: Colonel Fremont's Western Expeditions Pictorialized," *Oregon Historical Quarterly* 65, no. 2 (June 1964): 132–172; "Henry Lewis' Moving Panorama of the Mississippi River," *Louisiana History* 6, no. 3 (Summer 1965),: 239–272; "Thomas Clarkson Gordon's Moving Panorama of the Civil War: Battle Scenes of the Rebellion," in *Civil War Panorama:*

A Moving Panorama Painting Entitled "Battle Scenes of the Rebellion" by Thomas Clarkson Gordon, 1841–1922 (Dearborn, Mich.: Henry Ford Museum and Greenfield Village, 1959), 6 pp., unpaginated. Another notable scholar was Martha L. Heilbron, who edited the journal kept by Henry Lewis on his sketching trip along the Mississippi, *Making a Moving Picture in 1848: Henry Lewis' Journal of a Canoe Voyage from the Falls of St. Anthony to St. Louis* (Saint Paul: Minnesota Historical Society, 1936).

42. Avery, "The Panorama and Its Manifestation in American Landscape Painting, 1795–1870"; Scott B. Wilcox, "The Panorama and Related Exhibitions in London," M. Litt Thesis, University of Edinburgh, 1976 (unprinted); for a modest dissertation covering both circular and moving panoramas, Karin Hertel McGinnis, "Moving Right Along: Nineteenth Century Panorama Painting in the United States," University of Minnesota, June 1983 (unprinted).

43. Wilcox, "The Panorama and Related Exhibitions in London"; Hyde and Avery wrote about moving panoramas in the *Sehsucht* catalog (1993); and Hyde in *Panoramania!*, pp. 131–168; Avery, "Movies for Manifest Destiny: The Moving Panorama Phenomenon in America," in *The Grand Moving Panorama of Pilgrim's Progress,* pp. 1–12; Henry M. Sayre, "Surveying the Vast Profound. The Panoramic Landscape in American Consciousness," *Massachusetts Review* 24 (Winter 1983): 723–742.

44. Mimi Colligan, *Canvas Documentaries: Panoramic Entertainments in Nineteenth-Century Australia and New Zealand* (Melbourne: Melbourne University Press, 2002); Hudson John Powell, *Poole's Myriorama! A story of traveling showmen* (Bradford on Avon: ELSP, 2002); Damer Waddington, *Panoramas, Magic Lanterns and Cinemas. A Century of "Light" Entertainment in Jersey 1814–1914* (St.

Lawrence, Jersey: Tocan Books, 2003); Martha A. Sandweiss, *Print the Legend: Photography and the American West* (New Haven: Yale University Press, 2002); Edward Ziter, *The Orient on the Victorian Stage* (Cambridge: The Cambridge University Press, 2003); Jeffrey Ruggles, *The Unboxing of Henry Brown* (Richmond: The Library of Virginia, 2003); Russell A. Potter, *Arctic Spectacles: The Frozen North in Visual Culture, 1818–1875* (Washington: University of Washington Press, 2007); John Bell, *American Puppet Modernism* (New York: Palgrave, Macmillan, 2008), ch. 2.

45. Angela Miller's "The Panorama, the Cinema, and the Emergence of the Spectacular," *Wide Angle* 18, no. 2 (April 1996): 34–69 relies on standard second-hand sources, and does not make a difference between circular and moving panoramas.

46. Laurent Mannoni, *Le grand art de la lumière et de l'ombre: archéologie du cinéma* (Paris: Nathan, 1994). In English: *The Great Art of Light and Shadow*, trans. Richard Crangle (Exeter: University of Exeter Press, 2000). Ulrike Hick wrote a few pages about the moving panorama in *Geschichte der optischen Medien* (Munich: Wilhelm Fink Verlag, 1999), pp. 251–260.

47. Charles Musser, "Toward a History of Screen Practice," *Quarterly Review of Film Studies* 9, no. 1 (Winter 1984): 59–69 (quot. p. 59). The first chapter of his *The Emergence of Cinema: The American Screen to 1907* in *History of the American Cinema*, vol. 1 (Berkeley: University of California Press, 1990) was dedicated to forms that preceded the appearance of "modern motion pictures" (p. 55).

48. My "Toward a History of Peep Practice," in *A Companion to Early Cinema*, ed. André Gaudreault, Nicolas Dulac, and Santiago Hidalgo (Oxford: Wiley-Blackwell, 2012), pp. 32-51.

49. New York: Verso, 2002. Bruno

claims that the settings of travel lectures "were often architecturally reconstructed to be experienced in spatial form by the audience" (pp. 117–118). This is an exaggeration—beside Albert Smith's *Ascent of Mont Blanc*, few other examples existed. Bruno briefly discusses the Kineorama (p. 161), and the Pleorama and the Maréorama (p. 183).

50. Barbara Maria Stafford and Frances Terpak, *Devices of Wonder. From the World in a Box to Images on a Screen* (Los Angeles: Getty Research Institute, 2001), pp. 94–95. My critique of Stafford's views in "Peristrephic pleasures," pp. 237–238, n. 18. Norman M. Klein, *The Vatican to Vegas. A History of Special Effects* (New York: New Press, 2004), ch. 9, "Panoramas: A Crow's Nest Over London; Walking Through Gettysburg" (pp. 180–190). Klein's discussion of the moving panorama is either undocumented or based on Joseph Earl Arrington's article "Leon D. Pomarede's Original Panorama of the Mississippi River," *Bulletin of the Missouri Historical Society* 9, no. 3 (April 1953): 261–273. Klein claims (p. 189) that "Banvard's Seven Mile Panorama" was destroyed by fire in 1850. However, it was never advertised as a "seven mile" panorama, and the one that was destroyed was Pomarede's. It is misleading to call Pomarede's work "the *Dissolving Views* panorama" (p. 188). Dissolving views were a distinct medium, while Pomerade's painting only included a few translucent 'dioramic' sequences. The statement "By 1850, panoramas add steam power and even steamships" (p. 189) is odd. Klein seems to think that the small mechanical figures Pomarede used (how does he know that there were 250?) were steam-powered. The expression "moved by machinery, driving out thick black smoke from its heated furnace" (from the *Daily Picayure*, not from the *New York Herald*) most likely indicates that the figures were animated by a clockwork or by a hand-crank. There are other slips as

well— "small steady light" has turned into "a snail steady light" (p. 188).

51. Friedberg, *Window Shopping*, p. 36. Jonathan Crary notes panorama's "ambulatory ubiquity" in *Techniques of the Observer* (Cambridge, Mass: MIT Press, 1989), p. 113, but does not try to integrate panoramas into his theory. He refers to moving panoramas in "Géricault, the Panorama, and Sites of Reality in the Early Nineteenth Century," *Grey Room 9* (Fall 2002): 5–25.

52. Trans. Joachim Neugroschel (New York: Urizen Books & Mole Editions, 1977, orig. *Panorama oder Ansichten vom 19. Jahrhundert*, 1938).

53. The quotation is from the cover; whether it is directly from Sternberger is unclear. I have compared the translation with the German version, *Panorama oder Ansichten vom 19. Jahrhundert* (Suhrkamp Taschenbuch 179, 1st ed., 1974, orig. 1938).

54. Sternberger influenced Wolfgang Schivelbusch, *Disenchanted Night: The Industrialization of Light in the Nineteenth Century*, trans. Angela Davies (Berkeley: University of California Press, 1995, orig.1983); *The Railway Journey. The Industrialization of Time and Space in the 19th Century* (Berkeley: University of California Press, 1986, orig. 1977). The latter refers to Sternberger's "panoramization of the world" (pp. 61–62).

55. Sternberger, *Panorama*, pp. 82–83.

56. Griffiths, *Shivers Down Your Spine*, ch. 2.

57. C. M. S., "Points of View," *Brooklyn Eagle*, April 15, 1900.

58. Dr. Judd, "The Old Panorama," *Billboard,* Dec. 3, 1904.

59. Samuel B. Waugh's moving

panorama of Italy, which was first shown in 1849 and later extended was cut up. The final scene, the Bay and Harbor of New York recorded from just above the Battery, has been preserved at the Museum of the City of New York. It is painted in watercolor on canvas, and measures 99 1/5 ´ 198 1/4 inches (see appendix). About other segments, Llewellyn Hubbard Hedgbeth, "Extant American Panoramas: Moving Entertainments of the Nineteenth Century," Ph.D. dissertation (New York: New York University, 1977, unprinted), pp. 197–198.

60. Collins, *Banvard's Folly*, p. 24; A grandson "remembered playing among the cylinder rolls as a child." John Hanners, *"It Was Play or Starve": Acting in the Nineteenth-Century American Popular Theater* (Bowling Green, Ohio: Bowling Green State University Popular Press, 1993), p. 53. Edith Banvard, the artist's youngest child, thought that the Mississippi panorama was sold in pieces for theater scenery (ibid.).

61. Bouton, *Round the Block,* p. 158.

62. Also known as "Garibaldi's Campaigns." http://library.brown.edu/cds/garibaldi/ (last visited March 19, 2012).

63. Dyer Library/Saco Museum, "Saco Museum wins prestigious 'Save America's Treasures' grant to preserve the Moving Panorama of Pilgrim's Progress," News Release, Dec. 11, 2009. See also Peter Morelli and Julia Morelli, "The Moving Panorama of Pilgrim's Progress: The Hudson River School's Moving Exhibition," in *The Panorama in the Old World and the New* (Amberg: Büro Wilhelm/Verlag Koch—Schmidt—Wilhelm GbR, and International Panorama Council, 2010), pp. 58–62.

64. Copy of the handwritten lecture in EH (from Saco Museum). A descriptive pamphlet, *A Glimpse of*

The Golden Land: Emerson's Celebrated California Paintings [Boston, May 1852] is said to survive at the Bancroft Library, University of California Berkeley, but the library has not been able to locate it.

65. In a rare letter a young girl, who attended a Mississippi panorama with her schoolmates, writes, "It was a beautiful picture and is said to be a correct representation of the scenery about the river." Her letter opens a window to uneventful provincial life interrupted by the moving panorama show. From "Charlotte," a student at the Utica (N.Y.) Female Academy, to her cousin Miss Mary E. Derbyshire, Hartwick Seminary, Otsego, Co*[unty]*, N.Y., March 7, 1860, unprinted (EH).

66. Ruggles, *The Unboxing of Henry Brown*, p. 93.

67. Yuri Tsivian analyzes such factors in *Early Cinema in Russia and its Cultural Reception*, trans. Alan Bodger (Chicago: University of Chicago Press, 1998, Russian orig. 1991).

68. The cinematic apparatus refers not only to technical elements, such as the screen, the projector and its lightbeam, the auditorium, etc., but also to the psychological conditions of reception. The apparatus is both material and mental. The early ahistorical apparatus theory was influenced by Lacanian psychoanalysis. *The Cinematic Apparatus*, ed. Teresa de Lauretis and Stephen Heath (London: Macmillan, 1980). I discuss the apparatus in contexts, where spectators negotiate their experiences. Marita Sturken and Lisa Cartwright, *Practices of Looking. An Introduction to Visual Culture* (Oxford: Oxford University Press, 2001), pp. 56–61.

69. Mrs. Humphry Ward wrote in *Robert Elsmere* (London: Smith, Elder & Co., 1901, p. 349): "His heart torn with a hundred inarticulate cries of memory and grief, he sat on beside the water, unconscious of the passing of time, his gray eyes staring sightlessly at the wood-pigeons as they flew past him, at the occasional flash of a kingfisher, at the moving panorama of summer clouds above the trees opposite."

70. W.A. Spicer, *Our Day in the Light of Prophecy* (Washington, D.C.: Review and Herald Publishing Assn., 1917), p. 205.

71. George Santayana, *Winds of Doctrine. Studies in Contemporary Opinion* (New York: Charles Scribner's Sons, 1913), p. 97. Santayana was referring to Henri Bergson's idea of the universal mind.

72. Miller writes in *Tropic of Capricorn* (Grove Press, 1994, orig. 1961): "The whole continent is a huge volcano whose crater is temporarily concealed by a moving panorama which is partly dream, partly fear, partly despair" (p. 42). Clarke writes in *2001 Space Odyssey* (New York: ROC, 2000, orig. 1968): "They followed Dimitri out of the main lounge into the observation section, and soon were sitting at a table under a dim light watching the moving panorama of the stars" (p. 58).

73. Jess Stearns (with Larry Geller), *Elvis' Search for God* (Murfreesboro, Tenn.: Greenleaf Publications, 1998), p. 19.

74. William Pyne, *[pseud. Ephraim Hardcastle], Wine and Walnuts; or, After Dinner Chit-Chat* (London: Longman, Hurst, Rees, Orme, Brown, and Green, 1824), 2d edition, pp. 281–282.

75. Pabst, *Essai sur l'histoire des panoramas et des dioramas*, p. 17. Pabst (fn. 5) found the anecdote from J.-J. Hittorff, "Origine des panoramas," in Daly, *Revue générale de l'architecture*, vol. 2 (Paris 1841), p. 2227. According to Pabst, the authenticity of the anecdote was questioned by Philippe Le Bas in *Univers pittoresque*, vol. 25 (Paris 1844), p. 321.

76. For Chinese stories about illusionistic paintings coming alive, Wu Hung, *The Double Screen, Medium and Representation in Chinese Painting* (London: Reaktion Books, 1996), pp. 102–104. These anecdotes go further into magic than the ones related with the Eidophusikon and the panorama, but express similar issues.

77. "Panoramas," *Chambers's Journal of Popular Literature, Science and Arts* 33–34, no. 316 (January 21, 1860): 34.

78. The cat version may have originated in the *Portland Oregonian* in 1889. It was retold in newspapers as far away as New Zealand, where it was reported by the *Bay of Plenty Times* 21, no. 2899 (October 31, 1892): 4. The *Bay of Plenty Times* claimed that it had happened in "a war cyclorama building several days ago." Thanks to Suzanne Wray for chasing the cat through the media.

79. I elaborate my idea of topos in "Dismantling the Fairy Engine: Media Archaeology as Topos Study," in *Media Archaeology: Approaches, Applications, and Implications*, ed. Erkki Huhtamo and Jussi Parikka (Berkeley: University of California Press, 2011), pp. 27–47. The basis of topos study is Ernst Robert Curtius, *Europäische Literatur und lateinisches Mittelalter* (1948), trans. Willard R. Trask as *European Literature and the Latin Middle Ages* (London: Routledge & Kegan Paul, 1979 [1953]).

80. There is no consensus about its definition, methods, tools, or even its field. Erkki Huhtamo and Jussi Parikka, "An Archaeology of Media Archaeology," in *Media Archaeology: Approaches, Applications and Implications*, pp. 1–21.

81. Friedrich Kittler, *Optical Media: Berlin Lectures 1999*, trans. Anthony Enns (Cambridge: Polity Press, 2010). "March of the machines" refers here to Eugene Deslaw's classic silent film (1927).

82. John Durham Peters,
"Introduction: Friedrich Kittler's Light
Shows," in Kittler, *Optical Media*, p. 5.

83. For critical readings of
Foucault's contribution to historical
method, Patricia O'Brien, "Michel
Foucault's History of Culture," in *The
New Cultural History*, ed. Lynn Hunt
(Berkeley: University of California Press,
1989), pp. 25–46; Keith Windschuttle,
The Killing of History (San Francisco:
Encounter Books, 1996), pp. 131–171.

84. Lisa Gitelman, *Always Already
New: Media, History, and the Data of
Culture* (Cambridge, Mass.: MIT Press,
2006), p. 10.

85. Friedrich Kittler,
Aufschreibesysteme 1800/1900 (Munich:
Wilhelm Fink Verlag, 1985), in English
as *Discourse Networks 1800/1900*,
trans. Michael Metteer with Chris
Cullens (Palo Alto, Calif.: Stanford
University Press, 1990). "Notation
systems" would have been a more
literal translation. Thomas Sebastien,
"Technology Romanticized: Friedrich
Kittler's Discourse Networks
1800/1900," *MLN* 105, no. 3, German
Issue (April 1990): 584. Jonathan Crary,
*Techniques of the Observer: On Vision
and Modernity in the Nineteenth Century*
(Cambridge, Mass.: MIT Press, 1990).

86. In his review of the
Techniques of the Observer, Geoffrey
Battchen pointed out weaknesses
in Crary's historical construct. For
example photography, which also
emerged in the first half of the
nineteenth century, does not match
the transition Crary posited, because
it continues the perceptual tradition
epitomized for Crary by the earlier
camera obscura model. Geoffrey
Battchen, "Seeing Things. Vision and
Modernity," *Afterimage* 19, no. 2 (Sept.
1991): 5–7.

87. Carolyn Marvin, *When Old
Technologies Were New: Thinking About
Electric Communication in the Late
Nineteenth Century* (New York: Oxford
University Press, 1988), p. 8.

88. The form "panoramic mania"
was used in "The Panoramas, &c.,"
Littell's Living Age 29, no. 362 (April 26,
1851): 184 (reprinted from the *Morning
Chronicle*, issue unknown).

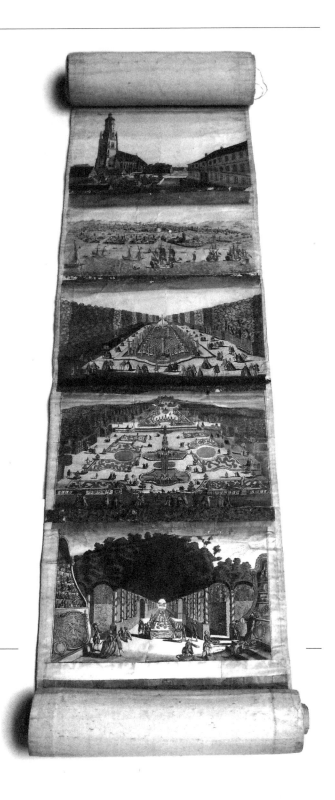

2. THE INCUBATION ERA:

ANTECEDENTS AND ANTICIPATIONS

MOVING PANORAMA—
AN ETYMOLOGICAL EXCAVATION

Encountering the words *moving panorama* in a forgotten document makes the media archaeologist's heart pound faster, but the cause may be just a false alarm. For a "moving panorama" is not always a moving panorama. The nomenclature was vague, sometimes deliberately—the showmen understood the attraction value of mysterious titles. A case in point: on April 23, 1808, one industrious person informed the inhabitants of New York City that he had "completed his moving panorama," which had "cost eight years of uninterrupted application."[1] This "wonder of persistence and ingenuity" was exhibited at 190 William Street in the rear of the Stollenwerck brothers' jewelry store. The same attraction was reintroduced numerous times over the years with various labels, such as "P. M. Stollenwerck's Mechanical Panorama" or "New Mechanical Panorama."

A writer named Dewey Fay concluded already in 1847 that this attraction was not a moving panorama. The expression Stollenwerck's Panorama degraded the meaning of the word panorama, because it had been applied to "a common puppet-show." In Europe," Fay added, such an attraction "would have been styled a picturesque and mechanical theatre."[2] The exhibit was a clockwork-operated model with numerous moving mechanical figures representing "a Commercial and Manufacturing City."[3] A painted perspective view was used as a background for the machinic antics of the figures. The only real novelty was the expression

Figure 2.1
Vertically mounted roll of hand-colored *vues d'optique*
prints for a peepshow box. France, late 18th century.
Author's collection.

"moving panorama." Similar attractions had already been seen and would keep appearing on the exhibition circuit throughout the century.[4]

This expression is thought to have appeared in public for the first time in December 1800 in newspaper announcements promoting the Christmas pantomime *Harlequin Amulet, or the Magick of Mona*, performed at the Drury Lane theater in London.[5] Its fanciful plot dealt with the life of the ancient Bards of Wales and their dispersal by the evil genius Morcar. During the finale the "distance" [back-shutter] of a scene representing "a gothic hall, ornamented with banners, trophies and statues" was "observed to open, and exhibit[ed] a moving panorama of the most magnificent buildings of London, among others, Westminster Abbey, St. Paul's, and Carlton House."[6] How the views were connected with the plot is unclear.[7] They must have formed a sequence, but whether it consisted of a continuous picture roll or a series of separate paintings ("flats") cannot be determined with certainty.

Whatever it was, the critics were not impressed with Thomas Greenwood's creation. According to the *Morning Chronicle*, the pantomime "contains a profusion of beautiful scenery. . . . Its principal defect is, that the last scene is not sufficiently striking and magnificent to form a suitable conclusion."[8] Drury Lane's competitor's, Covent Garden's, Christmas pantomime, *Harlequin's Tour; or, The Dominion of Fancy* (1800), contained scenes of Margate Pier, Dandelion, Road from Margate to Tunbridge, Tunbridge Wells, Charing Cross, Scarborough, Ullswater Lake, Bath, Weymouth, Forest Landscape, and Fancy's Pavillion. One wonders whether these were connected views as well.

It is quite possible that similar scenic effects had already been tried, but under different names. A 1796 variety entertainment at the Sadler's Wells included something with a curious title: "ENGLAND'S GLORY, or, THE WOODEN WALLS OF BRITAIN [the navy]. In the course of which will be given, as a progressive Scenic Picture, a View of the Most Brilliant Naval Actions, which have taken place since the Year 1793."[9] The subject matter may to point to the influence of Barker's Panorama, where canvases of naval engagements were often seen.[10] Was this a moving panorama, or a series of separate views on rollers? Uncertainties persist.[11]

The difficulty of determining the identities of early spectacles can be demonstrated by having a closer look at a production called *Aegyptiana* (or "Egyptiana"), staged by the theater manager and author Mark Lonsdale at London's Lyceum Theatre in 1802. Fortunately, the *Lady's Monthly Museum* described it in detail:

> The various matters which form the subjects of this divertissement are in general Egyptian. The front scene is a map of lower Egypt, which displays, on an extensive scale, the very astonishing ramifications of that wonderful river, the Nile. On this being rolled up, a continual series of scenes are exhibited, copying the very face and manners of the country; as the hieroglyphic painting of Isis and Osiris; the Pyramids; camel; desolate tracts of Africa; display of the national character; views on the Nile; the harbour of Alexandria; Pompey's pillar; the great square at Cairo, &c. & c.; accompanied by descriptive readings,

*which, while the paintings amuse the fancy, inform the understand-
ing; and, for the sake of variety, a few comic or serio-comic subjects
are introduced; among which Milton's L'Allegro will be deemed no
small acquisition, when we consider that it is recited while a series of
shifting scenery co-operates to bring home to the senses a lively idea
of the poet's fertile imagination.*[12]

Aegyptiana appealed to the curiosity raised by Napoleon's Egyptian campaign
(1798–1801). After the French had been defeated, large numbers of antiquities
were shipped to England, including the Rosetta Stone, which was put on display
at the British Museum. The show's large-scale illustrations were based on a book
about the French expedition.[13] In addition to the Egyptian scenes, *Aegyptiana*
also included readings from Gothic novels and Milton's *L'Allegro*. The former
were illustrated by "Machinery and Painting, in Six Picturesque Changes," and
the latter by ten successive pictures, "Produced by a System of Machinery upon
a plan entirely new."[14] "Continual series of scenes" and "series of shifting scen-
ery" seem to indicate a moving panorama. John Britton, who wrote and delivered
the "descriptive readings," characterized it as such in his autobiography.[15] How-
ever, the book was published in the heat of the mid-century "panoramania," so
he may have projected a fashionable concept back into the past.[16]

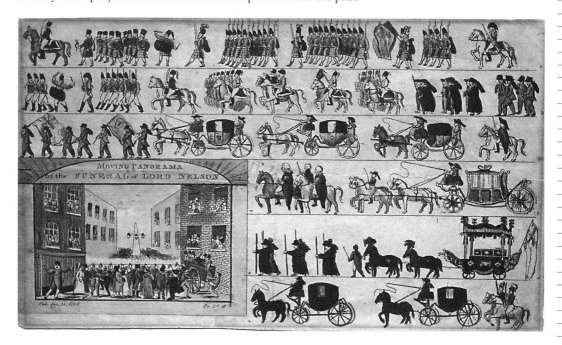

Figure 2.2
Moving Panorama of the Funeral of Lord Nelson, paper toy,
published Jan. 25, 1806 [London]. This is one of the first
known documents with the words "moving panorama" referring
to a continuous picture moving across a proscenium. The
figures are meant to be cut out and pasted together into
a procession that moves across the "stage" between the
houses (through vertical slits on its sides). Author's collection.

The *Lady's Monthly Museum* found *Aegyptiana* "at once adapted to the virtuoso, the statesman, and the warrior," but it proved a failure.[17] Lonsdale's obituary blamed another, more modest show that was presented at the Lyceum at the same time, but in a smaller auditorium: Paul de Philipsthal's Phantasmagoria, a magic lantern horror entertainment. The text complained that *Aegyptiana* had been "too classic: such a mode of rational amusement did not suit the inclinations of the *beau monde*. The shadows of the *Phantasmagoria*, though terrific, were attractive! The Publick chose to be terrified, rather than informed."[18] It hardly needs to be pointed out that similar accusations have accompanied media ever since.

Whatever the true nature of these shows was, the concept moving panorama was already gaining some currency.[19] A 1801 translation of a French novel characterized Étienne-Gaspard Robertson's *Fantasmagorie* (a more elaborate version of Philipsthal's show, exhibited in permanent premises in Paris) as "a sort of moving panorama."[20] Even more interestingly, a recently discovered paper toy, published on January 25, 1806, clearly states: "Moving Panorama of the Funeral of Lord Nelson."[21] Strips of figures are meant to be cut out from a sheet of paper and pasted together. The procession will march across a stage (through slits in its both ends). The basic elements of the moving panorama are present in this penny toy, which was published soon after Nelson's state funeral (January 5–9, 1806). It may well have been modeled on existing shows; a moving panorama about Nelson's funeral was exhibited in Nottingham a year later.[22]

OFFSHOOT OF THE PANORAMA, OR A FORM OF VISUAL STORYTELLING?

It is unlikely that these early efforts were inspired solely by Barker's circular panoramas. When it comes to picture rolls, there were many precursors. A far from exhaustive list should include ancient Egyptian sequential pictures, the Bayeux tapestry, the long narrative on the Dacian wars carved in spiral form on Trajan's Column in Rome, and picture scrolls of all kinds, including ones depicting processions.[23] These developments could be characterized—to paraphrase Egon Friedell—as the moving panorama's incubation era.[24] It is impossible to discuss them all; we will concentrate on picture (sc)rolls in public storytelling.

Picture scrolls have been particularly common in Asia. In China and Japan there were two basic forms: the hanging scroll and the handscroll.[25] The latter concerns us. The earliest preserved examples from China date from the fourth and the fifth centuries CE, although the tradition is older.[26] Japanese picture scrolls (*emaki*) were influenced by imported Chinese scrolls, and already produced in great numbers between the ninth and the sixteenth centuries CE. The main Chinese contribution was the landscape scroll. It has been said that "the

viewer becomes a traveler in these paintings, which offer the experience of moving through space and time. There is frequent depiction of roads and paths that seem to lead the viewer's eye into the work."[27] Japanese handscrolls (*emaki* or *emanimono*) developed more varied narrative conventions with characters, events, environments, and "special effects."[28] Their lively mode of expression has led scholars to compare them with *manga* and *anime*.[29]

Handscrolls are normally enjoyed in private. Generally the scroll is wound open from a wooden dowel on the left-hand side and collected around another on the right-hand side. Only a small portion, wide enough to be comfortably held open between one's outstretched hands, is visible at one time. Surrounded by the user's arms and hands, the view forms a kind of framed screen. The unfolding reveals carefully calculated compositions, visual surprises, and dynamic effects. As the art historian Wu Hung states, "a handscroll is literally a moving picture, with shifting moments and loci."[30] The experience is interactive and personal—it is the user who decides the speed and the rhythm.[31]

When picture scrolls were used in public storytelling, the situation was configured differently. There was no tactile access; the scroll was handled by a professional storyteller, often by means of a kind of apparatus.[32] As Victor H. Mair's *Painting and Performance* (1988) demonstrates, Asian traditions of visual storytelling and picture recitation knew two basic forms: one that used picture scrolls, such as the Chinese *pien*, the Javanese *wayang bèbèr*, and the Japanese *etoki*, and another that resorted to sheets of pictures hung in front of the audience, such

Figure 2.3
Wayang bèbèr performance, organized for the Dutch linguist
G. A. J. Hazeu in the palace of Yogyakarta, Java, 1902. Photograph by Kassian Cephas. Courtesy of KITLV/Royal Netherlands Institute of Southeast Asian and Caribbean Studies.

as the Iranian *parda-dar*, the Indian *par* and the European *Bänkelsang* ("bench-sing-ing," or *Moritat*).[33] The factor that connects traditions is the singer-storyteller.

The *wayang bèbèr* ("scroll theater," from *wayang* = performance and *ambèbèr* = to unroll) is particularly intriguing, because its technical apparatus evokes the moving panorama in an almost uncanny way. It is often considered the most archaic form of the Javanese shadow theater, although it did not use puppets at all.[34] The earliest known description was noted by a Chinese traveler in 1416:

> They have a class of men who make drawings on paper of such things as men, birds, beasts, eagles, or insects; [these drawings] resemble scroll-pictures; for the supports of the picture they use two wooden sticks, three ch'ih [feet] in height, which are level with the paper at one end only; sitting cross-legged on the ground, the man takes the picture and sets it up on the ground; each time he unrolls and exposes a section of the picture he thrusts it forward towards his audience, and, speaking with a loud voice in the foreign language, he explains the derivation of this section; [and] the crowd sits round and listens to him, sometimes laughing, sometimes crying, exactly as if the narra-tor were reciting one of our expository tables [p'ing-hua].[35]

The box (*kotak*) in which the scrolls were stored also functioned as a presen-tation stand. It had holes to hold the sticks around which the painting had been scrolled. During the performance, five or six picture scrolls were rolled from one stick to another so that the face of the storyteller (*dalang*) remained hidden behind them. This has to do with the *dalang*'s identity: he was not just an enter-tainer, but also a kind of exorcist and shaman.[36] *Wayang bèbèr* was considered holy, until it gradually turned into a children's entertainment.[37]

It would be tempting to declare *wayang bèbèr* a preform of the moving panorama, as Olive Cook has done.[38] Harold Forster has gone even further, characterizing it as "a long scroll covered with a series of heroic scenes that was unwound like a primitive cinema."[39] We should be careful with such sweeping parallels. The cultural context in which *wayang bèbèr* flourished was very dif-ferent from the environments where moving panoramas were exhibited, and so were its social and ideological roles. There is no direct evidence to indicate that *wayang bèbèr* ever influenced Western traditions, although sailors and merchants may well have experienced it and attempted to imitate it.[40] The fact that Asian shadow theater is known to have influenced European developments (since the seventeenth century) does not change the situation.[41]

PEEPING AT PICTURE ROLLS

Peepshows have been exhibited in many parts of the world, including North Africa, the Near East, India, China, Japan, and the West.[42] Although their cultural trajectories have not yet been excavated, the form seems to have originated in Europe and spread elsewhere along trade routes, and in the wake of imperialistic expeditions. Although its sizes and external decorations vary, the basic presentation apparatus is fairly similar everywhere. Pictures are loaded inside a show box, and changed by pulling them up and down with strings, removing and inserting them by hand, or by turning a hand-crank. The spectators view them through one or more peepholes, often with magnifying lenses. Unless the box is used privately, a fee is charged for the right to peep.

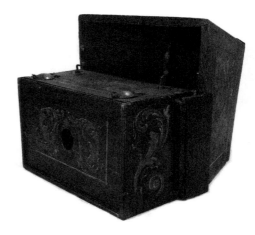

Most peepshows contained separate pictures, but models with picture rolls were already known in the early eighteenth century, as a very rare example in François Binetruy's collection demonstrates.[43] It contains a picture roll produced by a printer named Albrecht Schmidt in Augsburg. The roll is eighteen centimeters wide and nearly ten meters long, and consists of fifty-six numbered and hand-colored Biblical engravings; each has a description in Latin and German, and a biblical reference.[44] Because the box is fairly small, and has only one peep hole (without a lens), it was probably meant for private use. The thematically continuous roll supports this idea. Presenting so many views to a single customer would have led to financial ruin. The roll also seems to have been permanently installed in the box.

It was not always so. The late Pierre Levie had in his collection a salon peepshow that contained a detachable adaptor for picture rolls, and several rolls, all from eighteenth-century printers in Augsburg, and of the same size and format as Binetruy's roll.[45] Removing the adaptor makes it possible to insert bigger single views one by one. In public peepshows the possibility of changing the rolls was all important. One such eighteenth-century peepshow exists in the author's collection. The picture roll is wound around horizontal dowels near the base and operated by cranks in the front corners. The views are reflected from an angled mirror, and peeped at through a magnifying lens. The peepshow must have been used by an itinerant showman. It still has its leather straps for mounting it on the back; the precious lens and the backside (which was opened during the viewing to provide illumination) are protected by wooden panels during transportation.[46]

Figure 2.4
A peepshow box with a picture roll. Albrecht Schmidt, Augsburg, Germany, ca. 1726. Courtesy of François Binetruy Collection.

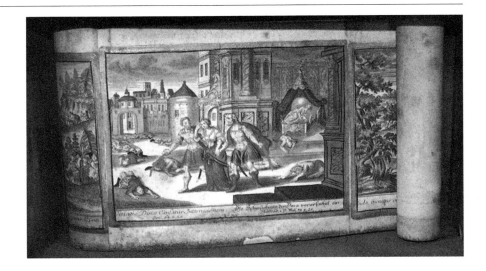

This peepshow accommodates rolls of standard-sized engravings known as *vues d'optique* ("perspective views"), produced in great quantities in Europe in the second half of the eighteenth century; even a second-hand market existed.[47] They were crudely engraved, printed, and colored, but could be made more attractive by adding figures, and punching pinholes and cutting out sections, and covering them with pieces of colored silk or paper. When the direction of light cast into the box was shifted, the scene underwent a transformation. Such tricks may have been adapted from theatrical scenography; they anticipated the much more elaborate effects produced on a gigantic scale in the Diorama.

The few rolls of *vues d'optique* that are known to survive raise questions. Were they put together by printers, printsellers, or showmen? Were they based on premeditated iconographic schemes, or concocted arbitrarily? An example at the Getty Research Institute (c. 1750–1790) consists of forty hand-colored *vues d'optique* joined side by side. Twenty-eight prints are from the well-known publisher Georg Balthasar Probst (Augsburg), one from Henry Overton (London), and the rest from unidentified publishers. All have been mounted into a kind of optical voyage, which begins from Dunkirk, explores London, continues to Holland, Hamburg, Augsburg, Vienna, and Venice, and ends up with views of Constantinople and Cyprus. Judging by its pristine condition, the roll must have been used in private.

Gian Piero Brunetta has analyzed another roll, preserved at the Biblioteca Casanatense in Rome. It consists of seventy-one *vues d'optique*, all from Augsburg and modified for light effects. The subject matter is more heterogeneous. The roll begins with the story of Adam and Eve and their expulsion from Paradise, and proceeds to allegories of the five senses, the influence of the planets, and the

Figure 2.5
Close-up of the picture roll inside a peepshow box. Roll signed by Albrecht Schmidt, Augsburg [ca. 1720]. Courtesy of François Binetruy Collection.

seven wonders of the world. A geographic world tour follows, beginning with Martinique, featuring naval battles and catastrophes, and continuing to European cities. From the thirty-ninth view much of the rest is dedicated to Italy, with quick detours to Saint Petersburg and Augsburg. The roll concludes with Biblical scenes, which may have been an attempt to enclose the secular scenes within the sacred history.[48] There are iconographical clusters, but whether these were part of an overarching scheme is uncertain.

The three rolls in the author's collection all support the idea that the connections were more or less random.[49] In one case the prints have been connected horizontally and in two vertically—the choice depended on the structure of the view box. One of the rolls still has its original dowels. The nineteen views have all been enhanced by hand-painting and collage to make them livelier and to create smooth transitions from one view to the next. The views are from the eighteenth century, except one, which depicts a Napoleonic battle from 1812, indicating that the roll was still in use after that time.[50] All three rolls show signs of heavy use—they have repairs and damage; parts of torn views have been used as patches on the reverse.

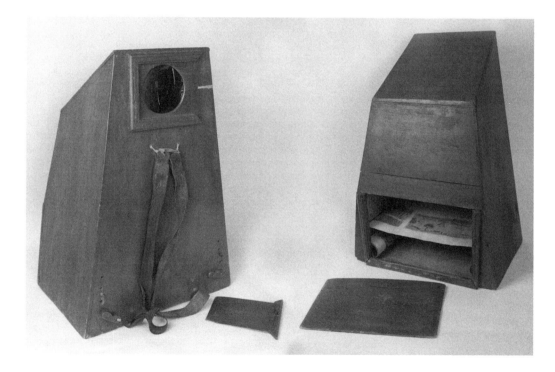

Figure 2.6
An itinerant showman's peepshow box, Central Europe, second half of the eighteenth century (front and back views). This showbox has a crank-operated system for presenting a roll of standard-sized *vue d'optique* prints. The openings are closed by panels during transportation. Author's collection.

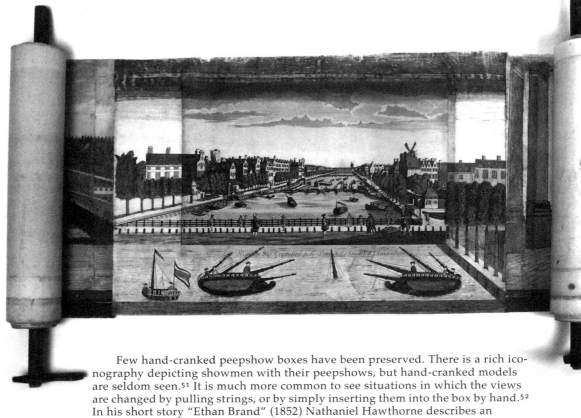

Few hand-cranked peepshow boxes have been preserved. There is a rich iconography depicting showmen with their peepshows, but hand-cranked models are seldom seen.[51] It is much more common to see situations in which the views are changed by pulling strings, or by simply inserting them into the box by hand.[52] In his short story "Ethan Brand" (1852) Nathaniel Hawthorne describes an itinerant peepshowman's presentation (based on one he had seen). In the midst of "Napoleon's battles and Nelson's sea-fights," the peepers get to experience a "gigantic, brown, hairy hand—which might have been mistaken for the Hand of Destiny, though, in truth, it was only the showman's—*pointing its forefinger* to various scenes of the conflict, while its owner gave historical illustrations."[53] The pointing hand, the staple of visual storytelling, intruded in a curious way.

Should we conclude that models with picture rolls were uncommon? The evidence may well deceive us. The painters and engravers may have found strings more appealing than the hand-crank, just as they preferred to show women and children peeping into the box instead of grownup males.[54] Once an iconographic motive becomes established, it may turn into a scheme followed for generations by illustrators, notwithstanding what really happens on the streets and marketplaces.[55]

Figure 2.7
A roll of *vues d'optique* from a peepshow box, consisting of
eighteenth-century views, and one of a Napoleonic battle
from 1812. Preserved with its original wooden dowels.
Author's collection.

Les Grotesques (1838) provides an example of discrepancies in the documentation. The book discusses street entertainments based on the author's ("an archaeologist") personal observations in Paris (or so he would like us to believe). A peepshow is characterized both as a *panorama roulant* ("moving panorama") and as *l'Optique* (the common name for the peepshow box in France).[56] The first makes us assume that the views formed a roll. The accompanying illustration displays a huge peepshow on wheels—alas, it is operated by strings. The words moving panorama are

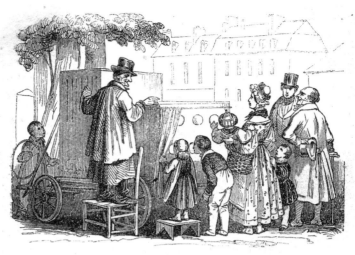

interesting, however, because they show that the observer may have perceived a parallel between these two forms of entertainment, one declining and the other emerging. For the peeper the choice between strings and hand-crank made little difference. Gluing one's eyes to the peephole made the mechanism invisible.[57]

PARKLANDS IN BOXES: CARMONTELLE'S TRANSPARENCIES

In the late eighteenth century the picture roll reappeared in a new form: the roll transparencies created by the Frenchman Louis Carrogis, known as Carmontelle (1717–1806). Carmontelle was a colorful character who spent most of his career as a reader and director of entertainments in the household of the powerful Duc d'Orléans, dedicating his time to alleviating the ennui of the ruling classes. The little playlets he wrote, *Proverbes dramatiques,* were performed in the salons of the aristocracy as a popular pastime.[58] The garden he designed, Le Jardin de Monceau, was a status symbol, a place for aesthetic and ritualistic meditation, and a context for social gatherings, while the profile portraits he painted accumulated into a unique gallery of the *ancien régime* on the brink of being wiped aside by the French Revolution.[59]

Carmontelle began producing roll transparencies in the early 1780s, when he

Figure 2.8
Large peepshow exhibited in the streets of Paris, from Un Archéologue, *Les Grotesques. Fragments de La Vie Nomade* (Paris: P. Baudouin, 1838), after p. 138. Author's collection.

was nearing seventy.[60] They were yet another form of entertainment for his mentor's family and friends. Carmontelle's presentations were widely admired in the aristocratic circles, but they came to an abrupt end when the revolution broke out.[61] After leaving the Orléans household, Carmontelle moved to an apartment in Paris.[62] For the rest of his life he depended on the benevolence of others, but kept presenting his transparencies privately, and even painting new ones. After his death (1806), all his belongings, including the transparencies, were sold at auction.[63] They disappeared from view until 1929, when the art historian Pierre Francastel saw some in a private collection and wrote about them.[64]

The roll transparencies were painted in watercolor and gouache on imported China paper or its European imitation, James Whatman's wove paper.[65] At least five survive, as well as fragments of others.[66] The rolls are between thirty-two and fifty-three centimeters high; their lengths vary, "depending on the number of objects depicted consecutively," as Carmontelle himself noted.[67] The average length is about 12.5 meters, but there is one, *Les Saisons,* that is no less than forty-two meters long.[68] All (except *Les Saisons)* depict similar subjects: park lands with trees, lakes, rivers, country roads, villas, palaces, garden pavilions,

Figure 2.9
Louis Carrogis (Carmontelle), "Figures Walking in a Parkland."
Sequence from a roll transparency. Watercolor and gouache
with traces of black chalk underdrawing on translucent
Whatman paper (the size of the roll: 18 5/8 × 148 7/16 in.).
1783–1800. Courtesy of the J. Paul Getty Museum, Los Angeles.

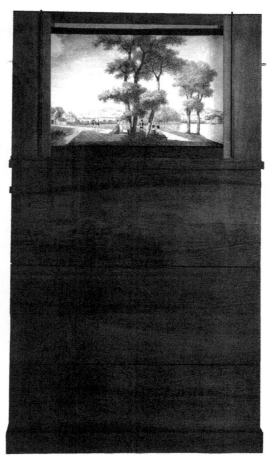

and curiosities like simulated pyramids, obelisks, and ruins. Tiny figures are seen strolling, chatting, rowing on boats, and riding on coaches, recalling the ways the ruling classes spent their time. To create a sense of continuity, the seams between the sheets have been masked by trees and other details; additional elements have been painted on the reverse side to accentuate the atmosphere and the illusion of depth.

Each transparency was enclosed in its own presentation box.[69] Although no original boxes seem to have survived, we can get an idea of their structure from a *mémoire* Citizen Carmontelle, as he now called himself, wrote to the National Convention in the "Year III of Liberty" (1794–1795).[70] He was probably looking for a way to profit from his ideas, and may have heard about Claude Chappé's success in promoting his optical telegraph to the authorities.[71] Carmontelle's effort was unsuccessful, but his report is a stroke of luck for the media archaeolo-

Figure 2.10
Carmontelle's roll transparency depicting a fantasy landscape with scenes of the countryside in its backlighted presentation box. Musée Condé, Chantilly. Photograph: René-Gabriel Ojéda. Courtesy of Réunion des Musées Nationaux / Art Resource, NY. The presentation box is a replica commissioned by the collector Gabriel Dessus, who donated the transparency for Musée Condé in 1936.

gist. It describes three types of transparencies: ones attached to a window pane so that a different season can be superimposed on the view; large-scale transparencies for public outdoor celebrations; and roll transparencies. Wisely, Carmontelle does not claim to have invented the transparency, which was already used at theaters and public celebrations. He presents his suggestions as improvements.[72]

The illustration Carmontelle attached to the *mémoire* depicts one of the boxes ready for presentation. It shows an almost uncanny resemblance to a television set. There is a large square opening at the front, and a similar one at the back.[73] The picture roll moves across the opening from one vertical cylinder to another by means of a hand-crank. In Carmontelle's drawing the device has been placed against a window to illuminate it from behind; to optimize luminosity, the rest of the window has been covered with heavy curtains. During the presentation Carmontelle turned the crank and served at the same time as the narrator, resorting to his long experience as a salon entertainer. When the presentation was over, the openings were covered by hinged panels to protect the fragile roll.

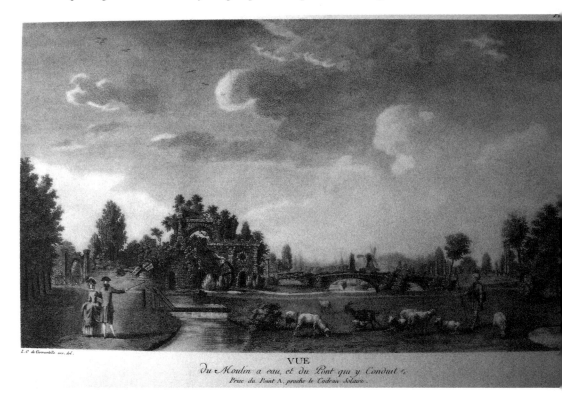

Figure 2.11
Louis Carrogis (Carmontelle), "Vue du Moulin a eau, et du Pont qui y Conduit, Prise du Point A. proche le Cadran Solaire," engraved by J. Couché. Plate 2 from *Le Jardin de Monceau, près de Paris, appartenant à son Altesse sérénissime Menseigneur le duc de Chartres* (Paris: Delafosse, 1779). In this series of engravings Carmontelle indicated ways of exploring Jardin de Monceau. Author's collection.

The environments Carmontelle depicted were known as *jardins pittoresques* or *jardins Anglaises*. They were fashionable parklands influenced by English ideas of landscaping, to which the French added their own accents.[74] In contrast to the austere mathematical regularity of French-style gardens such as Versailles, picturesque gardens emphasized the dynamics between the natural and the cultural, the real and the fantastic, the spontaneous and the constructed. Some gardens, such as Méréville, which was redesigned by Hubert Robert from 1786, underwent dramatic transformations from the old ideal to the new one.[75] The results were thoroughly artificial combinations of whimsical rural landscapes and historicist reminiscences. Perhaps the most extravagant was the Jardin de Monceau, designed by Carmontelle for his mentor, the Duc de Chartres.[76]

The Jardin de Monceau was known as "Chartres's Folly" because of its exuberance and cost. Carmontelle himself wrote that his aim was to bring together "all times and all places."[77] The result was a fantasyland, where the visitors encountered one cultural reference after another.[78] There was an island with a flock of sheep, a Dutch windmill, a Chinese gateway, a Turkish tent, a ruin of a temple of Mars, a Roman Naumachia, and many other simulations.[79] In the winter garden there were painted trompe l'oeil trees that were revealed from behind a mirror wall by means of a push button.

According to Monique Mosser, the guiding ideas behind such environments were movement and constant surprises.[80] Modalities of physical mobility were as if built into the garden design.[81] As they moved around, the visitors encountered "tableaux" that could not be anticipated by just looking at a map. One had to explore the environment by penetrating it physically. This echoes classic Chinese garden theory (an influence on the English garden), which knew two modes of viewing, "watching in motion" and "watching fixedly."[82] According to Lou Quingxi, "winding corridors, rolling stone-step roads or zigzag mountain paths are all good places for watching in motion and enjoying the shifting beauty of garden—each move offers visitors fresh visual surprises."[83]

As John Dixon Hunt has noted, Carmontelle defined a specific itinerary that should be followed through the "quantity of things" of the Jardin de Monceau.[84] This is interesting, because, as Hunt has explained elsewhere, the poetics of garden design knows different kinds of movement.[85] Hunt classifies them into three categories: the procession or ritual, the stroll, and the ramble.[86] While both the stroll and the ramble involve personal initiative-taking (the former with a goal and purpose, the latter without preordained routes or destinations), the ritual implies an imperative to follow a preordained path and purpose. The modalities of walking have since been associated with media culture in many ways.

Carmontelle's idea of exploring the Jardin de Monceau in a ritualistic manner could be associated with the "ritual" of his media presentations. The spectators of his roll transparencies were moved through the landscape by the power of the crank. They had only one route to follow, and had to adjust their desires to the presenter's pace and narrative logic. They were no longer in command of their strolls or rambles—their routes, walking speeds, or rhythmic alternations between motion and stasis. The roll transparencies could therefore be interpreted

as mediatic transpositions of the perceptual-behavioral codes of the *jardin pittoresque* experience.[87] Other media forms, such as the circular panorama, gave more opportunities for strolling or rambling, although they also imposed limitations; initiative-taking happens only within preset constraints in the realm of media.

Laurence Chatel de Brancion has paid attention to an interesting detail: the role of horse-drawn carriages. She notes, for example, that "at the end of each transparency, the same image is always repeated: that of a carriage driving off," corresponding with the words "The End." At least one of the transparencies begins with a profile view of a "Berlin" that has just entered through a gate; the horses face right, to the direction of the roll.[88] This may indicate that the spectators are supposed to feel as if they were observing the scenery from the window of a (phantom) carriage, or it may quite as well be just a way to frame the narrative as a trip to the countryside.[89]

Chatel de Brancion has a tendency to narrativize the rolls. She interprets the tiny figures as protagonists in stories that evade us.[90] The presentations lasted for an hour or more, so there would have been plenty of time to stop the crank and tell anecdotes about the characters.[91] The *post mortem* auction catalog claimed that the transparencies were "a continuation of the country and society amusements generally known as the *Proverbs* of Monsieur Carmontel[le]."[92] The preface to the *Nouveaux proverbes dramatiques* (1811) went even further, stating that "the same incidents of life that he described with the quill in his little dramas, he described with the paint brush in what he called his transparencies [*transparens*], sort of continuing paintings. Putting them in motion made groups of persons of both sexes, of all ages and conditions, displaying a thousand attitudes, or rather, engaged in a thousand different actions, pass in front of one's eyes. These rolls of picturesque scenery were another selection of *Proverbes dramatiques*."[93] Georges Poisson has found visual motives that support this argument, but it is unlikely that the transparencies ever had a tight overall narrative framework.[94]

There may have been other influences. Carmontelle certainly knew Chinese scroll paintings, and perhaps also peepshow boxes with picture rolls.[95] A traveling peepshowman is seen at the village fair sequence in *Les Saisons*.[96] Another possible influence is the shadow theater, also known as "Italian shadows" or *ombres chinoises*. Carmontelle must have been familiar with François Dominique Séraphin's (1747–1800) "Spectacle of shadows with changing scenes," which was performed at l'hotel Lannion in Versailles from 1772 onward.[97] Séraphin even had a portable version for the residences of the nobility. In 1784 he moved to the new arcades built around the Palais-Royal, the urban residence of duc d'Orléans. Because Carmontelle's time was divided between the duc's country estate of Villers-Cotterêts and the Palais-Royal, it is likely that he saw Séraphin perform "hits" like the "Broken Bridge."[98] It is worth pointing out that both Carmontelle's and Séraphin's apparatuses used back-lighting, and their scale was fairly similar.

Yet another influence may have been the itinerant magic lantern show, another well-known sight at the time.[99] Carmontelle may even have used a magic lantern himself, as the well-informed Baron de Frénilly suggested in his memoirs. He remembered a presentation he had witnessed in his youth:

Before leaving this man who so much amused my youth, I must say
a couple of words concerning a magic lantern which he exhibited one
night at my father's. Contemporary personages were shown in action.
Their appearances, costumes, adventures, peculiarities, were all passed
in review, and with this, abundance of anecdotes, bons mots, sly hits,
and Savoyard buffoonery. This representation, full of wit and taste, is
still perfectly visible to me, though it is sixty years since I saw it.[100]

Frénilly had just before this written about Carmontelle's transparencies, so he
must have known the difference. According to his memory, the transparency
"renewed itself continually, presenting to the eye landscapes, towns, monuments,
balls, illuminations, conflagrations—a crowd of scenes from life."[101] This differs
from how he described the magic lantern slide show, which concentrated on hu-
mans, emphasizing their "appearances, costumes, adventures, peculiarities."[102]
The reference to "Savoyard buffoonery" (*la grosse bêtise savoyarde*) indicates that
Carmontelle must have imitated the unrefined patter of an itinerant lanternist,
and perhaps mimicked the characters' voices as well.[103]

Finally, it is time to turn to the transparency that differs from all the rest:
Les Saisons (1798).[104] Carmontelle created it when the revolution was already
raging. His former mentor Louis Philippe II, the Duke of Orléans (with his new
alias Philippe Égalité), had been executed in the heat of the terror five years
earlier. Choosing the changing of the seasons (an age-old *topos*) as the theme of
his longest roll (42 m) allowed Carmontelle to depict a society in transition. *Les
Saisons* contains familiar scenes of aristocrats biding their time in the country-
side, but there is also more emphasis on the common people: work in the fields,
a village fair, and dramatic moments like a house on fire. Although such rustic
scenery was a French tradition, and definitely not a political statement, one feels
the winds of change blowing. The roll ends with a view of carriages returning to
Paris through Porte Saint-Denis—a rare moment of topographic realism.[105]

Chatel de Brancion's attempt to read Carmontelle's transparencies as the
"Cinema of the Entertainment" by anacronistically projecting filmic vocabulary
back into the past feels forced and unnecessary.[106] However hard one tries to argue
along such lines, the transparencies do not turn into movies. When she claims
that they "are often *erroneously* likened to a sort of panorama" one must counter
the argument: they anticipated the moving panorama apparatus in an astonishing
way.[107] As *Les Saisons* demonstrates, Carmontelle was able to adjust his subject
matter to the changing social realities. Had he been younger, he might have turned
his salon amusements into a public entertainment, and become an entrepreneur-
showman in the manner of Étienne-Gaspard Robertson, whose *Fantasmagorie* was
performed nightly a short walk away from where Carmontelle lived.[108]

How unique were the roll transparencies? A structurally similar, probably
homemade showbox (dated c. 1780) with a hand-painted translucent picture roll,
has been preserved at the Spielzeugmuseum in Salzburg.[109] Similar viewers may
have existed elsewhere, perhaps created without knowledge of each other. It is
also worth asking how important the difference between the presentation box

with a "screen" and the peepshow box really was. The former could be viewed by an audience, whereas the latter accommodated one peeper at a time (or at most a handful of them). The salon context could, at least partly, obliterate the difference.[110] Both watching together and taking turns were modes of sharing experiences. Of course, in the case of the peepshow, solitary viewing was another possible mode of use.

Did Carmontelle's transparencies influence the evolution of the moving panorama? We do not know what happened to them between the more than a century between the auction and their rediscovery by Francastel in 1929. However, it seems they never disappeared entirely from cultural memory. They were routinely mentioned in dictionaries, and may even have been displayed in an exhibition.[111] Although it is unlikely there is a link, there are interesting parallels between the careers of Carmontelle and the Russian medical doctor, explorer, and miniature roll panorama painter Pavel Pyasetsky (1843–1919). For decades from the 1870s onward, Pyasetsky painted detailed watercolor roll panoramas, which he presented both in public lectures and in private houses with a "special device" he invented.[112]

Pyasetsky's rolls have been divided into four groups: military subjects, the construction of railroads in Russia, oriental trips (China, Japan, Port Arthur), and "court" rolls, commissioned from or with consent of the Russian Imperial Court.[113] The normal height of Pyasetsky's rolls was 48.5 centimeters, which roughly corresponds with the dimensions of Carmontelle's transparencies. Their length varied (to borrow Carmontelle's words) "depending on the number of objects depicted consecutively." The parallels are intriguing. Both worked in socially stratified prerevolutionary societies, making presentations for their elites. Whereas Carmontelle served the Orléans household, Pyasetsky's *Maecenas* was the Russian tsar, for whose family and court he performed. All this does not indicate that any direct connection would have existed; the parallels demonstrate only that a demand for remarkably identical small-scale visual presentations may emerge in partly similar social circumstances.

MINIATURE PANORAMAS: FROM POPISH PLOTS TO ALTONA'S ENTERTAINMENTS

Rolls of miniature prints had been enclosed in tiny palm-sized viewing boxes long before Carmontelle came up with his idea of roll transparencies. A surviving example, probably from the late seventeenth century, tells the story of the "Popish Plot," a political conspiracy that took place in England

Figure 2.12
Toy moving panorama for children in a crudely made wooden viewing box. British, c. 1830. The hand-colored picture roll contains scenes from well-known nursery rhymes, including "Ding Dong Bell" (pictured). Author's collection.

in 1678 and reverberated widely in the popular imagination.[114] Another roll depicts the "cries of London."[115] Such tiny viewers seem to have been produced throughout the eighteenth century.[116] They may have been just curiosities in the manner of anamorphic pictures and seductive images hidden in everyday objects, but could also have served ideological purposes as tokens of the owner's beliefs.[117]

Continuing this tradition, a crudely printed picture roll in a little viewing box (British, c. 1830s-1840s) in the author's collection teaches children with illustrated scenes from familiar fables. One should not overlook the impact of such ephemeral objects. By becoming part of the routines of the everyday, they influenced the life practices and the imagination of the users. As scholars like Gaston Bachelard and Susan Stewart have demonstrated, miniaturization is the counterpart of magnification in a complex cultural play with scale and transforming "optics."[118] Things that are kept in the pocket or in a purse and manipulated with one's fingers are at the other extreme from huge spectacles. They are tactile, familiar, and "protointeractive," whereas public panoramas and dioramas overwhelm the visitors by enveloping them in "untouchable" wrap-around surroundings. To enjoy the experience, one is asked to surrender passively to the overall impact.

High quality miniature roll panoramas became popular around 1820, just as the moving panorama was gaining momentum, but figuring out who may have influenced whom is difficult.[119] Meticulously printed and hand-colored strips of continuous processions, horse races, rivers, or famous streets like Unter den Linden, the Champs-Elysées, and Nevsky Prospekt were wound around dowels and enclosed in handsome cylindrical containers.[120] Robert Havell's exquisite *Costa Scena or a Cruise along the Southern Coast of Kent* (1823) was accompanied by a guidebook, like many moving panorama shows. There were even narrative ones, such as Henry Alken's cartoon-like *Panorama of the Progress of Human Life* (1820).[121] Judging by their superior production values, such products must have been meant as curiosities for the wealthy. Exquisitely hand-painted panorama rolls depicting rivers, cities, and processions were brought back by Western travelers from the Indian city of Lucknow, pointing to one possible source of inspiration.[122]

As the century progressed, penny versions representing events like the yearly Lord Mayor's Show in London were published in great quantities.[123]

Figure 2.13
A palm-sized viewer box containing a picture roll of the "Popish Plot," late seventeenth century. Photo: Erkki Huhtamo. Courtesy of Jacqueline and Jonathan Gestetner Collection.

When illustrated magazines began to appear in the 1840s, they occasionally treated their readers with extended panoramas of topics like the Thames and the Crystal Palace exhibition. A version of the latter was serialized in the *Illustrated London News* (to be cut out and pasted together by the reader), and also sold as a premounted roll in a handsome wrapper.[124] Much like the ancient Chinese and Japanese hand scrolls, it offered a virtual trip back and forth along the corridors of the Crystal Palace. The illustrated magazines frequently published descriptions and illustrations of moving panorama shows, so links between these forms must have been forged in the reader's mind.

A particularly interesting artifact is the "panorama handscreen" or "mechanical screen fan."[125] It was a French invention that appeared in the 1820s, and was sold at shops specializing in optical toys, jewelry, paintings, and fashionable furniture.[126] One of the most famous was Giroux near the Palais-Royal.[127] Among other things, *La Mode* (1849) listed its mechanical toys, automatic organs, and "paintings with figures and movements like in a real diorama."[128] The handsome panorama handscreen fitted perfectly in the company of such curious items. Besides, there were many other types of mechanical handscreens (*écran mécanique*), including ones influenced by Daguerre and Bouton's Diorama, opened in Paris in 1822.[129]

Figure 2.14
Robert Havell (1769-1832), *Costa Scena or a Cruise along the Southern Coast of Kent, the Drawing taken from Nature*. London: Robert Havell, [1823]. Continuous hand-colored aquatint picture roll (81 mm x 5,450 mm) in a handsome wooden cylinder depicting Britannia and Neptune. A guidebook explaining the scenes in the manner of moving panorama shows was also published. This example belonged to the well-known painter William Henry Pyne (1769-1843, see chapter 4), who scratched his name on the cylinder. Author's collection.

Some surviving examples of the panorama handscreen bear the label of Giroux. It identifies the product as *écran-panorama* and mentions that it has been patented. A patent for five years had been granted to the brothers Robert-Michel and Claude-Lambert Gaucheret on February 28, 1820.[130] An 1825 dictionary indicates that the idea had not yet been turned into a product.[131] Whether Giroux was waiting for the five years protection to expire, or acquired the patent from the original inventors, he may have become the manufacturer. Years earlier he had patented "improvements" to Sir David Brewster's kaleidoscope, and also produced folding paper peepshows and *Phenakisticopes* (and later Daguerre's Daguerreotype cameras).[132]

The *écran-panorama* has an illustrated cardboard frame with a cutout window, attached to an elegantly turned wooden or ivory handle. A roll of translucent pictures, enclosed in cylindrical containers on both sides of the window, is operated by two knobs. Various designs and subjects are known, which points to a significant volume of production.[133] An example in the author's collection depicts the four seasons. Much like in Carmontelle's *Les Saisons*, tiny figures are engaged in seasonal activities; one season glides smoothly into another. The frame depicts a group of bourgeoisie biding their time in a park. Another handscreen I have seen follows people strolling in a picturesque parkland on the outskirts of Paris, with glimpses of both the countryside and the city in the distance.[134] Yet another one depicts scenery from Girardon's Ermenonville, the *jardin pittoresque* immortalized by its association with Jean-Jacques Rousseau.[135]

It is not impossible that a relationship may have existed between the *écran-panorama* and Carmontelle's roll transparencies. Carmontelle was famous, and had lived a stone's throw away from Giroux's shop. The panorama handscreen reflects aesthetic ideals that originated among the upper classes and were adopted by the bourgeoisie. However, there are also designs that are unrelated to Carmontelle's transparencies. An example I have seen depicts the interior of a theater or opera house; we see the spectators in their boxes, and the orchestra playing. On the stage, a succession of scenes in the clouds is unfolding; a mythological or dream sequence with living actors, or perhaps a scenic illusion. The reference point may well be a contemporary theatrical production.[136] Such delicate objects must have served as curiosities and conversation pieces, rather than as practical objects, such as firescreens.[137]

Figure 2.15
Moving panorama handscreen (*écran panorama*) depicting the four seasons. Possibly by Alphonse Giroux, Paris, 1820s. Author's collection.

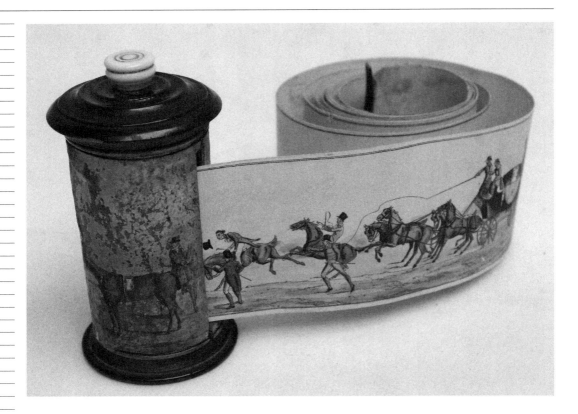

The turned handle of the *écran panorama* recalls another of Giroux's optical novelties: the phenakistiscope, or as he called it, *Phenakisticope*. It was a philosophical toy for creating cyclical moving pictures based on the phenomenon known as persistence of vision.[138] Animation discs were attached to a handle, spun, and observed from a mirror. Interestingly, the London printer S. W. Fores gave his own set of phenakistiscope discs an intriguing title: *Fores's Moving Panorama, or Optical Illusions, Giving Life and Activity to Inanimate Objects. A Nut for Philosophers to Crack* (1833).[139] Thomas McLean's competing product was called *Magic Panorama*.[140] This was a clever way of gaining discursive surplus value for the product by associating it with a popular public spectacle; that the principle of motion was entirely different did not matter.

Another fad was the Myriorama, also characterized as a "moveable Picture."[141] It was a boxed set of cards depicting slices of a long landscape. The cards could be arranged in any order, creating a nearly infinite number of panoramic views.[142]

Figure 2.16
Henry Alken, *Going to Epsom Races*, miniature roll panorama
in a wooden container, hand-colored aquatint (London:
S. & J. Fuller, 1819). 1.5 inches × 15.2 feet. One of the
earliest English miniature roll panoramas in a cylinder.
Author's collection.

The advertisements presented surreal-sounding calculations about the enormous number of combinations.[143] This gave Myriorama a pseudoscientific aura, but it was also associated with neoclassical interests in the ruins of the Antiquity and Romantic reverie. Arranging the cards was a *voyage pittoresque* on the tabletop. Indeed, Jean-Pierre Brès, the inventor, named his second set *Componium Pittoresque* (1825).[144] This experience of exploring myrioramic landscapes differed from those offered by roll transparencies or panorama handscreens, but all were, in one way or another, related to the ideology of the *jardin pittoresque*.

Whether such panoramic toys had a relationship with public spectacles is not easy to figure out. Some may have been sold at fairs and shows. There is a

Figure 2.17
Fores's Moving Panorama, or Optical Illusions, Giving Life and Activity to Inanimate Objects. A Nut for Philosophers to Crack, a set of phenakistiscope discs, J. Fores, London, 1833. Author's collection.

case, however, where private consumption and public presentation became connected in an intriguing way. It has to do with three Hamburg-based brothers, the painter and professor Christoffer Suhr (1771–1842) and his printer brothers Cornelius (1781–1857) and Peter (1788–1857) Suhr. They were known for their prints, such as a series of town cries (*Ausruf in Hamburg*, begun in 1808–), and costume plates collected in *Hamburgische Trachten* (1812).[145] They also painted illusionistic cosmorama-like city and landscape views that were exhibited all around Europe, sometimes under the title Europorama.[146] The pictures were peeped at through magnifying lenses. They were about a meter high and four meters wide, and stretched in concave half-circles (kinds of half-panoramas).[147]

In the 1820s the Suhrs published a miniature roll panorama depicting the public amusements between Hamburg and the nearby city of Altona. As usual, it was enclosed in a cylindrical container.[148] Interestingly, a magnified version was produced by pasting the roll on wider paper, and adding elements by watercolor. The sky was made higher, and roads lined with

Figure 2.18
"Panorama of a Trip from Hamburg to Altona and back." An extended version of a printed roll panorama published by Suhr, Hamburg, 1820s. This version, which may be almost contemporary, includes watercolored landscape elements and figures cut out from Suhr's earlier publications. Hand-colored lithograph edition by Hermann Barsdorf Verlag, Berlin, 1909. Author's collection.

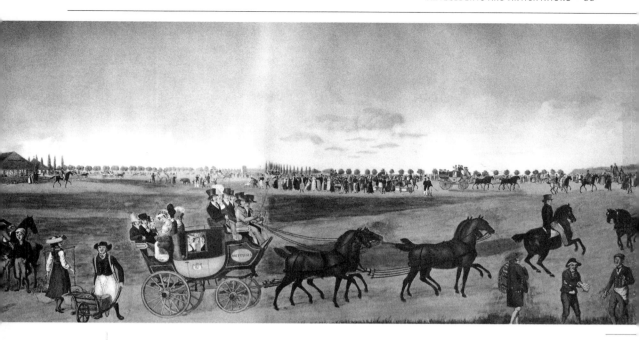

trees, extending toward the viewer, added (as in Carmontelle's transparencies, the trees hide the seams between the sheets).[149] To make the scene livelier, cutout figures from Suhr's earlier publications were collaged in the landscape (an "art" already practiced by peepshowmen). This extended version may well have been displayed publicly in a hand-cranked viewbox like the ones used by Carmontelle.[150] The dimensions (46 × 492 cm) are intriguingly close to the latter's transparencies.

Figures 2.19 + 2.20
Street sellers from Christoffer Suhr's collection of prints *Der Ausruf in Hamburg* (The Cries of Hamburg), 1808 (facsimile edition by Hermann Barsdorf, Berlin, 1908). The lady (plate 28) sells haddock and the young man (plate 32) celery from Berlin. Both have been used as additional cutout figures in Suhr's "Panorama of a Trip from Hamburg to Altona and back" (above). Author's collection.

NOTES

1. In *The American Citizen*, George Clinton Densmore Odell, *Annals of the New York Stage* (New York: Columbia University Press, 1927–49), vol. 2, p. 303. According to Odell, "This amusing mechanical toy represented a commercial and manufacturing town, with surrounding water, with vessels entering and departing, carriages and people of all descriptions passing over the bridges, manufacturers at work at their different employments, etc." The source of information is not revealed. In 1814 the panorama was shown "in the rear of Stollenwerck's and Brothers' Jewellery Store" (vol. 2, p. 432) and in the spring 1816 in the same place as "Stollenwerck's Mechanical Panorama," "having undergone a thorough repair" (vol. 2, p. 461).

2. Dewey Fay, "Panoramic Painting," *Home Journal* 40, no. 91 (Oct. 2, 1847): 3.

3. "P.M. Stollenwerck's Mechanical Panorama," undated broadside (New York Historical Society) gives a detailed description of the attraction. The overall effect was said to be such that "for a moment the Spectator thinks he is viewing all the reality of active life." The machinery would be revealed for an additional 25 cents.

4. In August 1826 Peale's museum advertised a Swiss mechanical panorama: "All the figures moves [sic] as though they were living, such as Men, Women and numerous Animals, among which are horses, cows, sheep, camel, elephant, &c." (Odell, *Annals*, 3, p. 294). In 1823 the Columbian and City Museum on Tremont street, Boston, advertised "a moving Panoramic View in Turkey, having men, women, horses, palanquins, boats, vessels, &c. &c. in motion, passing and repassing 20 feet." In *Christian Watchman* 4, no. 11 (Feb. 22, 1823): 44.

5. *Harlequin-Amulet or The Magick of Mona. The songs, chorusses, &c. with a description of the pantomime. First acted at The Theatre Royal, Drury Lane, Monday, December 22, 1800* (London: C. Lowndes, [1800 or 1801]), p. 8 (HL). The premiere was on December 22, 1800.

6. *Star* (London), no. 4468 (Dec. 23, 1800). The words *moving panorama* were mentioned in several publications, including the *European Magazine* 39 (Jan. 1801): 41 (Altick, *The Shows of London*, p. 198).

7. Richard Carl Wickman, "An Evaluation of the Employment of Panoramic Scenery," Ph. D. Dissertation, Graduate School of the Ohio State University 1961 (unprinted), p. 171. Wickman notes that the *European Magazine* 39 (Jan. 1801): 41, mentions, "A brilliant rainbow appears." This matches the text sung in the Finale, " Thus at length, the storm blown over,/Sunbeams bright and calm succeed;/Thus thro' dreary wilds each lover,/Finds at last the flow'ry mead" (*Harlequin-Amulet or The Magick of Mona: The songs, chorusses, &c. with a description of the pantomime*, p. 16).

8. *Morning Chronicle* (London), no. 9860 (Dec. 27, 1800). The name of the painter was mentioned in the newspaper advertisements, also on the day of the premiere, in *Morning Chronicle*, no. 9855 (Dec. 22, 1800).

9. Playbill, original in Finsbury Public Library, UK, microfilm in the Ohio State University Theater Collection, OSUTC Film 1448. Noted by Wickman, "An Evaluation of the Employment of Panoramic Scenery," p. 169. The program also included a ventriloquist, dances, scenic spectacles, a tight-rope walker, and a Harlequinade.

10. The permanent rotunda was opened in 1793 with "The Grand Fleet at Spithead in 1791." It had also exhibited "Lord Howe's Victory and the Glorious First of June" (1795) and "Lord Bridport's Engagement" (1796).

11. Much later a critic described what was ostensibly a moving panorama proper: "The *flats*, as the back scenes are technically termed, are connected in one continuous view, presenting to the spectator, as they are drawn successively over the stage, every grand and beautiful feature of the landscape." "The Diorama at the Bowery Theatre," *The Critic: A Weekly Review of Literature, Fine Arts, and the Drama* 1 (1829): 104. The critic was describing a "moving diorama" shown as part of a play at New York's Bowery Theater in 1828.

12. "Egyptiana," *The Lady's Monthly Museum, or Polite Repository of Amusement and Instruction*, vol. 8 (London: Vernor & Hood, June 1, 1802), p. 203.

13. One of the painters was Robert Ker Porter, who had exhibited huge semicircular battle paintings at the Lyceum since 1800. Charles Pugh (scene painter from Covent Garden), William Mulready, and others were also involved. "The English Opera-House," *The Harmonicon*, 1830, First Part (London: for the Proprietors, Samuel Leigh), p. 129.

14. Altick, *The Shows of London*, p. 199.

15. John Britton, *The Auto-Biography*, part 1 (London: for the Author, 1850), p. 101. Britton writes that a "series of pictures" was "so adapted and applied as to produce a moving panorama for the stage, and I was engaged to write and read a short description of each successive object as it was shewn to the audience."

16. A panorama show with a theme reminiscent of *Aegyptiana*, Henry Warren's, Joseph Bonomi's, and James Fahey's *Grand Moving Panorama of The Nile*, had just been presented in London. It premiered at the Egyptian Hall in July 1849.

17. "Egyptiana," *The Lady's Monthly Museum*, p. 204.

18. *Gentleman's Magazine*, ed. Sylvanus Urban, Feb. 1815, p. 189.

19. The *Literary Gazette* purported to "fill a chasm in the over-stocked periodical literature of this scribbling era, and to lay as it were a moving panorama of the learning, arts, sciences, political history, and moral and intellectual and ornamental advance of the age, continually before your readers." *Literary Gazette; and Journal or Belles Lettres, Arts, Politics, &c. for the year 1817* (London: Henry Colburn, publisher, 1817), p. 69.

20. Charles Pigault-Lebrun, *My Uncle Thomas: A Romance*, from the French, vol. II (New York: John Brennan, 1810), p. 213 (footnote). Translation originally published in London in 1801, the French original in 1799.

21. The only known example is in EH.

22. Google Books lists a broadside for a "moving panorama, representing funeral honours, ceremonies, magnificent procession, observed commemorate our late gallant hero, Lord Viscount Nelson" (Thursday, Jan. 1, 1807, the Theatre of Nottingham, Nottingham: Burbage and Stretton, 1806). "Hydraulic experiments" were presented before the panorama. I have not seen this source.

23. John D. Anderson, "The Bayeux Tapestry: A 900-Year-Old Latin Cartoon," *Classical Journal* 81, no. 3 (Feb.–March 1986): 253–257; Ian Richmond, *Trajan's Army on Trajan's Column* (London: British School at Rome, 1982). The Dutch designer Tjebbe van Tijen has used the picture scroll as a form of organizing digital data. See his "Imaginary Museum Projects," http://imaginarymuseum. org (last visited Aug. 13, 2011).

24. Egon Friedell, *Kulturgeschichte der Neuzeit* (Munich: C. H. Beck, 1827–1832).

25. Julia Hutt, *Understanding Far Eastern Art* (New York: E.P. Dutton, 1987), pp. 27–29; Jerome Silbergeld, *Chinese Painting Style: Media, Methods, and Principles of Form* (Seattle: University of Washington Press, 1982), pp. 12–13.

26. Hung, *The Double Screen*, p. 63.

27. "Scroll Painting," *Encyclopedia Britannica On-Line* (www.britannica. com/eb/article-9066397, last visited March 22, 2008).

28. Hideo Okudaira, *Emaki. Japanese Picture Scrolls* (Rutland, Vt.: Charles E. Tuttle Co., 1962); Miyeko Murase, *Emaki: Narrative Scrolls from Japan* (Japan: Asia Society, 1983). The *emaki* use tricks like houses without roofs—*fukinukiyakata*—to display what is happening inside (much like videogames like *The Sims*) and "golden clouds" that covered parts of the scene and served various narrative purposes.

29. Nobuo Tsuji, "Early Medieval Picture Scrolls as Ancestors of Anime and Manga," in *Births and Rebirths in Japanese Art*, ed. Nicole Coolidge Rousmaniere (Leiden: Hotei Publishing, 2001), pp. 53–82. Japanese scrolls have been compared with animation films by Isao Takahata, *Juniseikki-no Animation* ("Animation in the 12th century") (Tokyo: Studio Ghibli Co., a Division of Tokuma Shoten Co., 1999). The "languages" of Japanese picture scrolls and the cinema have been compared by Taihei Imamura, "Japanese Art and the Animated Cartoon," *Quarterly of Film Radio and Television* 7, no. 3 (Spring 1953): 217–222.

30. Hung, *The Double Screen*, p. 59.

31. In China, the rewinding of the scroll was sometimes used as a reverse reading; an innovative painter could anticipate it when creating the scroll. Hung, *The Double Screen*, pp. 58, 63.

32. Such traditions continue in the Bengal region of India. Beatrix Hauser, "From Oral Tradition to 'Folk Art': Reevaluating Bengali Scroll Paintings," *Asian Folklore Studies* 61, no. 1 (2002): 105–122; Pika Ghosh, "Unrolling a Narrative Scroll: Artistic Practice and Identity in Late-Nineteenth-Century Bengal," *The Journal of Asian Studies* 62, no. 3 (August 2003): 835–871.

33. Victor H. Mair, *Painting and Performance. Chinese Picture Recitation and its Indian Genesis* (Honolulu: University of Hawaii Press, 1988). According to his tentative conclusion the original home of such traditions was ancient India. Narrative scroll paintings are still created and used for visual storytelling in villages of the Midnapur region of West Bengal in India. Most people living in these villages are named Chitrakar, "maker of pictures." The topics of the paintings often come from contemporary news items such as the World Trade Center terrorist attacks, the AIDS crisis, the Tsunami catastrophe, and even James Cameron's film *Titanic*. *India Express: Sacred and Popular*, ed. Sointu Fritze, Claire Gould, Sanna Juntunen, Erja Pusa (Helsinki: Helsinki City Art Museum's Publications, No. 90, 2006), pp. 124–125.

34. Mallay Kant-Achilles, Friedrich Seltmann, and Rüdiger Schumacher, *Wayang Beber: Das wiederentdeckte Bildrollen-Drama Zentral-Javas* (Stuttgart: Franz Steiner Verlag, 1990); reviewed by Rene T. A. Lysloff in *Asian Music* 24, no. 1 (Autumn 1992/ Winter 1993): 146–151; E. U. Kranz, *Bulletin of the School of Oriental and African Studies*, University of London, vol. 54, no. 3 (1991): 637–638; Alit Djajasoebrata, *Shadow Theater in Java: The Puppets, Performance and repertoire* (Amsterdam and Singapore: Pepin Press, 1999), pp. 11–13.

35. Quot. Mair, *Painting and Performance*, p. 3. Ma Huan was the Ming dynasty admiral Cheng Ho's secretary who accompanied him in

Southeast Asia. Hecht, *Pre-Cinema History* (entry 284A) quotes Ma Huan's description [1416] via a Dutch text by W. P. Groeneveldt, *Verhandelingen van het Bataviaasch Genootschap van Kunsten en Wetenschappen* (Batavia: 1877 [or 1880]), part 39, p. 53.

36. Ward Keeler, *Javanese Shadow Plays, Javanese Selves* (Princeton: Princeton University Press, 1987). Keeler does not mention *wayang bèbèr*.

37. In the end of the stand on which the sticks were attached there was a small box for offers from the audience (Kant-Achilles, Seltmann, and Schumacher, *Wayang beber*, p. 42).

38. Olive Cook, *Movement in Two Dimensions* (London: Hutchinson & Co, 1963), p. 54.

39. Quot. Mair, *Painting and Performance* (p. 58) from Forster's *Flowering Lotus: A View of Java* (London: Longmans, 1958).

40. Demonstrations were organized for Western linguists and anthropologists, for example for the Dutch linguist G. A. J. Hazeu, who attended one in the palace of Yogyakarta, 1902. Most published photographs from this session exclude Hazeu, creating an impression that we are witnessing a genuine event. Spectators are seen sitting both in front of the scrolls and on the sides. This arrangement was used in some traditions of the Javanese shadow theater, but in *wayang bèbèr* the audience is thought to have sat in front of the picture roll, helping the *dalang* to hide his face. Djajasoebrata, *Shadow Theaters in Java*, pp. 18–19.

41. Georg Jacob, *Geschichte des Schattentheaters* (Hannover: Orient Buchhandlung Heinz Lasaire, 1925), p. 159.

42. Peepshows are mentioned only in passing by Mair, *Painting and Performance*.

43. Thanks to Mr. Binetruy for an opportunity to study this item. Its dimensions are 32.5 ´ 36 ´ 40 cm. A peepshow box with a picture roll was described in *Walbergens Sammlung natürlicher Zauberkünste* (Stuttgart, 1754), in Georg Füsslin, Werner Nekes, Wolfgang Seitz, Karl-Heinz W. Steckelings, and Birgit Verwiebe, *Der Guckkasten: Einblick—Durchblick—Ausblick* (Stuttgart: Füsslin Verlag, 1995), pp. 17, 20. A photograph of a peepshow box with a roll, most likely for home use, is on p. 20.

44. "Albrecht Schmidt excud. AV"; Schmidt was active in Augusta Vindelicorum (Augsburg) in the early eighteenth century.

45. Pierre Levie, *Montreurs et vues d'optique* (Brussels: Sofidoc, 2006), p. 59.

46. An earlier peepshow with a similar technical arrangement, but for salon use exists in FB. Its more sophisticated mechanism allows the adjustment of the angle of the mirror and there are tin oil lanterns on both sides to provide illumination.

47. *Il Mondo nuovo. Le meraviglie della visione dal '700 alla nascita del cinema*, ed. Carlo Alberto Zotti Minici (Milano: Mazzotta, 1988); *Viaggio in Europa attraverso le vues d'optique*, ed. Alberto Milano (Milan: Mazzotta, 1990); *Vedute del "Mondo Novo." Vues d'optiques settecentesche nella collezione del Museo Nazionale del Cinema di Torino*, ed. Donata Pesenti Campagnoni (Turin: Umberto Allemandi & C./Museo Nazionale del Cinema, 2000).

48. Gian Piero Brunetta, *Il viaggio dell'icononauta dalla camera oscura di Leonardo alla luce dei Lumière* (Venice: Marsilio Editori, 1997), pp. 286–287, the roll is illustrated in plate 53. In its caption the number of the views is given as 69.

49. One roll has translucent elements for light effects. Except for a few pairs of views with related topics (scenes of Paris, the Ranelagh Gardens in London, etc.), its subject matter jumps from country to country, including in one case a view of a celebration in China. At present the roll consists of twelve views. The seller from whom the roll was purchased on eBay in 2002, had cut out at least six views and sold them separately. Details in EH. In its "Photographica & Film" Auction, Oct. 1, 2011, the Auction Team Breker (Cologne) offered a roll of 12 horizontally connected *vues d'optique*, that we said to be "mostly Parisian scenes." The roll was preserved with its wooden dowels, but it is difficult to tell if it was for private of public use.

50. On the reverse side of another roll there is a piece of newspaper used as a patch, mentioning "la Commune de Paris," an assassination, [Henri] "Rochefort" leaving Bordeaux for Arcachon, and "la Révolution." Therefore, most likely the roll has still been used around 1871.

51. No hand-cranked peepshows are pictured in Richard Balzer, *Peepshows: A Visual History* (New York: Harry N. Abrams, 1998). I have seen a Russian bronze statue depicting a showman with a hand-cranked model. The "tympanon" of the box has the word *panorama* in Russian (MG).

52. This arrangement was also used in Chinese and Japanese peepshows. It resembles the mechanisms for changing drop-scenes at theaters and may have been influenced by them. Peepshow boxes are kinds of actorless miniature theaters; some had painted interiors and proscenium arches.

53. Quot. Avery, "The Panorama and Its Manifestion in American Landscape Painting," p. 218.

54. My former student Vishal Dar encountered a peepshowman in New Delhi in 2003. His modern peepshow contained a hand-cranked picture

roll with a collage of images mostly cut out from illustrated magazines, representing Bollywood stars, etc. Another modern Indian peepshow was sold on eBay Germany in 2006. Its configuration resembled the one Dar saw. The roll had been put together from magazine illustrations. These devices resemble the early peepshow in FB.

55. Some boxes contained string-operated puppets, referring to a possible connection with Punch and Judy–type marionette theaters. Mechanical marionettes and even living animals were also used on top of the peepshow boxes to attract attention. A print titled "A Showman," c. 1800, shows a squirrel running on a treadmill on top of the peepshow (EH).

56. "Un Archéologue," *Les Grotesques: Fragments de La Vie Nomade* (Paris: P. Baudouin, 1838), p. 125. Engraving after p. 130. The topics of the views that are mentioned are discontinuous rather than sequential.

57. No peepshow boxes with rolls of continuous scenery are known, although there were continuous rolls of *vues d'optique* of royal processions.

58. François-Auguste Fauveau de Frénilly, *Souvenirs de Baron de Frénilly*, new edition (Paris: Librairie Plon, 1909), pp. 7–8.

59. They could be compared with Nadar's "gallery of the contemporaries" or August Sander's portraits of Weimar Germany. About 500 have been preserved at the Musée Condé, Chantilly, and elsewhere. Philippe Jullien, "Les talents de société de Carmontelle," *Connoisseur des Arts* (January 1965), pp. 80–86. The history of the portrait collection is told by Jean Baillais, "Carmontelle" (unprinted, no date, six typewritten pages, Músee Condé MS 12-96-38-70. The text accompanies the portfolios of Carmontelle's portraits).

60. Laurence Chatel de Brancion, *Carmontelle au jardín des illusions* (Château de Saint-Rémy-en-l'Eau: Éditions Monelle Hayot, 2003); *Carmontelle's Landscape Transparencies. Cinema of the Enlightenment*, trans. Sharon Grevet (Los Angeles: The J. Paul Getty Museum, 2008, orig. *Le cinéma au Siècle des lumières*, 2007). The references are to the English translation. Terpak writes about Carmontelle and the roll at the Getty ("Figures Walking in a Parkland," current length, 377 cm) in Stafford and Terpak, *Devices of Wonder*, pp. 330–335. About *Les Saisons* (now called *Les Quatre Saisons*), *Les Quatre Saisons de Carmontelle: Divertissement et illusions au siècle des Lumières*, ed. Ileana Andrea Altmann (Paris: Somogy éditions d'art and Musée de l'Île-de-France, 2008). I have adopted the title *Les Saisons,* which was used in the auction catalog compiled after Carmontelle's death.

61. A. Augustin-Thierry, *Trois Amuseurs d'Autrefois: Paradis de Moncrif, Carmontelle, Charles Collé* (Paris: Librairie Plon, [1924]), p. 138. Duc d'Orléans had died in 1785, after which his son, Duc de Chartres, had adopted his title. The new Duc d'Orléans, Louis Philippe II, became known for his *anglomanie*, liberal ideas, and opposition to the king. He adopted the name Philippe Égalité. During the Republic, as Citoyen Égalité, he was elected to the National Convention, but was executed during the Reign of Terror in the autumn of 1793.

62. 22, rue Vivienne. Armand Joseph de Béthune, former Duc de Charost, rented one or two of his transparencies for the generous compensation of 4,000 francs. Chatel de Brancion, *Carmontelle au jardín des illusions*, p. 200. Poisson speaks about Duc de Chaulnes. Georges Poisson, "Un transparent de Carmontelle," *Bulletin de la Société de l'Histoire de l'Art francais*, year 1984 (publ. 1986), p. 171.

63. The catalog included eleven

transparencies made between 1783 and 1804. Chatel de Brancion, *Carmontelle's Landscape Transparencies*, appendix 2, pp. 131–132.

64. M. Gabriel and Mme Dessus owned four, measuring 12.5 meters ´ 51–53 cm, and a fifth 18 m ´ 40 cm. Pierre Francastel, "Les transparents de Carmontelle," *L'Illustration*, 17 August 1929 (no. 4511), p. 159.

65. "China paper" was a generic term used about Japanese paper. Chatel de Brancion, *Carmontelle's Landscape Transparencies*, pp. 23–24.

66. The information in Chatel de Brancion, *Carmontelle's Landscape Transparencies* (appendix 3, p. 133) and *Les Quatre Saisons de Carmontelle* (pp. 32–33, n. 22) is confusing. It seems that of the five in the Dessus collection, one is at Musée Condé, Chantilly, two in private collections and two have been cut into fragments and dispersed. There is also a fragment at the J. Paul Getty Museum, *Les Saisons* at the Musée-de-l'Île de France, Sceaux, and one in Mrs. Rachel Lambert Mellon's collection at the Oak Spring Garden Library, Upperville, Virginia.

67. Carmontelle, "Report on the transparent tableaux of Citizen Carmontelle, year 3 of liberty," in Chatel de Brancion, *Carmontelle's Landscape Transparencies*, appendix 1, p. 129.

68. Birgit Verwiebe, *Lichtspiele: Vom Mondscheintransparent zum Diorama* (Stuttgart: Füsslin Verlag, 1997), pp. 28–31.

69. Three transparencies, *Les Saisons* (Musée de l'Ile de France, Sceaux), the one in the Paul-Louis Weller Collection, and the one in a private American collection (probably Mrs. Rachel Lambert Mellon Collection, Oak Spring Garden Library, Upperville, Virginia) were in old view boxes, and the one in Musée Condé, Chantilly in a box Mr. Dessus had ordered).

Poisson, "Une transparent," p. 173, fn. 14. The box that contained *Les Saisons* is said to be "ancient but not original" (*Les Quatre Saisons de Carmontelle*, p. 20.). Bruno's *Atlas of Emotion* (p. 168) contains a photograph of a modern replica of Carmontelle's view box with two original rolls, mistaken as "an apparatus used for rolling panoramic wallpaper." The pictured rolls were bought by Galerie Perrin (Paris) from the Dessus Collection in a Chartres auction on 24 May 1987, cut into pieces and sold as fragments.

70. The document is at the Bibliothèque Doucet, Paris, and reproduced in Poisson, "Un transparent," pp. 174–175. An English translation in Chatel du Brancion, *Carmontelle's Landscape Transparencies*, appendix 1, pp. 129–130 [wrongly dated 1792]. Poisson's transcription is more accurate.

71. Patrice Flichy, *Une histoire de la communication moderne: espace public et vie privée* (Paris: Editions la découverte, 1991), p. 19.

72. *Lumière, transparence, opacité: Acte 2 du Nouveau Musée National de Monaco*, ed. Jean-Michel Bouhours (Milan: Skira, 2006) contains an essay by Chatel de Brancion (pp. 68–73).

73. The size of the opening seems to be about 45 ´ 65 cm, based on the illustration, and the statement that the opening is "d'environ 26 pouces" [65 cm]. Carmontelle probably means its width, rather than the measure across.

74. John Dixon Hunt, *The Picturesque Garden in Europe* (London: Thames & Hudson, 2003), ch. 4, 5.

75. Hunt, *The Picturesque Garden*, pp. 96–97.

76. Part of it survives as a public park in Paris. Carmontelle designed it in the 1770s. Augustin-Thierry, *Trois Amuseurs d'Autrefois*, p. 139; Grace Dalrymple Elliott, *During the Reign*

of Terror: Journal of My Life during the French Revolution*, trans. E. Jules Méras (New York: Sturgis & Walton, 1910, orig. 1856), p. 221 (note). Grace Elliott was one of the younger Duc d'Orléans's mistresses. For an analysis of masonic references in the design of the Jardin de Monceau, see David Hays, "Carmontelle's Design for the Jardin de Monceau: a Freemasonic Garden in Late-Eighteenth-Century France," *Eighteenth-Century Studies* 32, no. 4 (1999): 447–462.

77. In the preface to *Le Jardin de Monceau, près de Paris, appartenant à son Altesse sérénissime Monseigneur le duc de Chartres* (Paris: Delafosse, 1779).

78. This is supported by the title Musée Condé has given to its transparency, "Paysage de fantaisie animé de scènes champêtres." Nicole Garnier-Pelle, *Paysages. Chefs-d'oeuvre du Cabinet des dessins du musée Condé à Chantilly* (Paris and Chantilly: Somogy éditions d'art and Musée Condé, 2001), p. 72.

79. *Jardins romantiques français. Du jardin des Lumières au parc romantique 1770–1840*, ed. Catherine de Bourgoing (Paris: Les musées de la Ville de Pars, 2011), pp. 49–52.

80. Monique Mosser, "The Roving Eye: Panoramic Décors and Landscape Theory," in Odile Nouvel-Kammerer, *French Scenic Wallpaper 1795–1865* (Paris: Musée des Ars Décoratifs/ Flammarion, 2000), pp. 194–209.

81. About this neglected issue, see *Landscape Design and the Experience of Motion*, ed. Michel Conan (Washington, D.C.: Dumbarton Oaks Research Library and Collection, 2003).

82. Lou Quinxi, *Chinese Gardens*, trans. Zhang lei and Yu Hong (China Intercultural Press, 2003), p. 138.

83. Ibid. See also Stanislaus Fung, "Movement and Stillness in Ming Writings on Gardens," in *Landscape*

Design and the Experience of Motion, pp. 243–262.

84. Hunt, *The Picturesque Garden*, p. 121.

85. John Dixon Hunt, "'Lordship of the Feet': Toward a Poetics of Movement in the Garden," in *Landscape Design and the Experience of Motion*, pp. 187–213.

86. Ibid., pp. 188-190.

87. Hunt believes that the Jardin de Monceau "re-created in three dimensions and at full scale" the experience of the transparencies, although the latter were created *after* the parc. Hunt, *The Picturesque Garden*, pp. 120–121.

88. Chatel de Brancion, *Carmontelle au jardín des illusions*, p. 205.

89. Ibid., p. 38.

90. Ibid., p. 75.

91. A dictionary from 1819 states that Carmontelle "turned several of his proverbs into transparencies, and his transparencies into proverbs," adding that the presentations lasted "an hour or longer." F[rancois]-X[avier] de Feller, *Supplément au Dictionnaire historique, formant la suite de la nouvelle édition . . .*, vol. 2 (Paris: Méquignon fils Ainé & Guyot Frères, 1819), p. 46. In a slightly modified form—now saying the transparencies were displayed for "a full hour" and omitting the word "several," etc.—the information was integrated into subsequent editions. "Notice sur Carmontelle," in *Fin du Repertoire du Théatre Francais*, vol. 1, ed. M. Lepeintre (Paris: Mme Veuve Dabo, 1824), p. 65.

92. Quot. Chatel de Brancion, *Carmontelle's Landscape Transparencies*, p. 49. Chatel de Brancion endorses the idea, considering "this new mode of expression as a continuation of his theater" (p. 50).

93. Author's translation. "Avertissement," in Carmontelle, *Nouveaux proverbes dramatiques*, vol. 1 (Paris: Le Normánt & Delaynay, 1811), pp. viii–ix. Who wrote the preface? Perhaps the same person who wrote the auction catalog, possibly Carmontelle's friend Richard de Lédans. Mme Mierral-Guérault, "L'oeuvre picturale de Carmontelle," *Bulletin des Musées de France*, Oct. 1949, p. 226.

94. Poisson, *Un transparent*, p. 171.

95. Stafford and Terpak, *Devices of Wonder*, p. 334. Terpak considers Chinese landscape wallpaper as a possible influence, and wonders if Carmontelle was influenced by extended topographical prospects of towns as well. Chatel de Brancion thinks that Japanese picture scrolls were a possible influence (*Carmontelle's Landscape Transparencies*, pp. 31–32). Still, they were more rare in Europe than the Chinese. Neither Chinese nor Japanese scrolls were translucent.

96. Chatel de Brancion imagines this as Carmontelle's self-portrait, although the apparatus is quite different (*Carmontelle's Landscape Transparencies*, pp. 104–105).

97. Austin Dobson, *At Prior Park and Other Papers* (London: Chatto & Windus, 1912), p. 38. About Séraphin and his "Spectacle des ombres à scènes changeantes," see Mannoni, *Trois siècles de cinéma*, pp. 25–32; Jac Remise, Pascale Remise, and Regis van de Walle, *Magie lumineuse du théâtre d'ombres à la lanterne magique* (Tours: Balland, 1979), pp. 250–254. Séraphin is said to have used Carmontelle's *Proverbs* in his presentations (p. 250).

98. According to Mannoni, the size of the screen of the eighteenth-century shadow theater was circa 65 ´ 130 cm. It was elevated c. two meters from the ground. *Trois siècles de cinéma*, pp. 26–27.

99. Deac Rossell, *Laterna Magica—Magic Lantern*, vol. I (Stuttgart: Füsslin Verlag, 2008), ch. 3.

100. Frénilly, *Souvenirs*, p. 8, trans. in Dobson, *At Prior Park*, appendix A, p. 276. "Savoyard buffoonery" stands for *la grosse bêtise savoyarde*. Terpak has interpreted this as a presentation of a roll transparency (*Devices of Wonder*, p. 331). I disagree, for the reasons I have given in the text.

101. Frénilly, *Souvenirs*, p. 8, trans. in Dobson, *At Prior Park*, appendix A,, p. 275. This sounds like *Les Saisons*.

102. The auction catalog mentions "more than 30 tableaux colored by the same process as the transparency, mounted between two clear Glass plates, showing a variety of Landscape Vistas enriched with Pavilions and various Figures." Were they glass lantern slides?

103. Carmontelle may have connected with a tradition. Voltaire—whose portrait he painted at least three times—is known to have given a tongue-in-cheek magic lantern show on December 10, 1738, at the Château de Cirey-sur-Blaise for the company of Marquise du Châtelet. His imitations of the Savoyard's speech made everyone scream of laughter. Quot. Mannoni, *Le grand art de la lumière et de l'ombre*, p. 109. According to Madame Graffigny, Voltaire accidentally spilled oil and set himself on fire (ibid.).

104. It is owned by the Musée de l'Ile de France in Sceaux. *Les Saisons* was dated 1798 in the auction catalog for Carmontelle's effects, but because of its length and Carmontelle's age it may have been begun earlier. It was marked "not sold." Perhaps it had already been sold or reserved for someone. Chatel de Brancion, *Carmontelle's Landscape Transparencies*, appendix 2, p. 132.

105. According to Lavit, the only recognizable site is Porte Saint-Denis. Some scenes may have been inspired by Méréville, le désert du Retz, or Jardin de Monceau, but the references have been incorporated into "fantasy landscapes for the purpose of spectacle." Jean-Georget Lavit, "Les Quatres Saisons," in *Jardins en Ile-de-France dessins d'Oudry à Carmontelle* (Sceaux: Musée de l'Ile-de-France, 1990), p. 28.

106. Statements like "The 'filming' was done on the Orléans estates, Le Raincy and Saint-Leu in particular" (Chatel de Brancion, *Carmontelle's Landscape Transparencies*, p. 84) occur over and over again.

107. Chatel de Brancion, *Carmontelle's Landscape Transparencies*, p. 9 [author's emphasis]. Monique Moser also belittles their link with panoramas and evokes the cinema as a comparison in "*Rapporter le tableau sur le terrain*: Fabrique et poétique du jardin pittoresque," in *Jardins romantiques français*, p. 40.

108. In his *Mémoire* Carmontelle complains that he had to do everything by himself, perhaps implying that with collaborators his transparencies could be realized on industrial scale.

109. Part of Museum Carolino Augusteum. I saw it on display around 2005, and photographed it then. It may be one of the two devices described by Erich Stenger in "Das Pleorama," *Technikgeschichte* 28 (1939): 128 ff. According to Stenger, the picture rolls were 13 feet long and illuminated from behind. The viewing window measured 12 inches ´ 15.5 inches. Without seeing them, Oettermann seems to have mistaken these devices for peepshows with picture rolls (*The Panorama*, p. 63).

110. See my "The Pleasures of the Peephole: An Archaeological Exploration of Peep Media," in *Book of Imaginary Media: Excavating the Dream of the Ultimate Communication Medium*, ed. Eric Kluitenberg (Rotterdam: NAi Publishers, 2006), pp. 74–155.

111. According to Pinson, Carmontelle's transparencies were shown at the Galerie Lebrun in 1829 (*Explication des ouvrages de peinture et sculpture, exposés au profit de la caisse ouverte pour l'extinction de la mendicité*, Paris: Galerie Lebrun, 1829, no. 234, pp. 43–44). Stephen C. Pinson, "Speculating Daguerre," Ph.D. diss., History of Art and Architecture, Harvard University, 2002 (UMI Microfilm 3051258), pp. 105–106. Pinson tells us that L. J. M. Daguerre's oil painting of the Holyrood Chapel was shown "alongside Carmontelle's transparencies." Pinson has turned his dissertation into *Speculating Daguerre: Art and Enterprise in the Work of LJM Daguerre* (Chicago: University of Chicago Press, 2012), which I was not able to consult.

112. G. Printseva, "P. Ya. Pyasetsky. Panorama Londona v dni prazdnovaniia 60-letiia tsarstvovaniia korolevy Viktorii," ("The Panorama of London during the celebration of the sixtieth anniversary of Queen Victoria's reign by Pavel Pyasetsky"), in *The Culture and Art of Russia, Transactions of the State Hermitage*, 40 (St. Petersburg: The State Hermitage Publishers, 2008), pp. 266–279 (English summary, p. 405). The article was partly translated for me by Daria Khitrova, who also went to consult the Hermitage archive, where several surviving rolls by Pyasetsky are kept.

113. Printseva, "P. Ya. Pyasetsky," p. 267. The court rolls covered topics like the tsar's official visits abroad and Moscow during the coronation of Nicholas II.

114. Catholics were accused of planning to assassinate the king Charles II, which spurred a violent anti-Catholic reaction. The sole surviving copy is in JJG. There were other types of long lateral prints, such as depictions of the dance of the death. Some were based on frieze paintings in churches. For late-seventeenth-century examples: *Ich sehe was, was du nicht siehst! Die Sammlung Werner Nekes*, eds. Bodo von Dewitz and Werner Nekes (Göttingen: Steidl & Museum Ludwig, 2002), pp. 294–295.

115. At CBA. Sean Shegreen, "From broadside to book: pen and pencil in the *Cries* of London," *Word & Image* 8, no. 1 (Jan.–March 2002): 57–86, and "'The Manner of Crying Things in London': Style, Authorship, Chalcography, and History," *Huntington Library Quarterly* 59, no. 4: 405–463. Another roll, *The Common Cries of London* (220 ´ 8 cm), without box, is at the Lilly Library, Indiana University, Bloomington.

116. There is a tiny eighteenth-century palm-size view box with a roll of religious characters in FB. It is missing the front panel, which makes its identification difficult.

117. I have not seen erotic picture rolls in viewing boxes, but they may have existed. About seductive images hidden in minuscule objects, Jean-Pierre Bourgeron, *Les Masques d'Eros: Les objets érotiques de collection à système* (Paris: Les Editions de l'Amateur, 1985).

118. Gaston Bachelard, *Poetics of Space*, trans. Maria Jolas (Boston: Beacon Press, 1969, orig. 1958); Susan Stewart, *On Longing: Narratives of the Miniature, the Gigantic, the Souvenir, the Collection* (Durham: Duke University Press, 1993).

119. Such prints may have been influenced by prospects of cities such as the one that accompanied Corneille le Bruyn's *A Voyage to the Levant; or travels in the principal parts of Asia Minor, the Islands of Scio, Rhodes, Cyprus, etc., with an account of the Most considerable cities of Egypt, Syria and the Holy Land* (London: Jacob Tonson and Thomas Bennet, 1702). It was a folding view of the Constantinople waterfront, 38.2 cm high and 191 cm long. When the view was offered for sale on eBay in April 2008 (without the book and mounted as a roll), the prospect was anachronistically listed as a "panorama." A four meters long engraving of the Thames from the Westminster Bridge to the London Bridge, originally published by Samuel and Nathanael Buck in 1749, was anachronistically labeled "Panorama of London 1749" when it was reissued in 1972. *Panorama of London 1749* (London: Sidgwick & Jackson, 1972). John Wellsman talks about "panorama" in his introduction.

120. Examples are known from France, Germany, and Russia, and particularly from England. Early ones at YCBA include Henry Alken's *Going to Epsom Races* (London: S. and J. Fuller, 1819, also in EH), and Robert Havell Jr.'s *Panorama of London* (1822), which follows the Thames from Vauxhall Bridge to Wapping. Other early examples are Havell's *Costa Scena or a Cruise along the Southern Coast of Kent* (1823, a sea voyage from Greenwich to Calais, EH), and the German *Lindenrolle* (1820), a *pair* of nearly four-meter-long roll panoramas showing both sides of the Unter den Linden. Hyde, *Panoramania!*, pp. 137–138, 157–158.

121. London: S. and F. Fuller, [1820]. The miniature panorama narrated a contemporary man's development "illustrating Shakespeare's Ages." It had 35 scenes and was altogether 455 cm long (EH).

122. Two examples, one from the Yale Center for British Art and another from the British Library, were shown in the exhibition India's Fabled City: The Art of Courtly Lucknow at the Los Angeles County Museum of Art in 2010–2011. The former depicts buildings in Lucknow along the north side of the river Gomti (c. 1826 or earlier) and the latter a royal procession in Lucknow. Stephen Markel with Tushara Bindu Gude, *India's Fabled City: The Art of Courtly Lucknow* (Los Angeles: LACMA, Del Monico Books, and Prestel, 2010), pp.

84, 86–90. Hyde mentions an Indian scroll depicting the Durbar procession of Akbar II, watercolor, dated c. 1815 (*Panoramania!*, pp. 136–137, 159). Scrolls like these may have influenced Robert Havell, one of whose relatives was a resident of Madras (ibid., p. 137).

123. They resemble the folding keys included in the descriptive booklets for Barker's & Burford's Panorama, The Strand, London. Herbert, *A History of Pre-Cinema*, vol. 2, between pp. 32–33, 44–45.

124. There was a black and white and a hand-colored version. The former is in EH.

125. I am indebted to Ralph Hyde for sharing his on-going research with me. Hyde lectured about this topic at the Magic Lantern Society's Annual General Meeting at the Magic Circle, London, on Jan. 22, 2011, and kindly provided me a copy of the lecture manuscript.

126. I have seen an example that depicts scenery along a river in an antique toy shop in Paris.

127. The shop was opened in 1799 at 7, rue Coq-Saint-Honoré (today's Rue Marengo). The business was founded by François Simon Giroux, who sold paint pigments and accessories for artists. In 1838, his son Alphonse Gustave Giroux became the director, and the company named Alphonse Giroux & Cie. Its main claim for fame today is L. J. M. Daguerre's original daguerreotype camera that it manufactured and marketed (1839). Alphonse Giroux was Daguerre's brother-in-law. In 1857, the shop moved to 43, boulevard des Capucines, where it remained until 1867, when it was taken over by Duvinage and Harinckouk. In 1874, Ferdinand Duvinage became the sole proprietor.

128. "V. de R . . .," "Bulletin des modes et de l'industrie," *La Mode, revue politique et littéraire*, 20th year,

Jan. 15, 1849. A similar store in London was A. Bouchet's Magasin de Paris, 74, Baker Street and 52, George Street, Portman Square.

129. Two examples of the diorama handscreen are in EH. Many different mechanical fans are in FB and JJG.

130. Claude Lambert's hand-written patent application was endorsed by the "Comité Consultatif des arts et manufactures" in its seance on Nov. 24, 1819 (no number, copy in EH). The patent was granted on Feb. 28, 1820, according to *Bulletin des lois du Royaume de France*, no. 364 (Paris: L'Imprimerie Royale, April 28, 1820), pp. 571–572.

131. *Dictionnaire technologique ou nouveau dictionnaire universel des arts et métiers . . .*, vol. 7 (Paris: Thomine & Fortic, 1825), p. 478. The entry says that the patent "has not yet been published." Thanks to Gabriele Koller and Ralph Hyde. The patent papers have the year "1825" added by hand, without an explanation.

132. The kaleidoscope is described in the patent as "Transfigurateur," "La Lunette Française," and "Kaléidoscope," 1818. No patent number can be found. The slipcase for an accordion peepshow titled "Optique No. 4, Avenue de Longchamp" (today's Champs Elysées) bears Giroux's logo; the former owner, Miss Agusta Tavel, has inscribed her name and the year 1827 on the slipcase (EH).

133. Ralph Hyde is researching the topic at the time of writing.

134. Sold on eBay UK on Jan. 22, 2009. The seller thought that it depicts the hills behind Sèvres (documentation in EH).

135. The garden is identified in a text plate in the beginning of the roll. Examples with Giroux's label have been sold by Pierre Patau in London (2006) and Sebastien Lemagnen in

Paris (2011) (documentation in EH).

136. William Macready used cloud scenery to mask the edges of a moving panorama by Clarkson Stanfield in Shakespeare's *Henry V* (Covent Garden, June 1839). The London *Times* reported: "Time is discovered upon a circular orifice occupied by clouds, which dissolve away, and present an allegorical scene representing 'the warlike Harry' with 'famine, sword, and fire at his heels leashed like hounds.' This scene vanishing, the play begins." Quot. Richard Carl Wickman, "An Evaluation of the Employment of Panoramic Scenery in the Nineteenth-Century Theatre," Ph.D. dissertation, Graduate School of the Ohio State University 1961 (unprinted), p. 205.

137. A patent for a related object was granted to the toymaker Pierre Henri Amand Léfort as an addition to his patent for the Polyorama panoptique (French patent no. 7974, February 21, 1849). In its addition (October 29, 1853) Lefort describes a *nouvel-écran* with a picture roll, or *suite de paysages*. It resembles the *écran-panorama*, except that it has flexible bellows on the backside, "a kind of camera obscura" (Lefort). Day-night effects are produced by opening or closing the back of the bellows. The patent seems a further improvement of the panorama handscreen. I saw an object like this at the shop of Denis Ozanne, Paris, around 1999–2000.

138. The Phenakisticope was Giroux's version of Joseph Plateau's phenakistiscope, introduced c. 1833. David Robinson, *Masterpieces of Animation 1833–1908*, *Griffithiana* 43 (December 1991); Maurice Dorikens, *Joseph Plateau 1801–1883 Leven r´tussen Kunst en Wetenschap/Vivre entre l'Art et la Science/Living between Art and Science* (Ghent: Provincie Oost-Vlaanderen, 2001).

139. Published by S. W. Fores, 41, Piccadilly, London, 1833 (EH).

140. *M'Lean's Optical Illusions; or, Magic Panorama* (Thomas McLean, 26, Haymarket, [London, 1833]) (EH). Ackermann & Co., used the words Phantasmascope and Fantascope, obviously referring to phantasmagoria. The magic lantern on wheels used in it was known as "Fantascope." One of the discs in Ackermann's first set shows a monster approaching "from the deep"—a well-known trick in phantasmagoria shows.

141. "New publications, and new editions, printed for Samuel Leigh, 18, Strand," catalog (London: Samuel Leigh & Baldwin, Craddock & Joy, [c. 1826]), 24 pp., unpaginated (EH). This novelty was invented around 1823 in Paris by Jean-Pierre Brès.

142. Ralph Hyde, "Myrioramas, Endless Landscapes. The Story of a Craze," *Print Quarterly* 21, no. 4 (2004): 403–421. The word myriorama is said to have been coined by John Heaviside Clark, who produced at least two versions, one with Greek and another with Italian scenery, for Samuel Leigh. Leigh also published Clark's Portable Diorama in 1826. Clark also designed a "Hellenicorama or Grecian Views," published by J. Burgis. Stafford and Terpak, *Devices of Wonder*, pp. 225, 227, 327–329.

143. "New publications, and new editions, printed for Samuel Leigh, 18, Strand."

144. It also contained a pedagogic booklet, *Traité Elémentaire du Paysage*. Hyde, "Myrioramas," p. 418. Leigh was already selling a version of the Myriorama in France around this time, renamed Polyorama. Brès may have wanted to differentiate his own product from it.

145. Rossell, *Laterna magica*, p. 114. Suhr published prints, playing cards and other products.

146. Dr. J. Heckschler, *Peter Suhrs "Panorama einer Reise von Hamburg nach Altona und zuruck"* (Berlin: Hermann Barsdorf Verlag, 1909), pp. 25–26.

147. Other exhibitors also displayed small-scale "panoramas," particularly in the German-speaking part of Europe. Many were more closely related with cosmoramas and peepshows rather than with circular panoramas. The pictures seen in Karl Georg Enslen's "Magic Carpet Art Gallery" were also exhibited as half-circles and viewed through magnifying lenses. (Oettermann, *The Panorama*, p. 225.).

148. Identical examples have been preserved in WN and GRC. The publishing date has been variously given as 1823, 1827, or 1828. Stafford and Terpak, *Devices of Wonder*, pp. 319–321.

149. The original (Staatsarchiv, Hamburg) was displayed in Sehsucht (*Sehsucht*, p. 211). A hand-colored facsimile edition was published by Hermann Barsdorf Verlag in Berlin, 1909 (EH). Stephan Oettermann does not think it was by Suhr (*Sehsucht*, p. 211), but the logo "CS" can be seen in the foreground; it refers probably to Cornelius Suhr, because Christoph would have been too busy by then as a professor at the Academie der Künste in Berlin.

150. Heckschler, *Peter Suhrs "Panorama einer Reise von Hamburg nach Altona und zuruck,"* p. 9.

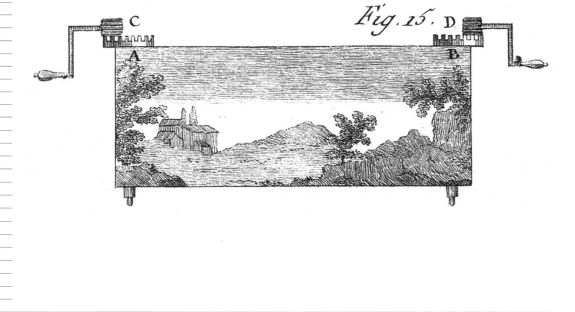

Figure 3.1
The earliest known illustration of a moving panorama
mechanism, from a plate of "catoptric amusements" (Pl.
2, Fig. 15) in Charles-Joseph Panckoucke's *Encyclopédie
méthodique, ou par ordre de matières; par une société
de gens de lettres, de savans et d'artistes* (Paris: chez
Panckoucke, 1782ff, the volume of plates). This widely
distributed illustration is almost exactly contemporary with
Carmontelle's earliest roll transparencies, and may have
influenced them, or vice versa. Quite possibly it also inspired
pioneers, who began creating large-scale moving panoramas
in the early nineteenth century. Author's collection.

3. LARGE AS LIFE, AND MOVING:

THE PERISTREPHIC PANORAMA

THE ELUSIVE MESSRS. MARSHALL

> *"I've stood, Edina [Edinburgh], on thy Earthen Mound*
>
> *So fam'd for Panoramas perestrephic [sic]."*
>
> Edinburgh Magazine, 1821[1]

"Peristrephic Panorama! What a world of mysterious magnificence is contained in those two tremendous titles! how sublime and unintelligible! how agreeably cacophonous to the common ear, and how super-syllabically sonorous to the lugs of learning!"[2] This mischievous comment by an anonymous writer hiding behind the pseudonym Jacob Goosequill was a reaction to a new spectacle. In tongue-in-cheek fashion, he suggested that the title would be shortened to "Periorama," to rhyme with other "oramas." But "peristrephic panorama" hardly needed modifications: it had been coined to sound strange, and strangely attractive.

 The peristrephic panorama gained much attention in the early nineteenth century, but of all "things panoramic" it is one of the least well known today. Histories mention it only in passing, and its apparatus and its vicissitudes remain obscure.[3] The only thing that is agreed upon is that it was a panorama in motion, a fact that is reflected in dictionary definitions. The 1902 *Webster's Dictionary* defined peristrephic as "turning around; rotatory; revolving; as, a peristrephic painting (of a panorama)."[4] The word *peristrephic* appeared around (or perhaps in) 1815, and was first used about shows by a team called Messrs. Marshall, founded in Edinburgh by Peter Marshall (c. 1762–1826).[5] His obituary stated, probably correctly: "artist, inventor of the ingenious Peristrephic Panorama."[6]

M'Dowall's New Guide in Edinburgh later reminded the reader: "Near the south end of the Mound, stands the PERISTREPHIC PANORAMA, Invented by the Messrs Marshall of Edinburgh, by which any length of country is exhibited, being a decided improvement to the Stationary Panorama."[7] Peter Marshall may have pioneered the moving panorama as a nontheatrical attraction. As early as 1809 he exhibited a canvas representing one hundred miles of the banks of the river Clyde; it was claimed to be "300 feet by a proportionate breadth."[8] According to a commentator, the spectators viewed the Clyde "as if travelling along its banks."[9] The painting was displayed at least in Edinburgh, Glasgow, London, and Dublin.[10] A moving panorama of the Thames followed.[11] In 1815 it was on display in Dublin. A local newspaper published an "impromptu" that does not leave doubt about its character:

> About travelling Balloons people make a great rout,
> The greatest of journies in them appear small;
> But at the Rotunda you'll quickly find out,
> How to go 30 miles without moving at all![12]

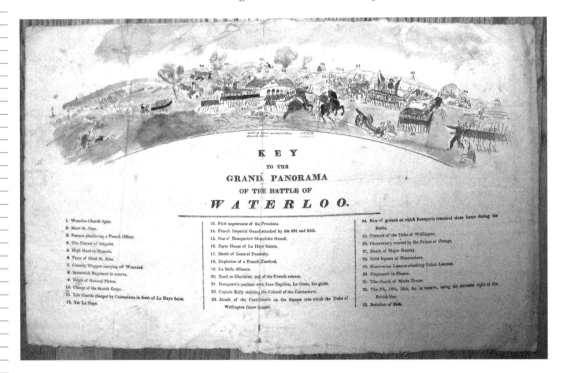

Figure 3.2
Key to the Grand Panorama of the Battle of Waterloo.
Hand-colored engraving. British, 1815 or soon afterward. Showman, painter, and printer unknown. This key was used to make sense of a panoramic painting that was probably produced and exhibited soon after the battle was fought on June 18, 1815. This "grand" panorama neither moved nor formed a full circle, and may have been relatively small. This could be the key to James Howe's (1780–1836) Waterloo panorama, but there is nothing to prove it. Author's collection.

The word *peristrephic* appeared at the same time as the title Messrs. Marshall, which may indicate that Peter's son William joined him at this point.[13] In 1817 "Mr. Marshall, Jun[ior]" was already listed as the manager of their exhibition in Dublin.[14] Another person who may have played a role was James Howe (1780–1836), a painter said to have worked on Peter Marshall's early panoramas.[15] After Napoleon's defeat in Waterloo, Marshall, like other speculators, heard opportunity knocking, and seems to have persuaded Howe to travel to the battlefield to take sketches.[16] His (perhaps not so) "Grand Panoramic Painting" was unveiled already on November 10, 1815, in a temporary wooden building that likely belonged to the Marshalls.[17] In the spring 1816 Howe is said to have painted another panorama of the battle of Les Quatre Bras (fought two days before Waterloo). Because it is said to have consisted of six scenes, it was probably a moving panorama. Both paintings were moved from Edinburgh to a wooden rotunda in Glasgow in June 1816.[18]

Howe's relationship to Messrs. Marshall is unclear, but it is known that the latter was exhibiting a *grand historical peristrephic painting of the ever-memorable Battles of Ligny, and Waterloo* in 1816 (views of Les Quatre Bras were added by 1819).[19] By 1817, Messrs. Marshall also had another show, *The Grand Marine Peristrephic Panorama of the Bombardment of Algiers,* on the exhibition circuit. A steady succession of productions followed in the coming years. The topics of their panoramas

Figure 3.3
"Part of the New Town, from Ramsey Gardens, Edinburgh," with Messrs. Marshall's wooden panorama rotunda in the foreground. Drawn by Thomas H. Shepherd, engraved by J. Rolph, and published by Jones & Co., Temple of the Muses, Finsbury Square, London, Jan. 23, 1830. messrs. Marshall's earlier rotunda was lower on The Mound where the neo-classical Royal Institution building (opened in 1826) is seen. Author's collection.

ranged from the Napoleonic wars to the shipwreck of the Medusa, the corona-
tion of King George IV, the polar expeditions, and the sea battle of Navarino.[20]
Peter and William Marshall do not seem to have painted these themselves.
Rather, they turned into entrepreneurs, commissioning paintings from others.

We don't know the name of any of the painters, but other information can
be found from promotional material. *The Grand Marine Peristrephic Panorama of
the Bombardment of Algiers* was painted "under the direction of Captain Sir James
Brisbane, from Drawings made on the Spot by eminent Naval Officers."[21] The
Grand Peristrephic Panorama of the Polar Regions (1820) was based on "drawings
taken by Lieut. Beechey who accompanied the Polar Expedition in 1818; and
Messrs. Ross and Saccheuse, who accompanied the expedition to discover
a North-West Passage."[22] The panorama of the coronation of King George IV
(1821) was produced "under the direction of Sir George Naylor . . . from drawings
made on the spot." The production process was clearly being "industrialized."

Messrs. Marshall's business model was evidently influenced by circular
panoramas. They exhibited in rotundas erected for the purpose, including the
one which first stood on Princes Street, at the North-East corner of the Mound,
in Edinburgh, and was moved up the Mound to make room for the Royal Institu-
tion, to a site where it remained until 1850.[23] In Dublin Messrs. Marshall built at
least three pavilions (in 1818, 1820, and 1823).[24] One of the reasons for building
rotundas was discovered by Scott Wilcox: Messrs. Marshall exhibited *both* peris-
trephic *and* static panoramas in turn.[25] The many temporary venues that they
used over the years were not necessarily rotundas, probably indicating that only
peristrephic panoramas were displayed in them.

In London Messrs. Marshall occupied the well-known showplace called the
Great Room at Spring Gardens more or less continuously between 1823 and 26.[26]
After Peter Marshall died in 1826, William Marshall seems to have cut back the
touring activities, even though he exhibited peristrephic panoramas in the Edin-
burgh rotunda and elsewhere until the late 1840s. Other showmen, like J. B.
Laidlaw, M. Barker & Co (unrelated to Robert Barker), Daguire & Co., and William
Sinclair (who introduced peristrephic panoramas to the United States), adopted
the concept. Laidlaw, who married Peter Marshall's only daughter, Catherine,
had business relationships with the Marshalls from early on. He may even have
been one of the Messrs. Marshall before starting his own panorama business.[27]

In the media Peter and William Marshall remained shady figures all their
lives. No articles seem to have ever been written about them. Even in their na-
tive town of Edinburgh no one bothered to tell their story. This may have to do
with their role as rather anonymous exhibitor-entrepreneurs. Unlike figures like
Barker and Burford, they never became part of the cultural establishment during
their tenure in London. Even in their main theater of operations—Scotland, Ireland,
and central England—they were just names in their titillating broadsides and
pamphlets.[28] What was their real contribution to the history of the panorama?

THE PERISTREPHIC PANORAMA — 69

THE APPARATUS ACCORDING TO AN EYEWITNESS

Wilcox considered peristrephic panoramas and moving panoramas as practically the same thing, yet it may be argued that the peristrephic panorama had features of its own.[29] One way to demonstrate this is to have a closer look at a rare first-hand description, noted in Dublin on August 12, 1828, by the German prince Hermann Pückler-Muskau. Pückler-Muskau toured England, Ireland, and France between 1826 and 1829, and took detailed notes about everything he saw, including media spectacles. He does not mention the showman's name, but comparing his description with a broadside for *Messrs. Marshall's Splendid & Extensive New Peristrephic Panorama of the late Tremendous Battle of Navarin* [Navarino] leaves no doubt about whose exhibition he saw.[30] The broadside confirms the accuracy of Pückler-Muskau's description, which is worth reproducing in full.[31]

> *After visiting the Courts of Justice, the Custom-house, and other magnificent buildings, I was going home, when I was tempted by the advertisement of a "Peristrephic Panorama" of the battle of Navarino. This is a very amusing sight; and gives so clear an idea of that "untoward event," that one may console one's self for not having been there. You enter a small theatre,—the curtain draws up, and behind it is discovered the pictures which represent, in a grand whole, the series of the several incidents of the fight. The canvass [sic] does not hang straight down, but is stretched in a convex semicircle, and moved off slowly upon rollers, so that the pictures are changed almost imperceptibly, and without any break between scene and scene. A man describes aloud the objects represented; and the distant thunder of cannon, military music, and the noise of the battle, increase the illusion. By means of panoramic painting, and a slight undulation of that part which represents the waves and the ships, the imitation almost reaches reality.*

> *The first scene represents the bay of Navarino with the whole Turkish fleet in order of battle. At the opposite extremity of the bay is seen Old Navarino and its fortress perched on a high rock; on the side of it the village of Pylos, and in the foreground the city of Navarino with Ibrahim's camp, where groups of fine horses, and beautiful Greek prisoners surrounded by their captors, attract the eye. In the distance, just at the extremity of the horizon, the allied fleets are faintly descried. This picture slowly disappears, and is succeeded by the open sea;—the entrance to the bay of Navarino then gradually succeeds. You distinguish the armed men on the rocks, and at length see the allied fleet forcing the passage. By some optical deception everything appears of its natural size; and the spectator seems to be placed in the Turkish position in the bay, and to see the admiral's ship, the Asia, bearing down upon him with all sails set. You see Admiral Codrington on*

the deck in conversation with the captain. The other vessels follow in extending lines, and with swelling sails, as if ready for the attack;— a glorious sight! Next follow the separate engagements of the several ships, the explosion of a fireship, and the sinking of some Turkish frigates. Lastly, the engagement between the Asia and the Egyptian admiral's ship on the one side, and the Turkish on the other, both of which, as you know, sank after an obstinate defence of many hours.

The battle is succeeded by some views of Constantinople, which give a very lively idea of Asiatic scenes and habits.[32]

By Permission, and under the Patronage of the Right Worshipful,
THE MAYOR.
ASSEMBLY ROOM,
PRINCE's STREET, BRISTOL.
MESSRS.
MARSHALL,
The original Inventors of the PERISTREPHIC PANORAMAS, and Proprietors of those of St. Helena, the Battles of Waterloo, Algiers, and Trafalgar, which received the most unprecedented patronage in this City, a few years since, beg most respectfully to intimate to the Nobility, Clergy, and Public of Bristol and its environs, that
THEY HAVE JUST OPENED,
IN THE ASSEMBLY ROOM, PRINCE's STREET,
Their Splendid & Extensive New PERISTREPHIC
PANORAMA
OF THE LATE
TREMENDOUS BATTLE
OF
NAVARIN
Fought in the Harbour of Navarin, in the Morea,
between the Fleets of Britain, France and Russia, combined against those of Turkey and Egypt.
Messrs. MARSHALL feel confident that this PANORAMA will give the highest satisfaction to those who may visit it; being PAINTED FROM THE OFFICIAL PLANS, by permission, and under the patronage of
His Royal Highness the DUKE of CLARENCE,
their Lord High Admiral, LORD VISCOUNT INGESTRIE, and other distinguished Naval Officers, who were in the Battle.
To which are added, Two Extensive VIEWS of the Ancient and Splendid City of
CONSTANTINOPLE,
Painted from Drawings made on the Spot by Captain SMYTH, R.N., Hydrographer to the Admiralty, &c.; the FIGURES and VESSELS being painted on the largest Scale, and accompanied by a FULL MILITARY BAND, giving a complete sensation of reality.
The VIEWS will be presented in the following Order:
1.—The Harbour, Bay, and Town of Navarin,
as they appeared prior to the Battle, with the whole of the TURCO-EGYPTIAN FLEET laying at Anchor in Order of Battle.
MUSIC—Turkish Air.
2 & 3.—Combined Fleets of Britain, France, & Russia,
entering the BAY OF NAVARIN, the ASIA very conspicuous, with Admiral Sir EDWARD CODRINGTON on the Quarter-Deck.—Hearts of Oak.
4.—The Death of Lieut. Fitzroy, of the Dartmouth
Frigate, and the COMMENCEMENT OF THE BATTLE.—Death of Abercrombie.
5.—The Sinking of a Brulot, or Turkish Fire - Ship,
by the PHILOMEL Gun-Brig.
The CAMBRIAN and GLASGOW Frigates engaged with the Turkish Vessels and Batteries.—Battle of Navarin.
6 & 7.—The Explosion of a Fire-Ship,
and a TURKISH LINE-OF-BATTLE SHIP in FLAMES. The Gallant Stations of the TALBOT FRIGATE, the RUSSIAN ADMIRAL's SHIP, BRESLAU, &c.—The Spectators are supposed to enter on the left side of the Bay, and proceed until they arrive at the right entrance, and thus have an accurate View of each Ship as engaged.—Battle Piece.
8 & 9.—The SINKING of a large Double-banked
EGYPTIAN FRIGATE, by the GENOA, 74 Guns—the Death of her Gallant Commander, Captain WALTER BATHURST—the ALBION, 74 Guns, boarding a Turkish Line-of-Battle Ship.—Britons, strike home.
10.—Daring position of the British Admiral's Ship,
the ASIA, (commanded by Sir E. CODRINGTON,) between the Egyptian Admiral's Ship and that of the Capitan Bey—Sir E. Codrington conspicuous on the Quarter Deck.—See the Conquering Hero, and Battle Piece.
It is impossible to describe the effects of these Views; the eye is continually attracted by Ships Blowing up, Sinking, or taking Fire; and the meetings between the Vessels are full of Wrecks. The situation of the Asia, between the two Turkish Admirals' Ships, is terrific, and at once shows the superior prowess of the British Navy.
11 & 12.—The Conclusion of the Battle Piece,
and the PERILOUS SITUATION of the French Admiral's Ship, LA SYRENE, commanded by Admiral DE RIGNY—the DARTMOUTH's BOATS towing off a TURKISH FIRE SHIP that was laying close to her—the gallant Station of the DARTMOUTH FRIGATE—the SCIPION, the TRIDENT, the BRISK, &c. with a Front View of the Town and Vicinity of NEW NAVARIN.—Rule Britannia.
13.—The City of CONSTANTINOPLE,
taken from the South, displaying SCUTARI, the SERAGLIO, SULTAN's PALACE, MOSQUE of St. SOPHIA, MAHOMED, JOHART, &c. Fountain of Sweet Waters, Entrance to the Harbour, &c. &c.—Blue Beard's March.
14.—The Suburbs of Constantinople, Galata, & Pera,
Displaying the TOWER OF GALATA, PALACES of the BRITISH AMBASSADOR, CAPITAN PACHA, Large FIELD of the DEAD, MOSQUE of BAJAZET, MILITARY ARSENAL, MARINE BARRACKS, TOWER of the JANISSARIES, the BOSPHORUS, &c.—Grand March.
Day-Exhibitions from Eleven till Four—Evening ditto from Six till Ten.
Admittance.. BOXES, 1s. 6d. GALLERY, 1s. STANDING-PLACES, 6d.
TICKETS FOR THE SEASON, FIVE SHILLINGS.
BOOKS, descriptive of the PANORAMA, the BATTLE, and the City of CONSTANTINOPLE, &c. to be had at the Door, price 6d.
SOMERTON, Printer, Narrow Wine-Street.

The translation (1832) contains a crucial mistake, claiming that the "screen" *(Leinewand)* is stretched "in a convex semicircle." The opposite is true: the painting was in a *concave* semicircle *(zurückweichenden Halbzirkel)*. Messrs. Marshall's Lower Abbey Street Pavilion, the likely showplace, was a rotunda, so the painting's curvature must have followed the wall. The situation recalls the circular panorama, except that the painting was in motion and covered only a half-circle.[33] Still, Pückler-Muskau talks about a small theater, and says that a curtain "drew up," so the audience must have been seated in an auditorium rather than standing on a viewing platform.[34]

The broadside lists twelve views about the battle.[35] The panorama begins with an "establishing shot" revealing the harbor, bay, and town of Navarino, where the Turkish-Egyptian fleet is at anchor (1). The combined fleets of Britain, France and Russia enter the bay (2 and 3), after which the battle begins; the scene includes the death of Lieutenant Fitzroy on the Frigate Dartmount (4). Several battle scenes follow; the ships belonging to the Allied fleet are mentioned by name and their commanders identified (5–10). Scenes 11 and 12 depict the "Conclusion of the Battle Piece," with dramatic incidents listed and "a Front View of the Town and Vicinity of New Navarin" shown. Finally, the audience was treated with a bonus—two "extensive views" of Constantinople (13 and 14).

Scenes 2 and 3, 6 and 7, and 11 and 12 have been listed together, indicating that they were

Figure 3.4
Broadside for *Messrs. Marshall's Splendid & Extensive new Peristrephic Panorama of the late tremendous battle of Navarin* …, broadside, the Assembly Room, Prince's Street, Bristol (Somerton, Printer, Narrow Wine-Street, [Bristol]), c. 1828. Courtesy of Harvard Theatre Collection, Houghton Library.

continuous moving scenes. This is confirmed by the broadside's description of views 6 and 7: "The Spectators are supposed to *enter* on the left side of the Bay, and *proceed* until they *arrive* at the right entrance, and thus have an accurate View of each Ship as engaged."[36] The other scenes, probably wide enough to fill the field of vision, were probably observed when the canvas been momentarily stopped. Another eyewitness stated clearly: "The great wooden rollers on which all these acres of canvass [sic] are made to *stop* twelve times in the course of their hourly unwinding; while a gentleman, who is seated in the dark among the spectators for that purpose, explains the result of each *stoppage*."[37] There were plenty of details to see. Already in the opening scene Pückler-Muskau's eye was attracted to the "lovely captured Greek maidens caressed by soldiers."[38]

Military music, sound effects, and lecturer's comments enhanced the overall effect.[39] Each view was associated with music, from a "Turkish Air" and "Britons, strike home" to the predictable "Rule Britannia." Horace Wellbeloved confirmed that "the illusion [was] considerably heightened by appropriate music proceeding from *invisible* instruments."[40] Another eyewitness mentioned "the intermediate accompaniment of a symphony supplied by a band of music up stairs [on a balcony?], which plays a dead march, or battle air, just as circumstances call for the visiters' sympathy."[41] Music and sound effects were probably used as *transitions* between the views. Decades later Charles Dickens confirmed this practice: "It is a law that canvas *can* only move to music; and a city with bridges &c., and a river would slowly pass on, and stop short when it was finally developed."[42]

Special effects added flavor to the scenes. "At the extremity of the horizon" Pückler-Muskau perceives the Allied Fleet, "faintly descried" (*wie in Duft gehuellt*, "as if wrapped in mist"). The view slowly disappears, until one sees only the open sea; the mouth of the Navarino Bay appears, with armed men seen on the rocks; the Allied Fleet (re)appears. One comment is particularly intriguing: "By some optical deception (*Durch optischen Betrug*) everything appears of its natural size; and the spectator seems to be placed in the Turkish position in the bay, and to see the admiral's ship, the Asia, bearing down upon him with all sails set." What were these "optical deceptions," and how were they realized?

The fleet in the mist, the undulating waves, and the ship sailing *toward* the spectator were probably separate from the canvas. Parts of the painting may have been made translucent, applying techniques introduced by Charles-Marie Bouton (1781–1853) and Louis-Jacques-Mandé Daguerre (1781–1851) some years earlier at the Diorama. The undulating waves could also have been produced by rotating mechanical devices behind the canvas, and magic lantern projectors may have been used to visualize the approaching and retreating figures.[43] Body-mounted magic lanterns used by a mobile operator had been already introduced.[44] Henry Langdon Childe used one to project a slide of a ghost ship in Edward Fitzball's "serio-comic" play *The Flying Dutchman! or, The Phantom Ship* at the Adelphi Theater in London in 1827.[45] The effect was imitated widely, and could easily have been copied by Messrs. Marshall.

CIRCULARITY, STASIS, AND MOTION—
THE FRENCH CONNECTION

Did the apparatus of the peristrephic panorama remain the same, or change over time? Was the canvas always presented as a concave semicircle? Unfortunately, there are no references to its (semi)circularity in Messrs. Marshall's promotional material. Years later John Timbs recalled their Waterloo panorama, "which the spectators viewed turning round."[46] A Dutch visitor, who saw the peristrephic panorama of the coronation of George IV at Spring Gardens, says that he sat in an amphitheater facing a "stage" (*tooneel*).[47] When the orchestra began a march, a long procession of "life size" (*levensgrootte*) figures started moving toward Westminster Abbey on a "broad canvas" (*breede strook doek*), "like a Panaroma" [sic] (*gelijk een Panaroma*). The view must have been wide, but whether it was curved is hard to determine.

Static circular panoramas had already been displayed in the Great Room at Spring Gardens. As early as 1805 John Thomas Serres exhibited there his *Panoramic Picture of Boulogne*.[48] Its key demonstrates that the painting was in the form of a circle, or almost: unlike at Barker's Panorama, the viewing platform was not in the center, but on the side facing Lane Street, where the entrance must have been.[49] It simulated the Stern Gallery of the flagship of Rear Admiral Louis, anchored in the port of Boulogne. Messrs. Marshall's amphitheater could have been positioned in a like manner. It is possible, although not very likely, that peristrephic paintings rotated in a full circle, but so that just a section was visible at a time (the rest being behind curtains, etc.). They may have been shown as semicircles whenever a rotunda was available; in other cases, the canvas may have been straight.

Messrs. Marshall never missed pointing out that the figures are "large as Life."[50] The broadside for the coronation panorama claimed that it had been "[p]ainted on 10,000 Square Feet of Canvas, and displaying nearly 100,000 Figures [!], 500 of the principal Characters on the Foreground the Size of Life." The showman's mathematics was a "liberal art." When witnesses marveled at the size of the canvas, it is difficult to tell if they were recounting their own experiences or re-enacting marketing slogans. A humoristic print titled *The Moving Panorama, or, Spring Gardens Rout* (1823) displays fashionable people trying to squeeze themselves in to see the coronation panorama.[51] A lady states: "I am told the King looks very majestic and elegant." A gentleman comments: "He is positively moving like life, and as large too." Jacob Goosequill joked about the same idea, when he wrote that "all the great men [were] painted to the life or death as it happened."[52]

The emphasis on size demonstrates the influence of the circular panorama. Immersion was enhanced by making the sources of the music and the effects invisible, and by seating the lecturer "in the dark among the spectators."[53] But the sequential nature of the canvas was even more important as Messrs. Marshall

themselves stated in a rare comment about the aesthetics of their show: "The Artists received the greatest assistance from the Painting being of the Peristrephic form, as they were thus enabled to connect and portray the most striking features of each day's battle."[54] It was the moving procession that "worked well" (*voldeed wel*) for the Dutch spectator, whereas the static views left him indifferent.[55]

Neil Arnott, who saw Messrs. Marshall's Napoleon panorama at Spring Gardens, wrote in his popular *Elements of Physics, or Natural Philosophy*:

> *Scenes representing the principal events were, in succession, and apparently on the same canvas, made to glide across the field of view, so designed that the real motion of the picture gave to the spectator the feeling of the events being only then in progress, and with the accompaniments of clear narration and suitable music, they produced on those who viewed them the most complete illusion.*[56]

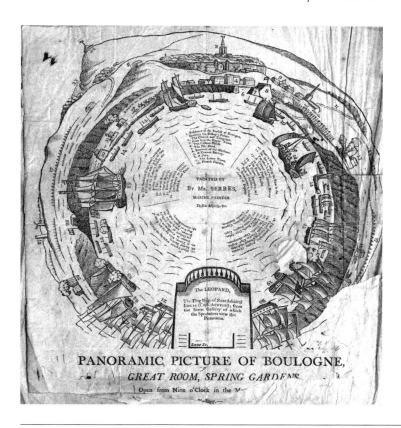

Figure 3.5
John Thomas Serres, key to the *Panoramic Picture of Boulogne*, exhibited in the Great Room, Spring Gardens (London), in 1805. The viewing platform, which was in the form of the Stern Gallery of the flagship of Rear Admiral Louis, is in an unusual way on the side of the panorama and not in the center. Author's collection.

No matter how overwhelming, immersive, and artistic it may have been, a circular panorama presented just a single stationary view; a single slice of time and prospect had been selected. In its prospectus (1806), the journal *Literary Panorama* wrote about the panorama's limitations, contrasting it with its own literary mission:

> A PANORAMA *is an ingenious device in the Art of Painting, wherein a Spectator, from an elevated central situation, by directing his attention to each part successively, inspects the whole. The principle and application is a happy effort of modern Art; and the popularity acquired throughout Europe, by this kind of exhibition, sufficiently proves its merit and attraction. But,* A LITERARY PANORAMA *possesses advantages over every exertion of the Graphic Art: it includes, at one view, a kingdom, or a continent; a whole community, however extensive its interests, or even the globe itself, with its innumerable diversities of inhabitants. Nor is such a performance confined to the contemplation of objects under a single aspect, or in their present state; it examines by retrospective consideration, the various events which have rendered them what they are, or looks forward, so far as human prudence can anticipate, and modestly predicts the natural result of those principles whose operations it exhibits to the Spectator.*[57]

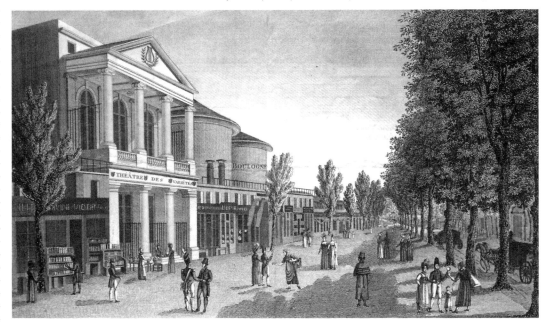

Figure 3.6
"Vue du Théâtre des Variétés." The famous twin panorama rotundas along Boulevard Montmartre on both sides of the Passage des Panoramas (Paris) are seen in this engraving. Drawn by Courvoisier, engraved by Eugène Aubert, first half of the nineteenth century. Author's collection.

The journal criticized the panorama also in its review of Barker's Grand Cairo (1810): "Neither motion nor sound can be comprized in a Panorama; and thus we perceive that even this, the nearest approach to a visible reality, stands in need [of] various allowances, and of the exercise of candour by the spectator."[58] The pioneers knew the limitations, and thought about solutions. Breysig suggested an actorless "cosmo-theater" or "autokinesit theater." The painting would have been much longer than the circumference of the rotunda's wall, and in motion, with painted cutouts moving at different speeds in front of it.[59] Even the central viewing tower would have been in circular motion on ball bearings, causing a bumpy feeling, as if the viewers had been traveling in a coach or on a ship. The plan was not realized, but it anticipated innovations of the late nineteenth century.

The American inventor Robert Fulton, who was stationed in Paris, suggested another solution. On 7 Floréal an 7 [April 26, 1799] he was granted a patent for importing Barker's panorama to France, but as an inventor he also wanted to improve its design.[60] In 1801 he patented an ingenious way of changing the paintings in an instant.[61] Up to eight canvases were stored on vertical rollers in an adjacent chamber, and moved around the rotunda by a mechanical cranking system.[62] Even more important, Fulton suggested that the paintings would be changed in the *presence* of the visitors, who would be given an opportunity to "travel from one capital of Europe to another without changing their place *[sans changer de place]*."[63]

One of the drawings shows visitors standing on the viewing platform, but because of the proposed solution they could have just taken a seat and enjoyed the landscape gliding past. Was Fulton's plan realized? As far as I know, no one has asked this question. My answer is: quite possibly. Fulton began constructing a pair of rotundas along Boulevard Montmartre (on both side of the current Passage des Panoramas), but sold his business in 1799 to another American, James W. Thayer, and his wife Henriette Beck. The 1801 patent could have ended in their hands as well. Because the twin rotundas were small (only 14 meters in diameter), they could have been adapted to the system. The best argument for its possible existence is the fact that until their demolition in 1831, the rotundas frequently displayed paintings that had *already* been exhibited in the same premises.[64]

The *Almanach des Spectacles pour 1830* contains an intriguing advertisement for an attraction named *Le Péristréphorama*, or *panorama mobile* ("moving panorama"), which was on display at the Passage des Panoramas, in the same location where a *Panorama de Rome* (probably by Pierre Prévost, 1804) was also shown— in one of the twin rotundas.[65] *Le Péristréphorama* might have been exhibited by Fulton's system. Unfortunately, the advertisement does not contain other details, including the topic. Another source only states that the *Péristréphorama* operated between 1829 and 1830.[66] Was it an effort to rescue the rotundas from pending demolition by introducing a peristrephic panorama, perhaps an import from England?[67]

We know that a *panorama mobile*, painted by L. J. M. Daguerre's former collaborator, the scene painter Pierre-Luc-Charles Cicéri, was exhibited in 1829 at

the Opéra as part of Scribe, Aumer, and Herold's ballet-pantomime *La Belle au bois dormant*.⁶⁸ It was received as a novelty, and could have inspired (or been?) the *Péristréphorama*. It is worth noting that Messrs. Marshall's *Peristrephic Panorama of the Shipwreck of the Medusa French Frigate* was advertised as French.⁶⁹ A British critic attacked the "wretched daubs of some discarded French scene painter," and recommended "banishing these 'French Peristrephic Panoramas' to the fairs, to which by right of demerit they belong."⁷⁰ Indeed, there were French moving panoramas, but they did not become common.⁷¹

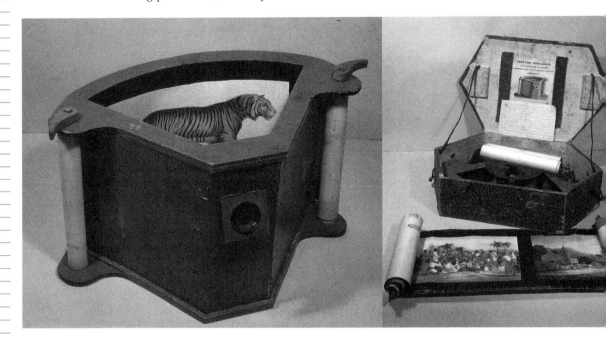

One of those cases that resist being interpreted just as coincidences is an ingenious toy named Cyclorama, patented in the early 1830s by the Parisian bookseller Auguste Nicolas Nepveu, who had his shop inside the Passage des Panoramas (No. 26)—practically next to the twin rotundas.⁷² It was a triangular view box with a peephole at the front and a knob-operated picture roll stretched along its concave rear wall.⁷³ The views moved much like peristrephic panoramas. Did Nepveu get his inspiration from the *Péristréphorama*, Suhr's *Europorama* (shown in Paris some years earlier) or perhaps from a British peristrephic panorama? Or was the idea really a sudden flash of his own imagination? How exciting it would be to know.

Figure 3.7
Auguste Nicolas Nepveu, *Cyclorama*, miniature moving panorama. France, first half of the 1830s. Except for being a peepshow, the apparatus of this desktop viewer resembles the peristrephic panorama. Courtesy of the Turin Film Museum.

UNCLE JACK AT THE MOVING PANORAMA SHOW

And they call them such queer names, one can't pronounce them. I suppose in a few years we are to leave off talking English. There's the Diorama (where they turn you about till you feel quite qualmish), the Cosmorama, the Peristrephic Panorama, and the Apollonicon, and the Euphonon, and I know not what besides picture exhibitions without end. Pleasure, pleasure, is the only thing thought of now. Any thing to squander money away, and amusement. O these are sad times!

—*"The Praise of the Past," The Inspector, Literary Magazine and Review* (1827)[74]

At Spring Gardens, Jacob Goosequill experienced "charges of cavalry and discharges of infantry, great guns, thunder-bombs, flying artillery, lying troops, and dying soldiers." Tongue-in-cheek, he announced his desire to take part in the commotion: "Like Don Quixote and the puppets I longed to attack the peristrephic people sword in hand, and kill a few dozen Frenchmen on canvas."[75] His feigned patriotic fervor evokes an incident Arnott claimed he had witnessed in the same showplace: "A young man seeing a party of British preparing to board an enemy's ship started from his seat with a *hurra*, and seemed quite surprised when he found that he was not really in the battle."[76]

These discursive snippets were anything but isolated. In 1831 the *Brighton Guardian* reported an "amusing incident," said to have taken place at J. B. Laidlaw's bombardment of Algiers panorama "on Thursday evening."[77] A sailor who was said to have taken part in the battle jumped into the "sea" to rescue the flagship Queen Charlotte—only to crash

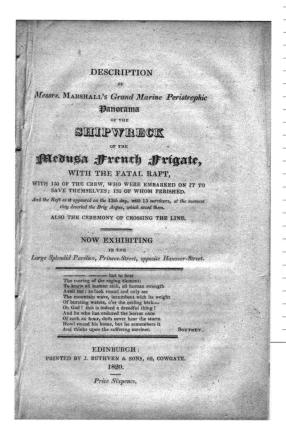

DESCRIPTION
OF
Messrs. MARSHALL'S *Grand Marine Peristrephic*
Panorama
OF THE
SHIPWRECK
OF THE
Medusa French Frigate,
WITH THE FATAL RAFT,
WITH 150 OF THE CREW, WHO WERE EMBARKED ON IT TO
SAVE THEMSELVES; 135 OF WHOM PERISHED.
*And the Raft as it appeared on the 13th day, with 15 survivors, at the moment
they descried the Brig Argus, which saved them.*
ALSO THE CEREMONY OF CROSSING THE LINE.

NOW EXHIBITING
IN THE
Large Splendid Pavilion, Princes-Street, opposite Hanover-Street.

— but to bear
The roaring of the raging element:
To know all human skill, all human strength
Avail not: to look round and only see
The mountain wave, incumbent with its weight
Of bursting waters, o'er the reeling bark—
Oh God! this is indeed a dreadful thing!
And he who has endured the horror once
Of such an hour, doth never hear the storm
Howl round his home, but he remembers it
And thinks upon the suffering mariner. SOUTHEY.

EDINBURGH:
PRINTED BY J. RUTHVEN & SONS, 69, COWGATE.
1820.

Price Sixpence.

Figure 3.8
The cover of *Description of Messrs. Marshall's Grand Marine Peristrephic Panorama of the Medusa French Frigate* (Edinburgh: J. Ruthven & Sons, 1820). Author's collection.

through the green cloth stretched in front of the painting. The audience's shock was "electrical," but gave way for laughter. In 1843 it was *The Albion*'s turn to report a "ludicrous incident" at Gordon's British Diorama in Edinburgh. Jack, a drunken sailor, saw the "critical position of the British troops in the Awful Khyber Pass," and went through a series of mishaps worthy of the "thorough-bred tar" at Laidlaw's panorama.[78]

The protagonist of W. H. Barker's short story "The Battle of the Nile" (1838), another sailor, recounts his drunken escapades, including his attack on a mechanical theater, the Battle of the Nile, at the Bartholomew's fair.[79] Encouraged by "a precious nip from a bottle of rum," the sailor defends Admiral Nelson's fleet against the French by using oranges as cannonballs. The combination of intoxication, patriotic fervor, and illusionistic spectacle leads to a momentary destruction of normalcy. A kind of antidote to it was a song probably inspired by Messrs. Marshall's panorama: "What in my mind made it still seem the stranger, Though I stood *in the midst*, I stood out of danger."[80]

Figure 3.9
George Cruikshank (1792–1878), "The Battle of the Nile," an illustration to W. H. Barker's story "The Battle of the Nile" (1838) *Bentley's Miscellany*, April 1838. The illustration shows a drunken sailor attacking a mechanical theatre of the battle of the Nile, demonstrating the parallel between literary and visual topoi. Author's collection.

We will never know for sure if such incidents really happened; we should not forget that claiming to have seen something with one's own eyes is also an age-old topos. "Reports" glided easily into fiction and back, confusing truth and un-truth. Anecdotes that sound like word-of-mouth lore may also have been spread by exhibitors as marketing gimmicks. All this sounds familiar. The main character of Edison's silent film *Uncle Josh at the Moving Picture Show* (Edwin S. Porter, 1902), a country bumpkin on a visit to a city, causes havoc at a film screening in much the same way, failing to make a distinction between reality and fiction. Uncle Josh is a personified topos, and a descendant of all the drunken sailors, who raved at panorama shows half a century earlier.[81] This example shows that film culture did not inherit only material features from earlier shows; also the imaginary around it accommodated pre-existing discursive formulas.

The peristrephic panorama mixed educational and cultural pursuits with features from fairs and fairgrounds. Its status was reflected in the reactions it raised. The circular panorama and the Diorama were less problematic, because they were more "pure." One observer rejected Messrs. Marshall's panoramas by comparing them to the offerings of itinerant peepshowmen. They were "adapted to amuse and satisfy the tastes of that class of persons alone who frequent . . . halfpenny exhibitions."[82] The reviewer contrasted Messrs. Marshall's show with "our own delightful Panoramas," "the exquisite views of the Diorama," and even the theatrical scenery of the pantomimes.[83] To the eye trained by metropolitan spectacles Messrs. Marshall's offerings were vulgar.

But many saw both pros and cons. Although it was agreed that the views had been "painted for popular effect," it was also admitted that "there is a bustle, a variety, and a sort of attraction, even to adults as well as to younger folks, which imparts interest to this exhibition."[84] Arnott made an important observation, stating that "in its mediocrity [the peristrephic panorama] served to prove how admirably adapted such unions of painting, music, and narration, or poetry, are to affect the mind, and therefore to become the means of conveying most impressive lessons of historical fact and moral principle."[85] With the Napoleon panorama in mind, he praised the new possibility of depicting "the course of a human life" with moving pictures, anticipating the enormous genre that would, almost exactly a century later, include Abel Gance's epic silent film *Napoléon* (1927).[86]

The ambivalence of attitudes was expressed perfectly by Reverend Thomas Green-

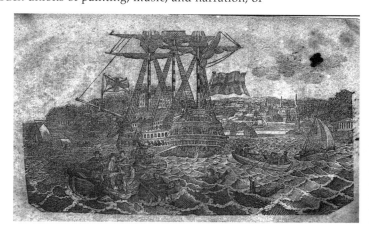

Figure 3.10
An illustration of a scene from a peristrephic panorama, from the booklet *Description of the Peristrephic Panorama … Illustrative of the principal Events that have occurred to Buonaparte, commencing with the Battle of Waterloo, The 18th of June, 1815, and ending with his Funeral Procession at St. Helena* (Guernsey: T. Greenslade, 1826). Author's collection.

wood in his poem "Battle Scenes, on viewing the Peristrephic Panorama of the Battle of Waterloo."[87] As far as a poem can be read as a first-hand account, it demonstrates the strong tension between fascination and horror:

> Oh! how can I gaze with delight
> On a scene so revolting as this?
> Has bloodshed attractions to rivet the sight,
> Or awaken emotions of bliss?

The poet feels "Soft Pity [as] the pageant of horror and death passes by," but admits that it is "a splendid display / And extorts the applause of the eye." "The music was part of the "allurement." The poet accuses the "pomp, and the glitter, and martial array" for disguising the real horrors of war, and speculates that if the views were "stripped of adornment" and the music mixed with the real sounds of the battlefield the impact might be different. He admits that his fascination raises a moral problem, but finds no cure: "Oh, curse on such charms! I would spurn their control, / And debar them for ever access to my soul!"

The peristrephic panorama proved to be a transitional form. In subsequent developments, moving panoramas became less concerned with immersion, and more occupied with visual storytelling. The showmen gave up the idea of building rotundas, the canvas lost its curvature, and the lecturer gained more prominence. No lecturers were ever identified by name in Messrs. Marshall's, J. B. Laidlaw's, or William Sinclair's publicity, but figures like Albert Smith, Joachim Hayward Stocqueler, and Leicester Buckingham attained celebrity status, enough to justify the entrance fee. The picture shrank, and was enclosed in a proscenium frame. Total immersion was either out of fashion or found impractical. The most intense competition now concerned length. Where typical peristrephic panoramas had lasted 30–60 minutes, the presentation time doubled. Instead of just one roll containing 10–12 views, several were needed.[88]

The words *peristrephic panorama* were still evoked from time to time in the 1840s, but they were losing their original meaning. In the handbook to William Telbin's *The Panorama and Diorama of the Isle of Wight with the Interior of Senlis Cathedral* (post-1844) they were used simply to characterize a spectacle "by which the views are consecutively brought round to the spectator," distinguishing it from the circular panorama and the Diorama.[89] Peristrephic panorama had become synonymous with the words moving panorama.

Figure 3.11

The cover of *A Description of Marshall's grand historical peristrephic panorama of the ever-memorable battles of Ligny, Les Quatre Bras, and Waterloo*, nineteenth edition (Bristol: T. J. Manchee, n.d, c. 1820). Author's collection.

"PERIORAMAS" OF THE MIND,
OR THE DISCURSIVE DIMENSION

Peristrephic panoramas inspired significant discursive activity. The new word-combination was not applied only to rotating canvases and the showmen exhibiting them; it began leading a much more imaginative life. Its discursive drift was a kind of overture to what would to happen to the moving panorama later in the century. Already in 1820, it was used by a certain Mrs. Purcell in her novel *The Orientalist, or, Electioneering in Ireland*. Someone says to a lady, who had tried her hand in painting, but given it up: "It was not alone by the square foot you were in the habit of drawing, but by the acre—whole sheets of canvass [sic], in size resembling our peristrephic panoramas at the least."[90]

Motion had been left out from the comparison, but it had already inspired another author, who wrote in his *Peter's Letters to his Kinsfolk* (1819): "My position resembled that of a person visiting a peristrephic panorama, who, himself immoveable in a darksome corner, beholds the whole dust and glare of some fiery battle pass, cloud upon cloud, and flash upon flash, before his eyes."[91] The relationship between the immobility of the observer and the spectacle moving around him was expressed in many variations. An article about Mr. Joy, a self-centered Irish politician (1823), used it to describe his character: "While others are pacing with rapidity along the flags which have worn out so many hopes, Joy remains in stationary stateliness, peering with a side-long look at the peristrephic panorama that *revolves around him*."[92]

Texts like this almost make us believe that the canvas formed a full circle. With the circular panorama at the back of their minds, the writers obviously stretched it virtually. The things that circled around the observer could be almost anything. A "wanderer" in India was alarmed by "the peristrephic movement of several bats and owls round the ceiling of the room."[93] Political papers could give "a sight of the hidden machinery, by means of which the colossal panorama of Europe was made so ominously to revolve."[94] Politicians and diplomats were the showmen animating the *theatrum mundi*.

Jacob Goosequill likened the peristrephic panorama to a child's spinning top, characterizing it as a "huge round world turning on its invisible spindle."[95] *Blackwood's Edinburgh Magazine* made a cosmic leap by suggesting that "the whole visible nocturnal sphere is peristrephical."[96] This could be a veiled reference to astronomical clocks and orreries. A writer compared the mechanical figures of the "wonderful clock of Jacob Lovelace" (in Liverpool) to a rotating panorama: "The movements are 1st—A moving Panorama descriptive of Day and Night, Day is beautifully represented by Apollo in his Car, drawn by four spirited coursers, accompanied by the twelve hours, and Diana in her Car, drawn by stags attended by twelve hours, represents Night. 2nd—Two Guilt Figures in Roman costume who turn their heads and salute with their swords as the Panorama revolves."[97] Such machineries had been built for centuries, and may

have been an inspiration for the moving panoramas displaying processions.

The human body was often pictured as immobile, but the situation could be reversed: it was set in peristrephic motion. The *New Sporting Magazine* characterized the skater as a "Peristrephic Philosopher, a living lecture on the centre of gravity; though he now and then indulges you with a digression on the centrifugal force."[98] The dizzying spins of dancers likewise evoked a comparison to their "peristrephic performances."[99] Interestingly, the mind made the motion faster and faster, far exceeding the slow crawl of actual panoramic canvases. "Dizzying spins" would not be experienced in real performances until hand-cranking was replaced by electric motors in theatrical panoramas toward the end of the century.

Perhaps because the painting may not always have been curved, some texts associated the peristrephic panorama with linear movement. A skit titled "Munchhausen ride through Edinburgh" (1827) described a wild ride on a panicking horse through Scotland's capital.[100] The writer's phantasmagoric imagination has made the motion much faster than a panorama's mechanism would have allowed: "The castle and all its rocks, in peristrephic panorama, then floated cloud-like by—and we saw the whole mile-length on Prince's-street [sic] *stretched* before us."[101] Princes street intersects with The Mound, where Messrs.

VIEW FROM PRINCE'S STREET GARDENS EDINBURGH
Published by R. Grant & Son 82. Princes Street.

New Club. R.G.& Son St Andrew's Ch. Royal Institution Melville's Mont. Register House.

Fig. 3.12

"View from Prince's Street Gardens Edinburgh." Engraving by W. H. Lizars from a drawing by W. Banks. Published by R. Grant & Son, 82 Princes Street, Edinburgh, between 1834 and c. 1850. The print shows the Marshall Rotunda in the foreground (just about the words "Register House.") It was moved up the Mound from an earlier location, where the Royal Institution was built (and opened in 1826). Princes Street runs horizontally through the picture. Author's collection. A calotype by David Octavius Hill and Robert Adamson (c. 1843-1847) in the University of Glasgow Library, Special Collections (identifier: HA0465) shows Marshall's panorama rotunda on The Mound, with its competitor, Gordon's Diorama, on its side.

Marshall's rotunda was located. Was there a hidden reference to their activities in the story?

The mobilization of the observer's body may point to the Diorama, where the audience was turned around on a mechanical platform. The relationship between the two spectacles was confusing. *The Circulator of Useful Knowledge* found it necessary to remind its readers about the difference between the two spectacles: "In the Regent's Park [Diorama], the whole area in which the company is seated is made to move round from picture to picture, while the pictures themselves remain stationary; at Spring Gardens the spectators are fixed, and the pictures are caused to glide laterally and successively into view."[102] The *Gentleman's Magazine* mixed media by characterizing the Diorama as an exhibition, "in which the spectators are subject to the peristrephic motion of an amphitheatrical building."[103]

Travelogues did not play a central role in the repertory of peristrephic panoramas. Still, travel writers eagerly compared their experiences to them. In 1845 Andrew Archibald Paton described the beginning of his voyage along the Danube in an interesting manner: "I step on board—the signal is given for starting—the lofty and crimson-peaked Bloxberg—the vine-clad hill that produces the fiery Ofener wine, and the long and graceful quay, form, as it were, a fine peristrephic panorama, as the vessel wheels round, and, prow downwards, commences her voyage for the vast and curious East."[104] Associating the peristrephic panorama and the *rotation* of the ship as it sets out on its course is interesting. Henry Lewis used a similar make-believe trick when he presented his Mississippi panorama in the late 1840s (see chapter 8).

Another travel writer, Leitch Ritchie, compared the river journey to a peristrephic panorama as well, contrasting the river and the land journey:

We have hitherto been talking of the voyage of the Rhine: the land journey is a different thing. In the former, the scenery slips past you like a moving, or as the showmen say, a peristrephic panorama, and you see nothing but what is set down. On shore, you choose your own points of view, and group your own pictures. One moment the broad lake lies before you, basking in the sun, with its castellated ruins, fantastic steeps, and groves and vineyards, clearly defined and exquisitely contrasted. The next, all is dimness and doubt. A glimpse of the water appears far, far beneath through the trees, deep, mystic, unfathomable, and dimmed with the broken reflection of some broken turrets, of which the originals are invisible.[105]

It would be tempting to read these words as prolegomena to an aesthetics of perception with mediatic parallels. The river voyage, like the showmen's offerings, is constrained, because it is conditioned by the "apparatus" (the boat moving along the river). The land journey offers more freedom, because "the

eye wanders, with a kind of troubled delight, from lake to lake, from hill to hill, from steep to steep, from grove to grove, from castle to castle, that lie before it in overwhelming confusion."[106] The spectator on the platform of a circular panorama comes to mind, but it too has its limitations, preventing the observer from penetrating into the landscape; the relationship between the observer and the observed remains distanced.

Although his book was illustrated by Clarkson Stanfield, the eminent scene and moving panorama painter, Ritchie emphasized unencumbered perception at the expense of preset and mediated conditions. One assumes that neither the moving nor the stationary panorama fully satisfied him. However, there were others who were not bothered by such limitations and even considered them as sources of pleasure, as an article of "hints for the holidays" indicates:

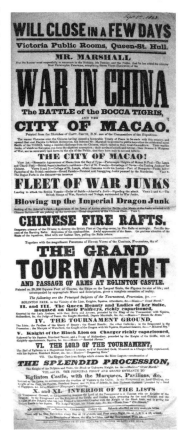

Or shall we journey in a BAROUCHE? *Pleasantest of land-carriages, whether horsed with chestnuts or bays. Tree and tower go swimmingly by, and whole fields of corn-sheaves seem of themselves to be hurrying to harvest-home. The whole world is a peristrephic panorama, and turnpike gates seem placed not to impede motion, but to promote [it]. Village follows village quickly, even in a thinly inhabited country, so rapid is the imperceptible progress of the sixteen hoofs; and we drive through towns and cities from sun to sun.*[107]

One could argue that observing the landscape from a moving barouche was more constrained/ing than strolling on the deck of a river boat and leaning over its railing. Still, vehicular perception was becoming a model for media experience. Carmontelle evoked the "Berlin" as a kind of viewing platform in motion. Trains, hot air balloons, and steamships opened up new perceptual experiences, challenging the space-time continuum.[108] Such experiences were simulated by enterprising showmen, who persuaded their audiences that virtual travel was not only a less cumbersome alternative, but even more impressive than the real thing.

Figure 3.13
Broadside for William Marshall's New Peristrephic Panorama, Victoria Public Rooms, Queen Street, Hull, England. Hand-dated September 1, 1843. Printed by Michael Charles Peck, 43 Lowgate, Hull. The program consisted of two parts: scenes from the War in China (in seven views) was followed by the Grand Tournament and Passage of Arms at Eglintoun Castle (in eleven views). Messrs. Grieve had painted moving panoramas of both topics for Covent Garden in 1839-1840. Although their contents (HL, EH) do not fully match Marshall's program, a connection is possible, because panoramas were often modified over time. Author's collection.

NOTES

1. "Edina, a Poem in Six Cantos," *Edinburgh Magazine, and Literary Miscellany* (Edinburgh: Archibald Constable), vol. 9 (Sept. 1821): 233.

2. Jacob Goosequill, "The Oramas," *London Magazine* 10 (Sept. 1824): 274. Predictably, the word was often misspelled: "perestrephic," "prestrephic," "periostrephic," etc.

3. Comment sums up the situation: "There is very little information available regarding the size of the canvas or, more importantly, its configuration." *The Painted Panorama*, p. 63. Comment referred to *Messrs. Marshall's grand peristrephic panorama of the coronation of His Majesty George IV* (1821).

4. *Webster's International Dictionary of the English Language. New Edition with Supplement of New Words*, ed. Noah Porter (Springfield, Mass.: G. & C. Merriam Co., 1902), p. 1068.

5. In 1815, Messrs. Marshall exhibited in Dublin two peristrephic panoramas, their "entirely novel peristrephic panorama, or Grand Revolving Display of all the Cities, Towns, Villages, Seats, and Beautiful Scenery, for 30 miles along the river thames" (first mentioned in *Freemans Journal*, April 5, 1815) and the "new Peristrephic Spectacle, which displays all the Waterfalls, Towns, Villages, Bridges, Seats and Romantic Scenery, for 100 miles along the River Clyde in Scotland, including an extensive view of the city of Glasgow" (*Freemans Journal*, August 18, 1815). No handbooks before 1816 seem to survive. The earliest is from 1816: *Description of Messrs. Marshall's grand historical peristrephic painting of the ever-memorable Battles of Ligny, and Waterloo, etc. Battles of Ligny and Waterloo. Description of Messrs. Marshall's grand historical peristrephic painting of the ever-memorable Battles of Ligny, and Waterloo, etc.* (Dublin:

W.H. Tyrrell, 1816, copy in the British Library, 1422.d.16). New editions were published in 1817 and 1818.

6. Sylvanus Urban, *Gentleman's Magazine: and Historical Chronicle, From January to June, 1827*, vol. 97, Part the First (London: J. B. Nichols, 1827), p. 190. Marshall died in Edinburgh at his house, 39, North Hanover Street, on Jan. 17, 1826; he was 64. A short obituary also appeared in *Blackwood's Edinburgh Magazine* 21, no. 123 (March 1827): 375. *Bryan's Dictionary of Painters and Engravers. New Edition Revised and Enlarged* (New York: Macmillan Co.; London: George Bell and Sons, 1904, vol. 3, p. 290) states: "Marshall, Peter, born in 1762; died at Edinburgh in 1826. He practiced as a painter, but is chiefly known as the inventor of a mechanical contrivance known as the Peristrephic Panorama."

7. *M'Dowall's New Guide in Edinburgh* (Edinburgh: Thomas and William M'Dowell, 1842), p. 68. Messrs. Marshall never neglected to mention in their publicity that they were the original inventors.

8. Wilcox, "The Panorama and Related Exhibitions in London," p. 65. The key to *A Grand & Interesting Exhibition of a Moving Panorama of Trafalgar, Representing the Splendid Victory achieved by Lord Nelson* (National Maritime Museum, NMM, London) depicts the panorama in a curved semi-circle. Numbered explanations have been listed at the bottom, on both sides of an added scene depicting Nelson's death. Graphic design points to early nineteenth century. The museum has attributed the panorama to Peter Marshall (perhaps because Messrs. Marshall displayed later a peristrephic panorama about the Battle of Trafalgar), but the key may not refer to a moving panorama at all. Only the title indicates motion. The production may have been a static semicircular painting, or a combination of two paintings, an overview of the battle

and a view of the death of Admiral Nelson. The key resembles the one printed for Robert Ker Porter's *The Siege of Acre* (1801).

9. *The Morning Chronicle*, Feb. 6, 1811, quot. Wilcox, "The Panorama and Related Exhibitions in London," p. 65.

10. Ralph Hyde, entry on Marshall for a planned panorama encyclopedia (unprinted). The panorama was revived as late as 1823 at the Lower Great Room, Spring Gardens (London) under the title *A Fashionable Tour for One Hundred Miles along the Banks of the Clyde …* while *Marshall's Grand Historical Peristrephic Panorama of the Ceremony of the Coronation, the Coronation Procession, And the Banquet Of His Most Gracious Majesty King George the Fourth* was being shown at the Great Room (photocopy in RH). A broadside for it can be glimpsed in the entrance hall to the Spring Gardens in the satirical print by C. Williams, *The Moving Panorama, or, Spring Gardens Rout* (London: J. W.Fores, 1823, BDC).

11. According to Wilcox, a moving panorama of the Thames was painted by the drawing master Patrick Gibson, and shown in Edinburgh in 1811. In 1812 Gibson exhibited another moving panorama of London sights, and three years later one on St. Helena" ("The Panorama and Related Exhibitions in London," p. 228). Peter Marshall seems to have exhibited a Thames panorama from 1813 onwards—did he acquire Gibson's panorama or paint his own? An unidentified early ad advertises a Grand Peristrephic Panorama at Trades' Hall, Glassford-street [Glasgow]. The subject is the Thames from Windsor Castle down to London. The showman is mentioned as A. Marshall [sic] (photocopy in RH). John Lockie's *Topography of London*, 2d ed. (London: Sherwood, Neely, and Jones and J.M. Richardson, 1813) lists "Panorama (Marshall's), Old Bond-St.—13 doors on the R. from 57, Piccadilly." The topic of the panorama is not mentioned. The information is

missing from the first edition (London: S. Couchman, printer, 1810). "Apiarian Museum" existed in the same location in 1810 (*Times*, April 17, 1810, p. 3). It displayed "correct panoramic views of the city of london and edinburgh." These are also listed in an undated broadside for the same institution (JJCB). It also mentions "A New Optical Machine, called the Phantasmiscope" (a magic lantern?). Was Peter Marshall involved?

12. "Impromptu on seeing Messrs. Marshall's Peristrephic Panorama," *Freemans Journal*, April 8, 1815. The article explained: "In order to understand the above, it must be observed, that on account of the Panorama's revolving, the spectators in imagination transfer the motion of the picture to themselves, and thus seem to enjoy all the pleasures with none of the inconveniences resulting from a real tour."

13. Little is known about the life of William Marshall. He married Miss Jane M'Lean on April 16, 1828, and their address was given as Gilmour Place (*Blackwood's Edinburgh Magazine* 25 [Jan.–June 1829]: 817). In 1830, the *Blackwood's Edinburgh Magazine* 26 (1830): 963, reported the birth of twin sons for "William Marshall, Esq. proprietor of the Panorama." He died before April 13, 1850, when *The Scotsman* mentioned the "late Mr W. Marshall." Four panoramas "of the late William Marshall" were auctioned on Feb. 21, 1851 (*Glasgow Herald*, Feb. 17, 1851). At least some were acquired by [John] Baker & Clark, who advertised their panorama on Jan. 17, 1852, at Cross Keys Assembly Room, Kelso [Scotland] (broadside in HL). The three subjects were Jerusalem, City of Berlin, and California and the Gold Regions.

14. *Freemans Journal*, Sept. 23, 1817. The ad mentions that "the other Proprietors have presented him with the entire Proceeds of the Exhibition, on This Day, Tuesday, the 23d Inst. For which Days he has Engaged Two [sic] Full Military Bands to Accompany

the Description of the Painting; and every exertion possible, shall be made, to render the Exhibition more than usually interesting." Was the purpose to celebrate the promotion of the young man? The program was *The Grand Peristrephic Panorama of the Battle of Algiers*. "Marshall Junior" was not mentioned in earlier ads, but the first anniversary of the Battle of Algiers was already celebrated on Aug. 27, 1817, for which occasion the panorama had been "decorated with Laurel &c." (*Freemans Journal*, Aug. 27, 1817).

15. A[lexander] D[urand] Cameron, *The Man Who Loved to Draw Horses: James Howe 1780–1836* (Aberdeen: Aberdeen University Press, 1986).

16. Robert Brydall, *Art in Scotland: Its Origin and Progress* (Edinburgh: William Blackwood and Sons, 1889) says that "it is told that, being advised to paint a panoramic view of the Battle of Waterloo, he visited the field, and finished within a month after his return, a panorama measuring 4,000 feet of canvas, well covered with incidents in the fight" (p. 425).

17. According to Cameron, "Peter Marshall and Son" were "known to be the owners after 1815 of a large wooden building near the head of Leith Walk [Edinburgh]." He does not reveal his source (*The Man Who Loved to Draw Horses*, p. 28).

18. Cameron's information is mostly from local newspapers, but his work is not fully annotated. The panorama of Les Quattre Bras has not been attributed to Howe by others.

19. Broadside for an exhibition in the Exchange Assembly Rooms, Market Place, Nottingham, "Whit-Monday, the 31st instant, 1819)" lists all three subjects (British Library).

20. There were others. A newspaper clipping (source unknown, hand-dated June 29, 1822) announced a show in Aberdeen, Scotland: "mr. marshall

most respectfully intimates to the Nobility and Public of Aberdeen, that he has now Opened in Mr. Morrison's *Hall*, Union Street, His Grand Peristrephic panorama of the *Sortie from Bayonne*, Where the Earl of hopetoun is seen falling from his Charger in the foreground, at the moment he is taken Prisoner by the French. Also, the ever memorable Storming of St. Sebastian, Where so many of our gallant Countrymen fell. Displaying one of the most desperate attacks recorded in the Annals of History. The Figures in the foreground, being all the size of Life, and the Picture being of the Peristrephic form, gives it every appearance of Reality. Also, a correct view of The Whale Fishery, Which concludes with TWO of the whaling vessels *encountering a Tremendous Storm*. The whole accompanied by a full Military Band, with appropriate Music." (HTC) Was only one of the Marshalls (William?) in charge?

21. By 1819, the handbook had reached the 13th edition: *British valour displayed in the cause of humanity: being a description of Messrs. Marshall's Grand Marine Peristrephic Panorama of the Bombardment of Algiers* … (Hull: R. Wells & Co., 1819). The title page says: "Now exhibiting in the Grand New Pavilion, North end of the Earthen Mound, Princes-Street [Edinburgh]." (NYPL). Views VII and VIII of Algiers on the day after the battle had been added.

22. It was known as the *Grand Peristrephic Panorama Of the Magnificent Scenery of the Frozen Regions* …, when it was displayed in Dublin at "Marshall's splendid new pavilion … in Lower Abbey-Street, Near Sackville-street." (*Freemans Journal*, July 21, 1820).

23. They received the building permission in 1818, probably to replace an earlier structure. Cameron, *The Man Who Loved to Draw Horses*, p. 34. Marshall's buildings were characterized for example as "The Grand New Pavilion," "the spacious

pavillion, Princes' Street, opposite Hanover Street," or "the Rotunda, Earthen Mound."

24. Ads in *Freemans Journal*, Feb. 6, 1818; July 21, 1820; March 20, 1823. The last mentioned was built to house Henry Aston Barker's panorama of the Carnival of Venice, brought from London. Messrs. Marshalls also exhibited at the Rotunda (1815, "entrance from Cavendish-row") and at the former Olympic Circus, 7, Lower Abbey-street, which they " enlarged and elegantly fitted up for the purpose" (*Freemans Journal*, April 8, 1817). In Glasgow, they displayed their *Grand peristrephic panorama of the Polar regions* in a "large new circular wooden building, George's Square." *Description of Messrs Marshall's grand peristrephic panorama of the Polar regions* ... (Leith, Scotland: William Heriot, 1821), title page. Original in Metropolitan Toronto Library. Other venues included the Athenaeum, Mytongate, Hull; Large Room, Lillyman's Hotel, Liverpool; the Masonic Hall, York Street, Bath; Exchange Rooms, Nottingham; Music Hall, Albion-street, Leeds; the Assembly Room, Prince's Street, Bristol.

25. Wilcox, "The Panorama and Related Exhibitions in London," p. 229.

26. *Theatrical Observer and Daily Bills of the Play*, on-line at www. archive.org (last visited Oct. 8, 2008). The London exhibitions began with the Coronation Panorama on March 11, 1823. Parallel showings of the Clyde panorama (June-Sept.) and The Shipwreck of the Medusa (from September) were organized in the Lower Great Room. The Coronation panorama was replaced by Ligny, Les Quattre Bras and Waterloo in November 1823, and it by the Napoleon panorama in late 1824. In 1825, sections of the battles of Genappe, Trafalgar, etc., were added. The London tenure came to an end on Aug. 5, 1826, after which the venue was demolished. The last program was The Bombardment of Algiers. It seems that Messrs. Marshall

never again exhibited in London.

27. According to the *New Monthly Magazine* 9 (Jan.–June 1818): 83, the marriage took place in Manchester. Laidlaw was said to be from Leeds. I will discuss Laidlaw's career (together with that of William Marshall) in detail in a forthcoming article.

28. Some panoramas, such as the Battle of Bannockburn (shown in 1827 at their Edinburgh rotunda, *Scotsman*, April 7, 1827), had more local interest. So did a production by local artists from Hull, *The Grand Moving Peristrephic Panorama of the Siege of Hull in 1643, And the Battles fought at Beverley, Anlaby, Hessle, and Kirk-Ella* [etc.], Kirkwood's Olympic Circus, Hull [old hand dating: March, 1829, broadside, HTC]. Messrs. Marshall's panoramas were often advertised "from London" to attract provincial audiences.

29. Wilcox writes: "The peristrephic or moving panorama, while it had limited initial success in London, would by mid-century far surpass the original form of the panorama in popularity." ("The Panorama and Related Exhibitions in London," p. 64.)

30. Undated broadside, the Assembly Room, Prince's Street, Bristol, printed by Somerton, Printer, Narrow Wine-Street (HTC). A handbook (Leith: William Herriot, 1828) survives in Glasgow University Library, but I have not seen it. The *Scotsman* advertised the same panorama, when it was shown at Marshall's Rotunda On The Mound, Aug. 17, 1831. Only ten battle scenes are numbered, followed by views of Constantinople, Amsterdam, and Southern Africa. J. B. Laidlaw displayed what may have been the same Navarin panorama in Hull (corner of Wellington-street and Queen-street), but only nine views were listed, and two views of the "Burning of the Kent East Indiaman, In the bay of Biscay" [March 1, 1825] added (*A Splendid New Panorama Of the Battle of Navarino*, undated broadside, copy in RH).

31. He may well have bought the show's handbook or obtained a copy of the broadside or handbill.

32. *Tour in England, Ireland, and France in the Years 1828 & 1829; with Remarks on the Manners and Customs of the Inhabitants, and Anecdotes of Distinguished Public Characters. In a Series of Letter. By A German Prince*, [trans. Sara Austin] (London: Effingham Wilson, Royal Exchange, 1832), vol.1l, pp. 160–162. Quot. Altick, *The Shows of London*, p. 202. I have used the translation in parallel with Hermann von Pückler-Muskau, *Reisebriefe aus Irland* (Berlin: Rütten & Loening, n.d.), pp. 9–11.

33. The viewing situation might perhaps be compared to the Cinerama theaters of the 1950s with their huge screens curving 146 degrees around the audience. Much like the Cinerama screen, the concave canvas of the peristrephic panorama increased the horizontal width of the view, enhancing the sensation of immersion. It may also have served a narrative purpose: the lecturer could direct the spectator's eye to a certain part of the picture (say, the left side), while another view was imperceptibly appearing (from the right). The visual logic, narrative structure, music, and sound effects worked together to turn the spectator's attention away from the fact that a sequence of more or less distinct views was presented.

34. The Bristol broadside also reveals that the setting was theater-like, because tickets were sold to boxes (1s. 6d.), the gallery (1s.) and standing places (6d.).

35. In Messrs. Marshall handbooks each view is numbered and described in detail (background information is added after each entry in smaller font). The structure of the guidebook supports the idea that the roll was stopped between the views.

36. Author's emphasis.

37. "New French Peristrephic Panorama," *New Monthly Magazine and Literary Journal* 12 (London: Henry Colburn, 1824), Jan. 1824, p. 11. (Emphasis added.) The panorama was *Messrs. Marshall's Original Historical Peristrephic Panorama of Twelve Views of the Ever-Memorable Battles of Ligny, les Quattre Bras, and Waterloo*, shown at the Great Room, Spring Gardens, 1823–1824.

38. My translation. The early English translation says "groups of fine horses, and beautiful Greek prisoners." Perhaps a literal translation was considered too graphic for the British, known for their sympathy for the Greek cause.

39. Sound effects are not mentioned in the broadside, but may be implied by a comment that follows scene 10: "It is impossible to describe the effects of these Views; the eye is continually attracted by Ships Blowing up, Sinking, or Taking Fire."

40. "Marshall's Prestrephic [sic] Panorama, Spring Gardens," in Horace Wellbeloved, *London Lions for Country Cousins and Friends About Town …* (London: William Charlton Wright, 1826), p. 57.

41. "Panoramas," *Times* (London), Dec. 30, 1824.

42. Dickens, "Moving (Dioramic) Experiences," p. 306. Original emphasis.

43. Such as the *Feux pyriques* (or *feux arabesques*), where discs with colorful abstract patterns rotated behind slotted and colored pictures, sometimes by means of a clockwork mechanism. An original eighteenth-century device with a large set of "software" has been preserved in JJG. In *Iwanovna* (Sadler's Wells, 1816) a transparent static panorama of Moscow in flames was used as a backdrop. "A roller was employed behind the transparency to effect the

flames." Sybil Rosenfeld, *Georgian Scene Painters and Scene Painting* (Cambridge: Cambridge University Press, 1981), p. 156. It could have been a *feux pyriques* apparatus.

44. According to Chevallier, Philidor, who gave a phantasmagoria show in Paris before Robertson, and may have been identical with Philipsthal, who appeared in London in 1802, used a magic lantern strapped to his body, not a Fantascope on wheels. [Jean] Chevallier, *Le conservateur de la vue*, 3d ed. (Paris: Chez l'Auteur, 1815), p. 290. The optician Philip Carpenter introduced c. 1821 an "Improved Phantasmagoria Lantern" meant to be strapped directly on the body of the moving operator. The only known example is in EH. It was described in his booklet *Elements of Zoology* (Liverpool: Rushton and Melling, 1823).

45. David Robinson, "Magic Lantern Sensations of 1827," *The New Magic Lantern Journal* 8, no. 4 (Dec. 1999): 14–15; "Further Adventures of the Flying Dutchman," *New Magic Lantern Journal* 9, no 4 (Summer 2003): 59–60.

46. *Curiosities of London* (London: David Bogue, 1855), p. 679. "Peristrephic, or Moving Polygonic Panorama" was mentioned in an article on phraseology, but whether there was a show bearing such a title is not known. "Refinements of Modern Phraseology," *The Polar Star of Entertainment and Popular Science* (London: A. Flower), vol. 6 (Nov. 1830–March 1831), p. 38.

47. A. van der Willigen, *Aanteekeningen op een togtje door een gedeelte van Engeland, in het jaar 1823* (Haarlem: Wed. A. I. Oostjes Pz., 1824), p. 246.

48. In *The Shows of London*, p. 136, Altick says that the 150-foot canvas depicted the "staging facilities for Napoleon's projected invasion of England and the flotilla he had assembled for the frustrated venture."

49. In EH.

50. The *Times* published an intriguing anecdote about watchmen, who arrest a person carrying a suspicious package they consider a stolen corpse. It proves to be "a large figure (used by artists), which the proprietor of the Peristrephic Panorama, at Spring-gardens, had lent to a friend." ("Laughable Mistake," June 16, 1823, p. 3). It was probably a painter's mannequin, rather than a mechanical figure, used in the show.

51. By C. Williams, *The Moving Panorama, or, Spring Gardens Rout* (London: J. W. Fores, 1823, BDC).

52. Goosequill, "The Oramas," pp. 274–275.

53. "New French Peristrephic Panorama," *New Monthly Magazine and Literary Journal* 12 (London: Henry Colburn, 1824), Jan. 1824, p. 11. The choice of words is interesting: "A gentleman, who is seated in the dark among the spectators for that purpose, explains the result of each stoppage, after the most approved manner of the halfpenny showman."

54. *A Description of Marshall's grand historical peristrephic panorama of the ever-memorable Battles of Ligny, Les Quarte Bras, Waterloo …*, 19th ed. (Bristol: T. J. Manchee, c. 1821), p. 2 (EH).

55. van der Willigen, *Aanteekeningen*, pp. 246–247. The static views were the coronation ceremony and the banquet.

56. Neil Arnott, *Elements of Physics, or Natural Philosophy*, vol. 2, part 1 (London: Longman, Rees, Orme, Brown and Green, 1829), p. 281.

57. "On Wednesday, October 1, 1806, will be published, (to be continued Monthly), Price Half-a-Crown … No. I of the Literary panorama: including a review of books, register

of events, and magazine of varieties." (London: C. Taylor, [1806]), pp. 1–2 (JJCB).

58. "Considerations on the Panorama View of Grand Cairo, composed by Mr. Barker from the Drawings of Mr. Salt, who accompanied Lord Valentia, now exhibiting in London," *The Literary Panorama, being a Review of Books, Magazine of Varieties, and Annual Register* [etc.], vol. 7 (London: Cox, Son, and Beylis for C. Taylor, 1810), p. 448.

59. Breysig's description has been quoted by Oettermann, *The Panorama*, pp. 25–26.

60. Robert Fulton, "Panorama, ou tableau circulaire sans bornes, ou manière de dessiner, peindre, et exhiber un tableau circulaire," French patent no. 150, applied February 25, 1799, granted 7 Floréal an 7 [April 26, 1799] (EH). It is this patent that has been discussed by historians, while the later one has been neglected. The public notary recorded the transfer of Fulton's rights to his panorama patent to Thayer on 17 Frimaire an 8 [Dec. 3, 1799]. (Ampliation, Extrait des Délibérations des Consuls de la République, Ministère de l'Intérieur, 14 Germinal an 8 [April 4, 1800]).

61. Robert Fulton, "Perfectionnement du Panorama," French patent, no number, 1 Germinal an 9 [March 10, 1801] (EH). This patent has been neglected by the historians.

62. Cook in *Movement in Two Dimensions* (pp. 32–33) claims that Barker's panorama painting *View of the Grand Fleet, moored at Spithead* (1794) had been mobile, which seems a misunderstanding. The idea was adopted by John L. Fell, *Film and the Narrative Tradition* (Berkeley: University of California Press, 1986 [1974]), p. 137. Fell's book was a pioneering effort, but because of the numerous mistakes it contains it should be used with caution.

63. The words *sans changer de place* may refer either to the experience of traveling virtually without physically leaving one's geographic home base (a *topos* frequently associated with immersive media), or to the possibility of not having to change one's place on the viewing platform. Compare: Laurent Mannoni, *Le grand art de la lumière et de l'ombre* (Paris: Nathan, 1994), pp. 171–172.

64. Comment, *The Painted Panorama*, p. 47.

65. *Almanach des Spectacles pour 1830*, vol. 9 (Paris: Barba, 1830), p. 249. The panorama of Rome and the Péristréphorama could be viewed for one price (1 franc). Georges Potonniée lists (but does not explain) the *Péristréphorama* in *Daguerre, peintre et décorateur* (Paris: P. Montel, 1935), pp. 72, 74.

66. H. Audiffret, "Cosmorama," in *Dictionnaire de la conversation et de la lecture*, vol. 17 (Paris: Belin-Mandar, 1835), p. 356.

67. M. Barker & Co.'s "Grand Historical Peristrephic, or Moving Panorama, of St Helena, &c." Great Room, Swan Tavern, Exeter, 1825 was advertised as *en route* for France (copy of broadside in RH).

68. The premiere was on April 27, 1829. The *panorama mobile* has been claimed to have been a collaboration between L. J. M. Daguerre and Cicéri. Marie-Antoinette Allevy (Akakia Viala) attributes the "panorama mobile" to Cicéri alone. It was received as a novelty in Paris. Marie-Antoinette Allevy (Akakia-Viala), *La mise en scène en France dans la première moitié du dix-neuvième siècle* (Paris: Librarie E. Droz, 1938), pp. 60–61.

69. It was shown at the Lower Great Room, Spring Gardens while the *Original Historical Peristrephic Panorama of Twelve Views of the Ever-Memorable Battles of Ligny, les Quatre Bras, and Waterloo* was on display in the Great Room in 1823–24. About its competition with the exhibitions of Géricault's painting, Lee Johnson, "The 'Raft of the Medusa' in Great Britain," *Burlington Magazine* 96, no. 617 (August 1954): 249–254; Jonathan Crary, "Géricault, the Panorama, and Sites of Reality in the Early Nineteenth Century," *Grey Room*, no. 9 (Fall 2002), pp. 5–25.

70. "New French Peristrephic Panorama," *New Monthly Magazine and Literary Journal* 12 (London: Henry Colburn, 1824), Jan. 1824, p. 11. The panorama was Messrs. Marshall's *Original Historical Peristrephic Panorama of Twelve Views of the Ever-Memorable Battles of Ligny, les Quattre Bras, and Waterloo*, at the Great Room, Spring Gardens, London (1823–1824). When Monsieur Daguire & Co.'s Celebrated Grand Historical Revolving Panorama of the French Revolution [of 1830] was exhibited in Sudbury on Jan. 18, 1838, it was claimed to have been brought from "the Palais Royal Rue St. Honore Paris" and painted "from Drawings made on the spot by eminent Artists, who were themselves active in the several battles." The proprietors were said to have been "at Paris at the time." Broadside at www.sudburyhistorysociety.co.uk/Images/Image18_01_1838.jpg (last visited May 29, 2010).

71. One was displayed in London during the mid-century panoramania, but it was an exception. It depicted Paris, St. Cloud and Versailles, and was shown at the Linwood Gallery, Leicester Square. It had been painted by Charles-Antoine Cambon, an experienced scenic artist and former pupil of the celebrated master Pierre-Luc-Charles Cicéri, but a British reviewer found that it was "not equal to the Dioramas [moving panoramas] by English artists." *The Almanach of the Fine Arts for the Year 1852*, p. 144. The broadside identifies the painter as "E. Cambon" which must be a spelling mistake (E for C) (JJC). The panorama

concluded with "the great display of Water-works at Versailles—the jets being of real water" (ibid.).

72. The only known surviving copy is at the Turin Film Museum. *La magia dell'imagine, Macchine e spettacoli prima dei Lumière nelle collezioni del Museo Nazionale del Cinema*, ed. Paolo Bertetto and Donata Pesenti Campagnoni (Milan: Electa, 1996), pp. 219, 222–223. The museum also has another early moving panorama toy named Betts Pictorial Noah's Ark, made by Philip, Son & Nephew in England (ibid., pp. 220, 224-225). It shows a procession of animals entering Noah's ark, and may have been inspired by panoramic lantern slides about the same topic. Copy of the same toy exists in JJG as well.

73. Cyclorama was an addition to an earlier patent for "panorama de salon" or "panorama portatif" granted for Nepveu on March 13, 1830 (French patent no. 4300). Nepveu applied for a patent for *perfectionnements* (including the Cyclorama) on the same day, but he only submitted the drawings on Oct. 11, 1832. The patent was granted on March 13, 1833 (French patent no. 5181). It is possible that the toy was only manufactured after that date. Nepveu specified that the name he had chosen meant a "*vue circulaire, vue circulante, vue qui tourne sur une cylindre.*" The last two sound like synonyms of "peristrephic." (Copies in EH).

74. "The Praise of the Past," *The Inspector, Literary Magazine and Review* (London: Effingham Wilson, 88, Royal Exchange, 1827), vol. 2, pp. 34–35.

75. Goosequill, "The Oramas," p. 275.

76. Arnott, *Elements of Physics*, p. 282.

77. The story was also quoted by another source, which strengthens the impression that it is a topos. "An Amusing Incident …," *A Political Observer* (London: William Carpenter),

Sat., April 16, 1831, p. 12.

78. "Ludicrous Incident," *Albion, A Journal of New, Politics and Literature*, March 11, 1843, pp. 2, 11.

79. *Bentley's Miscellany*, April 1838. Repr. in *Old "Miscellany" Days: a Selection of Stories from "Bentley's Miscellany"* (London: Richard Bentley and Son, 1885), pp. 287–290.

80. Ettrick Shepherd, "Noctes Bengerianae No. II," *The Edinburgh Literary Journal: Or, Weekly Register of Criticism and Belles Lettres* (Edinburgh: Constable & Co.), no. 19 (March 21, 1829), p. 259. My emphasis. The song is "Dennis Delany," which was featured in collections of Scottish popular songs.

81. Similar figures were evoked by filmmakers, cartoonists, and writers alike. Stephen Bottomore, *I Want to See This Annie Mattygraph: A Cartoon History of the Movies* (Pordenone: Le giornate del cinema muto, 1995), pp. 52–53; "The Panicking Audience? Early cinema and the train effect," *Historical Journal of Film Radio and Television* 19, no. 2 (June 1999): 177–216. Porter's film was based on Robert W. Paul's *The Countryman's First Sight of the Animated Pictures*. Charler Musser, *Before the Nickelodeon: Edwin S. Porter and the Edison Manufacturing Company* (Berkeley: University of California Press, 1991), p. 192.

82. "New French Peristrephic Panorama," p. 11.

83. A reviewer found a peristrephic panorama of Napoleon's Egyptian campaign (shown in a Rotunda on the Mound, Edinburgh) "spiritedly but coarsely painted, and described to the spectators by a man who has the most awful Paisley twang ever heard," *Edinburgh Literary Journal, or, Weekly Register of criticism and belles lettres*, July–Dec. 1830, p. 310. *Bonaparte in Egypt* was not Messrs. Marshall's; it was shown in a short-lived competing rotunda nearby.

84. "Panoramas," *Times* (London), Dec. 30, 1824. The article was about Messrs. Marshall's peristrephic panorama of the battle of Trafalgar and the life of Napoleon (1824).

85. Arnott, *Elements of Physics*, p. 282.

86. In the 1856 edition the meaning of the presence of Napoleon in the successive views was made even more clear. Arnott's thinking points toward "hero"—centered cinematic biopics. Neill [sic] Arnott and Isaac Hays, *Elements of Physics, or, Natural Philosophy, General and Medical* (Philadelphia: Blanchard and Lea, 1856), p. 379.

87. Rev. Thomas Greenwood, *Scripture Sketches; with other Poems and Hymns* (London: J. Hatchard and Son, 1830), pp. 95–100.

88. The coronation panorama lasted less than an hour. A broadside from Manchester for the Ligny, Les Quatre Bras, and Waterloo panorama says it is "upwards of 400 feet," while another one (from Liverpool) measures it as "now 350 feet," after a new scene had just been added. The version shown in Manchester contained this addition, and also a new (opening) scene, which explains the 50 foot extension.

89. Cheltenham: J. Hadley [post-1844], p. 8. (GRI). "J. C. H.," the writer of the introduction, has not been identified. Telbin's Panorama and Diorama of the Isle of Wight was exhibited in Cheltenham in 1846 (Ralph Hyde, personal communication).

90. [Mrs. Purcell], *The Orientalist, or, Electioneering in Ireland; a Tale, by Myself* (London: Baldwin, Cradock, and Joy, 1820), vol. 2, p. 296 (UCLASC).

91. [Peter Morris,] *Peter's Letters to his Kinsfolk*, vol. 2 (Edinburgh: William Blackwood and London: T. Cadell and W. Davies, 1819), p. 26.

92. "Sketches of the Irish Bar.—No. V: The Solicitor-general, Mr. Joy," *New Monthly Magazine, and Literary Journal* 5, no. 30 (1823): 489. My emphasis.

93. *Journal of a Wanderer: Being a Residence of India, and Six Weeks in North America* (London: Simpkin, Marshall & Co., 1844), p. 39.

94. *Blackwood's Edinburgh Magazine* 57, no. 353 (March 1845): 321.

95. Goosequill, "The Oramas," p. 275.

96. *Blackwood's Edinburgh Magazine* 22 (1827): 385.

97. George H. Heffner, *The Youthful Wanderer: An Account of a Tour through England, France, Belgium, Holland, Germany* (Orefield, Pa.: A. S. Heffner, 1876), p. 41.

98. Sylvanus Swanquill, "January," *New Sporting Magazine* (London: Baldwin & Cradock), vol. 2, no. 9 (Jan. 1831) p. 184.

99. *Blackwood's Edinburgh Magazine* 73, no. 449 (March 1853): 268.

100. The broadside for the panorama of the *Ever Memorable Battles of Ligny, Les Quatre Bras, and Waterloo* suggested that the "spectators actually fancy them[s]elves riding through the Field of Battle." Photocopy in RH.

101. "Munchausen Ride Through Edinburgh," *Mirror of Literature, Amusement and Instruction* 10, no. 286 (Dec. 8, 1827): 387–388. My emphasis. Article was previously published in *Blackwood's Edinburgh Magazine*, issue unknown.

102. "Peristrephic Exhibition," *The Circulator of Useful Knowledge, Amusement, Literature, Science, and General Information* (London: A. Applegath for Thomas Boys, 1825), p. 318.

103. *The Gentleman's Magazine and Historical Chronicle*, ed. Sylvanus Urban (London: John Nichols and Son), vol. 95, part 2 (July-Dec. 1825), "Dioramas," p. 259.

104. Andrew Archibald Paton, *Servia, Youngest Member of the European Family or, A Residence in Belgrade and Travels in the Highlands and Woodlands of the Interior, during the years 1843 and 1844* (London: Longman, Brown, Green, and Longmans, 1845), pp. 66–67.

105. Leitch Ritchie, *Traveling Sketches on the Rhine, and in Belgium and Holland. With Twenty-Six Beautifully Finished Engravings, from Drawings by Clarkson Stanfield*, Esq. (London: Longman, Rees, Orme, Brown, Green, and Longman, 1833, orig. 1832), pp. 81–82.

106. Ritchie, *Traveling Sketches*, p. 82.

107. "Hints for the Holidays, No. III," *Blackwood's Magazine* 20, no. 117 (Sept., 1826): 399. This text was later quoted by Thomas Allan Croal, *A Book about Traveling, Past and Present* (London and Edinburgh: William P. Nimmo, 1877), p. 102.

108. Schivelbusch, *The Railway Journey*, ch. 4. "Panoramic Travel" (pp. 52–69).

4. ROLLING ACROSS THE STAGE:

THE MOVING PANORAMA AND THE THEATER

SPECTACLE TAKES OVER:
FROM SERVANDONI TO
DE LOUTHERBOURG

The 1800 yearbook of the Prussian Monarchy compared the panorama to a theater stage, where the spectators became characters and poets, filling the scene with a story.[1] Nearly two centuries later Lee Parry characterized the panorama as a form of "Landscape Theater."[2] The circular panorama certainly dramatized the experience, but theatrical parallels fit much better to the moving panorama. Its apparatus was influenced by stagecraft and the moving panorama itself was adopted by the stage in the early nineteenth century. Theater historians like Allardyce Nicoll, Richard Southern, and Sybil Rosenfeld covered many aspects of theater architecture, scenography, scene painting and exhibition practices, but said little about moving panoramas.[3] An exception is Richard Carl Wickman's remarkable unpublished 1961 dissertation.[4]

The baroque theater was a kind of viewing machine, a system for presenting scenic illusions. Its most characteristic feature was the wing stage, which became nearly ubiquitous in the Western world.[5] Sets of painted wings were placed symmetrically on both sides of the stage. They became progressively smaller, ending at the rear of the stage in a painted back-shutter. Each wing had a corresponding upper wing that displayed clouds and parts of the sky. By connecting the wings mechanically underneath the stage, they could be drawn to the sides along rails in perfect synchronicity. Another scene could be introduced while the previous

Fig. 4.1
Philippe Jacques de Loutherbourg (1740–1812). Hand-colored stipple engraving by Page from "the Original Picture in the Possession of Mrs. Loutherbourg." Published by G. Jones, London, August 1, 1814. Author's collection.

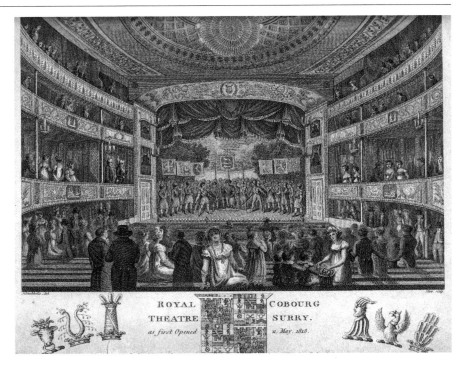

one was disappearing; the scene on the back-shutter was replaced at the same time. Such sudden transformations often happened in plain sight of the audience.

The wing stage restricted the actors' movements, serving as a suggestive background rather than as an acting space.[6] In British theaters the actors mostly performed on the forestage (a platform *in front of* the proscenium arch). This was defended by the need to make the actors' voices heard. However, efforts to push them to the other side of the proscenium arch already appeared in the eighteenth century.[7] In 1762 the theorist Francesco Algarotti claimed that actors performing on the *avant-scène* (forestage) destroyed the visual illusion, and called for the abolition of this practice.[8]

Tensions developed between spectacular sets and the human presence. Actors were increasingly seen as *elements* of the scenic view. This is what the ballet master Jean Georges Novarre must have meant when he stated: "Any decoration whatever is a *picture* ready to receive a number of figures. The performers and dancers are the personages to adorn and embellish it."[9] Although it was "acted out" on the stage, the resulting development was related to the gradual formation of what we now call media culture. The connection between the audience and the living actors that sensed each others' presence in the shared physical space of

Fig. 4.2
"Royal Cobourg Theatre Surry [sic] as first Opened 11,
May, 1818." Engraving by James Stow from an original
by Robert Blemmell Schnebbelie. From *Londina Illustrata*
(London: Robert Wilkinson, 1819). Author's collection.

the theater, was challenged by situations, where the spectacle was either without human actors, or these became turned into "mediated" representations, as on the cinema screen.

Although performers were entirely eliminated from the theater stage only exceptionally, their role was challenged by the mechanical effects introduced by generations of Italian stage designers, like the Galli-Bibiena family. These had a strong impact on opera and ballet, and later on "illegitimate" genres such as the pantomime, the melodrama, equestrian spectacles, and the aquadrama.[10] Forms like the Shakespearean drama were initially left outside their influence, because they were seen as vehicles for actors.

In displacing the performer the influence of Jean-Nicolas Servandoni (1695–1766) was crucial. Servandoni, whose mother was Italian and father French, received his art education in Rome. He moved to Paris in 1724, and was admitted in 1731 to the French Academy as a landscape painter. He began to design spectacular sets for the opera, and was also invited to work in countries like Portugal and England. For our purposes Servandoni's most important productions were the extravagant spectacles he created between 1738 and 1743 and 1754–1758 at the Salle des machines, the king's theater at the palace of Tuileries.[11] The first one, *Saint Pierre de Rome* (1738), was also the most radical. It was an enormous recreation of a painting by Giovanni Paolo Pannini, depicting cardinal de Polignac's visit to Saint Peter's Basilica in Rome. There was neither a plot nor actors; the giant painting itself was the spectacle.

Stephen Pinson's characterization of this work reminds one of such nineteenth-century spectacles as the Panorama, the Diorama, and the Néorama: "The effect, which according to Servandoni served to transport viewers into the actual interior of the church, was achieved through precise linear perspective and a subtle gradation of tone achieved through lighting to recreate relief and depth. The ambient light of the cathedral was produced by the strategic placement of small lanterns across the stage."[12] Servandoni's aim was to create a theatrical spectacle where "painting alone occupied the attention of the spectators."[13] He promised "continuous movement," often for an hour, claiming to have used "all that architecture, painting, and mechanics have been able to contribute on the topic."[14]

Servandoni's spectacles were often based on mythological themes and featured actors in nonspeaking roles, but their visual and mechanical effects made them famous. Two innovations were especially important: the manipulation of scale and the treatment of perspective.[15] The sets were only partially visible, seemingly extending beyond the stage. Columns were so large that they seemed to continue straight through the ceiling of the theater. Servandoni also used the curvature of the horizon line. Instead of focusing on a central vanishing point, the spectators' gazes were made to wander from left to right, up and down, and back again. Similar ideas were later used in theatrical "cycloramas," as well as in panoramas and dioramas. It is not clear whether they were adopted directly from Servandoni, or from his successor Philippe Jacques de Loutherbourg (1740–1812).[16]

De Loutherbourg was an Alsatian landscape and battle painter, who ended up in Paris, where he was elected to the French Academy already in 1767, thirty-one years after Servandoni. He left the French capital in the early 1770s, probably because of personal and financial scandals. In London he persuaded David Garrick (1717–1779), the artistic director of Drury Lane, to hire him as his stage designer. De Loutherbourg promoted himself as the new Servandoni, who was well-known in England, thanks to his work at the Royal Opera House, Covent Garden.[17] Although he had little experience, de Loutherbourg's work as a stage designer and painter, as well as the creator of Eidophusikon, an extremely influential audiovisual attraction, earned him a firm place in the cultural establishment of the British capital.

Garrick and de Loutherbourg's collaboration is legendary.[18] Garrick, whose long reign at Drury Lane lasted from 1747 to 1776, had begun his own innovations years earlier. He was determined to introduce the refined techniques of the Italian and French scenography to the somewhat backward and insular British stage. Not only did he promote a new realistic style of acting; he imported ideas about lighting and scene design, setting the stage for de Loutherbourg's innovations. De Loutherbourg saved many mediocre productions. His work ranged from designing the painted scenery to lighting, costumes, and novel mechanical effects. He began to use asymmetrically placed wings, groundrows, and backdrops. He was also adept in effects of light.[19] His scenery was realized by his assistants in a style that has been characterized as romantic realism.[20] Hidden lights with colored filters modified the mood. Backlit transparencies had been known since the court masques of Inigo Jones, but de Loutherbourg perfected them. Quick transformations and mechanical-optical illusions became his hallmarks.

De Loutherbourg's emphasis on topography anticipated the moving panorama. To prepare his designs for *The Camp* (1778) and *The Wonders of Derbyshire* (1779), he traveled around the Kent and Derbyshire countryside taking sketches. Later he extended his "voyages pittoresques" to other regions.[21] Theatrical moving panoramists like Clarkson Stanfield followed in de Loutherbourg's wake.[22] *The Wonders of Derbyshire* had eleven scenes depicting recognizable localities, illuminated with colored lights to mimic different times of the day. The program booklet said nothing about the unremarkable plot, concentrating on geographic information about each site. This directly anticipated the descriptive booklets routinely sold at moving panorama shows.[23]

De Loutherbourg's final work for the stage was John O'Keeffe's spectacular pantomime *Omai: or, A Trip around the World* at Covent Garden, 1785. Its story was a hodgepodge of fantasy, exoticism and topicality inspired by Captain Cook's last voyage and mixed with typical pantomime elements.[24] It presented a veritable world tour from Otaheite to Plymouth Sound and London, on to the Snowy Rocks of Kamtschatka, Sandwich Islands, Tongatabu, and back to Otaheite.[25] De Loutherbourg's designs were based on drawings and prints by John Webber and William Hodges, who had accompanied Cook on his voyage.[26]

Late eighteenth-century British audiences could not get enough of views of both their own country and distant lands. Productions like *Omai* at the same

time satisfied and sparked geographic curiosity, contributing to a trend to replace stock scenery with accurately designed topographical sets. The *Daily Universal Register* (soon to be named the *Times*) captured the essence of *Omai*:

> To the rational mind what can be more entertaining than to contem-
> plate prospects of countries in their natural colourings and tints.
> —To bring into living action, the customs and manners of distant
> nations! To see exact representations of their buildings, marine
> vessels, arms, manufacturers, sacrifices, and dresses? These are the
> materials which form the grand spectacle before us—a spectacle the
> most magnificent that modern times has produced, and which must
> fully satisfy not only the mind of the philosopher, but the curiosity
> of every spectator.[27]

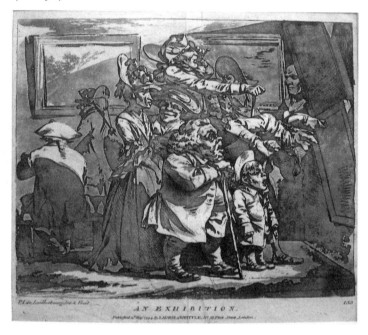

Robert Barker patented his great invention only two years after *Omai's* premiere, which may not have been a total coincidence. The desire to be transported into a simulated elsewhere was in the air. It was the moving panorama that proved the ideal medium for bringing "the customs and manners of distant nations" into "living action."

Figure 4.3
Philippe Jacques de Loutherbourg (1740-1812), "An Exhibition."
Etching and aquatint, printed in sanguine ink. Published
May 12, 1794 by Laurie & Whittle, No. 53 Fleet Street, London
(first edition 1776). Lively commentary on the visitors'
reactions to paintings in an exhibition. Loutherbourg's
Eidophusikon situated itself between theatrical presentations
and art exhibitions. Author's collection.

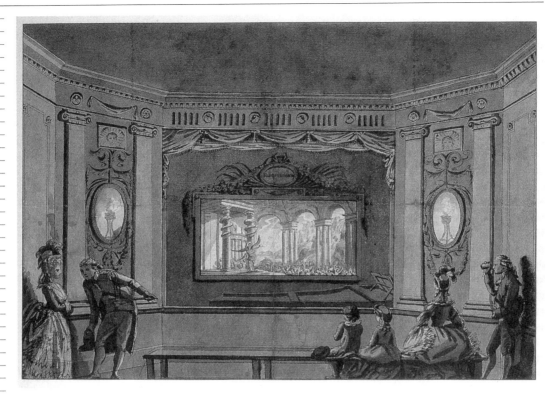

THE MOVING PICTURES OF THE EIDOPHUSIKON

De Loutherbourg's main contribution to the culture of spectacles was Eido-
phusikon, a show of "imitations of natural phenomena, represented by Moving
Pictures."[28] Although a scholar has recently belittled its importance as "a vastly
scaled-down version of Servandoni's spectacle," it was widely imitated, and its
strange title resonated far and wide.[29] De Loutherbourg had left Drury Lane,
so the time was ripe for something new.[30] He produced his show privately, and
opened it on February 26, 1781, in a private house at Lisle street near Leicester
Fields [Square], a stone's throw away from where Barker's Panorama would be
erected a decade later.[31]

The scale of Eidophusikon was reduced, which made its mechanical elements
easier to manipulate. It combined features from art exhibition, theatrical effects,

Figure 4.4
Edward Francis Burney (1760–1848), "The Eidophusikon
Showing Satan arraying his Troups on the banks of a Fiery
Lake with the Raising of Pandemonium from Milton,"
watercolor painting, 1782. Courtesy of the Trustees of
the British Museum.

private salon, and mechanical machinery. The visitors first saw a waiting room with de Loutherbourg's paintings, which sent a signal: the show was for the "Nobility and Gentry."[32] The spectacle was shown in a small theater for about 130 spectators.[33] As far as Edward Francis Burney's watercolor (1782), the only known illustration of Eidophusikon, can be trusted, the scenes were experienced through a kind of double frame.[34] The audience sat on benches in front of a square opening with a curtain. Beyond it was another wall with a smaller opening, slightly above the spectators' eye-level. This is where the views were seen. On a lower level between the walls, hidden from gazes, was a grand piano.

The main attractions were five "imitations": "Aurora, or the Effects of the Dawn, with a View of London from Greenwich Park," "Noon, the Port of Tangier in Africa, with the distant View of the Rock Gibraltar and Europa Point," "Sun set, a View near Naples," "Moon light, a View in the Mediterranean, the Rising of the Moon contrasted with the Effect of Fire," and "A Storm and Shipwreck."[35] While the scene was changed, a transparency was displayed, and Mr. and Mrs. Arne produced music.[36] For the second season (starting in January 1782), four new scenes were introduced, in addition to the Storm and Shipwreck, which remained in the program because of popular demand.[37] The most notable new scene was "Satan arraying his Troops on the Banks of the Fiery Lake, with the Raising of the Palace of Pandemonium, from Milton 14," featured by Burney in his painting.

Unfortunately, de Loutherbourg did not leave for posterity any description of his system or apply for a patent. No physical trace of it remains. Except for a few hints in the newspapers, our knowledge of the mechanism of his creation is based on a single source, the book *Wine and Walnuts, Or After Dinner Chit-chat* (1823), written by the artist, illustrator, and writer William Henry Pyne (1769–1843). When Pyne saw the show—probably in 1786, when it was exhibited by

another showman at a show-room called Exeter 'Change— he would have been only seventeen years old, and his book appeared thirty-seven years later.

There are other reasons to be skeptical about the accuracy of Pyne's description.[38] He wrote it not as a historian, but a special purpose in mind to suggest for "some little circle of ladies, who have attained a proficiency in landscape painting (and many such there are that could be named), to make a joint effort of their talents, and endeavor to form

Figure 4.5
Andrew Edmundson, Sketch for a Speculative Reconstruction of Eidophusikon. Courtesy of EDM Studio, Vancouver, Canada.

a stage upon de Loutherbourg's plan."[39] The description must therefore be read as do-it-yourself instructions for a parlor pastime. Had Eidophusikon been trivialized to such an extent, or is Pyne engaged in role play, posing as a ladies' authority? His role model was the academic painter Sir Joshua Reynolds, who—Pyne claims—brought ladies from his circle to de Loutherbourg's show to learn drawing from the nature.

Pyne's description may have been deliberately simplified, but it is all we have. It emphasizes the perspective illusion: "The space appeared to recede for many miles, and his horizon seemed as palpably distant from the eye, as the extreme termination of the view would appear in nature."[40] This was probably realized by combining a translucent background image with irregularly placed cutout wings, "receding in size by the perspective of their distance," much like de Loutherbourg had done at Drury Lane.[41] Pyne claims that he used Argand lamps, which is unlikely, because they were introduced in England only in 1784, and first used at Drury Lane in February 1785.[42] A row of hidden oil lamps above the proscenium, fitted with interchangeable color filters, is more likely.

The waves were painted and varnished pieces of wood fixed to rods and made to ebb and flow by "a machine of simple construction," while the clouds had been painted on strips of linen and attached to a frame, "which rose diagonally by a winding machine."[43] Thanks to this contrivance, the clouds seemed to approach the spectators from the horizon. Both the waves and the clouds were made more dramatic by lighting.[44] Such methods were widely used in baroque scenography.[45] De Loutherbourg also simulated the rising moon, which was probably realized by placing a lamp inside a tin can with a round hole, and lifting it slowly behind the transparent background view. Panorama showmen inherited this trick and used it so often that it became a cliché.

Three more features deserve attention. First, the foreground of the opening scene was made of cork and "covered with minute mosses and lichens." Similar materials were used in panstereoramas, three-dimensional miniature models. Du Bourg's cork model of Mount Vesuvius caught fire and destroyed the Great Room of the Spring Gardens (Messrs. Marshall's future venue) in 1785.[46] Second, the miniature elements. Ships were represented with "beautiful models [that] went over the waves with a natural undulation." Whether these were actual miniatures or flat pasteboard cutouts cannot be determined, but because they were said to be "correctly rigged" the first alternative is possible. Tiny human figures, possibly mechanical marionettes, appeared in the Pandemonium scene. De Loutherbourg had used

Figure 4.6
Wind machine, from Georges Moynet, *La machinerie théatrale: Drucks et décors* (Paris: La Librairie illustrée, n.d., c. 1893, 268). Rotating the drum created the sound of howling wind. Machines like this were used on stage for centuries. A similar device was also utilized by Le Théâtre Mécanique Morieux de Paris, and has been preserved at the Musée des Arts Forains, Paris (see chapter 10).

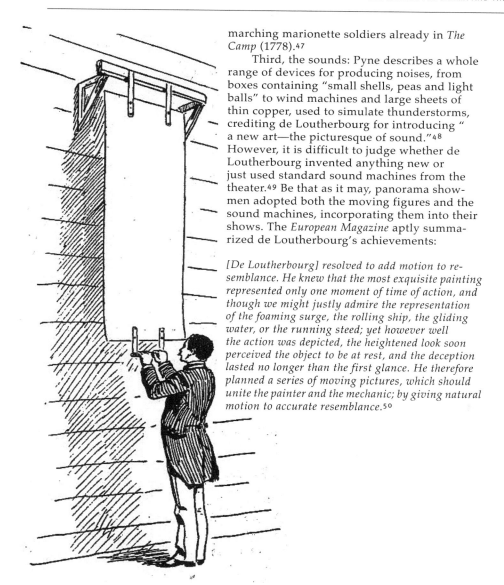

marching marionette soldiers already in *The Camp* (1778).[47]

Third, the sounds: Pyne describes a whole range of devices for producing noises, from boxes containing "small shells, peas and light balls" to wind machines and large sheets of thin copper, used to simulate thunderstorms, crediting de Loutherbourg for introducing " a new art—the picturesque of sound."[48] However, it is difficult to judge whether de Loutherbourg invented anything new or just used standard sound machines from the theater.[49] Be that as it may, panorama showmen adopted both the moving figures and the sound machines, incorporating them into their shows. The *European Magazine* aptly summarized de Loutherbourg's achievements:

[De Loutherbourg] resolved to add motion to resemblance. He knew that the most exquisite painting represented only one moment of time of action, and though we might justly admire the representation of the foaming surge, the rolling ship, the gliding water, or the running steed; yet however well the action was depicted, the heightened look soon perceived the object to be at rest, and the deception lasted no longer than the first glance. He therefore planned a series of moving pictures, which should unite the painter and the mechanic; by giving natural motion to accurate resemblance.[50]

Figure 4.7
Thunder generator, from Georges Moynet, *La machinerie théatrale: Drucks et décors* (Paris: La Librairie illustrée, n.d., c. 1893, 264). Thunderstorms could be simulated by a suspended sheet of metal.

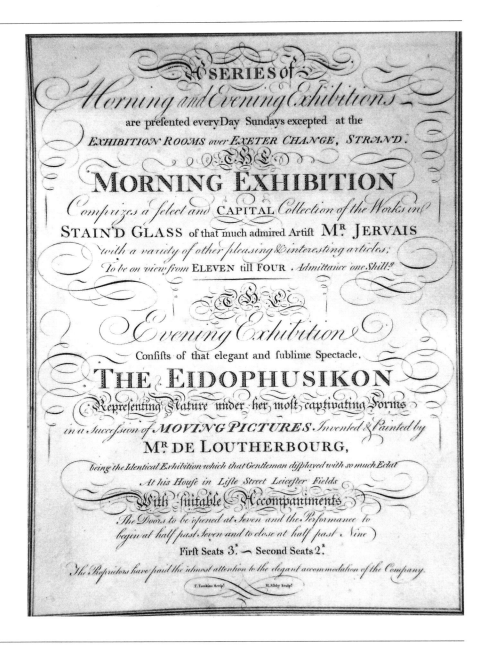

Figure 4.8
Broadside for Eidophusikon, presented at Exeter 'Change,
London [1786]. This is the version probably seen by William
Henry Pyne (1769–1843), who left a detailed description of
it. The showman states that the exhibition is identical to the
one given by de Loutherbourg, but we should not take such
claims at face value. Courtesy of Richard Balzer Collection.

EIDOPHUSIKON, MECHANICAL THEATERS, AND
THE REALM OF SPECTACLES

The history of the original Eidophusikon is relatively brief. After two seasons (1781–1782) de Loutherbourg sold it to his former assistant, Chapman, who reintroduced it in 1786 at Exeter' Change, a well-known amusement place on the Strand; a few years later it reappeared at Spring Gardens.[51] In February 1799 the newspapers announced a New Eidophusikon, "on a scale infinitely superior in size," and with the "aid of accumulated light, and power of mechanism."[52] Its nature remains vague, but the show included singing and recitation, Mr. Wilkinson playing Musical Glasses, and a Learned Dog that could "distinguish gold from silver, or tell the value of any piece of money."[53] The New Eidophusikon was evidently a variety entertainment, but the revival was short, because it burned down in March 1800.[54]

Imitated eidophusikons kept appearing here and there; the American painter Charles Willson Peale presented his own version in Philadelphia in May 1785, probably from secondhand sources.[55] De Loutherbourg's creation is routinely considered the source of a great and long-lasting wave of popular spectacles known as "mechanical theatres." What connected them was the effort to "imitate" natural and human-made phenomena by mechanical and optical means. Eidophusikon was certainly influential, but because its secrets were not explained publicly and its lifespan was limited, one should vary about identifying it as the sole source. There were others, such as the French mechanics, physicists, and aeronauts Pierre and Degabriel, whose itinerant shows amazed audiences as early as the 1780s.[56] They may have drawn inspiration from the same sources as de Loutherbourg, namely the aesthetics of imitation, and the Enlightment-era interest in mechanical human-made wonders.[57]

Still, the word Eidophusikon was often evoked, also on stage.[58] In 1820 Edmund Kean commissioned a tempest scene "in the style of the Eidophusikon" for his *King Lear* at Drury Lane.[59] When Clarkson Stanfield's moving panorama of the Plymouth Breakwater was presented at the Theatre Royal, Birmingham, it was advertised as "Eidophusicon [sic], or Moving Diorama."[60] Stanfield had also worked on an "Eidophusikon [written with Greek characters] Or, Image of Nature, shewing The Beauties of Nature and Wonders of Art," produced for W. T. Moncrieff's Egyptian extravaganza *Zoroaster, Or, the Spirit of the Star*. It was a "progressing Scene" with dioramic effects, "in an unprecedented extent of 482 feet."[61] The opening view displayed an Arab camp by twilight, and was followed by an unlikely succession of sights, including the Pyramids and the Sphinx, the Colossus of Rhodes, the Bay of Naples with the eruption of Mount Vesuvius by moonlight, a vision of "home sweet home" in the sky, Tivoli, and the destruction of Babylon. Actors and chorus performed in front of the moving canvas, most likely a moving panorama.[62]

When the "German Artist" W. Dalberg proposed to revive the Eidophusikon, he planned to include "Picturesque Scenery, Panoramas, Dioramas, and Physi-oramas."[63] Some of the scenes recalled de Loutherbourg, but there was also a "Diorama of the Ladyes [sic] Chapel, Southwark," and a "moving panorama of English Scenery, from Windsor to Eton, the Exhibition of which was universally admired at Drury Lane theatre."[64] Whether Dalberg's show was realized or not, it is interesting to see, how it attempted to build a bridge between Eidophusikon and later spectacles it had purportedly influenced.[65]

Such a fusion became even more evident when the Monteith Rooms in Buchanan Street, Glasgow, exhibited a production called *The Eidophusikon, or Moving Diorama of Venice* in 1841. It took the spectators on a ride along the canals of Venice in the previous century, before "its final decline."[66] The atmospheric effects harked back to de Loutherbourg's artificial magic: a thunderstorm was followed by the sun shining and a rainbow appearing; the sun was seen to sink beneath the horizon, followed by the evening lights of the small Church of La Carita, with a procession of monks. The trip ended with the "gaily illuminated Rialto," while "the pale chaste moon, casting her broad beams around, and throwing a flood of light on every object, looks calmly on."[67]

De Loutherbourg's Eidophusikon had united the painter with the musician, the sound artist, and even the poet. In spite of its minuscule size, it was a multi-media spectacle *avant la lettre*. Still, its true relationship to the subsequent spectacles was debated for decades. It was pointed out that some called de Loutherbourg a "Panoramist," and classified Eidophusikon as a panorama, whereas others found this incorrect.[68] Horace Wellbeloved made such a compar-ison already in 1826, adopting a middle position, which emphasized both its achievements and its limitations. His point of comparison was the circular pan-orama; had he thought about the moving panorama, he might have chosen his words differently.

> *A good panorama is the nearest approach to deception in painting, that has ever been achieved. It is an English invention, of recent date, and has given rise to many other "oramas," the Diorama, the Cosmorama, the Naturama, &c. It is curious that de Loutherbourg, whose extraordinary powers in imitating the effects of nature were fully developed in his Eidophusikon, should never have thought of it. This Eidophusikon was a closer imitation of nature; but the motion and change of colour assisted it: the Panorama is a mere painting, and may be considered as a greater triumph of the art.*[69]

THE PANORAMA, THE PANTOMIME, AND THE ART OF HETEROGENEITY

Moving panoramas may have been used on stage as early as 1800, but they became common toward 1820. In 1819 we encounter Clarkson Stanfield's (1793–1867) "moving Panorama with a View of the City of York" as part of *Richard Turpin* at Astley's Royal Amphitheatre in London.[70] It has been suggested that it was Stanfield who "first introduced on the stage a connected series of views moving in front of the spectator," an idea that was "adopted at all the other Theatres in London."[71] From the early 1820s onward scene painters began to create moving panoramas in increasing quantities. The list of the most significant names includes, besides Stanfield, John Henderson Grieve (1770–1845) and his sons Thomas (1799–1882) and William (1800–1844), David Roberts (1796–1864), William Telbin (1813–1873), William Beverl[e]y (c. 1814–1889), and Charles Marshall (1806–1890).[72]

What explains this outburst? The adoption of gaslight no doubt played a role, because it made adjusting the stage lighting easier, and helped to illuminate the canvas.[73] It should not be forgotten that outside the theater moving panoramas had been displayed for years, and Messrs. Marshall's peristrephic panoramas were gaining widespread attention, although they would not be seen in London until 1823. Wickman has noted that theatrical moving panoramas became more numerous after 1823, the year the London filial of Bouton and Daguerre's Diorama also opened.[74] Combining the luminosity of transparencies with the moving canvas created the hybrid "moving diorama." Although the celebrated "moving dioramas" by Stanfield, Roberts, Beverl[e]y, and others normally contained only a limited number of transparent scenes, they surely profited from gas lighting.

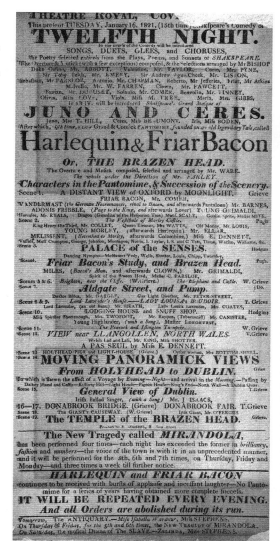

Figure 4.9
Grieve's moving panorama of a sea voyage from Holyhead to Dublin, shown as part of *Harlequin & Friar Bacon Or, The Brazen Head*, playbill, Covent Garden, 1821. The panorama shows "the effect of a Voyage by *Evening—Night—* and arrival in the *Morning*," which may indicate that transparencies with light effects were used. The Paris Diorama was opened in 1822, and the one in Regent's Park in 1823, so these effects preceded the dioramic ones. Author's collection.

David Mayer offers another explanation.[75] He concentrates on the pantomime, a genre that flourished already in the eighteenth century, but went through crucial changes under the influence of the master Clown Joseph Grimaldi (1778–1837). During his tenure at Covent Garden, which lasted from 1806 to 1823, Grimaldi turned pantomime into a vehicle for political satire. Mythological themes and acrobatic pursuits of the harlequinade were overshadowed by contemporary issues and witty commentaries by the Clown. This happened without sacrificing the pantomime's flexible, whimsical, and inclusive character. After Grimaldi's retirement the genre entered a period of crisis.[76] The satirical commentaries of the Clown were replaced by spectacular elements, variety acts and special effects derived from a new genre—the extravaganza.[77]

The moving panorama was one of these elements. It was normally displayed at the back of the stage, where it was initially hidden behind the painted back-shutter.[78] This was motivated by the structure of the wing stage, but also by other technical issues: by placing the panorama at the back of the stage its ma-chinery could be hidden, and did not have to be removed after the panorama had been rolled. In spite of its large size, the view was not particularly wide. The moving panorama was framed in multiple ways; by the evening's program and the play it was part of; by the wing stage; by scenic elements such as mockup balloons and ships, ground-rows of waves, and moving cutout figures placed in front of it; and by actors performing on the foreground. All this made deep mental immersion by the spectators almost impossible.[79]

The moving panorama's roles were in no way uniform. Efforts were made to incorporate it into the pantomime by having the characters perform in front of it, as in *Harlequin and the Dragon of Wantly; Or, More of More, Hall* (Covent Garden, 1825).[80] William Grieve's panorama of the Thames was used as a mobile back-ground for a "Grand Sailing Match" between Harlequin, Spitfire, St. George, and Don Giovanni [!], toiling in their stationary boats in the foreground.[81] Beside creating an illusion of motion, the panorama was also a satirical visualization of a widely debated proposal by a certain Colonel Trench for the improvement of the Thames Embankment. This gave the scene a split temporality: the characters competed here-and-now, while the background simulated a possible future.[82]

Some panoramas served continuity by transporting characters (and the audience) from one location to another. Covent Garden's *Harlequin and Georgey Barnwell, or, the London 'Prentice* (premiered Dec. 26, 1836), contained Charles Marshall's "Georgey's Dioramic Walk from the Borough of Southwark to Camber-well" (scene 5).[83] As the canvas moved, the actor impersonating Georgey pre-tended to walk slowly "From the Borough of Southwark to Camberwell; passing The "Rainbow" Public House, The Haunted Mile-stone!, The Murderer's Gibbet!!, —and Goblin's Style!!!, . . . And final arrival at Camberwell Grove by Moon-light!"[84] It was more common to place the characters in a mock-up vehicle, such as a boat or the gondola of a balloon. During the presentation of Clarkson Stanfield's "panoramic views" of *The Passage of the Rhine* (1828) characters were supposed to be in a cutout ship in front of the moving canvas.[85]

Pantomimes reacted quickly to current topics. York's Theatre Royal's comic

pantomime *Harlequin Pedlar; Or, the Fairy of the Oak* (April 8, 1831) already included *Donaldson's Grand Moving Diorama of the RAIL ROAD!* The playbill described its course: "*With Steam Engines, Travelling that distance in fifteen minutes, commencing at the starting place MANCHESTER* And passing in succession through Eccles, over Chat Moss, Newton Bridge, the Sankey Viaduct, &c. *And Concluding at the LIVERPOOL STATION*."[86] The Liverpool-Manchester line, the world's first passenger railway, had been opened barely half a year earlier (September 15, 1830), so many spectators must have had their first experience of it by "riding" with the moving canvas. When the humorist Thomas Hood wrote in 1839 about railway travel that it offered "no alternative but to watch the moving diorama that was gliding past the window," the comparison may already have been familiar.[87]

Travelogues were common. The end of the Napoleonic wars ended the isolation of the British Isles; the thirst for impressions of the outside was insatiable. Everyone was not able to travel, but topographic views and panoramas served as substitutes. The master was Stanfield, who was also a successful landscape and marine artist and book illustrator. His "moving dioramas" (as he preferred to call them) were often based on sketches he had taken in England and abroad. Stanfield kept large folders of sketches, which he displayed for his friends and used as a repository for moving panoramas, dioramic views (exhibited at the British Diorama as well as at his own Poecilorama), oil paintings, and illustrated travel books and albums.

A new panorama by Stanfield was always an event. His works saved many mediocre productions, although their relationship to the pantomime was normally loose. Commenting on Stanfield's "moving diorama" of the Plymouth Breakwater, shown as part of *Harlequin and the Flying Chest* (1823), a reviewer aptly summarized its value: "The scenery is everything; and there is nothing besides."[88] Stanfield's panorama depicted seaside scenery around the Plymouth Breakwater, a huge national construction project that had been in progress for over a decade. The program booklet contains a foldout key of Stanfield's painting as its frontispiece, in the manner of the booklets for Burford's circular panorama on the Strand.[89]

Figure 4.10

"Stanfield's Grand Picture," playbill for Clarkson Stanfield's Moving Diorama shown at as part of *The Queen Bee, or Harlequin & the Fairy Hive* (scene 13; premiered Dec. 1828 at Drury Lane). Producing a separate playbill for Stanfield's panorama emphasizes how highly it was valued. Author's collection.

Because the key to the Plymouth panorama lists features such as the "vessel in distress," the "effects of heavy storm," and the "rainbow" (all missing from the illustration), Mayer suggests that "the diorama was embellished by cut-out pieces representing a ship, clouds, and a rainbow drawn in front of the moving diorama and agitated in such manner as to suggest the ship in difficulties and the storm succeeded by a rainbow."[90] Be that as it may, dioramic light effects were certainly used.

A similar key was published for Stanfield's "Grand Diorama of Venice."[91] It depicts the panorama's route around the canals, but does *not* indicate that when the view moved past Lido, a chorus of singing gondoliers appeared on the stage. This was revealed by a review complaining that "it does not sound well to hear an invisible scene-shifter call out to a pasteboard gondolier, who seemed to be rowing as well as he could, 'D—d ye, keep close to the lamps.'"[92]

To get a better idea about the panorama's role within the pantomime, let us have a closer look at two Covent Garden productions.[93] As the playbill informs us, on Monday night, January 21, 1828, the evening began with the first part of Shakespeare's *Henry IV*, followed by the *New Comic Grand Pantomime, called Harlequin and Number Nip, of the Giant Mountain*. As usual, the playbill duly credits the creators of the painted scenery, music, dresses, and the "Tricks, Changes, Transformations, and Decorations." The list of characters includes eccentric creatures such as "Number Nip, (a Gnome possessing the Power of assuming all Forms and Characters)," "The Emperor Japano-Longo-Heado, (afterwards Pantaloon)" and "Mine-Frow-Dumple-Doddy-Squatzer-Down-Kin-Fromp."

The scenes shift wildly between locations and levels of reality. The pantomime begins with a view of the Giant Mountain [Mt. Fuji?], and the palace of the Emperor Japano-Longo-Heado. The interior of the earth follows, after which we enter the palace, and continue to the "Blue Valley" and a Magic Fountain. The Palace of Number Nip, "in the Centre of the Earth," is next. Soon we are in Holland to witness "The Scheldt Frozen Over" and a fair on ice.[94] We move to London to inspect the Hammer-

Figure 4.11
Theatre Royal, Covent Garden, London, playbill for Monday, January 21, 1828. The program included David Roberts's "Grand Panoramic Naumachia," a moving panorama, which contained a representation of the sea battle of Navarino, among other topics. Author's collection.

smith suspension bridge and the Regent's Park Colosseum, which was under construction. There Grieve offers the spectators a sneak preview of Thomas Hornor's huge panorama of London.[95] We move to the Zoological Gardens, comic skits about shop owners, St. Giles's Church "by Moonlight," the Thames near Rotherhithe, "The New Bridge over the Serpentine River," Hyde Park, Kensington Gardens, and the Esplanade at the end of the Chain Pier, Brighton, with "a distant View of the Town."

The view of Brighton "recedes as the Vessels sail away," making way for David Roberts's panorama. It is described in the playbill as "Grand Panoramic Naumachia, Representing the Passage to Gibraltar, Then to the Archipelago, with an Endeavour to give, as near as Scenic Power will afford, a Representation of The Battle of Navarino, By the Combined Fleets of England, France, and Russia, opposed to the Turco-Egyptian Fleet. The Panorama terminating with An Allegory, Representing the Genius of England, France, and Russia, hovering over their brave Heroes of the Ocean."[96] When it is over, the action moves abruptly to the Piazza della Colonna in Rome during the Carnival, where Signor il Diavolo Antonio performs on the slack rope and Mr. Wilson on the tight rope (in front of the canvas). Grieve's view of icebergs follows, and the pantomime concludes at the "The Grotto of the Dolphins, the Abode of the Fairy of the Fountains," where the rivalry between Number Nip and his competitor Crystilla is brought to an end.

The panorama had practically no connection with the rest. It was a special attraction that had patriotic interest of its own.[97] The naval battle of Navarino (Navarin) had been fought just a few months earlier (October 20, 1827). The destruction of the Ottoman-Egyptian fleet by the combined British, French, and Russian forces was considered a major blow for the Ottoman empire and a boost for the Greek pursuit of independence, strongly backed by the Britons. Covent Garden was not alone. The Surrey Theatre presented the *Kaloskeneteknephusikineon; or Grand Naumachiacal* [sic] *Panorama*, visualizing the battle with views by Stanfield's disciple Philip Phillips.[98] Other Navarino panoramas included the ones exhibited by Messrs. Marshall and William Sinclair; there was also Robert Burford's circular version.[99]

Roberts dealt with the search for the Northwest passage in a "moving diorama" that was included in Covent Garden's *Harlequin, and Cock Robin: or, Vulcan & Venus* (1829).[100] It must have been inspired by the heavily publicized departure of Captain John Ross, the well-known arctic explorer, on his latest voyage in May 1829. A closer look reveals that Roberts's painting was based on an earlier voyage by William Edward Parry.[101] The panorama loosely follows Parry's 1824–1825 voyage, until it slips into pure fantasy. Instead of returning home after yet another failed attempt, Parry's remaining ship Hecla triumphantly reaches Japan.[102] The panorama ends with a view of "the Bay and City of Jeddo [Edo, Tokyo], Capital of the Japan Islands, from the Terrace of the Emperor's Palace." The ending serves the plot, because the following scene (19) takes place at "The Cave of Jamna, in the Japanese Island," creating a continuity. The ending is also nationalistic wishful

thinking.[103] The pantomimic imagination had no scruples about converting facts into patriotic fairytales.

Roberts's panorama was positioned after a scene (27) at "The Saloon of the New Bazaar, Oxford Street, leading to the Diorama Exhibition Room." The place was real—the British Diorama had opened its doors there the year before, and Roberts (with Stanfield) were producing paintings for it. Not only that: on the stage there was a signboard that stated: *Walk in and See* MR. ROBERT'S [sic] NEW MOVING DIORAMA OF THE POLAR EXPEDITION." The audience was supposed to imagine it had been teleported into the British Diorama—to a show within a show! The use of the signboard anticipates today's product placements; a commercial liaison may well have existed between Covent Garden and the British Diorama.

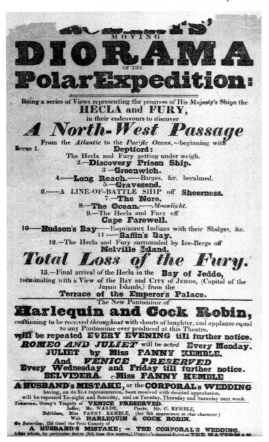

The novelist and future prime minister Benjamin Disraeli associated theatrical panoramas with nationalistic propaganda in his satirical novel *The Voyage of Captain Popanilla* (1827). "His Excellency the Fantaisian Ambassador," visiting the railroad state of Vraibleusia [a veiled portrait of Britain], goes to the theater, and discovers that "this evening the principal characters and scenes were omitted, to make room for a moving panorama, which lasted some hours, of the chief and most recent Vraibleusian victories. The audience fought their battles o'er again with great fervour."[104] The trend Disraeli had detected became even more prominent in the years to come. Having mediated propaganda *replace* live actors was something media culture of the future would be doing in countless ways.

Neil Arnott assessed the cultural possibilities of theatrical moving panoramas from a different and broader perspective:

There are very few scenes on earth calculated to awaken more inter-esting reflections on the condition of human nature than that beheld by a person who sails along the river Thames from London to the sea, a distance of about sixty miles, through the wonders which on every side there crowd on the sight—the forest of ships from all parts of the world—the glorious monuments of industry, of philant[h]ropy, of science—the marks of the riches, the high civilization, and the happiness of the people. Now this scene was last year in one of our

Figure 4.12
"Roberts' Moving Diorama of the Polar Expedition," playbill for David Roberts's moving diorama exhibited as part of *Harlequin and Cock Robin* (Covent Garden, 1929). Printing a separate playbill for the moving panorama points to the attention it was receiving, but also to its semi-independent status. Author's collection.

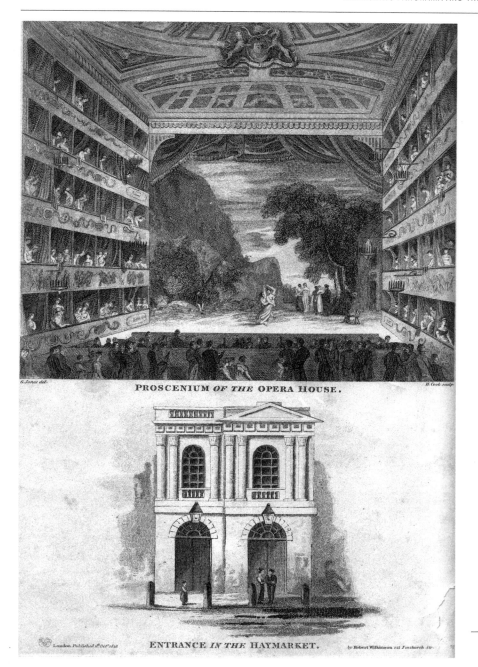

Fig. 4.13
Proscenium of the Opera House, Haymarket. Engraving by
Henry R. Cook from original by G. Jones. Dated October 11,
1816. From *Londina Illustrata* (London: Robert Wilkinson,
1819). Author's collection.

theatres strikingly portrayed by what was called a moving panorama of the southern bank of the Thames. It was a very long painting, of which a part only was seen at a time gliding slowly across the stage, and the impression made on the spectators was, that of their viewing the realities while sailing down the river in a steam boat. In the same manner the whole coast of Britain might be most interestingly represented—or any other coast, or any line of road, or even a line of balloon flight.[105]

Here the theatrical context in effect faded out of sight, and the panorama became the center of attention. Arnott's progressivist vision left no room for either the whimsical antics of the pantomime or for narrow-minded propaganda—it was the promise of the moving panorama as a virtual vehicle for advancing the civilizing process that counted.

VIRTUAL VOYAGING
WITH THE BALLOON PANORAMA

All who have ever travelled by a balloon speak with rapture of the pleasure afforded them by the moving panorama of the country below.

—*The Mechanics Magazine, 1837*[106]

An interesting subgenre of the theatrical moving panorama was the balloon panorama, which reflected the popularity of balloon ascents as a public attraction. Crowds gathered at market squares and pleasure gardens to witness, how aeronauts departed on their daring adventures. Anticipating the Space Shuttle launches in our time, they came to see the lift-off—the eyes followed the balloon until it disappeared from sight. The outcome would be found out from newspapers or by word-of-mouth. Balloon ascents broke the routine of everyday life. It was exciting to experience the aeronauts risk their lives in the name of progress. Like arctic explorers, they pushed the limits of the unknown.

As different as they may seem, the culture of attractions associated balloon ascents with optical spectacles. Showmen like Pierre & Degabriel and Étienne-Gaspard Robertson tried their hand in both, posing as pseudoscientists in the tradition of natural magic, a current that went back to the early modern era.[107] Wizard-savant-charlatans demonstrated all forms of human ingenuity, from optical

and mechanical illusions to the effects of magnetic fluids and aerial flights. Even a ghost show could be turned into a demonstration of human superstitions, as Robertson did with his *Fantasmagorie*.

A central point was to keep the source of the illusion, the projection apparatus (the fantascope, a high tech magic lantern on wheels), securely hidden behind the screen. The ghosts that attacked the audience from the dark were left hovering in a deliberately ambiguous space between the rational and the irrational.

In balloon ascents the technical apparatus —the balloon itself—was the focus. Its role was emphasized by displaying it publicly (for money) before the ascent. Stunts and announcements raised curiosity—efforts to break records of altitude and scientific experiments, messages dropped from the skies, and unusual passengers. In 1850 *Punch* suggested that some "intrepid aeronaut" would soon ascend "with a bull, or a giraffe, or, it may be, an elephant."[108] The balloon was often richly decorated, and fireworks were launched in midair. Still, the flight itself was not very attractive visually. The breathtaking views were reserved for the aeronauts, whereas the spectators were left on the ground as distant bystanders.

This was the opportunity the creators of balloon panoramas seized upon. The spectators were placed in the position of the aeronauts, and the world below was depicted as the balloonists had purportedly experienced it.[109] The observer became a surrogate aeronaut. Circular panoramas professed to do something similar, but they could raise the viewpoint only to modest heights—to the level of an observation tower or a mountain top. The balloon panoramas rose much higher, to altitudes reserved for a selected few. The possibilities they offered for the spectators of the time could perhaps be compared with the breathtaking surrogate experience of watching on a giant screen film footage shot by astronauts from orbit and incorporated into the IMAX film *Space Station*.

Figure 4.14

Handbill of the entertainments at Royal Gardens, Vauxhall (London), during the first week of September 1839. Printer: Balne Brothers, London. The program includes a night ascent by Charles Green in his Coronation Balloon, and a *Moving Panorama of the Rhine*. Author's collection.

MISSING.

CHARLES MATHEWS,
ESQ.

It is said that the above Gentleman, actuated by a strange propensity for rising in the world, *left his home*, at Highgate, perpendicularly, this Morning, IN A BALLOON, and has not since been seen or heard of.

If this be the fact, there can be no doubt (from his known habits of punctuality) that he will be AT HOME, at the English Opera House, on *Thursday next*, 15th of March, when he will probably give an account of his

ADVENTURES IN THE AIR.

N.B. If he will return to his disconsolate Friends, *the Public*, he will be kindly received, and

NO QUESTIONS ASKED.

SATURDAY, March 10, 1821.

The balloon panorama appeared soon after moving panoramas had become common on stage, but the idea of a balloon trip was used earlier by the actor Charles Mathews in one of his popular one-man performances known as *At Home*. Mathews was said to have been planning a balloon ascent, which his wife had forbidden.[110] The idea was adopted for his *Adventures in Air, Earth, and Water* (1821), where Mathews was lifted up and down on stage in a simulated balloon. To raise curiosity, an extensive prepublicity campaign was organized by the Lyceum Theatre, claiming that Mathews had embarked on his balloon trip and was missing.[111]

The earliest balloon panoramas were painted by the Grieve family. Perhaps the first was included in *Harlequin and Poor Robin; or, the House that Jack Built* (Covent Garden, 1823–1824), where the aeronauts Clown and Pantaloon have an "Aeronautic Excursion" from London to Paris. The lift-off takes place from Vauxhall Gardens, a popular pleasure spot where balloon ascents were often organized. A commentator explained: "The scenery begins to be *drawn down*, and exhibits most beautiful bird's-eye views, with an effect, such as actually to make the audience imagine themselves high mounted in the air!"[112] In other words, the roll moved vertically from one horizontal roller to another. Another one was included in *Harlequin and the Magick Rose: Or, Beauty & the Beast* (1825–1826), offering aerial perspectives of cities like Constantinople and St. Petersburg.[113]

Probably the most notable balloon panorama was Grieve's *Aeronautikon! or, Journey of the Great Balloon*, painted for *Harlequin and Old Gammer Gurton; Or, the Lost Needle* (Drury Lane, 1836).[114] It was inspired by a well-publicized long-distance flight by Charles Green with two companions, Thomas Monck Mason and Robert Holland, just a few weeks before the Christmas-time premiere (November 7–8).[115] The giant balloon crossed the English Channel at night and landed near Weilburg in the Duchy of Nassau the next morning. To commemorate the achievement the balloon was named the Great Nassau Balloon.[116]

Figure 4.15
"Missing. Charles Mathews, Esq." flyer, March 10, 1821 (printer: Lawndes, Drury Lane, London), circulated to raise interest in Mathews's upcoming performance in his *At Home* Series, *Adventures in Air, Earth, and Water* (1821). Mathews's disappearance was a hoax, although he had been considering a balloon ascent. Author's collection.

COMPLETE OVERFLOWS
General Reduction of Prices
ALLS, 7s. BOXES, 4s. PIT, 2s. GALLERIES, 1s.
HALF-PRICE
OXES 2s. PIT, 1s. GALLERIES, 6d.
In consequence of this Reduction, the FREE LIST (except the Public Press) is abolished.

inth Night of the New Grand Pantomime !
MOST SUCCESSFUL for the Last 30 YEARS !

heatre Royal, Drury Lane

is Evening, WEDNESDAY, January 4th, 1837,
Their Majesties' Servants will perform Auber's popular Opera of

Masaniello!

asaniello, (a Neapolitan Fisherman) Mr. WILSON, Don Alphonso, Mr. DURUSET,
, Mr. MEARS, Pietro, Mr. BEDFORD, Moreno, Mr. HENRY, Ruffino, Mr. F. COOKE.
Elvira, (Bride of Alphonso) Miss BETTS,
Fenella, (Masaniello's Sister) Madame PROCHE GIUBELEI.
BOLERO, by Mr. GILBERT and Miss BALLIN.

After which will be revived, (not Acted these Seven Years) the Musical Entertainment of

AUL & VIRGINIA!

WITH THE FOLLOWING POWERFUL CAST:—
aptain Tropic, Mr. SEGUIN, Don Antonio, ..., Mr. DURUSET,
Paul, (First Time) Miss ROMER,
que, .. Mr. GIUBELEI, Diego ... Mr. BEDFORD, Alhambra, .. Mr. HENRY,
astian, Mr. MEARS, Sailor, Mr. HONNER, Officer, Mr. HEATH,
Virginia, Miss SHIRREFF,
Jacintha, Miss POOLE, Mary, Mrs. C. JONES.
nclude with (9th Time) an entirely New Splendid Comic CHRISTMAS PANTOMIME, called

HARLEQUIN AND
ldGammerGurton
Or, THE LOST NEEDLE!

THE OVERTURE AND MUSIC COMPOSED BY MR. RICHARD HUGHES.
The New Grand and extensive Scenery by
GRIEVE, Mr. T. GRIEVE, and Mr. W. GRIEVE,
Principal Properties, Tricks and Transformations by Mr. BLANIRE and Assistants.
echnical Devices by Mr. NALL. The Machinery by Mr. PALMER, and Mr. BENTON.
THE PANTOMIME PRODUCED UNDER THE DIRECTION OF MR. HOWELL.

UNT SKIDDAW, BY STAR-LIGHT!

Sprites" having a lark—black spirits and white, red spirits and grey,
Magician, who has led himself by the Devil, and in love with Emma) Mr. HONNER,
Messrs. Walsh, Miller, Price, Tett, C. Tett, Maworby, Caulfield, Santry, Chant, Willis, Healy, Jones, Birt, Atkins, Tolkin, Butler

INTERIOR of the VILLAGE.

Gammer and Gammon at daggers drawn—battle royal between the village "Yorks and Lancasters."
Robin, (a Forester, elder Son to Gammer Gurton, and in love with Emma) Mr. P. SUTTON,
his Brother, a Peasant) Mr. T. MATTHEWS, Doctor Matte, (the Village Apothecary, betrothed to Emma) Mr. F. COOKE,
neon, (the Bedlam, Enemy to Gammer) Mr. P. COOKE, Dame Chatte, Mr. SHUTER,
aughter,(in love with Robin) Miss FAIRBROTHER, Tib,(Gammer's Maude) Mrs. EAST, Doll, (Chatte's Mayde) Miss BARNETT

COUNTRY CHURCH, SEEN THROUGH A FOREST.

The nasal effects of a golden shower—a long procee makes "a short work of it.
Jerulia, (Queen of the Fairies, and Protectress of Old Gammer Gurton and her Party) ... Miss MARSHALL,

INTERIOR of the BAILLIE'S HOUSE.

he jury not yet in Rubico, and the needle not true to the Pole—found sticking somewhere else—diversttionables and unsentimonables.
stor Basilie, (Justice of Peace & Quorum) Mr. FENTON, Seapthrift, (his Clerk) Mr. BLAKE, Beadle, Mr. BOUNCE.

AIRY LAKE, BY MOON-LIGHT!

fference of opinion between fairies and furies.—We want a change, and most of all THE CHANGE which they would bring us.
Fairies—Mesdames Marano, Bennett, Sutton, J. Sutton, E. Jones, Miller, Panormo, A. Marano, Reed, Chester, E. Lee, Mears, &c.

A STREET IN GREENWICH.

quin, .. Mr. HOWELL, Columbine, Miss FAIRBROTHER,
Clown, .. Mr. T. MATTHEWS, Pantaloon, Mr. F. SUTTON,

ATER MILL, AND PUBLIC HOUSE.

The wheel of Fortune, and the flower of Life—angling—Fish and near fresh—Clown and Pantaloon have plenty of sack.

COACH OFFICE, AND SHOE SHOP.

New school of drawing—book-keeping by simple entry—difference between French and English years.

INTERIOR OF A LARGE KITCHEN.

utting capers and making puddings—washed white and done brown—concentrated essence.
A POTTERY, AND PRINTING OFFICE.
First impressions—patent scrubbing brushes—a regular tyger—the most useful footman going.
Milliner, Miss FLOUNCE, who will introduce, by particular desire,
THE POPULAR CASHEWNUT DANCE!
THE NEW NATIONAL GALLERY.
Anticipation of a cold, and effect of a warm bath—a lean fiddler—a man of fashion and his admirers.
A CELEBRATED MAN of FASHION, by JIM CROW

AERONAUTIKON!
OR
JOURNEY of the GREAT BALLOON

Representing Views of the following Places, as seen therefrom
IN THE LATE AERIAL VOYAGE!

1. (DAY-LIGHT) VAUXHALL GARDENS.
2. The THAMES, ST. PAUL'S, The BRIDGES.
3. GREENWICH HOSPITAL AND PARK—WOOLWICH.
4. THE MEDWAY, GAD'S HILL,
 Rochester Bridge, Castle, and Cathedral.
5. (TWI-LIGHT) DOVER CASTLE, AND TOWN.
 HARBOUR, AND SHAKSPEARE'S CLIFF. (Descent of a Letter to the Mayor of Dover).
6. (NIGHT) THE CHANNEL.
7. (MOON-LIGHT) CALAIS PIER, AND THE REVOLVING LIGHT.
8. (MORNING) THE RHINE.
9. Cologne Cathedral--Bridge of Boats--Deutz
 BONN—SEVEN MOUNTAINS—DRACHENFELS.
 THE MOSELLE.
10. COBLENTZ, AND EHRENBREITSTEIN.
11. Caub. Ruins of Gutenfels & the Pfaltz.
12. BACHARACH.
13. BINGEN, MAUSETHURM, EHRENFELS,
 RUDESHEIM, and JOHANNISBERG.
14. MAYENCE, DOM KIRCHE, &c.
 TOY SHOP, and CONFECTIONER'S.
Swearing black's white—a warm reception to a new-hotter—how to prove a child not your own—safe stud, safe teal.
THE BASALTIC CAVERN!
flame's up, the old trick played.
CERULIA'S ENCHANTED BOWER!
IN THE CENTRE OF WHICH, WILL TAKE PLACE A
Splendid Irradiation of Fireworks !
Fireworks discharged for going off so well—a new light thrown on the stage.

To-morrow, The Devil on Two Sticks, The Waterman. And The Pantomime
On Friday, (First Time at reduced Prices) Fra-Diavolo. And The New Pantomime
On Saturday, Madlle. DUVERNAY will re-appear. And The New Pantomime
On Monday, will be produced (for the First Time at this Theatre) Rossini's Grand Opera of

Cinderella ; or, The Fairy Slipper

with New and appropriate Scenery, Dresses, Characteristic Dances,
Transformations, &c. To which will be added The New Pantomime.

OLD GAMMER GURTON
With the Aeronautikon by Messrs. GRIEVE

having been pronounced by the acclamations of the Public as the greatest hit for years past, will be
performed Every Evening 'till further Notice.

Every Part of this Theatre was so crammed last Evening to see

THE DEVIL ON TWO STICKS

that it will be performed To-morrow Night, with the New Pantomime.

STALLS, 7s. BOXES, 4s. PIT, 2s. GALLERIES, 1s
HALF-PRICE
BOXES, 2s. PIT, 1s. GALLERIES, 6d.

Figure 4.16
Theatre playbill for the pantomime *Harlequin and Old
Gammer Gurton; Or, the Lost Needle*, Drury Lane that includes
Grieve's balloon panorama *Aeronautikon! or, Journey of the
Great Balloon*. London, 1836. Author's collection.

The *Theatrical Observer* stated that *Aeronautikon!* presented "views of the different places seen by Mr Green and his companions, during their late aerial voyage."[117] However, the names of the aeronauts do not appear in the playbill, which only mentions the "great balloon . . . in the late aerial voyage." Why was the well-known name of Green omitted? It may have been considered unnecessary, because the adventure was still in everyone's mind, but legal issues may also have been involved. Perhaps Green wanted money for the use of his name? Yet, as in the case of Roberts's Polar panorama, spectacle was more important than documentary-like realism. Comparing the panorama with the actual route of the Great Nassau Balloon will demonstrate that Grieve's work was closer to fantasy than to a newsreel-like representation of the journey.[118]

The key to *Aeronautikon!* is divided into two vertical columns. The sights have been numbered 1–33 (left) and 1–35 (right). The numbers run from the bottom to the top, confirming that the panorama was unrolled from a vertical roller above the stage to another one near the floor (forward motion was represented by "going up"). The section that includes the panorama begins with a ground-level scene of Vauxhall Gardens (left, 1). It may have been a traditional stage set with flats on both sides (trees) and a pavilion at the back. Although the key does not show it, a large mock-up balloon was placed in the center. According to Charles Dickens, it was "a practicable balloon, *not* attached to the canvas."[119] There is visual discontinuity between the opening view and the next one, an oblique bird's-eye view from the balloon flying over the Westminster Bridge (left, 2).

To rely on Dickens, at the moment of the ascent, "the garden, wondering spectators, trees, all went down rapidly, the balloon remaining stationary."[120] At the same time, the panorama must have slowly started rolling behind the balloon, where the aeronauts were placed.[121] The panorama moved continuously over the English landscape until it reached Dover in the evening (left, 27). The nightly crossing of the English Channel has been represented only by a narrow horizontal stretch with the word *Channel:* obviously a placeholder for dioramic light effects. The left column (and the first roll?) ends when the balloon reaches Calais (left, 30–33).

The right column (the second roll?) begins when the balloon is flying over the cathedral of Cologne in the morning (right, 1). The journey follows the Rhine to Rudesheim (right, 32), the ruins of Klopp (right, 33) and Johannisberg (right, 34). The final view represents the cathedral of Mayence from the ground level (right, 35). This may have been a drop scene behind which the end of the panorama was hidden. The balloon with its travelers was probably in the center, with the local inhabitants greeting them. Dickens claimed that the "large balloon which blocked up the centre of the canvas" was removed during the interval and replaced by "a tiny one, which was put away high in the air, in its proper place, where it took up no room."[122] He also confirms that the large balloon was brought back to the stage in the end.

From London to Calais the panorama followed Green's, Monck Mason's and Holland's flight fairly accurately, but turned then to an entirely different

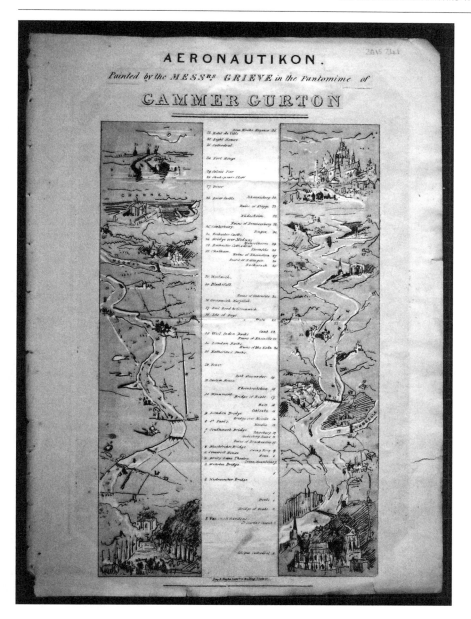

Figure 4.17
The key to Grieve's balloon panorama *Aeronautikon!
or, Journey of the Great Balloon*. London, 1836. Courtesy of
Jacqueline and Jonathan Gestetner Collection.

direction. The Great Nassau Balloon crossed the Rhine very early in the morning, but it neither followed its course nor reached Mayence. Why was the route changed? The production schedule may have been an issue. The British landscape was easy to sketch, but no such information was available about the latter part of the journey. When Green and his companions reached the European continent darkness had already fallen; the aeronauts saw only dark. After flying over Liège they lost their sense of direction, wondering if the wind had carried them to Poland or Russia.[123]

The Rhine valley was an easy choice, because it was a well-known tourist destination, and illustrations were easily available. Both the *Aeronautikon!* key and a surviving watercolor sketch resemble the folding guide maps of the region produced from the mid-1820s onward.[124] In them the Rhine valley is displayed from an oblique bird's-eye view. The second half of the *Aeronautikon!* could be interpreted as a magnified adaptation of Friedrich Wilhelm Delkeskamp's (1794–1872) map, except that the latter follows the river in the opposite direction from Mayence to Cologne.[125] The spectators hardly complained about not being shown what Green and his companions had (not) seen. Perhaps they did not even notice the difference.

The horizontal spools posed problems. The heavy painting came down easily, but collecting it on the lower spool was a challenge. A contemporary description stated that "the Aeronautikon was so bungled that the view of London was at a standstill for a full five minutes, whilst Gravesand, Rochester, &c. came tumbling on to it, leaving the unlucky metropolis covered with creases."[126] The lower roller must have got stuck.[127] Another challenge was continuity. Some moving panoramas were spatially and temporally continuous in the manner of the miniature roll panoramas of city streets, rivers, and processions.[128] When the distance was longer and several locations were visited, this was no longer possible. In the *Aeronautikon!* the time-space was therefore condensed elliptically, omitting those parts of the journey where nothing interesting happened.

Continuity could be enhanced by lighting, made easier by the new gas lamps.[129] The playbill confirms that some scenes were translucent. In the panorama, the journey began in "day-light," the balloon reached Dover at "twi-light" and crossed the English Channel in the dark. Calais Pier and the "Revolving Light" (lighthouse) were seen by "moon-light," and the Rhine reached at sunrise.[130] Light effects made it possible to "edit" the Channel crossing. A dark transparent stage drop may have been lowered in front of the panorama, making it possible to remove the mockup balloon and to prepare the second roll of the panorama. Such "manouvres in the dark" anticipated in their own way film editing.

The "aeronautikons" migrated from the stage to the exhibition circuit, where a "battle of aeronautikons" took place in 1841–1842.[131] William Marshall exhibited a "Vertical and Horizontal Moving Diorama of the AERIAL VOYAGE OF THE GREAT NASSAU BALLOON" in his Edinburgh Rotunda, claiming that it was "on a perfectly novel principle by Machinery, Expanding Apertures, &c."[132] The neighboring Gordon's British Diorama countered with "AERONAUTIKON, or Aerial Flight of the GREAT NASSAU BALLOON of 1836; comprised in an Grand Vertical Moving Picture of

14 Views."[133] Gordon claimed to have painted it himself from Thomas Grieve's sketches.[134] Both were shown in other cities as well, and one of them may have ended up in P. T. Barnum's American Museum in New York in 1847.[135]

Emphasizing the tightening grip of visual media on the imagination, balloon experiences were related with optical spectacles. Monck Mason compared what he saw with peristrephic panoramas: "The docks, canals, bridges, buildings, streets, roads, parks, and plantations [appeared] to recede in a peristrephic order, to make way for new prospects, and give occasion to renewed admiration and applause."[136] On his own ascent Henry Mayhew noticed a panoramic effect, which was produced by the balloon's apparent lack of motion: "The earth appeared literally to consist of a long series of scenes, which were continuously drawn along under you, as if it were a diorama [moving panorama] beheld flat upon the ground, and gave you almost the notion that the world was endless landscape stretched upon rollers, which some invisible sprites were evolving for your especial enjoyment."[137]

Such comparisons were obviously a recurring topos, as a description of the "solemn stillness" and "awful grandeur" of an ascent the writer made with Charles Green in 1829 demonstrates:

> Old and New London Bridges, were like two feeble efforts of the works of man; and here we saw the triumph of nature over art, and the littleness of the great works of man. At one time, on nearing Battersea Bridge, we observed a small, black streak ascending from the surface of the Thames, which we concluded to be the smoke from a Richmond steam packet. At that time the course of the balloon was south-east, although the smoke above alluded to was driven towards the west. The air being so serene we felt no motion in the car, and we could only know we were quietly moving, from seeing the grappling irons (which hung from the car) pass over the earth rapidly from field to field; whilst the scene seemed to recede from our view like a moving panorama. At our greatest altitude a solemn stillness prevailed, and I cannot describe its awful grandeur and my excitement.[138]

According to the magazine editor, this description demonstrated "that the scenic attempt at Covent Garden Theatre, a few years since, to illustrate a balloon ascent, by moving scenery, was in accordance with the real effect." The editor did not think that the newly opened Regent's Park Colosseum, with Thomas Hornor's giant panorama of London (sketched from the top of St. Paul's Cathedral), was a match: "We thought ourselves richly rewarded by the view of the Colosseum Panorama, but what must have been their sensations at a distance of 6,600 feet high, when with the huge machine they appeared little more than a speck."[139] Still, Colosseum's steam-powered elevator (the world's first) was some kind of a compensation for at least some visitors: "Less than three minutes were sufficient to raise the almost unconscious *aeronauts* to the level of the first gallery on which they entered safe and sound."[140]

When it comes to the people on the ground, the sight of the descending balloon may have elicited sensations not unlike those felt by the spectators attacked by virtual ghosts in a phantasmagoria show. When the Great Nassau Balloon approached the ground in the German countryside, it was claimed that "the people, struck with terror, thought at first that it was one of the heavenly bodies that had fallen from its orbit. It would be difficult to give an idea of the consternation spread among the people, who were trembling for the safety of their houses, likely to be crushed under the enormous mass."[141]

Whether it had any basis in reality or not, this idea was picked up by George Danson when he painted his own Aeronautikon for William Marshall. In the scene, where the balloon descends in the Valley of Elberne, "the Inhabitants, never having seen a Balloon, are running in all directions, and seek security in ambush, whilst some few assist our gallant countrymen, who are engaged in allowing the gas to escape."[142] This incident provided a welcome opportunity to break the relative monotony of the views from the balloon by poking fun at peasants—and Germans too.

THE LURE OF THE MARKET AND
PERFECTION IN INVISIBILITY

David Mayer lamented the "willingness to present a diorama scene without har-lequinade characters," considering it "symptomatic of an increasing preference for spectacle at the expense of comedy."[143] It could be claimed that the increasing interest in visual representations without living actors was a sign of media culture in the making. The actorless spectacles of Servandoni and de Louther-bourg introduced artificial worlds that were visual, aural, and mechanical. This trend continued in the circular panorama, the Diorama, and the moving panorama, although the latter never fully abandoned the human; the lecturer's presence just outside the border of the represented world was physical.

Professional scene painters created illusionistic scenery rapidly and convincingly. From the early 1820s they were regularly credited in the playbills; names like Clarkson Stanfield could be larger than the names of the actors. Still, the star painters must have felt frustrated when they had to submit to theatrical conventions and the stage managers' wishes. They began creating panoramas for traveling showmen, at first anonymously. This was the case with Stanfield and Roberts, who painted a moving panorama of the bombardment of Algiers for J. B. Laidlaw in 1824.[144] Laidlaw exhibited it far and wide, without ever mentioning the painters' names (this must have been part of the agreement).

Scene painters also began joining or starting commercial ventures. Stanfield's Poecilorama (1826) was shown at the Egyptian Hall, Piccadilly, the future venue

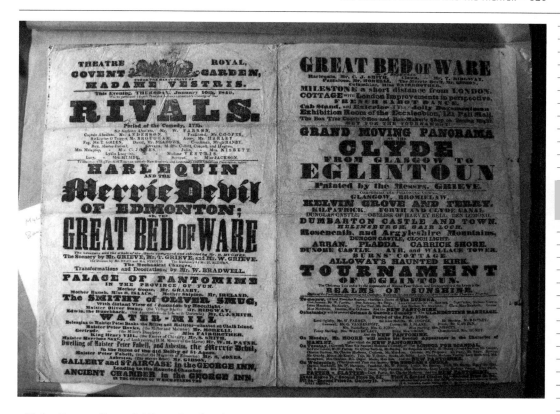

of John Banvard's and Albert Smith's famous moving panoramas.[145] Stanfield and Roberts also became involved in the British Diorama, which operated between 1828 and 1836 at the Royal (later Queen's) Bazaar at 73 Oxford Street. The trend became more prominent in the 1840s, when Charles Marshall launched his nontheatrical career with the Kineorama. A particularly ambitious venture was Thomas Grieve and William Telbin's *Route of the Overland Mail to India*, which was shown at the Gallery of Illustration on Regent's Street. Grieve and Telbin's venue became a kind of movie theater *avant-la-lettre*, where one ambitious production followed another (see chapter 6).

Moving panoramas also continued to be exhibited in theaters. Some resembled the ones on the commercial exhibition circuit. Roberts's Polar panorama and Grieve's *Aeronautikon!* had sacrificed accuracy for the requirements of the pantomime. This was no longer the case with Messrs. Grieve's *War with China*, a newsreel-like panorama about the on-going Opium War, which was added to the *Castle of Otranto, or, Harlequin and the Giant Helmet* (Covent Garden, 1840).

Figure 4.18
Theatre Royal, Covent Garden, playbill for January 16, 1840.
The pantomime *Harlequin and the Merrie Devil of Edmonton; or, the Great Bed of Ware* included Messrs. Grieve's "Grand Moving Panorama of the Clyde from Glasgow to Eglintoun."
Author's collection.

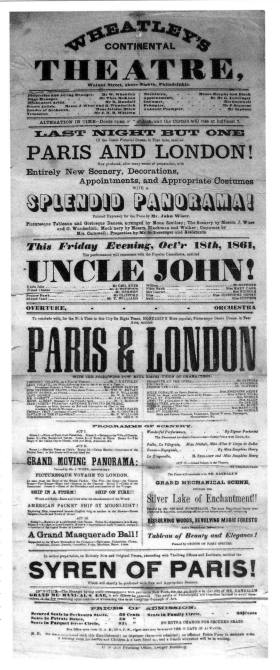

It presented "views of the most interesting Disputable Points of THE EASTERN QUESTION; Including a Series of 'Moving Accidents by Flood and Field,' or, PAST and PASSING EVENTS OF 1840."[146] Emphasizing its semi-independent status, the *War with China* was the culmination, followed only by a symbolic finale, "A Grand National Tableau."

Moving panoramas were integrated with other scenic effects and techniques. They became a standard feature of the illusion-producing machineries of melodramas and spectaculars. Something paradoxical happened: as they became more and more refined, partly thanks to new possibilities such as electric motors, they lost their identity, becoming invisible. This process was discussed by Wickman (1961), who demonstrated how moving panoramas spread from pantomimes to other theatrical genres, including the Shakespearean drama.[147] He classified them into scenic transformation panoramas, ascent-descent, or vertical panoramas, ship-storm-sea scene panoramas, and racing scene panoramas.[148]

Scenic transformation panoramas bridged locations. Charles Kean used this possibility in his interpretation of Shakespeare's *King Henry the Eighth* at the Princess Theater (1855). Grieve's moving panorama, a careful re-enactment of sixteenth-century London, transported the audience along the Thames from Bridewell Palace to Greenwich, to witness the christening of the infant Princess Elizabeth.[149] In Shakespeare's *Timon of Athens* (Sadler's Wells, 1851), Samuel Phelps used a moving panorama to shift the action from a wood outside Athens to the city's walls. The section depicting the walls had "a sizeable cut-out in the cloth," which suddenly revealed the actors impersonating Alcibiades and his soldiers.[150] When the panorama ended, they marched onto the stage from behind the canvas. In William Macready's production of *Henry the Fifth* (Covent Garden, 1839), parts of Stanfield's translucent moving diorama were matched with identical sets and

Figure 4.19
Wheatley's Continental Theatre, Philadelphia, playbill for Friday, October 18, 1861. Printed by U.S. Job Printing Office, Ledger Building. The performance of Moncrief's hit play *Paris and London* included a moving panorama "representing a Picturesque Voyage to London," painted by John Wiser. According to the playbill, *Paris and London* was already seen in Philadelphia for the fifth time in eight years. Author's collection.

actors placed behind the canvas; these were magically revealed by lighting.[151]

"Ascent-descent, or vertical panoramas" could also be used to transport characters (and by implication, spectators) from one physical location to another. In Charles Kean's version of *Faust and Marguerite* (Princess Theatre, April 19, 1854) a vertically rolling canvas was used in a scene where Marguerite dies and is carried to heaven by a chorus of angels.[152] As the canvas began to move, physical props (a church and a fountain, etc.) were pulled *down* through a trap-door, while the actors remained suspended from above. Similar tricks had been realized with magic lanterns and vertically movable lantern slides already during the phantasmagoria era.[153]

The history of ship-storm-sea scenes on stage is long. Even de Loutherbourg's "Storm and Shipwreck" must have been influenced by earlier examples. The moving panorama was often combined with mechanical waves, artificial thunder, and even wind; the opening scene of Shakespeare's *The Tempest* was a perfect test case, and was used several times.[154] For purposes like this, the magic lantern became a potential alternative for painted panoramic scenery, because it was easier to manipulate, and lantern slides were cheaper and quicker to paint. Henry Langdon Childe, who projected a moving ghost ship in Fitzball's *Flying Dutchman* already in 1827 (at Adelphi, London) developed his tricks further. A quarter of a century later, he created a "Dioramic & Pictorial Illusion of a Storm and Wreck" for the Surrey Theatre's *The Tempest* in 1853.[155]

However, panoramas of sea voyages were not wiped aside overnight. In the same year two were included in the Boston Museum's interpretation of J. R. Planché's and Moncrieff's extravaganza *Paris and London; or, A Trip to Both Cities* (originally shown in 1828). A smaller one unfolded behind the windows of a boat's cabin, and a larger one as a background for a scene taking place on the deck. At Wheatley's Continental Theatre's interpretation in Philadelphia (1861), the moving panorama again contained familiar elements: "SHIP IN A STORM! SHIP ON FIRE!! Wrecks and Rafts—Boats and Crew after the abandonment of the Wreck."[156] In a Paris theater a mock-up of a boat was rocked by a storm on stage.[157] It had been cut open so that the spectators could see what was happening inside the cabins. It was enveloped by moving panoramas rolling along curved tracks from the rear toward the sides of the proscenium arch.

A moving panorama was first used as a backdrop for a riding scene in H. M. Milner's equestrian spectacle *Mazeppa* at Philip Astley's Royal Amphitheater, Westminster in 1831.[158] The possibilities of synchronizing a moving canvas with a horse in motion were still limited. The panorama moved slowly, and there was no treadmill. The introduction of the electric motor made truly spectacular riding and racing scenes possible in the 1880s. Motors were used to control both the treadmill and the moving background.[159] The moving panorama was connected into an endless loop running between two cylinders. Because of its speed and the heat of the action, the audience did not notice that the same views were repeated over and over again.

This solution was used in the sensational production of Lew Wallace's *Ben-Hur* at the Broadway Theater in New York (1899). Three moving panoramas,

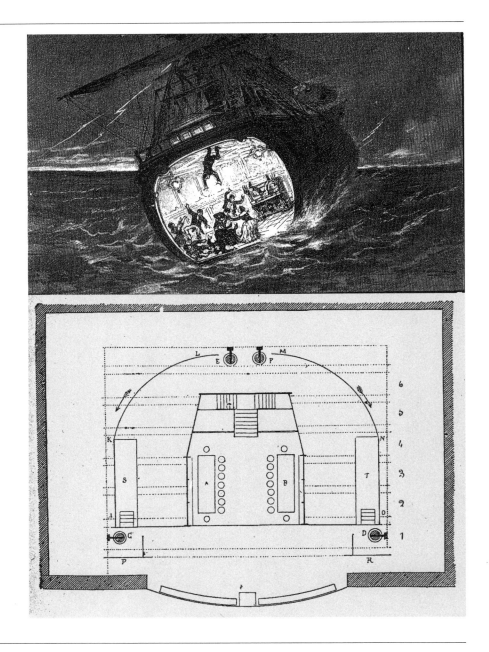

Figure 4.20
Scenic design featuring a rocking boat surrounded by moving
panoramas running on both sides. Presented in an
unidentified theater in Paris as part of a pantomime. From
Georges Moynet, *La machinerie théatrale: Drucks et décors*
(Paris: La Librairie illustrée, n.d., c. 1893, 85). The diagram
shows the layout of the stage from a bird's-eye perspective.

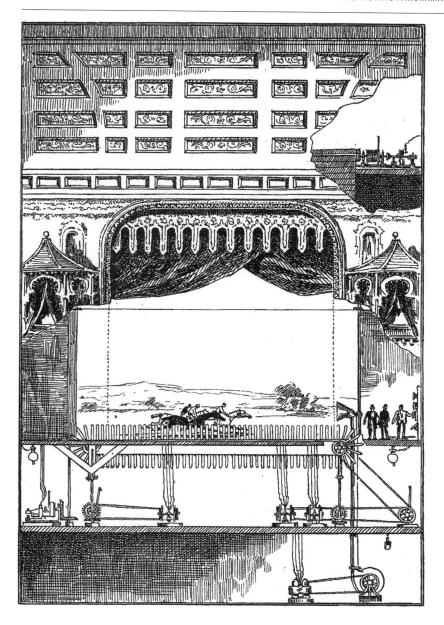

Figure 4.21 + 4.22

Horses running on a treadmill in front of a moving panoramic background. The fence in front of the horses moved as well, adding to the illusion. From the last act of Charles Barnard's *The County Fair*, produced by Neil Burgess at the Union Square Theatre, New York, 1889. Tricks like this required perfect coordination between stage machinery and human operators. From Georges Moynet, *La machinerie théatrale: Drucks et décors* (Paris: La Librairie illustrée, n.d., c. 1893, 331).

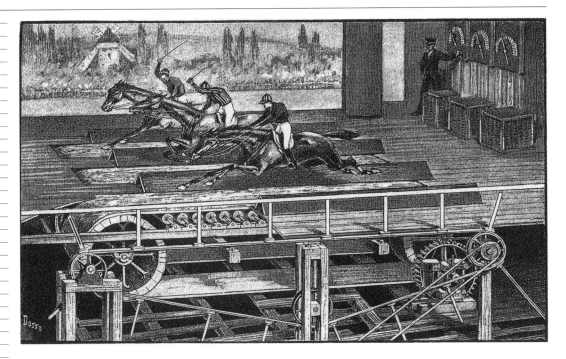

one laterally at the back and two obliquely on the sides, formed a seamless setting for a 40-second race between two chariots driven by four horses running on treadmills.[160] But even when taken to such an extreme, the theatrical technology could not create a sense of total immersion; the introduction of the "cyclorama" (or "horizon"), a curved atmospheric backdrop, did not provide a real solution either.[161] With the advent of cinematographic spectacles, the physical and mechanical simulation of reality on stage came to a dead-end. Although it was still presented in a frame, no theatrical racing scene could match the chariot race of Fred Niblo's *Ben-Hur* (MGM, 1925), which had been shot by no less than forty-two motion picture cameras and dynamically edited. In the world of film musicals, Busby Berkeley's great optical illusions went much further than any stage-bound Ziegfeld Follies.

While the audience was being awed by *Ben-Hur* at the Broadway Theater, one final wave of panoramic attractions, more spectacular than ever before, was ready to hit astonished spectators. Circular and moving panoramas had been merged, and their possibilities married with techniques from the stage, and brand new technological innovations. The new combinations were revealed to the public in a spectacular environment that looked directly into the future—the Paris Universal Exposition of 1900 (see chapter 10).

Figure 4.22

NOTES

1. "Das Panorama," *Jahrbücher der Preussischen Monarchie under der Regierung Friedrich Wilhelms des Dritten* (Berlin: Johann Friedrich Unger), Jahrgang 1800, vol. 2, p. 638. Another source from 1803 characterized the panorama as a "peculiar kind of theatre, where the spectator should embrace, from a central point, a circular horizon." *Monthly Mirror* (London: for the Proprietors by J. Wright), vol. 15 (1803), p. 99.

2. Lee Parry, "Landscape Theater in America," *Art in America* 59, no. 6 (Nov.–Dec. 1971): p. 52.

3. Allardyce Nicoll, *The Development of the Theater: A Study of Theatrical Art from the Beginnings to the Present Day*, 5th ed. (London: George G. Harrap & Co., 1966, orig. 1927); Richard Southern, *Changing Scenery: Its Origin and Development in the British Theater* (London: Faber & Faber, 1952) and *The Georgian Playhouse* (London: Pleiades Books, 1848); Rosenfeld, *Georgian Scene Painters and Scene Painting*.

4. Richard Carl Wickman, "An Evaluation of the Employment of Panoramic Scenery," Ph. D. dissertation, Graduate School of the Ohio State University 1961 (unprinted).

5. Stage designs by masters like Giacomo Torelli were published as collections of engravings. I have seen a *vue d'optique* depicting the interior of the theater in Verona during a performance (Paris: Louis-Joseph Mondhare, c. 1759–1780). It shows the wing stage symmetrically from the point-of-view of the auditorium. There were also peepshow boxes disguised as miniature theaters, complete with tiny proscenium arches and other scenographic elements. These could have sets of wings on the sides and even an upper wing with a series of painted clouds hanging overhead.

6. Gods and mythological creatures, carried by machines from above or below, could make their appearances beyond the proscenium.

7. Nicoll, *The Development of the Theater*, p. 156.

8. In *Saggio sopra l'opera in musica*, Nicoll, *The Development of the Theater*, p. 154. For theater managers economic reasons were a factor in the campaigns to remove the forestage, because that gave more space to accommodate paying customers.

9. In 1760, author's emphasis. Quot. Russell Thomas, "Contemporary Taste in the Stage Decorations of London Theatres, 1770-1800," *Modern Philology* 42, no. 2 (Nov. 1944): p. 70.

10. Michael R. Booth, *Victorian Spectacular Theater 1850–1910* (Boston: Routledge & Kegan Paul, 1981), p. 60. This foreshadows the role of film comedies and musicals as sites of "experimentation" during Hollywood's Golden Age.

11. They were called Spectacles de Décoration. "Waterfalls, thunderstorms and cloud formations were some of the special effects. (These effects must certainly be considered the fore-runner of the Eidophusikon.)" (Hecht, *Pre-Cinema History*, p. 383, no. 548). Information comes from Alfred Auerbach, *Panorama und Diorama: Ein Abriss ueber Geschichte und Wesen volkstuemlicher Wirklichkeitskunst* (Grimmen: Verlag Alfred Waberg, 1942), 2 parts, pp. 42 and 36 resp. Chatel de Brancion claims that Servandoni "utilise pour présenter ses créations la salle des machines des Tuileries, immense espace dans le château déserté," obviously ignoring that the name referred to a theater (*Le cinéma au Siècle des lumières*, p. 13). The mistake has been re-enacted in the translation: "As for Servandoni, he used the machine room of the Tuileries—a huge space in the deserted palace." (*Carmontelle's Landscape Transparencies*, p. 13).

12. Pinson, "Speculating Daguerre," p. 30. Pinson refers to *Description abrégée de l'eglise de Saint Pierre de Rome, et de la représentation de l'interieur de cette église, donnée à Paris dans la Salle des Machines des Thuilleries [sic] aux mois de Mars et d'Avril de l'année 1738, par le Sieur Servandoni, architecte & peintre de l'Academie Roiale [sic] de Peinture* (Paris, 1738).

13. Pinson quotes "La Forest enchantée, représentation tirée du poême italien de la Jérusalem délivrée, Spectacle . . . exécuté sur le grand Théâtre du Palais des Thuileries pour la première fois le Dimanche 31 Mars 1754 (Arsenal MS 2757)." ("Speculating Daguerre," pp. 30–31).

14. Jean-Nicolas Servandoni, *Description du Spectacle de Pandore* (Paris: Pissot, 1739), pp. 8–9, quot. Marc Olivier, "Jean-Nicolas Servandoni's Spectacles of Nature and Technology," *French Forum* 30, no. 2 (Spring 2005): p. 37. Olivier says that Servandoni has "received virtually no focused scholarly attention in the last forty years" (p. 43, fn. 4).

15. Olivier, "Jean-Nicolas Servandoni's Spectacles of Nature and Technology," p. 34.

16. For an overview of his career, *Philippe Jacques de Loutherbourg, R.A. (1740–1812)* (London: Greater London Council, n.d.).

17. Iain McCalman, "Magic, Spectacle, and the Art of de Loutherbourg's Eidophusikon," in *Sensation & Sensibility: Viewing Gainsborough's Cottage Door*, ed. Ann Bermingham (Yale: Yale Center for British Art and the Huntington Library, 2005), p. 185.

18. Christopher Baugh, *Garrick and Loutherbourg* (Cambridge: Chadwyck-Healy, 1990). For Eidophusikon, Baugh relies, as usual, on Pyne (pp. 78–83).

19. De Loutherbourg's *forte* were atmospheric effects. His paintings dramatized the play of light to such an extent that they were sometimes criticized as excessive. J. M. W. Turner is known to have studied and admired his paintings. Walter Thornbury, *The Life of J. M. W. Turner, R.A.: Founded on Letters and Papers Furnished by His Friends and Fellow-Academicians,* new rev. ed. (London: Chatto & Windus, 1897), pp. 112–113.

20. De Loutherbourg's oil painting "Coalbrookdale by Night" (1801, Science Museum, London) has been considered an early manifestation of the technological sublime, demonstrating the effects of the industrial revolution on the rural landscape. Still, the social and the technological was probably less important for him than the expressive quality of the flames illuminating the clouds of smoke against the night sky. Rather than announcing the industrial revolution, they may carry hidden messages about the Vulcanic play of occult forces. Andreas Bluehm and Louise Lippincott, *Light! The Industrial Age 1750–1900. Art & Science, Technology & Society* (New York: Thames & Hudson, 2001), pp. 90–91.

21. An 1806 dictionary defines this concept as a trip to study and represent the nature, habits, costumes, and monuments (both ancient and modern) of a country. A. L. Millin, *Dictionnaire des Beaux-Arts,* vol. 3 (Paris: Desray, Librairie, 1806), pp. 822–823. The entry lists several illustrated books with *voyage pittoresque* in their title, the earliest from 1781. The words were later used in the title of a collection of topographic prints published between 1821 and 28. *Voyages pittoresques et romantiques dans l'ancienne France* was a joint venture between Charles Nodier, Alphonse de Cailleux and baron Isidore Taylor. Daguerre contributed to it (Pinson, "Speculating Daguerre," p. 3).

22. A scene in Goethe's novel *Elective Affinities* (1809) demonstrates how *voyage pittoresque* sketches (made with the help of a camera obscura) were displayed. *Elective Affinities,* trans. David Constantine (Oxford: Oxford University Press, 1994), p. 182. One senses a desire toward photography, which had not yet been invented. Goethe adopted the same habit on his trip to Italy.

23. *An account of the Wonders of Derbyshire, as introduced in the Pantomime Entertainment at the Theatre-Royal, Drury-Lane* (London: G. Bigg printer, and sold by W. Ranall, 1779) (HL).

24. An account of the voyage was published in 1784. Nicoll, *The Development of the Theater,* p. 198. Another inspiration was a Polynesian native brought to London in 1775.

25. *A short account of the new pantomime called Omai, or, A Trip round the World; performed at the Theater-Royal in Covent-Garden. With the recitatives, airs, duetts, trios and chorusses; and a description of the PROCESSION. The Pantomime, and the Whole of the Scenery, designed and invented by Mr. Loutherbourg. The Words written by Mr. O'Keeffe; And the Musick composed by Mr. Shields* (London: T. Cadell, 1785). (UCLASC).

26. Rosenfeld, *Georgian Scene Painters,* p. 35. Captain Cook's voyage inspired a panoramic wallpaper, *Les Sauvages de la mer Pacifique,* produced by Joseph Dufour, and introduced at the French Industrial Exposition in 1806. It came with an explanatory guide about its contents: "A mother will give, without noticing the effort, history and geography lessons to her lively, intelligent, questioning little daughter." Nouvel-Kammerer, *French Scenic Wallpaper 1795–1865,* p. 172.

27. Quot. Altick, *The Shows of London,* pp. 120–121.

28. Advertisement, *Morning Herald,* March 14, 1781, quot. Ralph G. Allen, "The Eidophusikon," *Theater Design and Technology,* Dec. 1966 (repr. in Herbert, *A History of Pre-Cinema,* vol. 2, pp. 82–88, quot. p. 83). The name was a combination of three Greek roots, meaning sight, nature, and image. Nicoll, *The Garrick Stage,* p. 118. The word may well have been influenced by the word Holophusikon, the name of Sir Ashton Lever's museum that operated on the north side of Leicester Square between 1775 and 1784. Tom Taylor, *Leicester Square; Its Associations andIts Worthies* (London: Bickers and Son, 1874), pp. 447–455. Taylor erroneously claims that the museum (which operated earlier in Manchester) was moved to the Leicester House in 1771.

29. Pinson, "Speculating Daguerre," p. 41. No evidence indicates that Servandoni and de Loutherbourg ever met, but the latter may have known Servandoni's decorations at the Salle des machines, because they were still performed when he came to Paris. Pinson notes that de Loutherbourg collaborated with one of Servandoni's students, Antoine de Machy (p. 40).

30. The reason seems to have been a pay dispute with Richard Brinsley Sheridan, Garrick's successor. Garrick resigned in 1776.

31. It was fronting Leicester Street (Dobson, *At Prior Park,* pp. 111–112). Following this lead and using Richard Horwood's map of Georgian London (1792) the address may have been 4 Lisle Street.

32. Eidophusikon was said to be a "new species of painting." The expression is probably from a contemporary newspaper. McCalman, "Magic, Spectacle, and the Art of de Loutherbourg's Eidophusikon," p. 191. The ticket price was five shillings, enough to keep the general public away. William B. Scott, "Barker and

Burford's Panoramas," *Notes and Queries*, June 22, 1872, p. 523.

33. G. Speight, *History of the English Puppet Theater*, p. 123, quot. Sybil Rosenfeld, "The *Eidophusikon* Illustrated," *Theater Notebook*, 1963/4, p. 52 (repr. in Herbert, *A History of Pre-Cinema*, vol. 2, pp. 79–82).

34. Rosenfeld, "The Eidophusikon Illustrated," pp. 52–54. Burney's painting may be based on a later performance at Exeter Change in 1786, the same place where it was seen by Ephraim Hardcastle [William Henry Pyne], *Wine and Walnuts; or, After Dinner Chit-Chat* (London: Longman, Hurst, Rees, Orme, Brown, and Green), 2d ed., 1824, vol. I., p. 284.

35. The Tangier scene was replaced by the more topical "The Bringing of French and Dutch Prizes into the Port of Plymouth with a View of Mount Edgecumbe." After fifty-nine performances the show closed in May, but it reopened in the fall. De Loutherbourg introduced the second version on Jan. 31, 1782. The Storm and the Shipwreck was added some weeks later. The program is reproduced as appendix B in Dobson, *At Prior Park*, pp. 277–281.

36. Newspaper ad for the "Thirty-Ninth Night of Performance," undated [April 1781] (JJCB).

37. It was updated later by adding a recent catastrophe, the sinking of the Halsewell East Indiaman.

38. Dobson, *At Prior Park*, p. 277.

39. Pyne, *Wine and Walnuts*, pp. 281–282.

40. Ibid., p. 284.

41. Ibid., p. 285.

42. Rosenfeld, *Georgian Scene Painters*, p. 62. The Argand lamp was invented c. 1782 by Ami Argand in

Switzerland, based on Lavoisier's ideas about combustion. Argand demonstrated his invention in Paris in 1783, where the idea was stolen by the pharmacist Quinquet, who soon began manufacturing "Quinquet" lamps. They had a round wick and air channels both inside and around it for air circulation, and a glass chimney (Guerin, *Du soleil au xenon*, pp. 14–15).

43. Pyne, *Wine and Walnuts*, p. 299.

44. Altick claims that de Loutherbourg antipated the "double effect Diorama" (Daguerre and Sébron) in a pantomime. By changing the direction of the light falling on semi-transparent scenery painted from both sides, the "Cavern of Despair" transformed into the "Temple of Virtue." Altick does not name the production or reveal his source (*The Shows of London*, p. 120).

45. Cloud machines were the origin of stage machinery. Southern says that mechanically moving clouds were invented in 1574–1575 (*Changeable Scenery*, p. 31); compare with Colin Visser, "Scenery and Technical Design," in *The London Theater World, 1660–1800* (Carbondale: Southern Illinois University Press, 1980), pp. 101–104. A review in the *Whitehall Evening Post* (March 1, 1781) claimed the clouds were more successful than the waves: "The last scene is a tempest, which is progressively brought on by a variation of sky, that does infinite credit to the ingenuity of the artist. The water, however, appeared to us (perhaps from sitting too near it) not to be managed with so much skill; the transverse direction of the pieces, from which the deception arises, was too apparent, and that in a great measure from the waves being too abruptly angular." Quot. W. J. Lawrence, "Water in Dramatic Art," *The Gentleman's Magazine*, ed. Sylvanus Urban (London: Chatto & Windus), vol. 262 (Jan.–June 1887), pp. 540–553 (quot. p. 546). Lawrence claims de Loutherbourg gave

his performance at the Patagonian Theater (pp. 545–546), probably referring to the Great Room on Panton Street, where Eidophusikon was later shown by Chapman (the Patagonian puppet theater had occupied the premises earlier).

46. The catastrophe at the Great Room, Spring Gardens (formerly Cox' Museum) may have been caused by the miniature cannons in a cork model of the Windsor Castle. Nearby shops selling canes and tops were robbed in the confusion by criminals, who posed as firemen (unidentified clipping, hand-dated April 2, 1785, JJCB).

47. Rosenfeld, *Georgian Scene Painters*, p. 33.

48. Pyne, *Wine and Walnuts*, p. 296.

49. About early sound effects in theater, Visser, "Scenery and Technical Design," pp. 107–110.

50. *European Magazine* 1 (1782): 182.

51. The information comes from the memoirs of the author, antiquarian, and topographer John Britton (1771–1857), who claimed he performed at Chapman's New Eidophusikon in 1799. *The Auto-Biography of John Britton*, part 1 (London: Printed for the Author, as Presents to Subscribers to "The Britton Testimonial," 1850), pp. 97, 99. After Chapham's regular entertainer Mr. Romer had quit on May 25, 1799, it was announced on May 27 that a Young Gentleman, perhaps Britton, would be making his first appearance in the entertainment Comical Corner, which consisted of "recitation, anecdote and song." (newspaper cuttings, JJCB).

52. At the Great Room on Panton Street. Newspaper advertisement, hand dated Feb. 26, 1799 (JJCB).

53. Newspaper ad, hand dated Jan. 30, 1800 (JJCB). The dog is

mentioned with the largest font in a broadside (hand dated Jan. 18, 1800) that also mentioned two new scenes, Moon Eclipse and New View of Liverpool (JJCB). The combination brings to mind the way Robertson's *Fantasmagorie* developed in Paris. The ghost projection was only one of its attractions, many of which were live acts.

54. The destruction was attributed to a fire started in a brothel opposite the Tennis Court in James Street, Haymarket by the *Monthly Mirror* (London: J. Wright for the Proprietors, 1801), vol. 14 (1800), p. 176.

55. Odell refers to a lecture by Lewis Hallam is New York in 1785, said to have contained "two scenes from Loutherbourg's Eidiphusicon [sic]." These were probably imitations as well. (Odell, *The Annals*, 1, p. 232). Peale's show was called "Perspective Views with Changeable Effects; or, Nature Delineated, and in Motion." Altick, *The Shows of London*, p. 126.

56. Pierre's and Degabriel's "bewegende Kunstbilder" (moving paintings) were for example advertised in the *Intelligenz-Blatt der freien Stadt Frankfurt*, no. 77 (Sept. 11, 1788). Oettermann's *Ankündigungs-Zettel* contains several handbills of their shows.

57. According to the fencing master Henry d'Angelo (1716–1802), his father had seen something he called "Le Tableau mouvant" (moving painting) in Venice, its "scenes being painted as transparencies and the figures being all black profiles." He says that an imitation of it was created with Servandoni for the French royal children. *The Reminiscences of Henry Angelo*, vol. I (New York: Benjamin Blom, 1969, orig. 1904), p. 8. Was this a mechanical theater or a shadow show?

58. A show called Skiagraphic that opened at the New Exhibition Room, Panton-Street on June 13, 1799, included an "Omalephusikon," which

was a representation of the town of Leith, Scotland (broadside in JJCB). In 1837 [hand-dated] the Saloon of Arts, Leicester Square (Saville House) advertised "The Eidephusicon [sic], a Beautiful Exhibition of Animated Scenes! Picturesque and Mechanical, Illustrative of National Characteristics and Historical Events" (two different broadsides in JJCB). It included "dioramic effects."

59. Allen, "The Eidophusikon," mentions that a playbill for *King Lear* from April 27, 1820 announces: "In Act III, A Land Storm, After the manner of Loutherbourg's Eidophusicon [sic] Designed and executed by Marinari and Assistants (Andrews, Hollogan, and W. Dixon)." (n. 21). Booth, *Victorian Spectacular Theater 1850–1910* speaks about the magic lantern used to create "kaleidoscopic flashes" for obviously the same production, which he dates 1821. The reference comes from Terence Rees, *Theater Lighting in the Age of Gas* (London: Society for Theatre Research, 1978), pp. 81–83. Wellbeloved mentions "the splendid Eidophusicon [sic], exhibited a few months since at Drury-lane" (*London Lions*, p. 28).

60. Broadside, Theatre Royal, Birmingham, June 29, 1824. The performance was for the benefit of the General Hospital and featured a comedy called *West Indian*, and an opera titled *Libertine* (JJG).

61. Broadside for April 22, 1824, in JJCB. The scenery was by Stanfield, Molinari, Roberts, and assistants. The "Eidophusikon" has not been attributed to anyone in particular, so it may have been a collaboration.

62. *Zoroaster, or, the Spirit of the Star, a Grand Melo-dramatic tale of Enchantment, in two acts, as performed at the New Theatre Royal, Drury Lane, with Universal Approbation, First produced Easter Monday, April 19, 1824, by W. T. Moncrieff, Esq.* (London: J. Limbird, 1824), pp. 23–26 (HL). Some details

are not clear. After a caravan of merchants has appeared "at a distance crossing the Deserts near the Pyramids" and a chorus of merchants has sung a song, "Merchants, Camels, Slaves, Equipage, &c. increase in size, and advance to the front; it is now broad day. Merchants depart" (p. 23). Were live actors, or a phantasmagoria-like rear projection used to create the effect of approach? Because it is said, "The back part of the Scene disappears, and discovers the eidophusikon..." actors are more likely; a projection at the back of the stage would not have been very effective.

63. "Prospectus of an Exhibition to be called the Eidophusikon," in C. W. Ceram, *Archaeology of the Cinema* (New York: Harcourt, Brace & World, [1965]), p. 54. It likely is from JWB (like the majority of the illustrations). The title indicates that W. Dalberg was trying to raise funds to realize the show, which explains the choice of silk.

64. The latter sounds much like Stanfield's "Grand Local Diorama of Windsor and its vicinity, which was exhibited at Drury Lane in 1829–1830. It premiered as part of *Jack in the Box; or Harlequin and the Princess of the Hidden Island* on Dec. 26, 1829. Dalberg may have acquired it.

65. Hecht mentions a broadside titled "Brief description of M. Dalberg's Udorama and Cosmorama now exhibiting at the above establishments" (London: J. Johnson, hand dated 1830; Guildhall Library, London). The Udorama is "a model from nature." (Hecht, *Pre-Cinema History*, p. 83, no. 137B.) An unidentified newspaper cutting in JJCB (hand dated 1830) confirms that it was a physical model of a Swiss scene with atmospheric light effects. The Cosmorama featured four pictures by Messrs. Medows and Cooper. This may refer to the same Mr. Dalberg.

66. *The Eidophusikon, or Moving Diorama of Venice, displaying, in*

fourteen views, the principal canals, palaces, churches, shipping, &c. &c. of this gorgeous city . . . (Glasgow: W. and W. Miller, 1841) (University of Wisconsin Madison Library). It was designed and executed "by the artists of The Aeronautikon and Lake of Geneva," the machinery was by D. Thomson and music under the direction of Mr. Hilpert. The proprietor of Gordon's British Diorama in Edinburgh (The Mound) was claimed to be operating the Monteith Rooms, so the painter may have been [William] Gordon who is said to have been responsible for one of the Aeronautikons. An advertisement in John Wilcox, *Guide to the Edinburgh and Glasgow Railway* (Edinburgh: John Johnstone, and W. and A. K. Johnston et al., 1842), p. 136, mentions both productions and venues.

67. *The Eidophusikon, or Moving Diorama of Venice*, pp. 15, 17–18. A fold-out key depicts the entire panorama. A view of Lago Maggiore was exhibited as a bonus.

68. William B. Scott in *Notes and Queries*, June 22, 1872; William Shepard Walsh, *A Handy Book of Curious Information: Comprising Strange Happenings in the Life of Men* (Philadelphia: J. B. Lippincott, 1913), p. 565. Walsh argued against Tom Jones's article "Moving Pictures to Cinematographs," *Notes and Queries* (Dec. 24, 1910), which used the expression "De Loutherbourg, the painter, who was also termed the panoramist." Jones's article is full of mistakes. In Mrs. Clement Parsons, *Garrick and his Circle* (New York: G. P. Putnam's Sons and London: Methuen & Co., 1906), Eidophusikon is also called "that interesting panorama" (p. 104).

69. Wellbeloved, *London Lions*, p. 74.

70. *The Spectacular Career of Clarkson Stanfield 1793–1867: Seaman, Scene-Painter Royal Academician* (Sunderland: Tyne and Wear County Council Museums, 1979), pp. 26, 87.

71. "Dioramas, Panoramas, &c.," *The Almanack of the Fine Arts for the Year 1851*, ed. R. W. Buss (London: George Rowney & Co., 1851), p. 163. The article mention a moving panorama of the Isle of Wight and the Needles as his first such work, but I have not been able to trace it.

72. Robin Thurslow Lacy, *A Biographical Dictionary of Scenographers 500 B.C. to 1900 A.D.* (New York: Greenwood Press, 1990), passim.

73. Hermann Hecht, "History of Lighting in the Theatre," *New Magic Lantern Journal* 5, no. 3 (April 1988): 10–12.

74. Wickman, "An Evaluation of the Employment of Panoramic Scenery," pp. 173, 180.

75. David Mayer III, *Harlequin in His Element: The English Pantomime, 1806–1836* (Cambridge, Mass.: Harvard University Press, 1969).

76. Ibid., p. 7, and passim.

77. Mayer says that this term was applied to pantomimes as early as 1824, although it was more commonly associated with J. R. Planché's burlettas in the 1830s. Ibid, p. 73).

78. In *Puss in Boots* ([Covent Garden], 1832), a moving panorama of a sea voyage by Messrs. Grieve used stationary cutout ships as flats on both sides of the stage, while a ground-row depicting the sea (with sailing boats), covered the front. (Rosenfeld, *Georgian Scene Painters*, p. 158).

79. In Grieve's *Moving Panoramick Views From Holyhead to Dublin*, shown as part of *Harlequin & Friar Bacon Or, The Brazen Head* (1821), cutout vessels were drawn across the stage to enhance the illusion of the sea voyage; a figure of a steamboat may even have been blowing smoke. Atmospheric effects were added: "the moon rises, throws its rays upon the water, and with it midnight is gone; the sky brightens, and morning shew the mountains round the bay of Dublin." A review in *European Magazine* 79 (1821): 68, quot. Altick, *The Shows of London*, p. 199. An original playbill for the performance on Jan. 16, 1821 (Covent Garden) is in EH. The pantomime was coupled with Shakespeare's *Twelfth Night*, as well as his "grand masque" *Juno and Ceres*. The cutout elements are not mentioned, but the panorama contains "the effect of a Voyage by *Evening— Night*—and arrival in the *Morning*" [italics in original]. Whether this was achieved by altering the lights or by using transparencies (two years before the Regent's Park Diorama was opened and provided inspiration for such scenes) cannot be determined.

80. Playbill for May 23, 1825 (EH). The pantomime was shown with Shakespeare's *Julius Caesar*.

81. They were participating in the Cumberland Cup, a well known yearly yacht race on the Thames. Since the late 1950s, the Czech Laterna magika theater has combined live actors with projected backgrounds. At the Montreal Expo 1968 their performance contained a scene with a character on roller skates; the filmic background created an illusion of his wild ride through the city streets. *Nearly All About the Magic Lantern: A Collection of Articles*, ed. Jiri Hrbas (Prague: The Czechoslovak Film Institute, 1968); Jarka Burian, *The Scenography of Josef Svoboda* (Middletown, Conn.: Wesleyan University Press, 1971), pp. 83–89.

82. Another scene displayed the tunnel under the Thames, which was expected to set the river on fire. The digging had started in February 1825, so the topic was timely. The tunnel opened in 1843, inspiring foldout accordion peepshows and printed images of all kinds. As an expansion of this topic to the tunnel under the English Channel is the film Georges Méliès made in 1907, *Le tunnel sous La*

132

Manche ou le Cauchemar anglo-français (305 m). *Méliès: Magie et Cinéma*, ed. Jacques Malthête and Laurent Mannoni (Paris: Paris-Musées, 2002), p. 261.

83. The form "Georgey" is used in the playbill instead of "George" (in EH). The pantomime contained elements from George Lillo's well-known play *The London Merchant (Or The History of George Barnwell)* that had been first performed in 1831.

84. Playbill (EH) and *The Songs, Chorusses, Dialogue, &c. in the New Grand Historical, comic Christmas pantomime, called Harlequin And George Barnwell, or the London 'Prentice* (London: W. Kenneth, [1836 or 1837]), p. 14 (HL).

85. It was produced for C. Pelham Thompson's "Melo-Dramatic Entertainment" *The Dumb Savoyard, and his Monkey* (Drury Lane, 1828). Playbill for April 19, 1828, in EH.

86. Playbill in EH. The railway panorama was preceded by "Six Musical Horses!—A Quadrille by the Horses." Moving panoramas about railway travel were rare, but in 1834 a Padorama about the Liverpool-Manchester Railroad was exhibited in London. *Descriptive catalog of the Padorama, of the Manchester and Liverpool Rail-Road, Containing 10,000 square feet of Canvass [sic], now exhibiting at Baker Street, Portman Square* (London: E. Colyer, 1834). (Electronic copy at YBL.) In front of the Padorama there were "miniature mock-ups, also in motion, of various kinds of rolling stock—locomotive engines and wagons filled with goods, cattle, and passengers" (Altick, *Shows of London*, p. 203). It was shown in Brooklyn in 1835 (Odell, *The Annals*, 4, p. 110).

87. Thomas Hood, *The Comic Annual* (London: A. H. Baily and Co., 1839), p. 101.

88. "Pantomimes," *London Magazine*, Feb. 1824, pp. 200–201.

The reviewer commented: "We happen to have been enjoying the rains of Plymouth, and can speak to the correctness and spirit of the views." He also offered a precious peek at the problems of operating mechanical attractions: "The effect of this fine scenic display is somewhat impaired by the poverty of the machinery (ye rude mechanicals!). The fore-ground [sic] first stutters past, a few paces; and then the back-ground [sic], which is water, stammers on after it: this is what we never saw in nature. But perhaps it is a clever attempt to bring on sea-sickness in the spectator."

89. *Harlequin and the Flying Chest; or, Malek and the Princess Schirine: A new grand comic Christmas Pantomime, comprising the Songs, Chorusses, Recitative, and Dialogue. with A Description of the Business of each Scene, as first performed At the Theatre Royal, Drury Lane, Friday, Dec. 26, 1823*, second edition (London: John Miller, 1823), p. 20 (HL). The panorama (scene 12) is described pp. 20–22. It included "a vessel in distress, amidst all the appalling effects of a heavy storm, the sky then clears, the arch of peace, the rainbow, rises over the waves" (p. 22). Work on the Breakwater in the Plymouth Sound had started in 1812.

90. Mayer, *Harlequin in His Element*, pp. 72–73.

91. Shown as part of *Harlequin and Little Thumb* (Drury Lane, Christmas season 1831), and other productions.

92. *Times*, Dec. 27, 1831. Quot. Mayer, *Harlequin in his Element*, p. 136. Wickman, "An Evaluation of the Employment of Panoramic Scenery," p. 192, also assumes that ground rows for waves and mock gondolas in front of the panorama were used.

93. Playbill in EH.

94. This view, by Thomas Grieve, may have been recycled from an earlier production. In a Covent Garden

handbill for Jan. 4, 1826, we find "The Scheldt frozen over, on which is a Fair, with groups of Skaters, Cars, Horses, &c.," also by Grieve, as part of "A Panoramick Aerial Voyage" in the pantomime *Harlequin and the Magick Rose: or, Beauty & the Beast*. Was the scene salvaged from the panorama for later use? The moonlight effect is not mentioned, so Grieve could also have re-painted the view as a "dioramic" version (EH).

95. The views about the Colosseum are interesting, because they provide an instance of *meta-mediatization*, one medium commenting on another. The Colosseum was opened to the public—in unfinished state—in January 1829, so the pantomime offered a sneak preview of one of London's most famous sights. Whether Thomas Grieve based his interpretation—"supposed to be taken from the top of St. Paul's"—on Hornor's sketches, on the painting-in-progress, or only on his imagination is not known, but a promotional agreement may well have existed.

96. The word *naumachia* also referred to the aquadrama, a battle simulated in a pool of water with model ships, but this presentation was most likely a painting.

97. Roberts painted another war panorama, *Roberts' Grand Panorama of Porsibasilartikasparbosporas*. It dealt with the Russian campaign in Turkey in 1828, and premiered on Dec. 26, 1828, as part of *Harlequin and Little Red Riding Hood* (Covent Garden). A separate playbill (EH) was produced for this panorama only, called simply *Roberts' Moving Panorama: In Ten Compartments*. There were ten views. The panorama began with a visit to St. Petersburg and ended in Constantinople. In-between there were scenes related to the Russian campaign, but also "The Desert by Sunset—and Halt of a Caravan (6) and "Splendid Gondola of the Grand Seignor [sic]—and Castle of the Seven

Towers" (9). If there is an overall narrative logic, it is hard to decipher.

98. It was shown as part of *Harlequin and the Astrologer of Stepney, or, The Enchanted Fish and the Fated Ring*. It was preceded by "a variety of experiments with brass balls, &c. by Mr. Nelson Lee," and followed by a scene at "Westminster, from Searle Wharf" with a "Gazette Extraordinaire," and "Clown colored with smoke and glory." Playbill for Feb. 4, 1828, in JJC.

99. A "historical, peristrephic or revolving dioramic panorama" of the war between the Turks and the Greeks, "ending with the ever memorable Battle of Navarino" was shown at the Rotunda at Great Surrey Street, Blackfriars Road in 1828, probably by William Sinclair, who seems to have been leasing the place (soon afterward he introduced the peristrephic panorama to the United States). I will discuss Sinclair's colorful career in a forthcoming article. Pückler-Muskau saw in Dublin Messrs. Marshall's version, which may have been the same one painted by Roberts for Laidlaw. In 1831 Jean-Charles Langlois presented in Paris a circular Navarino panorama using as viewing platform a model based on the deck of the warship Scipion that had taken part in the battle (Oettermann, *The Panorama*, p. 159).

100. This moving panorama has not been discussed in Potter, *Arctic Spectacles*, although it is listed in his chronology of arctic spectacles, p. 213.

101. This can be found out by analyzing three playbills in EH. One (no date) details the thirteen sections of the panorama. Two others feature it as part of the pantomime *Harlequin, and Cock Robin: or, Vulcan & Venus*, Jan. 7, 1830, and Feb. 15, 1830. The playbills don't mention the explorer's name, but the panorama follows "His Majesty's Ships the Hecla and Fury" on their voyage. Fury is lost. These facts correspond with Sir

William Edward Parry's (1790–1855) third voyage in 1824–1825, which he described in his *Journal of a Third Voyage for the Discovery of a Northwest Passage, from the Atlantic to the Pacific, Performed in the Years 1824–25, in His Majesty's Ships Hecla and Fury, Under the orders of Captain William E. Parry* (Philadelphia: H.C. Carey and I. Lee, 1826). The formulation used in one of the playbills, "to discover A North-West Passage From the Atlantic to the Pacific Ocean," may derive from the book's title. In *Panoramania!* Hyde mistakes the topic as "Cpt Ross's recent quest for the North-West Passage" (p. 131).

102. Some details are out of place, like view 10: "Hudson Bay—Esquimaux Indians with their Sledges, &c." The voyage headed to Baffin Bay, which is seen in the next view.

103. Already in 1820 Drury Lane presented a pantomime titled *The North West Passage; Or, Harlequin Esquimaux*. Although it did not contain a moving panorama, the painted scenery anticipated later productions: "The Frozen Sea and Icebergs," "The Northern Phenomenon, Crimson Snow," "The Prince Regent's Straits, with the HECLA at Anchor." (playbill for Dec. 20, 1820 in EH). Compare with Mayer, *Harlequin in his Element*, pp. 303–308. Mayer has reproduced (p. 307) a sketch for a later moving diorama of the polar expedition by J. H. Grieve, painted for Covent Garden's *Old Mother Hubbard and Her Dog* (1835). It was influenced by an expedition by Captain John Ross (of 1831?) that also provided the subject matter for a moving panorama exhibited by J. B. Laidlaw.

104. Benjamin Disraeli, *The Voyage of Captain Popanilla* (1827), in *Popanilla and other Tales* (Freeport, New York: Books for Libraries Press, 1970, orig. ed. 1934), p. 64.

105. Arnott, *Elements of Physics*, vol. 2, part 1, pp. 280–281.

106. P.P.C.R., "Balloon-ways versus Railways," *The Mechanics Magazine, Museum, Register, Journal, and Gazette* 27 (Apr. 8–Sept. 30, 1837), p. 249.

107. Pierre and Degabriel gained attention for their attempted balloon ascent in Strasbourg already in 1784, but they were also traveling with their mechanical spectacle. A descriptive pamphlet of their balloon experiment was published in French and German in 1784. Their work was also discussed by Christian Kramp in his *Geschichte der Aerostatik* in the same year (Strasbourg; Verlag der akademische Buchhandlung, 1784), vol. 2, pp. 230–233. The first volume of Étienne-Gaspard Robertson's *Mémoires récreatifs, scientifiques et anecdotiques d'un physicien-aéronaute* (Paris: chez l'auteur, 1831–1833) centered on *Fantasmagorie*, while the second concentrated on his ballooning experiments. On Robertson, Françoise Levie, *Étienne-Gaspard Robertson. La vie d'un fantasmagore* (Longueil: Éditions du Préambule and Sofidoc, 1990).

108. "Summer Novelties in Balloons," *Punch* 19 (July–Dec. 1850), p. 52.

109. The trajectory was continued by Nadar's aerial photographs of Paris taken from hot-air balloons and Raoul Grimoin-Sanson Cinéorama, a cinematographic balloon panorama show at the 1900 Universal Exposition in Paris. The camera person was a surrogate air traveler transmitting the experience to the audience. About Nadar's ballooning mania, Elizabeth Anne McCauley, *Industrial Madness. Commercial Photography in Paris 1848–1871* (New Haven: Yale University Press, 1994), pp. 144–145.

110. Mrs. Mathews [Anne Jackson], *A Continuation of the Memoirs of Charles Mathews, Comedian*, vol. 1 (Philadelphia: Lea & Blanhard, 1839), p. 111.

111. Ibid., pp. 112–115.

112. *The Theatrical Observer and Daily Bills of the Play*, no. 653 (Monday, Dec. 29, 1823), [p. 2], original italics. When the balloon descends in the gardens of the Tuileries, "the palace is beautifully illuminated." Dioramic effects were probably used, just like in Clarkson Stanfield's "moving diorama" of the Plymouth Breakwater, which was simultaneously on display at Drury Lane. Broadsides for Jan. 7, Jan. 31, and Oct. 11, 1824, in JJCB.

113. Broadside, Jan. 4, 1826, Covent Garden (EH). The pantomime premiered at Christmas 1825.

114. This balloon panorama is mentioned by Rosenfeld, *Georgian Scene Painters* (p. 157), but the date (1833) is wrong, and the name of the pantomime misspelled. Altick also records it (*The Shows of London*, p. 201). Neither mentions the name *Aeronautikon!* The premiere was announced in the *Theatrical Observer and Daily Bills of the Play*, no. 4687 (Dec. 24, 1836). "Aeronautikon" (nearly) rhymes with "Eidophusikon"— is it a coincidence? Grieve had already painted a representation of Green's ascent for *Harlequin Mother Shipton; or Riquet with the Tuft* (Covent Garden 1826–27). Playbill for Monday, Jan. 1, 1827 listed by James Cummins Bookseller, New York, on Abebooks. com (August 2011).

115. Holland's account was published in the *Times* on Nov. 22, 1836. Monck Mason's "The Vauxhall Balloon: Mr. Monck Mason's Account of the Late Continental Trip" appeared in the *Times* on Dec. 23, 1836, on the eve of the premiere. It was developed into *Aeronautica; or, Sketches Illustrative of the Theory and Practice of Aerostation: Comprising an Enlarged Account of the Late Aerial Expedition to Germany* (London: F.C. Westley, 1838).

116. The *Times* joked about the word: "It is likely to loosen the teeth of half the children who try to pronounce it." (*Times*, Dec. 27, 1836).

Covent Garden's *Harlequin and Georgey Barnwell, or, the London 'Prentice* (premiere Dec. 26, 1836) contained "Green's flying omnibus balloon to New York. Passengers in a merry-key. Balloon Race between Mr. & Mrs. Green." (playbill in EH).

117. *Theatrical Observer and Daily Bills of the Play*, no. 4689 (Dec. 27, 1836).

118. The views have been listed in the playbill (EH) and in the key to panorama, of which the only known copy was discovered in 2008 (JJG).

119. Dickens, "Moving (Dioramic) Experiences," p. 306 [original italics]. Dickens wrote 30 years after the fact, and did not mention the *Aeronautikon* by name, but because of this theater effect it is unlikely he would have been describing one of the later roadshow versions of the *Aeronautikon*. According to Rosenfeld, the balloon panorama in *Harlequin and Poor Robin* was also "unrolled behind a static cut-out balloon." (*Georgian Scene Painters*, p. 158). No source of information is given.

120. Dickens, "Moving (Dioramic) Experiences," p. 306.

121. Eyewitness Charles Rice confirmed this in *The London Theater in the Eighteen-Thirties*, ed. Arthur Colby Sprague and Bertram Shuttleworth (London: The Society for Theater Research, 1950), p. 11. The *Aeronautikon* broadside mentions that a letter to the Mayor of Dover was dropped when the balloon was flying over Shakspeare's [sic] Cliff at Dover. One can imagine the actors doing this from the gondola of the balloon, commenting on the scenery, and engaging in all the other actions described by Monck Mason and Holland in their writings. Monck Mason's *Aeronautica* confirms that letters were dropped with small parachutes to the Mayors of Canterbury and Dover (p. 35).

122. Dickens, "Moving (Dioramic) Experiences," p. 306.

123. Monck Mason, *Aeronautica*, p. 77.

124. Friedrich Wilhelm Delkeskamp, *Panorama des Rheins und seiner nächsten Umgebungen von Mainz bis Cöln* (Frankfurt: F. Wilmans, 1825) came with the booklet "The Traveller's Guide down the Rhine from Mayence to Cologne." There were many editions. The point-of-view of these panoramas resembles the "God's Perspective" in videogames like *Sim City* and *The Sims*. The sketch is in the Victoria and Albert Museum, repr. Altick, *The Shows of London*, p. 201.

125. The first English version was published c. 1829 (Hyde, personal communication), but there was also *Panorama of the Rhine and the Adjacent Country, from Cologne to Mayence* (London: Leigh and Son, 1835), which followed the same route as the *Aeronautikon*. Commenting on his first balloon trip in 1847, Albert Smith stated that the "bird's-eye panorama" from a balloon "has simply a map-like appearance—very like what the view would be coloured, which was the frontispiece to Tombleson's Rhine" (in Hatton Turnor, *Astra Castra. Experiments and Adventures in the Atmosphere* (London: Chapman and Hall, 1865), p. 212. Smith was referring to a similar map in William Tombleson's *Upper Rhine* (London: Black & Armstrong, c. 1832), which was reprinted numerous times.

126. Rice, *The London Theater in the Eighteen-Thirties*, p. 23. Rice saw this happen on Feb. 18, 1837. He had already seen the performance on Dec. 27, 1836, describing the Aeronautikon as "a bird's eye view of the places over which Mr Green and his companions passed in their late aerial flight" (p. 11). Rice's full manuscript is in HTC.

127. The machinery must have resembled the systems of pulleys and cranks used to lower and raise curtains and act-drops.

128.　Panoramic views were also published in illustrated magazines like *Illustrated London News*. Several strips were printed one above the other to be cut out and pasted together into a roll.

129.　Such "editing by light and dark" seems to have been codified by 1836. Its ingredients were already present in the *Harlequin and Poor Robin* (1823). Rosenfeld, *Georgian Scene Painters*, p. 157.

130.　During the flight of the Nassau balloon, the moon did not appear, as Monck Mason indicated in *Aeronautica*. The Rhine was crossed early in the morning before sunrise.

131.　Whether any of these was Grieve's original is unclear. Broadside for "Mr. Green's Night Balloon Ascent," Vauxhall Gardens (Sept. 2–6, hand-dated: 1839) mentions "the Moving Panorama of the Rhine" as one of the attractions. Could this have been the second reel of Grieve's original *Aeronautikon*? (EH).

132.　*Scotsman*, Aug. 18, 1841. The "Daguernama [sic] or Dioramic Views of the Shrine of the Holy Nativity . . ." was also displayed. The exhibition opened on Aug. 18, 1841. www.edinphoto.org.uk/1_edin/1_edinburgh_in_1842_dioramas.htm. An ad in the *Caledonian Mercury*, Jan. 31, 1842, listed the views: "London as seen from the Dome of St Paul's, Greenwich, Dover, Calais, Cologne, Coblentz, Bacharach, Johannesburg and the Descent of the Balloon in the Valley of Elbene." Marshall also used the title *The Aeronautikon: or a Flight in the Great Balloon from London to Germany* (Exchange Rooms, Manchester, Dec. 23 [1841 added by hand], broadside, Science Museum, London). The panorama was painted by George Danson from drawings by David Roberts and Clarkson Stanfield. Perhaps the same panorama was shown at Victoria Rooms, Hull, in Sept. 1845 under the superintendence of W. Laidlaw (was he a relative of J. B.

Laidlaw? Photocopies in RH).

133.　Ad in Wilcox, *Guide to the Edinburgh and Glasgow Railway*, p. 136.

134.　Wilcox, "The Panorama and Related Exhibitions in London," p. 230—source: *The Scotsman*, Dec. 18, 1841. The description makes the panorama sound like a close approximation of the original.

135.　" The Editor's Table," *Knickerbocker* (New York: John Allen), vol. 29 (March 1847), p. 284. The editor had seen "the moving panorama as it spread out before the eye of GREEN, the distinguished aeronaut, and his companions, on their air-voyage from 'Vox-al-Ge-yard'n' as the exhibitor terms it, to Mayence in Germany." (p. 284).

136.　Monck Mason, *Aeronautica*, p. 220. For camera obscura, pp. 220–221; for the magic lantern, p. 44. The latter is used to illuminate a situation when the clouds open, revealing a glimpse of the sea underneath: "Across the field of view which thus became exposed, a solitary ship might now and then be seen to pass, entering at one side like the spectral representation in some magic lantern, and having sped its course, silently disappearing on the other."

137.　Henry Mayhew, "In the Clouds," *The Albion, A Journal of News, Politics, and Literature* 11, no. 41 (Oct. 9, 1852): p. 489. The balloon's apparent lack of motion that produced the impression of a moving panorama underneath was also emphasized by James Glaisher, "Mr. Glaisher's Twelfth Balloon Ascent" (1863), in Turnor, *Astra Castra*, p. 245. A balloon trip evokes the panorama also in "Three Trips in the Air," *Chambers's Edinburgh Journal*, New Series, 15, nos. 366–391 (Jan.–June 1851), p. 302.

138.　[P.T.W.], "Recent Balloon Ascent," letter to the editor by P. T. W., *Mirror of Literature, Amusement, and*

Instruction 13, no. 376 (June 20, 1829). The ascent took place on June 10, 1829,from the Jamaica Tea-gardens, Rotherhithe, near London.

139.　The Colosseum had the highest viewing platform of all panoramas, but visitors could also climb to the top of the dome, and compare the panorama of London with the landscape outside. Klein has characterized panoramas as "scripted, phantasmatic skyscrapers" using Colosseum as an example, but without mentioning the elevator (*From the Vatican to Vegas*, p. 181).

140.　Jefferys Taylor, *A Month in London; or, Some of its Modern Wonders Described* (London: Harvey and Darton, 1832), pp. 79–80. The author's emphasis.

141.　A letter, *Times* (Nov. 22, 1836). Whether true or not, the report is interesting, because the tone differs from the matter-of-fact style of news reports of sightings of balloons flying high overhead.

142.　*Extraordinary Novelty!, Aeronautikon: Or, a Flight in the Great Balloon from London to Germany*, broadside, Exchange Rooms, Manchester, c. 1840–1841, photocopy in RH).

143.　Mayer, *Harlequin in His Element*, p. 300.

144.　James Ballantine, *The Life of David Roberts, R.A.* (Edinburgh: Charles and Adam Black, 1866), p. 25. Roberts painted a Navarino panorama for Laidlaw in 1828. It was shown in Amsterdam. A Dutch handbook was included in a list of publications from 1829 as *Beschrijving van het beweegbaar Panorama van den zeeslag van Navarino; alsmede van dat der stad Konstantinopel* (Amsterdam: J. B. Laidlaw), mentioned in: *Naamlijst, van uitgekomen boeken, kaarten, prentwerken, enz. 1829–1833*, Negende deel (Amsterdam: C. L. Schleijer, n.d.), p. 80. Laidlaw is listed as "eigenaar

[owner] van het Panorama van Algiers."
(Laidlaw's Algiers panorama was com-
missioned from Roberts and Stanfield).
The views of Constantinople, as well
as Laidlaw's and Marshall's earlier
relationship, may indicate that the
same panorama was exhibited by
Messrs. Marshall.

145. Poecilorama consisted of
illuminated paintings, some with
dioramic transformations. The exhib-
ition was on a relatively small scale,
and was said to combine "the leading
mechanical principles of the Diorama
with the magnifying power of the
Cosmorama." The paintings were
viewed through lenses; no panorama
roll was used. *La Belle assemblée,
or Court and Fashionable Magazine*
(London and Edinburgh: Geo. B. Whit-
taker and Oliver and Boyd), vol. 3
(Jan.–June, 1826), pp. 136–137.
Stanfield sold the Poecilorama to
the painter William Armfield Hobday
(1771–1831), whose efforts to exhibit
it failed, after which he sold it to Mr.
Fitzpatrick, the treasurer of Astley's
Theatre. "Memoirs of William Armfield
Hobday, Esq.," *Arnold's Magazine of the
Fine Arts* (London: M. Arnold), vol. 2
(1831), p. 388.

146. *Songs, choruses and dialog,
in the grand, romantic, legendary,
burlesque and comic Christmas panto-
mime, entitled the Castle of Otranto,
or, Harlequin and the Giant Helmet.
Performed for the first time at the Theater
Royal, Covent Garden, on Saturday,
December 26th, 1840* (London: S. G.
Fairbrother, [1840], p. 14. The
panorama's newsreel-like views
have been listed on pp. 14–16 (HL).
Another newsreel-like war panorama
was Charles Marshall's "diorama"
of the First Anglo-Afghan war for
Drury Lane's *Harlequin Jack Sheppard,
or, The Blossom of Tyburn Tress!* in
1839. *Harlequin Jack Sheppard, or,
The Blossom of Tyburn Tress!* A Comic
Pantomime, Produced at the Theatre
Royal, Drury Lane, December 26th,
1839, under the sole direction of W. J.
Hammond (London: John Duncombe

and Co., no date), p. 21 (scene 12) (HL).

147. Wickman, "An Evaluation
of the Employment of Panoramic
Scenery," p. 164. The following
discussion is indebted to Wickman's
pioneering work.

148. Ibid., p. 164. There is some
vagueness in Wickman's categories.
Some of these had their origins in
pantomimes, but developed further
in other contexts. On p. 164 Wickman
lists pantomime panoramas as
a (fifth) category of its own, although
it overlaps with some of the others.
He also mentions "scenic-transition
panoramas," (p. 164) but later
analyzes at length "scenic trans-
formation panoramas" (pp. 202–),
which is more inclusive and *includes*
scenic-transition panoramas. My four
categories are a corrected list.

149. The sketches, mounted on
interconnected wooden panels,
together with a broadside for the
performance on May 16, 1855, have
been preserved at VATL. True to his
concern for historical accuracy, Kean
announced (in the BS), "I have taken
advantage of the historical fact of
the Lord Mayor and City Council
proceeding to the Royal Ceremonial in
their State Barges, to give a Panoramic
View of London, as it then appeared,
concluding with the Old Palace of
Greenwich, where Anne Boleyn resided
at the time."

150. Wickman, "An Evaluation
of the Employment of Panoramic
Scenery," p. 211.

151. *The Spectacular Career of
Clarkson Stanfield*, p. 26. This was
Stanfield's final product for the stage.
The trick was used during transitional
prologues, turning them from textual
to audiovisual. The moving panorama
may have been installed exceptionally
at the front of the stage, immediately
behind the drop curtain. Wickman,
"An Evaluation of the Employment of
Panoramic Scenery," p. 210.

152. Wickman, "An Evaluation
of the Employment of Panoramic
Scenery," pp. 283–288. Sketches from
VATC (pp. 285–287).

153. Later in the century vertical
mechanical "up and down Jesus"
lantern slides became common in
magic lantern shows. Jesus is made
to rise to heaven by means of a hand-
crank (EH).

154. Wickman, "An Evaluation
of the Employment of Panoramic
Scenery," p. 230–35 mentions ex-
amples of productions of *The Tempest*
where they were used.

155. Broadside for Oct. 10, 1853
(JJCB). Childe is listed as "the
Scientific Inventor" responsible for
"The Dioramic Effects," which must
mean here magic lantern projections,
Childe's specialty.

156. Playbill for Oct. 18, 1861 (EH).
The moving panorama, depicting a
view "as seen from the Deck of the
Steam Packet," had been painted by
John Wiser.

157. Georges Moynet, *La machinerie
théatrale: Drucks et décors* (Paris:
La Librairie illustrée, n.d., c. 1893),
pp. 81–90. The theater's name is not
mentioned. In a shipwreck scene in
Le Corsaire (Her Majesty's Theatre,
London, July 1856), the stage was
wrapped from all three sides by
a continuous curving painted scene.
Its novelty was acknowledged by the
Illustrated London News: "The complete
withdrawal of what are technically
called the wings, and the substitution
of a broad expanse of panoramic
atmosphere, extending over the whole
area of the stage, is a new, bold,
and successful idea." *ILN*, 29 (July
19, 1856): 67, quot. Wickman, "An
Evaluation of the Employment of
Panoramic Scenery," pp. 325–326.

158. Mazeppa was based on an
eponymous narrative poem by Lord
Byron, published in 1819.

159. According to Wickman ("An Evaluation of the Employment of Panoramic Scenery," pp. 259–264), the first such spectacular horse race scene was in *The County Fair* at Proctor's Theater, New York, March 1889. Another early example was in *Paris Port de Mer* (1891, Paris, Théâtre des Variétés). Some theaters experimented with revolving stages as an alternative to treadmills, but these were difficult to handle.

160. The technology was explained in *Scientific American* 83, no. 8 (August 25, 1900): 119; Gwendolyn Waltz, "Filmed Scenery on the Live Stage," *Theater Journal* 58, no. 4 (December 2006): 556–558; A. Nicholas Vardac, *Stage to Screen: Theatrical Origins of Early Film: David Garrick to D. W. Griffith* (New York: Da Capo Press, 1987 [1949]), pp. 79–80. The film industry often placed actors in a mock-up car and filmed them against a mobile rear projection.

161. Wide vistas and distant views had been used on stage already in the early nineteenth century, but they had been static. These included motion effects, created by changing backlighting and other means. Rosenfeld, *Georgian Scene Painters*, pp. 155–161.

5. TRANSFORMED BY THE LIGHT:
THE DIORAMA AND THE "DIORAMAS"

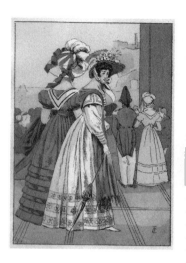

THE INVENTION AND DISSEMINATION OF A NEW SPECTACLE

The Diorama is one of the "known unknowns" of media history. The history of the moving panorama is so closely connected with its vicissitudes that a closer look is needed. The basic ideas and apparatuses of these two spectacles were fundamentally different, but hybrid forms developed, as evinced by the common word-combination *moving diorama*. Although the original Diorama was a permanent large-scale urban attraction, stripped-down and shrunken "road show" versions were exhibited in contexts that were not very different from those where moving panoramas were shown.[1] The identity of such shows is often difficult to pinpoint because of their whimsical nature, as well as the fragmentary nature of documentation.

The Diorama was invented by the French painters Charles-Marie Bouton (1781–1853) and Louis-Jacques-Mandé Daguerre (1781–1851). Like Barker's Panorama, it was a building-vision-machine, and just like *panorama*, its name was a neologism, a combination of the Greek roots *dia* (through) and *horama* (view).[2] The referent was transparency painting, but the word drifted away from its original meaning. *The Leisure Hour* had a good reason to state (in 1886): "Like panorama, diorama is a word now somewhat loosely applied."[3] By the end of the century the word had been applied to exhibits, where taxidermic animals or wax figures were combined with "naturalistic" props and painted backdrops.[4]

Figure 5.1
Fashion plate depicting ladies at the Paris Diorama, producer unknown, c. 1820s. The background scene has been adapted from Jean-Henri Marlet's lithograph "Le Dyorama [sic] port de Boulogne," from his series Tableaux de Paris (1821-1824). Author's collection.

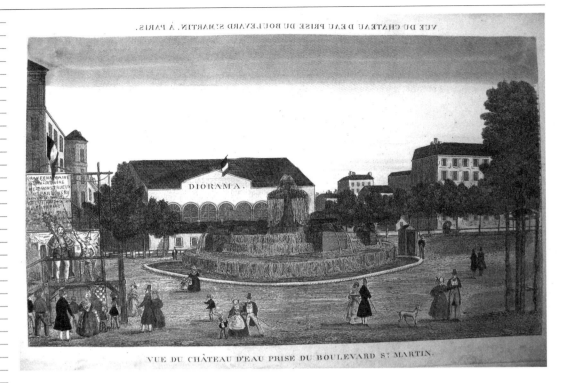

VUE DU CHÂTEAU D'EAU PRISE DU BOULEVARD S? MARTIN.

But its connotations became even more complicated—today it often signifies col-lectable miniature models, which is a far cry from the original huge spectacle.[5]

When the original Diorama is mentioned, it is usually associated with Da-guerre's name only because of the *daguerréotype*, the early photographic process he was involved in developing.[6] It was Joseph Nicéphore Niépce's (1765–1833) invention, which Daguerre improved, made public, and named after himself after Niépce's death. By "donating" photography to the humankind—against a large pension from the French government—Daguerre gained both a comfortable life and a mythological afterlife. As part of the agreement, he wrote a frequently reprinted manual, where he revealed the secrets of the daguerreotype and the Diorama.[7] Bouton's contribution was equally important, but his name has fallen into oblivion.

Bouton (and possibly Daguerre as well) gained experience by assisting Pierre Prévost (1766–1823), the foremost French panorama painter.[8] Bouton became recognized as an outstanding painter of landscapes and interior views, while Daguerre worked as a set designer at the Théâtre Ambigu-Comique and

Figure 5.2
"Vue du Chateau d'Eau prise du Boulevard St. Martin."
Vue d'optique engraving, France, 1820–30s. The view shows Bouton and Daguerre's Diorama building, as well as showmen entertaining passers-by on the boulevard. Notice the mirror writing at the top, reversed when observed through the lens of a peepshow box. Author's collection.

the Paris Opéra, gaining opportunities to experiment with visual illusions on a grand scale. As Daguerre wrote in an article in which he announced the Diorama as a coming attraction, the mighty profile of the panorama loomed in the background; it was impressive but immobile. He presented the Diorama as an improvement that provided a "complete means of illusion, animating the tableaux by various movements found in nature."[9] Bouton and Daguerre's spectacle was a mammoth synthesis of the panorama, illusionistic painting, and stage design— a theater without actors and stories, "partly optical, partly mechanical."[10]

The Paris Diorama opened its doors on July 11, 1822, at 4 Rue Sanson (corner of Place du Château-d'Eau, near today's Place de la Republique), and operated until it burned down in 1839, the same year the invention of the Daguerreotype was announced; after that Daguerre retired.[11] A second Diorama was opened in London's fashionable Regent's Park in 1923 under the management of Daguerre's brother-in-law, the architect, art dealer, and painter Charles Arrowsmith.[12] As I have discovered, it went bankrupt after a few years of operation.[13] Bouton, who seems to have run into problems with Daguerre, grasped the opportunity and moved to London in 1830 to reinvigorate it. He successfully ran the Regent's Park Diorama for a decade, but decided to return to Paris in 1840 after the destruction of the Diorama.

With Daguerre out of the spotlight, Bouton opened a new Diorama along the Boulevard Bonne-Nouvelle (1843), and after it also burned down, yet another one on the Champs-Elysées.[14] In London, Charles Caius Rénoux (1795–1846), and after his death Joseph Diosse, kept the Diorama running.[15] But the mid-century panoramania was gathering speed, and the Londoners were also anticipating the Crystal Palace Exhibition. It opened its doors on the first of May, 1851, a few days after the Diorama closed its own. As a little known epilogue, two dioramas Bouton had painted in Paris—*St. Mark's, Venice by Day and Night* (1845) and *The Town & Valley of Fribourg, in Switzerland* (1843)—were displayed at a newly opened showplace called Hungerford Hall (The Strand) in 1851, perhaps with equipment salvaged from the defunct Regent's Park Diorama.[16]

Speculators opened dioramas in cities like Liverpool, Manchester, Bristol, Dublin, Edinburgh, Berlin, Breslau [Wroclaw], Cologne, Vienna, Stockholm, Madrid, and even Havana.[17] Their apparatuses and offerings were anything but uniform, and most were short-lived. The list may seem impressive, but is really quite short. A contemporary gave an explanation: "The vast expense and inconvenience of erecting buildings of such immense size for this exhibition, must preclude its extension beyond a very few places in England."[18] Renewing the program was another concern. A German suggested a network to "make possible a frequent exchange of the exhibited pictures, thereby guaranteeing a perpetual fascination with the new."[19]

Although no such network was established, canvases were transported from place to place. Daguerre's and Bouton's dioramas were sent to dioramas elsewhere in England and Scotland.[20] Diosse's painting of St. Mark's Basilica

Figure 5.3
Broadside for a diorama by August(in) Siegert (1786–1869).
Vienna, 1820s. Siegert received his artistic education in
Paris and worked as a painting professor at the university of
Breslau [today's Wroclaw]. Siegert's four diorama pictures
depicted views from southern Italy, and were exhibited in
three spacious rooms decorated in the manner of tents.
They were viewed from balcony-like open galleries without
lenses. The broadside claims that the building had been
erected for this purpose in the beginning of Florianigasse,
near the glacis of the city wall. Author's collection.

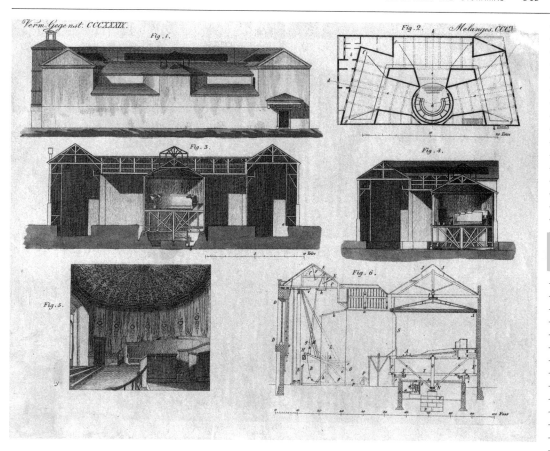

in Venice, first shown at Regent's Park in 1847–48, made its way to the Meister brothers' *Grosses Diorama* in Cologne, while Nikolas Meister's *Die Königliche Burg Stolzenfels* became the final program of the Regent's Park Diorama, paired with Diosse's *Mount Etna*.[21] Diorama canvases were acquired and commissioned by speculators, who brought them to the United States. Their presentations may have been a far cry from the sophisticated illusions conjured up by Bouton and Daguerre, but at least they disseminated the idea far and wide.

Figure 5.4
Series of diagrams of Bouton's and Daguerre's Diorama
(1822), from *Bertuch's Bilderbuch für Kinder*, vol. 12, no. 23
(Weimar: Verlag des Landes Industrie Comptoirs, 1823).
Author's collection.

THE DIORAMA AS A VISION MACHINE

The main features that distinguished the Diorama from competing spectacles were its exhibition apparatus and painting technique. The basic structures and dimensions of the Dioramas in Paris and London were more or less identical, which is logical, because similar paintings were exhibited in both.[22] The audience was placed in a rotating amphitheater.[23] In Paris, there were nine boxes at the rear for forty people, while the main part of the salon accommodated 310 spectators; there were only a few benches at the front, so most of them had to stand. The Regent's Park auditorium housed only 200 visitors because of its more comfortable seating.[24] Both were decorated with medallions of famous artists, as well as with translucent ceiling arabesques. Ticket prices were high, indicating that the Diorama was a refined amusement, not a penny show for the common people.[25]

Media theorists have been excited about the rotating auditorium, because it can be read as a token of later trends in media culture. It seems to have anticipated modalities of mobile spectatorship, ranging from theme park attractions to everyday experiences, and revolving architecture.[26] However, most theorists have based their judgments on the apparatus only, paying scant attention to its historical context. Before making sweeping generalizations across time and space, one should explore how the contemporaries conceived the function and meaning of this artifact, and also to keep in mind that the rotating auditorium itself never became a mainstream contraption; it has been used only occasionally since then.[27]

Pierre Châtelain, the architect of the Paris Diorama, and the designer of its rotating auditorium, faced a challenge that was above all practical.[28] It was decided early on that the show would consist of two giant pictures undergoing transformations, and that the audience would not walk "from room to room" to view them. Therefore it became "necessary that the seats and all the spectators, with the interior of the amphitheatre itself, should be moved round slowly and imperceptibly."[29] Turning the audience from picture to picture was easier than manipulating two giant pictures on a single "stage" one after another. The spectators were not allowed to enter or leave during the presentation, because the auditorium was dark: the dioramic effect required a strong contrast with the illuminated picture.

The British Diorama, a competitor at the Royal (later Queen's) Bazaar at 73 Oxford Street between 1828 and 1836, boasted that its pictures were shown "without the disagreeable sensation of a turning Saloon."[30] Yet the reason may again have been practical: the rotating auditorium was protected by a patent, and the indoor space within the bazaar was limited. Artificial lights were used for the same reason, although it was also touted as an improvement: "Fine Weather or Sun Shine is not at all necessary to shew the various Brilliant effects which these Pictures produce."[31] The four paintings that made up the program were easier to handle, because they were smaller and mounted on rollers. They

were revealed one by one by from behind an unusual shutter-like curtain that consisted of four movable wooden boards.[32]

Bouton's and Daguerre's gigantic (c. 22x14 meters) paintings were viewed through dark "tunnels" that matched the opening at the front of the turning platform. Recalling Servandoni's spectacles, their far ends masked the edges of the paintings, making them seem to extend infinitely beyond the frame. This negated the panorama's all-embracing principle; each painting presented only a preselected section of the horizon seen as if through "an open door or window."[33] The solution was more limited than the panorama's 360-degree view; the wraparound environment was traded for controlled illusions in motion. Some commentators compared it with the peepshow. The *Penny Magazine* stated that "were it not that the Diorama can be seen by many persons at the time, and with much ease to the spectators, the principle involved does not offer much advantage over the Cosmorama" (a permanent peepshow salon, with peeping lenses embedded side by side in its walls).[34]

No effort was made to connect the two pictures thematically or spatially. A commentator correctly noted that "you could not, by any possible sketch of fancy, or abstraction of mind, imagine yourself transported from the one to the other."[35] One painting normally depicted an exterior and the other an interior. The best remembered subjects are Swiss mountain valleys and interiors of cathedrals and chapels, but in reality there was more variety: city views, harbor scenes, the biblical deluge, the Shrine of the Nativity in Bethlehem, Napoleon's tomb, and even topical subjects such as the Edinburgh fire of 1824, and the battle for the Hotel de Ville in Paris during the revolution of 1830.[36]

Although most of the paintings depicted existing locations, geographical verisimilitude was not the main concern. Making the scenes uncannily "alive" and achieving a sense of "being there" were more important. For this purpose, fine linen was chosen, and painted with partly opaque, partly translucent colors. The painting was illuminated by natural light from above and behind by opening and closing hidden panels, and transformed by a complex system of color

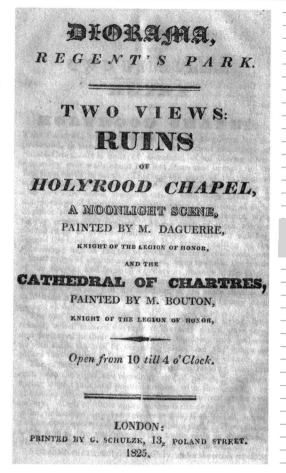

Figure 5.5
The cover of Regent's Park Diorama's program leaflet, printed by G. Schulze, London, 1825. The view of the Holyrood Chapel, attributed here to Daguerre, may have been painted by Hippolyte Sébron. Author's collection.

screens, shutters, pulleys, and counterweights. Such tricks had their origins in the scenic effects used at theaters. They made astonishing transformations possible—the sun rose or set; the fog dissipated; shadows moved across the landscape in front of the spectators' incredulous eyes.

The effects were not always equally elaborate. A reviewer pointed out that in Bouton's early *Chapel of Trinity in the Cathedral of Canterbury* the light effect was "permanent," while in Daguerre's view of the Valley of Sarnen it was "variable."[37] When Prince Pückler-Muskau visited the Paris Diorama (on Jan. 16, 1829) he found (Daguerre's or Hippolyte Sébron's) view of St. Gotthard "well painted and very like," but was disappointed, because "there is no change of light and shadow, as in the far superior Diorama in London."[38] Routine may have taken the place of innovation. Financial difficulties caused by the political turmoil of 1830 and its aftermath, the fading of the novelty, and the repetitiveness of the landscape-plus-interior formula made refreshing the spectacle a pressing issue.[39]

Formal tricks, such as a virtual door that seems to open and close, were not enough to turn the tide. A commentator regretted that "such representations as these should be had recourse to," pointing out that the "optical deception" of the door "reveals nothing to [the spectator's] sight."[40] Such gimmicks "should have been employed to far more purpose than it has ever yet been in these exhibitions," he added. Daguerre's "View of Mont Blanc taken from the Valley of Chamonix" (1831) was enlivened by props said to be brought from Switzerland.[41] The painting was observed through an open furnished chalet, and the space in-between was filled with props like trees and stones, and perhaps even a live goat.[42] Such tricks gave a material form to the three-dimensionality the Diorama had alluded to by painterly means. The critics were not impressed, and nothing like it was ever tried again.

More successful was an innovation Daguerre considered the fulfillment of dioramic painting: the double-effect diorama.[43] It helped the Diorama to emerge from its state of bankruptcy.[44] The technique was introduced to the public with *Le Bassin central du commerce a Gand* (exhibited 1834–1836), and used in the celebrated canvases *Une messe de minuit à Saint-Etienne-du-Mont* (Midnight Mass at Saint Etienne-du-Mont, 1834–1837) and *Éboulement de la vallée de Goldau, en Suisse* (Landslide in the Valley of Goldau, Switzerland, 1834–1839). The canvas was painted from both sides with partly different elements, and illuminated both by natural light and by hidden lamps. The result was a dramatic "decomposition of forms"—hidden elements appeared, much longer atmospheric transformations took place, etc.[45]

One should be careful not to exaggerate Daguerre's role. Bouton may have been victimized by Daguerre's flair for self-promotion. In a notice read for the Institut de France about the life of Baron Isidore-Justin-Séverin Taylor, who had helped to finance the Diorama, Henri Delaborde stated outright that the original idea came from Bouton, who suggested for Taylor and Daguerre to develop it together.[46] An article published in London in 1836 claimed that Bouton was not only the inventor, but also the true master of diorama painting. The comment

may be biased, reflecting the adoption of "Chevalier" Bouton by the London society, but it is worth taking into account, because it differs so radically from the version in the history books:

> Since his departure from Paris, the Diorama in that city has lost its chief attraction, as M. Daguerre, who now paints the pictures there, and who learnt his art from M. Bouton, is unable to produce those very extraordinary effects which for the last two seasons have delighted the public of this metropolis.[47]

Although both Bouton and Daguerre submitted oil paintings to the yearly salons, Bouton's profile was more academic than Daguerre's, who, as Pinson says, struggled for appreciation as a painter; although well-known as a cultural figure, he was considered more an artist-inventor.[48] Last but not least, Bouton's dioramic canvases may have been appreciated in London not only because they were fine paintings, but also because they were less gimmicky and showy.

The fate of Hippolyte Sébron (1801–1879), Daguerre's "right hand," was even more cruel.[49] He was a faithful shadow figure toiling behind Daguerre's towering public persona. As Baron Alfred Auguste Ernouf stated in his early history of photography, producing the canvases became Sébron's responsibility when Daguerre immersed himself in his photographic experiments.[50] The full extent and nature of Sébron's contribution has remained obscure, but an extraordinary handwritten document, discovered by François Binetruy, sheds completely new light on it. In the note, which he wrote in 1856 or soon afterwards, Sébron describes his career, including his paintings.[51] The broad claims he makes must be taken with caution, but his non-accusatory, humble, and slightly resigned tone, as well as the quality of the information, speak for the general reliability of his words.

Sébron's note contains a detailed record of his contributions to the Diorama.[52] He first informs the reader that he began his career (like Daguerre), at the Théatre Ambigu-Comique and the Paris Opéra, from which he was recruited to the Diorama. He was paid well, but required to work under the principle of *sic vos non vobis* (Thus do ye, but not for yourself). After Bouton's departure, Daguerre proposed a deal that entitled Sébron to be credited as a collaborator, without making him a full partner.[53] Daguerre may have been afraid of losing Sébron, whose skills had been noticed: he painted five dioramas in London for "a British speculator," who exported them to the United States and "made a small fortune." In spite of lucrative prospects, Sébron chose "the shadow of glory in Paris to the fortune abroad."

The least surprising revelation concerns the double-effect diorama, which Sébron claims to have perfected himself, painting the famous Diorama canvases, *Le Bassin central du commerce a Gand*, *Une messe de minuit à Saint-Etienne-du-Mont*, and *Éboulement de la vallée de Goldau, en Suisse* (the last two, "entirely by myself"). This was confirmed already in 1840, when a journal characterized Sébron as the "gentleman whose able brush painted all M. Daguerre's later dioramas."[54] With

a slightly bitter tone, Sébron mentions the government pension granted for Daguerre for the double-effect dioramas, "on which I alone worked, which I perfected, and the secret of which I only knew."

The most striking revelations concern the 1820s, his invisible period at rue Sanson. Sébron lists nearly all the famous dioramas routinely attributed to Daguerre, both then and now, as his own creations. Among others, his list includes the celebrated interiors of the Roslyn monastery and the Holyrood Chapel. Of the thirty paintings exhibited at the Paris Diorama (including those by Bouton, on which he worked as a collaborator), Sébron claims to have painted alone no less than fourteen. If true, this would make him a far more productive diorama painter than Daguerre. Fortunately, his claims got public support from *Blackwood's Edinburgh Magazine* in 1841:

> Sebron is a most excellent artist, whether for interior or exteriors; but he chiefly devotes himself to the former. He commenced his artistical career by painting the dioramas, which all the world has been taught to ascribe exclusively to Daguern and Bontas [sic], his employers, and the accurate drawing he displayed in them is well known all over Europe.[55]

Was Sébron just a workhorse, a brilliant but servile craftsman executing his master's designs? The fact that at least two of the five dioramas he was commissioned to paint in London—*Belshazzar's Feast* and *The Departure of the Israelites out of Egypt*—were "only" magnified conversions of John Martin's and David Roberts's oil paintings, might make one think so.[56] Sébron was frank about the nature of his contributions. In his list he carefully noted when a diorama he had painted (such as *Déluge*) was based on Daguerre's composition, or on sketches taken in Bretagne and Switzerland (probably by the well-traveled Sébron himself; for example *Vue de Saint-Gothard*). Later in life, when Sébron worked for several years in the United States, he provided ample evidence of his own artistic vision.

"THIS WONDROUS EXHIBITION," OR THE DIORAMA'S RECEPTION

Both in Paris and London the Diorama led to a burst of discursive activity—one too rich to be fully explored here. The word appeared frequently in magazine articles, book titles, plays, and popular songs, including one penned by the grocer and minor poet Thomas Hudson:

> I went to th' Regency Park,
> And seed Diorama by sun-shine;
> Inside 'twur all in the dark,
> Excepting the gleams of the moon-shine.[57]

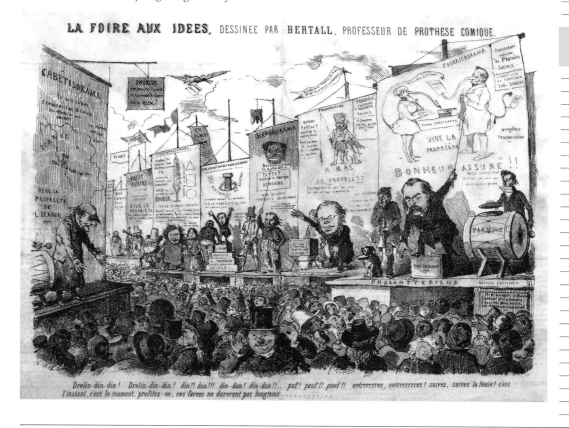

Figure 5.6
Bertall [Albert Arnould], "La foire aux idées" (The Fair of
Ideas), political cartoon from *Journal pour rire*, no. 37
(Oct. 1848). Utopian and socialist thinkers are shown as
showmen marketing their own "oramas." The cartoon was
published in the thick of the revolutionary "Crazy Year"
of 1848. Author's collection.

In Paris, the vaudeville play *Le Zodiaque de Paris* personified the Gemini, or the twins Castor and Pollux, as the painters Panorama and Diorama; the former praised profusely his *nouveau venu* brother.[58] In Charles Nodier's *Histoire du Roi de Bohème* (1830), a delightful dialogue between anthropomorphic representations of Reason and Imagination, a list of "ramas" was self-evidently included in the latter's verbal-philological demonstration of "erudition."[59] The peculiar habits of the inhabitants of both cities were scrutinized in books bearing the fashionable word diorama in their label.[60]

"Rama talk" resounded in the streets as well, as the ever-observant Prince Pückler-Muskau found out on his trip to Paris in 1829. He noted that the Parisians' fascination with words ending in "ana" had recently shifted to "amas," *et le change est pour le mieux*.[61] Honoré de Balzac kept commenting on the quickly changing discursive fashions among "certain classes of Parisians" in *Le Père Goriot* (1835), where he parodied the linguistic patter inspired by "the recent invention of the Diorama, which had carried optical illusion one stage further than the Panorama."[62] A young artist's slang "infects" the inhabitants of a boarding house, who begin using expressions like "healthorama," "chillyorama / chillyrama," "souporama," "cornorama," and—last but not least—"Goriorama."[63]

Like panoramas, the Diorama became a standard for assessing reality. When the organist Vincent Novello and his writer wife Mary traveled from Munich to Salzburg to meet Wolfgang Amadeus Mozart's widow, they noted in their diary that "the Houses gradually change their form and approach more to the Swiss Character, such as those which are represented in the view of the village of Sarnen at the Diorama."[64] The well-traveled Lady Morgan also testified that the Diorama produced "an illusion so perfect, that the mind, when left to itself, is never for a moment awakened to the belief that this wondrous exhibition is not the thing it represents."[65] However, as a magazine writer pointed out, the *locus* was really inseparable from artifice:

> *In fact, the illusion is absolutely perfect in its kind; that is to say, it produces all the effect both of reality and of illusion at the same time; it conveys to the spectator all the pleasure to be derived from seeing the actual object which it represents, added to that which results from the feeling that you are only looking at an artful imitation of it.*[66]

Often the wonderment about the illusion took precedence over the depicted site. Pückler-Muskau felt that it was "impossible to deceive the senses more effectually," while Herzog Bernhard zu Sachsen-Weimar-Eisenach praised the rain effect by saying that the "illusion is so perfect that one believes to hear the rain falling."[67]

Nathaniel S. Wheaton, the rector of Christ Church, Hartford, Connecticut, found it nearly impossible to believe that the scene in front of him "was a painting on a plain surface."[68] Indeed, others suggested that the exhibit was an architectural model rather than a flat canvas. Thomas Shepherd's explanation, which harked back to theatrical scenography, and perhaps also to the Eidophusikon,

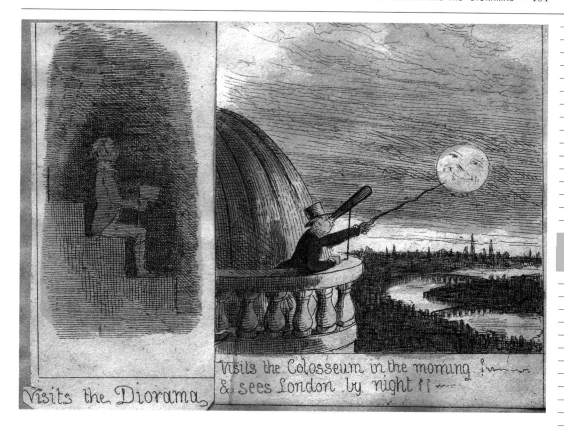

may have misled others: "The body of the picture is painted, on what scene-painters technically term a flat, and this main or perpendicular subject is sided by wings or side scenes, or painting on the floor, by raised bodies and by other optical and pictorial effects, till the delusion is perfect and almost incredible."[69] A lady was said to have been "so fully convinced that the church represented was real, that she asked to be conducted down the steps to walk in the building."[70] Whether by obstinacy, misinformation, or dependence on inherited formulas, the anecdote takes the form of a classic topos account.

Visitors are said to have developed "reality checks." In the foreground in Bouton's diorama of the Chapel of the Trinity in Canterbury Cathedral (1822), there was a flight of stairs under repair, with pieces of marble and tools strewn around, and two workmen taking a nap. The scene was so convincing that

Figure 5.7
Two frames from "Paul Province's Visit to London," a folded print (leporello) made up of twenty four London images, c. 1846. The visitor is seen in the darkness of the Regent's Park Diorama, and in the Colosseum viewing George Danson's panorama *London by Night* (installed in 1846), making a "reality check." From a Victorian scrapbook. Author's collection.

a French writer claimed that some spectators thought the painting had been left unfinished, while some ladies asked for their shawls to protect themselves from the humidity of the chapel.[71] Another story was told about a gentleman, who "the other day was so convinced that the two workmen were actually flesh and blood, that he threw some half-pence at the lazy fellows to rouse them, and was surprised to find no other result produced than that of his own very proper exclusion from the room."[72]

What did the visitors think about the auditorium? Perhaps inspired by the prevailing neoclassical trend, more than one writer considered it not as an absolute novelty, but rather as a revival of the rotating Roman amphitheater built by Gaius Scribonius Curio (90BCE–49CE).[73] Because the rotation was slow, it caused an "Einsteinian" dilemma: which one was in motion—the painting or the floor? According to Jefferys Taylor, "no one . . . perceived the motion until another and brighter view burst upon the eye from left."[74] In an early article that purported to introduce the Diorama for readers who had not yet visited it, the lateral *movement* of the paintings was described as an essential aesthetic feature of the new spectacle:

> While we are gazing at the above scene of enchanting natural beauty [the first view], and feeling all the sensations that would be called forth by its actual presence, a bell rings, and we presently perceive that the whole is moving away from us, "with the slow motion of a summer cloud," and seems to be gliding, we know not how, behind the walls of the apartment; but so gradually, that it produces exactly the effect of a distant prospect, apparently receding from us as we pass by it in travelling. While we are engaged, however, in observing this motion, and wondering how it is contrived, our attention is again claimed and rivetted by the scene which we now perceive to be assuming the place of that which is passing away.[75]

It was only then that the writer revealed how the effect had been realized; the turning auditorium had purely instrumental value for him.[76] Several commentators detected an inverse relationship between the Diorama and the peristrephic panorama. One magazine expressed the issue in a clear and down-to-earth manner: "In the Regent's Park, the whole area in which the company is seated is made to move round from picture to picture, while the pictures themselves remain stationary; at Spring Gardens the spectators are fixed, and the pictures are caused to glide laterally and successively into view."[77]

With flair and wit, Jacob Goosequill transposed the discussion to an entirely different "sphere," evoking the great confrontation between the Ptolemaic and Copernican world views:

> The earth revolving on its own axis saves the sun, moon, and stars, a great deal of unnecessary trouble in performing their several diurnal circles according to the old system; but except the giddy delight of

> *participating in the vertiginous motion of the dioramatic platform,*
> *a spectator posted there is not immediately aware that he reaps any*
> *peculiar advantage. Whether the scene perambulates about the specta-*
> *tor, or the spectator about the scene; whether the object moves past*
> *the eye, or the eye past the object, is, philosophically considered, quite*
> *insignificant. Except, indeed, the spectator have a fancy for orbicular*
> *progression,—if he have any inclination for a circular jaunt, I would*
> *strenuously recommend him a turn or so on the horizontal wheel of*
> *the Diorama. Indeed I have heard many people express their entire*
> *approbation of this new kind of merry-go-round and its unaccompa-*
> *nying scenery.*[78]

Although he admired the paintings, the moving platform had a "hue of a hum-
bug"; besides, it caused him "terrestrial sea-sickness." He admitted that the
amount was "trifling," but enough to detract "from the pleasure of [his] excur-
sion round the inner wall of the Dioramatic establishment." Goosequill advised
the proprietor "to divert the enthusiasm of his steam-engine, or whatever
'old mole' it is that works beneath his platform," and to return to "the ancient
model," where pictures circle around immobile spectators (in other words, to the
perfectly simultaneous peristrephic panorama).

Whether Goosequill was serious about his dizziness or not, others also char-
acterized the Diorama as a place "where they turn you about till you feel quite
qualmish."[79] Another problem with the "roundabout room" were the "sounds
underground"—the noise of the cranking system.[80] Sound helped; music was
played not just to enhance the atmosphere, but also to drown out the noise, an-
ticipating the role of the piano in silent film screenings.[81] The rotating platform
created less comments than the visuals, but there were occasional hostile out-
bursts. Eugène Viollet-le-Duc, the French architectural theorist and proponent of
the Gothic Revival, made one of the most devastating comments: "The Diorama
stinks of the machine, and man, fortunately, is horrified by the machine."[82]

Viollet-le-Duc's comment should be read as a manifestation of the fierce de-
bates pro and con the machine that raged throughout the century, antagonizing
"aesthetes" and "utilitarians."[83] By their detractors, machines were related with
industrial mass production, dehumanization, masses, deskilling, uniformity,
and looming threat to existing values. Art represented the opposite: the unique,
the imaginative, the sublime, the cultured, the privileged. The Diorama did all
it could to court the "society" and to associate itself with the latter set of values.
It did so by suppressing popular-cultural associations, and hiding (rather than
emphasizing) the mechanical machinery. Coating the experience with taste and
style was not enough for an elitist observer, horrified about surrendering one's
body to the machine, even an innocuous one.

THE METAMORPHOSIS
INTO AN ITINERANT ATTRACTION

The "dioramas" that were exhibited by itinerant showmen and other specula-
tors took many forms. Closest to the original were the giant paintings claimed
to have been purchased from the permanent Dioramas in France and England.
Further away were the endless varieties of shows that exhibited pictures—large
or small, translucent or not—advertised as dioramas.[84] Furthest along the scale

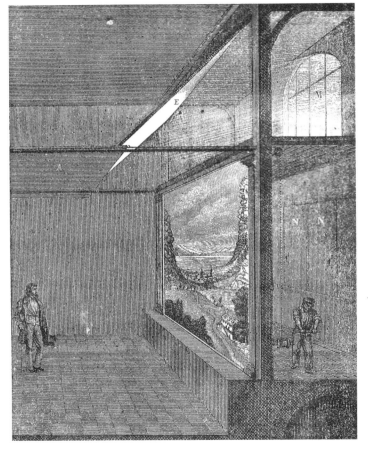

were the attractions that were really something else—mechanical theaters, moving panoramas, or magic lantern shows that evoked dioramas, sometimes in name only. The researcher faces a world of perplexing complexity. Yet the task is not to separate "real" dioramas from "fake" ones. It is to understand the complex interplays and mixtures of media-cultural forms in their blind, idiosyncratic but collective, quests toward new cultural formations.

In the United States, "Daguerre's Magical Pictures from Paris, representing the wonderful effects of day and night, invented by Mons. Daguerre six years before his Daguerreotype" were advertised by showmen named Maffey & Lonati.[85] They claimed to have imported three "Spirited Pictures," depicting the Church of St. Etienne du Mont in Paris, the avalanche at Goldau, Switzerland, and Venice on a festival night.[86] Canvases of the first two subjects had been presented at the Paris Diorama between 1834 and 1837 and 1835–1839, but one should be skeptical

Figure 5.8
Demonstration of a simplified diorama's mechanism from
Adolphe Ganot, *Physique purement expérimentale à l'usage
des gens du monde* (Paris: Chez L'Auteur-Éditeur, 1859),
p. 388 (fig. 225). A mechanism like this one could possibly
have been used in a touring diorama show. Author's
collection.

about Maffey & Lonati's claims, not the least because *Eboulement de la vallée de Goldau, en Suisse* had been on display and destroyed when the Paris Diorama burned down.[87]

Exhibiting Bouton's, Daguerre's and Sébron's huge pictures in temporary venues would have been difficult and costly, and realizing their elaborate light effects nearly impossible.[88] Maffey & Lonati's canvases were probably scaled-down copies, perhaps by Sébron himself. The canvases Sébron had painted in London, including *Crucifixion, with the City of Jerusalem, Belshazzar's Feast,* and *The Departure of the Israelites out of Egypt,* had already been displayed in the United States. Other paintings may also have been imported from the British Diorama.[89] This made sense, because their quality was good, but their size was only about half of Bouton's and Daguerre's giant canvases. The gaslight effects did not require natural light, and were therefore easier to implement in less than ideal settings.

Sébron stayed in the United States from 1849 until 1854 or 1855. He had brought with him two dioramas, *La vue du port de Brest, prise de la Batterie Rose* (1823) and *Intérieur de la chapelle du Holy-Rood a Edimbourg* (1823), both attributed to Daguerre, but possibly painted by Sébron himself.[90] Although they were torn into pieces by the hurricane that hit New York in 1849, native showmen like Robert Winter and Mark R. Harrison kept touring with their "chemical dioramas."[91] Suzanne Wray's persistent efforts have uncovered their extensive travels.[92] Both painted their own double-effect dioramas according to European models. The topics were familiar: cathedral interiors, Belshazzar's Feast, the City of Jerusalem and the Crucifixion, Holy Sepulchre, and the Departure of the Israelites were all featured in their programs. The attribute "chemical" probably refers to the illuminant, oxy-hydrogen gas or camphene. The inevitable accidents, tragic as they were, helped preserve close-ups of the exhibition culture.[93]

Dioramas were also associated with the name Hanington [Hannington], which referred to the brothers Henry and William J. Hanington [Hannington], who began their careers as commercial decorative painters and glassblowers in New York.[94] They became showmen in the early 1830s, first exhibiting a "Phosphorama" in 1832, possibly a Cosmorama-like picture gallery, and demonstrations of "Fancy Glass Blowing." In 1835 they adopted the City Saloon on Broadway as a permanent venue, a "Dioramic Institute," for their "dioramas." These included, among others, "The Conflagration of Moscow," "The Deluge," "Dioramic Representation of The Great Fire in New York," "The Conflagration of Charleston," "Stellar Universe, a Moving Telescopic Diorama," "Lunar Discoveries," "The Creation of the World," and "Crimean War" ("Russian War").[95] The shows were sometimes advertised as peristrephic or moving dioramas. Although the brothers went bankrupt in the early 1840s, their dioramas continued to be exhibited around the country (perhaps by others under the familiar name).[96]

Whereas showmen like Winter and Harrison transplanted the French tradition on American soil, Hanington's "dioramas" were related to mechanical theaters. The latter's origins are often traced back to the Eidophusikon, but other re-

156

FREE STREET HALL!

IN LIBBY'S NEW BLOCK, PORTLAND.

Monday Evening, Jan. 13th, 1851,

AND EVERY EVENING DURING THE WEEK.

CROWDED HOUSES NIGHTLY

TO WITNESS HANNINGTON'S GREAT

MOVING DIORAMAS!

PANORAMA OF THE HUDSON RIVER!

—WONDERFUL—

ITALIAN FANTOCCINI,

OR LIFE-LIKE MECHANICAL FIGURES,

And the Grand Dioramic Spectacle of the

Conflagration of Moscow!

Which has been exhibited for the last six weeks to overflowing houses, and giving more general satisfaction than any other Exhibition ever offered in Portland.

Tickets Only 12 1-2 Cents, without distinction of age

Doors open at 7 o'clock: Panorama to commence moving at 7 1-2

Order of Exhibition——Part First. A Moving Panorama of the

HUDSON RIVER!!!

PAINTED BY S. A. HUDSON, ESQ., (Artist of the Panorama of the Mississippi and Ohio Rivers,) which gives a delightful view of the following places ; Germantown, East Camp, Oak Hill, Hudson City, Columbiaville, Kinderhook, Schodac, Castleton, Greenbush, East Albany, and City of Troy; also, a view of the Troy Boats, the Steamer Rip Van Winkle, the Steamer Isaac Newton, the Boating as they appear on the river, with the Landings between Germantown and Troy.

SECOND GRAND SCENE, AN

ITALIAN LANDSCAPE!

Introducing a variety of Moving Figures—the scene commencing with a Funeral Procession of Monks, bearing a deceased brother to his last home by Torch Light, who enter the Abbey—the effect is much increased by the Illuminated Stained Glass Windows, Tolling of Bells and Solemn Music. Night is succeeded by the rich tints of an Italian sunrise. In this scene the delighted eye rests in the far distance on ranges of mountains studded with beautiful foliage, at the base of which flows a noble river, bearing the picturesque vessels peculiar to the country. Some are busy fishing, others making sail. During the scene a Boat Race takes place. On the foreground, the Shepherd is seen driving a herd of Cattle, enlivening his task by the soft music of a Rustic Pipe. Distant Church bells are heard. The whole concluding with a humorous conflict between two Goats ; presenting a busy scene of animated nature.

DROP SCENE,

Naval Engagement between Constitution & Guerriere.

FOURTH GRAND SCENE - THE SEA—Introducing

A STORM AND SHIPWRECK,

At the commencement the rolling of the surf is distinctly heard. Vessels are seen tacking from side to side in a manner truly nautical, others sailing before the wind. In the course of the representation a storm arises, the sea becomes agitated—the deep reverberation of thunder is heard, accompanied with lightning and torrents of rain. A vessel appears as if beating off a lee shore : she fires a signal of distress, and is answered from the Fort, from which a life-boat is sent to her assistance—the crew are saved, but the vessel is lost.

Fifth—New and Splendid Drop Scene, by the celebrated Lehr, Scenic artist of the Boston Museum,

View of Polo Temple, Taihow, China.

SIXTH.—Magnificent Dioramic Scene of a Splendid

FAIRY GROTTO.

The dazzling beauty of this scene far exceeds anything of the kind ever presented to the public. An immense range of beautiful Basaltic Columns, composed of the most brilliant colored glass and precious stones, rest on the silver waters of the Fairy Lake, on which are seen gliding Fairies drawn by Swans, amid the warbling of birds of the richest plumage. Towards the conclusion of the scene, the Genius of the Fairy Regions appears at whose command a SUPERB SUB MARINE FAIRY PALACE arises, the whole presenting a dazzling tableau of magnificence, once seen, never to be forgotten.

After which the much admired

ITALIAN FANTOCCINI;

OR, LILLIPUTIAN FAMILY.

The Mechanism of the figures composing the fantoccini, is pronounced by competent judges, to be the most natural and Life like ever exhibited in this country. Such was the curiosity to witness their performances in the principal cities of the Union, that they were exhibited without any other attraction to crowded and admiring houses. Their wonderful feats and extremely natural motions invariably leave the audience in a maze of surprise and admiration. These apparently animated Automatons have invariably been greeted with enthusiastic applause from every audience. They have been brought to such perfection in the resemblance of Nature, as to defy all competition, surpassing any thing of the kind in the world. The following figures will be introduced. The Polander, the Sailor, Negro Extravaganza, with Song and Dance, the Bottle Juggler, Cane Balancer, and the Ball Tosser. Also, the humorous performance of comical Joey, the Clown.

The whole to conclude with the Magnificent Representation of the

Conflagration of Moscow!

Introducing the Marching of Troops, Firing of Cannon, Report of Musketry, Incendiaries Firing the City &c., until the wide spreading flames reach the Kremlin, the whole terminating in a Terrific Explosion.

Appropriate Music every Evening. THE LADIES are informed that strict order will be maintained, and that they can with perfect safety and equal propriety visit the entertainment, either with or without gentlemen.

☞ THERE WILL BE AN EXHIBITION

Saturday Afternoon, commencing at 3 o'clock,

For the accommodation of those who cannot attend in the evening. Schools admitted in a body on reasonable terms. The Hall will be darkened, in order to produce the same effect as in the Evening.

☞ Likewise one in the Evening at 7 1-2 o'clock.

lated attractions, such as Johann Nepomuk Maelzel's (1772–1838) *Conflagration of Moscow*, were also widely shown and copied (also by Hanington).[97] Combining transparencies, mechanical motion, sound effects, and perhaps even explosives, it influenced other concoctions, including *Lewis and Bartholomew's Great National and Historical Moving Diorama of the Battle of Bunker Hill and the Conflagration of Charlestown*, that was exhibited widely around the United States.[98]

Hanington's shows belong to this lineage. *The Knickerbocker* summarized their nature by saying that "there is certainly a most wonderful effect produced by means of machinery, painting, and the management of light."[99] In Hanington favorites like the "Fairy Grotto" dioramic illuminated backgrounds were combined with mechanical effects, including animated figures. Yet everyone did not agree that "Fairy Grotto" was wonderful. It triggered a sarcastic comment by the author Enoch Cobb Wines, who found it "perfectly beautiful, if beauty consists in bringing as many gorgeous colors together as five hundred dollars will buy, and in first painting and then pulling backward and forward certain stiff and brawny figures on what are called swans, under the cognomen of 'Fairies.'"[100]

Another feature that may have repelled those who were looking for more subdued and cultured experiences was Hanington's soundscape. The "Italian Landscape" may have been accompanied by distant church bells and "the soft music of a Rustic Pipe," but the overall impact of their shows at the City Saloon was much more cacophonic. City sounds were of course much louder than those of the countryside, but even though it was in the heart of the Broadway, close to another noisy attraction, P. T. Barnum's American Museum, the Hanington extravaganza managed to make itself heard, judging by a neighbor's testimony:

> At precisely a quarter past seven o'clock in the evening, the opening music at Hannington's Diorama, (a near neighbor,) strikes up as was its wont. I can as usual hear the thunder and rain appertaining unto the "Deluge." At eight o'clock to a minute, I can still hear the first blast of martial music of Napoleon's army as it is entering Moscow; then, as of old, follow the conflagration, the reports of the artillery, the booming of the cannon, and finally, the usual explosion, and the falling of the Kremlin. Next in order is the Great Fire in New York. The ringing of the bells — the rattling of the engines — the sudden flashes of light — the roar of the flames — the cries and shouts of the distracted citizens — are given, as the bills have it, "with appalling effect!" Afterward, comes the representation of the newly-discovered regions in the moon. I can tell when the exhibition reaches this part, by the flapping of the wings of the man-bats. Then succeeds a half hour of silence, and I know that the Cosmorama is being exhibited: suddenly the clarinet and piano strike up a slow march, and then I know that all is over, and the audience is retiring.[101]

It is significant that the writer was able to visualize the show merely by its sounds, without entering the hall. The exhibition had been internalized to such

Figure 5.9
Hannington's Great Moving Dioramas! Panorama of the Hudson River! Wonderful Italian Fantoccini, or Life-Like Mechanical Figures, And the Grand Dioramic Spectacle of the Conflagration of Moscow!, broadside, Free Street Hall in Libby's New Block, Portland [Maine], Mon. Jan. 13, 1851. The showmen may or may not have been the Haningtons themselves. Author's collection.

an extent that he could follow its course by its aural features only. This brings to mind Jacob Goosequill's remark about Messrs. Marshall's "peristrephic music shaking the tiles off the neighbouring houses," or a very similar remark by Nathaniel Hawthorne about a mechanical theater performing in Boston (see chapter 11). It is quite possible that the sounds of these shows did not permeate the neighborhood by mistake (like the smell from restaurants lingering in the streets). The novel soundscape served as an attractor. An American, who visited Liverpool in 1825, noticed a "curious sign, labeled *Eidouphusicon* [sic]." He soon found out that "it points to an exhibition of natural scenery and natural phenomena. Regularly at 10 o-clock, they come to 'the thunder-storm' and 'the shipwreck.' There is a tremendous beating of tin pans, and the pattering of peas for rain and hail."[102]

By the 1850s Hanington's programs must have felt conservative. Their continuing success can be explained by Hanington's "trademark." The audiences knew what to expect, and enjoyed the show because it matched their expectations. But the power of tradition also merged with the lure of the new. When Beall's [Beale's] and Craven's moving panorama of the sea route to California was shown in Cincinnati, the *Ladies' Repository* highlighted a single scene, one with extensive dioramic and sound effects: "In passing around Cape Horn, this panorama introduces all the reality of a storm. You hear the loud voice of the thunder, the red glare of the lightning, and the patter and then the rush of the rain, and the whistling of the wind, just as perfectly as though you were at midnight on board a vessel, plowing your way through the waves of the stormy Cape."[103]

In the second half of the century the meaning of the word *diorama* became less and less distinct. Following the earlier practice by scene painters like Clarkson Stanfield, moving panoramas were often designated as dioramas, although dioramic light effects were usually limited to just a few scenes. This explains why Miss Eliza Leslie misinformed young ladies so emphatically in her *Behaviour Book* (1859). She first explained that a "panorama, correctly speaking, is a large circular representation of one place only," continuing:

> It is difficult to imagine whence originated the mistake of calling a diorama a panorama, which it is not. A diorama is one of those numerous flat-surface paintings of which we have had so many, (and some few of them very good,) and which, moving on unseen rollers, glide or slide along, displaying every few minutes a new portion of the scenery.[104]

According to Miss Leslie's logic, Sébron's diorama *The Departure of the Israelites* was only "a colossal picture," because it did not move and was not circular. The situation became even more confusing. In England the magic lantern showmen sent by the Royal Polytechnic Institution (London) to give presentations in the provinces were known as Dioramic Lecturers, while a showman named W. M. Fitch distinguished his hand-painted lantern slides from his photographic slides by characterizing them as "dioramic paintings."[105] B. J. Malden's "Wonders

of the World" was called a "grand dioramic lecture." It contained "65 magnificent dioramic dissolving views," projected with his "newly invented TRIPLE APPARATUS" (triunial magic lantern).[106]

Reflecting the increasingly complex nomenclature, many entertainments incorporated different media forms, as Robert Winter's advertisement in the *Columbia Spy* (September 27, 1856) demonstrates:[107]

> *R. Winter's Unrivalled Exhibition of Chemical Dioramas, Chrystalline Views, Chromatropes, &c., At Odd Fellows' Hall, Columbia, Pa., For a Few Days Only. The Entertainment commences with a large collection of* CHRYSTALLINE VIEWS, *representing ancient and modern cities, rains, sea views, moonlight, winter and summer scenes, fire and volcanic eruptions. After which numerous* CHROMATROPES *and* METAMORPHOSES. *To be followed by the large* CHEMICAL DIORAMAS, *(passing through all the gradations of light peculiar to the natural day.) First scene,* MILAN CATHEDRAL, *the night scene of which will show the celebration of mid-night [sic] Mass. Second,* COURT OF BABYLON: *the night view of the brilliant scene of Belshazzar's Feast.*[108]

The chromatropes and metamorphoses were mechanical lantern slides, and the chrystalline views probably lantern slides used to project dissolving views. The chemical dioramas were illuminated dioramic paintings. In England, W. D. Hall's *Diorama of Egypt and Palestine* (1857) was tooted as "Cyclorama. The imposing Dioramic and Scenic effects of which never fail in exciting the highest gratification in every beholder, embracing Beautifully Illuminated Scenes in nearly all parts of the World!"[109] Hall claimed that he had worked at the Cyclorama (the moving picture spectacle at Regent's Park Colosseum), so the main attraction may have been a moving panorama with dioramic effects. Ending the show with the mesmerizing "Chromatrope or Chinese Fireworks" reveals that a magic lantern was also used.

NOTES

1. I will use a capital letter to refer to Bouton and Daguerre's invention (Diorama), and lower case to all other forms designated with this word.

2. An early commentator thought it meant "two views" (dis + horama). Alexis Donnet, *Architectonographie des Théatres de Paris* (Paris: Didot, 1821), p. 318. This mistake was repeated in the *Nouveau Dictionnaire de la Conversation*, vol. 10 (Bruxelles: Librairie Historique-Artistique, 1845), p. 62.

3. "Panoramas and Dioramas," *Leisure Hour* (London), 35 (1886): 47.

4. Karen Wonders, *Habitat Dioramas: Illusions of Wilderness in Museums of Natural History* (Uppsala, 1993, Acta Universitatis Upsaliensis, Figura Nova Series 25); Stephen Quinn, *Windows on Nature: The Great Habitat Dioramas of the American Museum of Natural History* (New York: Harry N. Abrams, 2006).

5. My "The Diorama Revisited," in *Sonic Acts XIII—The Poetics of Space, Spatial Explorations in Art, Science, Music & Technology*, ed. Arie Altena and Sonic Acts (Amsterdam: Sonic Acts Press/Paradiso), 2010, pp. 207–228.

6. Even Griffiths does so in *Shivers Down Your Spine*, p. 42. Stephen Bann demotes Bouton into Daguerre's "chief assistant in the creation of the diorama" in *Parallel Lines: Printmakers, Painters and Photographers in Nineteenth-Century France* (New Haven: Yale University Press, 2001), p. 102.

7. L. J. M. Daguerre, *Historique et description des procédés du Daguerréotype et du Diorama*. Nouvelle Edition, corrigée, et augmentée du portrait de l'auteur (Paris: Alphonse Giroux et Cie, 1839). (UCLASC). The section on the Diorama may have been included to justify the larger compensation paid for Daguerre than

for Niépce's son, his inheritor.

8. Pinson found no contemporary evidence of Daguerre's involvement with Prévost ("Speculating Daguerre," p. 24). Prévost's obituaries point out only Bouton's affiliation with him. See *Annuaire nécrologique ou complément annuel*, year 1823, ed. A. Mahul (Paris: Ponthieu, October 1824), p. 242. Étienne-Gaspard Robertson's *Mémoires* claims that Bouton, "still young," worked on an early panorama of Paris that Robertson intended to realize with Mr. [Denis] Fontaine (vol. 1, p. 324). Fontaine was one of Prévost's assistants; was Prévost involved as well?

9. Louis-Jacques-Mandé Daguerre, "A M. Le directeur des Annales Françaises [dated April 28, 1821]," *Annales françaises des arts, des sciences et des lettres* (Paris), vol. 8 (2nd series, vol. 2), 1821, p. 93. Daguerre announced that the building permission had been granted. The name, the place, and all the essential features had already been decided.

10. Timbs, *Curiosities of London*, p. 252. Another commentator mentioned that the Diorama "resembles a small theatre." *Leigh's New Picture of London; or a View of the Political, Religious, Medical, Literary, Municipal, Commercial, and Moral State of the British Metropolis . . .* (London: Samuel Leigh, 1824–1825), p. 382. Note the visual references in the title.

11. Address was also given as Rue (or Boulevard) Bondi (on the other side of the building). The destruction of the Diorama on March 8, 1839 was reported in the *Gentleman's Magazine*, ed. Sylvanus Urban, vol. 11, new series (April 1839), p. 424. Daguerre [or Sébron?] is said to have been working on a new diorama, the interior of the Church of Santa Maria Maggiora [sic], which was nearly ready when the fire broke out.

12. The Regent's Park Diorama opened on Sept. 29, 1823. A

British patent was applied for by John Arrowsmith on Feb. 10, 1824: "Diorama, or Method of Exhibiting Pictures. Arrowsmith's Specification. A.D. 1824, No. 4899," on-line at www.midley.co.uk. (last visited Dec. 25, 2007). There seems to be no French patent. The relationship between Charles and John is unclear; they may have been the same person (Wood, "The Diorama in Great Britain in the 1820s," nn. 7 and 8.) or brothers of Daguerre's wife. There is a broadside, "Programme of a new MUSICAL & SCENIC ENTERTAINMENT ENTITLED 'Facts and Scraps, or Selections from my Album,' by MR. J. ARROWSMITH, F.R.A., and a series of dissolving views, Under the superintendence of Mr. W. COX, in aid of the funds of the Dalston Philantropic Institution," in JJCB. The event took place on Thursday Evening, April 20, 1854.'Was this the same J[ohn?] Arrowsmith?

13. "Smith, J., Diorama, Regent's Park, and of Paris, printer" was declared bankrupt in 1828 ("Alphabetical List of English Bankrupts, from 22d June to 23d July, 1828," *Blackwood's Edinburgh Magazine*, Sept. 28, 1828, p. 402). George Elwick, *The Bankrupt Directory: Being a Complete Register of All the Bankrupts . . . from December 1820 to April 1843* (London: Simpkin, Marshall, and Co., 1843, p. 380) specified: "Smith Jacob, Diorama, Regent's park, printer, July 22, 1828." The bankruptcy process continued through 1831, when the *Law Adviser* (1831, p. 331) talked about a hearing concerning "SMITH, Jacob, Diorama, Regent's Park, Middlesex, and of Paris, primer [sic]." Was Jacob Smith John Smith (The Arrowsmiths also used "Smith")? The Regent's Park Diorama's bankruptcy may have been caused by too heavy initial investments.

14. Helmut and Alison Gernsheim, *L. J. M. Daguerre: The History of the Diorama and the Daguerreotype* (New York: Dover, 1968, 2d rev. ed., orig. 1956), pp. 39–40. Pabst discusses

Bouton's new Diorama in *Essai sur l'histoire des panoramas et des dioramas* (p. 21), referring to an entry by M. Thénot in *Encyclopédie du dix-neuvieme siècle, répertoire universel des sciences, des lettres et des arts, avec la biographie des hommes célébres*, vol. 10 (Paris: Au Bureau de l'encyclopédie du XIXe siècle, 1848), pp. 258–260. Thénot says that several diorama paintings were *larger* than 20 x 14 meters, for example *Incendie d'Edimbourg*, *Mont-Blanc* and *Forêt Noire*. He provides lists of the dioramas painted by Bouton in London, and in Paris after his return. The latter were *Vue de la ville de Fribourg, effet graduel d'une neige au printemps* (1843), *Interieur de la basilique de Saint-Paul* (1843—painted in London?), *Déluge* (1844), *Intérieur de l'eglise de Saint-Marc* [Venice] (1845), *Inondation de la Loire* (1847) and *Vue de Chine* (undated by Thénot, but according to Pabst, p. 21, 1847), depicting Canton during the lantern festival. The list is incomplete, because the book was published in 1848. The diorama in the Bazar Bonne-Nouvelle (20. Boulevard Bonne-Nouvelle) burned down on July 14, 1849; the building was only partly damaged (*Paris guide, par les principaux écrivains et artistes de la France*, Paris: Librarie Internationale, 1867, p.1300). *Vue de Chine* and *Interieur de la basilique de Saint-Paul* were destroyed (*Dictionnaire de la Conversation et de la Lecture*, Seconde édition, Paris: Firmin Didot, 1873, vol. 3; B. de Corgy, "Bouton," p. 616). The superintendent of the London Fire Brigade, Eyre M[assey] Shaw, included the Paris Diorama fires of 1839 and 1849 in his list of major theater fires, but omitted the one that destroyed the British Diorama in 1829. Eyre M[assey] Shaw, *Fires in Theaters* (London: E. and F.N. Spon, 1876), p. 45.

15. Rénoux was mentioned in 1840 as "a new artist" in the review of his first diorama shown at Regent's Park, *The Shrine of the Nativity at Bethlehem* (based on David Roberts's sketches). *Gentleman's Magazine*, ed. Sylvanus

Urban (London: William Pickering, John Bowyer Nichols and Son,), vol. 14, New Series (July-December 1840), p. 411. The painting was shown again in 1850 (*Athenaeum*, no. 1201, Nov. 2, 1850, p. 1143). Diosse returned to France, and is said to have opened in mid-July 1852 a diorama in Brest with the photographer André-Adolphe-Eugène Disdéri; it failed and closed within six months. *Encyclopedia of Nineteenth-Century Photography*, vol. 1, ed. John Hannavy (New York: Routledge, 2007), p. 417.

16. Undated broadside in VATC. Part of the Hungerford Market was turned into an "Entrepot of Industry & Science." The detailed story is in *Railway Record, Mining Register, and Joint Stock Companies' Reporter* 8, no. 32 (no. 399) (Aug. 9, 1851): 530. There were two auditoriums, one for popular-scientific demonstrations and the other for dioramas. The auditorium showing a moving panorama of Wellington's funeral burned down on March 31, 1854, because of careless use of gas jets. Bouton's dioramas must have been removed by then. It was rebuilt as a music hall, but the area was sold in 1862 and came to house the Charing Cross Station. Because two views were shown, one wonders if the Regent's Park Diorama's rotating auditorium was reinstalled here? Altick attributes St. Mark to Diosse (*The Shows of London*, p. 171), but may be wrong: the review in the *Art-Union Monthly Journal of the Arts* (10 [1848]: 163) for the 1848 exhibition of *Mount Etna* and *The Interior of St. Mark's Church, Venice* links the former with Diosse, but does not mention the latter's painter, who could have been Bouton.

17. About the Stockholm Diorama, Åke Abrahamsson, "Panoramats skenvärld—1800-talets bildteatrar," in *Stadsvandringar*, 15, ed. Britt Olstrup, Irene Sigurdson, et al. (Stockholm: Stockholms Stadmuseum, 1992), pp. 15–16. The Madrid diorama opened in 1838 "next to the silversmith business

of Martinez" [*Fabrica plateria*] with a view of the interior of the Church of San Lorenzo del Escorial, painted by the Frenchman "Juan" Blanchard, who had worked in Spanish theaters since 1826. Manuel Ossorio y Bernard, *Galería biográfica de artists españoles del siglo xix* (Madrid: Moreno y Rojas, 1883–1884), pp. 85–86. He must have been Henri-Léon-Charles-Pharamond-Pierre Blanchard (1805–1873), who had worked early at the Paris Diorama, and left for Mexico in 1838. The Madrid Diorama was described in D. Ramón de Mesonero Romanos, *Manual histórico-topográfico, administrativo y artistico de Madrid* (Madrid: D. Antonio Yenes, 1844), pp. 395–396. It operated for at least 12 years. "Bellissimas perspectivas" were also displayed (probably cosmorama-like smaller paintings). D. P. F. M., *Madrid en la Mano ó El amigo del forastero en Madrid y sus cercanías* (Madrid: Gaspar y Roig, Editores, 1850), p. 323. The Havana Diorama operated between 1827 and 1829. The painting was by the Frenchman Jean-Baptiste Vermay (1786–1833), a pupil of David, who moved to Havana in 1816 and played a central role in the artistic life of the city. The diorama was converted into a theater (Teatro Diorama) in 1830, but the building was destroyed by a hurricane in 1846. D. José Maria de la Torre, *Lo que fuimos y lo que somos o la Habana Antigua y Moderna* (Habana: Spencer y Compania, 1857), pp. 77, 120, 171; Antoni Kapcia, *Havana: The Making of Cuban Culture* (Oxford: Berg Publishers, 2005), p. 49 (only the Teatro Diorama is mentioned).

18. From the only surviving copy of the program booklet for the Manchester Diorama, quot. Wood, "The Diorama in Great Britain in the 1820s. Part 3."

19. C. Seidel, "Ueber Panoramen, Dioramen und Neoramen," *Berliner Kunstblatt*, 1 (1828), p. 67, quot. Erich Stenger, *Daguerres Diorama in Berlin. Ein Beitrag zur Vorgeschichte der Photographie* (Berlin: Union

Deutsche Verlagsgesellschaft, 1925), p. 64 (author's translation); W. Neite, "The Cologne Diorama," *History of Photography* 3, no. 2 (April 1979): 107.

20. A chart of the diorama paintings known to have been shown in Britain is included in Wood's "The Diorama in Great Britain in the 1820s." The Liverpool and Edinburgh dioramas were the most active.

21. The Cologne diorama operated from 1843 until 1869, surviving longer than any other. The diorama of the Gropius brothers in Berlin closed in May 1850, after twenty-seven years. *Sehsucht*, pp. 202–203. The best source is Stenger, *Daguerres Diorama in Berlin*, which also lists the dioramas and pleoramas displayed there (pp. 66–68). No paintings by Daguerre or Bouton are included. Diosse's *Mount Etna* is known for its triple-effect transformation.

22. Georges Potonniée, *Daguerre, peintre et décorateur* (Paris: P.Montel, 1935); Gernsheim, *L. J. M. Daguerre*, ch. 2; R. Derek Wood, "The Diorama in Great Britain in the 1820s," *History of Photography* 17, no. 3 (autumn 1993): 284–295, and "Daguerre and his Diorama in the 1830s. Some financial announcements," *Photoresearcher* (European Society for the History of Photography, Croyton, UK), no. 6 (1994/95/96), pp. 35–40 [Wood's articles are on-line at www.midley.co.uk, copyright R. Derek Wood and Taylor & Francis; last visited Dec. 25, 2007]; Pinson, "Speculating Daguerre." For the London Diorama building, *The Diorama, 17–19 Park Square East, Regent's Park, London. A Property of the Crown Estate*, offering the building for lease, booklet (c. 1983, EH).

23. The auditorium of the Paris Diorama also had a third position, which was used for preparing new paintings. According to Gernsheim, there was even a *fourth* gallery for displaying dioramas (*L. J. M. Daguerre*,

p. 23). In the 1830s three views were sometimes displayed simultaneously, also when the Diorama burned down in March 1839 (Potonniée, *Daguerre*, p. 88).

24. Gernsheim, *L. J. M. Daguerre*, pp. 20, 23. The drawings of the 1924 Diorama patent display a seating arrangement identical with the one in Paris. A plate of "Arrowsmith's Diorama" published in the *London Journal of Arts and Sciences* 9, no. 54 [1824–] 1825, plate 13, shows a solution with 4–5 rows of benches. At the back there may be one row of stalls, although a person is seen standing.

25. The ticket price to the Paris Diorama was 3fr for the boxes, and 2fr 50 for the amphitheater. In 1832, the amphitheater price was lowered to 2fr. Between 1833 and 1839 a unique ticket price of 2fr 50 was used, probably meaning that the gradation of the auditorium had been removed. During the same period, a ticket to the panorama cost one franc. (Potonniée, *Daguerre*, pp. 70–71.) The price changes were not very significant. At Regent's Park the ticket price was two shillings, a considerable amount.

26. Chad Randl's *Revolving Architecture. A History of Buildings that Rotate, Swivel and Pivot* (New York: Princeton Architectural Press, 2008) *omits* the Diorama, although it mentions the moving panorama (p. 39). Another omission is the viewing platform of the Battle of Sedan Panorama (Alexanderplatz, Berlin, 1883). Its revolving outer circle, 1,5 meters wide, was powered by an engine. Depending on the number of visitors, the speed could be varied (Grau, *Virtual Art*, pp. 123–124).

27. The Cologne Diorama may also have had a rotating auditorium. Neite, "The Cologne Diorama," p. 105. A temporary diorama shown in Bristol (1825) had a "turning saloon"; R. Derek Wood, "The Diorama in Great Britain

in the 1820s. Part 1." Rotating stages have been more common than rotating auditoria. For the latter, Pronaszko's model for a "mobile theatre" Teatr Ruchomo (1933) and in particular the work of Jacques Polieri, such as his Théâtre Mobile (1960) provide examples. Arnold Aronson, "Theatres of the Future," *Theater Journal* 33, no. 4 (Dec. 1981): 496–498. The rotating auditorium of the outdoor Pyynikki Summer Theater, Tampere, Finland, was designed by architect Reijo Ojanen in 1959 and holds c. 800 spectators. The Roman amphitheater built by Gaius Scribonius Curio (90BCE–49CE) is said to have had a moving auditorium.

28. Donnet, *Architectonographie*, p. 323. Châtelain was granted a patent (no. 829) for *montagnes russes* (proto roller coasters) on Nov. 22, 1817. M. Christian, *Description des machines et procédés spécifiés dans les brevets d'invention, de perfectionnément et d'importation*, vol. 10 (Paris: Madame Huzard, 1825), p. 11; he also designed a noted panoramic attraction, Charles-François-Paul Delanglard's *Géorama* (1823). See *Bulletin des sciences géographiques, etc. économie publique; voyages*, vol. 1 (Paris: Au bureau du Bulletin, 1824), p. 267.

29. *London Journal of Arts and Sciences* (London: Sherwood, Jones & Co. and W.Newton, 1825), vol. 9:339. Compare: "The Diorama," *The Magazine of Science, And School of Arts*, July 4, 1840, reprinted in Herbert, *A History of Pre-Cinema*, 2, pp. 103–105 (quot. p. 104).

30. "British Diorama and . . . Exhibition of Works of Art, is now open at the Royal Bazaar, 73, Oxford Street, nearly opposite the Pantheon," two-sided broadside, n.d. [c. 1829], GRI.

31. London's poor weather and polluted air must have caused problems for the Regent's Park Diorama. The use of artificial light to enliven Stanfield's view of the York Cathedral on fire ironically caused a fire that destroyed the British Diorama

and the entire Bazaar in 1829. Both were soon rebuilt.

32. "The screens are contrived so as to close centrally, two meeting vertically, and two horizontally." "Diorama and Physiorama, Oxford-street," *Gentleman's Magazine*, 1830, p. 447. The use of the word "screen" about the sliding panels is interesting. Altick (*The Shows of London*, p. 169) compares this curtain to a "rudimentary camera shutter." It brings to mind the mechanical dissolvers that were used in front of magic lantern lenses to achieve the "dissolving view" effect, and anticipated the extraordinary "Screen-O-Scope" the designer and architect Frederick Kiesler created for the Film Guild Cinema he designed, New York, 1928–29.

33. "Diorama," *Annales françaises des arts, des sciences et des lettres* (Paris), vol. 10, 2nd series, vol. 4 (1822), p. 394. Formulation from Alex. Lenoir.

34. Anon., "On Cosmoramas, Dioramas, and Panoramas," *The Penny Magazine*, Sept. 17, 1842, p. 364. Similar idea was expressed by Arnott, *Elements of Physics*, vol. 2, part 1, p. 278. The first Cosmorama was opened in Paris in 1808. The London Cosmorama was opened in 1820 and at first located on St. James's Street, before moving to Regent's Street in 1823 and remaining open there until the late 1850s. See my "Toward a History of Peep Practice," pp. 39-41.

35. "The Diorama," *Mechanics' Magazine, Museum, Register, Journal, and Gazette* (London: Knight and Lacey, 1827), 6, no. 159 (Sept. 9, 1826): 289–291 (ref. p. 291).

36. The event took place on July 28, 1830. The view was on display at the Paris Diorama from Jan. 23, 1831, to Jan. 20, 1832.

37. "The Fine Arts: The Diorama,"

The European Magazine, and London Review (1823), p. 341. Potonniée claims that after his first diorama painting (the Chapel of the Trinity in the Canterbury Cathedral) Bouton gave up the "play with light" and created "illusionistic paintings in the style of Prévost's panoramas." *Daguerre*, p. 57.

38. [Bouton's] view of Venice he found "a bad painting." Pückler-Muskau, *Tour in England, Ireland, and France*, vol. 2, letter 14, pp. 302–303.

39. *Lettres sur le Salon 1834* said that the Diorama "is only visited by foreigners anymore" (Paris: Delaunay, 1834, p. 304). In 1835 it was reported that the Diorama will soon be demolished, which the "friends of the arts will grieve." ("Panoramas. Etc.," A[bel] Hugo, *France pittoresque ou description pittoresque, topographique et statistique des départements et colonies de la France*, tome III, Paris: Delloye, 1835, p. 120.) The double-effect dioramas saved it for some time, but it is worth asking whether the fire of 1839 may have been deliberately started (although it damaged Daguerre's laboratory as well).

40. "Diorama. Regent's Park," *Mechanics' Magazine, Museum, Register, Journal, and Gazette* 9, no. 241 (March 29, 1828): 158.

41. It was probably influenced by Colonel Langlois's panorama of Navarin, which opened on Jan. 31, 1831. Langlois introduced the idea of the *faux terrain*, or illusionistic landscape between the painting and the viewing platform. A simulated boat served as the viewing platform; the spectators entered the deck through furnished cabins. *Jean-Charles Langlois (1789–1870). Le spectacle de l'Histoire* (Paris: Somogy, 2005), p. 59; Pinson, "Speculating Daguerre," p. 195.

42. *Le Courrier des Théâtres* (Nov. 17, 1831) claimed that there were live animals: "Des animaux vivants sont là et leur présense est le dernier

trait d'exactitude." According to an anecdote, during the visit of the royal family one of the young princes asked the king if the goat was alive, to which the king answered: 'You must ask Mr. Daguerre himself' (quot. Potonniée, *Daguerre*, p. 85, from *Le Courrier des Théâtres*, Nov. 19, 1831). It would be tempting to suggest that the Swiss props influenced the scenography of Albert Smith's *Ascent of Mont Blanc*, and Daguerre's view of Mont Blanc the moving panorama William Beverley painted for Smith, but this cannot be proven.

43. All the examples Daguerre mentions in his *Historique et description des procédés du Daguerréotype et du Diorama* (p. 73) are double-effect dioramas: *Une messe de minuit à Saint-Etienne-du-Mont* (1834, with Sébron), *Eboulement de la vallée de Goldau, en Suisse* (1835, with Sébron), *Inauguration du Temple de Salomon* (1836) and *Un sermon dans l'église royale de Santa Maria Nuova, à Monreale en Sicile* (1838).

44. According to Wood, "Daguerre and his Diorama in the 1830s. Some financial announcements," Daguerre was in bankruptcy between March 20, 1832, and Feb. 20, 1835.

45. Daguerre uses the expression *décompositions des formes* in his *Historique et description des procédés du Daguerréotype et du Diorama*, p. 73.

46. Henri Delaborde, "Notice sur la vie et les travaux de M. le baron Taylor . . . lue dans la séance publique annuelle du 30 ottobre 1880," in Victor Champier, *L'Année Artistique*, troisième année, 1880–1881 (Paris: A. Quantin, 1881), p. 605.

47. "Diorama, Regent's Park," *Court Magazine* (London: Edward Churton, 1836), vol. 8 (January–June 1836): 229–230. The writer made the observation "from our own knowledge," and clearly favored London over Paris.

48. Pinson, "Speculating Daguerre," pp. 6–9.

49. *Revue de Rouen et de la Normandie*, 2d semester (Rouen: E. Le Grand, 1836), p. 70. One wonders if this secretly referred to the fact that the extremely productive Sébron had just one arm.

50. Baron [Alfred Auguste] Ernouf, *Les inventeurs du gaz et de la photographie* (Paris: Hachette, 1877), p. 128. Ernouf thought that Sébron followed Daguerre's instructions (p. 130).

51. In FB. It is not clear for whom Sébron wrote his notice, or if he meant it to be published. Writing his notice after both Daguerre's and Bouton's deaths of course protected Sébron against their objections.

52. The notice also lists other artworks he had produced, including their owners.

53. This is said to have been announced on Oct. 20, 1834 in a number of French journals Sébron lists, but I have not been able to confirm it.

54. "The Louvre: Salon of 1840 (Sixth Notice)," *The Literary Gazette; and Journal of the Belles Lettres, Arts, Sciences, &c.*, no. 1220 (June 6, 1840), p. 363. These three dioramas were identified as Sébron's own works in "Beaux-arts. Exposition nationale d'Anvers. (Aout 1837.) Troisième et dernier article," *Revue de Bruxelles* (Bruxelles: La Société nationale, November 1837), p. 133.

55. "Modern Schools of Art in France, Belgium, and Switzerland," *Blackwood's Edinburgh Magazine* 50, no. 314 (December 1841): 703. The article mentions that lately Bouton has painted Spanish and Italian subjects, including "a series of views of St Mark at Venice, and the Duomo at Milan." (p. 703) Did he paint dioramas of these subjects on commission as well,

shown in the United States? *Musée des familles: lectures du soir* (Paris, vol. 6, 1839, p. 347) stated that as a young man Sébron executed "les plus belles toiles du Diorama."

56. When the latter was shown at the Queen's Bazaar's British Diorama in London, it was mentioned as "Mr. D. Roberts's Grand Picture of the 'Departure of the Israelites out of Egypt, painted with Dioramic Effect, by H. Sebron, pupil of Mr. Daguerre.'" Thomas Smith, *A Topographical and Historical Account of the Parish of St. Mary-le-Bone* (London: John Smith, 1833), p. 319. Martin fought hard against Sébron's version of his work, but lost. He explained to a House of Commons committee: "This diorama was a most infamous piece of painting, and the public were given to understand that I was the painter; this was ruining my reputation, and at the same time taking that from me which ought to be my own, my copyright." *Mechanics' Magazine, and Register of Inventions and Improvements* 7, no. 1 (whole no., 27, Jan. 1836), p. 33.

57. Thomas Hudson, "Billy Bumkin's Peep at The Lions of London," in his *Comic Songs. Collection the Seventh* (London: Gold and Walton, 1826), p. 7. The need to adjust one's eyes to the relative darkness of the auditorium appeared in another popular song as well: "The Diorama, in Regency-Park, Where, as to *their lights*, we're *quite in the dark*." In *The Universal Songster: Or, Museum of Mirth* (London: Jones and Co., 1834), vol. 3, p. 434.

58. Mrs. Théaulon, Ferdinand et Bisset, *Le Zodiaque de Paris. Vaudeville-épisodique en un acte* (Paris: Duvernois & Sédille, 1822), scene 9, pp. 16–19. In the other side of the Channel the Diorama was also characterized as the panorama's "younger offspring, twin-born of the same parent." "The Diorama," *New Monthly Magazine and Literary Journal* (London: Henry Colburn, 1824), vol. 12, no. 46 (Oct. 1, 1824), p. 441.

59. Charles Nodier, *Histoire du Roi de Bohème et de ses sept chateaux* (Paris: Delangle Frères, 1830), p.148.

60. P. Cuisin, *Le rideau levé, ou, Petit diorama de Paris* (Paris: Eymery, Delaunay & Martinet, 1823); Andrew Wilkie, *The Diorama of Life; or, the Macrocosm and Microcosm Displayed: Characteristic Sketches and Anecdotes of Men and Things* (London: Edward Barrett, 1824). Pierce Egan's bestseller *Life in London, or, the Day and Night Scenes of Jerry Hawthorn, Esq. and his Elegant Friend Corinthian Tom* (London: Sherwood, Neely, and Jones, 1821) was translated as *Diorama anglais ou promenades pittoresques à Londres* (Paris: Didot, 1823).

61. *Tour in England, Ireland, and France*, vol. 2, letter 17, p. 301.

62. Honoré de Balzac, *Old Goriot*, trans. Marion Ayton Crawford (Harmondsworth, Middlesex: Penguin Books, 1985 [1951]), p. 74.

63. Balzac, *Old Goriot*, pp. 74–76.

64. July 13, 1829. Vincent Novello and Mary Sabila Hehl Novello, *A Mozart Pilgrimage: being the travel diaries of Vincent & Mary Novello in the year 1829*, ed. Rosemary Hughes (London: Novello and Co., 1955), p. 63.

65. Lady Morgan, in *Athenaeum*, Aug. 13, 1836, pp. 570–572, quot. Galperin, *The Return of the Visible*, p. 66.

66. "Dioramas and Cosmoramas," *New Monthly Magazine and Literary Journal* (London: Henry Colburn and Co., 1823), vol. 9, no. 1. (1823): 49. During the early silent film era, both aspects could be *produced* by the hand-cranked film projector. A phantom ride film shot from the front of a railway engine could be turned into a travelogue by cranking slowly, while fast cranking emphasized visceral qualities in the manner of theme park rides.

67. Pückler-Muskau, *Tour in England, Ireland, and France*, p. 63 (letter 7, visit the Regent's Park Diorama on Dec. 23, 1826); *Reise Sr. Hoheit des Herzogs Bernhard zu Sachsen-Weimar-Eisenach durch Nord-Amerika in den Jahren 1825 und 1826*, ed. Heinrich Luden (Weimar: Wilhelm Hoffmann, 1828), part 1, p. 304. He saw *L'abbaye de Rosslyn* (1824) at Regent's Park.

68. Nathaniel S. Wheaton, *A Journal of a Residence During Several Months in London; including Excursions through Various Parts of England; and a Short Tour in France and Scotland; in the Years 1823 and 1824* (Hartford: H & F.J. Huntington et al., 1830), p. 152.

69. His widely read book may have contributed to confusions. *Metropolitan Improvements or London in the Nineteenth Century* (London: Jones & Co. 1827), pp. 80–81. Another commentator wondered: "Is this diorama really, as the proprietors assert, a flat surface . . . or is it as I suspect, painted on the principle of the horizontorium, deriving all its effects from an optical or perspective deception?" Dubitans, in *Kaleidoscope* 5 (June 14, 1825): 420. Quot. R. Derek Wood, "The Diorama in Great Britain in the 1820s Part 2" (1993). Horizontorium refers to the baroque wing stage.

70. Frederick C. Bakewell, *Great Facts: A Popular History and Description of the Most Remarkable Inventions During the Present Century* (London: Houlston & Wright, 1859, p. 106.

71. J. P. Brès, "Le Diorama," *Le Musée Des Variétés Littéraires*, vol. 1, no 7 (December 1822), p. 293. One wonders if the writer is the inventor of the Myriorama (see chapter 2)?

72. "The Diorama," *European Magazine, and London Review* (London: Sherwood, Jones, & Co, 1823), vol. 84 (July–Dec. 1823), p. 342. The same source tells an incident, reported by

"a friend of ours," where a French girl asked her mother why all the rubbish had been left lying in front of the painting (p. 342).

73. Brès, "Le Diorama," p. 293; "Diorama," *Annales belgiques des sciences, arts et littérature* (Gand: J.-H. Houdin), vol. 12, 2d semester 1823), pp. 183–184.

74. Taylor, *A Month in London*, p. 74.

75. "Dioramas and Cosmoramas," *New Monthly Magazine and Literary Journal*, p. 494.

76. Years later a writer claimed that the pictures were behind green curtains: "We are still seated in that roundabout room, by which, after the curtain has fallen upon the moonlit cathedral, we are shifted face to face with some rural scene in the full glories of a summer sun." Does memory fail him, did this happen, or does he mean a diorama without a "roudabout room"? W[illiam] W[ilthew] Fenn, *Half-Hours of Blind Man's Holiday or Summer and Winter Sketches* (London: Sampson Low, Marston, Searle, & Rivington, 1878), vol. 1, pp. 299, 302.

77. "Peristrephic Exhibition," *The Circulator of Useful Knowledge, Amusement, Literature, Science, and General Information* (London: Thomas Boys, 1825), p. 318.

78. Jacob Goosequill, "The Oramas," p. 275. In "Dioramas," *Gentlemen's Magazine*, Sept. 1825, the Diorama was characterized as an exhibition "in which the spectators are subject to the peristrephic motion of an amphitheatrical building" (p. 259).

79. "Q.Q.Q,," "The Praise of the Past," *Inspector, Literary Magazine and Review* (London: Effingham Wilson, 1827), vol. 2, pp. 34–35.

80. Bakewell, *Great Facts*, p.103. The noises made him realize that "the scene before him was slowly moving

away" (the platform was rotating).

81. "You are then regaled with solemn church music, and assist at the vespers," wrote "an American Gentleman" [John Sanderson], *Sketches of Paris: In Familial Letters to His Friends* (Philadelphia: E. L. Carey & A. Hart, 1838), p. 246. Anno Mungen, "BilderMusik," *Panoramen, Tableaux vivants und Lichtbilder als multimediale Darstellungsformen in Theater- und Musikaufführungen vom 19. bis zum frühen 20. Jahrhundert* (Remscheid: Gardez! Verlag, 2006), pp. 179–188.

82. Letter, Oct. 14, 1836, in Eugène Viollet-le-Duc, *Lettres d'Italie: 1836–37* (Paris: L. Laget, 1971), pp. 166–67, quot. and trans. Pinson, "Speculating Daguerre," pp. 152–153. Viollet-le-Duc may have been thinking about Pierre Chatelain's work as a designer of "Russian Mountains," or proto–roller coasters, where the bare apparatus was directly seductive.

83. John Heskett, *Industrial Design* (London: Thames & Hudson, 2001, orig.1980), p. 27; Humphrey Jennings, *Pandemonium 1660–1886: The Coming of the Machine as Seen by Contemporary Observers*, ed. Mary-Lou Jennings and Charles Madge (London: Picador, 1987).

84. Oettermann's *Ankündigungs-Zettel* contains numerous examples from Continental Europe.

85. Suzanne Wray has researched their backgrounds and collected numerous notices about their shows, beginning in September 1840 in New York. The view of Venice must be the one already paired with Sébron's *The Departure of the Israelites out of Egypt*, when it was shown in Baltimore around 1836 (broadside in FB). It may be the one originally painted by E. Lambert for the British Diorama, but Bouton also painted a view of Venice, which was shown in Paris in 1828–29.

86. For other programs, Peter E. Palmquist and Thomas R. Kailbourn, *Pioneer Photographers from the Mississippi to the Continental Divide: A Biographical Dictionary, 1839–1865* (Stanford: Stanford University Press, 2000), p. 410.

87. Other unidentified pictures, including *Paris under Charles IX*, depicting the St. Bartholomew's day's massacre in 1572, and *The Sicilian Vespers, Or Palermo in 1282!* (at the Court House, Cleveland, August 1842; ad in *Cleveland Herald*, Aug. 18, 1842) were shown. Avery, "The Panorama and its Manifestation in American Landscape Painting," p. 49.

88. According to Avery, American reviewers did not pay much attention to their dioramic effects, considering them "as conventional easel pictures in which certain details or features of light and atmosphere were merely enhanced." The dioramic aspects may not have been fully realized. "The Panorama and its Manifestation in American Landscape Painting," pp. 44–45. Avery's claim that "paintings from Paris, Regent's Park, and Royal Bazaar Dioramas were all staple fare of diorama presentations in New York in the 1830s and 1840s" is exaggerated (ibid., p. 43).

89. Avery, "Dioramas in New York, 1826–1849," *Panorama newsletter*, Spring 1990, pp. 5–11.

90. Avery, "The Panorama and its Manifestation in American Landscape Painting," pp. 51, 70. The Brest picture was last shown at Regent's Park in 1837 and the Holyrood one in Edinburgh in 1835. Wood, "The Diorama in Great Britain in the 1820s, Part II." Sébron's *Crucifixion, with the City of Jerusalem* was shown in Philadelphia in 1835 and New York 1840, and probably elsewhere. David Karel, *Dictionnaire des artistes de langue Française en Amérique du Nord* (Quebec City: Presses de l'Université Laval, 1992), p. 743.

91. *The American Quarterly Register and Magazine*, 1849, p. 354.

92. Suzanne Wray, "R. Winter's Unrivalled Exhibition of Chemical Dioramas, Chrystalline Views, Chromatropes, &c. The Traveling Exhibitions of Robert Winter," *Magic Lantern Gazette* 19, no. 4 (Winter 2007): 8–19; "In the Style of Daguerre: Two 19th Century American Showmen and Travelling Exhibitions of Chemical Dioramas," paper read at the International Panorama Conference, Plymouth, UK, 2007 (unpublished).

93. Wray has pointed out that the word "chemical" was mentioned in early texts announcing the Daguerreotype, and could have been linked with the dioramas through Daguerre. A much publicized catastrophe happened to Harrison in Quebec on June 12, 1846, when the theater and the dioramas were destroyed, and 40–50 people killed. The cause was an overturned camphene lamp ("In the Style of Daguerre").

94. The brothers Henry and William Hanington started as commercial artists in New York about 1832. Henry disappears from records around 1855–1856, but William seems active as late as 1870. George C. Groce & David H. Wallace, *The New-York Historical Society's Dictionary of Artists in America 1584–1860* (New Haven: Yale University Press, 1966), pp. 288–289.

95. The Haningtons profited from a hoax started by the New York *Sun* newpaper in 1835, by claiming that Sir John Herschel, the famous astronomer, had detected life in the moon. They added a diorama of *Lunar Discoveries* to their program already in the same year. Matthew Goodman, *The Sun and the Moon: The Remarkable True Account of Hoaxers, Showmen, Dueling Journalists, and Lunar Man-Bats in Nineteenth-Century New York* (New York: Basic Books, 2008), p. 223.

96. *Hannington's Great Moving Dioramas! Panorama of the Hudson River! Wonderful Italian Fantoccini, or Life-Like Mechanical Figures, And the Grand Dioramic Spectacle of the Conflagration of Moscow!*, broadside, Free Street Hall in Libby's New Block, Portland [Maine], Mon. Jan. 13, 1851. (EH).

97. Maelzel conceived it in Vienna in 1813. It was displayed for decades both in Europe and in the United States. Joseph Earl Arrington, "John Maelzel, Master Showman of Automata and Panoramas," *Pennsylvania Magazine of History and Biography* 84, no.1 (January 1960): 56–92. Arrington discusses the itineraries and versions of the Conflagration of Moscow (pp. 89–92).

98. Arrington, "Lewis and Bartholomew's Mechanical Panorama of the Battle of Bunker Hill."

99. "Moving Diorama," *The Knickerbocker. New-York Monthly Magazine* (New York: Clark & Edson), vol. 6 (July 1835), p. 83. It mentions that Hanington's version of the Conflagration of Moscow was "similar to Maelzel's" (p. 83).

100. "The Author of *Two and a Half Years in the Navy*" [Enoch Cobb Wines], "Hanington's Dioramas," *Gentleman's Magazine*, ed. William E. Burton (Philadelphia: Charles Alexander, 1838), vol. 3 (July–Dec.), pp. 291–292.

101. "Odds and Ends. From the Port-Folio of a Penny-a-Liner," *Knickerbocker: Or, New-York Monthly Magazine* (New York: Clark and Edson), vol. 8 (Dec. 1836), pp. 710–711. The writer had just returned to the city from his vacation, which may have enhanced the perception.

102. Carter, *Letters from Europe*, p. 55.

103. "Editor's Table," *Ladies' Repository* 11, no. 8 (Aug. 1851): 319. The broadside promoted this scene in advance, promising "a vivid Portraiture

of Vessels Rounding Cape Horn in a Terrific Storm." The production seems the same as "Smith & Beale's Grand Moving Panorama [of] the Grand Route to and from California! By Sea and Land!," undated broadside, Masonic Hall, Chestnut St. [Philadelphia] (HL). Beale must have changed his partner to Craven at some point.

104. Eliza Leslie, *Miss Leslie's Behaviour Book: A Guide and Manual for Ladies* (Philadelphia: T. B. Peterson and Brothers, 1859), p. 241.

105. Edmund H. Wilkie, in *Optical Magic Lantern Journal and Photographic Enlarger*, 1901, pp. 40–42, 60 (quot. Hecht, *Pre-Cinema History*, p. 449, No. 447.) A program and catalog of the Royal Panopticon of Science and Art, Leicester Square (London, 1855) (GRI) mentions that Leicester Buckingham's lectures were illustrated by Dioramic Views. The descriptions ("7. The House of Sallust, restored, 8. The House of Sallust, in ruins") indicate that the "Dioramic Views" were dissolving views. Some were made by the well-known lantern slide manufacturer Carpenter & Westley; W. M. Fitch, *Grand Magic Lantern Entertainment*, broadside, 1880–1890s (EH).

106. Town Hall, Streatham, Jan 22, 1896, broadside (copy in EH). Malden was said to have lectured for ten years at the Royal Polytechnic Institution in London. He developed a special trunial lantern named Malden Trinopticon, manufactured by Thomas J. Middleton, London.

107. Wray, "R. Winter's Unrivalled Exhibition," pp. 8–19.

108. Repr. in ibid., p. 16.

109. "Diorama of Egypt and Palestine!" Lecture Room, Castle St., Aylesbury, Friday evening, April 3, 1857 (broadside, JJCB).

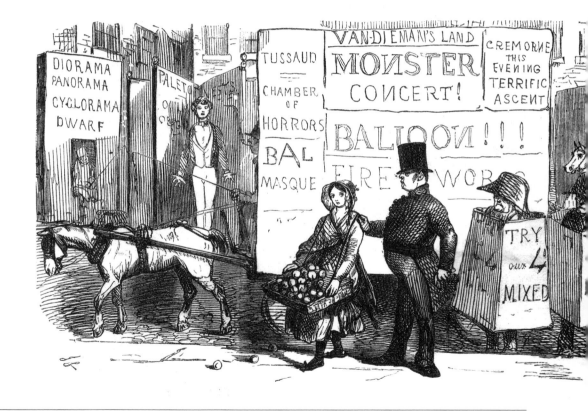

Figure 6.1
John Leech, "The Real Street Obstructions," *Punch*, XIX, no. 471 (July-Dec., 1850), p. 30. Broadsides promoting panoramas, dioramas and cycloramas are seen as part of the advertising landscape covering the streets of London. The text comments: "What with Panoramas and Paletots, Dioramas and Balloons, Registered Shirts, and Monster Concerts, there is no getting along the principal metropolitan thoroughfares without being reminded by some overwhelming van that all is van-ity." Author's collection.

6. PANORAMANIA:

THE MID-CENTURY MOVING PANORAMA CRAZE

DRY SEASON ON RAINY ISLANDS

In unserer an Pano-, Cosmo-, Neo-, Myrio-, Kipo-

und Dio-Ramen so reichen Zeit.

—M.G. Saphir, Berliner Courier, March 4, 1829[1]

A writer hiding behind the pseudonym "One Tom" exclaimed in 1824: "*The Ramas!*—One would think the population of the British Metropolis had turned Turks, and this was the season of the Ramadan; for we have the Diorama, Cosmorama, Panorama, Peristrephic-panorama, and Naturorama, all inviting the public to pay for a peep."[2] *The Etymological Compendium* seconded: "Reader, did you ever see the diorama, or the cosmorama, or the poecilorama, or any of the panoramas? If not, we advise you to go and see the whole of them immediately, because they are all very pretty affairs, and well worth seeing. But what is the meaning of these terrible-looking, fearfully-sounding words?"[3] Such litanies were not just playing with words—they reveal the impact and interdependence of the new spectacles.

During the 1830s and 1840s moving panorama shows continued touring England, but they do not seem to have attracted very special attention. The nationwide activities of Messrs. Marshall declined after the death of Peter Marshall in 1826. Except for the panorama of the sea battle of Navarino that Prince Pückler-Muskau saw in Dublin, no further national "hits" can be associated with their name.[4] Their tenure in London came to an end on August 5, 1826, when the Great Room at Spring Gardens, their regular venue, was closed, and demolished soon afterward.[5] William Marshall (as "Mr. Marshall") continued to exhibit

in Edinburgh until the late 1840s.[6] In 1850 it was announced that the rotunda would be demolished—ironically, just as panoramania had caught London by storm.[7]

Instead of focusing on a single feature, the exhibitions could be very heterogeneous both in form and content, as a program J. B. Laidlaw exhibited in Manchester (c. 1837–1838) demonstrates. Adhering to the mode of exhibition used by Messrs. Marshall, he claimed to have "erected, at a great expense, a Building on purpose."[8] The title of the program in his advertising broadside was long and detailed:

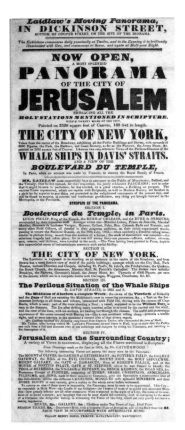

Now open, A Most splendid Panorama of the city of Jerusalem embracing all the holy stations mentioned in the scripture, within twenty miles of the city, Painted on 2520 square feet of Canvas, 140 feet in length. The City of New York, Taken from the centre of the Broadway, exhibition of all the Public Buildings and Streets, with upwards of 6000 Figures, the Park, the Harbour, and Coast Scenery, as far as the Narrows, the Jersey Shore, & c. painted on 2480 square feet of Canvas. Like wise two very extensive Views of the Perilous Situation of the Whale Ships in Davis' Straits. And a view of the Boulevard du Temple, In Paris, when an attempt was made by FIESCHI, to destroy the Royal Family of France.[9]

As the broadside shows, the four sections were shown in the following order: Boulevard du Temple, in Paris; The City of New York; The Perilous Situation of the Whale Ships in Davis Straits, in 1835–1836; Jerusalem and the Surrounding Country. Closer scrutiny reveals that they had quite different characters, both thematically and formally. There were glimpses of New York and Jerusalem, whereas the Paris and the Davis Straits sections had (more or less) topical interest: Giuseppe Fieschi had attempted to assassinate Louis Philippe on July 28, 1835, and the whaling boats Middleton, Viewforth, and Jane had been trapped in ice in the Davis Straits in 1835–1836. The assassination was a *single* view, while the ships were shown in "two very extensive Views." The New York section also may sound like a single view, but in fact it was a moving panorama divided into five "views" (or stops) and taken from an "eminence" opposite the City Hall. It made a complete circle around the elevated observation point. Laidlaw also exhibited another version, where this New York panorama was preceded by three connected views depicting the approach to the city from the sea, experienced from "a boat or vessel."[10]

The concluding section displayed Jerusalem in "a Variety of Views in succession," and was said to be based on "drawings

Figure 6.2
James B. Laidlaw, *Laidlaw's Moving Panorama in Dickinson Street* [Manchester], broadside, printer: Wilmot Henry Jones, Manchester, c. 1837. Author's collection.

made on the Spot in 1834, *by Mr. [Frederick]* CATHERWOOD." Catherwood was
a well-known architect, illustrator, and explorer, who had provided the sketches
for Robert Burford's circular panorama of Jerusalem (1835), exhibited later in
Catherwood's own rotunda in New York (1838).[11] The key in the handbook for
Laidlaw's show demonstrates that his moving panorama was based on the *same*
sketches as Burford's panorama.[12] Both consisted of two wide views, one facing
north and the other facing south. In the keys the views don't quite connect seam-
lessly into a full circle, but this may well have happened in the paintings.

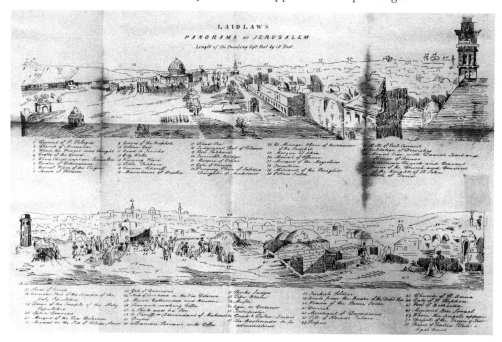

The viewing point is the roof terrace of the so-called "Palace of Pontius
Pilate" or "Aga's house" [today's el-Omariye college on the northern edge of the
Harem al Sharif or Temple Mount]. As the broadside states, there are "Numerous
Groups of FIGURES, consisting of TURKS, ARABS, CHRISTIANS, ARMENIANS, PILGRIMS,
and JEWS, each in their respective Costumes" standing in the foreground on the
terrace, which adds ethnographic interest and colorful visual spectacle.[13] It is in-
teresting to discover that the same design could be used as both static and mov-
ing variants. There seem to have been very few moving panoramas in which the
spectator's viewpoint *rotates* around a single observation post, but one wonders
if this could have been more common that earlier assumed.

Figure 6.3
Key to [James B.] *Laidlaw's Panorama of Jerusalem*, from
*Description of a View of the City of Jerusalem and the
Surrounding Country, Now Exhibiting at the Panorama in this
Town* (Hull: John Hutchinson, 1837). Author's collection.

Although the parts of Laidlaw's show may have been collected on the same roll, the format was discontinuous; no inner necessity connected its elements, which could be rearranged, modified, and replaced at will.[14] However, the general development led toward more coherence. A step in this direction was Charles Marshall's Kineorama, which opened on March 15, 1841, in London. Marshall (1806–1890) was a well-known scene painter (unrelated to Messrs. Marshall), who had created theatrical moving panoramas since the 1820s.[15] The Kineorama, or "Moving Views," promised "a novel combination of the expansive Panorama and the illusory Diorama."[16] The word was used to differentiate the production. The "series of consecutive and connected Views" took the audience on "a Tour through the most interesting portions of Turkey, Syria, and Egypt, from Constantinople to Cairo." The views were illuminated by gaslight; a mech-anism moved colored pieces of silk (probably in front of the hidden gas jets) to create atmospheric effects, while the auditorium had been disguised as a large tent with "striped drapery."[17]

The Kineorama combined and refreshed familiar elements by paying me-ticulous attention to details and overall effect. Although both the views and the guidebook made references to the recent Turkish war, Kineorama was essentially just a visual travelogue of the Near East. Theatrical moving panoramas had pre-sented armchair voyages for years, but their routes were usually closer to home; peristrephic panoramas had concentrated on topical subjects rather than travel. Kineorama anticipated the vogue for moving panoramas as means of virtual world travel.[18] It is not a surprise that Marshall contributed to the mid-century panoramania by further travelogues such as the *Great Moving Diorama, presenting a Grand Tour Through Europe* (1851).[19]

THE MOVING PANORAMA
PENETRATES AMERICAN CULTURE

Verily, a journey up Broadway was in those days almost

a circling of the globe.

—*Odell on the supply of moving panoramas in New York in 1850*[20]

Although there had been some false signals (such as Stollenwerck's exhibitions—see chapter 2), large-scale rolls of pictures in motion were introduced in the United States only in 1828 through the theater, nearly a decade after moving panoramas had begun rolling routinely across the stage in England. The first may have been included in a staging of James Fenimore Cooper's novel *The Red*

Rover in Philadelphia.[21] New York witnessed the scenic novelty in May, when the Park Theater presented a "Moving Panoramic View from Calais to Dover" as an interlude to Planché and Moncrieff's extravaganza *Paris and London; or, a Trip to Both Cities*. It was said to be an import from the Adelphi Theatre in London.[22] Another one was included in the same theater's production of C. Pelham Thompson's hit play *The Dumb Savoyard and His Monkey* in the fall.

The Bowery Theater, which had just been rebuilt after a devastating fire, countered in November with a "moving diorama" (or "Eidophusicon") inserted in William Dunlap's new play *A Trip to Niagara, or Travelers in America: A Farce in Three Acts*. Created by the theater's scene painters under the direction of Mr. Jones, it depicted a steamboat trip on the Hudson river from New York City to the landing at Catskill in eighteen "scenes." Although it was said to be a "continuous view," the distance it covered would have been too long for a seamless presentation. The panorama may have rolled behind a cutout steamboat with its "works" in motion; mechanical miniature boats, including one "hoisting up the sails," were also used.[23] The dioramic light effects included the (indispensable) storm, the setting sun, and house lights in the distance.[24] The presentation was accompanied by music, which was soon also issued as sheet-music.[25]

The production must have been influenced by British predecessors, but the "scenic trickery" may well have drawn additional inspiration from mechanical theaters that had been exhibited in the city for years. In the preface to the printed edition, Dunlap readily admitted that the moving diorama was the real motivation behind the play: "The following Farce, for, be it remembered, it makes pretentions to no higher character, was written at the request of the Managers, and intended by them as a kind of running accompaniment to the more important product of the Scene-painter."[26] This is a perfect summary of the tendency that had been developing for years: media spectacle was gaining ground at the expense of human actors and plots. A critic, who agreed that there was "not the slightest connection with the dramatic fable," chose to review the panorama under "Fine Arts."[27]

As a representation of a river journey the Hudson panorama anticipated later American panoramas.[28] Its independent nature was emphasized by the fact that already in 1829 it was presented as a separate attraction at Vauxhall Gardens, one of the city's pleasure gardens, where it was preceded by a "splendid drop scene, representing the city and Harbour of New York."[29] In the fall of 1830 it was Niblo's Garden's turn to introduce a Grand Peristrephic Panorama with "connected views" of the Battle of Navarino.[30] It must have been considered a novelty, because it remained on display for months. The following year Niblo's Garden presented a peristrephic panorama of Waterloo, St. Helena, and the funeral of Napoleon.

Both were brought over from England by a showman named William Sinclair, who seems to have exhibited the latter as early as 1821.[31] The broadside, however, claimed: "It was brought from Spring Garden [sic], London, to the Saloon in Niblo's Garden, New York," referring to Messrs. Marshall's presentations.[32] Sinclair's panoramas were exhibited around the United States and

Canada until at least the 1840s. Nothing indicates that the semicircular arrangement was ever used, although a special building was erected for the Napoleon panorama in St. Louis in 1838, because the existing ones were not large enough.[33] The word peristrephic was adopted by others as well. In 1842 T. C. Bartholomew advertised "A Peristrific [sic] Scene of unrivalled splendor, called the Enchanted Isle, Or, Approach to the Magic Grotto, of the Sultan of the Genii!!"[34] It was claimed to provide "a series of continuous Scenes, which pass in succession," but was most likely a mechanical theater.

H. Stewart Leonard wrote in 1950: "Yankee ingenuity brought about the development of the panorama which consists of a canvas wound from one vertical roller to another behind an enframement or stage opening."[35] We already know that "Yankee ingenuity" began to grapple with the moving panorama long after it had been introduced in Europe. Still, the idea that it was an American invention caught the imagination and has persisted. This must have had something to do with the suddenness with which American industrial products burst onto the European scene in the mid-century, especially through the Crystal Palace exhibition. As the British *New Monthly Magazine and Humorist* wrote, "The introduction of moving panoramas of scenery into this country by the Americans, has been most beneficial to the progress of knowledge."[36]

Circular panoramas did not catch the American imagination (until the latter part of the century); the pioneer John Vanderlyn died in poverty. They may have been considered too static, European, and academic. Henry Aston Barker's and Robert Burford's Panorama of Athens, which was donated to Harvard University in 1819 and displayed for decades, was used as an ideological vehicle to spread a sense of the United States as an inheritor of the civic values of classic Greece.[37] American Hellenism may have appealed to the aspirations of the elites of the East Coast, but it hardly corresponded with the general character of the American civilization. Moving panoramas expressed it much better. Because everything is on a great scale in the American nature, the *Lady's Journal* argued, "it remained for an American [John Banvard] to produce something analogous."[38] The showmen used similar arguments:

> In fulfillment of this natural effect, it was reserved for America to be the first to attempt works of art on a gigantic scale, and to furnish paintings on an extent of canvass [sic] equal to the distance traversed by a Londoner in an ordinary trip on board a steamer. The Colosseums and the Panoramas had long been viewed as masterpieces of gigantic art; but what are these compared to a Panorama four miles in length? The fact is before us.[39]

It would be tempting to suggest that the movement of the canvas itself attracted Americans, because they were living in a society in motion. Cultural historians like Leo Marx have provided plenty of evidence about the cultural imaginary around the machine (including the train) penetrating the wilderness.[40] A link between the American character, the new means of transportation and moving

panoramas was detected by Ephraim Stowe, Esq., an old gentleman from Hub-
bardston (Mass.). Otis A. Bullard's *Panorama of New York City* (1850) inspired him
to concoct verses that may not deserve a place in the golden book of poetry, but
that greatly delight the media archaeologist:

> *There has been a time, so the knowing ones say,*
> *When, to go to New York, took a week and a day;*
> *But when the stage coaches were put on the track,*
> *In a week and a day you could go and come back.*
> *Well, Yankees are never content to go slow,*
> *And their heads are brimful of invention, you know,*
> *So a great "Iron Horse" was put on a railway,*
> *That would carry you there in less than a day.*
> *And now, if you choose, you may jump on the cars*
> *And go nearly there by the light of the stars:—*
> *Take dinner at Hubbardston, sup on the way,*
> *And in the great City take breakfast next day.*
> *Well, this was indeed a remarkable feat, -*
> *And the wise ones declared it could never be beat;*
> *But in process of time, new wonders arise,*
> *That strike the beholder with greater surprise -*
> *For now, since the great Panorama has come,*
> *You can see the whole city and not go from home;*
> *You pay but a quarter for the artistic skill,*
> *And saunter down Broadway, while sitting stock still.*
> *Spread out on the canvas, this gigantic place*
> *Lies before you as plain as the nose on your face;*
> *And to see all the wonders o'er this spacious field,*
> *You have nothing to do just keep your eyes peeled.*[41]

The geographically scattered and expanding American civilization favored
transportable media forms. Beside the horse and the cart, the bulky panorama
rolls could be transported by riverboats or trains. The latter could also be used to
organize excursions to carry provincial spectators to shows in nearby cities.
Josiah Perham, the "father of the cheap excursion system," transported large
numbers of people to Boston to witness a panorama by William Burr he had re-
named as *Perham's Pictorial Voyage, known as the Seven Mile Mirror to Canada, American
Frontier and the Saguenay*. But Perham did not leave it at that: he also organized
tours to the sites depicted in the panorama, placing the spectator-travelers "in
position to compare the beauty of the one and the truthfulness of the other."[42]
This anticipated by half a century similar practices of the silent film era.[43]

Imported panoramas, as well as the dioramas exhibited by Maffey & Lonati,
Robert Winter, Mark R. Harrison, and others, gave audiences glimpses of foreign
lands, but Americans were more curious about their own continent. The ex-
panding frontier, the experiences of the pioneers, the Indian wars, the voyages

of discovery, and the Civil War provided plenty of topics. Virtual trips through the wilderness, adventures along the great rivers, and expeditions across the continent were (in)directly connected with the imaginations of all Americans. Moving panoramas fascinated everybody—those who were planning to go West and those who preferred to stay behind. New audiences could be found everywhere, as long as the exhibitors managed to convince the population that their programs were morally and ethically sound.

When Sinclair's peristrephic panorama visited Cincinnati, it was announced that the show "is nothing of a theatrical exhibition, so that no religious scruples need prevent anyone from visiting it."[44] This idea was endorsed by religious apologists concerned with disseminating the principles of pious life. In *The Young Man's Friend* (1849), the Puritan Daniel C. Eddy drew a sharp distinction between "dangerous amusements" and "innocent amusements." The former included dancing, gambling, social drinking, and the theater, where "more characters are ruined . . . than by any other device of Satan."[45] The list of innocent amusements comprised useful reading, music, literary lectures, religion, as well as "paintings, and other works of art."

Eddy's examples of the latter include "Voyage to Europe," "Scenery of the Rhine," and "Views of the Mississippi and Ohio," which reveals that he had moving panoramas in mind (although he did not use these words):

The late works are well-adapted to the common mind, and though in many cases destitute of artistic skill, are really valuable in giving us an idea of the scenery of various countries which we have never visited. These exhibitions form a pleasant and profitable mode of securing recreation, and deserve the patronage of all young people. The artists in almost all cases are young men, and deserve the support of community for the services which they have rendered.[46]

JOHN BANVARD,
OR THE MAKING OF A MYTH

The American production really got underway in the 1840s, yet its origins went back to the previous decade. Pioneers like John Rowson Smith (1810–1864) and John Banvard (1815–1891), who gained success with their huge Mississippi panoramas in the 1840s, had moved to the Mississippi region by the mid-1830s,

Figure 6.4
Large broadside announcing the opening of John Rowson Smith's *Gigantic Moving Panorama of the Tour of Europe* at the Stock Exchange, Leeds, UK, on March 25 [1852]. The panorama contains a sequence on the Ascent of Mont Blanc, a topic made popular by Albert Smith in London. After exhibiting it around Europe, John Rowson Smith brought his panorama to the United States. Author's collection.

and were active in miscellaneous painting jobs. The former created theatrical scenery in St. Louis, while Banvard may have worked briefly as a scene painter on what is known as America's first showboat, the Chapman family's Floating Theatre, and is also said to have created dioramic paintings displayed on a flatboat.[47] These early efforts were modest in scale and ambition. As part of her Polite Illusions show, a certain Miss Hayden, an itinerant female magician, exhibited in 1839 Smith's early panorama of the Mississippi, and introduced the next year a "grand moving diorama of the cities of Jerusalem, Venice, &c."[48] At least the scene depicting Venice had been painted by Banvard from secondary sources.[49]

Things began to change when Banvard's panorama of the Mississippi began touring the country in 1846. Based on a lengthy sketching trip along the river, its scale and ambition were unprecedented. The self-taught Banvard was not shy about his achievement, which he claimed to be three miles long. Almost identical articles about his life, which must have been based on material supplied by the panoramist himself, began pouring out from the press. Many recounted an episode supposed to have taken place when Banvard was still a boy living in his family's home in New York City. Banvard, so the story goes, created an entertainment for which he even printed little broadsides (with his friend, the son of the poet Samuel Woodworth). The episode would sound like a legend had one of these crudely printed documents not survived:

> *Banvard's Entertainments,*
> *(To be seen at No 68 Centre street, between White and Walker.)*
>
> *Consisting of*
>
> *1st. Solar Microscope*
> *2nd. Camera Obscura,*
> *3d. Punch & Judy,*
> *4th Sea Scene,*
> *5th. Magic Lantern.*
> *Admittance (to see the whole) six cents.*
> *The following are the days of Performance viz.*
> *Mondays, Thursdays, and Saturdays.*
> *Performance to commence at half past three P.M.*
>
> *John Banvard Proprietor.*
> *F. Woodworth, Printer, 521 Pearl street.*[50]

Figure 6.5
The cover of the booklet *Banvard; or the Adventures of an Artist; A Biographical Sketch* (London: Reed and Pardon, 1851). Author's collection.

Did the boy exhibit his show publicly, or just for family and friends? The latter option is more likely. The program imitates the routines of entertainers whose exhibitions Banvard may well have seen. It is impossible to tell how functional his devices were. The "Sea Scene" may have been an imitation of the stock scene included in almost all mechanical theaters. The Mississippi panorama pamphlet characterized it as "a respectable diorama of the sea, having moving boats, fish, and a naval engagement." [51] Banvard may well have had access to John Babcock's popular handbook *Philosophical Recreations, or Winter Amusements* that appeared in 1820, and was reprinted numerous times. It instructed the young hobbyist how to construct and use devices such as solar microscopes, camera obscuras, and magic lanterns. As it happens, Babcock's example of do-it-yourself mechanical lantern slides is none other than "A Storm at Sea."[52]

There was nothing exceptional in home-made versions of public entertainments. The famous lantern slide painter Joseph Boggs Beale, the moving panorama showman Albert Smith and many others constructed and exhibited toy panoramas as children.[53] During the Civil War a schoolboy named Willie Kingsbury cut out pictures of soldiers and war scenes from *Harper's Weekly*, colored them, and pasted them onto a scroll. With his self-made moving panorama apparatus he gave performances for boys and girls in the attic.[54] Detailed instructions could be found from children's magazines and books.[55]

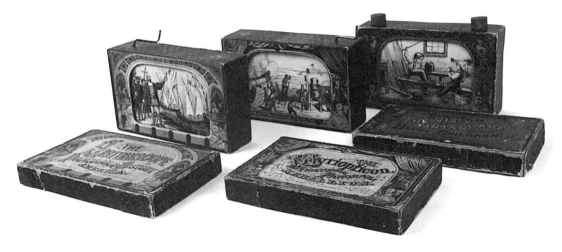

When the game and toy maker Milton Bradley released his first toy moving panorama, *The Myriopticon: A Historical Panorama of the Rebellion,* in 1866, he must have built on this tradition just as much as he imitated the "War Shows" touring the country. The company's history claims that Bradley drew the pictures himself, although many of them are based on iconographical models found from

Figure 6.6
Milton Bradley's three toy moving panoramas: *The Historiscope*, *The Myriopticon*, and the *Panorama of the Visit of Santa Claus to the Happy Children*. Springfield, Massachusetts, after 1866. Author's collection.

illustrated magazines and other public resources.⁵⁶ In spite of its minuscule size, *The Myriopticon* made it possible to re-enact public panorama shows in the privacy of one's home. It was delivered with a lecture text, a handsome broadside, and a set of tiny entrance tickets. Bradley encouraged children to create an active relationship with their toy panoramas, as the booklet that accompanied his *Panorama of the Visit of Santa Claus to the Happy Children* (c. 1870) clearly stated:

> After this descriptive lecture may have become old, it is suggested that the young members of the family take turns in preparing original lectures to be delivered at the exhibitions. The great variety of scenes admit of the greatest freedom in the lectures, and nothing can afford a better subject for compositions than these pictures, as thereby two objects are attained; first, the study of pictures, and second, the practice in composition.⁵⁷

From the outset, self-promotion played a role in Banvard's rise to fame and fortune. The handbook of his Mississippi panorama (published in 1847) began with a thirteen-page autobiography; the river and the panorama could wait. Countless other publications described Banvard's adventures on his sketching trip, including episodes such as hunting for game, surviving an attack by organized bandits, a shipwreck, and braving the burning sun, which made his skin peel off "from the back of his hand and from his face."⁵⁸ The story of struggle and persistence came into fruition in the "Largest Picture ever executed by Man."⁵⁹ As early as 1853 Banvard's story was included in a children's book and retold many times as an elevating example for the young.⁶⁰ His life on the Mississippi made great reading (decades before Mark Twain's *The Adventures of Huckleberry Finn*, 1884), and raised curiosity toward his panorama. Banvard did his best to meet the expectations by lecturing in the colorful style of a frontiersman, which matched perfectly the roughness of his panorama.⁶¹

Banvard's "Three-Mile Picture" may have been the *primum mobile* of the wave of American moving panoramas that rose in the late 1840s, but others soon took the opportunity. The showmen stalked each other's offerings, and their paths frequently crisscrossed. News spread by newspapers, as well as word-of-mouth, influenced their itineraries and products. A competitive marketplace emerged within a few years. Some of Banvard's competitors tried to fashion similar myths about themselves. Otis A. Bullard (1816–1853), the creator of a *Panorama of New York City* (1850), disseminated stories about his humble beginnings, poor education, natural talent, and persistence. The moral of his story was, "God helps those who help themselves."⁶² In reality there were both success stories and failures; ambitious products and cheap exploits. As the *Evening Mirror* admitted, "In these days of panorama mania, of course there are daubs exhibited, dignified with the title of 'panorama,' which are but frauds upon the public, and are calculated to affect seriously the interests of those whose exhibitions are really meritous."⁶³

TRIPS TO THE WORLD AND THE HEART:
PANORAMIC GENRES IN AMERICA

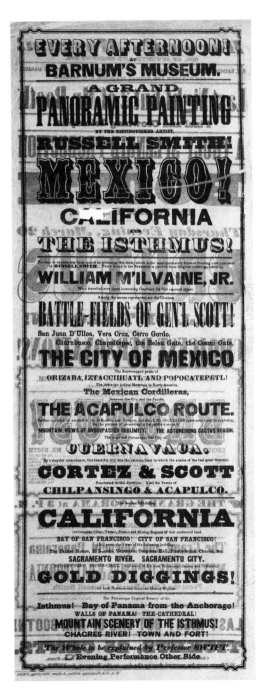

Virtual voyaging across the North American continent was the most important of the early panorama genres. The mighty Mississippi River defined the frontier between civilization and wilderness, and inspired no less than seven competing panoramas.[64] All except one—the Dickeson-Egan Panorama, which will be discussed in chapter 8—conformed to the same basic formula. Based on sketching trips along the "Father of Waters," they purported to offer the spectators armchair cruises up or down the river. The direction depended on the performance—to avoid damaging the painting by rewinding it, the showmen simply changed the direction. This practice was expressed in a British panorama handbook with words that almost recall *Alice in Wonderland*: "The reader will be kind enough to commence reading the following description from the end, when the Panorama commences moving from that extremity."[65]

The Mississippi panoramas inspired others; panoramas transported audiences far and wide. To prepare William Burr's *Seven Mile Mirror! or, A Tour of 2000 Miles on the Great Lakes, the Niagara, St. Lawrence and Saguenay Rivers* the artists claimed to have walked much of the way.[66] Otis A. Bullard depicted New York City, Godfrey N. Frankenstein Niagara Falls, M. Luther Emerson and George Brewer the Mammoth Cave of Kentucky, and J. H. Fitzgibbon Kansas and the Indian Nations.[67] Venturing further, Capt. Donnavan and Sherman & Tousey took audiences to Mexico, while Skirving's panorama of *Fremont's Overland Route to Oregon and California*, Siegler's *Grand Moving Panorama of a Voyage from New York to Sanfrancisco* [sic] *Via Cape Horn*, Farrand & French's *Panorama of an Overland Trip to California*, Smith & Beale's *California by Sea and Land*, L. Eaton Emerson's *A Glimpse of the Golden Land*, and some years

later (George) Tirrell & Co's *Panorama of California* all ended up in an earthly utopia by the Pacific, the "golden state."

Panoramic trips to Europe included Walter McPherson Bayne's *Gigantic Panorama of a Voyage to Europe* (which premiered as early as in 1847), Samuel Bell Waugh's *Mirror of Italy*, or *Grand Tour through Italy*, Hutchings's *Grand Classical Panorama of the Mediterranean*, and Benjamin Champney's *Great Original Picture of the River Rhine*. The latter was connected with two unrelated views of the French Revolution of 1848, which may have been used as drop-scenes while the reels were being changed.[68] P. T. Barnum commissioned a *Grand Moving Picture of the Crystal Palace*, a virtual visit to the Great Exhibition of 1851.[69] It began with a bird's-eye view "taken at the Altitude of a Balloon," and then took the spectators on a stroll down the aisles of Joseph Paxton's great glass house. The views were said to be fifteen feet tall and have been painted from sketches taken "on the spot." They could quite as well have been based on photographs or the detailed miniature roll panorama distributed by the *Illustrated London News* for its readers.[70]

Benjamin Russell's and Caleb P. Purrington's *Original Panorama of a Whaling Voyage Round the World* premiered in 1848.[71] It did not create a genre; the *South Sea Whaling Voyage*, painted by Samuel L. Culvert and exhibited by Captain E. C. Williams between 1858 and 1866, is one of the few others that are known.[72] Panoramas of polar explorations were more numerous. The genre was pioneered by the Philadelphian showman Edmund Beale, the uncle of the future lantern slide painter Joseph Boggs Beale, who commissioned from the scene painter George Heilge a panorama about the First Grinnell Expedition (1850).[73] Other arctic panoramas were inspired by the sensational return of Dr. Elisha Kent Kane from his second expedition in 1855, and his untimely death soon afterward.[74] Panoramas about arctic exploration, such as Messrs. Marshall's *Grand Peristrephic Panorama of the Polar Regions* (1820), had been displayed in England decades earlier, but they don't seem to have directly influenced American products.

Predictably, religion also provided inspiration—after all, the moving panorama was deemed morally safe and suitable even for children, women, and churchmen. The Boston-based artist Henry Cheever Pratt introduced already in 1849 a "Magnificent and Highly-finished Panorama[,] A Walk in the Garden of Eden with Adam and Eve," which had been inspired by John Milton's *Paradise Lost* (1667).[75] In the same year the Cincinnati-based artist J. Insco Williams began exhibiting his *Panorama of the Bible*, which depicted the sacred history from "Chaos" and the "Creation of Light or Caloric" to the "Babylonish [sic] Captivity." Because it covered only the Old Testament, the artist may have been planning a sequel. Instead, he had to paint the same thing all over again, because the original was destroyed in a fire in Philadelphia in the spring of 1851.[76] Williams was trying to "awaken in the public mind" an interest in Biblical Literature:

> In this age of improvement, whilst Panoramic Paintings are becoming numerous, and eliciting a good degree of public favor, as a new mode of presenting either truth or fiction, the subject which our artist has

‹ Figure 6.7
Broadside for Russell Smith's (1812-1896) moving panorama of Mexico, California, and the Isthmus (1850), on display at Barnum's Museum, Philadelphia, in March 1851. The lecturer was Professor Swift. The panorama was based on drawings made on his travels by the landscape artist and author William McIlvaine, Jr. (1813-1867). P. T. Barnum opened his museum in Philadelphia in 1849 at the Corner of the Seventh and Chestnut Streets, but it burned down already on December 30, 1851. Author's collection.

184

chosen is well timed, and even neccessary [sic] to the wants of society; for, whilst as a work of great beauty, it cannot fail to secure the admiration of all lovers of the fine arts, it will have the rare merit of improving the feelings of the heart.[77]

A particularly successful production was the recently rediscovered and restored *Moving Panorama of Bunyan's Pilgrim's Progress* (1850; also known as *Bunyan's Tableaux*), which was, as its title indicates, based on John Bunyan's classic Christian allegory *Pilgrim's Progress* (1678). The choice was far from fortuitous, because the book was widely read in America in the 1830s and 1840s, when the Anglican faith became involved in a fundamentalist-liberal controversy.[78] Beside its moral and religious goals, the panorama manifested evident aesthetic ambitions.[79] It was a collaboration by a group of well-known and respected painters: Frederic Church, Edward Harrison May, Daniel Huntington, Joseph Kyle, Jacob Dallas, Jasper Cropsley, F.O.C. Darley and Peter Paul Duggan. Whereas many panorama painters remained anonymous (perhaps by choice), this time everybody's name was listed. Most spectators must have known the subject matter by heart, which is why the broadside emphasized another asset, exclaiming: "THE STORY IN COLOR!" It proudly quoted the *Literary World*:

We take such an exhibition as that recently opened of the panoramic painting of the Pilgrim's Progress, as one of the best signs of the times. Its predecessors were, with whatever other merit, all in the commonest spirit of appeal to idle curiosity, and gratification of a desire for a little everyday information with regard to the physical peculiarities of the Mississippi River, Cuba, and California.[80]

The search for balance between popular exhibitions and higher cultural values worked well. An identical copy was soon produced to meet the demand—a small but significant step that anticipated film distribution.[81] The Bunyan panoramas remained in circulation for many years, inspiring yet another version in 1867, and possibly serving as a model for lantern slides as well.[82]

Moral values were also promoted by *Johnson's Moving Panorama of the Drunkard*, presented with a vocal concert by the "popular and talented New England songsters."[83] It told a "thrilling, mirthful, sad, moral, and instructive" temperance story of a drunkard's fate by means of twenty scenes said to contain 200 figures, painted in oil.[84] It is no wonder that the panorama was also evoked in purely literary endeavors, such as William Arnot's book *The Drunkard's Progress; Being a Panorama of the Overland Route from the Station at Drought, to the General Terminus in the Dead Sea* [1853] demonstrates. It was illustrated by thirteen engravings by John Adam, while the descriptions were said to be given by "John Bunyan, Junior."[85]

Humorists did not neglect the moving panorama either. The minstrel group New Orleans Serenaders presented an extravaganza called "the Musical PA-NOR-A-MA, Executed by the IN-FAINT ORPHEANS on the RUSH-ING-HORNS, EX-TIN-guishing all the

‹ Figure 6.8
Sequence from the newly restored *Moving Panorama of Pilgrim's Progress*. Photograph: Matthew Hamilton. Courtesy of Dyer Library / Saco Museum, Saco, Maine.

RESURRECTION OF HENRY BOX BROWN AT PHILADELPHIA.

DIS-TIN-guished PERFORMERS Of the age, and sufficiently seasoned without the aid of MUSTARD."[86] The piece was "supposed to commence at the CASTLE GARDEN and proceed up BROADWAY to the SOCIETY LIBRARY, and thence to CALIFORNIA, ILL-LUMI-NATED by a DRUM-ON LIGHT." The "Splendour" was promised to "excell the Grand Carnival Scene in MONT A CRISTI." There was likely no panorama at all, but the references must have been familiar for everybody. Also in the humoristic vein, the comic lecturer Artemus Ward created a panorama spoof about his experiences among the Mormons (see chapter 8), and the well-known cartoonist Thomas Nast a *Grand Caricaturama* (1867), which consisted of thirty-three "grand histori-cal paintings," satirical commentaries on episodes from the American history.[87]

Last, but not least, one should not forget the *Grand Panorama of American Slavery*, exhibited by the former slave Henry Box Brown, who had sensationally escaped from slavery in a sealed crate sent by railroad to Philadelphia.[88] Except for two views, the panorama that accompanied his lectures did not concentrate on his personal experiences, depicting slavery in a more general way.[89] Much of the success of Box Brown's exhibition was based on the reality effect created by his own presence. He exhibited a box, which was said to be identical to the one in which he had been sent to freedom. Even at his advanced age he ritually emerged from it in every performance. This symbolic resurrection was illus-trated in the broadsides and became his trademark.[90] Like Banvard, Brown was the absolute center of his show; the panorama, no matter how attractive, was secondary to his personal aura.[91]

Figure 6.9
"Resurrection of Henry Box Brown at Philadelphia," from a broadside for his *Original Grand Panorama of American Slavery*, shown at British School, Earl Street, Stafford, Feb. 20, 1854. Courtesy of Harvard Theatre Collection, Houghton Library.

Another moving panorama containing scenes of slavery was Ball's *Splendid Mammoth Pictorial Tour of the United States, Comprising Views of the African Slave Trade…* (1855), by the African-American artist James Presley Ball Sr. (1825-1904).

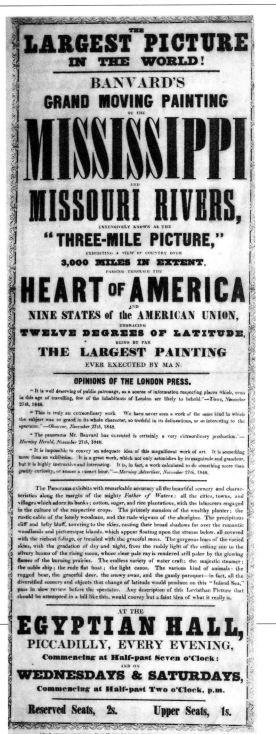

THE AMERICAN INVASION OF THE BRITISH ISLES

"The Mississippi Panorama certainly started the miles of painted canvas that three times daily roll across and back again, before the tarry-at-home travellers."

—Albert Smith and John Leech, *A Month: A View of Passing Subjects and Manners* (1851)[92]

Most American showmen were content with the domestic exhibition circuit, but some were eager to gamble for higher profits across the Atlantic. Because of regular shipping routes, shared language, and historical and economic connections, England was the logical starting point for their foreign ventures. Success in London, the entertainment capital of the world, was seen as a stepping stone for other markets as well, including the Continental Europe.

Opening the trail, on September 27, 1848, Banvard embarked on a boat to Liverpool with the Mississippi rolled around four giant cylinders. After reaching the British Isles, he headed toward London. Soon after his exhibition opened at the Egyptian Hall in late November, it became clear that something extraordinary was underway. A few weeks later a foreign correspondent sent a lively report about the situation to the American *Home Journal*, demonstrating how effectively mass communications were already spreading the news:

Figure 6.10
Broadside for John Banvard's *Grand Moving Painting of the Mississippi and Missouri Rivers*, Egyptian Hall, London, c. 1850. Author's collection.

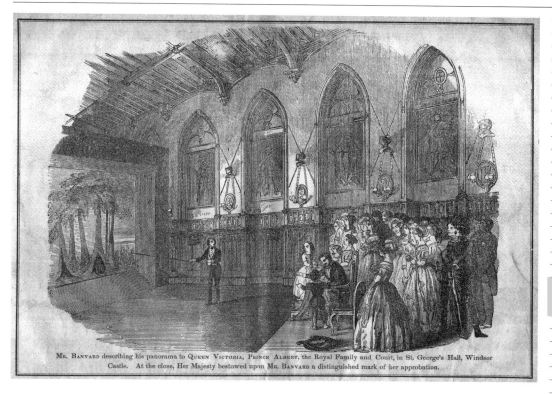

MR. BANVARD describing his panorama to QUEEN VICTORIA, PRINCE ALBERT, the Royal Family and Court, in St. George's Hall, Windsor Castle. At the close, Her Majesty bestowed upon MR. BANVARD a distinguished mark of her approbation.

> *Banvard has set the artists all at work here, and his name is so famil-*
> *iar and his success so great, that he is quoted in all the pantomimes*
> *and at some of the most popular theaters; conundrums are made on*
> *his name, to the great amusement of the audience. The benefit which*
> *English and American artists have derived from his skill and ingenu-*
> *ity will long be felt, and they reflect much credit on the inventive*
> *genius of a live-born Yankee.*[93]

It was inevitable that others would try to profit from the situation. John Skirving's panorama of Colonel Fremont's Overland Route to Oregon and California literally followed Banvard's footsteps, opening at the Egyptian Hall in April 1850.[94] Teamed with a colorful showman known as Professor Risley, John Rowson Smith was among the first.[95] The news that a competing Mississippi panorama had arrived alarmed Banvard, who started cautioning the British against cheap imitators. When his panorama began touring the provinces, he had to fight against "impostors," who, as he claimed, had even adopted the title

Figure 6.11
John Banvard presenting his panorama to the royal family in St. George's Hall, Windsor Castle. From *Description of Banvard's Pilgrimage to Jerusalem and the Holy Land; Painted from Authentic Drawings made upon the Spot during an Extensive Journey, undertaken expressly for the Work, in Four Immense Volumes; Presenting in Minute Detail*

The Sacred Localities; the Cities, Mountains, Plains and Rivers; celebrated in Scriptural History. Now Exhibiting at the Georama, 596 Broadway, 1853 [New York: John Banvard, 1853]. Author's collection.

"Banvard's Panorama of the Mississippi." In a notice he placed in the *Manchester Guardian* (1851), Banvard characterized the other painting as "a bit of dirty, ragged canvas, containing a few scenes copied from 'Banvard's;' and the rest of it invented and made up for the occasion."[96] A discursive battle broke out. The newcomers Risley and Smith launched a counterattack in the preface to the handbook they sold for the spectators:

> *In other attempts to convey to the eye and mind of the spectator a reflex of these grandest works of Nature's hand, there are very many serious drawbacks—putting aside the crude effort of the uncultivated artist [Banvard]—many of the most beautiful views on the banks of the great Mississippi are entirely omitted, and many of the scenes introduced are entirely imaginary. In the work now presented to the public there is not an inch of attractive landscape omitted—not a patch of inlet—not a rock—nay, scarcely a tree.*[97]

The roughness of Banvard's painting was well known—indeed, even before sailing for Europe he had been advised to add some "artistic finish."[98] Still, his "Three Mile Picture" offered an epic armchair voyage to a romantic borderland where civilization was having its hard but triumphant struggle against wilderness. Nothing quite like it had been experienced by London audiences. There were scruples about the length of the panorama, but the performance did last more than two hours and the canvas was said to move most of the time.[99] As Charles Dickens noted, a big part of the attraction was Banvard's Yankee character: "There is a mixture of shrewdness and simplicity in the latter [Banvard], which is very prepossessing; a modesty, and honesty, and an odd original humour, in his manner of telling what he has to tell, that give it [the show] a peculiar relish."[100]

Banvard's success was crowned by an invitation from Queen Victoria and Prince Albert to perform for the royal family at the Windsor Castle. True to his style, Banvard never failed to mention this in his publicity.[101] Having toured England, he exhibited in Paris, and traveled then to Near East to take sketches for a new panorama.[102] After returning to New York, he established a permanent show-place named Georama at 596 Broadway, and put his even more gigantic panorama of Jerusalem and the Holy Land on display. Hurting from past experiences, Banvard asked in the descriptive booklet for "a great personal favor should any of the audience see a person taking sketches from the painting, to inform one of the ushers, as his painting of the Mississippi was basely pirated when on exhibition in New York, in 1847."[103] Frontiersman style had given way to a more refined idiom, reminiscent of Albert Smith's calculated antics at the Egyptian Hall.

Punch wrote about "Monster Panorama Manias" as early as in 1849, but it was Albert Smith who coined the word *panoramania* the next year in a witty article he wrote to the *Illustrated London News*.[104] He satirized panorama-madness by fantasizing about localized panoramas of the future, such as "The Paddington Canal, from its mouth to the Second Cataract, at the locks on the Harrow-road"; "The Overland Mail from the City to Greenwich"; "The Queen's visit to Claremont"; and "The Thames, from Chelsea to Rotherhithe." A panorama of "Oxford-street, from its rise in Holborn to its fall into the Bayswater-road" would "depict every house, on both sides of the way at once, by a novel perspective arrangement; and, for a small consideration, [we] shall allow tradesmen to attach what placards they choose to their establishment."

Dioramic effects would of course be included: "*Tottenham-court-road, by sunrise; The Simoon, at the Regent Circns* [sic], with clouds of dust; *The Pantheon by Night,* with the illuminated clock at the Princess's Theatre (safe for applause); *The Departure of a Caravan* (by order of the police) from the corner of Vere-street; *The Broken-down Hansom,* by sunset; a touching spectacle; and *Night on the Hyde-park Prairie,* with bivouac of vagrants." The culmination of Smith's imaginary panorama was the Egyptian Hall, the "Karnac of Piccadilly," at the "junction of the Mississippi with the Nile." The quip referred to two panoramas that had recently been exhibited there; one wonders if Smith had already decided that he would join their company with his own production.

Smith considered Banvard as the cause of the panoramania, but the *Almanack of the Fine Arts* added another impetus: the approaching Crystal Palace Exhibition. It speculated that the "prospect of the influx of foreign visitors during the period in which the Crystal Palace in Hyde Park would continue to be open, caused great activity amongst the painters of Panoramas," adding that this led to fierce competition about exhibition rooms.[105] Londoners had been well prepared during the preceding decades, but the 1840s was a dry season.[106] The early enthusiasm raised by peristrephic and pantomime panoramas had evaporated. Most moving panoramas still touring the country lacked ambition; typically, they randomly combined unrelated topics into "newsreels." Even the battling Aeronautikons were re-enactments of balloon panoramas already seen in theaters.

Figure 6.12
The title page of *Description of Banvard's Pilgrimage to Jerusalem and the Holy Land; Painted from Authentic Drawings Made Upon the Spot During an Extensive Journey, Undertaken Expressly for the Work ... Now Exhibiting at the Georama, 596 Broadway* (New York: John Banvard, 1853). Author's collection.

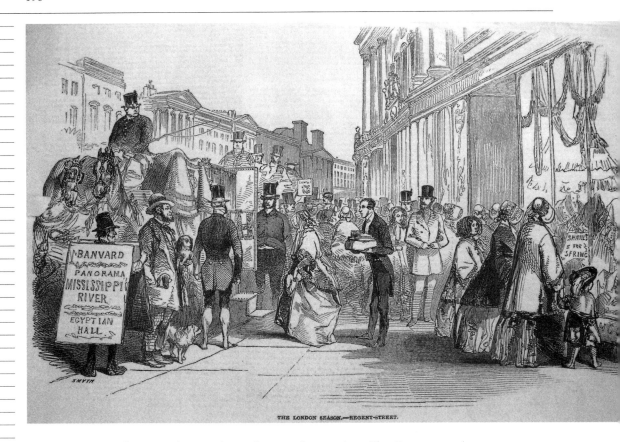

THE LONDON SEASON.—REGENT-STREET.

The general state of visual spectacles was low. The Cosmorama (a permanent peepshow salon at 209, Regent Street) and the Diorama remained open but their novelty had faded long ago. The former needed side attractions, ranging from wax figures to xulopyrography, to survive, and the latter in fact closed its doors on the eve of the Crystal Palace Exhibition. Dissolving views, projected by double magic lanterns, were gaining attention, but their heyday was still ahead. Photography was having a huge impact on visual culture, but it was not used in public spectacles—photographic lantern slides were yet to be invented. The "stereoscopomania," sparked by the introduction of the stereoscope, the first true domestic media machine, would explode only after the Crystal Palace Exhibition.[107]

The only event of real note was the reopening of the refurbished Colosseum. In late December 1848, barely a month after Banvard's Mississippi had begun to roll at the Egyptian Hall, an elaborate media spectacle called Cyclorama was

Figure 6.13
The panoramania in London: a scene from Regent's Street with a "sandwichman" advertising John Banvard's Mississippi panorama. *Illustrated London News*, 14, March 31, 1849. Author's collection.

opened there as an addition attraction.[108] Its preparation had taken long, for as early as 1838 it had been announced that Charles-Marie Bouton, the manager of the nearby Diorama, was to paint a "Cyclorama . . ., an "extraordinary exhibition . . ., a revolving picture, 120 feet in diameter and 40 feet high, upon the principle of the Diorama."[109] Bouton's return to Paris made this impossible, and so the Cyclorama was realized by George Danson and Son, also responsible for the Colosseum's gigantic *Paris by Night*.[110]

The Cyclorama was a multimedia re-enactment of the Lisbon earthquake of 1755. Rather than as a moving panorama, it was characterized as "an exhibition of moveable paintings," or a "moving picture." This made sense, because it was revealed that "the machinery is so contrived that no portion of the picture is rolled upon drums or cylinders, but . . . is kept continually extended, so that no bending or collapsing takes place on the canvass [sic]."[111] A continuous series of "flats" may have been used. Besides, there was no lecturer—the goal was to offer an intense audiovisual experience, supported by music played with the Grand Apollonicon and elaborate dioramic and sound effects.[112] A newspaper stated that the Cyclorama had "the broad and beautiful character of de Loutherbourg."[113] Eidophusikon's shadow was still looming in the background.

COUNTERING WITH QUALITY:
BRITISH PRODUCTIONS OF THE PANORAMANIA ERA

Geography now-a-days is fearfully outraged, in the distribution of the different quarters of the habitable globe, for we find Calcutta within five minutes' walk of the Nile; and the Arctic Regions next door but six to New Zealand, which is separated from Australia by a narrow neck of cab-stands.

—*Punch* (vol. 18, 1850, p. 163)

The media environment was becoming dense. Countless bill posters were covering walls and fences, and "sandwichmen" roaming in the streets, advertising many kinds of products, including Banvard's panorama.[114] Illustrated magazines published reports about other cultures, world news, and innovations in transportation, communication and entertainment. In its first issue (May 14, 1842) the *Illustrated London News* announced, using an appropriate metaphor, that it would

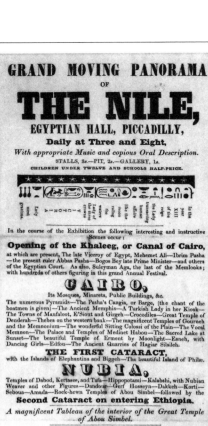

"keep continually before the eye of the world a living and moving panorama of all its actions and influences."[115] Its copious illustrations were cut out by readers, and collaged on folding screens and scrapbook pages. Mass distributed stereocards, cabinet cards, cartes-de-visite photographs and lithographed trade cards all added to the Victorian "frenzy of the visible."

Passenger trains, ocean-going steamships, the telegraph, and improved postal systems influenced the sense of space and time, affecting colonialism, imperialism, and commercial capitalism in the process. The preface to the handbook of John Rowson Smith's *The Tour of Europe* (1852) situated the moving panorama within this context: "The telegraph, the railway, and the Steam-Boat have been making great changes and doing their utmost to bring about a Brotherhood of Nations;—may not also the Pencil of the Artist claim its share in this great work; here we have the Exploration of a Continent showing in a pictorial form the energies of past ages and many of the great Features of the present civilised and intellectual world."[116] The beginning interplay of media channels and their integration into a changing technological environment signaled a transition toward "media culture."

Moving panoramas opened up new prospects for visual education, which gained much momentum in the second half of the century. In the United States it received impulses from the so-called "object lesson," an educational ideology that emphasized direct sensory impressions as the foundation of learning.[117] From the examination of concrete, tangible objects the attention broadened to visual representations. The emphasis on the visual prompted professionals from many fields to move to the panorama business. Thomas Allom, a well-known architect and writer, whose *Polyorama of Constantinople, the Bosphorus and Dardanelles* was first presented in 1850, explained why he had become a showman:

Figure 6.14
Henry Warren, Joseph Bonomi, and James Fahey, *Grand Moving Panorama of The Nile*, Egyptian Hall, Piccadilly. Broadside, 1850. The broadside emphasizes the panorama's educational intentions by stating that it "will be found to form a most complete and instructive illustration of the collection of Egyptian Antiquities in the British Museum." Author's collection.

The mode of conveying information with amusement, by means of moving Panoramas, is now fully recognized as one of the most legitimate uses to which the arts may be applied. Instruction so attractive cannot fail to exert a powerful influence, by conveying just and comprehensive ideas to all classes of the community, concerning other countries and their inhabitants, and, provided such scenes are brought before the public with truthfulness and power, are, in their impression on the mind, second only to the expensive and often inconvenient and painful realities of travel.[118]

The Egyptologist Joseph Bonomi (1796–1878) joined the trend with *The Grand Moving Panorama of the Nile*, which had been painted by Henry Warren and James Fahey from his sketches. It premiered as early as July 1849 at the Egyptian Hall, soon after Banvard had vacated it. Careful attention had been paid to archaeological and historical details, but the fact that the painting had been done hastily could not be hidden. *Punch* poked fun at its expense in a cartoon showing an artist escaping a crocodile, transporting a large roll of drawings on camelback, and finally painting the panorama with a huge brush while running back and forth in front of the canvas in the studio.[119] A reviewer accused the painting of its "deficiency of magnitude" (small size), adding ironically that its atmosphere was "generally cool and grey, like that of a cold summer in England." The "effects of sun-set and of moon-light (including a sun-rise, probably too much like a sun-set reversed)" could not save the production.[120]

The painting was soon sold to the American Egyptologist Geo[rge] R. Gliddon, who took it to the other side of the Atlantic, momentarily reversing the influx of panoramas. Although a duplicate was quickly produced for the British market, the American handbook claimed that the panorama had been originally meant to be displayed *simultaneously* in England and America.[121] If this is true, it must be the first time that such parallel media distribution on an international scale was attempted. The handbook, which was packed with detailed and academic-sounding information about the topic, revealed details about the painting's pictorial and narrative logic:

It is the intention of the respective Proprietors, in England and in America, as time enables them, to represent pictorially such objects of science or historical interest as the Traveller is now supposed to pass by in his boat at night, and therefore without notice, to add New Tableaux to the present Panorama.[122]

The wording is revealing. In the balloon panoramas dark-for-night had been used for bridging lacunas in the narrative continuity; here the night was a placeholder for scenes that were *missing*. When the newly painted replacement was introduced, it was advertised as the "large [sic] moving panorama of the Nile." It had been "wholly Re-Painted, Enlarged, and rendered more interesting by the addition of . . . scenes," including several views of Cairo.[123] Ever so industrious,

Warren, Bonomi and Fahey tried to profit from the heated situation by quickly producing yet another work, an *Original Diorama of the Holy Land*, but it was overshadowed by a higher quality product about the same topic, *The Diorama of Jerusalem and the Holy Land*, painted by William Beverl[e]y from sketches by William Henry Bartlett.[124]

The supply of moving panoramas became so overwhelming that exhibitors struggled to find suitable halls. The repertory included European destinations, the Near East and the Holy Land, India, Australia and New Zealand, as well as the arctic regions, wars, and many other topics.[125] Three "colonial panoramas" depicting sites like New Zealand, Australia, Ceylon, and Brazil were exhibited under the superintendence of Samuel Charles Brees, the principal engineer and surveyor to the New Zealand Company. These were not just entertainment for the sake of entertainment. Brees's exhibition was recommended for "intending emigrants."[126] For this purpose, the guidebook contained practical information about the services of the New Zealand Company (which had been incorporated in 1841), in shipping, mailing, and the purchase of land.

Because of colonial connections, India was a particularly popular subject. One of the most celebrated products of the era, *The Route of the Overland Mail to India, from Southampton to Calcutta* (Gallery of Illustration, 1850), took the audience to its gates. It was logical that others would continue the journey. W. Wallace Scott's *New Oriental Diorama: Life and Scenes in India* (1850) was promoted as its "sequel" and was explained by the same lecturer, Joachim Hayward Stocqueler.[127] Spectators were supposed to imagine themselves accompanying a colonial officer on his trip from Calcutta to his regiment in Lahore.[128] Another attempt to "supply the deficiency" of abandoning the traveler "to make the best of his way alone" was T. C. Dibdin's *Diorama of the Ganges* (1850).[129] It used elaborate "set pieces" (props) in front of the canvas to add light and shade, smoke, steam, and passing objects.[130]

Another feature that made Dibdin's panorama unusual was its first part, a moving *circular* 360-degree panorama of Calcutta, "taken" from the summit of a colonial landmark, a column called the Octerlony Monument. The audience was as if swiveled around, anticipating the early silent films known as circular panoramas shot by Edwin S. Porter and others.[131] Dibdin's choice of a circular "panning shot" was motivated less by technical or aesthetic experimentation than by geographical necessities. As the handbook explains, a view "taken from the plain" would not have been able to give a "general view of so flat a city."[132] Something similar had been attempted years earlier by J. B. Laidlaw in his moving panorama of Jerusalem (c. 1837–1838), but the solution remained uncommon.

The Route of the Overland Mail to India was generally considered the crowning British achievement of the early panoramania era. An observer found it "honorable for the successful attempt to elevate the moving panorama from a mere source of instruction to a work of art."[133] It was no doubt the main reason that made another writer laud the British products over the American imports:

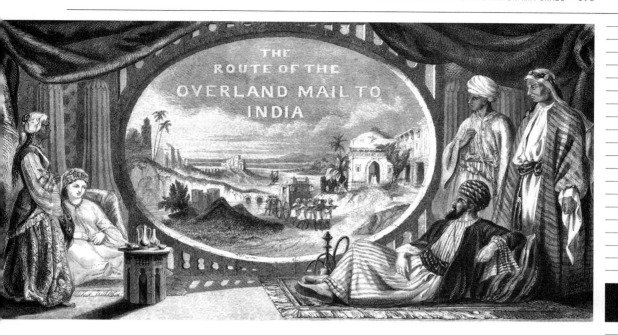

The success of the long Moving Panoramic Pictures from New York, has excited what would almost appear to be an insatiable taste for that class of artistic productions in our metropolis. Strange it is that we should have received such a hint from a nation by no means distinguished for its school of painting; and we suspect the explanation will be traceable to certain broad effects which alike characterize Transatlantic scenery and manners. How far this species of attraction will be realized in the success of the English Moving Panoramas and Dioramas which have just burst upon the town for its holiday novelties, we will not venture to predict. As regards composition, drawing, colour, and other means of art, our own pictures are, unquestionably, of the highest class; whilst they are as remarkable for their freedom of exaggeration, and adherence to nature, as their American prototypes were characterized by those equivocal recommendations.[134]

The Route of the Overland Mail to India was a joint venture by a team founded by two great scene painters, Thomas Grieve and William Telbin, who painted the general scenery and invited John Absolon to contribute the human figures and John Frederick Herring, Sr., and Harrison Weir the animals.[135] The music was commissioned from the noted composer Michael Rophino Lacy, and the lecture from Joachim Hayward Stocqueler, a well-known author of popular books about

Figure 6.15
Title of the moving panorama *The Route of The Overland Mail to India*. Hand-colored engraving published in: *The Route of The Overland Mail to India* (London: Archley and Co., 1850). Author's collection.

India; the production was sponsored by the Peninsular and Oriental Steam Navigation Company.[136] A showroom named Gallery of Illustration was rented from an imposing neoclassical building by John Nash (14, Regent's Street), and elegantly refurbished.[137] The combination appealed to the audience. Between 1850 and 1852 the performance was claimed to have been given over 1,600 times for more than 400,000 visitors.[138]

Grieve and Telbin's "diorama" was noted not only for its outstanding visual quality, but also for its extensive dimensions.[139] The panorama eschewed continuity in favor of *tableaux* witnessed through an oblong-oval aperture. Curiously, it was claimed to have "increased in size when the stationary pictures are exhibited."[140] A report confirmed that stationary views did indeed alternate with moving sequences such as the crossing of the desert from Cairo to Suez.[141] The unusual (perhaps unique) adjustable frame added dynamism to the visual narrative, while the oval shape of the frame associated the production with academic traditions of display.

Because the panorama was illuminated by gaslight, and large portions of the canvas were translucent, the frame must have enhanced the impression of luminosity (in the manner of the "tunnels" in front of the pictures at the Regent's Park Diorama). An observer must have expressed many spectators' impressions:

> The series comprises strikingly original representations of the many picturesque and beautiful localities which the traveller visits in his journey, and the points of view selected are interesting and novel. The journey over the desert is admirably set forth, the blank wastes of sand, the glaring smothering sunlight, and the midnight camp, are all wonderfully rendered, giving a reality to the scenes, which completely dispels the idea that we look only on a painting, and we almost feel the heat and oppression of the Desert.[142]

Figure 6.16

"Encampment by Night," a scene from Grieve and Telbin's moving panorama *The Route of The Overland Mail to India*. Hand-colored engraving published in: *The Route of The Overland Mail to India* (London: Archley and Co., 1850). Author's collection.

Whether it was their original intention or not, Grieve and Telbin's team immediately set out to prepare new products. For a few years, the Gallery of Illustration became almost like movie theater. In 1851 a dioramic view of the winter garden inside the Crystal Palace was added to the beginning of the show, and scenes of the Taj Mahal to the end.[143] A smaller moving panorama, *Diorama of our Native Land, Illustrative of England and its Seasons* by Grieve, Telbin, Jones, Absolon, and Herring, was introduced in an adjacent room. Reflecting the national pride spurred by the Crystal Palace exhibition, it was an effort to profit from the crowds drawn to the city by the exhibition. Inadvertently recalling Carmontelle's *Les Saisons*, it depicted "the amusements and employments of a country-life during the several varieties of spring, summer, autumn, and winter."[144] *King's College Magazine* found it "extremely well calculated to please" the British audience, but after its spectacular predecessor it must have felt like an anticlimax.[145]

Next came another patriotic effort, the *Grand National and Historical Diorama of the Campaigns of Wellington* (1852), which became topical when the 83-year-old Duke of Wellington, a revered national hero, died (but not before attending a private viewing of the panorama).[146] The artists, who had begun their panorama two years earlier, may have anticipated this.[147] The formula remained much the same. The panorama was said to emphasize "*pictorial* but just ideas of sites, actions, local color and costume."[148] Stocqueler lectured, published Wellington's biography for extra income, and was accompanied by Rophino Lacy's music. Perhaps because it depicted well-known events of the past rather than contemporary issues, it was less successful than *Route of the Overland Mail*.[149]

The Gallery of Illustration team steered back to the present with *The Ocean Mail to India and Australia* (1853). Stocqueler and Rophino Lacy were joined by Samuel Moss, a naturalist and Australia specialist, as additional commentator.[150] The audience was asked to imagine it had boarded the brand new (real) steamship Argo; a "product placement" agreement between its owner, the General Screw Steam Shipping Company, and the gallery, may well have existed. To alleviate monotony, the "passengers" landed from time to time to "sojourn at some of the principal towns."[151] After exploring the Australian colonies, the panorama ended at the recently discovered gold regions of Mount Alexander, summing up its colonial underpinnings.

Grieve and Telbin's next product followed Britain's involvement in the Crimean War (1853–1856). *Events of the War* became a kind of evolving newsreel. Stocqueler's "illustrated lecture" was supported by diagrams, and new views were added as the war went on.[152] However, the business no longer worked as before. The programs became combinations of this and that, apparently to capture the audience's waning interest. A 1854 advertisement announced a combination of an illustrated lecture on the North-West Passage, views of Constantinople and St. Petersburg, and the *Ocean Mail* (during its final month).[153] The Arctic views were probably a shorter sequence, perhaps purchased from others.

After five years, the Gallery of Illustration had ended up in a crisis. An impresario later recalled a meeting with Grieve, who had said that "the attraction of their splendid pictures of the Overland Route and other subjects was declin-

Figure 6.17
"The Needles," "The Dead Camel," "Mahmoudic Canal," and
"Moors and Arabs on Horseback." Scenes from Grieve and
Telbin's moving panorama *The Route of The Overland Mail to
India*. Hand-colored engravings published in: *The Route of
The Overland Mail to India* (London: Archley and Co., 1850).
Author's collection.

ing, and that he wished, if possible, to find a tenant for the Gallery."[154] *The Route of the Overland Mail to India* was sold or rented to the touring American showman George W. Cassidy, who traveled with it and may even have taken it to Continental Europe; it was eventually incorporated into the touring panorama shows of Poole & Young.[155] The Crimean war panorama appeared at the Theatre Royal in Dublin in late 1855, where it was incorporated into a Christmas pantomime—just like countless other panoramas.[156] Because of their high quality, other panoramas from the Gallery of Illustration may have enjoyed similar afterlives. The Gallery of Illustration was rented to the musicians Thomas and Priscilla German Reed, who used it for musical entertainments from February 1856 until well into the following decade.[157]

Grieve and Telbin may have considered this arrangement temporary, because they were planning a new attraction named Georama, and kept listing the Gallery of Illustration as their offices.[158] The prospectus for the new stock

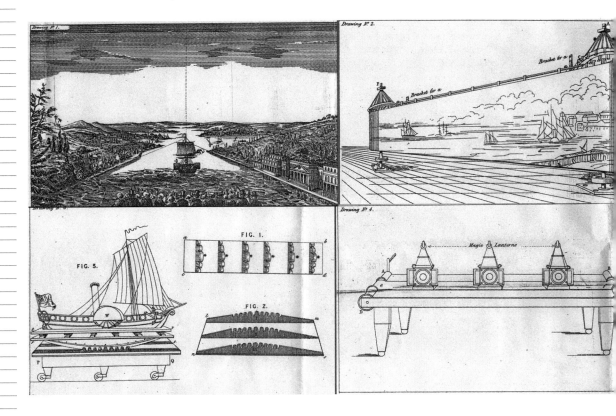

Figure 6.18
Illustrations from Edward Sparkhall, "Exhibiting Pictorial Representations," British patent no. 313 (1855).

company introduced "a new and improved principle" patented by an inventor named Edward Sparkhall in 1855.[159] In earlier Dioramic Exhibitions—potential investors were told—"the scenery passes from right to left, or from left to right, in front of the spectator." At the Georama it "passes sideways, or on each side of the spectator." Both sides of a street, river, canal, or harbor would be depicted at the same time. The spectators would be sandwiched between two moving canvases, making them feel as if they were "in the act of moving forward whilst the scenery will appear to be fixed and stationary."[160] This was a shift from prosaic illustrated lectures toward totally immersive simulator rides.[161]

Whether it was a demonstration of the limits of the imagination or a calculated effort to appeal to mainstream taste, the proposed subject matter was conventional: travelogues to France, Italy, Turkey, the lakes of America, and the Rhine. The prospectus was far less adventurous than the patent, perhaps to avoid frightening potential investors. Sparkhall wanted to place the spectators on a "vibrating, oscillating, or gyrating" ship (or other vehicle) and to add rolling canvases of domes, ceilings, etc., above the spectators' heads to complete the illusion.[162] His patent also described an unusual alternative for painted panoramas: rows of magic lanterns moving on conveyor belts behind translucent screens. Each lantern would have rear-projected a part of a wide slowly moving scene. Projections were becoming a viable alternative to roll paintings, but Sparkhall's suggestion was rather impractical. Grieve and Telbin's role as the company's artists further explains why this option is not mentioned in the prospectus.

Although the prospectus optimistically suggests that the attraction could be shown in galleries "throughout the provinces," nothing else was heard about the General Exhibition Company.[163] Similar ideas were tried out on the theater stage from time to time, but anything as complex as Sparkhall's brainchild did not materialize until Hugo d'Alesi's *Maréorama* was exhibited at the turn of the next century (see chapter 10). Until then, the sense of immersion remained psychological rather than a psychophysical thrill induced by the apparatus.

NOTES

1. "In our time so rich in pano-,
cosmo-, neo-, myrio-, kipo-, and
dioramas," quot. Stenger, *Daguerres
Diorama in Berlin*, p. 73, fn. 58.

2. "One Tom," "Sights of London,
Etc. No. II," *The Literary Gazette: A Week-
ly Journal of Literature, Science, and
the Fine Arts*, March 20, 1824, p. 188
(HTC). The quotation shown that Albert
Smith's reaction to panoramania
nearly a quarter of a century later was
not without precedent.

3. William Pulleyn, *The Etymo-
logical Compendium, Or, Portfolio of
Origins and Inventions*, 2d ed. (London:
Thomas Tegg, 1830), p. 48.

4. Judging by the *Scotsman* (Nov. 10,
1830), William Marshall may have
adopted the variety format: "Messrs
Marshall have made a most interesting
addition to their beautiful Panorama of
Botany Bay, Algiers [Bombardment of
Algiers?] &c. of several Views illustra-
tive of the principal events of the late
Revolution in Paris." The reaction to
the events of 1830 in Paris was almost
immediate (it is unlikely the reference
was to the Great French Revolution).

5. The *Theatrical Observer; and
Daily Bills of the Play* wrote about it six
times in 1823, which is exceptional
for a show that was not a play at Drury
Lane or Covent Garden. The *Theatrical
Observer* can be consulted online at
www.archive.org/ (last visited March 25,
2012). *Theatrical Observer; and Daily
Bills of the Play*, No. 1454 (Aug. 3., 1826).
The demolition was noted by *La Belle
Assemblée* that added: "Marshall's
Peristrephic Panorama was, we believe,
one of the latest raree-shows to be
seen at that long-accustomed haunt."
*La Belle Assembleé, or, Court and
Fashionable Magazine* (London: Geo. B.
Whittaker), vol. 4 (July–Dec. 1826): 182.
The final program was *Bombardment
of Algiers*.

6. *The Scotsman* reveals

programs, but not their exact content.
A sample: Botany Bay, with views
of the Revolution in Paris (1830),
Calcutta, Paris continued (1831),
Amsterdam, Capetown, Calcutta (1831),
Aeronautikon, Daguernama [sic] (1841),
Lago Maggiore ("Marshall's Diorama,"
1842), Seven views of the French
Revolution [of 1848 or 1830?] added
to the panorama (1848), Hudson River
(1850). Wilcox's list of peristrephic
panoramas shown in the same venue
in "The Panorama and Related Exhibit-
ions in London" (p. 335) is long, but
very different; the issue requires
investigation. According to Daniel
Frazer's *The Story of the Making of
Buchanan Street* (Glasgow: James Frazer,
1885), "One of the most popular
exhibitions [shown at the Monteith
Rooms] was Marshall's panorama,
descriptive of the scenes in Paris
during the Revolution in 1832." (p. 71.)
A smaller outbreak of violence also
took place in Paris June 5–6, 1832).

7. "Panorama of the Hudson,"
Scotsman, April 13, 1850. The Panorama
of Hudson was the last program in the
rotunda. The notice mistakenly mentions
that "the Panorama was built about
20 years ago by the late Mr W. Marshall,
who claimed the merit of being the
first that invented large moving
paintings." Peter Marshall had ob-
viously been forgotten. On February 17,
1851, the *Glasgow Herald* advertised
the auction of four panoramas "of the
late William Marshall," together with
machinery and "utensils." A broadside
for Baker & Clark's Panorama, dated
January 17, 1852 (printed by Alex. Elliot)
announces a panorama "Originally . . .
the property of the late Wm. Marshall,
Esq., of Edinburgh." The Panorama
displayed Jerusalem, the city of Berlin
and California and the gold regions.
A descriptive lecture was given by
Mr. John Baker (HL).

8. "In Dickinson-street, bottom
of Cooper Street, on the site of the
Diorama." Was the diorama building
just modified? (Broadside in EH).
Laidlaw's venture may have been

unsuccessful, because by 1842 he
exhibited at Newall's Buildings,
Market-Street. According to the *Musical
World: A Weekly Record of Musical
Science, Literature and Intelligence* (16,
no. 290, new series, vol. 9, no. 198,
Thu, Oct. 14, 1841) Laidlaw also
erected a panorama building in Liver-
pool; it had been turned into a concert
room named The Portico. Heavy invest-
ments may explain why his panoramas
and machinery were auctioned at
Newall's Buildings in 1842 (*Manchester
Guardian*, Sept. 24, 1842).

9. In EH. The broadside reveals
that the presentation lasted between
one and one-and-half hours.

10. *Description of a view of the City
of New York, The Panorama of which is
now exhibiting here, and beautifully con-
nected with a pleasure sail for five miles
up the bay . . . Painted for the Proprietor,
J. B. Laidlaw, from drawings taken on
the spot* (Hull: John Hutchinson, 1838)
(WM). The handbook also describes
the views of the whaling ships, but
they are not mentioned on the title
page. The broadside for *Laidlaw's
Celebrated Panorama of the City and Bay
of New York* (Victoria Rooms, Queen-
street, Hull [early hand-date: Sept., 1839]
(EH) includes the Boulevard du Temple
view, but not the whaling ships or
Jerusalem. Laidlaw kept changing the
combinations.

11. Catherwood (1799–1854)
returned to London from the Near
East in 1835. He collaborated with
Robert Burford (Barker's successor)
on panoramas of Jerusalem, Thebes,
Karnak and Ruins of Baalbek, all based
on his drawings. In 1838 Catherwood
opened a rotunda in New York with
the Jerusalem painting (Oettermann,
The Panorama, pp. 317–323). It burned
down in 1842 with the Jerusalem and
Thebes panoramas. Victor Wolfgang
von Hagen, *Frederick Catherwood Archt.*
(New York: Oxford University Press,
1950), pp. 41–42, 47–51, 82–84.
The Jerusalem panorama was also
exhibited in Philadelphia. *Description*

of a View of the City of Jerusalem and the Surrounding Country, now Exhibiting at the Panorama, Broadway, Corner of Ninth and George Streets, Philadelphia. Painted by Robert Burford, from Drawings taken in 1834 by F. Catherwood, Architect [no printer or date](NYPL). A broadside for Baker & Clark's Panorama (see note 7) states that the moving panorama of Jerusalem they had obtained from the late William Marshall "comprises 15 Views on the most Extensive Scale in three Sections" and was "Painted from Sketches taken by David Roberts, Esq., R.A., in the year 1840." If this is correct, it is unlikely it was the one Laidlaw had exhibited earlier, in spite of connections between Laidlaw and Marshall (HL).

12. *Description of a View of the City of Jerusalem, and the Surrounding Country, now exhibiting at the Panorama in this Town. From Drawings taken in 1834* (Hull: John Hutchinson, 1837) (EH). Catherwood's name is not mentioned, perhaps indicating that his designs had been used without permission (but his name appears in the broadside). The key identifies the work as "Laidlaw's Panorama of Jerusalem." It is mentioned that the "Length of the Painting [is] 140 Feet by 18 Feet," which corresponds with the measurements given in Laidlaw's Manchester broadside: "Painted on 2520 square feet of Canvas, 140 feet in length." Only the Jerusalem panorama is described in the handbook. Did Laidlaw plan to exhibit it separately? I have compared the key with the one for the Burford panorama in *Description of a View of the City of Jerusalem and the Surrounding Country, now Exhibiting at the Panorama, Broadway, Corner of Price and Mercer Streets, New York. Painted by Robert Burford, from Drawings taken in 1834 by F. Catherwood, Architect* [no printer or date] (NYPL).

13. The key to the handbook reveals that the group includes Catherwood taking sketches and the Egyptologist Joseph Bonomi, who was later part of a team that exhibited a moving

panorama of the Nile at the Egyptian Hall (1849).

14. In Feb. 1839 at the Swan Theatre's Great Room in Exeter, "Along side the view of Jerusalem were shown three smaller views of the Boulevard du Temple (where an assassination attempt was made on Louis Philippe), the Coronation of Queen Victoria, and Captain Ross's arctic voyage. In March a panorama of Calcutta was substituted for Jerusalem." Sam Smiles, "Panoramas in Exeter 1816-1864," *Newsletter of the International Panorama and Diorama Society* 5 (new series), no. 2 (Autumn 1989), pp. 6–9. Did "smaller" mean shorter or less important? The panorama that was auctioned in Manchester in 1842 (*Manchester Guardian*, Sept. 24, 1842) consisted of "21 series of views." The assassination was missing, and the whale ships had been replaced by (or incorporated into?) "the perilous voyage of Captain Ross to the arctic regions, in four views." Queen Victoria's coronation (four views), war in China (three views) and a representation of Calcutta had been added. Four views of Jerusalem were also listed [had a part of the panorama been removed?]. The auction announcement indicates that the views may have been a single roll. Was the panorama of Calcutta the one displayed in Marshall's Rotunda in Edinburgh in 1831?

15. An early one was shown at the Surrey Theatre (London) on Feb. 24, 1829, with the comedy *Wild Oats* and the "Melo-Drama" *Maid and the Magpie*. It was based on the Turkish War, depicting the passage of the Danube by the Russians on May 27 [1828], the bombardment of the Fortress of Braila in Bulgaria, Fortress of Varna, Constantinople, and a Turkish Ballet. The latter scene may have served as a backdrop for dancers (broadside in JJG). On June 16, 1830, Marshall's "Complete Panorama of New London!" was shown at the Surrey with *The Progress of a Law-Suit; or, the Travels of a Sailor* (broadside in JJCB). In 1839

he painted a moving panorama about the Anglo-Afgan war for Drury Lane's *Harlequin Jack Sheppard, or, The Blossom of Tyburn Tress!* (handbook in HL). Philip Marshall, *Charles Marshall R.A. His Origins, Life, and Career as a Panorama, Diorama, Landscape and Scenic Artist* (Truro, Cornwall: Aston Publishers, 2000). For theater, pp. 21–24, panoramas and dioramas, pp. 25–30; Clara Erskine Clement and Laurence Hutton, *Artists of the Nineteenth Century and Their Works*, vol. 2 (Boston and Cambridge: Houghton, Osgood and Co. and the Riverside Press, 1879), pp. 94–95; Altick, *The Shows of London*, p. 201.

16. "Kineorama, or Moving Views," advertising card (VATC); *Mr. Charles Marshall's Kineorama*, advertising broadside (VATC); "New and interesting pictorial exhibition, 121, Pall-mall. —On Monday, March 15, 1841, will be opened, Mr. Charles Marshall's . . . Kineorama . . .," unidentified newspaper cutting (JJCB).

17. The system caught fire in July 1841, but luckily no one was injured, and the flames were put out before they damaged the canvas. Whether the exhibitions continued is unknown. Altick, *The Shows of London*, p. 168. "Public Exhibitions. Easter Novelties," *The Mirror of Literature, Amusement and Instruction*, vol. 37 (London: Hugh Cunningham, 1841), p. 253.

18. Neither the promotional material nor published comments mention a lecturer. Perhaps the details were meant to be read afterwards from the guidebook, *Description of Mr. Charles Marshall's Kineorama; with Keys: Constituting Turkey, Syria, & Egypt* (London: W.S. Johnson, 1841) (JJCB). It contains 14 sketches of the views, which would have aided the memory. By 1857 Marshall had added a lecturer, as is shown by *Delhi: Notices of the Great Indian Rebellion: more particularly in relation to Mr. Charles Marshall's Great Picture of Delhi. The Descriptive and Explanatory Lecture, every half-hour, By Mr. Gregory* (London: Published at

the Delhi Exhibition, 1857) (VATC).

19. Marshall's ad in the *Musical World* 29, no. 29 (July 19, 1851): 448.

20. Odell, *The Annals*, 5, p. 584.

21. Dorothy B. Richardson, *Moving Diorama in Play. William Dunlap's Comedy* A Trip to Niagara *(1828)* (Youngstown, N.Y.: Teneo Press, 2010), pp. 82–83. The information is rather vague.

22. Kevin Avery, "The Panorama and Its Manifestation in American Landscape Painting," p. 53. The Adelphi production was reviewed by *The London Literary Gazette and Journal of Belles Lettres, Arts, Sciences, &c.,* no. 575 (Saturday, Jan. 26, 1828), p. 60. The moving panorama was not mentioned, but a scene on board a steam-packet [from Calais to Dover] was found "highly comic and entertaining." A 1853 production at the Boston Museum contained two of them: one visible through a cabin window and the other from the ship's deck. (Wickman, "An Evaluation of the Employment of Panoramic Scenery in the Nineteenth-Century Theatre," pp. 235–236.) A production at Wheatley's Continental Theater, Philadelphia (1861) contained a moving panorama by John Wiser, "As seen from the Deck of the Steam Packet." (Broadside for Oct. 18, 1861 in EH).

23. Richardson, *Moving Diorama in Play*, pp. 58–59. The "motion of the steamboat's works" is mentioned in "The Diorama at the Bowery Theater," *Critic: A Weekly Review of Literature, Fine Arts, and The Drama* 1 (1829): 104.

24. "The Diorama at the Bowery Theatre," *Critic*, p. 104.

25. The sheet music for the scene, arranged by W. Taylor, was published in *New York Mirror, and Ladies' Literary Gazette* 6, no. 47 (May 30, 1829): 400 (EH). It may be the same as William Goodwin, *The diorama: performed at the*

Bowery Theater, sheet-music (New York: Wm. Taylor, n.d.). A copy, dated "c. 1829, exists at the Thomas A. Edison Collection of American Sheet Music, Library of the University of Michigan (I have not seen it)." *New York Mirror, and Ladies' Literary Gazette* also published the "First movement of the diorama scene, in the Dumb Savoyard," arranged by Mr. De Luce, in vol. 6, no. 50 (June 20, 1829): 376 (EH).

26. Preface, *A Trip to Niagara, or Travelers in America: A Farce in Three Acts* (New York: E. B. Clayton, 1830). The panorama is described as a "Diorama, or Moving Scenery" (Act 2), pp. 26–27. (GRI).

27. "The Diorama at the Bowery Theatre," *Critic*, p. 104.

28. No doubt it was performed in a New York theater. When *The Dumb Savoyard, and his Monkey* was performed at Drury Lane in London in 1828, it featured Clarkson Stanfield's moving panorama of the "Passage of the Rhine" (broadside for April 15, 1828 in EH).

29. *New York Evening Post*, July 30, 1829. This is not noted in Richardson, *Moving Diorama in Play*. The exhibitions were to begin August 4. Having just lost the Bowery Theater for financial reasons, its ousted manager Charles Gilfert, who was behind Dunlap's play, died on July 30, 1829, the same day the announcement was published. Richardson, *Moving Diorama in Play*, p. 37.

30. Odell, *The Annals*, 3, pp. 537–538.

31. In the Assembly Rooms, Ingram Street, Glasgow (*Glasgow Herald*, June 11, 1821). It sounds very similar to the one Messrs. Marshall exhibited also in 1821 (*Glasgow Herald*, Sept. 7, 1821) and later, described in *Description of Marshall's grand peristrephic panoramas: Battle of Genappe, St. Helena, and the most interesting events that have occurred to*

Bonaparte, from his defeat At the Battle of Waterloo, Until the Termination of his Earthly Career at St. Helena; and the memorable Battle of Trafalcar (London: J. Whiting, 1825) (GRI). The Navarin panorama Pückler-Muskau saw in Dublin in 1828 was displayed in the Marshall Rotunda in Edinburgh in 1831 (*Scotsman*, Aug. 17, 1831), so Sinclair could not have it. Most likely he brought with him a panorama shown in 1828 in London at the Rotunda (Great Surrey Street, Blackfriars Road) as *A Historical, peristrephic or revolving dioramic panorama illustrative of all the principal events that have occured* [sic] *during the War between the Turks and Greeks . . .*, or the *Grand Surrey Panorama of the Greek War.* (*London Literary Gazette*, no. 572, Jan. 5, 1828, p. 830. Sinclair seems to have leased the Rotunda and ceded it in 1830 to the radical atheist agitator Richard Carlile (1790–1843), whose supporter he may have been. "W. Sinclair, Proprietor of the Panorama, Music Hall" is mentioned as one of Carlile's donors in *Lion* (London: Richard Carlile), 3 (Jan. 2–June 26, 1829): 213. Rotunda had been used as a music hall. Carlile used it as a lecture hall until 1832. Theophila Carlile Campbell, *The Battle of the Press: As Told in the Story of the Life of Richard Carlile* (London: A. & H. B. Bonner, 1899), pp. 121–123. The problems Carlile was having with the authorities may explain Sinclair's move to the United States. I will discuss this issue in a forthcoming article.

32. Now open *Sinclair's Celebrated Grand Peristrephic or Moving Panorama of the Great Battle of Waterloo, St. Helena, and the Funeral Procession of the Great Napoleon, &c.,* shown "At the Hall lately erected in the New Brick Buildings facing the Savings Bank, Tremont St. [Boston]. No date [1830s] (HTC). Sinclair's name was usually mentioned in the broadsides, handbooks and newspaper notices.

33. McDermott, *The Lost Panoramas of the Mississippi*, p. 10. The source is

not given, but McDermott refers to a report in the *Missouri Republican*, Aug. 25, 1838.

34. *Grand National Exhibition. T. C. Bartholomew & Co. Respectfully inform the Citizens of Portsmouth that their celebrated Historical Moving Dioramas, The Battle of Bunker Hill, Is now open for Exhibition at Jefferson Hall . . .*, broadside, July 1842 (EH).

35. *Mississippi Panorama. The life and landscape of the Father of Waters and its great tributary, the Missouri*, ed. Perry T. Rathbone (St. Louis: City Art Museum of St. Louis, 1950), p. 128.

36. "Panorama of the Nile," *New Monthly Magazine and Humorist* 87, 3d part for 1849 (London: Chapman and Hall, 1849), p. 130.

37. Caroline Winterer, *The Culture of Classicism: Ancient Greece and Rom in American Intellectual Life 1790–1910* (Baltimore: Johns Hopkins University Press, 2002), pp. 66–67. The painting was displayed at various places between 1821 and 1842 and destroyed in a campus fire in 1845.

38. "Banvard's Panorama," *Lady's Journal*, undated clipping, p. 472 [late 1840s?] (JJCB).

39. Professor Risley and J[ohn] R[owson] Smith, *Professor Risley and Mr. J. R. Smith's Original Gigantic Moving Panorama of the Mississippi River, extending from the Falls of St. Anthony to the Gulf of Mexico, painted by John R. Smith, Esq. . . . Being one-third longer than any other pictorial work in existence: four miles in length* (London: John K. Chapham and Co., 1849), p. iv (MHS).

40. Leo Marx, *The Machine in the Garden: Technology and the Pastoral Ideal in America* (London: Oxford University Press, 1964).

41. Extract, from *Norton's Hand Book of New York City* ([New York:]

Albert Norton, 1859), p. 4. Stowe is said to be nearly seventy years of age (in 1859).

42. *Descriptive and Historical View of the Seven Mile Mirror of the Lakes, Niagara, St. Lawrence, and Saguenay Rivers . . .* (New York: Baker, Godwin & Co, 1854), p. 46 (quot. from *National Intelligencer*); also p. 3 (HL). The alternate title *Perham's Pictorial Voyage, known as the Seven Mile Mirror to Canada, American Frontier and the Saguenay . . .* appears on the cover. Perham had obtained William Burr's *Seven Mile Mirror! or, A Tour of 2000 Miles on the Lakes . . .* and renamed it (broadsides for both versions in HTC); Arrington, "William's Burr's Moving Panorama of the Great Lakes, the Niagara, St. Lawrence and Saguenay Rivers." Later train excursions were organized with circular panoramas as destinations. A broadside (EH) announces "Excursions to the Cyclorama of the Battle of Gettysburg at 541 Tremont St., Boston, just above Dover Street, from May 20 to 29, 1885, inclusive." The trip was organized by the Old Colony R.R. (railroad) Main Line Division. A round-trip ticket included free admission.

43. Railway and steamship companies sponsored early films to make their routes known and to persuade spectators to make real journeys after seeing the virtual ones. Charles Musser, *Edison Motion Pictures, 1890–1900: An Annotated Filmography* (Gemona: Le Giornate del Cinema Muto & Smithsonian Institution Press, 1997), p. 33; Lynne Kirby, *Parallel Tracks: The Railroad and Silent Cinema* (Durham: Duke University Press, 1997), pp. 21–23, 37.

44. Undated notice from the *Catholic Telegraph; Cincinnati Directory*, in the Archives of Mount St. Joseph, Ohio, quot. Mary Agnes McCann, *The History of Mother Seton's Daughters: The Sisters of Charity of Cincinnati Ohio, 1809–17*, vol. 1 (New York: Longmans, Green and Co., 1917), pp. 221–222.

45. Daniel C. Eddy, *The Young Man's Friend*, 2d ed. (Lowell, Mass.: Nathaniel L. Dayton; Gould, Kendall and Lincoln, 1850), p. 108.

46. Ibid., p. 100.

47. Banvard referred to working with the Chapmans only in unpublished autobiographical jottings written late in life (Banvard Family Papers, Microfilm Roll 1, MHS). There is no external evidence. In "John Banvard's Moving Panorama of the Mississippi, Missouri, and Ohio Rivers" Arrington wisely omitted this episode, but John Hanners has promoted it as a fact in his writings on Banvard, such as "The Great Wizard of the North: John Banvard and His Floating Theaters," *Traces of Indiana and Midwestern History* 2, no. 2 (Spring 1990): 26–35. The flatboat dioramas are mentioned already in "Adventures of the Artist" in the first edition of the *Description of Banvard's Panorama of the Mississippi River, Painted on Three Miles of Canvas: Exhibiting a View of Country 1200 Miles in Length, Extending from the Mouth of the Missouri River to the City of New Orleans; being by far the Largest Picture ever Executed by Man* (Boston: John Putnam, 1847), pp. 5, 7 (EH). This resembles the activities of the Austrian Sattler family, who lived on a riverboat and sailed in Central Europe in the 1830s displaying their panoramas and cosmorama paintings. A painting by Johann Michael Sattler showing the family on the boat on the Elbe near Magdeburg (1833) has been analyzed by Nikolaus Schaffer, "Vier Salzburger in einem Boot: Ein ungewöhnliches Familienbild also wichtige Ergänzung zum Sattler-Panorama," *Das Kunstwerk des Monats* (Salzburg: Salzburger Museum Carolino Augusteum), vol. 15 (April 2002): 168.

48. Arrington, "John Banvard's Moving Panorama of the Mississippi, Missouri, and Ohio Rivers," p. 210. In one of Smith's later pamphlets his early panorama was said to have been two hundred feet long. It was claimed

to have been destroyed in a fire. McDermott, *The Lost Panoramas of the Mississippi*, pp. 49-50.

49. Ibid., p. 210; William G. Carson, *Managers in Distress: The St. Louis Stage, 1840–1844* (St. Louis: St. Louis Historical Documents Foundation, 1949), p. 120. Banvard's name is given as "Banvara." The Venice panorama is mentioned in the 1847 *Description of Banvard's Panorama of the Mississippi River*, p. 8.

50. [later pencil date: 1820s]. Banvard Family Papers, Microfilm Roll 1 (MHS). This episode was told for example in "John Banvard's Great Picture.—Life on the Mississippi," *Living Age* 15, issue 1847 (Dec. 11, 1847): 511.

51. *Description of Banvard's Panorama of the Mississippi River*, p. 3. In "John Banvard's Moving Panorama of The Mississippi, Missouri, and Ohio Rivers" Arrington mistook the "Magic Lantern" as the "6th" scene. Collins obviously copied this from Arrington and not from the original broadside, mentioning about a "homely omission of a 5th entertainment." Paul Collins, *Banvard's Folly. Thirteen Tales of Renowned Obscurity, Famous Anonymity, and Rotten Luck* (New York: Picador, 2001), p. 1.

52. [John Babcock,] *Philosophical Recreations, or Winter Amusements: a Collection of Entertaining & Surprising Experiments . . . Together with the Wonders of the Air Pump, Magic Lanthorn, Camera Obscura, &c. &c. &c. . . .* (London: Thomas Hughes, [1830]), p. 164; on magic lanterns, pp. 160–165. Similar information was available earlier, see William Hooper, *Rational Recreations . . .*, (London: for L. Davis, J. Robinson, B. Law, and G. Robinson, 1774).

53. According to Boggs Beale's handwritten diary he built his panorama between January and August 1856. It was two feet high, 150 feet

long, and contained 70 scenes. I have read a copy at the AMLT (from the original at the library of the Historical Society of Philadelphia). For Smith's story about his toy panorama, see his *The Story of Mont Blanc* (London: David Bogue, 1853), p. 2.

54. The boy lived in Waterbury, Connecticut. Alice Eliza Kingsbury, *In Old Waterbury: The Memoirs of Alice E. Kingsbury* (Waterbury, CT.: Mattatuck Historical Society, 1942), ch 2. (no page numbers). James Marten refers to this source in "History in a Box: Milton Bradley's Myriopticon," *Journal of the History of Childhood and Youth* 2, no. 1 (2009): 6–7: Marten's article mentions neither the two different versions of the Myriopticon, nor Bradley's other moving panoramas, the Historiscope and the Santa Claus Panorama, or Kriss Kringle's Christmas Tableaux, "A Beautiful Moving Diorama with Scenes and Figures." Marten mistakenly states, "Panoramas had been popular in the United States since the late eighteenth century, when artists and promoters began offering travelogues to the Holy Land or down the Mississippi through a series of paintings on a canvas hundreds of feet long and several yards high that slowly scrolled from one reel to another" (p. 5). Willy Kingsbury appeared (without source information) in Marten's *The Children's Civil War* (Chapel Hill: University of North Carolina Press, 1998), p. 164; and in *Lessons of War: The Civil War in Children's Magazines*, ed. James Marten (Wilmington, Del.: Scholarly Resources, 1999), p. 74.

55. A later example is *The Boy's Own Book of Indoor Games and Recreations. An Instructive Manual of Home Amusements*, ed. Morley Adams (London: The Boy's Own Paper Office, n.d.). The topics include "How to Make a Diorama," (pp. 82–88), "Peep Shows. How to Make and Work Them," (pp. 121–128), "Artificial Fireworks. How to Make and Work Them," (pp. 128–134), "Dissolving Pictures," (pp. 118–121). Another book that contains similar

information is A. Rose, *The Boy Showman and Entertainer* (London: George Routledge & Sons and E. P. Dutton & Co., n.d.). The topics include "A Panorama," (pp. 142–147), Peep Shows (pp. 36–43), Artificial Fireworks (pp. 94–107), Shadow Shows (pp. 176–193). (Both in BDC).

56. James J. Shea, as told to Charles Mercer, *It's All in the Game* (New York: G. P. Putnam's Sons, 1960), p. 80. The book claims that the idea came to Bradley "with astonishing ease" as he was examining a German toy drum! (p. 79). It quotes a letter sent to Bradley by B. R. Davis from Vermont. It suggests that the Myriopticon entertained his family and the neighbors almost like a real moving panorama show. The letter is interesting, whether it is genuine or made up (pp. 81–82).

57. "Directions to the Proprietor of the Santa Claus Panorama" (Springfield, Mass.: Milton Bradley, n.d. [1866–1870]) (JJG, EH).

58. "John Banvard's Great Picture—Life on the Mississippi," *Living Age* 15, no. 1847 (Dec. 11, 1847): 511–515. The article is said to be from *Howitt's Journal*. Recycling articles was common. The title anticipates Mark Twain's autobiographical *Life on the Mississippi* (1883). Other examples in Banvard Family Papers (MHS).

59. The myth-building continued with a children's book, Nan Hayden Agle & Frances Atchinson, *Ingenious John Banvard* (New York: Seabury Press, 1966).

60. *The Good Shepherd and Other Stories* (New York: Leavitt & Allen, 1853), pp. 26–29 (EH). Banvard is featured in the chapter on "Panaoramas" [sic] as an American who has "won high renown" as a panorama painter (p. 29).

61. Years later "the merest schoolboy" commented in the British *Telegraph*

(July 15, 1873): "To the American Banvard belongs the honor of having painted the biggest and the most hideous panorama—that of the Mississippi—on the jack-towel principle, ever seen in this or any other country."

62. *Bullard's Panorama of New York City* (Northfield, Vt.: Cristian [sic] Messenger Office, post-Oct. 1852), hand-marked, "Mechanics Hall, Tuesday, Feb. 24 [1857?](EH). Quot. from *Rochester Daily Herald*. At the time of the presentation Bullard was already dead; see *Brief Sketch of the Life of O. A. Bullard, together with Recommendations, and Opinions of the Press in regard to his Panorama of New York City* (Albert Norton, 1851) (AAS). *Norton's Hand Book of New York City* is essentially a handbook to Bullard's panorama, which Norton then owned. It contains 44 engravings based on it, as well as testimonials and poems it inspired.

63. Quot. [William Burr], *Descriptive and Historical View of the Seven Mile Mirror of the Lakes, Niagara, St. Lawrence, and Saguenay Rivers . . .* (New York: Baker, Godwin & Co, 1854), p. 48. "Miserable daubs" were also mentioned in "Burr's Mirror of the St. Lawrence," *The Albion: Journal of News, Politics and Literature* 8, no. 39 (Sept. 29, 1849): 465.

64. In *The Lost Panoramas of the Mississippi* McDermott concentrated on five major ones by John Banvard, John Rowson Smith, Henry Levis, Sam Stockwell and Leon Pomarede. Samuel A. Hudson's panorama (for which Arrington dedicated a study, "Samuel A. Hudson's Panorama of the Ohio and Mississippi Rivers") is considered minor, and the Dickeson-Egan panorama too different. He briefly described John Stevens' *Panorama of the Sioux War* (1862), which was related with the Mississippi region, but painted more than a decade later.

65. S. C. Brees, *Guide and*

Description of the Panorama of New Zealand (London: Savill & Edwards, c. 1850), p. 13 (BL).

66. Arrington, "William Burr's Moving Panorama of the Great Lakes, The Niagara, St. Lawrence and Saguenay Rivers." Broadsides in HTC, EH.

67. Broadside for *Emerson's New and Magnificent Panorama of the Mammoth Cave, in Kentucky* (1860) in EH. Emerson was from Haverhill, Mass. Did he obtain Brewer's panorama, or create his own (said to be painted by O. R. Fowler)? Broadsides for Donnavan's *Grand Serial Panorama of Mexico*, and Sherman & Tousey's *Mammoth Panorama of Northern Mexico* (HTC).

68. Champney's panorama was destroyed in the fire in the New York Crystal Palace on Oct. 25, 1858. *Norton's Hand Book of New York City*, p. 32.

69. *Grand Moving Picture of the Crystal Palace, or [the] vast Artistic Moving Painting of the World's Fair or, Mirror of the Whole Exterior and Interior of the Crystal Palace Embracing every feature of Splendor, Utility, or Interest therein.* Shown at Stoppani Hall, Broadway [New York], undated [1850s] broadside (HTC). It was painted by a group of painters led by Signor Delamano.

70. *The Illustrated London News Grand Panorama of the Great Exhibition of All Nations 1851* (EH).

71. Broadside in HTC. The panorama is in the storage of the New Bedford Whaling Museum, New Bedford, Mass. I saw the rolls there in May 2009. Samuel Eliot Morison, *Introduction to Whaler out of New Bedford: A Film based on the Purrington-Russell Panorama of a Whaling Voyage Round the World 1841–1845* (New Bedford, Mass.: Old Dartmouth Historical Society, 1962). Elton W. Hall, *Panoramic Views of Whaling by Benjamin Russell* (New

Bedford, Mass.: Old Dartmouth Historical Society, Sketch no. 80, 1981). The Peabody Essex museum (Salem, Mass.) has a smaller artisanal moving panorama of a whaling voyage in its wooden viewing box. It is dated c. 1860 and made by the carriage painter Thomas F. Davidson from Salem, Mass, where he is said to have displayed it.

72. John L. March, "Captain E. C. Williams and the Panoramic School of Acting," *Educational Theater Journal* 23, no. 3 (Oct. 1971): 289–297; Avery, "The Panorama and Its Manifestation in American Landscape Painting," pp. 157–158. *Grand South Sea Whaling Voyage. Illustrated on 8000 Feet of Canvas! The Splendid A1, Coppered and Copper-Fastened Whale Ship Elizabeth Starbuck, Frank Hine, Commander, Will Sail on Monday, Tuesday, and Wednesday Evenings, March 7th, 8th, & 9th [1853, 1859, 1864, or 1870] From her Moorings in Corinthian Hall [Rochester, N.Y.]*, broadside (EH). The name Hine is a mystery; did the panorama belong to him at some point (before Williams?), or was he just a stand-in? The program corresponds with the version Williams exhibited around 1858–1860 before he added "A Genuine Boat and Living Crew," and other performative elements (March, p. 295). A collection of Williams-related documents is at the Kendall Institute Library, The New Bedford Whaling Museum, New Bedford, Mass.

73. Potter, *Arctic Spectacles*, p. 120. The 57 scenes were based on engraved plates in a book written by the explorer Elisha Kent Kane. In his boyhood diary Beale mentions uncle Edmund often. He must have been an inspiration to construct the miniature moving panorama (copy of the handwritten diary in AMLT). Heilge also painted a moving panorama of a trip to California and back "by sea and land," exhibited by Smith & Beale (broadside in HL).

74. For the Kane panoramas, see Potter, *Arctic Spectacles*, pp. 130–136.

75. "Splendid Work of Art: Magnificent and Highly-finished Panorama A Walk in the Garden of Eden with Adam and Eve Designed & Painted by H[enry] C[heever] Pratt, of the Boston Artists' Association," broadside (Boston: Hooton's Press, 1849). World Cat does not specify the collection where this source is kept, but the National Gallery of Art, Washington, has another broadside for a presentation at Cabot Hall [Chicopee?], 1850, titled *Pratt's Great Botanical and Poetical Panorama of the Garden of Eden, as Described in Milton's Paradise; an Immense Moving Picture of Nature!*

76. *A Short History of J. Insco Williams' Panorama of the Bible, containing a scriptural account of each scene: to which is appended a few practical notes, taken from various authors of distinction, by Rev. S. H. Chase, M.D.* (Cincinnati: Printed by the Gazette Co., 1857), p. 2 (HL).

77. Broadside, Boylston Hall, Washington Street [Boston], Oct. 31, 1849 (HTC). Another religious product was *Hathaway's Panorama of the Life of Christ*, already displayed in 1850.

78. Avery, "The Panorama and Its Manifestation in American Landscape Painting," p. 237.

79. In this sense it could be compared with the *Route of the Overland Mail to India* (1850), a collaboration between the highly esteemed scene painters Thomas Grieve, William Telbin, and others.

80. *The Story in Color! Bunyan's Pilgrim's Progress. Illustrated by Messrs. Kyle, May, Huntington, Cropsley, Church, Darley, Dallas and Paul Duggan.* Undated broadside [1850s], HTC, SMC.

81. The second version (1851) is the one kept and restored at the Saco Museum, Maine. Of its 54 views 41 have been preserved.

82. Avery, "The Panorama and Its Manifestation in American Landscape Painting," p. 247. Avery does not write about the lantern slides about the *Pilgrim's Progress*.

83. The World Cat finds a broadside ("Kind friends, we are with you! Exhibition. Johnson's moving panorama of The drunkard . . .") for such an entertainment (New London, Ct.: D. S. Ruddick, 1852), but does not mention where it is located. I have not found information about the New England songsters, so this may have been a parody.

84. *Johnson's Moving Panorama of the Drunkard*, Broadside, Oxford, Ontario, May 13, 1852 (AAS).

85. [William Arnot,] *The Drunkard's Progress; Being a Panorama of the Overland Route from the Station at Drought, to the General Terminus in the Dead Sea* (Edinburgh: Johnstone and Hunter, 1853), title page.

86. Society Library Rooms, New York, February 14,1849 (broadside in EH). One of the members was "Mast. Ole Bull," who played a violin solo. He has been mixed up with the Norwegian violin virtuoso with the same name. Mast. Ole Bull was an American named Frederick Buckley, whose relatives also performed in the group. Drummond light means oxy-hydrogen gaslight, which was still a novelty.

87. *Five Paintings from Th. Nast's Grand Caricaturama* (New York: The Swann Collection of Caricature and Cartoon, 1970), p. 6. The preserved five paintings are at the Library of Congress as part of the Swann collection.

88. Ruggles, *The Unboxing of Henry Brown*. Henry Box Brown, *Narrative of the Life of Henry Box Brown* (Oxford: Oxford University Press, 2002, orig. 1851) does not mention the panorama, because it was produced later.

89. The second part contained two views with Brown, "H. B. Brown Escaping," and "H. B. Brown released in Philadelph[i]a." There were unrelated views in-between, which makes one wonder how Brown covered this topic in his lecture. Brown's broadside for a presentation at Earl Street, Stafford (UK), Feb. 20, 1854 (HTC).

90. Broadsides for performances at Earl Street, Stafford (UK), Feb. 20, 1854, and New Market-Hall, Camborne (UK), Oct. 20, 1855 (HTC). The African-American artist Glenn Ligon referred to the box in his installation *To Disembark*, first shown in 1993. Sounds (like Billie Holliday singing *Strange Fruit*) emanate from four boxes that match the measurements of Box Brown's box.

91. In 1850 W. W. Brown, who called himself "the American Fugitive Slave," exhibited "Brown's Original Panorama of American Slavery" around England. *The Durham Chronicle* advertised his show on Nov. 1, 1850 (photocopy in RH). A broadside at Tyne and Wear Museum (photocopy in RH) details the program for Wells's lectures in the Seamen's Hall, South Shields. There was a "series of VIEWS, accurately describing, by ACTUAL EVENTS, the various thrilling incidents in the Life of an American Slave." The views were said to have been painted on "2,000 Feet of Canvass [sic]." Yet another example, *Grand moving panorama, illustrative of the great African and American slave trade!*, with a lecture by Revd. W. H. Irwin, who introduced a fugitive slave, Charles Freeman, was shown at the Cosmorama Rooms, 209 Regent Street, London around 1853. Freeman's autobiography (1853) was for sale at the premises (broadsides in JJCB).

92. Albert Smith and John Leech, *A Month. A View of Passing Subjects and Manners* (London: "Month" Office, 1851), p. 237.

93. W. H. R., "Letter from London," *Home Journal* 9, no. 211 (February 23, 1850): 2. The letter is dated Jan. 23, 1850, so it took only a month to reach the readers.

94. Joseph Earl Arrington, "Skirving's Moving Panorama: Colonel Fremont's Western Expeditions Pictorialized," *Oregon Historical Quarterly* 65, no. 2 (June 1964): 132–172. The panorama was painted by Joseph Kyle, Jacob A. Dallas, J. Lee, and possibly also by Skirving. According to Arrington, Colonel Fremont's sketches from his expeditions were used (among other sources), but otherwise he had nothing to do with the panorama. In *John Charles Fremont: Character As Destiny*, Andrew Rolle misleadingly presents the panorama as Fremont's own endeavor (Norman: University of Oklahoma Press, 1991), p. 147.

95. The moving panorama was just one episode of "Professor Risley's (Richard Risley Carlisle, 1814–1874) colorful career. He performed as an acrobat with a child, traveled to Japan with his troupe in 1864, and ended up touring the United States and Europe as a promoter for a troupe of Japanese acrobats. Aya Mihara and Stuart Thayer, "Richard Risley Carlisle: Man in Motion," *Bandwagon: The Journal of the Circus Historical Society* 41, no. 1 (Jan.–Feb. 1997): 12–14; Aya Mihara, "Little 'All Right' Took the Stage: A Tour of the Japanese Acrobats in Western Europe," *Ohtani Women's University Studies in English Language and Literature* (Japan), vol. 23 (March 1996): 99–114. Frederik L. Schodt is working on a book length study of Risley's life and career (as of March 2012).

96. *Manchester Guardian*, Jan. 25, 1851.

97. *Professor Risley and Mr. J. R. Smith's Original Gigantic Moving Panorama of the Mississippi River*, p. vii.

98. *The Albion, A Journal of News,*

Politics and Literature 7, no. 35 (Aug. 26, 1848): 416.

99. An English churchman who saw the panorama in Boston in 1847 said that "it took two hours and a half in almost continuous unrolling." A Pioneer of the Wilderness [A. W. H. Rose,] *The Emigrant Churchman in Canada*, ed. Rev. Henry Christmas (London: Richard Bentley, 1849), vol. 1, p. 82. In his *Furlough Reminiscences, Thoughts and Strayings, the Kote Masool, and the Duel* (Calcutta: P. S. D'Rozario and Co., 1849), Captain William Henry Jeremie explained that a friend "of scientific eminence" had devised a way to measure the canvas, concluding it was much shorter than claimed. Laramie wrote about the "Gigantic Deceiver" and the "Mississippi Hippopotamus." (pp. 75–76.).

100. Charles Dickens, "The American Panorama," in *To Be Read at Dusk and other Stories, Sketches and Essays* (London: George Redway, 1898), pp. 86–87 (orig. in the *Examiner*, Dec. 16, 1848).

101. The back cover of the program booklet for his new panorama of Jerusalem and the Holy Land (1853) displayed Banvard in front of Victoria, Albert, and the family. *Description of Banvard's Pilgrimage to Jerusalem and the Holy Land; Painted from authentic drawings made upon the spot during an extensive journey, undertaken expressly for the work, in four immense volumes; Presenting in Minute Detail The Sacred Localities; the Cities, Mountains, Plains and Rivers; celebrated in Scriptural History* ([New York: John Banvard,] 1853), p. 26 (EH).

102. The booklet of Banvard's life was translated as *Banvard, ou Les aventures d'un artiste* (Paris: Typographie Dondey-Dupré, 1850). (MHS).

103. *Description of Banvard's Pilgrimage to Jerusalem and the Holy Land.*, p. 4. About Banvard's colorful

later career as a theater owner and author, see Collins, *Banvard's Folly*; John Hanners, "John Banvard (1815–1891) and his Mississippi Panorama," Ph.D. Dissertation, Michigan State University, Depertment of Theatre, 1979 (unprinted), ch. 3 (pp. 107–130). The Mississippi panorama was revived for the last time in New York in 1881 (p. 130).

104. "Monster Panorama Manias, *Punch* 17 (July–Dec. 1849): 14; Albert Smith, "Composite Columns, No. V: Panoramania," *Illustrated London News*, Aug. 5, 1850." In the United States, *The Living Age* quoted the *Morning Chronicle*: "Last season introduced the panoramic mania. . . ." It expected "the general favor extended to the whole race ending in *rama*" to "ripen into a most astonishing harvest of exhibitions of the kind for the coming season." "The Panoramas, &c.," *The Living Age* (Boston), vol. 29 (April, May, June 1851): 184.

105. "Panorama Painting," *Almanack of the Fine Arts for the Year 1852*, ed. R. W. Buss (London: George Rowney, 1852), p. 160.

106. Banvard inspired a British Mississippi-panorama as early as 1849: *Sealy's Late Carter's Gigantic Moving Panorama of the Mississippi! Missouri, and Yellow Stone Rivers, Now Exhibiting in this Town* (Dursley: Rickards and Workman, n.d., post-July 1850). The broadside (YBL) lists reviews of performances at Bristol, Exeter, Plymouth, Guernsey, etc., in 1849–1850, the earliest being from Bristol, Assembly Rooms, Princes Street (*Bristol Mercury*, Oct. 20, 1849). All press quotations refer to either "Mr. Carter's Colossal Panorama," or "Mr. Carter's Colossal panorama of American Scenery," confirming that Carter had died only recently. Quotation from the *Western Times* (Feb. 9, 1850) identifies the artist as an Englishman, Mr. Danson, probably the well-known panorama and scene painter George Danson.

210

107. George Sala wrote about "stereoscopic mania" that had "taken possession of London" in "Since this old cap was new," *All Year Around* 2, no. 30 (Nov. 19, 1859): 76–80. Sala was identified as the writer by R. D. Wood, "The Old Cap Anew: [Commonplace marvels of Photography in the 1850s]," *Professional Photographer* (UK: Market Link Publishing), vol. 32, no. 12 (Dec. 1992): 14.

108. *A Description of The Royal Colosseum, Re-opened in M.DCCC.XLV, Under the Patronage of Her Majesty the Queen, and H.R.H. Prince Albert, Re-embellished in 1848* (London: J. Chisman, 1848). Bound together with *Description of the Royal Cyclorama, or Music Hall: Albany Street, Regent's Park. Opened in MDCCCXLVIII* (London: J. Chisman: 1848). The Cyclorama has been reproduced in ten plates between pages 8 and 9. (EH).

109. *The Civil Engineer and Architect's Journal* 1, no 14 (Nov. 1838): 382. It was said that the Cyclorama will be "opened by subscription," which may refer to a search for investors and shareholders. I have not found other mentions about Bouton's involvement. This episode has not been noted by previous scholars.

110. The machinery was realized, as promised in 1838, by William Bradwell from the Covent Garden.

111. Report from the press preview, unidentified newspaper clipping, hand-dated Dec. 20, 1848 (JJCB).

112. Apollonicon was an organ-like instrument by Messrs. Bevington & Sons, of Greek Street, Soho, London. Beethoven, Mozart, Meyerbeer, Mendelsohn, a Brazilian melody and a Portuguese dance were played by Mr. Pittman. "Lisbon, at the Cyclorama," unidentified newspaper clipping, hand-dated March 30, 1850 (JJCB).

113. Unidentified newspaper clipping, hand-dated May 26, 1849 (JJCB).

114. The cartoon "The Real Street Obstructions" by John Leech in *Punch* 19 (1850): 30 (EH) shows such posters on display. An illustration titled "The London Season. Regent-Street," in *ILN* 14 (March 31, 1849) shows a "sandwich" man walking on the Regent Street advertising Banvard's Mississippi panorama at Egyptian Hall. A print titled "Cross Readings, No. 1" (London: W. Jeffery, c. 1840) shows a fence covered by overlapping broadsides, including one for the Colosseum. When read column by column from top to bottom composite, surrealist-like sentences emerge (EH).

115. *Illustrated London News* 1, no. 1 (May 14, 1842).

116. J[ohn] R[owson] Smith, *Descriptive Book of the Tour of Europe, the Largest Moving Panorama in the World*, Linwood Gallery, Leicester Square, London, Sept. 1853 (Frankfort a/M: C. Horstmann, 1853), p. 5 (JJCBL).

117. The discourse on object lessons had already begun in the 1830s, but gained more ground toward mid-century. An influential pedagogical summary was A[donijah] S[trong] Welch, *Object Lessons: Prepared for Teachers of Primary Schools and Primary Classes* (New York: A. S. Barnes & Burr, 1862). The concept and the idea behind it were broadened and adopted by many different fields. See Meredith A. Bak, "Democracy and Discipline: Object lessons and the stereoscope in American education, 1870–1920," *Early Popular Visual Culture* (forthcoming).

118. Thomas Allom, *The Polyorama of Constantinople, the Bosphorus and Dardanelles*, 3d ed. (London: W. S. Johnson, 1850), p. iii (EH). According to an unidentified newspaper clipping (JJCB), the panorama was painted by Desvignes and Gordon from Allom's sketches. Critics praised it, because it had been "executed in bold, sometimes hasty, dashing manner, it arrives at its object almost without any assistance from dioramic effects,

by its own force of light and shade." "The Moving Panoramas, Their Beauty, and Importance," *London As It Is Today: Where to go, and what to see, during the Great Exhibition* (London: H. G. Clarke & Co, 1851), p. 280.

119. "Monster Panorama Manias," *Punch*, July 14, 1849.

120. "The Moving Panoramas, Their Beauty, and Importance," p. 279. The guidebook (see note 121) stated that the painting was above 800 feet in length, and eight feet in breadth (p. 5).

121. Geo. R. Gliddon, *Hand-book to the American Panorama of the Nile, Being the Original Transparent Picture exhibited in London, at Egyptian Hall, Piccadilly . . .* (London: James Madden, 1849), p. 17 (EH). The handbook contains heavily annotated appendixes about the geography, philology, chronology and history of Egypt, as well as diagrams and charts.

122. Ibid., p. 8.

123. The new version was exhibited at the Gallery of Painters in Water Colors, 53, Pall Mall. Broadside in JJC.

124. Bartlett's panorama was shown at the St. George's Gallery, Hyde Park Corner, Warren, Bonomi and Fahey's again at the Egyptian Hall.

125. Wilcox, "The Panorama and Related Exhibitions in London," pp. 132–153.

126. "Miscellaneous Exhibitions," *London As It Is Today*, p. 271. The exhibition was at 393, Strand.

127. "Oriental Diorama," *Almanach of the Fine Arts for the Year 1851*, ed. R. W. Buss (London: George Rowney & Co., 1851), p. 164. One wonders if there was a business relationship between the exhibitors of these panoramas. An ad for a book based on *The Route of the Overland Mail to India* was included in the guidebook (see note 128).

128. W. Wallace Scott, *New Oriental Diorama: Life and Scenes in India Illustrated in an Imaginary Tour*, Willis's Rooms, King Street, St. James's, 1850, guidebook, p. 3 (JJCB). It was painted by W. W. Scott, Wilson, Desvignes, Thompson, Grey, Adams, Battie, and Fenton.

129. *An Illustrated Description of the Diorama of the Ganges*, Portland Gallery, 316, Regent Street, Langham Place, Opposite the Polytechnic Institution (London: Published in the Gallery, to be had of all booksellers, 1850), p. 3 (JJCB). Sketches were taken by James Fergusson. Yet another India-related product was Philip Phillips's *Grand Moving Diorama of Hindostan* (Asiatic Gallery, Baker Street Bazar, 1853).

130. "Diorama of the Ganges," *Almanach of the Fine Arts for the Year 1852*, ed. R. W. Buss (London: George Rowney & Co., 1852), p. 160.

131. Also known as "panoramas" or "panoramic views." Charles Musser, *Edison Motion Pictures, 1890–1900. An Annotated Filmography* (Gemona: Le Giornate del cinema muto/ Smithsonian Institution Press, 1997), Film Title Index.

132. *An Illustrated Description of the Diorama of the Ganges*, p. 3. The text criticizes an unnamed panorama, probably the *New Oriental Diorama*, for trying to do this unsuccessfully.

133. "Holiday Sights," *The Musical World: A Journal of Music, the Drama, Literature, Fine Arts, Foreign Intelligence, &c.* (London: W. S. Johnson, 1851), vol. 25: 411.

134. "Exhibitions for Easter," *Illustrated London News*, March 30, 1850, p. 220.

135. *The Route of the Overland Mail to India, from Southampton to Calcutta* (London: Gallery of Illustration, 14 Regent Street, Waterloo Place, 1850),

Fifth Edition of 5000, exhibition handbook (EH).

136. On the P&O Company sponsorship, Robert McDonald, "The Route of the Overland Mail to India," *The New Magic Lantern Journal* 9, no. 6 (Summer 2004): 83–84. To cash on the success, Stocqueler wrote *The Overland Companion being A Guide for the Traveler to India via Egypt* (London: Wm. H. Allen and Co., 1850), which gave practical information, but also seems to follow his lecture for the panorama. He discussed his career as a panorama lecturer in *The Memoirs of a Journalist*, enlarged, revised, and corrected by the author (Bombay: Offices of the Times of India, 1873), ch. 4 (pp. 184 ff.).

137. The building was the former residence of Nash (1752–1835), who laid the guidelines for the facade of the Regent's Park Diorama, which was designed by Morgan and Pugin.

138. Richard Ford, *A Guide to the Grand National and Historical Diorama of the Campaigns of Wellington*, Gallery of Illustration, 14 Regent Street (London: by the proprietors, 1852), p. 3. In *Curiosities of London* Timbs says it was shown 1600–1700 times and "visited by upwards of 250,000 people" (p. 253). Messrs. Hamilton exhibited in 1876 a *New Overland Route to India*, which followed a different route, and also included a tour of India from Calcutta to Benares. It was said to have been painted by Messrs. Telbin (father and son?) with others, including the late marine artist Edwin Weedon. Broadsides in Evanion, JJCB.

139. *Bentley's Miscellany* confirmed it was "on a scale of unprecedented magnitude." (London: Richard Bentley, vol. 27, 1850), p. 356.

140. *London as it is To-Day*, p. 268.

141. *Musical World* 25, no. 13 (March 30, 1850): 203.

142. *Art-Journal* (London), vol. 12

(1850): 163. The panorama became a reference point for reality. The Chaplain of Lucknow Reverend Henry S. Polehampton characterized his desert crossing from Cairo to Suez in a letter in 1856: "The diorama of the overland route is a most faithful representation of all that takes place." *A Memoir, Letters, and Diary of Rev. Henry S. Polehampton, M.A.*, ed. Rev. Edward Polehampton and the Rev. Thomas Stedman Polehampton (London: Richard Bentley, 1858), p. 64. From Malta he wrote: "The streets remind me a good deal of pictures of Jerusalem which I have seen" (p. 58) From Alexandria he recommended: "See any of Bartlett's pictures, illustrating the East, which represent Eastern bazaars; they are very faithful" (p. 60). William Henry Bartlett was also known for *The Diorama of Jerusalem and the Holy Land*, based on his sketches.

143. Crystal Palace: *Critic, London Literary Journal* 10 (Sep. 15, 1851): 443; Taj Mahal: *Literary Gazette and Journal of the Belles Lettres, Arts, and Sciences*, no. 1789 (May 3, 1851), p. 319.

144. *The British Metropolis in 1851* (London: Arthur Hall, Virtue & Co, 1851), p. 269. *The Literary World* (9, no. 243, July–Dec. 1851: 254) said it was accompanied by "letter-press descriptions" by Thomas Miller, who was a well-known author of nostalgic books about British country life, such as *Rural Sketches* (London: John Van Voorst, 1839), which included a chapter about the attractions at a country fair (pp. 133–161). Altick claims there were poetry recitations by actor Frederick Viring (*The Shows of London*, p. 460). I have not encountered his name in my sources.

145. *King's College Magazine* (London: Houlston and Hughes, vol. 2, 1852), p. 273.

146. *Wellington Anecdotes. A Collection of Sayings and Doings of the Great Duke* (London: Addey and Co., 1852), p. 74.

147. "The Diorama of the life of the duke of wellington has also been for some time in progress," in an advertisement, *Athenaeum* (London), no. 1207 (Dec. 14, 1850), p. 1315.

148. Ford, *A Guide to the Grand National and Historical Diorama of the Campaigns of Wellington*, p. 3. A detailed and favorable review was published in *Colburn's United Service Magazine and Naval and Military Journal* (London: Colburn & Co.), 1852, part 2 (June 1852), pp. 284–286.

149. To increase its patriotic appeal, views of Wellington's corpse lying in state, the funeral procession, etc. were later added, with funeral music (broadside, hand-dated Feb. 23, 1853, JJCB).

150. *A Guide to the Diorama of the Ocean Mail to India and Australia* (London: |Gallery of Illustration, 1853).

151. Ibid., p. 5.

152. Premiered in 1853. Undated broadsides in JJCB. For example in 1855 views of the Battle of Inkerman [Nov. 5, 1854] and of a great storm in the Black Sea (a moving scene with "mimic thunder and lightning") were added. *Art-Journal* (London: George Virtue, new series, vol. 2, 1855), p. 98.

153. The *Athenaeum*, No. 1371 (Feb. 4, 1854), p. 152. The arctic views were said to be based on "Pictorial Authorities principally contributed by Captain Inglefield, R.N.," who had made an expedition in 1852–1853. Compared with the extensively advertised and reviewed *Overland Route* and *Campaigns of Wellington*, there is little information about this program.

154. Willert Beale [Walter Maynard], *The Light of Other Days Seen Through the Wrong End of an Opera Glass* (London: Richard Bentley and Son, 1890), p. 244.

155. G. W. Cassidy, *Cassidy's Diorama of the Route of the Overland Mail to India, from Southampton to Calcutta* (London: William Stevens, Published for the Proprietor, 1856) (EH). The handbook is nearly identical, except that the "descriptive details" are given by Cassidy, and the music by Madame von Schweiso, "from the Royal Colosseum." Cassidy exhibited a copy of Samuel A. Hudson's panorama of the Ohio and Mississippi rivers in Germany in 1850–1851, but it was destroyed in the fire of the Krollsche Establishment in Berlin on Feb. 1, 1851, p. 128; *Die Volksbötin* (Munich), vol. 3, no. 31 (5 February 1851), p. 128; *Magazin für die Literatur des Auslandes* (Berlin), no. 32 (March 15, 1851), p. 128. Waddington, *Panoramas, Magic Lanterns and Cinemas*, quotes an ad for Poole & Young's show in Jersey in 1875 that explicitly states that the Overland Mail to India,""acquired from Messrs. Grieve & Tolbin [sic]," forms the first portion of their entertainment. Scenes by others had been added (pp. 12–13).

156. *The History of the Theater Royal, Dublin, From Its Foundation in 1821 to the Present Time* (Dublin: Edward Ponsonby, 1870), p. 143. The pantomime was *Harlequin Blue Beard, the Great Bashaw! or the Good Fairy triumphant over the Genius of Discord.*

157. *A Dictionary of Music and Musicians* (A.D. 1450–1889), ed. Sir George Grove (London: Macmillan and Co., 1890), vol. 3, pp. 90–91. Later it also served as a lecture room under the management of Charles Dickens.

158. "The General Exhibition Company (Limited.) [for private circulation only]." Prospectus, hand-dated Oct. 1856 (JJCB). There were several well-known writers or poets in the board of directors: Charles Mackay, Henry Mayhew, Douglas Jerrold, and Alaric A. Watts. Altick (*Shows of London*, p. 481) commented on the prospectus in a note, but did not research its relationship to the patent. The word Georama was also used by John Banvard about his showroom in New York, and earlier referred to Langlard's sphere-shaped astronomical exhibition hall in Paris (1825).

159. Edward Sparkhall, "Exhibiting Pictorial Representations," British Patent no. 313 (1855). Copy in EH. This patent was mentioned but not analyzed in Hermann Hecht, "Some English Magic Lantern Patents," *New Magic Lantern Journal* 2, no 2 (January 1982): 2–3.

160. In his novel *Michael Strogoff: The Courier of the Czar* (1876) Jules Verne provided a discursive parallel of such a situation: "The raft swiftly threaded its way among the blocks of ice which were carried along in the current of the Angara. A moving panorama was displayed on both sides of the river, and, by an optical illusion, it appeared as if it was the raft which was motionless before a succession of picturesque scenes." Jules Verne, *Michael Strogoff: The Courier of the Czar*, translation (New York: Charles Schribner's Sons, 1895), p. 291.

161. One wonders if the idea was influenced by the stereoscope, which was just becoming a fad. It offered only three-dimensional still images, but wrapped around the field of vision and created an illusion of penetrating into the picture, turning it into a simulated "place."

162. In a letter reproduced in the prospectus, the essayist and poet Leigh Hunt fantasized about the simulation: "The next thing . . . will be some invention, by means of which flues and ventilators, for giving us a taste of the very climates through which we pass." Hugo d'Alési's *Maréorama* later took up the challenge of such multisensory simulation.

163. The company was mentioned in the "List of limited liability companies registered since December 22 [1855]," *Law Times Reports* 26 (September 1855 to March 1856): 186.

Later mentions cannot be found. In
1860 Grieve and Telbin painted
a *Stereorama* for Cremorne Gardens.
It was another unusual effort that
resembled circular panoramas, except
that "instead of being painted on a flat
surface, [the Swiss views] are literally
built after the fashion of an elaborate
'set' scene at the theatre, while large
portions of them are actually solid,
and effects of real water on a grand
scale are introduced." (*Times*, August
13, 1860). The newspaper suggested
that the attraction may have been
inspired by the "popular scientific toy,
the stereoscope."

7. PANORAMANIA IN PRACTICE:

ALBERT SMITH AND HIS MOVING PANORAMAS

THE NATURAL HISTORY OF A BOHEMIAN

When it comes to success and fame, the career of Albert Smith (1816–1860) was the culmination of the moving panorama as a medium. *Albert Smith's Ascent of Mont Blanc* was performed no less than 2,000 times between 1852 and 1858—for six seasons in a row—at the same venue, the Egyptian Hall. Smith became a fixture of the British metropolis; his entertainments "were as popular a feature of the London scene as Madame Tussaud's and the Tower of London."[1] Anachronistically, their status could be compared with the role of musicals like *Cats* and *Mamma Mia* in our time, performed barely a stone's throw away from where the Egyptian Hall used to stand.

The career of "Albert the Great" profited from the panoramania, but was far from typical. While for most showmen the primary attraction was the panorama, for Smith his own name was more important than the title of his entertainment.[2] The spectators came to hear him tell his stories, impersonate characters, sing songs, and, last but not least, display panoramas. In the speech he gave at the final performance of *Albert Smith's Ascent of Mont Blanc* he did not say a word about the panorama, although it was by the highly regarded scene painter William Beverl[e]y (c. 1810/14–1889), and frequently praised.[3] The words moving panorama were not mentioned in the publicity. The program booklet for *Albert Smith's Ascent of Mont Blanc* simply said: "The illustrative views have been

Figure 7.1
Portrait of Albert Smith, lithograph by Charles-Louis Baugniet (1814–86), 1844 (printer: Day & Haghe). Indicating that he is a literary man, Smith poses with a quill-pen, with the third volume of *Punch* on the table. Ironically, Smith had just left the magazine because of disagreements with its editor Mark Lemon. Smith dedicated this copy to his friend, the dramatist and critic Tom Taylor, who later became the editor of *Punch*. Author's collection.

painted from original sketches, by Mr. William Beverley, who accompanied Mr. Albert Smith to Chamouni."⁴ Paradoxically, at the peak of its success, the moving panorama was demoted to the role of mere illustration.

Smith was trained as a medical doctor, but was attracted to bohemian life already as a student. After nominally studying in Paris, he moved back to his home village of Chertsey for a while, and then permanently to London in the early 1840s. He built a career as a literary man, whose prolific output included novels, play adaptations, burlesques, song lyrics, and countless journalistic pieces for magazines like *Mirror*, *Punch*, *Bentley's Miscellany*, and *Man in the Moon* (which he edited). His popular series of little books of "natural histories" had been influenced by the French literary genre Walter Benjamin later called "panorama literature."⁵ They were character sketches of social types from gentleman snobs and ballet girls to idlers and "stuck up people." Readers praised Smith's writings for their wit and humor, but critics accused them of superficiality and imitation (in particular, of French sources).

Smith polarized opinions. One contemporary criticized his "boisterous, bumptious vulgarity" and "mountebank ways."⁶ Others were offended by his blatant self-promotion and tendency to ridicule those who were more privileged (and often more talented) than him. John Banvard's performance of the Mississippi panorama helped Smith realize that he could achieve success by combining his literary skills with lecturing, singing and mimicry. Transforming himself into a public performer made Smith shed some of his bohemian extravagance, and acquire a "varnish of politeness."⁷ Success helped him to obtain the status he had been craving for: to become a recognized cultural figure. Behind his facade he may have remained a bohemian, but in the lavish parties he gave to notables he was "our" Albert.

Smith was also inspired by a British tradition, where a single performer entertained the audience by impersonating characters, engaging in a kind of variety entertainment. The format was perfected by the actor Charles Mathews (1776–1835), who gained a legendary reputation for a long series of one-man productions known as *At Home*.⁸ Smith is said to have attended one of them

Figure 7.2
Collective portrait montage of Victorian notables, arranged around Queen Victoria and Prince Albert. Albert Smith is second from the right in the top row. Carte-de-visite photograph, unknown photographer, British, late 1850s. Albert Smith died in 1860 and Prince Albert the following year. Author's collection.

when he was only eleven years old.⁹ In his "monopolylogues" Mathews impersonated characters in comic everyday situations, switching roles (and costumes) in a matter of seconds. A contemporary characterized him with a media-metaphor as a "live kaleidoscope."¹⁰ Prince Pückler-Muskau, whose appetite for popular entertainments (including the peristrephic panorama and the Diorama) was endless, commented in awe on one of Mathews's performances:

> Imperceptibly, he passed from the narrative style to a perfectly dramatic performance in which with almost inconceivable talent and memory he placed before the eyes of his audience all that he had witnessed; while he so rapidly altered his face, speech, and whole exterior, with the rapidity of lightning, that one must have seen it to believe it possible.¹¹

Such monopolylogues (sometimes called polymonologues) became very popular, and inspired followers, including the actor, musician and illustrator John Orlando Parry (1810–1879), for whom Smith wrote song lyrics and the successful one-man show *Notes Vocal and Instrumental*. It premiered soon after Smith's own stage debut in June 1850. Parry not only played music, sang in different voices, and changed costumes; he illustrated his show himself with large watercolors.

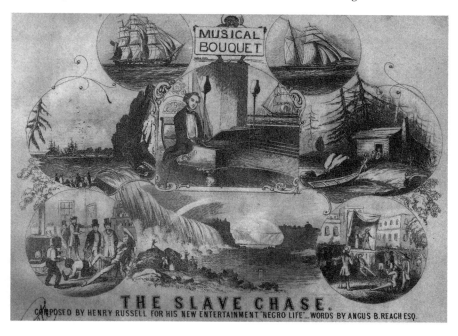

Figure 7.3
Cover illustration to the sheet music of Henry Russell's "The Slave Chase," composed for his panoramic entertainment *Negro Life*. Musical Bouquet, London, 1851. The illustration shows Russell performing in front of his moving panorama of *The Far West, or the Emigrant's Life* (shown together with *Negro Life*), surrounded by selected scenes from panoramas for both. Author's collection.

Another entertainer who went through a similar development was the popular composer Henry Russell (1812–1900), who worked as an entertainer in the United States in the 1830s, but returned to England, his native country, in 1841. His "vocal and pictorial entertainment" *The Far West; or, the Emigrants' Progress From the Old World to the New: and Negro Life, in Freedom and in Slavery* at the Olympic Theatre (1851) combined stories of emigration to the United States and of slavery, visualized by two moving panoramas. They rolled in the background, while Russell played, sang his songs, and chanted poems.[12] The *Illustrated London News* commended Russell for blending "the picturesque and poetic in intimate unison," and for showing "how each may be made mutually to assist the other, through the medium of music."[13]

As Mathews's, Parry's, and Russell's entertainments demonstrate, the format of Smith's entertainments was in the air. Mathews's *Trip to Paris* (1819) and *Trip to America* (1824) had already dealt with foreign travel, highlighting characters encountered along the way. What separated Smith's productions from earlier monopolylogues was the more prominent role he gave to the illustrations, as well as the decision to abandon costume changes and clown-like antics in favor of a formal evening suit; a choice that served Smith's societal aspirations.

AT HOME ON THE OVERLAND TRAIL

Smith's career as a public entertainer began in 1850 with *The Overland Mail*. It was based on a trip Smith made in 1849 to Italy, Malta, Athens, Smyrna, Constantinople, and Egypt, traveling light and economically backpack-style, true to his bohemian manners. To cover expenses and to create interest toward his upcoming entertainment, Smith published an account of his trip, *A Month at Constantinople*, just a few weeks before the premiere.[14] It got a cool reception from highbrow critics, but to their dismay it sold well. The book does not completely overlap with the performance, which concentrated on Smith's sojourn in Egypt and his journey back to England. Still, it gives a good idea about Smith's attitudes and the kinds of issues he presented to the audience.

Figure 7.4
The signatures of Albert Smith and his travel companion Joseph (Joe) M. Robins, on their way to Malta, Constantinople and Egypt, preserved on a page from the guest book of the Hotel des Étrangers, Naples (Italy), August 20, 1849. An ephemeral trace of media history: the trip gave the topic for Smith's first panoramic entertainment. Author's collection.

Adhering to a typical British habit, most things left Smith indifferent or disgusted, including the dancing dervishes of Scutari: "There was something inexpressively sly and offensive in the appearance of these men, and the desire one felt to hit them hard in the face became uncomfortably dominant."[15] At a slave market he saw "negros" for sale, which inspired a comment that now sounds outrageous: "If any person of average propriety and right-mindedness were shown these creatures, and told that their lot was to become the property of others and work in return for food and lodging, he would come to the conclusion that it was all they were fit for."[16]

Having reached Alexandria, Smith concentrated on graffiti carved on the surface of the "Pompey's pillar" by British tourists, rather than on historical and cultural information. He stated, with apparent honesty: "I tried to feel as other writers have felt—when, as they have affirmed the names of Herodotus, Ptolemy, and other ancients, rose up before them, as they gazed at the pillar—but I could not."[17] Such sarcastic but unpretentious and spontaneous-sounding discourse became Smith's trademark in the lecture room as well, when his "Literary, Pictorial, and Musical Entertainment" premiered at Willis's Rooms on May 28, 1850.[18] It was aptly summarized by the *Times*:

> In amusing his audience with an account of a journey from Suez to Boulogne, Mr. Albert Smith unites two distinct classes of entertainment—the instructive diorama [moving panorama], which has of late, become so much the rage, and the humorous song and character sketch, which belongs to the old "Mathews at Home."[19]

Another commentator wrote that where a "panorama exhibitor's" speech normally sounded "like a page of a dictionary read aloud," Smith offered more than just information, "introducing us to natives and exotics in a manner that makes us quite forget we are not actually sailing with him 'in his boat upon the Nile.'"[20] The *Times* reviewer pointed out that William Beverley's illustrations were "separate from each other, not connected as in other moving dioramas, and hence we would suggest that in future exhibitions the curtain should be lowered between each scene, and that a song should occur in the interval."[21] In the handbook that was sold to the audience for sixpence, the views are in a decorative frame, which may evoke the actual procenium.[22] Leaving the gaps between the views unhidden may have been caused by negligence, or out of respect for Beverley's compositions, but it may also have been a conscious effort to highlight Smith's stage persona.[23]

After the London engagement ended on July 10, 1850, Smith tried his luck on the touring circuit, crisscrossing England for the next one and half years.[24] A leaflet gives us an idea about his schedule.[25] Beginning at Tunbridge Wells on September 1, 1851 (soon after climbing the Mont Blanc), Smith visited forty-eight locations—both small communities and larger towns—before ending the tour on December 12. In most places he stayed only for a day or two. On Saturdays

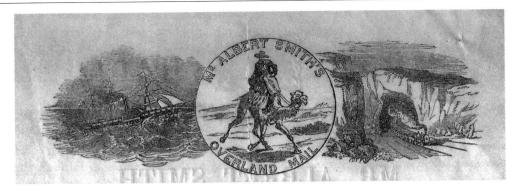

and Sundays he did not perform, but traveled part of the time. In a letter from Hanley in October Smith reported that "after Christmas the Overland Mail will terminate—in Great Britain at least," revealing that he had considered broader markets: "I am not going to America yet—not for years."[26] Charles Mathews and Henry Russell had done it, but in Smith's case only his fame crossed the ocean.

Smith revived *The Overland Mail* for a second season in London in February 1851, but performed in the capital only intermittently.[27] The circumstances were turning against him and other exhibitors, because the heat of the panoramania was beginning to cool down, and the approaching Crystal Palace exhibition was drawing all the attention. Although he continued performing here and there for several more months (while taking care of a huge load of literary duties, long before laptops and iPhones), Smith must have felt the need to come up with something new. The answer was: Mont Blanc.

THE ANATOMY OF AN ALPINE SPECTACLE

The problem with forming a picture of Smith's earlier years is that all the available information comes from his own accounts, which cannot be taken at face value. In *The Story of Mont Blanc* (1853) Smith drew his roots as a showman all the way back to his childhood, to a small moving panorama he had constructed and exhibited to his little sister.[28] After finishing his studies in Paris and returning to his native village of Chertsey (in Surrey near London) to practice as a country doctor, he claims to have produced a larger version, copying the pictures "on a comparatively large scale—about three feet high," and contriving with a carpenter "some simple mechanism . . . to make them roll on." The subject matter of both panoramas was the Mont Blanc, a topic that had passionately interested Smith since reading about it in his childhood.

Figure 7.5
The logo for Albert Smith's *Overland Mail* performance.
From a leaflet distributed at his performance at the Music
Hall, Ramsgate, July 16–17 [1851]. The same design was
used in broadsides, stationary, etc. An early example of
graphic design used for branding media products.
Author's collection.

Inspired by the founding of a local "literary and scientific institution," Smith then set out to display his panorama.[29] His account is worth reading:

> For two or three years, with my Alps in a box, I went round to various literary institutions. The inhabitants of Richmond, Brentford, Guildford, Staines, Hammersmith, Southwark, and other places, were respectively enlightened upon the theory of glaciers and the dangers of the Grand Plateau. I recall these first efforts of a showman—for such they really were—with great pleasure. I recollect how my brother and I used to drive our four-wheeled chaise across the country, with Mont Blanc on the back seat, and how we were received usually with the mistrust attached to wandering professors generally, by the man who swept out the Town Hall, or the Athenaeum, or wherever the institution might be located. . . . I recollect, too, how the heat of my lamps would unsolder those above them, producing twilight and oil avalanches at the wrong time; and how my brother held a piece of wax-candle end behind the moon on the Grands Mulets (which always got applauded); and how the diligence which went across the bridge would sometimes tumble over.[30]

Biographers have taken this story as factual, but Smith's lively mind may have worked creatively. The account fits a little too neatly into the context—a self-serving propagandist promoting his commercial entertainment. Conjuring up moving panoramas transformed an opportunist into a pioneer. Creating miniature panoramas was a common hobby among adolescent boys, so Smith may have constructed his own, or just enacted a topos. Details, such as the moon effect and the cutout diligence, were familiar from the Loutherbourgian tradition. But whether Smith's reminiscences were factual or imaginary, they reveal a showman's mindset.

Figure 7.6 + 7.7
Paper fan with the program of *Albert Smith's Mont Blanc* and scenes from William Beverley's panorama. Lithograph by Brioude Laguerie, rue des Fontaines 5, Paris; manufactured by Duvelleroy, 167 Regent Street, London, c. 1852. The detailed text confirms the fan's practical function as navigation tool: "The annexed plan of the ROUTE TO THE SUMMIT OF MONT BLANC will be found useful for reference during the lecture." Author's collection.

The emergence of alpinism established Mont Blanc's reputation as Europe's highest peak. Any ascents, even failed ones, became widely publicized. When the British tourist Erasmus Galton reached the top in September 1850 (when Smith happened to be in Chamonix), the *Illustrated London News* covered the event with a story and several illustrations.[31] The media-conscious Smith must have foreseen why Mont Blanc would make a great topic for a panoramic entertainment. The problem was ascending it first. He finally made up his mind, and began his adventure with a large team on August 12, 1851. William Beverley accompanied Smith to Chamonix to take sketches, but did not participate in the climb. The team made it to the top, in spite of Smith's poor physical condition and minimal preparation, to say nothing about the impressive amount of alcohol consumed during the ascent.[32]

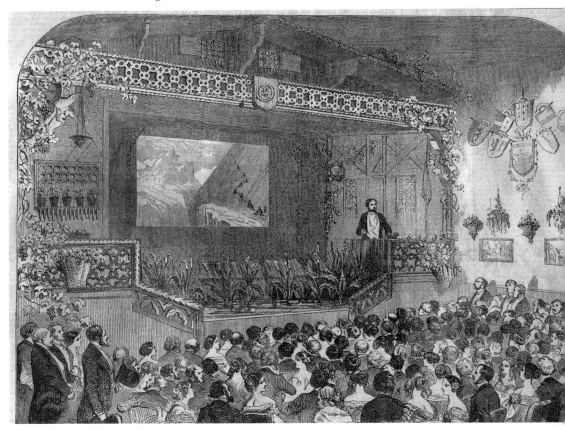

Figure 7.8
Albert Smith lecturing about his ascent of Mont Blanc at the Egyptian Hall, *The Illustrated London News* 21, no. 599 (Dec. 25, 1852): 565. The illustration depicts the first version of the scenery before the full chalet was built.
Author's collection.

Although Smith still traveled with the *Overland Mail*, he somehow managed to put the new entertainment together. *Albert Smith's Ascent of Mont Blanc* premiered at the Egyptian Hall on March 15, 1852, establishing his fame not only as a showman, but also as an alpinist (although reportedly he had been dragged to the top unconscious in a state of exhaustion and drunkenness). As expected, the production was featured in the *Illustrated London News*, with large illustrations based on Beverley's panorama.[33] The *Morning Advertiser* summarized the general opinion: "Viewed as a whole—as a diorama, musical, comic, and sentimental mélange—an 'at home'—a lecture, or a combined literary and imitative production, the 'Ascent of Mont Blanc' need not fear comparison with any two hours and a half of intellectual and social enjoyment ever offered to an appreciating public."[34]

Smith's alpine entertainment had three main elements: a meticulously designed set, the performance, and the panorama. The original set consisted of a proscenium evoking an alpine house, an ornamented lecture platform, and plants and objects to create a *chamois* atmosphere. For the second season (1853) this setting was made more tangible by replacing it with part of a wooden Swiss chalet in actual size, manufactured in Chamonix by the well-known woodcarvers Kehrli Frères.[35] There was a pool with water lilies and living fish, and banners of the Swiss cantons ornamenting the walls. Chamois skins, Indian corn, Alpenstocks, vintage baskets, knapsacks, and other "authentic" objects were distributed in the auditorium, and views of Switzerland displayed in the waiting areas as a kind of preshow.

The setting evoked theatrical scenography, although the *Illustrated London News* found it "not in the mere style of stage carpentry."[36] Unwittingly it recalled Daguerre's effort to enliven "Mont Blanc taken from the Valley of Chamonix" (1832) with actual props and (possibly) a living goat at the Paris Diorama. It could also be compared with exhibitions held at the Egyptian Hall when it was still Bullock's Museum. "Authentic" objects, from Napoleon's battle carriage to Mexican artifacts, were combined with representations of all kinds to produce what Roland Barthes called "reality effect."[37] In *The North Cape with a Family of Lapps* (1822), a "Lapponian" family lived with their reindeer and sleds in the exhibition space in front of an illusionistic painted background. Smith's huge chamois dog was a descendant of Daguerre's goat, while an official certificate of his ascent, signed by his mountain guides, was displayed at the entrance as an indexical sign to dispel any doubts.[38]

Smith entered the auditorium from a door that was part of the chalet and performed from its carved balcony. A kind of validation by association, no matter how surreal it may seem, occurred. In Smith's discourse, geographic and cultural information was interspersed with sarcastic slurs, as well as character sketches and imitations of people he had met along the way. From time to time the discourse broke into comic songs, the most famous being the conclusion, the satirical patter song *Galignani's Messenger*, which was often updated to reflect current topics of discussion.[39]

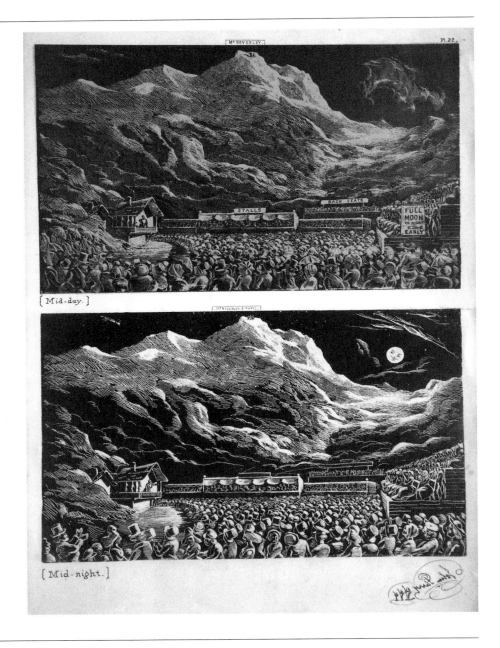

Figure 7.9

John Parry's cartoon about *Albert Smith's Ascent of Mont Blanc*, pl. 22, from his *Ridiculous things, scraps and oddities some with and many without meaning* (London: T. McLean, 1854). In this cartoon (from a series of three), Parry imagines that Smith has replaced his panorama with Mont Blanc itself, and moved his show to Chamonix, where he lectures all day, and on clear nights as well. William Beverley is stationed on the mountain, where he practices a mysterious new way a producing "real" dissolving views by using melting snow. This pair of images resembles dissolving views lantern slides. Author's collection.

Smith was a personified index pointing to his experiences, but his relationship to the whole was more complex. The show was inclusive rather than exclusive, a merger of the experienced and the imagined. The audience must have understood that his stories, including the characters he concocted, were mixtures of truth and fiction. Everything gained its significance through the character of Smith, whom the audience identified as the real Albert, not as a stage persona. The formal dress was a calculated class act to make him acceptable for the society he was courting, but beyond (and because of) that the audience appreciated his bohemian otherness. Although he abandoned costume changes, he posed as some of his characters in carte-de-visite photographs and stereocards.[40]

The panorama was presented in a unique way within the chalet. To reveal the canvas, part of its front wall was lifted up. During the intervals it was lowered again, and "a pretty effect [was] gained by the light through the curtained window."[41] The illustrations in the first part, which discussed the trip from England to Chamonix, were distinct horizontally moving views. The ascent moved vertically in the manner of the balloon panoramas, and the illustrations of the final part (the return) again horizontally.[42] The machinery must have been adjusted during the intervals.

Commentators often mentioned the small size of the illustrations—a significant issue, recalling the larger canvases at other showplaces. Although the impression may have been partly caused by the massive chalet-frame, immersion into the images had not been the goal. The panorama may have been beautifully painted and dioramically illuminated, but it was just an illustration. This was demon-

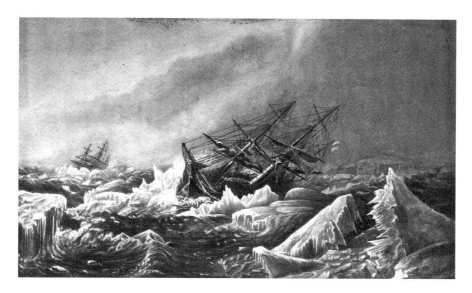

Figure 7.10
William Beverley (1811–1889), "Whalers' Ships Breaking Up on the Ice," gouache and pastel, 9 × 13 1/2 inches, British, before 1889. Scenes of arctic exploration and whaling were often depicted in moving panoramas; this could be a study for one of them. Author's collection.

strated, when, a day after the final performance of *The Ascent of Mont Blanc* (July 5, 1858), Smith embarked on a trip to China to collect material for his next entertainment. On the way to Canton via Alexandria, Cairo, Aden, and Singapore, he gave a charity performance in Hong Kong. He used many of the ingredients of the Mont Blanc entertainment, but no illustrations at all. It worked just fine.[43]

Smith returned on November 14, so soon that some people quipped he had been hiding in the Alps.[44] Beverley had stayed behind painting or supervising views from secondary sources.[45] The old formula was filled with new content. The full-scale stage set was a combination of a "Mandarin's Pavilion," the "Tea and Opium Tavern in Public Gardens," and "a Shop with part of a Street in Canton." Curiosities were put on display. For additional reality effect, their transportation crates were also displayed. The topic was timely, because the ending of the second Opium War (June 26) was raising curiosity toward China. However, soon after the premiere (December 22, 1858) it became evident that the new combination did not work as planned. By popular demand Smith salvaged parts of the previous entertainment, which resulted in a hybrid with a curious title, "The Rhine and China—Mr. Albert Smith's Ascent of Mont Blanc." This turned out to be his final effort. Bohemian lifestyle and the hasty trip to China had taken their toll. Smith succumbed to an attack of bronchitis on May 23, 1860, at the age of forty-four.[46]

NOUGAT GLACÉ DE MONT BLANC, OR MEDIA MARKETING

Smith was fortunate to have his younger brother as his business manager. As far as *The Story of Mont Blanc* can be trusted, Arthur Smith was his companion already on his earliest efforts as a showman. Throughout his career as a public entertainer Arthur remained Albert's constant shadow, controlling the logistics behind the scene. The journalist Edmund Yates, who knew both brothers, praised Arthur's talents in "money-taking, check-taking, money-payments, bill-posting, advertising, the comfort of the audience, everything, in fact, save the actual delivery of the lecture and songs."[47] Although it is difficult to judge how the labor was divided between the brothers, it is a token of Arthur's skills that he was hired by Charles Dickens to manage his lecturing business.[48]

Albert and Arthur Smith understood that success depended both on the product and on its marketing. On both areas they developed strategies that were ahead of their time, and anticipated the operations of the culture industry as theorized by Adorno and Horkheimer.[49] A model was provided by the notorious American showman P. T. Barnum (1810–1889), whom Albert met in 1844 when he first came to England to exhibit the midget whom he called General Tom Thumb

at the Egyptian Hall. Smith was asked to adapt a two-act playlet called *Hop-o'-my thumb; or the Seven League Boots* for the little man to perform.[50] Smith and Barnum made a short trip to the Shakespeare country, which Smith recorded in *Bentley's Miscellany*.[51]

During the trip Albert was initiated into Barnum's "philosophy" of humbug, or "the knack of knowing what people will pay money to see or support."[52] Barnum's strategy was to "put innumerable means and appliances into operation for the furtherance of my object, and little did the public see of the hand that indirectly pulled at their heart-strings, preparatory to a relaxation of their purse-strings."[53] Barnum's activities gave rise to the notion of *barnumizing*, as he himself proudly noted. By ruthlessness and business acumen, he demonstrated that anything, from human "freaks" (real or "designed"), a living Whale, and the "Swedish Nightingale" Jenny Lind to moving panoramas, cosmoramas, and illustrated lectures, could be barnumized for the purpose of "money getting."[54]

Albert's and Arthur's strategies could be classified as internal (changes to the program) and external (marketing and publicity). As Hollywood film producers would later discover, it was not enough to stick to a successful formula once it had been discovered; it had to be refreshed. So internally the challenge was to maintain a correct ratio between continuity and change, repetition and renewal. To attract audiences year after year, some changes were necessary. One of the assets of the travelogue format was its flexibility, which made it possible to choose different routes to the destination, Mont Blanc.[55] New stories could be concocted about personalities met along the route. Even Barnum's alter ego was made to appear in the Cologne cathedral (a city neither had visited). The logic was: Smith *could* have been there and *could* have met the characters he evoked.

Whenever needed, views could be commissioned from Beverley, or bought second-hand.[56] When the route was changed to "Holland, and up the Rhine; From London to Rotterdam and Brussels (then to Switzerland)" (1855), new views by Beverley, as well as "A Panorama of the Rhine by M. Groppius," were added.[57] The next season, there were again new views by Beverley and an "entirely new Rhine Panorama from Cologne to Heidelberg by P. Phillips."[58] Uniform visual style was not a concern as long as Smith served as the *cicerone*. The ascent, the culmination of the show, was left untouched until 1857, when Smith decided to turn the famous sequence into a short *Entr'Acte* without narration. He gave two reasons: the story had become "rather more than a twice-told tale," and with the additions the show was getting so long that it would "weary the audience instead of amusing them."[59] The changes were extensive enough to make the *Illustrated London News* regard the result as "a new entertainment under an old name."[60]

Another way to profit was opening a secondary "stage." This made sense, because Smith was paying the rent for the Egyptian Hall anyway and was struggling to satisfy public demand. In 1854 he purchased Allom's *Polyorama of Constantinople, the Bosphorus and Dardanelles*, which had been presented back in 1850 in the heat of the panoramania, and turned it into a "brand new" Albert Smith product. Allom's name was dropped, a new final scene (a fire in Constantinople)

painted by Beverley, and a lecture written by Smith and Ms. Shirley Brooks. Having Charles Kenney perform with the panorama in a smaller "New Room" at the Egyptian Hall was an easy way to cash on the situation. One wonders, if those who had seen Allom's performance a few years earlier, realized the name of the game.

An ephemeral medium closely connected with the programs were the pamphlets sold for the spectators. As Smith indicated in a letter, such "little sixpenny affairs" were a good source of extra income; no doubt they were also distributed from hand to hand, raising curiosity toward the show.[61] The pamphlets were essentially tourist guides, meant "less as a companion in the room than as a reference after 'MONT BLANC' has been visited."[62] Detailed information about prices, routes, etc., made them useful for those who were considering travel. The number of British travelers to the continent kept growing during the run of The Ascent of Mont Blanc.[63] At least some of them must have been influenced by Smith.

When it comes to external promotion, the Smith brothers were among the first to grasp the importance of graphic design. The promotional material used by most showmen (including Barnum) varied haphazardly without any consistency, whereas a uniform graphic identity was created already for The Overland Mail. The same recognizable elements were repeated in the stationery, program leaflets, and the broadsides. The central feature was a logo depicting Smith riding on a camel.[64] For The Ascent of Mont Blanc and China such detailing was taken much further. In the latter, a huge Chinese willow-pattern plate was pictured on the drop curtain, and used in miniaturized form as the embossed letterhead. A variation with Smith's portrait inserted in the plate, was used both in

Figure 7.11
The first editions of the sixpenny pamphlets for Albert Smith's three panoramic entertainments: The Overland Mail (1850–1851), Albert Smith's Ascent of Mont Blanc (1852–1859), and Albert Smith's China (1859–1860). Author's collection.

the broadside and in ceramic plates sold to the audience as mementos.[65]

All this signaled professionalism and ambition. Spin-off products were another way to spread Smith's image and make extra money, also through licensing contracts.[66] For the Mont Blanc show, there were paper fans with the evening's program, folding paper roses with scenes from the panorama, boxes of *Nougat Glacé de Mont Blanc*, a toy peepshow in the shape of the Egyptian Hall with a set of views from Beverley's paintings, stereocards, color prints, and even a board game.[67] Musical compositions, such as the *Echo de Mont Blanc* polka by Louis Antoine Jullien, were inspired by the entertainment and sold as sheet music.[68] The items for the China entertainment included another handsome toy peepshow, Chinese fans made of palm leaves, and the Chinese-style willow-pattern plate with Smith's portrait.

Some forms of promotion, such as the illuminations of the Egyptian Hall for landmark performances, were explicit, while others were barely noticeable.[69] Even Smith's regular daily walk with his huge chamois dog from his apartment at Percy Street (near Tottenham Court Road) to the Egyptian Hall turned into a moving indexical sign reminding passersby of his entertainment.[70] Newspaper comments and reviews also kept Smith in the spotlight. There are reasons to suspect that his own voice is sometimes heard between the lines. In return for free publicity showmen provided free tickets for editors and their families, and perhaps secretly paid for "independent" third-party recommendations. In his autobiography P. T. Barnum quotes a newspaper article about Jenny Lind, the "Swedish Nightingale," whose tour of the United States he organized, pointing out that it is an "unbought, unsolicited editorial article."[71] This must have been rare, indeed!

BARNUMIZED?

When P. T. Barnum returned to England in 1857, he found out that the "dentist," "literary hack," "contributor to *Punch*," and "writer for the magazines" had been "transformed to a first-class showman in the full tide of success."[72] According to Barnum's autobiography, Smith took him to dine at the Garrick

Figure 7.12
The portrait of Albert Smith on a willow pattern plate, produced as a souvenir for *Albert Smith's China*, and sold at the Egyptian Hall for one shilling. 1859. The same design was used in the broadside. Smith's iconic status made mentioning his name useless. An enormous willow pattern plate was also pictured on the act-drop (without Smith's face). Author's collection.

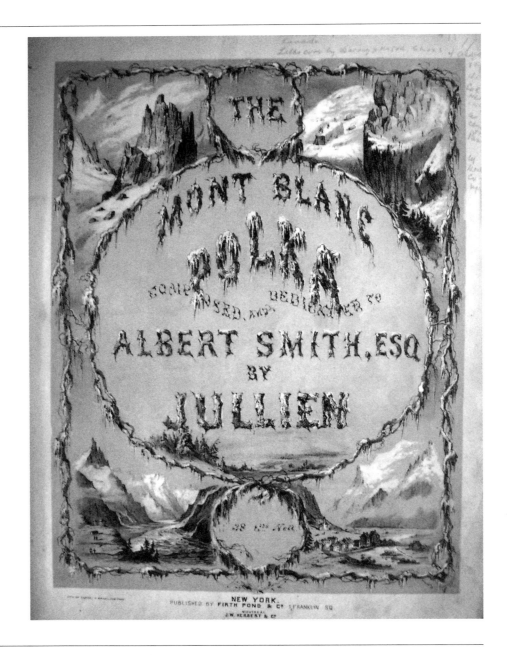

Figure 7.13
Cover of the sheet music of Louis Antoine Jullien's (1812–
1860) "The Mont Blanc Polka," inspired by *Albert Smith's
Ascent of Mont Blanc*. New York: Firth Pond & Co. and J.W.
Herbert & Co., 1850s. The illustrations are based on William
Beverley's panorama for *Albert Smith's Ascent of Mont Blanc*.
Author's collection.

Club, introducing him "to several of his acquaintances as his 'teacher in the show business.'" When he came to see the Mont Blanc entertainment, Barnum discovered that Smith had added a Yankee character named Phineas Cutecraft, whom he had purportedly met in the Cologne Cathedral trying to buy relics for his museum. The anecdote referred to Smith's and Barnum's trip in 1844, when Barnum had attempted similar purchases at the Warwick Castle.[73] Barnum was flattered by the homage.

Barnumization refers to the use of any available means to make a profit in show business. Although Barnum would probably have admitted that entertainment serves other goals as well, ranging from instruction to ideological propaganda and aesthetic innovation, in a capitalist economy these are subordinated to financial gain. The culture industry could be claimed to be at the same time a barnumized and a barnumizing endeavor. Barnum attracted anyone who could pay the entrance fee. Money-getting by any means necessary was his main goal. By doing so he opened doors to popular mass culture, where social divisions would be increasingly breached. Could we say that Smith had been barnumized? The enterprising brothers had certainly mastered the arts of profit making and media manipulation, but their attitude differed from Barnum's—perhaps it was qualitative barnumization.

Perhaps reflecting the rigidity of the British social hierarchy, Smith made no real efforts to broaden the social base of his audience, at least not toward lower ranks. The audience he wanted was already there—the challenge was to reach it, to convince it of the respectability of the show, and to keep it coming over and over again. One way of affecting attitudes was giving lavish champagne and oyster receptions for selected layers of the London society. Smith sent out invitations in the form of witty mock-passports that had to be submitted for border control at the entrance to the Egyptian Hall.[74] Passports evoked travel, but also boundaries and privileges. Another form of hospitality were gifts, such as a sheet of "twelfth night characters," cartoons of the personalities Smith evoked in the show, enclosed in an envelope with a colorful picture of the chalet-stage.[75]

The Smith brothers took utmost care of their audience's well-being, assuring people who would never have considered attending London's theaters because of their rowdy reputation and mixed audiences that the Egyptian Hall was safe, sound, and comfortable. Notices, such as "Filters filled with ICED WATER are placed in all parts of the room for the convenience of the audience," served this purpose.[76] The brothers ever constructed an elegant separate waiting room for the ladies, in addition to one for the general audience.

Smith enjoyed giving orders. On the surface they may seem to have been motivated only by practical efforts to enhance the quality of the experience, but underneath one can detect ideological currents. Requesting the spectators to refrain from bringing young children to the show, because "the little folks get wearied and restless, and are as troublesome to those who bring them, as they are annoying to the audience," can be related to the fact that Smith was a bachelor leading a bohemian life far from Victorian domestic ideals.[77] He was not offering

232

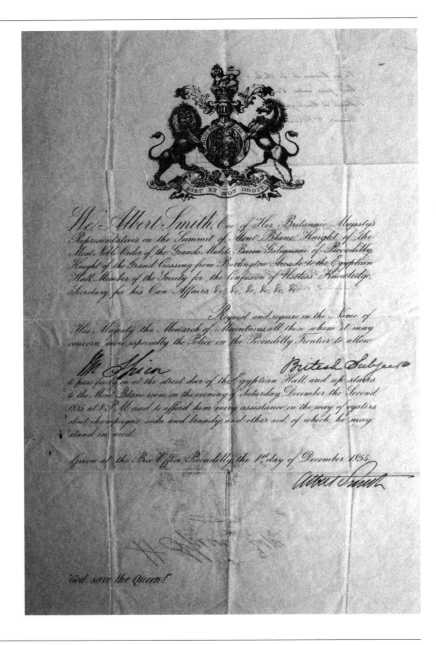

Figure 7.14
An invitation card in the form of a mock passport to Albert
Smith's evening reception at the Egyptian Hall on December 2,
1854. This copy was issued to the author and journalist
Henry Spicer, a familiar figure in London's literary circles.
As he mentioned in *China and Back: Being a Diary Kept, Out
and Home* (London: Albert Smith, 1859, 59), Smith later met
Spicer by a chance in Cairo, on his trip back from China.
Author's collection.

a family entertainment. The notices can be read as efforts to exercise power over the spectators, who often belonged to a higher social rank than Smith himself, the son of a humble country doctor. The following flyer, which was distributed to the audience, is a perfect example.[78]

> *The audience are respectfully but earnestly requested to be in their places by the time fixed for commencing the Entertainment, which is always most punctually kept. The confusion caused amongst those Ladies and Gentlemen already seated by the arrival of others after the Lecture begins, usually compels* MR. ALBERT SMITH *to stop until that portion of the audience is quietly settled. At the same time, as the gas goes down all over the room on the opening of the first View, some difficulty is experienced in finding out the numbers of the seats.*
>
> *To avoid occasional misunderstanding, it is also respectfully announced that no Bonnets will, under any circumstances, be admitted to the Stalls at the Evening Representations. The attendants have orders to enforce this rule as strictly as they would do at an Evening Concert, or the Opera; such a regulation being considered due to the general character of the audience. Should Ladies wish to leave their Bonnets, a room has been provided for that purpose.[79]*

A PARADE OF EPIGONES,
OR ANONYMOUS AFTERLIVES

Albert Smith's entertainments were admired and also lovingly parodied already in his lifetime.[80] What kind of an imprint did they leave in the show business? As we have seen, there were others, whose entertainments shared at least some of their features. While Smith was occupying the Egyptian Hall, W. S. Woodin was enjoying success with his one-man shows *Carpet-Bag and Sketch-Book* (performed more than 700 times), and *Olio of Oddities* elsewhere in London. The latter was characterized by the guidebook as a "mimical, musical, pictorial, polygraphic, and panoramic entertainment."[81] It was illustrated by dioramic views of the Lake District, based on sketches "taken from the spot."[82] In 1870, the Carpet Bag entertainment was revived at the Egyptian Hall, which cannot have been a coincidence.[83]

Although *Albert Smith's Ascent of Mont Blanc* was never presented outside the Egyptian Hall, others transmuted its contents into magic lantern shows that were shown far and wide. This was the case when a certain Mr. Martin advertized in February 1857 a "series of artistic and descriptive views [of] The Ascent

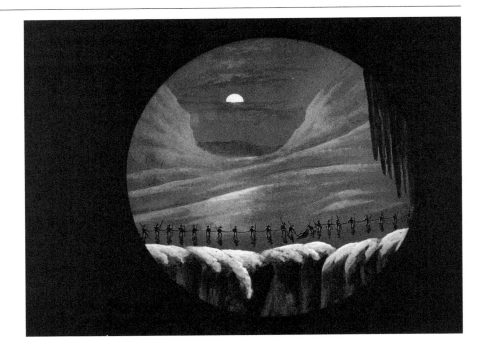

of Mont Blanc!! and Tour through Switzerland to the Rhine," to be projected at the Subscription Rooms, Hatherleigh.[84] Creating such copycat productions was not difficult. Beverley's designs could be copied by lantern slide painters from Smith's handbooks and magazine articles, and their products sold by retailers of optical goods.[85] To create the lecture, the lanternist found plenty of information from *The Story of Mont Blanc* and the press commentaries. As lantern lectures, Smith's entertainment very likely outlasted him by many years.

After Smith's untimely death others kept trying out similar formulas at the Egyptian Hall.[86] In 1861 Grace Egerdon (Mrs. George Case) premiered her *Latest Intelligence*, which lasted for two seasons. It included "Songs, Dances, Travellers' Stories, & Characteristic SKETCHES OF ODD PEOPLE."[87] Although there was no panorama, the entertainment had been influenced by Smith, written by his protégé Edmund Yates with N[icholas] H[erbert] Harrington. Egerdon was not the first woman in the business. As early as 1853-54 Mrs. Alexandra Gibbs had presented a one-woman show at the Hibernia in Regent Street, advertised as a "highly successful musical & novel entertainment, with pictorial illustrations, entitled the Emerald Isle."[88] The combination of travel stories, sketches of Irish character, songs, and panoramic illustrations of Ireland leaves no doubt about the source of inspiration.

In 1862 Yates followed in the footsteps of Smith and his own father, Frederick

Figure 7.15
"Crossing the Grand Plateau," hand-painted lantern slide, based on William Beverley's moving panorama for *Albert Smith's Ascent of Mont Blanc*. Sold by Yeates & Son, Dublin, 1850s. Author's collection.

Yates, debuting as an entertainer with *Invitations to Evening Parties and the Seaside*. It was shown "in the room which Mr. Albert Smith had so profitably occupied."[89] For their "duologue," Yates and his partner Harold Power managed to persuade William Beverley to paint two scenes, a drawing room and a seaside view. Predictably, a newspaper compared the show with Smith's performances: "As to the entertainment itself, it has been thoroughly successful with the public, who have welcomed it as in some sort a revival of the pleasing style of lecturing which the late Mr. Albert Smith so successfully introduced."[90]

Smith's ghost appeared again when Arthur Sketchley stepped on the stage: "He may now be found every evening at the Egyptian Hall, in the room once tenanted by Mr. Albert Smith, where now, instead of a lecture on Mont Blanc, a discourse on Paris is delivered."[91] The lecture was accompanied by panoramic views; the painter Matthew Morgan was said to have "laudably emulated the excellence of Grieve, Beverley, and Telbin, with whom we understand he has recently studied."[92] Rather different values were emphasized by the American humorist Artemus Ward (Charles Farrar Browne, 1834–1867), who stated outright that "The Panorama used to Illustrate Mr. WARD's Narrative is rather worse than Panoramas usually are."[93] Ward brought his Mormon entertainment over the Atlantic in 1866, because he was "very desirous to imitate" the example of Smith.[94]

Ward suffered from poor health and had to interrupt his performances already in January 1867. Echoing Albert Smith's career in a tragicomic manner, he died young a few weeks later. His panorama was acquired by the British humorist Walter Pelham, who used it to re-enact Ward's performance at the Egyptian Hall. A program leaflet (hand-dated September 1882) described his endeavor in a manner worthy of Ward:

Figure 7.16
Albert Smith as Robert Catesby, the Catholic conspirator
who tried to explode the parliament in the Gunpowder Plot
(1605). From Smith's pantomime *Harlequin Guy Fawkes; or
a Match for a King*, performed at the Olympic Theatre, March
31, 1855. Stereoview, possibly by London Stereoscopic
Company, 1855. Author's collection.

Figure 7.17
Handbill for Mrs. Alexandra Gibbs's (Formerly Miss Graddon) *Highly Successful Musical & Novel Entertainment, with Pictorial Illustrations, Entitled the Emerald Isle, With Songs, Legends, Traditions, Anecdotes, &c., of that Fairy Land.* The Hibernia, 309, Regent Street, adjoining the Royal Polytechnic Institution, London. After December 27, 1853. Author's collection.

Having purchased the bona fide World Renowned Artemus Ward's Diorama, [Walter Pelham] will endeavour to impersonate that Prince of American humourists, deliver the celebrated 'Mormon Lecture,' and exhibit the quaint and interesting pictures, with the original moon-ey and other amusing effects which created such a furore at the above Hall in 1866. As this entertainment will partake somewhat in character both of Artemus Ward and Walter Pelham, it will be given under the name-befitting title of ARTEMUS WARD-LTER PELHAM AMONG THE MORMONS.[95]

Smith and his followers emphasized the lecturer, but others gave the panorama more prominence. *Hamilton's Excursions* visited the Egyptian Hall several times over the years, beginning in the fall of 1860, a few months after Smith's death. Their "excursion to the Continent and back, in two hours" was explained by the well-known lecturer Leicester Buckingham.[96] The challenge was great, but his performance was received favorably; a critic thought it was constrained too much by the panorama: "If a little more prominence were given to the lecturer over the exhibitor, we might say that Albert Smith had found a not unworthy successor; but any such comparison is forbidden by the graceful homage paid, in a passing sentence, to the shade of him whose like we cannot hope to look upon." Buckingham said: "Of the glories and perils of Mont Blanc, it becomes, in this room, no living tongue to speak."[97]

What happened to Albert Smith's panoramas? His early biographer was not able to find any traces of them.[98] It is known that Smith's effects were sold in an auction in June 1860.[99] A broadside (c. 1863) shows that the well-known showman Moses Gompertz (c. 1814–1893) was in the possession of the "Great original diorama of the Rhine . . .; late the property of the world-renowned Mr. Albert Smith, Exhibited by him at the Egyptian Hall, Piccadilly, London, for three successive seasons

to upwards of 500,000 spectators."[100] Gompertz exhibited it in Cheltenham already in October 1860, less than half a year after Smith's death.[101] It was probably one of the canvases added to the *Ascent of Mont Blanc* in 1855–1856.[102]

By 1862 Gompertz was touring with *Lord Elgin's Tour Through Japan and China*, which may have been identical with the one advertised as "Albert Smith's Egyptian Hall Diorama, China and Japan."[103] Gompertz may have purchased Smith's China panorama as well, and added scenes about Japan. His show was characterized as a "rather effective panorama of the coasts of China and Japan."[104] Smith's panorama would have been generic enough to be associated with Lord Elgin's diplomatic-military manouvres in China and Japan in 1858–1860, at the time of Smith's own trip.

From Gompertz both panoramas ended in the hands of some musicians working for him, the aspiring exhibitors George W. and Charles Poole and Anthony Young, founders of the Poole showman dynasty. After the potential of these panoramas had been exhausted, parts of them may have been used in other Poole productions that crisscrossed the British Isles into the twentieth century. Because these contained large numbers of heterogeneous views, Beverley's paintings would have been useful raw material. An 1886 program booklet mentioned Albert Smith's panoramas among "Messrs. Poole's productions during the last half-century," and the long list of artists claimed to have worked for them included William Beverl[e]y.[105] Other productions of the panoramania era may as well have enjoyed anonymous and fragmentary afterlives as parts of Poole's Myrioramas.[106]

238

NOTES

1. Walter Goodman, *The Keeleys, on the Stage and at Home* (London: Richard Bentley and Son, 1895), p. 244. Paraphrased (without mentioning the source) by Raymund Fitzsimons, *The Baron of Piccadilly. The Travels and Entertainments of Albert Smith 1816–1860* (London: Geoffrey Bles, 1967), p. 13.

2. Henry Vizetelly, *Glances Back Through Seventy Years. Autobiographical and Other Reminiscences*, vol. 1 (London: Kegan Paul, Trench, Trübner & Co., 1893), pp. 318, 321.

3. [Albert Smith], "Speech delivered on the occasion of the 2000th representation of his 'Mont Blanc' entertainment, July 6, 1858," (later) typewritten manuscript, one page, Albert Smith Scrapbook (MSPM). Beverl[e]y's birthdate is unknown. A broadside for Theater-Royal, Manchester, Sat., Oct. 11, 1828 (in EH) lists a "Panoramic View of the City [of Nourjahad]" painted by the young Beverl[e]y for an oriental romance named *Illusion, or the Trances of Nourjahad*. W. Beverl[e]y is credited for the scenery with Parker, and Assistants. His brothers are also listed: H[enry] Beverl[e]y as an actor and [Robert] Roxby as a dancer. "The Roxbys and Beverleys," *Monthly Chronicle of North-Country Lore and Legend* 3, no. 29 (July 1889): 327–328. The article claims that William Roxby Beverl[e]y was born in Richmond, Yorkshire in 1824, which is impossible.

4. *Egyptian Hall, Piccadilly. Programme of Mr. Albert Smith's Ascent of Mont Blanc (August 12th & 13th, 1851) Represented, for the first time, at the Egyptian Hall, Monday, March 15th, 1852. The Illustrative Views have been painted from original sketches, by Mr. William Beverley, who accompanied Mr. Albert Smith to Chamouni. The music arranged by Mr. J. H. Tully*, program leaflet (two leaves), Albert Smith scrapbook (MSPM).

5. Smith's "Natural Histories" included "The Ballet Girl," "Stuck-up People," etc. He wrote about the Parisian flaneur in "Sketches of Paris: Musard's," *The Mirror of Literature, Amusement, and Instruction* (London: J. Limbird), vol. 33 (1839): 308–309.

6. Vizetelly, *Glances Back Through Seventy Years*, pp. 137, 317.

7. Ibid., p. 319.

8. Smith's friend Edmund Yates, whose father was Frederick Yates (Mathews's disciple who also performed his own monopolylogues), discussed this tradition in "Bygone Shows," *The Fortnightly Review*, ed. T. H. S. Escott (London: Chapman & Hall), vol. 39, new series (Jan. 1 to June 1, 1886): 633–647; see also Harry Furniss, "Single-Handed Entertainers," *Windsor Magazine* (London: Ward, Lock & Co.), vol. 25 (Dec. 1906 to May 1907): 485–492.

9. Fitzsimons, *The Baron of Piccadilly*, p. 102. The production was *Home Circuit*.

10. Harry Stoe van Dyk, "Mr. Mathews," in *Theatrical Portraits; with Other Poems* (London: John Miller, Simpkin and Marshall, Chappell and Son, 1822), p. 53.

11. Pückler-Muskau, *Tour of a German Prince*, 3, letter 4, Dec. 8, 1826. Quot. Ernest Bradlee Watson, *Sheridan to Robertson. A Study of the Nineteenth-Century London Stage* (Cambridge: Harvard University Press, 1926), p. 326.

12. *Songs in Henry Russell's Vocal and Pictorial Entertainment, Entitled The Far West; or, the Emigrants' Progress From the Old World to the New: and Negro Life, in Freedom and in Slavery*, booklet (London: John K. Chapman and Co., [1851] (online at archive.org. Last visited March 28, 2012). The panoramas are discussed in detail. The show combined two performances, which Russell first tried separately in

Richmond, Surrey. Andrew Lamb, *A Life on the Ocean Wave: The Story of Henry Russell* (Croyton, UK: Fullers Wood Press, 2007), p. 258.

13. *The Illustrated London News*, April 19, 1851, pp. 315–316. Quot. Lamb, *A Life on the Ocean Wave*, p. 258. Toward the end of his life Russell claimed that the panoramas had been painted by a certain Mr. Mason, recommended for him by Clarkson Stanfield, who would have put the finishing touches himself. Henry Russell, *Cheer! Boys, Cheer!, Memories of Men & Music* (London: John Macqueen, 1895), p. 236–244. One should doubt Stanfield's role. The *Times* found the panoramas "rather sources of information than works of art." (Sept. 12, 1853), quot. Lamb, *A Life on the Ocean Wave*, p. 268.

14. Albert Smith, *A Month at Constantinople* (London: David Bogue, 1850).

15. Ibid., p. 108.

16. Ibid, p 129. He was disappointed that no "fair Circassians and Georgians" could be seen (p. 128).

17. Ibid., p. 213.

18. *Illustrated London News*, May 25, 1850. The entertainment opened on May 28, 1850, at Willis's Rooms, King Street, London.

19. *Times*, May 29, 1850. The reviewer may have used advance material provided by Smith.

20. M. M. P., "Albert Smith's Entertainments. Music-Hall, Store-Street," *The New Monthly Belle Assemblée* (London), vol. 34 (Feb. 1851): 120.

21. Ibid. The word *diorama* reminds us that the views (or some of them) were translucent and backlit. This is supported by another remark, saying that Beverley's "skies are remarkable for transparency." Quot.

Thorington, *Mont Blanc Sideshow*, p. 124.

22. *A Hand-Book to Mr. Albert Smith's Entertainment entitled the Overland Mail* (London: Savill & Edwards, Published for the Author, 1850) (EH).

23. This reminds one about the role of the Japanese *benchi*, the silent film lecturers, who are said to have opposed the use of advanced film language, such as close-ups, so that they could enliven the film by their narration. Hiroshi Komatsu and Frances Loden, "Mastering the Mute Image: The Role of the Benshi in Japanese Cinema," *Iris: A Journal of Theory on Image and Sound*, no. 22 (Autumn 1996), pp. 33–52 (special issue on the Moving Picture Lecturer).

24. Smith's trajectories, especially for 1850, are not known. A broadside (MSPM) shows that he performed at the Corn Exchange in Peterborough on Tuesday, February 25 [1851]. Letter to "Dear Gye," [?] reveals he was in Edinburgh on March 31, 1851 (Albert Smith scrapbook, MSPM). In late April he performed at the Philharmonic Hall, Liverpool. *Musical World* 27, no. 18 (May 3, 1851): 285. A program leaflet shows he performed at the Music Hall, Ramsgate, July 16–17, 1851 (EH).

25. Pencil dated "1851," Albert Smith scrapbook (MSPM).

26. Albert Smith scrapbook (MSPM).

27. At the Music Hall on Store Street. M. M. P. revealed in "Albert Smith's Entertainments" that in February 1851 he performed in London on Monday evenings only and planned to resume his performances after Easter (pp. 120–121).

28. Albert Smith, *The Story of Mont Blanc* (London: David Bogue, 1853), p. 2.

29. Smith's (at age 25) first contribution to *Punch* was a parody of such an institution, [Tiddledy Winks],

"Transactions and Yearly Report of the Hookham-cum-Snivey Literary, Scientific, and Mechanics' Institution," *Punch, or the London Charivari* 1 (September 12, 1841).

30. Smith, *The Story of Mont Blanc*, pp. 33–34.

31. *Illustrated London News*, Feb. 8, 1851 (EH).

32. For an astonishing list of the food and drinks carried to the mountain by eighteen[!] porters, Smith, *The Story of Mont Blanc*, p. 159. The party consisted of three Oxford students and sixteen guides.

33. March 20, 1852, p. 244 ("Crevice in the Glacier du Tacconay"); April 10, 1852, p. 292 ("The Grands Mulets") (EH).

34. Quot. in *Handbook to Mont Blanc. A Handbook of Mr. Albert Smith's Ascent of Mont Blanc . . . First Represented at the Egyptian Hall, Piccadilly* [hand written: "second issue"], London: David Bogue, [1852], p. 8. In the Albert Smith Scrapbook (MSPM).

35. Fitzsimons, *The Baron of Piccadilly*, p. 125.

36. "The Ascent of Mont Blanc," *Illustrated London News* 21, no. 599 (Dec. 25, 1852): 565.

37. Roland Barthes, "The Reality Effect," in *The Rustle of Language*, trans. Richard Howard (Berkeley: University of California Press, 1989), pp. 141–148. Crary applied the notion to media history in "Géricault, the Panorama, and Sites of Reality." Oettermann, *The Panorama*, pp. 93–94, 129–131.

38. Breaking with its authentic role, the dog was used to carry boxes of chocolate for the children during the interval, and eagerly patted by the ladies. J. Monroe Thorington, *Mont*

Blanc Sideshow: The Life and Times of Albert Smith (Philadelphia: The John C. Winston Co., 1934), p. 168.

39. *Galignani's Messenger* was a well-known English-language newspaper published in Paris, founded by Giovanni Antonio Galignani (1757–1821) and continued by his sons after his death until 1884, after which it went to other hands.

40. One carte-de-visite shows him posing as "Edwards, Austrian Lloyd's engineer" (EH). It is interesting that he did this in photographs, but not on stage.

41. "The Ascent of Mont Blanc," p. 565.

42. Smith ascended with Charles Green on the Great Nassau balloon in June 1847 from Cremorne Gardens. The same summer he embarked also on a night flight with Mr. Gypson. The rough landing is said to have nearly killed Smith (Thorington, *Mont Blanc Sideshow*, pp. 79–82). Smith's descriptions of his balloon ascents have been reproduced in Turnor, *Astra Castra*, pp. 211–215.

43. "Mr. Albert Smith's Entertainment, chiefly relating to the Travelling English, and their Autumnal Peculiarities," The Club House, Hong Kong, Sept. 25, 1858. Albert Smith, *To China and Back: Being a Diary kept out and home* (Hong Kong: Hong Kong University Press, 1974, orig. 1859), pp. 61–62. The handbill has been reproduced on p. 62.

44. Smith, *To China and Back*, p. xvii.

45. These included "original sketches and photographs." An announcement about the Dec. 22, 1858 premiere listed the sources of the images as "Mr. Schrantz of Cairo, Messrs. Negretti and Zambra, Mr. Scarth, and Signor Baptista, of Hongkong, and the late Mr. Chinnery

and Yowqua, a native artist of Canton" (quot., Thorington, *Mont Blanc Side-show*, p. 208). The booklet for the show mentions that the views had been painted or supervised by Beverley, "with the Exception of the view of SINGAPORE, which is by Mr. P[hilip] Phillips." (EH)

46. A notice distributed to the audience on May 21, 1860, plainly states: "The kind indulgence of the audience is requested for mr. albert smith, who is suffering from an attack of Bronchitis." Albert Smith scrapbook (MSPM).

47. Edmund Yates, *Memoirs of a Man of the World: Fifty Years of London Life* (New York: Harper & Brothers, 1885), p. 149.

48. Raymund Fitzsimons, *Garish Lights: The Public Readings of Charles Dickens* (Philadelphia: J. B. Lippicott, 1970), p. 32 and passim.

49. Theodor Adorno and Max Horkheimer, *Dialectic of Enlightenment*, trans. John Cumming (London: Verso, 1979, orig. 1944).

50. Thorington, *Mont Blanc Side-show*, p. 49. The play was the French *Le Petit Poucet*, and written for Tom Thumb by Clairville and Dumanoir. Thumb appeared in it at the Théatre du Vaudeville in Paris, being served up in a pie, running between the legs of ballet dancers and driving on the stage in his miniature carriage. A. H. Saxon, *P. T. Barnum: The Legend and the Man* (New York: Columbia University Press, 1989), p. 143.

51. Albert Smith, "A Go-A-Head Day with Barnum," *Bentley's Miscellany* 21 (1847): 522–27, 623–28.

52. Ibid., p. 524.

53. P. T. Barnum, *Struggles and Triumphs, Or, Forty Years' Recollections* (New York: Penguin Books, 1981), p. 197.

54. Barnum commissioned moving panoramas, and after visiting the Royal Polytechnic Institution in London had their high-end magic lanterns and slides copied to present dissolving views at his American Museum in New York. Many of these attractions were later sold to touring showmen. The "Cosmorama Saloon" (or the "Cosmo-Panopticon Saloon") was one of the Seven Grand Saloons of the American Museum. Views from all around the world were exhibited behind lenses inserted into walls. It has been claimed that altogether 194 views were on display at the same time. Philip B. Kunhardt, Jr., Philip B. Kunhardt III, and Peter W. Kunhardt, *P. T. Barnum: America's Greatest Showman—An Illustrated Biography* (New York: Alfred A. Knopf, 1995), pp. 139–140.

55. The changes from season to season can be best studied from the nearly complete set of handbooks and leaflets in the Albert Smith scrapbook (MSPM). Many are also in JJCB.

56. For the 1853 season, Beverley painted a view of Chamonix during the inundation of 1852, from a sketch "taken on the Spot" by Smith. (MSPM)

57. Most likely it was German, and painted by the Gropius brothers, whose diorama in Berlin had closed in May 1850. Edmund Yates claimed he was with Arthur Smith, when the latter bought it in Birminghan "at a third-rate lecture-hall" for practically nothing. Yates, "Bygone Shows," p. 641. Its quality or condition may not have been great, as it was substituted for the next season.

58. Philip Phillips (1802/1803–1864) was a pupil of Clarkson Stanfield. He was married to the painter Elizabeth Phillips, who contributed to her husband's panoramas. Ellen C. Clayton, *English Female Artists*, vol. 2 (London: Tinsley Brothers, 1876), p. 231. Phillips's *Grand Moving Diorama representing Ireland, During the Visit of her Most Gracious Majesty,* *Queen Victoria, Prince Albert and the Royal Children* was exhibited at The Hyde Park Gallery, London, in 1850 (handbook in EH).

59. "Mr. Albert Smith's Ascent of Mont Blanc," handbill, Egyptian Hall, Nov. 24, 1856 (VATC).

60. "Mr. Albert Smith's Mont Blanc," *Illustrated London News* [1857], p. 548, clipping (JJCB).

61. Albert Smith to Mr. Partridge (?), Jan. 13, 1859 (EH).

62. Preface, *A Handbook of Mr. Albert Smith's Ascent of Mont Blanc, Illustrated by Mr. William Beverley. With Nineteen Outline Engravings of the Views. First Represented at the Egyptian Hall, Piccadilly. Monday Evening, March 15, 1852* (MSPM).

63. Thomas Cook began his continental group tours in 1855, taking his first party of tourists to Switzerland via Paris in 1863. Keith Hanley and John K. Walton, *Constructing Cultural Tourism: John Ruskin and the Tourist Gaze* (Bristol: Channel View Publications, 2010), pp. 31–33.

64. His brief experience on the back of a camel in Smyrna was very different from the one shown on the logo. Smith remarked: "Take a music stool, and having wound it up as high as it will go, put it in a cart without springs, get on the top, and next drive transversely across a plowed field." The camels of Smyrna were "muscular brutes," unlike "that consumptive, dull-eyed, ragged beast" he had seen in Astley's Circus, London. Smith, *A Month at Constantinople*, p. 34.

65. A broadside is in MSPM; a plate in EH. There is no text on the plate; the iconic familiarity of Smith's face had made a caption useless.

66. Toy peepshows were produced of the Ascent of Mont Blanc, Constantinople, and China enter-

tainments. They used separate views, reflecting the discontinuous nature of Smith's panoramas. Examples of all are in JJG and a variant of the Constantinople peepshow in RBC. The front side of the "The Diorama of Constantinople in Miniature" states, "Published by the kind permission of Albert Smith Esq. by A, & S, Joseph, Myers & Co, 144 Leadenhall St., London." (RBC) Myers advertised his peepshows in a catalog attached to Albert Smith, *Hand-Book to the Grand Moving Diorama of Constantinople, including The Dardanelles, and The Bosporus, up to the entrance of the Black Sea, which is now open, in the New Room, at The Egyptian Hall* (London: W.S. Johnson, [1854]), catalog p. 6 (RBC). About the Constantinople peepshow, Ralph Hyde, "Thomas Allom and his Panorama of Constantinople: The Visual Evidence of a Recently Discovered Peepshow," in *Panorama: Virtuality and Realities—11. International Panorama Conference in Altötting 2003*, ed. Gebhard Streicher (Altötting: SPA Stiftung Panorama Altötting & Verlag Koch—Schmidt—Wilhelm, 2005), pp. 76–83.

67. "The New Game of the Ascent of Mont Blanc," 2d ed. (London: A. N. Myers and Co., 1861) (MSPM). The date of the first edition is normally estimated c. 1856. The paper fan exists in EH.

68. Copy in EH.

69. In *The Mont Blanc Gazette and Illustrated Egyptian Hall Advertiser*, which was published from time to time, Smith announced "The Mont Blanc Omnibus," an elephant borrowed from the Zoological Gardens transporting passengers from the neighborhoods of Primrose Hill, Kentish, and Camden towns to the Egyptian Hall. This was probably just a funny Barnumian fantasy. Simkin, "Albert Smith: Entrepreneur and Showman," p. 25. I have not found any issues of *The Mont Blanc Gazette and Illustrated Egyptian Hall Advertiser* or its follow-up, *The China Times*.

70. Smith brought ten St. Bernard dogs to England, donating one to Edward, Prince of Wales, and another (named Linda), to Charles Dickens in 1857. A picture of Smith's dogs was published in *Illustrated London News*, Feb. 3, 1855.

71. Barnum, *Struggles and Triumphs*, p. 198. Article is said to be from the *New York Herald*, Sept. 10, 1850.

72. Ibid., pp. 255–256.

73. Ibid., p. 257. Smith, "A Go-A-Head Day with Barnum," pp. 623–624.

74. A copy of the rare "passport" is in EH, dated by ink 1854. Whether this trick was used only once is not known.

75. Copy in MSPM.

76. Program leaflet to *The Ascent of Mont Blanc*, 1857 (Albert Smith Scrapbook, MSPM). The handbooks contained precise information about how to get to the Egyptian Hall from different parts of London, including omnibus routes and fares.

77. This is from a card the size of a business card. (Albert Smith Scrapbook, MSPM).

78. One sheet, Albert Smith scrapbook (MSPM).

79. After opening his own showplace, the Georama, in New York, Banvard adopted similar practices. He reminded his audience: "The picture commences moving punctually at the time mentioned in the advertisements, by the time-piece before the audience. This rule has been adopted to prevent the unnecessary stamping and noise which visitors occasionally make some minutes before the time of commencement." *Description of Banvard's Pilgrimage to Jerusalem and the Holy Land*, p. 4.

80. In 1853 the Theatre Royal, Haymarket, performed "an Entirely New and Original Panoramic Extravaganza" titled "Mr. Buckstone's Ascent of Mount Parnassus." "Illustrative Views" had been painted by Charles Marshall, "who accompanied MrB. [sic] to the spot where they are exhibited." The scenes included "Exhibition Room of 'The Ascent of Mont Blanc,' at the Egyptian Hall (after Mr Albert Smith)." Playbill for the 12th performance on April 9, 1853 (MSPM). The playlet had been written by J. R. Planché and was published in *The Extravaganzas of J. R. Planché, Esq., (Somerset Herald) 1825–1871*, ed. T. F. Dillon Croker and Stephen Tucker, vol. 4 (London: Samuel French, 1879), pp. 258–292. John Baldwin Buckstone (1802-1879), the lessee of the Haymarket theater, also presented other burlesques inspired by the panoramania.

81. *Carpet-Bag and Sketch-Book* was performed at first in the Marionette Theatre at the Old Lowther Arcade on October 23, 1852, and moved to the former Salle Robin at Piccadilly, renamed by Woodin as Myriographic Hall. *Notes and Queries* 106 (9th series, 10, Oct. 25, 1902): 332; *Dramatic Register for 1853* (London: Thomas Hailes Lacy, 1854), p. 79. These were followed by *Cabinet of Curiosities* (premiere Dec. 21, 1860).

82. *Mr. W. S. Woodin's Olio of Oddities, an Entirely New and Original Mimical, Musical, Pictorial, Polygraphic, and Panoramic Entertainment*, Polygraphic Hall, King William Street, Charing Cross, program booklet (London: John K. Chapman and Co. [1855]), title page. His full name was William Samuel Woodin. Woodin may have painted the illustrations himself, for which he was trained. He had also served as a lecturer's in a Charles Marshall panorama.

83. E. H. Malcolm, "The Pantomimes," *New Monthly Belle Assemblée* (London: Robertson and Tuxford), vol. 72 (January to June 1870): 107.

84. Broadside for Friday evening, February 6, 1857, in JJCB. It says, "The Views have been painted from Drawings made by eminent Artists, with Picturesque Effects added by Mr. Martin, shewing the various Phenomena of the Alpine Regions, and will be accompanied by a full and complete description of the various objects of interest—the apparatus being capable of shewing the Views of the immense circumference of 100 feet, being lighted with the Hydro-Oxygen Gas, forming one of the most magnificent & interesting exhibitions of the day." Also chromatropes and a "Hydro-oxygen" microscope were presented.

85. There are two such hand-painted lantern slide sets (one complete and the other incomplete) in EH. A set of spectacular large slides based on *Ascent of Mont Blanc* is in MSPM.

86. One of the first to "occupy the apartment in which Mr. Albert Smith was accustomed to lecture" was the French conjuror Henri Robin, who had performed in London ten years earlier. Unidentified newspaper clipping, hand-dated Dec. 7, 1861 (VATC). About Robin, Mannoni, *Le grand art de la lumière et de l'ombre*, pp. 235–239, 257–258.

87. A broadside for the second season [1862] is in JJCB. It was performed at the Dudley Gallery, Egyptian Hall. Mr. George Case, "the eminent performer on the Violin and Concertina," assisted his wife.

88. *Mrs. Gibbs' (Formerly Miss Graddon) highly successful musical & novel entertainment, with pictorial illustrations, entitled the Emerald Isle, With Songs, Legends, Traditions, Anecdotes, &c., of that Fairy Land*, The Hibernia, 309 Regent Street, adjoining the Royal Polytechnic Institution [1853], broadside (EH). Gibbs was a well-known London actress. The views had been painted by Mr. Charles S. James.

89. Unidentified newspaper clip-

ping, hand-dated Dec. 13, 1862 (VATC). Yates later openly admitted that "My old friend Albert Smith's place had never been filled—his room at the Egyptian Hall was at that time actually vacant—and it would, I thought, be a great thing if I could adjust his mantle, and tread in his successful footsteps." (*Memoirs of a Man of the World*, p. 271.)

90. It also found differences, but these were mostly related to the young age of the performers, and the fact that there were two. "Messrs. Yates and Power's Entertainment," unidentified newspaper clipping, hand-dated Jan. 10, 1863 (VATC). Yates wrote about duologues as a variation of the monopolylogue in "Bygone Shows," pp. 644–645.

91. "New Entertainments," Unidentified newspaper clipping, hand-dated Feb. 13, 1864 (VATC).

92. Ibid.

93. "Artemus Ward among the Mormons, Egyptian Hall, Piccadilly," program leaflet, repr. in *Artemus Ward's Panorama (As Exhibited at the Egyptian Hall, London.)*, ed. T. W. Robertson and E. P. Hingston (New York: G. W. Carleton, 1869), p. 204. Ward occupied a smaller room on the same floor as the larger hall where Smith performed (p. 55).

94. Edward P. Hingston, *The Genial Showman Being the Reminiscences of the Life of Artemus Ward* (Barre, Mass.: Imprint Society, 1971, orig. 1870), p. 337. Hingston was Ward's friend and manager, and refers to discussions with him.

95. HTC. The replacement of "panorama" by "diorama" reflects a general trend. Just two views had translucent elements, the planned Mormon Temple (illuminated windows) and "Prairie on Fire." Interestingly, on December 23, 1882, Mr. James Turner presented at Albert Hall "his Great Lecture, 'Artemus Ward among

the Mormons,' Illustrated by a Comic Panorama, 'Rather Worse than Panoramas Usually Are.'" (broadside in LM). Did he get his panorama from Pelham, or have a new one painted?

96. *Descriptive Programme for this afternoon, Hamilton's Excursions to the Continent and back, in two hours, en route to Italy, France, Austria, Prussia, Switzerland and the Rhine*, program booklet, Egyptian Hall, Piccadilly [1860] (VATC). The entertainment was given Oct. 1–Jan. 12, 1861 (newspaper clippings, JJCB). There is a booklet for another Hamilton production, *The New Overland Route to India Via Paris, Mont Cenis, Brindisi and the Suez Canal*, in JJCB. It has been hand-marked "Egyptian Hall, Feb. 4, 1876." Buckingham was a journalist and minor dramatist, and the youngest son of the well-known traveler, lecturer and MP James Silk Buckingham. Buckingham started illustrated lecturing at the popular-scientific institution Royal Panopticon in the 1850s. He died young in 1867.

97. "The Egyptian Hall," unidentified clipping, hand-dated Oct. 4, 1860 (JJCB).

98. Thorington, *Mont Blanc Sideshow*, p. 234.

99. Aleck Abrahams, "The Egyptian Hall, Piccadilly, 1813-1873," *Antiquary* (London: Elliott Stock), vol. 42 (Jan.–Dec. 1906): 228.

100. Lecture Hall, St. Andrew's [Norwich], until Saturday March 7 [1863]. Photocopy in RH. Powell, *Poole's Myriorama!*, pp. 35–36. Gompertz's name is used, but the managers are listed as G. W. and C. Poole. The broadside explains: "In order to exhibit this beautiful illustration in all the principal Towns of the Provinces, the whole has been made portable and refitted with additions by the original artist, thus enabling the Proprietor to put this far-famed Work of Art before the

public with all its gorgeous effects as produced in London." The "diorama" was combined with unrelated subjects: Garibaldi's campaign in Italy, a diorama of the city of Jerusalem, and the crypt of the Holy Sepulchre. Could this be the British moving panorama on Gabibaldi's campaigns in the collection of Brown University?

101. *Cheltenham Examiner*, Oct. 23, 1860, quot. Powell, *Poole's Myriorama!*, p. 46.

102. The 1855 *Ascent of Mont Blanc* booklet announced new views by Beverley and "A Panorama of the Rhine by M. Groppius." The 1856 booklet mentioned "New views by Beverley and an entirely new the rhine panorama from cologne to heidelberg." The latter was painted by Philip Phillips. The 1857 booklet mentions an additional view by Beverley (crevasses of 1853 on the Glacier du Bossons to the Ascent), Rhine between Cologne and Johannisberg by M. Groppius, and Heidelberg and Chamouni after the fire by Phillips. Parts of the Groppius panorama may have been combined with that of Phillips. It is hard to figure out the nature of the panorama Gompertz was exhibiting. (booklets in Albert Smith scrapbook, MSPM).

103. Powell, *Poole's Myriorama!*, pp. 41, 55, 83. The *Cheltenham Examiner* (Oct. 23, 1860) also mentions Gompertz's Panorama of Garibaldi in Italy, adding an interesting note: "'The Ascent' and 'The Eruption' [of Vesuvius?] two distinct representations of which are given, were the property of the late Albert Smith; 'The Rhine,' from the city of Bonn to the Castle and town of Heidelberg was also purchased at the time of his decease, both being purchased by M. Gompertz." (quot. Powell, *Poole's Myriorama!*, p. 46). Could "The Ascent" have been the *Ascent of Mont Blanc*?

104. *The Newcastle Daily Chronicle*, Nov. 3, 1863, quot. Powell, *Poole's Myriorama!*, p. 40. The showmen were Young & Poole.

105. *Charles W. Poole's Royal Jubilee Myriorama; Picturesques trips around the World; All Over the World. Guide Book and Songs, Price Twopence.* 16 pp., booklet, hand-dated "1886," p. 3 (EH).

106. A rich documentation of Poole's activities are the Poole Family scrapbooks (JWB, owned by William Barnes, London [September 2008]). Partial copy in EH. Grieve and Telbin's *Overland Mail to India* ended up in the hands of Poole & Young—see chapter 6.

8. AN EXCAVATION:
THE MOVING PANORAMA PERFORMANCE

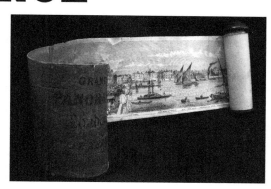

PARODYING THE PANORAMA

The moving panorama cannot be understood by concentrating only on the pain-
ted canvas. To understand its functioning as a medium, it is necessary to find
out how the paintings were activated in exhibition contexts, where the canvas
became part of a presentation and reception apparatus. Issues like cranking
speed, continuous vs. intermittent movement, the lecturer's performance, music,
sound effects, and visual effects all mattered, and so did the size, illumination,
and temperature of the auditorium, the audience's constitution and reactions,
the season, the time of the day, etc. Such issues have already been raised in pas-
sing, but it is important to have a more integral look at their interplay.

Unfortunately, very few detailed first-hand reports of actual moving pano-
rama shows have been preserved, making it necessary to turn to other sources.
Parodic stage performances and comic writings can give clues about what hap-
pened in the exhibition halls. Humorists knew the forms and clichés of pan-
orama shows inside out and poked fun at their expense. One of them was the
American comic lecturer Artemus Ward (1834–1867), who toured between 1864
and 1867 with his panorama spoof about the Mormons of Utah.[1] Following
the Banvardian trail, he began his performances in his home country, and then
brought his show to England.[2]

By choosing the Egyptian Hall as his venue Ward established a link with

Figure 8.1
*Grand Panorama of London and the River Thames. 18 Feet in
length.* Sold by Azulay, Thames Tunnel, London, 1849. This
miniature panorama, first issued by the *Illustrated London
News* in 1843 and later extended, represented a continuous
view of the river, an ideal the painters of large-scale river
panoramas for public exhibitions were unable to achieve.
Author's collection.

Albert Smith.[3] Without mentioning his name, the program booklet referred to the kinds of routines Smith was famous for. These included improvements to the show after each season, as well as orders to the audience.[4] Accordingly, Ward informed the spectators that "during the Vacation the Hall has been carefully Swept out, and a new Door-Knob has been added to the Door." He then advised them that "[a] person of long-established integrity will take excellent care of Bonnets, Cloaks, etc., during the Entertainment; the Audience better leave their money, however, with Mr. WARD; he will return it to them in a day or two, or invest it for them in America as they may think best."[5]

Ward's show had been prepared meticulously. His biographer informs us that after its American premiere Ward noticed that the panorama he had commissioned from a well-known scene painter (from Wallack's Theater, New York) was too large, artistic, and "ponderous," so he had it replaced with a smaller "inartistic and roughly-executed" one.[6] In the advertisements for his performances at Dodworth Hall, Broadway (New York City), Ward mentioned that the panorama would move "to beautiful music" (yes, a pianist was employed, but whether he was playing beautiful music is quite another thing) and be enhanced by "Stupendous Scenery, Steam-Moved Mechanism, and Gorgeous Gas Effects" (which was a hoax). Ward's hilarious list of hyperbolic clichés echoed earlier showmen's promises:

> A Mile of Pictures.
> Five Square Yards of Jokes.
> Sixteen Cubic Feet of Fine Moral Sentiment.
> Four Rods of Sad and Beautiful Pathos.
> A Door-Yard Full of Burning Eloquence.
> A Small Black Travelling-Bag containing Phosphorescent Quips.
> Petroleum Oil Paintings by the High Old Masters, etc., etc., etc.[7]

Soon after Ward's untimely death (1867), his executors edited a book about his Egyptian Hall performance, which contains the lecture text, outline drawings, notes, and stage directions. The illustrations apparently cover the entire panorama. They demonstrate that it was presented in a tableau-like gilt proscenium frame, with a row of footlights placed in front of it.[8] Some of the views were separate tableaux, while others were continuous. In other words, there were two alternating modes of presentation. The majority of the views were kept stationary when Ward lectured about them and pointed out their details with his riding whip—an eccentric substitute for the emblematic lecturer's pointer.[9] Other views were in slow motion while Ward was explaining them.

Ward had already impersonated other touring showmen, including a wax museum exhibitor. The Mormon performance, however, was inspired by his own experiences. Like earlier panoramists (whose well-publicized vicissitudes formed a kind of meta-experience for him), Ward collected his material on a long journey that took his from New York to California and Utah (via Panama), and

186 *ARTEMUS WARD'S LECTURE.*

The Prairie on Fire.

A prairie on fire is one of the wildest and grandest sights that can possibly be imagined.

back across the continent. Just like Albert Smith, he turned his adventures into a travel book.[10] Beside his idiosyncratic deadpan lecturing style, the success of his performance must have been at least partly based on the fact that the spectators knew the conventions of panorama shows, and were also familiar with the grievances the audiences often had.[11] Ward's show was therefore a true meta-performance.

A common source of complaints was the pianist. The showmen often recruited local musicians, so poor performances and misunderstandings of the showman's intentions must have taken place. Mark Twain (who met Ward in California and later lectured about him) wrote a comic piece titled "Scriptural Panoramist," in which a pianist, who is well-meaning but lacks a sense of taste, spoils a religious panorama presentation.[12] In a similar manner, Ward instructed his pianist to accentuate his skits with tunes that did not match the mood or subject matter of the views, for example by accompanying a tragicomic story about a young Mormon's suicide by "soft music." At one point the music became so loud that it drowned out Artemus's voice. Seeing him open his lips in an "excited dumb-show" made the audience "indulge in unrestrained laughter."[13]

Seasoned performers like John Banvard, Albert Smith, and Ward knew how to weave a narrative around incoherent imagery (in a way to edit it verbally), but mediocre productions could suffer from catastrophic atomism. Poor lecturers were unable to compensate for the lack of continuity and thematic logic of their illustrations. This was parodied in "Sarsfield Young's panorama," which was serialized in *Punchinello* in 1870.[14] It pretended to be the lecture text to a "series of panoramic views" a friend had bought at an auction, and was planning to exhibit. Referring to the carefree ways lectures were written, the commentary was based on the list of the views, without seeing "a foot of the canvas."

Figure 8.2
Lecturer's pointer, vignette from *Artemus Ward's Panorama*
(As exhibited at the Egyptian Hall, London.), ed. T. W.
Robertson and E. P. Hingston (New York: G. W. Carleton,
1869). Author's collection.

The subject matter keeps jumping comically. The Alps are followed by "A scene in the tropics," which gives way for "Winter in Spitzbergen," and this to the Grand Canal in Venice. The commentary pokes fun at the platitudes of unsophisticated showmen. The Pyramids are "highly interesting old buildings" that are "centuries old," while the Alps "which are permanently located in Switzerland, and favorably mentioned in all the geographies, are justly admired by tourists for their grandeur, natural beauty, and good hotel accommodations." The Golden Gate, "which guards the harbor of San Francisco . . . is open and shut by means of an earthquake." Some comments verge on the absurd, as when the "night on the prairie" is characterized as "a very dark night, with no moon, exceedingly cloudy, and all the fires out."[15] Obviously what was shown was just dark, blank canvas.

John Bell Bouton included a detailed description of a catastrophic panorama show in his *Round the Block: An American Novel* (1864), set in New York in the 1850s.[16] One of the characters is a self-made man named Wesley Tiffles, whose (mostly unrealized) ideas evoke P. T. Barnum's wild imagination. From "The American Menagerie of Trained Dogs" he jumps to another speculation, the Panorama of Africa. "Professor Wesley's" first—and last—public performance with the ridiculous canvas (painted by a pretentious but failed local artist) takes place in a small New Jersey town.

There is no way to please the heterogeneous audience. There are the clergymen looking for "truth"; there is the pompous *Besserwisser*, C. Skimmerhorn, Esq.; there are the village rascals with their pranks, and the seminary girls with their "oh's!" and "me's!" When he is just about to enter the auditorium (with a complimentary ticket distributed to the "leading men of the village," and his entire family following him, for free), Mr. Skimmerhorn tells to the less than self-assured Professor Wesley: "Every exhibition in this hall, for a year past has been a humbug—an outrage on the common sense of mankind. Perhaps yours is an exception, though, to be candid, I have my doubts of it."[17] And so it happens that the growing discontent of the audience leads to a general commotion, when the promised boa constrictors turn out to be just painted glimpses on the canvas.

How often did such things happen in real life? Charles Dickens confirms the "poor showman's" thankless role as a target for public ridicule.[18] Impatient or irritated spectators routinely pounded the floor with their umbrellas or walking sticks, requesting their money back. The word *shame* was shouted with "burning indignation." Dickens paints a portrait of the scandal-mongering "'worthy' fellow-citizen" Mr. Laycock, who finds the night miserable and loudly declares that the performance was "a wretched imposture and *take-in*." Laycock is Skimmerhorn's double; a very similar figure also appeared in Nathaniel Hawthorne's "Main Street" (see chapter 11).

Another common stock character was embodied in an elderly simplicissimus watching Henry Lewis's Mississippi panorama. "Apparently wrapt in the contemplation of the ever changing scenes," he shouted: "Well, who'd a thought it,—if they haven't got my very house right down here on this picture, yes,—that's the place—barn—the big walnut tree,—the old gate—and as the picture

came more fully into view—if there ain't old bally and the white mare, well, it is surprising how the mischief he come to get it so natural I don't know, stop the boat and let me get out."[19] For McDermott, this newspaper story is "one of the earliest testimonials to the panorama's 'magic realism.'"[20] But it may really be just another manifestation of a topos we have already met in the figure of Jack, the drunken sailor. Whether by innocence or drunkenness, such recurring characters personify the blurred borderline between reality and its representation.

Whether such characters and stories were real, imagined, or culturally transmitted, they point to social developments. The Eidophusikon, the Cosmorama, and the Diorama reached out to upper and upper middle-class visitors who were expected to know how to behave among their peers (which was not always the case). Moving panorama shows attracted a more heterogeneous clientele by combining the seductive popular culture with assurances of their moral quality, suitable for anyone irrespective of religious or political stance, gender, or age.

Although he played the role of a privileged outsider in his ivory tower, the Laycock-Skimmerhorn character is really a hybrid who feels the attraction of mass culture, but remains defensive because of its assumed threat to social hierarchies and refined manners. Barnumized entertainment exploited this tension. Freaks had been exhibited for centuries at both courts and marketplaces. Such sensational exhibits raised the curiosity of the emerging bourgeois middle class as well, but mixing with the popular crowds at fairs and similar gatherings was problematic. By being recontextualized within the walls of Barnum's American Museum or the Egyptian Hall, such attractions gained new legitimacy. Capitalistic entertainment business constructed a socially and morally sanctified safety zone (no matter how cynically calculated its premises really were).[21]

Similar issues affected visual spectacles. There were many of those, who could not even think about visiting theaters because of their reputation, but had no objections for lectures, plays, and other events at the American Museum, the Regent's Park Colosseum, or the Egyptian Hall. However, some commentators tried to define the fine line between exploitation coated as education, and truly elevating experiences. A writer who had just ridiculed the "barbarism" of Hanington's dioramas, recommended "Mr. Catlin's truly valuable and magnificent 'Indian Gallery'" as an alternative. He meant George Catlin's (1796–1872) Indian paintings, which were displayed with native artifacts he had collected on his painting trips along the frontier. The writer did not waver in his judgment:

> In [Catlin's gallery], there is real food for the intellect, a true and deep fountain of instruction, a field for the play and the higher powers and better sympathies of the soul; in [Hanington's diorama], there is empty show, there is vapid taste, there is pointless humor, there are grotesque caperings, there is, in a word, a ruthless caricaturing of the sublime and the beautiful in the features and operations of nature.[22]

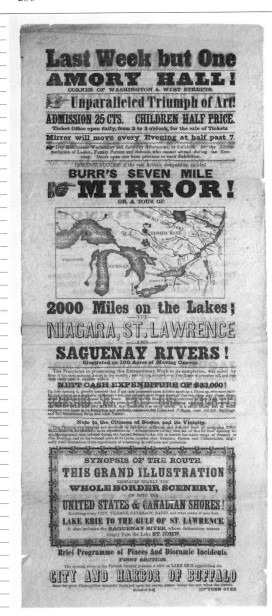

CONSTRUCTING CONTINUITY

Fictional descriptions of panorama shows suggest that the audience often became impatient before the show began, making noise, and calling for the curtain to be raised. "H'ist the rag," a voice called out to Professor Wesley in Bouton's *Round the Block*.[23] Such references pointed to a well-known habit: the showman gave his prologue next to a closed curtain. Artemus Ward did so too, "before any portion of the panorama was exhibited." After it had been raised, it refused to stay up; it was lowered again several times—during the intermission and at the end, but also "in the course of the lecture, and at odd points of the picture."[24] Disturbing the continuity and causing confusions between the static views and the moving sequences in such a way must have felt comic to the audience who knew the conventions.

That the curtain was used to punctuate the panorama was confirmed by the writer of a rare description of a performance of *Burr's Moving [Seven Mile] Mirror of the Lakes, The Niagara, St. Lawrence, and Saguenay Rivers* (1850):

For the convenience of unrolling and managing the square acres of canvas employed, the exhibition is divided by the fall of a curtain into half a dozen parts, giving the spectator about two minutes' breathing time between each. It is otherwise continuous, the eye, by a kind of pictorial license, gliding from one interesting point to another, and jumping over the intermediate space. Without this, an excursion from Buffalo to the Saguenay River would be un peu trop fort. We have varying effects of weather, season, and time of day; sunlight and moonlight, storms and calms, summer and winter.[25]

The relationship between continuity and discontinuity was complex. Theatrical moving panoramas of processions, city streets, and rivers respected the unity of space and time, and were rolled from the beginning to the end at

Figure 8.3
Broadside for William Burr's *Seven Mile Mirror! or, a Tour of 2000 Miles on the Lakes; the Niagara, St. Lawrence and Saguenay Rivers!* Amory Hall [Boston, 1850]. Burr's successful panorama, which was later exhibited by Josiah Perham, was one of the largest, said to be fifteen feet tall. Author's collection.

one go. However, they were often combined with disruptive elements like actors and cutout figures. As moving panoramas grew longer, the literal representation of continuous space became impossible. Although the Mississippi panoramists made months-long sketching trips, even hundreds of sketches could not cover the entire river. Had this been possible, no one would have had the patience to sit through the presentation. The underlying paradox became clear, when Banvard's panorama was claimed to follow the Mississippi for hundreds of miles, but was also advertised as a "three-mile painting" (in reality it was much shorter).

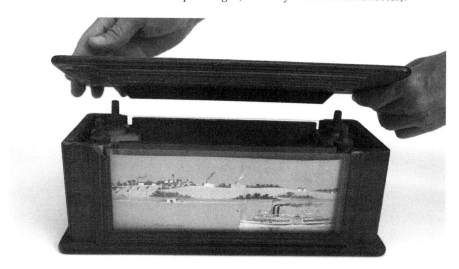

The impression of continuity was created artificially, because there was no alternative. The handbook of Risley and Smith's *Original Gigantic Moving Panorama of the Mississippi River* illuminates this issue. It admits that a view a spot named Madrid Bend "presents the general character of three-fourths of the lower Mississippi—viz., a regular curve or bend, and an uniform bank of trees." The reason: "It is one of the most monotonous scenes imaginable, and there is not ten feet of an elevation in the course of one hundred miles."[26] Again: "We must necessarily pass many small towns, as Bloomington, Uquawka, Clarksville, Quincy, Warsaw, &c., as they would prove uninteresting to the mass, and present no peculiarities."[27] It is worth paying attention to the choice of words: "[T]here is not an inch of attractive landscape omitted—not a patch of inlet—not a rock—nay, scarcely a tree." So only *unattractive* parts had been left out—but there were many of them.

The need to omit the uninteresting parts was also raised in the program leaflet for the Padorama (1834), a moving panorama about the recently opened

Figure 8.4

Excursion Views of Narragansett Bay and Block Island, two-sided moving panorama viewer for the desktop, with two picture rolls depicting continuous boat trips along the waterways of Rhode Island and Massachusetts. Published by Excursion View Co., Providence, R.I. (the color lithograph rolls printed by Clay and Co., Buffalo, N.Y.), patented in June 1878. The purpose of this viewer is unclear: is it an expensive souvenir or a device for boosting tourism? Author's collection.

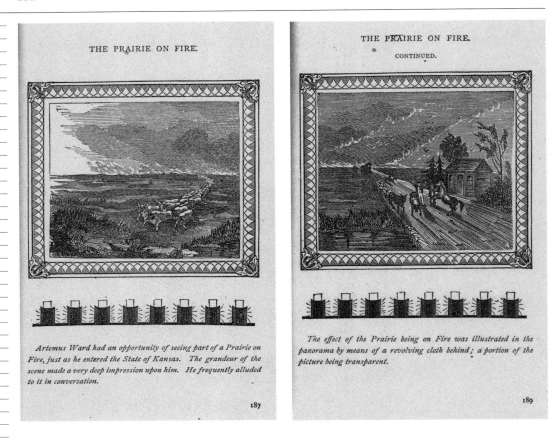

THE PRAIRIE ON FIRE.

THE PRAIRIE ON FIRE.

CONTINUED.

Artemus Ward had an opportunity of seeing part of a Prairie on Fire, just as he entered the State of Kansas. The grandeur of the scene made a very deep impression upon him. He frequently alluded to it in conversation.

187

The effect of the Prairie being on Fire was illustrated in the panorama by means of a revolving cloth behind; a portion of the picture being transparent.

189

railway between Manchester and Liverpool (a much shorter distance than the Mississippi):

> *It was considered desirable that the inhabitants of the metropolis, whose avocations may prevent them from seeing a real railway, should have an opportunity of forming a correct judgment by a faithful delineation of all the leading and prominent features of the Manchester and Liverpool railroad; the engines and carriages [cutout figures?] are correct models of those in actual use, and the pictorial portion of this exhibition has been painted by artists of acknowledged talent, from sketches made on the spot; a repetition of the views of excavations has been avoided, and the many uninteresting portions of the*

Figure 8.5
Artemus Ward's interpretation of "prairie on fire." From
Artemus Ward's Panorama (As exhibited at the Egyptian Hall, London.), ed. T. W. Robertson & E. P. Hingston (New York: G. W. Carleton, 1869). Author's collection.

road omitted, so that the artists do not profess an accuracy in distance
between the parts represented; otherwise they throw themselves on the
judgment of the public for the fidelity of those selected.[28]

The panorama painter was somewhat like a film editor, creating sequences by
"splicing" together discrete elements. There were two main challenges: identify-
ing the highlights, and creating an illusion of continuity between them. When it
comes to the Mississippi, some sights were considered indispensable: the cities
of St. Louis and New Orleans; Nauvoo (Illinois) with its great Mormon temple;
the Wabash Prairie (today's Winona) with Fort Snelling and camps of native
Americans; the Falls of St. Anthony, etc.[29] Stock scenes, such as the great fire
of St. Louis, collisions and explosions of steamboats, and prairie on fire were
common. The last mentioned became such a cliché that Artemus Ward used it as
the culmination of his Mormon panorama. It was presented—in a deliberately
abrupt manner—just before the final view depicting Brigham Young and his
enormous family at home.[30]

Accommodating disparate scenes within the overall composition often meant
sacrificing spatiotemporal verisimilitude. Events that were years apart were
shown along the same route, and mixed up with imaginary scenes. Including
interiors was particularly trying. Risley and Smith displayed a large stone basin
standing beside the recently abandoned Mormon temple in Nauvoo, Illinois,
adding that "in the basement is its real situation."[31] Sights that could not be seen
from the river were also a challenge—imaginary trips ashore was the solution.
Risley and Smith stated: "We now leave Galena, and, after passing some twenty
miles of hills towards Chicago, come upon the *Rolling Prairies of Illinois.*"[32] The
moving panorama show was inclusive rather than exclusive. Sacrificing verisi-
militude was in both the showman's and the audience's interest. The showman
gained possibilities for telling tales and anecdotes; the audience, extra visual
and aural attractions. As Curtis Dahl stated, "variety was a merit; digression
was a virtue."[33]

Most river panoramas represented only one shore; painting both sides
would have been costly, and their simultaneous presentation difficult.[34] As
a round-trip Bonomi, Warren and Fahey's *Grand Moving Panorama of the Nile*
(1849) was an exception. The spectators first traveled up the river from Cairo to
the Second Cataract observing the West bank, and returned facing the East bank.
Each trip was probably on a separate cylinder. When the change was taking
place, the spectators were treated with a "magnificent Tableau of the interior of
the Great Temple of Abou Simbel" (a drop scene).[35]

Henry Lewis's Mississippi panorama offered another solution: the most
interesting sights from both sides were displayed in an *alternating* mode, by
pretending that the spectators were on "Captain Lewis's" steamboat, which
was making circles, and then continuing to the original direction.[36] The *Herald
of Religious Liberty* endorsed the trick: "The painting 'rounds to,' like a graceful
steamer, wherever there are towns or beautiful views on both sides, or some rich

island scenes, or a lovely river view, so as to show it as the traveller sees it."[37] Did the audience really feel as if it was on a boat? Most likely it just participated in a play of make-believe. Charles Dickens referred to the need of suspending disbelief when he wrote about a moving panorama "which carried out the little fiction of its visitors being 'excursionists,' and taken over every leading city on the Continent."[38]

No matter what one did, there were elements that worked against a seamless illusion. The lecturer's explanations may have psychologically helped hiding the seams, but as a gatekeeper rather than an inhabitant of the imaginary world, he may also at times have accidentally shattered the illusion. A story about Henry Russell's *The Far West, or The Emigrant's Progress* (1851) performance points to the catastrophic miscommunication between the lecturer and the panorama operator:

> On more than one occasion Mr. Russell has stood with his back to the scene (as was his custom), pointing out to an attentive audience the solemn and splendid effect of the Falls of Niagara, when, had he looked at the picture he was describing, he would have observed it to represent the interior of a log-hut or negroes dancing in a plantation.[39]

In the imaginary performance in Bouton's novel *Round the Block* Professor Wesley gives instructions to the village idiot, who has been hired as the crank operator, by a code of coughs and foot stamping: "One cough was 'Stop;' two coughs were 'Go on;' one stamp was 'Slower;' two stamps were 'Faster.'"[40] When somebody in the audience finds it out, he starts deliberately distracting the performers by his own coughing. The lecturer switches to overt signals (saying "stop," "go on," "faster," "slower"), but the damage has been done. In a magic lantern show the lecturer and the projectionist were in the opposite ends of the hall; in a moving panorama show the lecturer and the "crankist" were close to each other, so proxemic oral communication—including communication breakdowns—must have taken place.[41]

Failed or primitive special effects could be equally disruptive. Albert Smith and John Leech joked about them: "Once I went to a great moving panorama of the Mississippi, and saw a phenomenon—something like an eclipse. The scene represented moonlight on the banks of the river; and suddenly the moon was obscured and all was dark, amidst a crash of falling tin and glass."[42] Both Artemus Ward and Robert Ganthony poked fun at the classic moon effect (which seems to have failed quite often, judging by their interpretations) in their performances. Ward pretended to be "a man short," which forced him to "work the moon" himself. An annotation explained the situation:

> Here Artemus would leave the rostrum for a few moments, and pretend to be engaged behind [the proscenium]. The picture was painted for a night-scene, and the effect intended to be produced was that of the

moon rising over the lake and rippling on the waters. It was produced in the usual dioramic way, by making the track of the moon transparent and throwing the moon on from the bull's eye of a lantern. When Artemus went behind, the moon would become nervous and flickering, dancing up and down in the most inartistic and undecided manner. The result was that, coupled with the lecturer's oddly expressed apology, the "moon" became one of the best laughed-at parts of the entertainment.[43]

Ward concluded his gag by promising to "pay a good salary to any respectable boy of good parentage and education who is a good moonist."[44] In Ganthony's parody the lecturer announced with great grandiloquence: "The moon will now shine forth with all its divine effulgence." But nothing happened—the candle had already been used to lubricate the stiff cogwheels of a cutout steamer. Sticking the wick into a piece of soap solved the problem, but displaying the moon and its reflection at the same time proved problematic, because the boy-moonist was short, and had to first climb on a chair and then jump down to perform the trick. The lecturer was forced to admit: "I cannot show you the moon and the reflection at the same time, but I will first show you the moon shining forth with all its divine effulgence."[45]

DISCONTINUITY AS STRATEGY

Some panoramas made no efforts to conceal the gaps between the views. One of them was Professor Montroville Wilson Dickeson's and I. J. (John J.) Egan's *Monumental Grandeur of the Mississippi Valley!* (c. 1850). According to McDermott's judgment, "it is not, properly speaking, a panorama of the Mississippi . . . it was rather a series of pictures which derived unity from the lecture."[46] For McDermott spatial continuity was a pre-condition for a *panorama*. H. Stewart Leonard saw things differently: "The other panoramas of the Mississippi had the scenery of the river as the major theme. The spectator either ascended or descended the river, depending on whether the panorama was being wound from left to right or from right to left. The Dickeson-Egan panorama did not have this limited interest in landscape; it reflected to a great extent the Doctor's interest in Indian culture, archaeology, habits and customs."[47]

The panorama was painted by Egan from Dickeson's sketches to illustrate the latter's lectures about his "Ærchiological" excavations in the Ohio and Mississippi river valleys. They focused on the "antiquities & customs of the unhistoried indian tribes." The painting (which survives at the St. Louis Art Museum) is currently 90 inches high and 348 feet long, and consisted originally of forty-five views, divided into three sections.[48] No effort was made to simulate the continu-

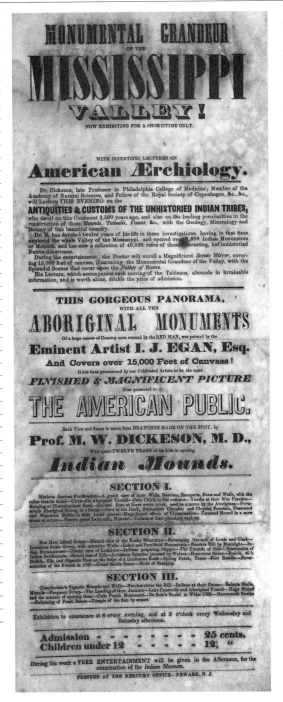

ity of the Mississippi—the views are separate *tableaux*. Many are historical, but there is also a "distant view of the Rocky Mountains," which has little to do with the route, didactic *tableaux* (including a cross section of a native tomb with African-American slaves digging it open), and a comic interlude, "Louisiana Squatter pursued by Wolves." The lack of continuity evokes "illustrated lectures," or lantern slide projections.

In some cases separate drop scenes were lowered *in front* of the canvas. Hardy Gillard's *Panorama from New York, over the Pacific Railway, to California* was preceded by a bird's-eye view of the country (40 ft. by 8 ft.), stretched on a wire. "A fifteen minutes' lecture is delivered from it. It is a key to the panorama, which contains 36 views, all painted from photographs."[49] Similar effects could also be used *within* the panorama itself. In Otis A. Bullard's *Panorama of the New York City* (1850), "single views of remarkable buildings and localities" were dropped over the panorama to provide more detailed glimpses of city life or of places which were outside the chosen route.[50] These included close-up portraits of New York's notable personalities, and even some *interior* views.

Bullard's drop scenes functioned as a form of "real-time" editing, but seeing them as an anticipation of film editing would be an exaggeration. Instead of serving as integrated narrative devices, the drop scenes were a demonstrative element. They displayed additional features and details for the spectators. In this sense they were not totally unlike the close-ups included in the early cinema of attractions—they served the audience's voyeuristic drive to see details and hidden features. The fact that they were separate from the panorama canvas must have worked against visual immersion. Their potentially disruptive effect had to be countered by the lecturer's narration.

The mechanical cutout figures and boats that moved in front of the canvas could also have a disruptive effect, especially when they

Figure 8.6
Panorama of the Monumental Grandeur of the Mississippi Valley, broadside for the panorama painted by John J. Egan (1810–1882) for the amateur archaeologist Dr. Montroville Wilson Dickeson (1810–1882), who supplied the sketches. C. 1850. The panorama survives in the St. Louis Museum of Art. Author's collection.

failed to work. In the handbook of his Mississippi panorama, Leon Pomarede emphasized his "new invention, exhibiting a great portion of the water craft moving by machinery, distinct and apart from the canvass [sic]," and explained it in detail:

> The majestic Steamers are made to move against the mighty flood, their engines in motion, and emitting smoke and steam from the chimney's [sic] and escape pipes. The hardy Flatboatsman and his cumbersome charge, float down the current guided by the brawny arms of the oarsmen, the motion being natural as life; and on the Upper Mississippi where the works of civilized man are rarely to be seen, the Indians in their shallow and easily overturned canoes, are paddling in life-like motion on the placid waters that bear the frail thing.[51]

Such tricks may have delighted the spectators, but they were hardly new, or "natural as life." In the "Panorama Skit" in his *Bunkum Entertainments*, Robert Ganthony pokes fun at their expense. He introduces the "magnificent steamer" The Albany, a flat cutout figure of a boat attached to a stick and operated by a boy behind the canvas.[52] The steamer moves awkwardly back and forth, in asynchronicity with the lecture and the moving canvas. The cogwheels refuse to turn, and "smoke, or rather cotton wool, is seen protruding from the smoke stack."[53] The lecturer admonishes the boy behind the scenes, inadvertently evoking the Brechtian alienation effect. When the chaos momentarily settles, the cranking reveals a series of advertising slogans ("Snooks Liver Pad," "Sucker Syrup," etc.) painted in the sky-part of the canvas.[54]

Both the (pseudo)continuity and the tableaux-based discontinuity had their own justifications, but in practice they were often combined: the tension between continuity and discontinuity was at the heart of the medium. Still, the tableau-format may have been associated with higher cultural values, which could explain why it was adopted for works with cultural pretentions, such as *The Route of the Overland Mail to India*, Albert Smith's *Ascent of Mont Blanc*, and *The Moving Panorama of Bunyan's Pilgrim's Progress*. The tableaux were associated

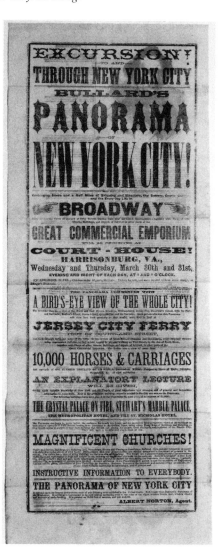

Figure 8.7
Bullard's Panorama of New York City! Broadside, Court House, Harrisonburg, Va., March 30–31 [1870]. Albert Norton exhibited Bullard's panorama for many years after the artist's, Otis A. Bullard's (1816–1853), untimely death. Author's collection.

THE AUTHOR AND HIS BUNKUM PANORAMA.

with framed (oil) paintings, while the (pseudo)continuous panoramas were accused of remaining on the surface. A richly decorated proscenium with curtains around the "window" across which the panorama moved could enhance the prestige effect. Whereas an armchair cruise along the Mississippi ended either in New Orleans or in Rush Island (depending on the cranking direction), *The Moving Panorama of Bunyan's Pilgrim's Progress* (*Bunyan's Tableaux*) took the spectators on a one-way metaphysical journey toward spiritual enlightenment.[55]

Figure 8.8
Robert Ganthony performing his "Panorama Skit."
Frontispiece to his *Bunkum Entertainments* (London: L. Upcott Gill, n.d. [1890s]). The "magnificent steamer" the *Albany* is seen in front of the moving panorama. Author's collection.

NOTES

1. Two later (serious) panoramas about the Mormons, Carl Christian Anton Christensen's "The Dimick Huntington Panorama" and the "Mormon Panorama" (1870s-1880s), have been preserved at the Brigham Young University Museum of Art, Salt Lake City, Utah. See appendix.

2. It premiered at the Egyptian Hall on November 12, 1866. The color-printed broadside advertised it as *Artemus Ward among the Mormons: An Illustrated Narrative of a Trip from New York to Salt Lake City* (VATC).

3. Hingston, *The Genial Showman*, p. 337; Ward, *Artemus Ward's Panorama*, pp. 54–55.

4. "Egyptian Hall, Piccadilly. Artemus Ward among the Mormons," program booklet [1867], reproduced in facsimile in Ward, *Artemus Ward's Panorama*, p. 203.

5. Ibid. Compare this with a notice by Albert Smith in *The Times*, Dec. 2, 1854: "During the recess the hall has been redecorated, and every attention paid to the approaches, seats, ventilation, and general comfort of the audience."

6. Hingston, *The Genial Showman*, p. 347. A program leaflet, "Artemus Ward His Programme" (Maryland Institute, Baltimore, February 8–11 [1865]) lists 20 scenes related with Ward's trip to Utah, but it is not identical to the performance at Egyptian Hall. Probably this was still the earlier panorama. The word *panorama* is not mentioned at all. (EH)

7. Ibid., p. 341.

8. Ward, *Artemus Ward's Panorama*, p. 58. The book claims that the views were painted from photographs taken by Savage and Ottinger, of Salt Lake City, the photographers to Brigham Young.

(p. 72, n. 10). Whether photographs were also used for views of the other locations is uncertain.

9. In New York Ward had used a fishing rod, then an old umbrella (*Artemus Ward's Panorama*, p. 71). A graphic representation of the riding whip has been reproduced numerous times in Ward's book as an indexical pointer to the views. The pianist may have played during the transitions between the views.

10. Artemus Ward, *His Travels: Part I—Miscellaneous, Part II—Among the Mormons* (New York: Carleton, 1865).

11. According to *Artemus Ward's Panorama*, "the wondrous gravity of the lecturer's face was fully visible at the time that he was uttering his best jokes" (p. 58).

12. In Twain's *The Celebrated Jumping Frog of Calaveras County, and Other Sketches* (London: George Routledge and Sons, 1867) the parody appeared embedded in a longer sketch titled "The Launch of the Steamer Capital" as "The Entertaining History of the Scriptural Panoramist" (pp. 146–151). It first appeared in the *Californian*, November 18, 1865. It was later often published as an independent text titled "A Scriptural Panoramist," although it appeared as "A Traveling Show" in Twain's *Screamers* (London: J. C. Hotten, 1871), pp. 146–150. The history of the text with all the variants, revisions, and unauthorized versions is complex.

13. Ward, *Artemus Ward's Panorama*, pp. 180–185.

14. "Sarsfield Young's Panorama," *Punchinello* (New York), Nov. 26, 1870, p. 135; Dec. 3, 1870, p. 158; Dec. 17, 1870, p. 190; Dec. 24, 1870, p. 204. *Punchinello* appeared only between April 2 and December 24, 1870.

15. This recalls Émile Cohl's animation *Le Peintre néoimpressioniste*

(1910) that presented absurd visualizations of artworks such as "Negroes making shoe polish in a tunnel at night." Donald Crafton has linked it to satires on art that began with Daumier's parodies of the Salon of 1840. *Emile Cohl, Caricature, and Film* (Princeton: Princeton University Press, 1990), p. 291.

16. Bouton, *Round the Block*. According to *Who's Who in American 1903–1905* (Chicago: A. N. Marquis & Co., 1903), Bouton (1830–1902) was an author and a journalist. *Round the Block* was a success; the 5th edition appeared in 1868.

17. Bouton, *Round the Block*, p. 242.

18. Dickens, "Moving (Dioramic) Experiences," p. 304.

19. *Courier* (Louisville), June 12, 1849, in Henry Lewis Press Book (MIHS), also quot. McDermott, *The Lost Panoramas of the Mississippi*, p. 140.

20. McDermott, *The Lost Panoramas of the Mississippi*, p. 139. In *Parallel Tracks* (pp. 64–65) Kirby has discussed a later manifestation of this topos tradition in Edwin S. Porter's film *Uncle Josh at the Moving Picture Show* (Edison, 1902), but without treating it as a topos.

21. Robert Bogdan, *Freak Show. Presenting Human Oddies for Amusement and Profit* (Chicago: University of Chicago Press, 1988) uses the notion "the social construction of freaks" (pp. 2–10).

22. "The Author of *Two and a Half Years in the Navy*" [Enoch Cobb Wines], "Hanington's Dioramas," p. 292.

23. Bouton, *Round the Block*, p. 246.

24. Ward, *Artemus Ward's Panorama*, p. 72.

25. *N.Y. Albion* (no date), quot. in *Descriptive and Historical View of*

Burr's Moving Mirror of the Lakes, The Niagara, St. Lawrence, and Saguenay Rivers, embracing the entire range of border scenery of the United States and Canadian shores, from Lake Erie to the Atlantic (Boston: Dutton & Wentworth, 1850), p. 45. (YBL).

26. Risley and Smith, *Professor Risley and Mr. J. R. Smith's Original Gigantic Moving Panorama of the Mississippi River*, p. 18.

27. Ibid., p. 13.

28. *Descriptive catalog of the Padorama*, pp. 7–8. The trains and carriages must have been cutout models in front of the moving canvas.

29. McDermott, *The Lost Panoramas of the Mississippi*, passim.

30. Ward, *Artemus Ward's Panorama*, pp. 186–194. A portion of the canvas was transparent. The effect "was illustrated in the panorama by means of a revolving cloth behind." (p. 189) Ward let the fire "go out occasionally" and "relight itself."

31. *Professor Risley and Mr. J. R. Smith's Original Gigantic Moving Panorama of the Mississippi River*, p. 14.

32. Ibid., p. 12.

33. Curtis Dahl, "Mark Twain and the Moving Panoramas," *American Quarterly* 13, no. 1 (Spring 1961): 31.

34. In the first photographic panorama book of the Hudson river both sides of the river were presented simultaneously, one upside down (like a mirror image). To follow the other shore, one had to turn the book upside down. Wallace Bruce, *Panorama of the Hudson, showing both sides of the river from New York to Albany* (New York: Bryant Literary Union, 1888). Photographs by G. Willard Shear, engraved by Moss Photo-Engraving Company. (EH).

35. *Grand Panorama of the Nile*, Egyptian Hall, broadside [hand-dated: March 1850] (EH).

36. Henry Lewis and Charles Gaylor, *Lewis' Panorama. A Description of Lewis' Mammoth Moving Panorama of the Mississippi River, from the Falls of St. Anthony to the City of St. Louis. . . . by Charles Gaylor, Director of Panorama* (Cincinnati: The Dispatch Office, 1949) (Photocopy from the Library of Congress in MHS), pp. 8–12 and passim.

37. *Herald of Religious Liberty*, Sept. 13, 1849, Henry Lewis Press Book (MIHS). Also quot. McDermott, *The Lost Panoramas of Mississippi*, p. 139.

38. Dickens, "Moving (Dioramic) Experiences," p. 307. One wonders if Dickens was referring to Hamilton's Excursions. He claims that the show was the Grand Tour, a typical topic for the Hamiltons.

39. Quoted from *The Modern Drama* (which I have not found) by W[illiam] Clark Russell, *Representative Actors* (London: Frederick Warne and Co., 1888), p. 479. The same source tells another anecdote about a "drunken fellow" who fell from the top of Russell's panorama to the stage.

40. Bouton, *Round the Block*, p. 239.

41. Bells, flashing lights, and even push button–operated electric signals were used as means on communication between lecturers and magic lantern operators, because they stood in the opposite ends of the hall.

42. Smith and Leech, *A Month*, p. 152.

43. Ward, *Artemus Ward's Panorama*, p. 159, fn. 29.

44. Ibid., p. 159.

45. Robert Ganthony, *Bunkum Entertainments* (London: L. Upcott Gill, n.d. [1890s]), p. 49.

46. McDermott, *The Lost Panoramas of the Mississippi*, pp. 170–171. The broadside (EH) uses the words "gorgeous panorama." I saw the Dickeson–Egan panorama (St. Louis Art Museum) exhibited in a proscenium frame but not in motion at the Minneapolis Institute of Arts, in "Currents of Change. Art and Life Along the Mississippi River, 1851–1861" (2004). Only one scene was shown, but the entire panorama could be explored as a digital replica on a screen.

47. *Mississippi Panorama: The life and landscape of the Father of Waters and its great tributary, the Missouri*, ed. Perry T. Rathbone (St. Louis: City Art Museum of St. Louis, 1950), p. 129. See also Lisa Lyons, "Panorama of the Monumental Grandeur of the Mississippi Valley," *Design Quarterly* (Minneapolis: Walker Art Center), no. 101/102 (1976), pp. 32–34.

48. 25 scenes survive. The three sections were probably on separate cylinders. The panorama was shown in motion in 1950 at the City Art Museum of St. Louis. See *Mississippi Panorama*, pp. 13–16, 127–135. The panorama is undergoing a restoration in 2011–2012. Examining the canvas, the panorama showwoman Sara Velas noticed orange dots on the lower front side of the canvas as indicators for the crank operator to stop the cranking, when each scene was in the proper position (Velas, personal communication, March 2012).

49. Unidentified newspaper clipping, dated on the envelope "1873" (HTC). The panorama was shown at St. James's Large Hall. There is a color-printed map of the United States with the text "GO and SEE Hardy Gillard's Great American Educational Panorama Over the Pacific Railway to California. This Map is a Guide to the Large Painting 40 ́ 8 ft. The Painting being a key to the Panorama." (JJCB).

50. Arrington, "Otis A. Bullard's Moving Panorama of New York City,"

p. 317. In the broadside (EH) it was claimed the spectator saw "Perspective Views of Forty-five streets" as the panorama moved along the Broadway. These must have been part of the moving panorama itself. In a way they added the depth illusion of the familiar *vues d'optique* seen in peepshow boxes to the lateral motion of the moving panorama. This was another way of "editing," even between two media.

51. Leon Pomarede, *A Guide to Pomarede's Original Panorama of the Mississippi River, from Mouth of the Ohio River, to the Falls of St. Anthony: By T. E. Courtenay* (New York: For the Author by George E. Leefe, 1849), p. 7 (MHS).

52. Ganthony, *Bunkum Entertainments*, pp. 42–45.

53. Ibid., p. 45.

54. Ibid., p. 46, illustration. It is hard to say if this could have happened in an actual panorama show. The proliferation of posters and billboards was a constant source of debate in the Victorian society. E. S. Turner, *The Shocking History of Advertising* (New York: Ballantine Books, 1953), ch. 6, pp. 119–132. Turner's title page has been adapted from the broadside that came with Milton Bradley's Myriopticon, released for the Christmas market 1866. Bradley's advertisement in *Colman's Rural World* 18, no. 24 (Dec. 15, 1866): 377 promotes the Myriopticon, the Zoetrope and other "games and amusements" (the Myriopticon and the broadside in EH).

55. I finally saw in March 2012 a digital copy of the entire restored *Moving Panorama of Bunyan's Pilgrim's Progress*. Although its tableau-structure is evident, the transitions between the scenes have often been masked with architectural elements, trees, and landscapes. The effect is more complex than I assumed. It is possible that the surviving version (1851) is more "fluid" than the lost original (1850). All the scenes are not of equal width, which would have emphasized motion and transitions. The reverse of the canvas contains markings that may be instructions for the crank operator, but their meaning is not clear. Thank you to Peter Morelli for the visual documentation.

9. INTERMEDIAL TUG OF WAR:
PANORAMAS AND MAGIC LANTERNS

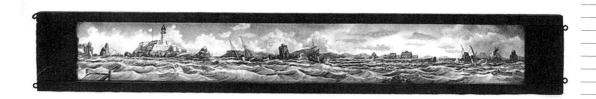

BY ANY MEDIUM AVAILABLE:
THE CIVIL WAR AND THE PANORAMA TRADE

In the thick of the panoramania Albert Smith already anticipated the medium's demise by penning the following spoof:

> DIORAMAS FOR SALE. *All sorts of Dioramas [moving panoramas] of everywhere to be sold cheap, the proprietors being about to quit the business, for whatever may turn up next. Dioramas of rivers, cities, colonies, voyages, tours, routes, &c. on terms that must realise little fortunes in the provinces. Also for sale, fifteen miles of damaged canvas. Grand moving diorama of the Route of the Overland Mail from Brompton to the Bank: also a fine panorama of Australia for sale, which, by merely altering the figures, will do equally well for Switzerland, Greece, or California. Several half-finished dioramas of Algiers, China, Edinburgh, the Thames, Norway, Upper Clapton, St. Gothard, the Brighton Railway, Naples, the Euphrates, Hampstead Heath, and other attractive subjects, to be sold under prime cost. Be in time. Improve the working mind, and make the poor man happy.*[1]

The prophecy was accurate. Many productions disappeared without a trace. Others were updated, renamed, and combined. The quip about the "little fortunes"

Figure 9.1

A long hand-painted magic lantern slide depicting seaside scenery in a storm. British or American, c. 1860-1880. 4 x 28 inches (with wooden frame). The slide would have been presented moving slowly across the slide stage of the magic lantern, producing an effect resembling that of moving panoramas. Author's collection.

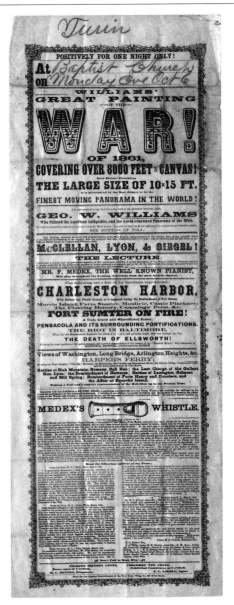

that could be made "in the provinces" was also correct; there were eager eyes in smaller communities. The medium may have been declining, but its downward curve was less steep than Smith suggested. Many moving panoramas were exhibited in the latter decades of the nineteenth century. Some were rather primitive folk-art concoctions (including several of the surviving ones), only faintly echoing the higher quality products of the past. Others were shown as "combinations" with variety programs. In the United States, the touring *Howorth's Hibernica* shows of the 1880s included moving panoramas of Ireland, together with various live acts; this anticipated the role of early silent films in variety theaters and fairgrounds.[2]

The outbreak of the American Civil War in April 1861 created a heated market for visual representations. Magazines did their best to profit from the situation, but their illustrations were small, without color, and often inaccurate. Photography captured personalities and scenes of war, including the horrifying aftermath of battles, but the most dramatic moments escaped the lens of the camera. Moving panoramas had an advantage: they offered large, colorful, and dramatic representations of the unfolding national drama. Already in 1862, Geo. W. Williams's *Great Painting of the WAR! of 1861* attracted audiences with a "Full and Complete representation of the Rebellion up to the Present Time."[3] To make the "finest moving panorama in the world" even more attractive, it was combined with performances of a musical genius, the Frenchman Fred. Medex, who "electrified the audience" with a toy penny whistle.

George K. Goodwin's (1830–1882) career as an entrepreneur demonstrates how extensive the moving panorama business could become. According to his obituary, Goodwin first ventured into the field in 1856 by purchasing a stake in Waugh's *Mirror of Italy*. It became so profitable that "he engaged in so many similar entertainments that he may truly be said to

Figure 9.2
Williams's Great Painting of the WAR! of 1861. Broadside for an exhibition at the Baptist Church, Turin, Lewis County, New York, on October 6, 1862. Printer: Troy Daily Whig, Troy, N.Y. [1862]. The painter was Geo[rge] W. Williams, who is said to have also painted "the American Antiquities" and a panorama of the Bible. Mr. Fred. Medex played selections from operas with the piano and a tiny toy whistle. Author's collection.

have owned more panoramas than any other man in the business." [4] The obituary lists five (!) different panoramas of Dr. Kane's expedition to the North Pole, four about the civil war, and several others. A sales notice Goodwin placed in the *New York Clipper* in 1865 offered "ten wax figures," "glass steam engine Fairy Queen," a "full set of scenery for halls," and several panoramas. The choice of words inadvertently confirms the prophetic accuracy of Albert Smith's previously quoted parody, which had been written more than a decade earlier:

FOR SALE. EXHIBITION PROPERTY CHEAP FOR CASH.

1st. *STANLEY & CONANT'S POLYORAMA OF THE WAR. With all the Battles complete. Fine lot wood cuts. Also printing [broadsides] enough for three months. This picture is most positively the best one in the United States.*

2nd. *ANOTHER, SAME SUBJECT, painted by Pearson Brothers for David Woodward & Co., with a Diorama of the Merrimac and Monitor.*

3rd. *PANORAMA, painted by T. G. Bartholomew. Subject: Bird's Eye View of London, Whaling Voyage, and Australia. Quite new, and has never been exhibited.*[5]

This notice gives the impression that the moving panorama as a medium was simply declining, but this may not be the whole truth. Moving panoramas had hardly driven Goodwin to bankruptcy; there was still a market for them for others to exploit. Like P. T. Barnum, Goodwin was a nervous speculator, who was constantly looking for new challenges; his next speculation was with traveling circuses and menageries.[6] Later in life he also functioned as a store owner, and as a manager for theaters, opera houses, and touring lecturers (including Artemus Ward).

The shows that circled the United Stated

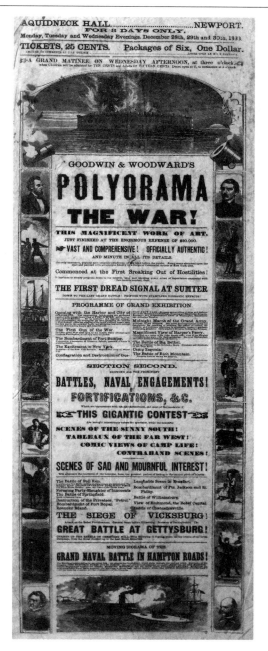

Figure 9.3
Goodwin's and Woodward's Polyorama of the War, broadside, Aquidneck Hall, Newport, Rhode Island, December 28–30, 1863. The views were meant to "alternate the emotions of the beholder, from the greatest pathos of feeling to the loudest pitch of hilarity." "Dancing Darkies among the Soldiers" obviously served the latter purpose. Using special effects, "the Transports are seen conveying the soldiers to Fort Sumter, while the rippling of the moon's silvery beams upon the dark waves, the crowded decks and glittering bayonets present a scene of surpassing [sic] beauty and magnificence." The show concluded with the confrontation of the battleships Monitor and Merrimac, where mechanical miniature vessels may have been used. Author's collection.

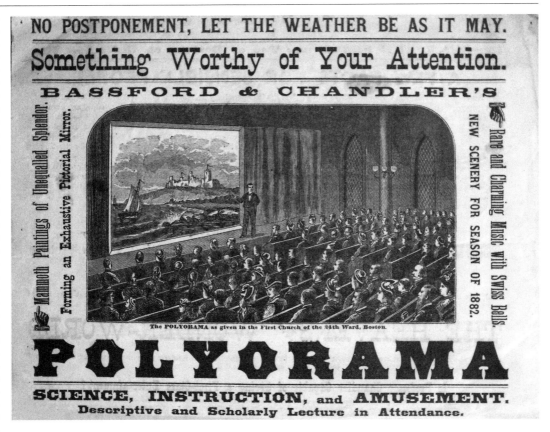

during the war and its aftermath were rarely advertised as moving panoramas; the words must have become oversaturated on the burgeoning entertainment market. We find titles like Stanley and Conant's Miratorium (or Polemorama or Polyorama), Pearson & Co's Mirror of the War, D. C. La Rue's Great War Show: the Wonderful Stratopateticon, and Wesley's War Tableaux, Lee Mallory's Pantechnoptemon, Wunderlich's Zographicon, and The Grand Panopticon of the War and Automaton Dramatique. What was exhibited is not always so clear. La Rue's "Wonderful Stratopateticon; or, Walking Army," which purported to present an "astounding combination of NINETY THOUSAND MOVING AND ACTING FIGURES," was most likely a physical model.[7]

 Stanley & Conant's Polemorama! or, Gigantic Illustrations of the War, by J. M. Stanley, a painter of Indian portraits and scenery, and A. J. Conant, an artist from St. Louis and one of the founders of the Western Academy of Art, was most

Figure 9.4
A moving panorama or a magic lantern show, from a broadside advertising Bassford & Chandler's Polyorama, United States, 1882. Author's collection.

likely a moving panorama, although these words have been carefully left out of the advertising broadside.[8] How the promotional logic functioned was revealed by a newspaper notice about a new entertainment named the Petroleoscopticon:

> THE PETROLEOSCOPTICON. — *There is a smack of humbug about this long, jawbreaking, tongue-twisting word, which is unfortunate; it is enough to tire one out to pronounce it, in fact, the exertion is too much for people in feeble health. . . . Notwithstanding all this, it is attached to one of the most pleasing entertainments that has ever visited our city, but why it should be called the Petro-(uh), is a wonder. We supposed that it was some kind of a Panorama, and went to the hall, we confess a little suspicious, but it is not a Panorama, we were spared the tedious, old-fashioned unrolling of daubed canvass [sic] to the sound of melancolly [sic], desponding melodeon.*[9]

After all this tongue-twisting, the writer finally revealed that the Petroleoscopticon was a magic lantern show, where the views "dissolve into each other in a most pleasing manner."[10] With many more or less similar products competing with each other on the market, a striking title was a way to differentiate one's offering from its competitors, or at least try to do so.

THE CHALLENGE AND DISSEMINATION OF DISSOLVING VIEWS

Magic lanterns had been used by exhibitors since the seventeenth century, but their technical possibilities had been limited.[11] A particularly difficult issue was the lack of powerful illuminants, which limited the brightness and scope of the projections, and as a consequence the size of the audience. Three innovations, all realized by the mid-nineteenth century, turned the magic lantern into a potential alternative to the moving panorama. These were the dissolving views, the oxy-hydrogen gaslight (calcium or limelight), and photographic lantern slides. Armed with these new "weapons," lanternists were in a position to compete with moving panorama companies and diorama exhibitors.

The correspondence between Henry Lewis and his brother George demonstrates that moving panoramists were aware of the situation.[12] While he was still working on his Mississippi panorama, Henry suggested for George the idea of investing in "magic lanthorns" displaying "dissolving scenes."[13] He had found out their advantages: "It can be transported from place to place without any difficulty, the whole thing not weighing 500 lbs." The projector was to be ordered from England, and the pictures produced with the help of a British slide painter

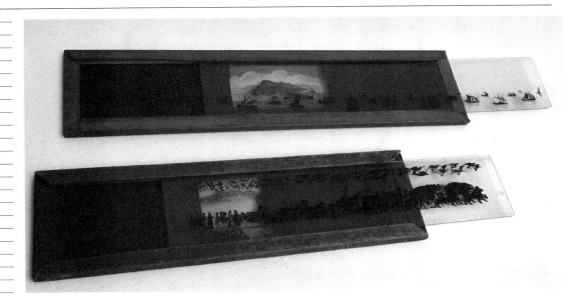

Henry had recently met: "We can, with such ease, be painting and introducing new subjects all the time we are travelling." Lewis dropped the idea, but others realized similar plans.[14]

Dissolving views are thought to have emerged in England in the 1820–1830s; the legendary lanternist and slide painter Henry Langdon Childe (1781–1874) and the magician Mr Henry have both been suggested as the inventor.[15] They must have been inspired by the Diorama, although dissolving views also followed in the footsteps of phantasmagoria, the magic lantern ghost show, where special effects played a central role. Two naval architects from Bombay, who had been given an opportunity to explore England for two and half years between 1838 and 1841, drew this connection. They had "learned that the mode adopted to produce this imposing spectacle [the Diorama] is a modification of an exhibition called the Phantasmagoria."[16] The link was obviously the dark auditorium and the use of light effects from behind the canvas; but from monsters the attention had turned to landscapes.

Childe's Scenic Views, shown at the Adelphi Theater in 1827, demonstrated "the various effects of light and shade."[17] The list includes familiar subjects from the Regent's Park Diorama (Holyrood Chapel, 1825; Roslyn Chapel, 1826). Mr Henry's broadside (1825) describes one of his "Dissolvent Scenes" as "an Imitation of the Paintings at the Diorama."[18] During the 1830s Childe's dissolving (or "dissolvent") views were seen so often at London's showplaces that the *Belle Assemblée* considered them too well known to need any description.[19] In

Figure 9.5
Panoramic magic lantern slides, one depicting Noah's Ark, and the other ships sailing past Gibraltar. Hand-painted on glass, British, mid-nineteenth century. Slides like these could mimic the effect of the moving panorama and were associated with it. Author's collection.

1837 Childe performed at the Adelphi with the lecturer James Howell who presented his "Eidouranions" (movable astronomical slides).[20] Childe's series of dissolving views included a "Moonlight Scene—Ship at Anchor," "St. Paul's Church, Bankside, with the Effects of a Rainbow," "Water Mill (Summer & Winter)," "Cupid and the Feather, or Love is the Lightest," "Nelson crowned by Fame!," "The Polar Regions, with Captain Ross," and "Esquimaux Village, & Wonderful Effects of the Aurora Borealis."[21] The dissolving views at the Royal Adelaide Gallery were accompanied by music only. This practice, which became common, recalled the aesthetics of the Diorama.[22]

Dissolving views became a viable alternative to panoramas and dioramas by the mid-century. Initially they required a pair of identical magic lanterns with a shutter blade that block-ed one of the lenses while the other one was revealed. The most basic "software" was lantern slides of identical scenes, but with minute differences. The day was made to turn into the night, and a calm sea into a stormy one. In principle any scene could be dissolved into the next one, creating a continuous projection. By revealing both lenses at the same time, slides could be superimposed, creating apparitions and dream sequences. A typical iconographical motive was the soldier's dream: a weary soldier sleeps on the battlefield, while memories of fighting and daydreams of home keep flashing in the sky (in other words: in his mind).[23]

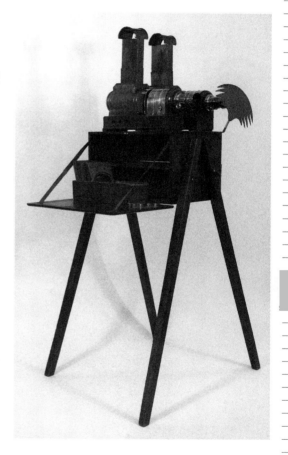

Figure 9.4
Henry Langdon Childe (1792–1874), "Eidouranion," or mechanical astronomical magic lantern slide, hand-painted, 1830–1850s. The label proudly extolls Childe's achievements: "Painter on Glass. Professor of Optics. Inventor of the Dissolving Views and the Chromatrope." The chromatrope was a mechanical rackwork slide that produced a kaleidoscopic effect. Author's collection.

Figure 9.5
Pair of Marcy's Sciopticon magic lanterns for dissolving views. Lorenzo J. Marcy, Philadelphia, c. 1870. Marcy's design was innovative. The lanterns contained his patented two-wick kerosene burners. They also had internal shutters and adjustable color filters for changing the atmosphere of the slides. The transportation box for the lantern pair was converted into a projection stand attached to long legs. Author's collection.

The pen of a certain Mrs. Abdy managed to scribble on paper some essential features of the new attraction:

> Are they not wondrous? how the sight
> Revels in changes quick and bright,
> Less like the work of mortal hand,
> Than some gay scene of fairy-land:
> Lo! from our fixed and rapt survey
> Object by object melts away,
> Yielding their shadowy forms and hues
> To merge in fresh Dissolving Views.
> The ancient castle seems to shine
> Reflected in the clear blue Rhine,
> Anon., the proud and stately tower
> Becomes a simple woodbine bower;
> Swift sailing ships, and glittering seas,
> Change to the churchyard's mournful trees,
> Whose dark and bending boughs diffuse
> Shade o'er the dim Dissolving Views.[24]

From the late 1850s such effects could be produced in more refined ways with the *biunial*, a single magic lantern with two lens tubes and a pair of gas illuminants. Heating a piece of compressed lime with a oxy-hydrogen gas flame produced a bright "limelight."[25] The gas jets were controlled by a dissolving tap, which made the dissolves smooth, and the mechanical shutter useless. An even more refined form of the magic lantern was the *triunial*, which appeared during the last quarter of the century. Its three lens tubes allowed complex effects and sequences. Dissolving views produced with a triunial lantern represented the ultimate achievement of magic lantern culture. The climax was reached, when the cinematograph (often used at first as a magic lantern accessory) was already making its breakthrough.

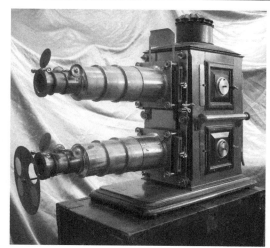

Dissolving views were a simpler and cheaper way of producing dioramic effects, but they were more than that. Compared with earlier visual spectacles, they offered more variety, new startling tricks, and possibilities to refresh the program much more frequently. Frederick Bakewell argued that they had an aesthetic of their own:

> There are no optical illusions more extraordinary than those shown in the exhibition of Dissolving Views. The effects of the changes in the diorama are only such as are seen in nature, the same scene being represented under different circumstances, and the marvel in that case is that such beautiful and natural effects can be produced on the same canvas. But Dissolving Views set nature at defiance, and exhibit metamorphoses as great as can be conceived by the wildest fancy.[26]

Most moving panoramas represented scenes of the real world; the events unfolded on a single plane of reality. Dissolving views were different—they shifted from topic to topic, and between levels of reality, gliding into fantasy and back again. Their transformations followed the logic of dreams rather than rivers, trails, or marching armies. An article suggesting a method of teaching literature made the difference clear. It recommended that "as the story is told, its scenery should be made to pass through the children's minds like a panorama," while "frequent pauses, with closed eyes, to develop the pictures that follow one another in dissolving views" should be used to "make the story a living reality to the children."[27]

The relationship between these media forms was negotiated not only by showmen and entrepreneurs, but also by contemporaries from all walks of life. Media gave rise to all kinds of discursive parables; too many to be discussed

Figure 9.6
Three part dissolving view slide set with a classic topic, lighthouse in the rising storm. Hand painting on glass, British, c. 1850–1870s. Author's collection.

Figure 9.7
Biunial magic lantern, preserved with its original oxy-hydrogen gas lighting system. Manufacturer unknown, sold by Wallis & Fraser, Edinburgh, Scotland, c. 1896. Sophisticated magic lanterns like this one represented the culmination of the medium just before the breakthrough of celluloid-based moving pictures. They enabled high quality projections and special effects. Author's collection.

here in detail. The moving panorama represented linear continuity, whereas dissolving views were associated with non-linearity, transformations, and fuzzy edges.[28] The historian Edward Jenks detected in feudalism the "blurred outlines and motley colours of the 'dissolving view.'"[29] Another historian subsumed one medium into the other by claiming that "the great panorama which time paints is but a species of dissolving views. It is but as yesterday since the present sites of towns and cities on the shores just referred to showed only the rude huts of Indian tribes."[30]

Dissolving views were frequently associated with the memory, with its lack of linear logic and sharply defined sequential recollections. At the same time they were also related with panoramas, as the following quotation demonstrates:

> In the kind of doze into which I had fallen, the whole panorama of my college life seemed to unroll itself before me. Not, indeed, with such a degree of distinctness as to enable me to grasp even its leading features; but rather as a series of dissolving views, each presenting some point or scene in my career that had unaccountably lingered in the memory, to the exclusion of events of seemingly greater importance.[31]

In an article about the relationship between dreams and hallucinations, Charles Dickens's *Household Words* characterized the mind "as a wizard chamber of dissolving views."[32] In dreams, it argued, "the pictures pass of themselves, the dissolving views roll on, the images of the imagination shine and mingle uncorrected by the sensations and uncontrolled by the will." Still, the incoherence of dreams is simply "imperfect recollection," whereas hallucination is "the permanent impotence of the attention and the will. The machinery of the panorama runs on of itself, because the guiding hand has been struck with paralysis." The involuntary flashes of dissolving views are merged with a panorama run amok, when rational control mechanisms of the mind break down.

Dissolving views and an "automatically" running moving panorama were also associated in Mark Twain's discussion of his dreams, as "picture after picture, incident after incident, a drifting panorama of ever-changing, ever-dissolving views manufactured by my mind without any help from me." Twain added even a third medium to the mix by stating that "it would take me two hours to merely name the multitude of things my mind tallied off and photographed in fifteen minutes."[33] James Stirling had combined all three already much

JEFF. AND THE SHOWMAN.

DISSOLVING VIEWS

Showman —At the end of the Avenue you perceive a white house, keep your eye on it and it will dissolve and fade from your view.

Figure 9.8
A satirical envelope from the time of the American Civil War, first half of the 1860s. The cartoon associates dissolving views with peepshows. The president of the Confederation, Jefferson Davis, sees his political ambitions fade. In reality dissolving views were a form of the magic lantern show. Author's collection.

earlier in his *Letters from the Slave States*: "The East differs from the West; the North differs from the South; and all are different to-day from what they were yesterday, or will be to-morrow. You have to daguerreotype a scene that is at once a moving panorama and a dissolving view."[34] As we will see later, such accumulation and assimilation of media references can be read as a symptom of the gestation process of a media-cultural imaginary, which in its turn testifies to the formation of media culture.

PANORAMAS AND THE COMING OF PHOTOGRAPHY

The Pearson Brothers promoted their *Grand Historic Mirror of the American War* by claiming that the moving panorama was updated weekly, based on sketches and reports from "distinguished artists" at the theaters of war.[35] Whether this was true or just promotional make-believe, it demonstrates an aspiration to newsreel-like dissemination of visual information, which was very different from the dreamy emphasis of dissolving views. Although the correctness of the representation was difficult to verify, verisimilitude was becoming a goal. All showmen emphasized the authenticity, accuracy, and topicality of their views.

Roland Barthes's notion "reality effect" emphasizes that media reality is a fabricated semiotic construct.[36] Transferring thousands of sketches on canvas did not automatically lead to an accurate duplication of reality.[37] Much of the reality effect was produced by contextual factors that could be easily manipulated by promotional efforts. It was common to emphasize the perils of the panoramist, from fighting Indians and pirates to surviving storms and near-starvation. Stories about cumbersome sketching trips were frequently circulated. As we have seen, even Albert Smith felt he needed to prove that he had actually climbed the Mont Blanc. The moving panoramist was introduced as a surrogate traveler-adventurer, who endured hardships so that others could enjoy the

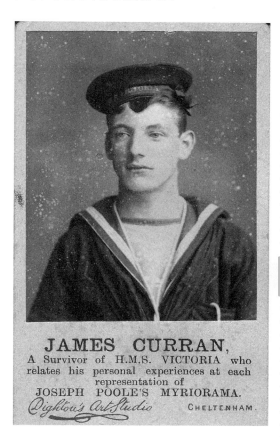

JAMES CURRAN,
A Survivor of H.M.S. VICTORIA who relates his personal experiences at each representation of
JOSEPH POOLE'S MYRIORAMA.
Dightou's Art Studio CHELTENHAM.

Figure 9.9
Carte-de-visite photograph of James Curran, a sailor who survived the sinking of H.M.S. Victoria (1893) and lectured about it in Joseph Poole's Myriorama show. Dightou's Art Studio, Cheltenham, c. 1893. Cards like this were sold to the audience as mementos. Author's collection.

world through his eyes in safety and comfort.

Steamboat captains, army officers, academics, and other respected individuals wrote testimonies. James Curran, a sailor who had been rescued from the sunken British battleship H. M. S. Victoria, confirmed the authenticity of Joseph Poole's Myriorama by testifying in person about his experiences in the show.[38] "Authentic" objects were presented as indexical evidence. When the panorama of *Dr. Kane's Arctic Expedition in Search of Sir John Franklin* was shown in Leavenworth, Kansas, "relics of the expedition," and even Myouk, one of the four dogs that had accompanied the expedition, were exhibited.[39] A copy of the box in which Henry Box Brown had been sent from slavery to freedom played a similar role in his performances.[40]

After its introduction in 1839, the dissemination of photography suggested new criteria of authenticity. Painting was unable to compete with the new medium in reproducing the surface of things; it had to find new roles, or at least to defend its status. It was only a matter of time before panoramists faced the challenge of photography. An early example was Jones's *Great Pantoscope of California, the Rocky Mountains, Salt Lake City, Nebraska & Kansas* (1852). As many as 1,500 daguerreotypes were painstakingly shot along the route the panorama was planned to depict, but pencil sketches were needed to point out how they were situated in the landscape.[41] Whether the daguerreotypes had been useful or not, the publicity invested the panorama with the miracle of "sun painting."[42]

Another example was *Barclay's Panorama of Jerusalem* (1855), produced by Dr. James T. Barclay, who had lived in Jerusalem as a missionary.[43] It was said to be based on Barclay's daguerreotypes, as well as on "large sketches, taken and colored on the spot." Some of them had been drawn with the help of a camera obscura "to insure the greatest possible accuracy." Barclay had been helped by his daughter, who was allowed, thanks to the "secrecy afforded her by a Moslem lady of distinction," to produce sketches inside the Tomb of David on Mount Zion. "Drawn by light, and painted in WUNDERLICH's best style," the results were said to be "perfect FACSIMILES of nature," so highly finished "that they may be viewed to great advantage through opera glasses."[44] The verisimilitude was the end-product of a hybrid process, where photography supported drawing and painting.

The case of Fitzgibbon's *Panorama of Kansas and the Indian Nations* (1857) was different. The broadside claimed that "all the faces seen in this picture are actual likenesses, painted from Daguerreotypes."[45] The daguerreotype was perfectly suited for this purpose, although it is unclear how important such likenesses were for the spectators. The promotional leaflet added an interesting detail, claiming that "the Indians did not like the look of the Camera Obscura [daguerreotype camera?], thinking some big Gun was about being discharged at them, and it had to be hidden from their view."[46] Perhaps as a safety precaution, most of the Indian Views were taken from a boat's hurricane deck.

Replacing the sketching process by photography did not spread rapidly, probably because photography was a cumbersome professional activity that required training and patience, particularly when practiced outdoors.[47] How-

ever, another form, the photographic lantern slide, had a powerful impact on the world of public spectacles. The Philadelphia photographers Frederick and William Langenheim patented their Hyalotype (glass positive) process in 1850, and exhibited specimens at the Crystal Palace Exhibition the next year. [48] Although the production of glass views began rapidly both in the United States and in Europe, it took nearly a decade before photographic lantern slides were more widely used in public shows. Once they took off, they became a novel and striking attraction, as the Langenheims had predicted: "The new magic lantern pictures on glass . . . must throw the old style of magic lantern slides into the shade, and supersede them at once, on account of the greater accuracy of the smallest details which are drawn and fixed on glass from nature, by the camera obscura, with a fidelity truly astonishing."[49]

In the United States, Peter E. Abel and Thomas Leyland were the first to exhibit photographic slides publicly, starting in 1860. They were probably also the first to use the word Stereopticon, which became, particularly in the United States, synonymous with the professional magic lantern show.[50] The word recalled the stereoscope, although photographic lantern slides were only monoscopic. Still, their high definition and wealth of details, combined with the brightness of the oxy-hydrogen limelight, made them seem three-dimensional.[51] The link was developed in an article about "Fallon's Stereopticon!," a show, which used the same magic lantern as Abel and Leyland, owned by John Fallon, the Chemical Superintendent of the Pacific Mills Print Works in Lawrence, Massachusetts:

> The delight which one person has in looking through the stereoscope, a thousand persons can have at once—so that there is sympathetic and social pleasure. THE STEREOPTICON, as it is called, takes the prepared stereoscopic view, and by fine lenses and the most intense of artificial lights, throws and magnifies the miniature view upon a canvas, to such an extent that every one in a building as vast as the Academy of Music can see with distinctness each scene. There is no straining of the vision; there is no weariness of the eye as in the stereoscope.[52]

The novelty of Fallon's show was emphasized by contrasting it with both panoramas and earlier magic lantern shows: "This chemical marvel is not a panorama, a magic lantern, or anything like what the eye has ever beheld, but is an entire new and miraculous apparatus."[53] Fallon's publicist claimed that celebrities like Oliver Wendell Holmes (a well-known physician and stereoscope enthusiast), Ralph Waldo Emerson, Henry Wadsworth Longfellow, the poet John G. Whittier, and professor Louis Agassiz all endorsed it.

The two main categories of photographic views in Abel & Leyland's and Fallon's Stereopticon shows were American and European scenery, and ancient and modern statuary.[54] Statues were especially suitable, because they produced a powerful illusion of three-dimensionality. Another important topic was the American Civil War. A broadside for a show titled Stereopticon! or Mirror of the

Rebellion simply listed a series of views about the conflict, relying on their veridical appeal.[55] Lantern slides of the war had a prominent role in the Langenheim catalog, although Theodor X. Barber suspects that most had been photographed from commissioned drawings, or engravings published in magazines like *Harper's Weekly*.[56] Photographs from the theaters of war were limited to portraits and views taken behind the front lines.

A WAR OF DISCOURSES

The competition between moving panorama exhibitors and magic lanternists heated up in the 1860s. The latter were the underdogs, so they needed to boost their credentials. They did so by resorting to hyperbolic strategies showmen had used for ages. Abel and Leyland did not spare words when they praised their instrument:

> *The Stereopticon is a new and powerful apparatus — (the only one now in the United States,) which, with the aid of the strongest artificial light that science has yet created, reproduces Photographic Pictures with Stereoscopic effects upon an extensive scale . . . with an accuracy and marvelousness almost magical, surpassing anything hitherto exhibited in America.*[57]

The elocutionist Frank H. Fenno provided mathematical calculations about the size of the images projected by his Calcium Stereopticon: "Nearly 100 fine pictures and objects will be shown, each magnified up to FIFTEEN TO THIRTY FEET SQUARE, according to the size of church or hall. As each scene covers 200 to 900 square feet of canvass [sic], the views would form a BRILLIANT PANORAMA, NEARLY ONE MILE LONG."[58] Likewise, the soap manufacturer Benjamin T. Babbitt, whose free stereopticon entertainments were presented outdoors at street corners, promised to project his views "to a greater size than the largest Panorama, throwing upon the screen, illuminated with its intense light, a beautiful ever-changing Panorama of objects of interest."[59]

Showmen were masters of the masquerade, revealing and disguising their offerings at the same time. Rev. O. R. Bacheler's *Illustrated Lecture on the Hindoos* was obviously a slide show, although the showman denied it: "In the preparation of these Paintings, the talent of several eminent Artists has been employed, and the work is executed in a superior manner. The paintings are not exhibited by a Magic Lantern."[60] Prof. Alexander's ILLUSTRATED LECTURES! *Historical and Miscellaneous* PAINTINGS (1883) was divided into seven "Panoramas" (the Old and the New Testament, the assassination of President Garfield, miscellaneous

views, the downward Course of the Drunkard, the New Tale of a Tub, and comic views).[61] By claiming that "all the scenes will be explained by the Lecturer as the Paintings pass in review before the audience" Alexander pretended he was exhibiting a moving panorama, but the program reveals that he was projecting lantern slides.[62]

Panorama showmen did not let magic lanternists enter their territory without defending themselves against the intruders. True & Hunter claimed they had "THE LARGEST MOVING PANORAMA IN THE WORLD!," assuring that their show was "no Magic Lantern or Paste-board Moving Figure affair, but a grand Historical Work of Art, which demands the attention of all classes at the present time."[63] Poole & Young endorsed their *New Canvas* [sic] *Diorama of the* OVERLAND ROUTE *From London to India* (1873) by highlighting its material support: "These views must not be confounded with magic lanterns and dissolving view slides, painted on a few inches of glass, magnified and reflected on a white sheet of calico. These productions are bona fide Panoramic and Dioramic Revolving Pictures."[64]

The war of discourses became an extensive and long-lasting confrontation. On the surface it was just a manifestation of normal competition between commercial exhibitors, determined to make a profit. On a deeper level it was a symptom of a broader process that was transforming visual culture. Walter Benjamin famously argued that the adoption of mechanical reproduction led to the replacement of the cult value of unique "auratic" things by the exhibition value of mass-reproduced articles.[65] Lithographs, photographic images, and film reels were all distributed as multiple identical copies, causing the idea of the original to lose its meaning.[66] As the forms and distribution channels of visual imagery multiplied, an increasingly arrogant and systematic competition for the eye developed.

Both moving panoramas and magic lantern shows retained a glimmer of the "aura" of

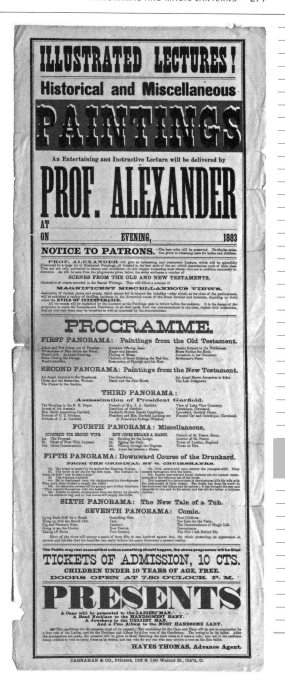

Figure 9.10

Prof. Alexander's *illustrated lectures! Historical and Miscellaneous paintings* (1883). Broadside in EH. A pencil note on the reverse side identifies the showman as "F. M. Alexander, New Harmony, Brown County, Ohio." Author's collection.

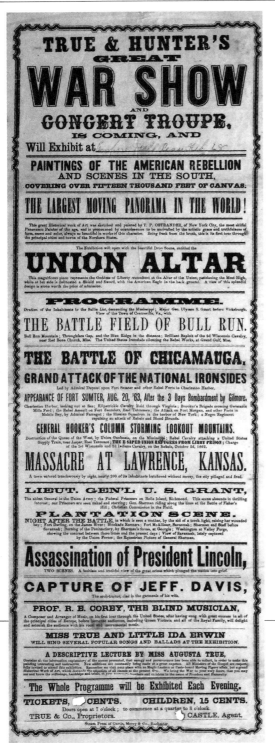

the original. Moving panoramas were genuine paintings, no matter how generic their subject matter or style may have been. The fact that a few copies were occasionally painted of successful panoramas does not fundamentally change the situation. The aura could also be artificially enhanced by performative elements (such as the objects and people exhibited for reality effect) and by promotional strategies, including stories about the showman's trials and tribulations (a possibility Benjamin did not take into account). Magniloquent expressions like "grand work of art," "vast artistic composition," "great and magnificent triumph of art," and "grand classical panorama" were used to frame the panorama with the aura of a unique work of art.

Early magic lantern slides were painted by hand, but their production became industrialized in the nineteenth century; the role of the human hand was increasingly marginalized.[67] The evaporation of their aura was resisted by exceptional magic lantern presentations, like those organized at the Royal Polytechnic Institution in London. Huge custom-made hand-painted slides of extraordinary quality were projected with high-tech equipment designed for the purpose.[68] Professional lecturers like John Stoddard and Burton Holmes, who promoted their regular tours of illustrated lectures for the burgeoning middle classes, also used custom made slides that were later collected into travel books bearing their names.

Still, standardization was the name of the day. The outlines of Philip Carpenter's "Copper Plate Sliders" (introduced in the 1820s) were burned on glass from engraved copper plates, and only colored by hand. Decades later, the American Joseph Boggs Beale created many series of greyscale paintings for the Philadelphian lantern slide producer C. W. Briggs. After being photographed, huge quantities of glass slides were printed from the negatives and colored for mass distribution.[69] Toward the end of the century even hand-coloring

Figure 9.11
True and Co., *True & Hunter's Great War Show and Concert Troupe*, broadside, printer: Curtis, Morey & Co, Rochester, after April 1865. Author's collection.

Figure 9.12
Broadside for an exhibition of "Magic Lantern and Music"
by William Ferguson, a. k. a. "the Blind Man." Found
between the pages of a 1896 medical ledger that used to
belong to a doctor from Johnson County, Arkansas. Long
magic lantern slides depicting moving animals entering
Noah's Ark and of the "Children of Israel Crossing the Red
Sea, and the Destruction of Pharaoh's Host" are described
as "moving panoramas." Author's collection.

was often eliminated by chromolithographic contact printing. A typical example of quantity production were the narrative "life model" slides shot in England by companies like Bamforth and York and Son with live actors and studio sets. It was not unusual to encounter identical slide sets in different showmen's presentations.

By 1900 it was possible to become a lanternist by buying a magic lantern and sets of pre-selected slides, complete with tickets and printed broadsides, from the Sears & Roebuck mail order catalog. The magic lantern show become part of an evolving media culture where the genuine aura of the original hardly mattered. The moving panorama was ill-suited to the era of mass media. Its bulky picture rolls were difficult to transport, costly to produce, and needed constant touching up. No matter how rapidly the painters may have been able to add views of transpiring events, they could not compete with photographs, lithographs, daily newspapers, and cinematographic moving pictures.

It is against this background that one should assess the idea of a "stereopticon panorama" Mark Twain recorded in his notebook in 1891. He was considering representing Bunyan's *Pilgrim's Progress* by means of photographic lantern slides:

> Dress up some good actors as Apollyon, Greatheart, etc., & the other Bunyan characters, take them to a wild gorge and photograph them — Valley of the Shadow of Death; to other effective places & photo them along with the scenery; to Paris, in their curious costumes, place them near the Arc de l'Étoile & photo them with the crowd — Vanity Fair; to Cairo, Venice, Jerusalem, & other places (twenty interesting cities) & always make them conspicuous in the curious foreign crowds by their costume. Take them to Zululand. It would take two or three years to do the photographing & cost $10,000; but this stereopticon panorama of Bunyan's Pilgrim's Progress could be exhibited in all countries at the same time & would clear a fortune in a year. By & by I will do this.[70]

Had Twain's stereopticon panorama been realized, it would have resembled life model lantern slide sets, except that it would have been produced and distributed on a global scale. The idea was in the air; Alexander Black's successful "picture play" *Miss Jerry* (1894) was based on a similar idea. By telling its story with no less than 250 photographic lantern slides it anticipated narrative silent cinema.[71] Still, Twain's all-embracing vision went much further than the early film culture, peering into a distant future where the latest Harry Potter film would reach the fans on cinema screens at practically the same moment all around world.

NOTES

1. Smith and Leech, *A Month*, p. 47.

2. Several Howorth broadsides in EH. The show was obviously targeted for the growing Irish immigrant population.

3. Broadside in EH (exhibited at the Baptist Church of Turin, Lewis County, New York, Oct. 6 [1862]). The broadside claims that Geo. W. Williams had "painted the American Antiquities, and the world-renowned Panorama of the Bible." The most famous panorama of the Bible was painted by John Insco Williams (1813–1870). Was Geo. W. possibly his relative who took part in the painting? The question remains open.

4. *New York Clipper*, Aug. 3, 1882. Other panoramas include "one of England, Chappel's Cuba [?], Warren's India, one of Ireland, one of New York, Bartholomew's Scotland, and one of Paradise Lost." Years later an old showman who claimed to have been employed by Goodwin in 1857 remembered, how he "bought and sold panoramas and also sent them out on the road under other showmen's management." Dr. Judd, "Fifty Years Recollections of an Old Amusement Manager," *Billboard*, Dec. 5, 1905, repr. in Joseph Csida and June Bundy Csida, *American Entertainment: A Unique History of Popular Show Business* (New York: Watson-Guptill Publications, 1978), pp. 46–48.

5. *New York Clipper*, 1865 (p. 200, issue unknown, before Aug. 17), www.fultonhistory.com/Fulton.html (last visited March 29, 2012). In the same year the *New York Clipper* also published an announcement about "Panorama canvas for sale cheap." An "Artist" from Troy, N.Y., tried to sell a canvas for a panorama of 30 pictures, on which five view of Irish scenery had already been painted. (p. 16, issue unknown, before March 25).

6. "Goodwin, George K.," in: "Olympians of the Sawdust Circle: A biographical dictionary of the ninteenth [sic] century American circus," compiled and edited by William L. Slout, 2005, www.circushistory.org/Olympians/OlympiansG.htm (last visited March 29, 2012).

7. *New York Clipper*, 1865 (p. 16, issue unknown, before March 25), www.fultonhistory.com/Fulton.html (last visited March 29, 2012). Mr. D. C. La Rue also presented at each exhibition his comic parlor entertainment "La Rue's Olio of Oddities." The title may recall W. S. Woodin's *Olio of Oddities*, presented several years earlier in England (see chapter 7)

8. This information comes from the broadside *Stanley & Conant's Polemorama! or, Gigantic Illustrations of the War,* Tremont Temple [Boston], c. 1862 (the Battle of the Pea Ridge, March 6–8, 1862, is in the final section). Online in the Americana Archive, American Broadsides and Ephemera, Series 1.

9. *Courier and Union*, Syracuse, N.Y. (March 25, 1867).

10. Ibid.

11. Rossell, *Laterna Magica*; Patrice Guerin, *Du soleil au xenon. Les techniques déclairage à travers deux siècles de projection* (Paris: Prodiex, 1995).

12. Henry and George Lewis, correspondence, William L. Clements Library, University of Michigan. Copies in EH.

13. Letter from Henry Lewis to George Lewis, Cincinnati, Ohio, July 29, 1849 (William L. Clements Library, University of Michigan, copy in EH). Also quoted by William J. Petersen, *Mississippi River Panorama. Henry Lewis Great National Work* (Iowa City: Clio Press, 1979), p. 27.

14. George Winter, the uncle of diorama showman Robert Winter had very similar plans in 1851, as his correspondence with his brother Charles shows. They saw the advantages, but were worried about the cost. (Letters from Charles to George Winter from Cincinnati, March 15 and 23, 1851, at Tippecanoe County Historical Association, Lafayette, Indiana (quoted by Wray in "In the Style of Daguerre.") Magic lanterns for dissolving views were still rare in the United States. In his first catalog the New York optician Benjamin Pike advertised a dissolving lantern pair, probably imported from Carpenter & Westley, London. Benjamin Pike, *Pike's Illustrated Descriptive Catalogue or Optical, Mathematical and Philosophical Instruments*, vol. 2 (New York: By the Author, c. 1848–1849), p. 215.

15. According to Edwin Dawes and Mervyn Heard ("M. Henry's Dissolving Views," *Realms of Light. Uses and Perceptions of the Magic Lantern from the 17th to the 21st Century*, ed. Richard Crangle, Mervyn Heard, and Ine van Dooren (London: The Magic Lantern Society, 2005, pp. 159–161), the first documented use of dissolving views was by Mr Henry in 1826, using the words "Dissolvent Views." Ads for Childe's performances at the Colosseum 1835–36 use "dissolving views" and "dissolvent views" interchangeably (clippings at JJCB). John Barnes believed that "Dissolving Views" first appeared in playbills from the Adelphi, 1837 (playbills in JWB, discussed in Barnes, *Catalogue of Collection*, part 2, p. 31), but a broadside for "Views of Life, Its Whims and Whimsicalities," Adelphi [1833] states: "The New Series of Dissolving Views were rapturously applauded." (JJCB). Other candidates are discussed by Mervyn Heard, *Phantasmagoria: The Secret Life of the Magic Lantern* (Hastings, East Sussex: The Projection Box, 2006), pp. 196–200; see also my "Ghost Notes: Reading Mervyn Heard's Phantasmagoria. The Secret Life of the Magic Lantern," *Magic Lantern Gazette* 18, no. 4 (Winter 2006): 10–20.

16. Jehangeer Nowrojee and Hirjeebhoy Merwanjee, *Journal of a Residence of Two Years and a Half in Great Britain* (London: Wm H. Allen and Co, 1841), pp. 30–31. The book also contains other things of interest for media history, including a description of the Royal Polytechnic Institution, London.

17. Heard reproduced the broadside without drawing this connection. *Phantasmagoria*, p. 204.

18. Ibid., p. 205.

19. *Belle Assemblée; a Magazine of Literature and Fashion*, vol. 5 (July–Dec. 1836), p. 48. The Adelphi Theater and the Regent's Park's Colosseum are mentioned. Other showings are mentioned in newspaper clippings in JJCB.

20. "Astronomy!" Theater Royal, Adelphi, Monday, March 20, 1837 (broadside in JJCB). The Eidouranions are said to have been completed "under the immediate superintendence" of Childe. This probably simply means they were created by Childe. Some surviving examples from Childe are in EH.

21. The broadside also states: "The novel and interesting features will be relieved and diversified by a variety of grotesque and splendid diminishing and increasing figures!" This demonstrates the continuing influence of phantasmagoria.

22. In the 1840s. The Royal Adelaide Gallery was in the Lothar Arcade, The Strand (broadsides in JJCB). The music was arranged by Mr. T. Adams, its musical conductor and director. A Biscenascope, probably a lantern pair (the biunial had not yet been invented) was used. The first mention of dissolving views in the United States is from 1844, when Mons. Blanchard [maybe Pharamond Blanchard the diorama painter] exhibited at New York's Apollo

a "series of comic dissolving views" with a Biscenascope (Odell, *Annals*, 5, p. 143). The Adelaide Gallery program included "Humorous and Grotesque Shadows." Perhaps they had been imported from there.

23. The same iconographic motive was used in a Civil War-era illustration in *Harper's Weekly* (Nov. 7, 1863, p. 709, EH), but its origins go further back in time, perhaps to the Napoleonic wars. There is also a song broadsheet, "A Soldier's Dream Before a Battle," written by "a Soldier of the Army of the Cumberland," and dated Camp Smith, Tennessee, Oct. 25, 1864. It is sung to the tune of "AIR—Shells of the Ocean" (copy in EH, location of original unknown). The text follows the dissolving views magic lantern sets of the soldier's dream (seven-part set in EH).

24. Mrs. Abdy, "Dissolving Views," *Metropolitan* (London), vol. 38, no. 149 (Sept. 1843), p. 72.

25. Limelight jets were also used in spotlights at theaters, which explains the metaphoric use of this term ("in the limelight") that survives, although the light source has long since disappeared from use.

26. Bakewell, *Great Facts*, p. 59.

27. Ellen E. Kenyon, "Teaching Literature," *School Journal: A Weekly Journal of Education* (New York and Chicago), vol. 51., no. 1 (July 6, 1895), p. 10. Also in *The Teachers' Institute: A Monthly Magazine of Education* 17, no. 1 (Sept. 1894): 242.

28. In texts in which landscapes were compared with stationary panoramas, dissolving views were used to describe the mist or haze surrounding them. Sir Samuel W. Baker wrote in *Eight Years in Ceylon*: "The panoramic view in itself is celebrated; but as the point in the road is reached where the termination of the monsoon dissolves the cloud and rain into

a thin veil of mist, the panorama seen through the gauze-like atmosphere has the exact appearance of a dissolving view" (London: Longmans, Green, and Co., 1874), p. 147. In *Modern War: or The campaigns of the first Prussian army, 1870–71*, Sir Randall Howland Roberts described the valley of the Moselle: "It was a magnificent panorama, to which the haze of an autumn morning lent a sort of dissolving-view appearance, as the breeze scattered the mists from different points, revealing new landscapes almost every moment." (London: Chapman & Hall, 1871, p. 89).

29. Edward Jenks, *A History of Politics* (London: J. M. Dent & Co, & The Macmillan Co, 1900), p. 83. Jenks explained that "In the popular form of entertainment known as 'dissolving views,' one picture is not suddenly replaced by another; the old picture gradually melts into the new by a nebulous and misty process" (London: 1817, p. 83).

30. C. C. Andrews, *Minnesota and Dacotah* (Washington: R. Farnham, 1857), p. 3.

31. J[ohn] D[elaware] Lewis, *Our College. Leaves from an Undergraduate's "Scribbling Book"* (London: G. Earle, 1857), p. 27.

32. "My Ghosts," *Household Words*, vol. 15, no. 360 (February 14, 1857), p. 166. The article may have been written by Dickens himself. The formulation "the mind is a wizard chamber of dissolving views" was revived by Rev. J. N. Fradenburgh in his *Witnesses from the Dust; or, The Bible Illustrated from the Monuments* (Cincinnati: Cranston & Stowe, 1886), p. 161.

33. Mark Twain, "What Is Man?," in *What Is Man? and Other Essays* (New York and London: Harper & Brothers, 1917), pp. 70–71.

34. London: John W. Parker and Son, 1857, p. 192.

35. The special arrangement had been made by the principal artist Robert Pearson. The Pearsons were from New York.

36. See chapter 7.

37. A broadside for *Hutchings' Grand Classical Panorama! of the Mediterranean* (HTC) announces it was "executed from Original Drawings made on the spot by an eminent Artist expressly for the purpose." The person(s) who produced the sketches did not necessarily paint the panorama.

38. A carte-de-visite photograph of Curran by Dightou's Art Studio, Cheltenham, was sold to the spectators (EH).

39. *Daily Times*, Leavenworth, Kansas, Aug. 21, 1860, p. 3; Aug. 30, 1860, p. 3. The semiwild dog was reported to have attacked another dog in the hall, and killed a pig on the street—maybe these stories were made up to increase the public's interest.

40. Ruggles, *The Unboxing of Henry Brown*, p. 117 and passim. An announcement for Brown's show in *Liverpool Mercury*, Nov. 12, 1850, states: "The box may be seen, and Mr. Brown in it, after each presentation" (Ruggles, p. 117).

41. Sandweiss, *Print the Legend*, pp. 48–82. Because there was no way of enlarging or reproducing daguerreotypes, the originals were discarded when the painting was finished. Obviously their semiauratic nature (daguerreotypes were unique items) did not count.

42. The photographer and showman John Whipple (Boston) may have tried to project daguerreotypes by means of the "megascope." In an 1850s broadside he advertised both Magnifying Daguerreotypes and Dissolving Views. It is not clear which views in the program belonged to these categories, although "Swiss Cottage;

First scene day, with a violent SNOW STORM. 2d night with FAIR WEATHER, 3d, day," must have been dissolving views. (*Optical Wonders. Whipple's Grand Exhibition of Dissolving Views! Magnifying Daguerreotypes, Kaleidoscope Pictures & Pyramic Fires*, Melodeon [Boston], Broadside, AAS). Whipple may have had access to photographic lantern slides, although his own crystallotype—process only produced paper prints from glass negatives. William Welling, *Photography in America: The Formative Yeats 1839–1900* (New York: Thomas Y. Crowell, 1978), p. 98.

43. *Barclay's new and only correct panorama of Jerusalem And vicinity ever painted, and Periscope of the Holy Land*, flyer, Corinthian Hall [Rochester, N.Y.], Oct. 24–28 [1856] (EH).

44. The panorama may have been painted by the American George Wunderlich, whose "Wunderlich's Zographicon" was displayed in Pennsylvanian cities and possibly elsewhere in 1863–1864. Wunderlich worked as a scenic artist at Sanford's New Opera House in Philadelphia. WorldCat.org finds handbooks for the Zographicon, but I have not seen them.

45. Broadside for *Fitzgibbon's Panorama of Kansas and the Indian Nations!*, Melodeon [Boston, 1857] (HTC).

46. Leaflet in HTC. The topos of confusing cameras with guns is common in nineteenth century material. Rolf H. Krauss, *Die Fotografie in der Karikatur* (Seebruck am Chiemsee: Heering-Verlag, 1978), p. 74.

47. A broadside for *Hine's Journey from Paris to Rome! Over the Alps* (Amory Hall, Boston) states it has been "Designed, Arranged and Painted by SAML P. HINE, from Daguerreotypes, Sketches, &c., taken of the Places represented, many of which were furnished the Artist by the Hon. S. G. GOODRICH, better known to the children and the world as the good 'Peter Parley.'"

The painter was willing to use anything useful as models. (AAS). Samuel Griswold Goodrich lived 1793–1860.

48. Welling, *Photography in America*, pp. 77–79. X Theodor Barber offers an excellent and detailed account about the early development of photographic lantern slides in "Evenings of Wonders: A History of the Magic Lantern Show in America," Ph.D. dissertation, Department of Performance Studies, New York University, 1993 (unprinted)," vol. 1, pp. 73–95.

49. Text from Langenheim's circular, published in the *Art-Journal*, London, April 1851, p. 106 (quot. Welling, *Photography in America*, pp. 78–79). Photographic lantern slides seem to have had a more immediate impact in the United States than in Europe, where many lantern shows continued to use handpainted slides—particularly dissolving views—for decades.

50. Photographic glass slides had already been projected by Frederick Langenheim on his tour of South America, and at The Philadelphia Hospital for the Insane as part of its "moral treatment" program. George S. Layne, "Kirkbride–Langenheim Collaboration: Early Use of Photography in Psychiatric Treatment in Philadelphia," *Pennsylvania Magazine of History and Biography* 105, no. 2 (April 1981): 182–202. The definitive source on Abel's, Leyland's, and Fallon's careers is Kentwood D. Wells, "The Stereopticon Men: On the Road with John Fallon's Stereopticon, 1860-1870," *The Magic Lantern Gazette* 23, no. 3 (Fall 2011): 3–34.

51. The Langenheims produced their first series of 126 photographic lantern slides already in 1850 Welling, *Photography in America*, p. 78. It has been claimed that such lantern slides were made by cutting glass stereoviews into two. Broken stereoviews are said to have been

turned into lantern slides. Barber, "Evenings of Wonders," vol. 1, p. 86.

52. *N.Y. Journal of Commerce*, quot. in: John Fallon, Esq., *Six Tours Through Foreign Lands. A Guide to Fallon's Great Work of Art. The World Illustrated. A Complete Mirror of the Universe, From the Earliest Times Down to the Present Day.* Price 10c. Presented Free to Each Purchaser of a Season Ticket. No date or publisher [1860s], p. 12 (AAS). The link between Abel, Leyland, and Fallon was demonstrated by Wells, "The Stereopticon Men," pp. 4–5. Leyland, who also worked at the Pacific Mills in Lawrence, was the lantern operator of "Fallon's Stereopticon," while Abel left the partnership and tried his own show.

53. *Sunday Times*, quoted in Fallon, Esq., *Six Tours Through Foreign Lands*, p. 4. Fallon claimed he had invented a revolutionary oxy-hydrogen magic lantern. The *N.Y. Journal of Commerce* stated that although the lantern used at the Royal Polytechnic Institution in London had been innovative, it "did not advance beyond the first discovery . . . it remained to Fallon to perfect it." Quot. in *Six Tours Through Foreign Lands. A Guide to Fallon's Great Work of Art*, p. 12. Barber thinks the equipment were imported from England (Barber, "Evenings of Wonders," vol. 1, p. 101). Wells agrees, suggesting John Benjamin Dancer from Manchester as possible manufacturer. Wells, "The Stereopticon Men," pp. 6–7.

54. It is likely that Langenheim's glass slides were used for the American scenery, while foreign subjects could have been obtained from European glass slide manufacturers such as Ferrier and Soulier (Paris) and Negretti & Zambra (London). Langenheims are known to have stocked the latter's glass stereoviews. Barber, "Evenings of Wonders," vol. 1, pp. 85–86. A 1862 broadside for Fallon's Stereopticon also listed "the full moon, Photographed by [John] Whipple, of Boston." AAS, reproduced

in the back cover of *The Magic Lantern Gazette* 23, no. 3 (Fall 2011).

55. A broadside, Clinton Hall [New York, 1863], names about sixty views, and promises "fifty other [unnamed] Magnificent Views." Most are related to the civil war, but the list also includes "Cupid Asleep," "The Three Graces," and "Bed-time Prayer." The program ends with portraits of three generals and president Abraham Lincoln—obviously photographic (EH). A small leaflet for "Perham's Mirror of the Rebellion!" (EH) lists war views, divided into two sections (15 + 12). The show may have been a moving panorama or a magic lantern show. Josiah Perham exhibited William Burr's *Seven Mile Mirror! or, A Tour of 2000 Miles on the Lakes* in the early 1850s, so the leaflet could point to a later stage of his career. Perham died in 1868, after failed investments in the Northern Pacific Railroad. In 1863 he was involved in a lottery to help invalid soldiers of the Civil War; earlier he had organized lotteries with moving panoramas as the main prize (to get rid of them). Arrington, "William Burr's Moving Panorama," pp. 158–162.

56. Barber, "Evenings of Wonders," vol. 1, p. 92.

57. *First Week of Abel & Leyland's STEREOPTICON*, Boston Museum, July 8, 9 & 10, 1861 (broadside, EH).

58. *Fairyland by Gaslight! An Evening of Wonders! . . . Illustrated Lecture on the Wonders of God and man*, broadside (c. 1890) in EH. Frank Honeywell Fenno (1857–1892) was a well-known elocutionist who wrote books about the art of speech. *Portrait and Biographical Record of Seneca and Schuyler Counties New York* (New York and Chicago: Chapman Publishing Co., 1893), p. 208.

59. "B. T. Babbitt's Magnificent Stereopticon Exhibition and Music Entertainment, using the oxyhydrogen or calcium lights," flyer, undated

(c. 1880s), stamped: "cor. Broad & Middle 8 oclock" (EH).

60. The broadside states the "lecture will be illustrated by thirty-five splendid transparent views, (Beautifully executed at an expense of $6.000) in OIL COLORS ON CANVAS, from Drawings taking [sic] on the spot." Most of the arguments for the superiority of panoramas or dioramas are listed, but the size of the paintings is not mentioned (AAS). Another showman declared: "These are not Magic Lantern Paintings, neither are they seen through glass, or magnified in any way, but are Painted on Canvas, and moves [sic] before the spectator." *The Grand Pictorial, Musical and Historic Exhibition, entitled, Cooke's Trip Across the Continent and a Voyage Across the Atlantic* (broadside, 1870s–1880s, HTC).

61. Broadside in EH. A contemporary pencil note identifies the showman as "F. M. Alexander, New Harmony, Brown County, Ohio." Alexander also gave prizes to the Laziest Man, the Handsomest Baby, the Ugliest Man, and the Most Handsome Lady.

62. Some of the slides ("How Jones Became a Mason," etc.) were by Joseph Boggs Beale, and published by C. W. Briggs. Beale's career and slide production will be discussed in Terry and Deborah Borton, *Before the Movies: American Magic-Lantern Entertainment and the Nation's First Great Screen Artist, Joseph Boggs Beale* (forthcoming).

63. True & Co., *True & Hunter's Great War Show and Concert Troupe*, broadside, printed by the Steam Press of Curtis, Morey & Co., Rochester [N.Y.] (EH). The program offered music composed and arranged by "Prof. R. E. Corey, the Blind Musician" (promoted as a famous European artist on his first American tour), and songs and ballads sang by Little Ida Erwin and Miss Augusta True, who also served as the lecturer—one of the first women I have encountered in this role.

64. "Poole and Young's New
Canvas Diorama of the OVERLAND
ROUTE From London to India. At
Concert Room, Rotundo (closing Nov.
1st 1873)," unidentified newspaper
clipping (HTC).

65. Walter Benjamin, "The Work
of Art in the Age of Mechanical
Reproduction," trans. Harry Zohn,
in *Illuminations* (Glasgow: Fontana/
Collins, 1979), pp. 219–253.

66. Some aura was left in early
silent films that could be purchased as
customized copies (black and white,
hand-tinted, or hand-colored). Early
exhibitors often edited films into
unique combinations.

67. Laurent Mannoni and Donata
Pesenti Campagnoni, *Lanterne magique
et film peint: 400 ans de cinéma*
(Paris: Éditions de la Martinière & La
Cinématheque française, 2009).

68. Brenda Weeden, *The Education
of the Eye: History of the Royal Poly-
technic Institution 1838–1881*
(Cambridge: Granta Editions, 2008),
pp. 44–50.

69. Borton, *Before the Movies*
(forthcoming).

70. Quot. Albert Bigelow Paine,
*Mark Twain, a Biography: The Personal
and Literary Life of Samuel Langhorne
Clemens* (New York: Harper & Brothers,
1912), vol. 3, p. 872. Showmen named
Pyle and McDonald had already exhibit-
ed a *Great Stereopticon Panorama of
Choice Selections of Foreign and Domes-
tic Views* (broadside, 1880s, in EH).

71. Alexander Black, *Miss Jerry,
with Thirty-Seven Illustrations from Life
Photographs by The Author* (New York:
Charles Scribner's Sons, 1895).

10. SENSORY BOMBARDMENT:

A MEDIUM'S FINAL FANFARES

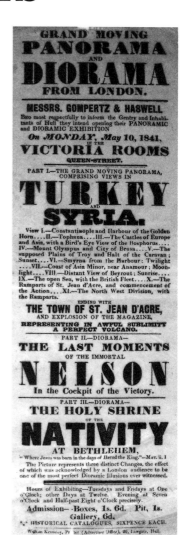

THE MYRIORAMA

AS A ROADSHOW ATTRACTION

In 1937 a handsome little booklet was published to celebrate the hundredth anniversary of an entertainment dynasty.[1] In anecdotal form it tells the story of a British family enterprise named Poole and the shows it had presented for generations of spectators. As corporate histories often do, the booklet includes a founding myth: a chance encounter between an "old showman" and two young musicians at Margate Sands in 1837. The showman, Moses Gompertz, persuades George and Charles Poole to play music to the moving panorama he is exhibiting; the brothers become his partners, and ultimately his successors. In another version of the myth the panorama was identified as *Sir John Franklin's Arctic Expedition*, and a third musician, Anthony Young, added. Gompertz was said to have died "a year or two later," leaving his show to the young trio.[2]

As most myths, this one contains seeds of truth, but not sown in the right places. If the meeting took place as suggested, Gompertz (c. 1813–1893) was only twenty-four years old. He is known to have exhibited a panorama of the *Arctic Regions* (*Sir John Franklin's Arctic Expedition*), but only in the 1850s (his earliest

Figure 10.1
The earliest known broadside for a show by Moses Gompertz (in partnership with Haswell) in the Victoria Rooms, Queen Street, Hull, on May 10, 1841. The program contains a moving panorama of Turkey and Syria, and dioramas of the last moments of Admiral Nelson and of the Holy Shrine of Nativity at Bethlehem. Author's collection.

known panorama about Turkey, Syria, and the Bombardment of Acre is from the early 1840s).[3] George and Charles Poole and Andrew Young may well have served as Gompertz's musicians, but very unlikely before the midpoint of the century.

The Pooles, whose extensive exhibition activities epitomize the moving panorama's final decades in England, were fond of disseminating statements about their origins and their history. In 1895, it was claimed in a newspaper article that "fifty-seven years ago" the partnership was named Gompertz, Poole and Young, and "fifty-six years ago" Poole and Young; in earlier advertisements it was stated that Poole and Young had been established in 1848.[4] The founding date 1837 may have been deliberately adopted in 1887, the year of Queen Victoria's Silver Jubilee, to align the family's career with that of the queen.[5]

The Poole historian Hudson John Powell has not found evidence about any of the family members working as exhibition managers or show owners before 1863, when George and Charles Poole were listed as managers for Gompertz's show.[6] Later in the same year Poole and Young were traveling on their own, exhibiting panoramas probably rented or bought from Gompertz.[7] In spite of losing one of his moving panoramas in a fire at the Grantham Exchange in November 1862, Gompertz was very much alive. He remained in the business until the 1870s, when his panoramas were still on the exhibition circuit.[8]

Poole and Young's decision to try their luck as entrepreneurs seems to have been motivated less by the moving panorama than by a fad named the Pepper's Ghost, a stage trick by Henry Dircks and John Henry Pepper, first presented in December 1862 at the Royal Polytechnic Institution in London.[9] It was a method of evoking a ghost by illuminating a hidden actor underneath the stage with a powerful light source. The figure was reflected from a sheet of glass placed obliquely between the stage and the auditorium, which made it possible to superimpose apparitions on actions taking place on the stage. Although the idea was not new, Pepper's Ghost became an instant sensation.[10]

The Pepper's Ghost was usually inserted as a highlight in a playlet. Although Pepper patented his "invention," it did not prevent others from exploiting it.[11] Poole and Young did not hesitate to present the "The Ghost!" Even Gompertz introduced his "Pepper's Ghost: Gompertz's Spectrescope and Spectral Opera Company," featuring an interpretation of Charles Dickens's *A Christmas Carol*, where spirits appeared in three occasions.[12] Spectroscopes, Phantoscopes, Aetherscopes, and other mystical-sounding apparatuses became common. As Étienne-Gaspard Robertson's "Fantascope" in his *Fantasmagorie* shows half a century earlier, these ghost-making devices were probably magic lanterns. Poole and Young used them in adaptations of popular operettas and scenes from operas like Gounod's *Faust*.

After the novelty of these tricks faded, the Poole family focused again on moving panoramas. Five brothers, George W. and Charles Poole's nephews, took over operations in the 1880s. As owners or managers, they operated massive shows that toured the British Isles. The family could have five to seven shows on the road simultaneously. Their mode of operation resembled those of traveling

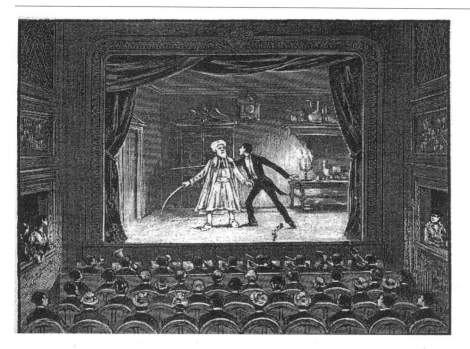

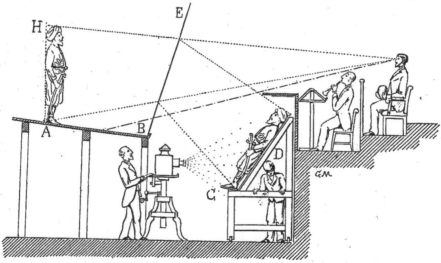

Figure 10.2 + 10.3
The Pepper's Ghost trick explained. From Georges Moynet,
La machinerie théatrale: Drucks et décors (Paris: La Librairie
illustrée, n.d., c. 1893, 277 & 279). Moynet associates this
trick with the French magician Henri Robin, who introduced
it in Paris. Robin claimed to be its inventor, contesting the
primacy of Henry Dircks and John Henry Pepper.

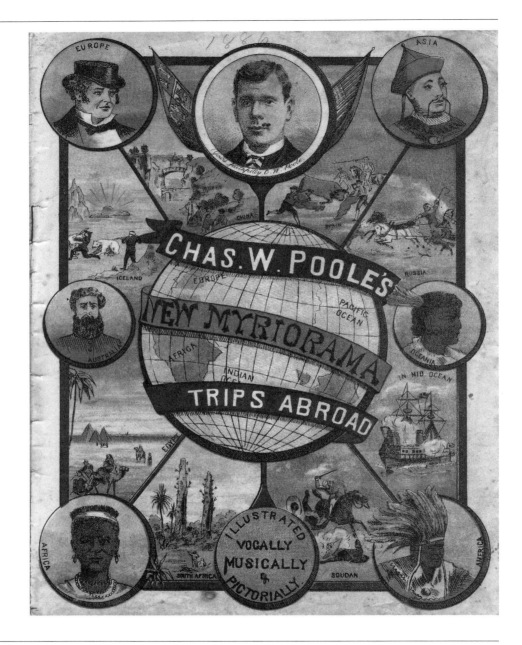

Figure 10.4
Cover of the booklet for Chas W. Poole's *New Myriorama,*
Trips Abroad, 1886. Author's collection.

circuses and fairground shows. The dozens of employees included panorama operators, singers, musicians, and variety artists. The shows traveled on special trains, and were preceded by extensive publicity. The panoramas were painted and repaired in studios located in London, Bristol, and Malmesbury, Wiltshire.

The effectiveness of the system was put on trial when Joseph Poole's panorama was destroyed by fire at the Newcastle Town Hall in January 1900. A complete replacement was opened at the same place in less than a week. Poole announced in the *Newcastle Daily Chronicle* that his Myriorama was "rising Phoenix-like from its ashes," thanks to the "enormous resources of the Poole firm and the untiring energy of the staffs at the various studios and stores of the Poole Bros." This created awe and much free publicity. Of course, the destroyed canvas had been fully insured.[13]

Most of the Poole panoramas were extensive world tours that began and ended in England, reflecting nationalistic ideology that saw Britain as the nexus of the world. A typical example, Cha[rle]s W. Poole's *New Myriorama Trips Abroad* (c. 1886) set out on its virtual voyage from London, "the wealthiest and largest city in the world." After presenting some of its sights, the trip continued via Bristol, the lakes of Killarney, Dublin, and Edinburgh to Liverpool, where the audience—like so many immigrants—boarded a boat to North America. The trip continued to South America, Africa, Australia, New Zealand, and via Madagascar to India, China, and Russia. A scene from Greek mythology, "Consulting the Oracle," abruptly followed, and the first part (first cylinder?) ended with a view of the Chapel of Nativity in Bethlehem.[14]

The next two parts dealt with the Egyptian and Sudan Wars, including an elaborate special effects scene—the bombardment of Alexandria. The journey home led from Cairo via Gibraltar, Italy, Switzerland, and Paris to Southampton, and then London. A humoristic scene about a squire relating a ghost story celebrated the British mindset. But this was not all: the spectators were still treated with the "Colinderies Exhibition" in South Kensington, and taken to the Charing Cross Station to greet the war hero General Wolseley. The show ended with the Royal Review that had taken place at the end of the Crimean War (1855–1856), with the queen driving past the troops. Several scenes were "illustrated by costly dioramic machinery," and songs and duets performed by "Chas W. Poole's Acme Concert Combination of Talented Artistes" [sic].[15]

The sources of this format went back decades. J. B. Laidlaw had already combined geographic and topical scenes, and the travelogues of the panoramania era "transported" audiences from place to place. Still, in its overflowing richness Poole's Myriorama belongs to the era of Jules Verne's *Around the World in Eighty Days* (1873), and Phileas Fogg's breathless romp around the globe.[16] The main difference was that Poole relied on visuals and effects rather than on a coherent

Figure 10.5

Half price ticket to Joseph Poole's *New Myriorama*, at Round Room, Rotunda, Dublin (backside). Chromolithograph, late 19th century. The ticket's dramatic graphic design is meant to create desire to see the show. Author's collection.

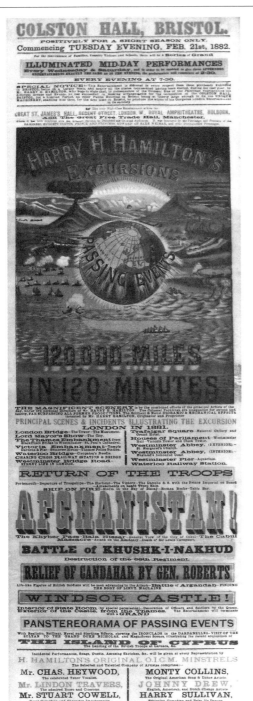

narrative. Verne's novel celebrated modern means of transportation, whereas the Myrioramas paid little attention to the realities of travel. Their zigzagging routes must have been edited together from scenes that just happened to be available in the studio.

The word "Myriorama" was introduced around 1883 by Joseph Poole, who defined it: "If we prefix *horama* with the Greek *myrioi*, which signifies various, we arrive at the latest development of this class of entertainment, 'Myriorama' meaning 'to view various scenes and objects.'"[17] The word was adopted by all the brothers and used like a trademark to distinguish their productions from competing offerings, in particular the "Excursions" of the Hamilton showman dynasty.[18] The Hamilton family has received much less attention than the Pooles, although its panorama business started earlier, in the 1850s at the latest. The formats, modes of operation, goals, and even the theaters of operation were quite similar, except that the Hamiltons also took their shows to continental cities like Paris and Brussels.[19]

Hamilton's Excursions were even more Vernean. Harry H. Hamilton promised to transport the audience "120 000 miles in 120 minutes," and William Hamilton "round the world in two hours."[20] Still, Verne's adventures were domesticated: the shows sounded like the offerings of a travel agency. Spectators were "travelers" and "tourists," and the "Route" promised "unrivalled for Beauty and Variety of Scenery, Regularity of Trains, Attentive Officials." "Sea Sickness, Shipwreck, or Railway Accidents" had been eliminated.[21] An advertising broadside depicted a "view and section of the Bessemer Saloon Steamer," a novelty boat designed for ferry traffic between England and France.[22] It had a swinging passenger saloon that would, "like the pendant compass, feel no motion even on the roughest sea." The Bessemer Steamer was a perfect metaphor for Hamilton's risk-free travel. Unfortunately, the steamer was a failed

Figure 10.6

Harry H. Hamilton's Excursions, broadside for a moving panorama performance at Colston Hall, Bristol, on Feb. 21, 1882 (printer: T. Upton, Birmingham). The handsome and colorful design demonstrates the ambitions of the Hamilton showman dynasty. Author's collection.

promise: its test voyages proved catastrophic, and the project was halted.[23]

Like Myrioramas, Hamilton's Excursions relied on visual extravagance rather than on coherent information. A broadside listed "The City of Moscow as it appeared on the occasion of the Duke of Edinburgh's Marriage. The Wonderful Transformation Scene from Winter to Summer! The Train in Motion passing through Mont Cenis Tunnel! The Channel Fleet! Our Great Iron Clads! The Neapolitan Punch and Judy! The Charing Cross Station and Thames Enbankment!" The sensory overload poured on the spectators was already noted in 1860: "The new exhibition… is not wanting in variety, but, if anything, lays itself open to the charge of being a little overcharged with that characteristic."[24]

Although (or because) the medium's appeal was fading, side-attractions were introduced. One of the Pooles confirmed that "a panorama is not self-supporting, and it must be supplemented by a variety entertainment."[25] "To render monotony impossible" singers, musicians and "Professor Hawthorne, the great American change artist" were added.[26] Hamilton's shows included acts like "The O.I.C.M. Minstrels" and "the Champion Scaters."[27] Another way to keep interest alive was special effects. The cutout boats and smoke effects Leon Pomarede used in his Mississippi panorama in the late 1840s would have been laughable to the audiences marveling at Poole's or Hamilton's "panstereoramas" and "stereoramas." One of the Poole brothers defined the stereorama as "a sort of set piece," mentioning "battle pieces, actions at sea, a cyclone." A popular one was the bombardment of Alexandria:

> The ships are cut out in profile, and so are the forts. In each of the guns a pinch of gun-cotton is placed, which makes a fine blaze, and gives off a splendid puff when the cue is given; and here is the big drum, you see, for the noise. They like lots of noise. When it is necessary to show the glowing track of the booming bomb as it hurtles through the air on its mission of death and destruction—why you see it's like this. The aforementioned track to death and destruction is cut out of the sky and sea. Here is one of Arabi's gunners. John, show the gentleman a firebox. In this a light is boxed up like the dark lamp of a policeman, just to show where it is wanted, and placed on the end of a stick follows the line of the bomb. Then the lethal weapon makes a hit in the fort or on the man-o'-warsman, the explosion occurs on the tick. Why, in a big scene we may have a dozen men stationed behind with gun-cotton, light boxes, magnesium flares, a reg'lar arsenal of thunder, lightning and fury."[28]

Figure 10.7

Hamilton's Delightful Express Excursions To the Continent and Back within Two Hours, a half-price complimentary family excursion ticket, Philharmonic Hall, Southampton [1860–1870s]. The ticket mentions a Mr. Heath as the lecturer, and may have been used by a competitor who had appropriated Hamilton's well-known name. The Hamiltons warned against such identity theft. Author's collection.

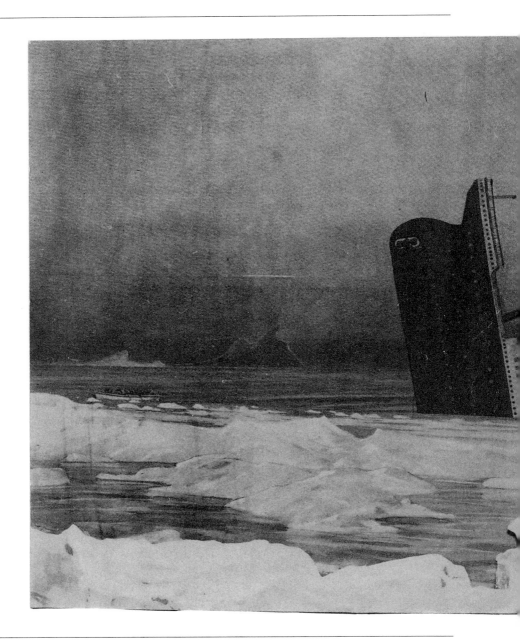

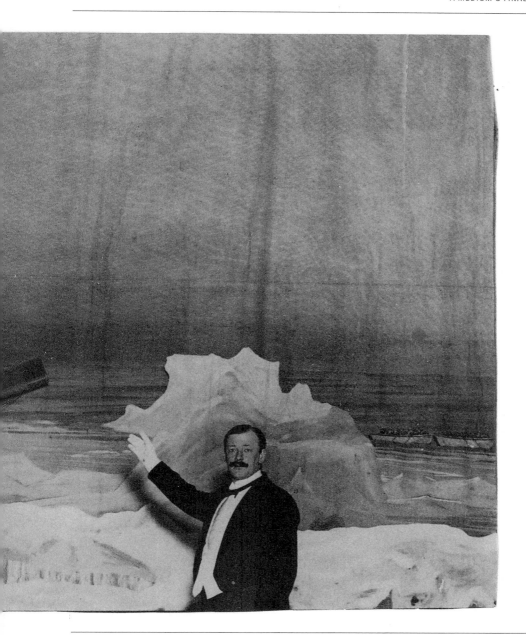

Figure 10.7
Poole's moving panorama of the sinking of the Titanic,
with the lecturer, John R. Poole, standing in front of the
canvas. Photograph from a folder of hand-written notes
for the lecture. Courtesy of the Bill Douglas Centre for the
History of Cinema and Popular Culture, University of Exeter.

Joseph Poole claimed that a set piece about the battle of Yalu (included in his panorama of the Sino-Japanese war) employed no less than "30 rollers, whereas the old plain panorama would have done it with four."[29] Rows of cutout figures moved in front of the main canvas. Such scenes evoked theatrical special effects as well as the mechanical theaters ("theater of the arts," "mechanical panorama," "picturesque spectacle," etc.), which had their roots in de Loutherbourg's *Eidophusikon*, Maelzel's *The Conflagration of Moscow*, Pierre's *Théâtre méchanique et pittoresque* and similar attractions. Poole's stereoramas demonstrate that relatively little had changed, except perhaps in scale and sophistication.

The venues grew as well—the Hamiltons used the Royal Amphitheatre of Holborn in London (3,000 seats) and Bristol's huge Colston Hall—but moving panoramas had reached their limits.[30] Huge canvases and elaborate set pieces were cumbersome and costly. Magic lanterns entertained audiences more easily. When cinematographs appeared in the late 1890s, the end was at sight. Admitting the inevitable, the Pooles added films to their programs, although as late as 1912–1914 John R. Poole still had a huge success with a Myriorama about the sinking of the *Titanic*.[31]No film cameras had documented the catastrophe. Supported by a descriptive lecture and "Unique and Mechanical and Electric Effects" (including a cardboard Titanic sinking into a slit in the canvas), Poole managed to offer something newspaper stories, magazine illustrations, lantern slides, and newsreels could not provide.

After the First World War the moving panorama's era was over.[32] The Hamilton family ceased its activities in the early years of the century (some of their panoramas ended up in Poole's hands). Members of the Poole dynasty continued to present Myrioramas on special occasions, particularly around Christmastime, until the late 1920s, but these were little more than nostalgic peeks into a glorious past. The family's attention (like Hamilton's) was now focused on the cinema. Anticipating the shift of emphasis from touring attractions to permanent ones, it had begun buying variety theaters in the late nineteenth century; cinemas were a logical step. The last of the Poole showmen, Jim Poole, died in 1998.[33] All the Myriorama canvases have been lost, but some cinemas once owned by the Pooles are still operating.

THE THÉÂTRE MORIEUX TIME CAPSULE

"Multimedia" spectacles that included moving panoramas were also produced outside the Anglo-American world. In continental Europe they were displayed by touring showmen, who set up their attractive pavilions at fairgrounds, market squares, and other gathering places. Except for broadsides and newspapers notices, these shows have left faint traces behind.[34] There is one glowing exception: *Le Théâtre Mécanique Morieux de Paris*. Its impressive remains were discovered in

Figure 10.8
Théâtre Mécanique Pittoresque Maritime Morieux de Paris. Chromolithographic poster, printed by Messager de Bruxelles, Belgium c. 1900. The illustrations show the variety of Morieux's programs: the 1900 Paris Universal Exposition (Le Palais de l'Électricité, top), exploration and travel, wars, fairground attractions, etc. The surviving diorama *Grand Carnaval sur glace à St-Pétersbourg* (The Great Carnival on Ice in St. Petersburg) is seen right toward the bottom (it is really a view of the Kremlin in Moscow). Mechanical marionettes moved in front of the dioramic canvas. Author's collection.

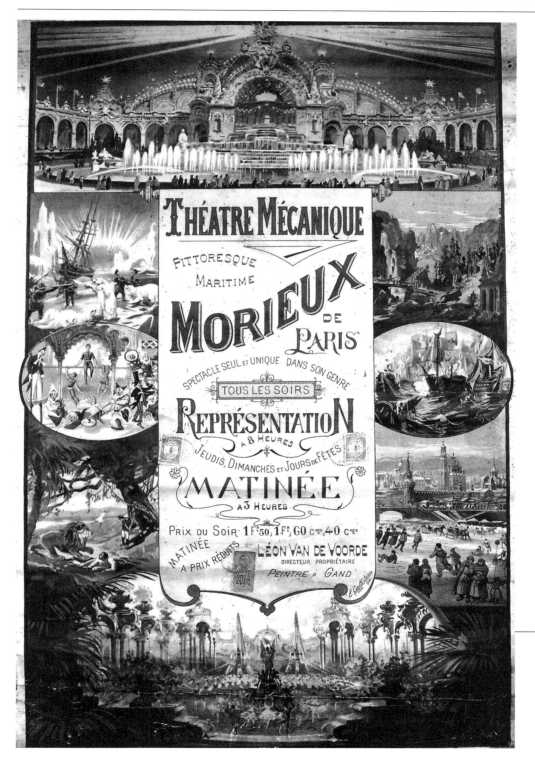

an abandoned warehouse in Ghent, Belgium, a few years ago. Although some material had been thrown away, and a few items were dispersed among collectors, in 2008 this remarkable find ended up in the collection of Jean-Paul Favand's Musée des Arts Forains in Paris, where it is being restored and cataloged.[35]

What was discovered is nothing less than a time capsule. Under decades of dirt, and in a state of neglect but basically intact, lay the remains of a show that traveled across Europe for decades: complete facades for the fairground building, with life-size statues and decorative panels; about 400 mechanical marionettes (with boxes full of cardboard mock-ups used in their fabrication); rails along which they moved; moving panoramas; dozens of large background paintings, many of them dioramic; an elaborate mechanical tableau; projectors and lantern slides; machines for special effects; and last but not least, large amounts of documentation, from broadsides and program leaflets to factures and correspondence.

The program booklets preserved at the Musée des Arts Forains repeat the same story of origins, tracing the enterprise back to 1809, when P[ierre?] Morieux is said to have founded it in Paris. Indeed, in François Binetruy's collection there is a rare German language broadside for a "Theatre Pittoresque" signed by "M. Morieux, Mechanikus aus Paris," exhibited on the Lower Juliusspital Promenade in Würzburg probably toward mid-century. The broadside explains that Morieux had given presentations along the Boulevard du Temple in Paris for twenty-two years. He may have begun touring with his show after that, but information about his travels still needs to be uncovered.

By the 1860s the business was in the hands of the Belgian diorama painter and mechanic Jean-Henri Vandevoorde (or Van de Voorde). "Mother Morieux" is mentioned in correspondence, so the transition may have involved family relationships.[36] As the company archive shows, Vandevoorde spent extensive periods in Bremen in Northern Germany, traveling with his show in the German-speaking territory.[37] His son Léon, who was also a skillful painter and a dedicated showman, as well as relatives named Edouard and Eugèn(e), may have divided their theaters of operation, the former given Belgium and Northern France, and the latter two Germany and Switzerland.[38] Léon's son Edmond toured with the show until at least 1932.[39]

The original Théâtre Morieux must have been a mechanical puppet theater in the manner of Pierre's famous "Picturesque and Mechanical Theatre" that operated in Paris in the early nineteenth century (from 1802), and countless touring "theatrum mundis," "mechanical exhibitions," or "theaters of arts."[40] Although mechanical marionettes played an important role in these attractions, many of them included painted scenes and perspectives enhanced by optical and mechanical means, "in imitation of nature."[41] The way Pierre's spectacle was described in the *Encyclopedia Londinensis* in 1821 applies to other similar shows as well:

> *It consists of a representation of landscapes, cities, sea-ports, &c. the different parts of which are in relief, and admirably contrived to render the perspective complete, and the general appearance of the whole*

is highly interesting. This scene is enlivened by numerous animated figures; carriages of every description cross the bridge; boats sail up the river; pedestrians crowd its banks; the sun gradually rises; the appearance of the sun perpetually changes, and occasionally the grand accompaniments and effect of a storm are portrayed.[42]

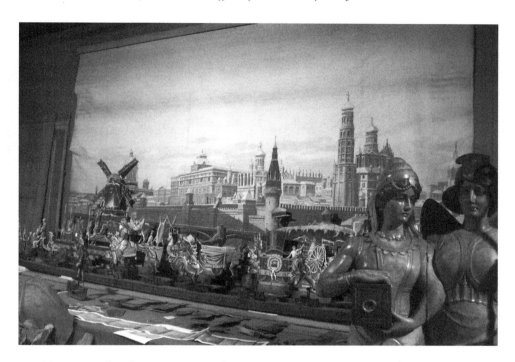

Just like Pierre, the Théâtre Morieux characterized itself as a "Grand Théâtre Mécanique, Pittoresque, Maritime," echoing a centenarian tradition. In earlier years its displays of ingenious mechanical puppets were combined with diorama pictures (including imitations of Daguerre's and Sébron's originals)—rows of figures moved in front of the paintings. Both marionettes and paintings were created by Jean-Henri Vandevoorde. Other elements were added as well. "Diophrama" referred to magic lantern projections, while "giant photographs" (*Der Riesen-Photograph*) were carte-de-visite photographs enlarged with a megascope, or opaque projector (the spectators were encouraged to bring their own pictures to be projected in public).[43] "The Imperator Bio" meant cinematographic moving pictures. The show often culminated in a mythological mechanical tableau depicting "The Festival of the Sun in the Realm of Jupiter."

Figure 10.9
Mechanical marionettes on their tracks in front of the diorama canvas of *Grand Carnaval sur glace à St-Pétersbourg* (The Great Carnival on Ice in St. Petersburg) in the workshop of the Musée des Arts Forains, Paris, May 2011. The scene is really the Kremlin in Moscow. The wooden figures on the right were part of the facade of the fairground pavilion. Photo: Erkki Huhtamo. Courtesy of Pavillons de Bercy/Musée des Arts Forains.

Moving panoramas (or "cycloramas," as they are called in the Morieux docu-
ments) seem to have been added in the early 1890s, although the early German
language Morieux broadside in the Binetruy collection already lists a "painterly
trip from London to Paris," which sounds like one. Be it how it may, moving
panoramas continued to be presented until the very end. At least four complete
examples have been preserved at the Musée des Arts Forains. All the rolls are of
standard size, 90 meters long and 2.31 meters high. Two of them are travelogues
that cover an entire roll. *Voyage pittoresque d'Alexandrie au pole nord* depicts a trip
from Alexandria to the North Pole via Naples, San Francisco, and Greenland, while
the *Grand Voyage autour du Monde* starts in Oostende, moves to Brussels, and final-
ly reaches the Sahara Desert via London, Moscow, Catania, and other places.[44] In
a rare moment of promotional self-reflexivity, in the Brussels scene we detect the
Morieux pavilion installed in a park, with a crowd of people gathered around it.

The two other panoramas share the same roll. The first 60 meters are covered by
L'Exposition Universelle de Paris 1900, an armchair trip to the universal exposition,
and the remaining 30 meters by the Russo-Japanese war (1904–1905).[45] Except for
the last subject, painted (and signed) by the theatrical scene painter Franz Gruber
of Hamburg, all the others seem to have been created at Léon van de Voorde's
atelier in Ghent. The painting quality and compositions are remarkable, but the
most intriguing feature is the handling of space. Both travelogues cover huge
distances, but localities that are in real life far apart melt into each other, eschew-
ing geographic verisimilitude. This elliptic, mobile continuity hides within itself
four-meter-wide "scenes." They may have been observed when the roll has been
temporarily stopped.

Figure 10.10
Grand voyage autour du monde (Grand Voyage Around the
World), moving panorama exhibited by *Le Théâtre Mécanique
Morieux de Paris*. Painted by Léon van de Voorde and helpers,
Ghent, Belgium, 1890s. Total length 90 meters. The scene
shown here connects Paris (Place de la Concorde) with Lyon
(Quai de la Saône). Courtesy of Pavillons de Bercy/Musée
des Arts Forains.

Similar liberties have been taken in the universal exposition panorama. The "tableaux" depicting the pavilions and other sights—including the building of the Maréorama, the most ambitious moving panoramic spectacle of all time—are remarkably accurate and detailed, but they have not been arranged in a manner that would correspond to an actual walk through the exposition grounds. The scenes are real but their mapping in space is imaginary. The Morieux panoramas therefore fall between the two extremes that are found in the history of the moving panorama: they are at the same time series of tableaux and continuous simulated landscapes.

Although mechanical figures—especially ships—had often been combined with moving canvases, their role in the Théâtre Morieux was more prominent,

Figure 10.11
Léon Van de Voorde's sketch for the moving panorama
L'Exposition Universelle de Paris 1900 (1900 Paris Universal
Exposition), exhibited by *Le Théâtre Mécanique Morieux de
Paris*. This part of the sketch shows in the center Le Globe
Céléste (The Celestial Globe), and the building housing
Hugo d'Alesi's Maréorama in front of the Eiffel tower.
Compare this with the finished panorama on the cover of
this book. Courtesy of Thomas Weynants collection.

which resulted in curious combinations. The canvases represent places that exist or events that have really taken place (a lecturer was used to emphasize their verisimilitude), but they also served as backdrops for the fantastic and playful actions of the marionettes.[46] What kind of psychological effects did such combinations have on the audience? Which one was more prominent—puppet fantasy or panoramic "reality"? It is too late to ask the spectators, but we can speculate that the fairground context made a difference: it melted the layers together, no questions asked and no answers given.

THE PAST AS FUTURE,
OR THE PANORAMA REVIVAL

"Paris by Night" is not a Panorama, but a Stationary Picture,

seen in its entirety at any hour of the exhibition.

—*The Colosseum Handbook*, Philadelphia, 1876[47]

When the mid-century panoramania took place, the popularity of the circular panorama was in decline. Barker's and Burford's Leicester Square Panorama and the Regent's Park Colosseum both closed in 1863–1864. Colonel Langlois's rotunda on the Champs-Elysées was a rare survivor, largely thanks to patriotic subject matter and governmental support.[48] It was in Paris that signs of a new interest in circular panoramas appeared. After an interval of decades, the Franco-Prussian

Figure 10.12
Regent's Park Colosseum, stereoview from the series
"Views of London," no. 50, possibly by London Stereoscopic
Company, 1850s. The fading fad of the circular panorama
(Colosseum was demolished in 1864) meets a new fad,
stereoscopomania. Author's collection.

war (1870–1871) brought fighting into the heart of Western Europe. The painter Félix-Emmanuel-Henri Philippoteaux (1815–1884), who became the manager of Langlois's rotunda after his death (1870), decided to revisit the traumatic events from a patriotic perspective. *Le Siége de Paris,* or the *Panorama of the Defense of Paris against the German Armies,* opened in November 1872, becoming an enormous success, and bringing the circular panorama business into the spotlight again.[49]

The signs of the times were also interpreted across the Atlantic. Pearson Brothers, who were known as painters of moving panoramas, announced in March 1875 that they were going to open in Boston a Cyclorama of Jerusalem.[50] It was said to be a "facsimile of the gorgeous spectacle of the Siege of Paris" they had visited in Paris. Yet its "astonishing perspective and wonderful aerial effect" had been applied to a topic suited to the American taste, and enhanced with "mechanical arrangements" handled by a "Machinist." The panorama was shown with "a life-like Tableaux" [sic] of Christ before Pilate, comprising twenty-seven wax figures.[51]

Beside Philippoteaux, the Pearsons may have been influenced by the New York Colosseum, an ambitious undertaking by a group of British businessmen, who had purchased the two enormous panoramas, *London by Day* and *Paris by Night,* from the demolished Regent's Park Colosseum.[52] An imposing iron rotunda was erected at the corner of 35th Street and Broadway and opened to the public on January 10, 1874.[53] Like its lost namesake, it offered beside the panorama a variety of entertainments, including a "Polytechnic Promenade" (a kind of popular-scientific curiosity cabinet), lectures, and demonstrations. The word "cyclorama" may have been chosen to distinguish the circular canvases from moving panoramas that were far more familiar to the Americans.[54]

The New York Colosseum was popular but short-lived. The *Cyclorama of Paris by Night* was sent to Chicago later in 1874, and then to the Centennial Exhibition in Philadelphia (1876). The New York Colosseum was dismantled and re-erected in the latter city, but not until it had housed the "Panorama of the Siege of Paris and the Franco-Prussian War," Philippoteaux's own copy of his famous painting also on its way to the Centennial city.[55] In 1881, two representatives of a French stock company, Edward Kamper and "Baron" de Mannerheim, arrived in New York to raise interest in a new panorama planned for the American market. The

Figure 10.13
Cover of the weekly program leaflet for the New York Colosseum, March 21, [1874]. Author's collection.

New York Times found it necessary to explain the nature of their venture, as if the circular panorama had been completely wiped out from memory:

> *For some time the particular amusement rage in Europe has been for panoramas, of which there are established exhibitions in Vienna, Paris, London, Madrid, Berlin, and other large cities. These exhibitions are not at all in the nature of the roller pictures, under the names of "panoramas," with which this country has been afflicted, but are the work of notable painters, and aim, primarily, to be perfect from an artistic point of view. They are permanent features in the cities where they are exhibited, having buildings specially devoted to their display, and do not travel from place to place.*[56]

The panorama revival developed around stock companies. Businessmen took the lead, and hired academically trained painters to do the work. Many stationary circular panoramas made their way to exhibitions. The Universal Exposition of 1889, held in Paris, included Henri Gervex's and Alfred Stevens's *L'Histoire de siècle*, Charles Castellani's *Tout-Paris* (both depicted groups of French celebrities in panoramic settings, which was unusual), and two panoramas by Théophile Poilpot (1848–1915), *Panorama du Pétrole*, and another one for the Compagnie Générale Transatlantique.[57] The last mentioned, which was generally hailed as one of the highlights of the exposition, depicted the shipping company's fleet at anchor outside Le Havre, and was viewed from the simulated deck of the luxurious ocean liner *La Touraine*, which was then under construction.[58]

The new wave of oil-painted panoramas impressed the visitors by their painterly values, huge dimensions, and calculated subject matter. The frozen, *tableaux vivants*-like quality of the moment captured on the circular canvas could exert a certain fascination. An American who visited de Neuville's and Detaille's panorama of the battle of Rézonville in Paris found it "thrilling, awful and graphic, like a bloody battle-scene suddenly frozen or struck into silence and immovability by power superhuman." But he also felt that "motion and noise are the only things lacking to make it appear entirely real."[59]

The cyclorama may have been a revelation to unaccustomed eyes, but as a medium it had little to do with current developments in communications and technology. It was massive but static; for image-hungry spectators it offered only one frozen moment. Displaying smaller "dioramas" on the side became a common way to add more visual content. The vantage-point of Philippoteaux's *Panorama of the Defense of Paris* was *outside* the city walls; the audience observed

Figure 10.14
Tradecard depicting the rotunda housing Théophile Poilpot's Panorama de la Compagnie Transatlantique at the Paris Exposition Universelle of 1889. Chromolithograph for the chocolate manufacturer Guérin-Boutron. Author's collection.

the dramatic event from a distance. This made a diorama about what was happening *inside* the beleaguered city (along the avenue d'Orléans) interesting.[60] Below Poilpot's panorama for the Compagnie Générale Transatlantique there were dioramas depicting engine rooms, cabins, and salons of the company's ocean liners, as well as the docks of New York, Marseille, and Bordeaux.[61]

Some dioramas were displayed on their own; Poilpot painted seven for the "exposition of the arts of the woman" (1892), while Hoffbauer's diorama of "Paris through the ages" at the Carré Marigny on Champs-Elysées (c. 1886) offered "historical and archaeological promenades in different quarters of ancien Paris" by means of "eight grand views in natural size."[62] Yet another diorama was exhibited during the Universal Exposition of 1878 in the Jardin des Tuileries to raise money for the construction of the Bartholdi statue (later the Statue of Liberty).[63] Such dioramas may not have been as sensational as they had been in the heyday of Bouton, Daguerre, and Sébron, but contrary to Karen Wonders's claim, neither the word nor the thing itself had disappeared.[64]

In the panoramas the visitors walked around the viewing platform as they pleased, identifying landmarks with an explanatory booklet in hand.[65] From the 1870s onward it became common to use a lecturer, who stood on the viewing platform with the visitors. This practice, which must have been influenced by moving panorama shows, was normal in the United States, where public lectures were very popular. Such a situation was described by Brander Matthews in a story titled "On the Battle-Field" (1888). A journalist visits the cyclorama of the battle of Gettysburg, where he finds a crippled war veteran serving as lecturer. He discovers that the lecturer is actually just a boy, who has identified himself (through "mental metempsychosis") with the veteran who had lectured at the panorama and passed away. The boy himself had been crippled in an accident at the panorama.[66]

The lecturer enlivened the experience, but could not solve the basic issue: the painting was static. Attempts were made to animate the canvas with projected atmospheric effects. At the New York Colosseum, *Paris by Night* was enhanced "with the storm, lightning, wind, and rain effects."[67] When the cyclorama of the Siege of Paris was exhibited in San Francisco (1891), the list of effects all but overshadowed the painting: "1—Full Military Band, Afternoon and Evening. 2—Brilliant Lectures, Musical Interpolations. 3—Bugle Calls, Echo Refrain.

Figure 10.15
Poster by Jean-Louis Forain (1852-1931) for *Exposition des arts de la femme*, organized by la Société de l'Union des Arts décoratifs at Palais de l'Industrie, Paris, 1892. The exposition included seven dioramas by Théophile Poilpot about the theme *La Parisienne du siècle*. Re-issued in *Les Maîtres de l'Affiche* (Paris: L'Imprimerie Chaix, 1899), Pl. 186. Author's collection.

Figure 10.16
Jules Chéret's (unsigned) advertising card for a diorama of New York, commissioned by the Union Franco Américaine to promote the construction of the Bartholdi Statue (later: Statue of Liberty). The diorama was shown in the Tuileries Garden during the Exposition Universelle of 1878. The diorama ticket permitted the visitors to enter the statue's head, on display at the Champ de Mars. Chromolithograph, Impremerie J. Chéret & Cie, c. 1878. Author's collection.

4—Cannonading and Musketry Firing. 5—The Battlefield by Night. 6—The Dead March, Gathering up the Wounded. 7—Men and Horses in the Mad, Furious Rush of War. 8—Paris Seen by Lightning Flashes. 9—The Great Storm, Thunder, Lightning and Rain."[68] Such additions increased the theatricality of the panorama to almost Wagnerian heights, but they were hardly a long term solution.[69]

PANORAMAS, PATENTS, AND THE UNIVERSAL EXPOSITION OF 1900

The late nineteenth century was a world in motion: the urban environment was evolving, new means of communication and transportation proliferating, and the whirlwinds of commercial capitalism raging. Demands for dynamic audience attractions were escalating as well. Spectator sports were designed to domesticate the anonymous masses of industrial and clerical workers by positioning them as passive spectators observing physical feats from a distance. The melodrama theater produced more and more "realistic" and spectacular illusions on stage; the famous chariot race of *Ben Hur* was just one example among many. No matter how impressive the circular panoramas may have been, they were also anomalies; enormous relics from a world that was no more.

As the end of the century approached, panoramas were increasingly enhanced by the latest technology. A case in point was Charles A. Chase, an inventor from Chicago, who replaced the painting with slide projections in his Electric Cyclorama.[70] Chase hung a kind of chandelier in the center of the panorama rotunda and provided it with ten synchronized double-lens or biunial magic lanterns to project a circular photographic panorama; when needed, it could be changed instantaneously to another. The magic lanterns could also be used for dissolving views and potentially combined with cinematographic moving pictures as well. Although Chase's project did not advance beyond prototype demonstrations, the idea was widely reported in journals such as the *Scientific American* and the French *Cosmos*, inspiring others.[71]

Many patents were applied for, granted, and buried, but a few materialized in Paris at the Universal Exposition of 1900.[72] Its role as a symbolic gateway to the new century was

Figure 10.17

World's Fair 1492–1892. A miniature moving panorama, most likely sold at the Chicago World's fair (although this copy is stamped "THE FAIR A. McOmber, Benton Harbor, Mich."). The roll, copyrighted 1892 by A. F. Phelps, contains a moving panorama of the presidents of the United States, and some views from the fair. The sides of the box are covered by chromolithographs of the landing of Columbus (top), the Masonic Temple of Chicago, the U.S. Capitol, and a list of the presidents. The front legs serve as knobs to move the panorama. Author's collection.

widely understood; businesses, politicians, inventors, designers, and artists alike wanted to be seen as harbingers of modernity. The Compagnie Générale Trans-atlantique was one of them. The panorama it had commissioned from Poilpot had been one of the highlights of the 1889 exposition, but it had been station-ary.[73] The company wanted something new and striking, and so it entered into a collaboration with three inventors, Louis-Alfred Berthon, Charles François Dussaud, and Georges Jaubert, who had patented a sound-recording device called "microphonographe."[74] They had also managed to synchronize its sounds with the moving images produced by another novelty, the *Cinématographe Lumière*.[75]

The visitors were meant to experience, "both with their eyes and their ears, the main events taking place on large ocean liners," including the port of Joliette, a huge boat raising its anchor, people saying their farewells, the whistle an-nouncing the departure, and scenes of life on board with their typical sounds, all in "grandiose proportions."[76] The Phonorama, as the result was called, hardly fulfilled the expectations. Some short films were shot by the Lumière cameraman Félix Mesguich in the streets of Paris, not at ports or on boats. They were com-bined with sounds, but only a few visitors could experience them at the same time through earphones.[77] The production time had been too short, and the technology too rudimentary.[78] The Phonorama was a minor attraction, and so the Compagnie Générale Transatlantique had to resort to plan B: commissioning another panorama from Poilpot, a circular view of the city of Alger from the top of the Mosquée de la Pêcherie, with the company's fleet seen at anchor in the port. The format was too familiar, and the pavilion received little attention.

This time the center stage belonged to others. Virtual voyaging was all the rage—Auguste Francovich's and Antoine Gadan's Stéréorama mouvant and Hugo d'Alési's Maréorama were panoramic sea voyages, Raoul Grimoin-San-son's Cinéorama a cinematographic balloon trip, and Marcel Jambon's and A. Bailly's Panorama Transsibérien a railway journey across Siberia from Russia to China. All these attractions emphasized motion and dynamism. They bor-rowed ideas from the past, but none of them was a moving panorama in the customary sense. The artists, inventors, and entrepreneurs did their best to camouflage their offerings as something unprecedented.

The idea behind the Stéréorama mouvant ("moving stereorama") was pat-ented by the painters Francovich and Gadan in 1895.[79] It was originally meant as an addition to an existing panorama rotunda. Francovich and Gadan wanted to add a motor-driven circular "diorama" around the building (outside), observed from thirty-one dark chambers around its perimeter. Five concentric metal circles of cutout waves and ships in motion were to be placed between the viewers and the painting. With the help of light effects, the attraction was to represent a cruise from Marseilles to Menton. Because its dimensions had to match the size of the "internal panorama" (or other circular building), the length of the planned "dio-rama" was to be as long as 99 meters and 56 centimeters.

When the attraction finally opened its doors at the exposition, the idea had been modified. The rotating cylindrical painting, the moving waves, and the ships had been realized, but there was no panorama rotunda inside the cylinder

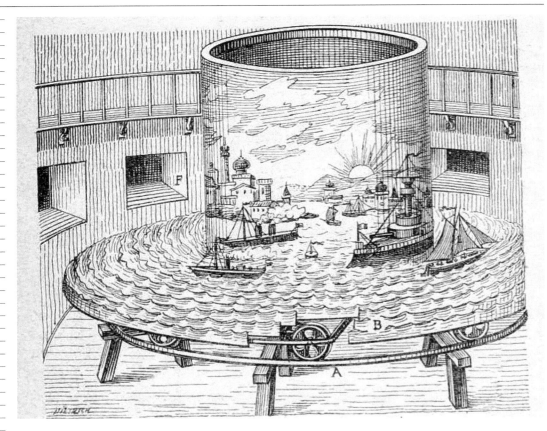

on which the journey had been painted. The scale was much smaller, possibly because the pavilion inside which it was located housed other exhibits as well (including dioramas). The topic had been changed to a sea voyage along the Algerian coast for an obvious reason: the *Stéréorama mouvant ou Poème de la mer* ("Poem of the Sea") was part of the Algerian section. The audience experienced it through square window-like openings, but these formed only a semicircle. Commentators compared the viewing situation to a ship with its cabin windows, but this was not explicitly emphasized by the design, which was closer to museum dioramas or shop windows.[80]

The Stéréorama mouvant was praised for its artistic quality, and received the jury's Grand Prix, but it was really a descendant of the mechanical theaters of the past. The circularity recalls Johann Adam Breysig's unrealized "cosmotheater" or "autokinesit theater," as well as an attraction described in a patent by

Figure 10.18
A diagram of the mechanism of Francovich and Gadan's Stéréorama, 1900. From *Le Monde Moderne* (Paris: Albert Quantin), vol. 12 (July–December 1900), p. 539.

the French artist Henri Motte in 1890.[81] The name Stéréorama may have referred to the three-dimensional effect of Francovich's and Gadan's creation, resounding with the word stereoscope.[82] In fact, another attraction named Stéréorama had already operated at the Eiffel Tower after the Paris Exhibition of 1889.[83] It was a version of August Fuhrmann's recently introduced Kaiser-Panorama, a cylindrical stereoscopic peepshow apparatus for multiple spectators that soon grew into a huge network of venues across Continental Europe.[84]

"VEHICULAR AMPLIFICATION," OR THE QUEST FOR IMMERSION

Le Panorama Transsibérien, le Maréorama, and le Cinéorama had a common feature, which could be called "vehicular amplification." They did not just invite the audience on imaginary journeys like countless moving panoramas before

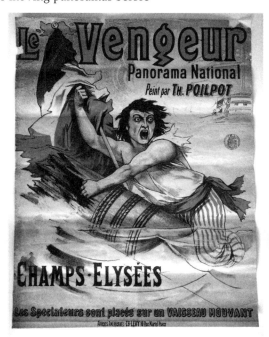

them.[85] Instead, they enhanced their reality effect by turning the auditorium into a vehicle—train, boat, or hot-air balloon. This was not new. In his Navarino panorama (1831) Colonel Langlois had already simulated the deck of the warship Scipion (which had taken part in the confrontation) as the viewing platform.[86] Poilpot had used a similar solution in his panorama for the Compagnie Générale Transatlantique (1889), and gone a step further in his "steam panorama" Le Vengeur (1892), where a gas engine made the boat-platform roll and pitch. Although the painting and the concentric circles of cutout waves that surrounded it were static, the rocking platform created the illusion of motion.[87]

When it comes to moving panoramas, a boat for thirty participants had already been used in Carl Ferdinand Langhans's Pleorama exhibit at Gropius's Diorama in Berlin (1832–1833). Canvases rolled by on both sides, as they also did in Edward Sparkhall's 1855 patent (see chapter 6).[88] All in all, however, there were relatively few examples, which probably has to do with the moving panorama's identity as an itinerant attraction.[89] Because the shows were

Figure 10.19
Poster for Théophile Poilpot's panorama *Le Vengeur*. *Panorama National* (1892). Paris: Affiches Américaines, Ch. Levy, 10 Rue Martel. The dramatic poster announces that "the spectators are placed on a ship in motion." Author's collection.

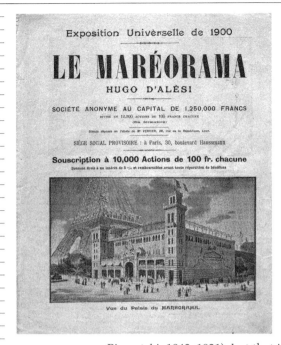

Exposition Universelle de 1900

LE MARÉORAMA

HUGO D'ALÉSI

SOCIÉTÉ ANONYME AU CAPITAL DE 1,250,000 FRANCS

DIVISÉ EN 12,500 ACTIONS DE 100 FRANCS CHACUNE
(En formation)

Statuts déposés en l'étude de Mᵉ VERNIER, 38, rue de la République, Lyon.

SIÈGE SOCIAL PROVISOIRE : à Paris, 30, boulevard Haussmann

Souscription à 10,000 Actions de 100 fr. chacune

Donnant droit à un intérêt de 5 % et remboursables avant toute répartition de bénéfices

Vue du Palais du MARÉORAMA.

not permanent, transporting elaborate "vehicles" and erecting them over and over again would have been cumbersome and costly. It was easier to make the audience imagine it was sitting in a contrivance crossing seas or lands.

Universal expositions knew no such limitations. Their attractions had to look and feel as if they were permanent. Budgets were high, because the projects were backed by governments, corporations, or stock companies. The Panorama Transsibérien was commissioned by the Compagnie Internationale des Wagon-Lits (a sleeping-car enterprise) to promote the Moscow-Beijing railway, which was then under construction. It was exhibited between the Siberian section of the Russian Pavilion and the Chinese Pavilion. The system had been designed by the architect Chédanne, and the canvas painted by the French theatrical scene painters Marcel Jambon and his son-in-law A. Bailly, who had traveled to Russia to take sketches (only Bailly made it to the Far East).[90]

This attraction has often been attributed to the famous Russian military doctor, traveler, and watercolorist Dr. Pavel Pyasetsky (Piasecki, Piassetski, 1843–1921), but that is a mistake caused by a curious coincidence: Pyasetsky exhibited his own moving panorama about the *same* topic in the Siberian section of the Russian building.[91] It was hundreds of meters long and divided into several rolls, but it was only a 48.5-centimeter-tall miniature painted in watercolor.[92] Photographic lantern slides in color were projected in the same room, so claims that it was watched from the windows of "some railway cars" are absurd.[93] This small-scale exhibit has simply been confused with the international sleeping car company's megashow.

Jambon and Bailly's panorama was installed as a kind of symbolic passageway between the Russian and the Chinese Pavilions; representations of the railway stations of Moscow and Beijing (housing restaurants) were in its opposite ends. Moving scenery depicting the still unfinished railway route between these two cities was viewed from three authentic but stationary railway cars. They are said to have contained a dining room and smoking salon, luxurious sleeping compartments, and even a beauty parlor and a gym.[94] The goal was to convince the visitors of the comforts the international sleeping car company was offering its clients. The illusion of travel was enhanced by three zones of moving cutouts —from the sandy ground next to the tracks to trees further away—rotating as endless loops in front of the main canvas. The speeds had been carefully calculated so that the elements closest to the spectators moved fast, and the ones

Figure 10.20
The cover of the prospectus for the Maréorama stock company, four pages, 1899–1900. Author's collection.

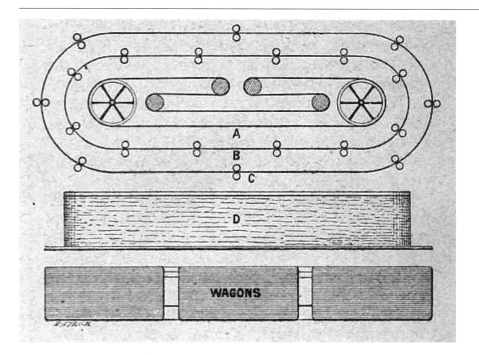

behind them progressively slower.[95]

A related way of using moving rows of cutouts was described by Henri Motte in his 1890 patent (mentioned earlier). Motte's auditorium consisted of three stationary railway cars as well. The main difference was that the moving canvas and the rows of cutouts were *circular* (evoking Francovich and Gadan's Stéréo-rama). As an alternative, the railway cars could be moved along circular tracks to the opposite direction compared with the painting and the cutouts. Most interestingly, Motte mentions in passing yet another option: the scenic elements could be rotated endlessly between two cylinders; the canvas and the strips of cutouts would be straight rather than cylindrical. This arrangement closely resembles the Transsiberian railway panorama, and one wonders if it was based on Motte's patent (which had been granted for fifteen years, and was therefore still valid).[96]

Pyasetsky's miniature panorama was awarded the jury's Grand Prix, whereas the reception of Jambon and Bailly's spectacle seems to have been more mixed. An American found it "certainly remarkable," but considered the journey "dull."[97] A Japanese visitor thought that the idea of promoting a new railway line by simulating the journey in advance was interesting, but the result disappointed him; the mechanism did not function properly:

Figure 10.21
Ground plan of Jambon's and Bailly's Transsiberian railway panorama. The audience sat in railway cars (bottom). Closest to it was the railway's track bed that moved in the manner of a treadmill 300 meters per minute. Behind it there were two rows of cutouts rotating endlessly 120 meters and 40 meters per minute. Behind them, Jambon's and Bailly's background canvas moved five meters per minute.

From *Le Monde Moderne* (Paris: Albert Quantin), vol. 12 (July-December 1900), p. 539.

312

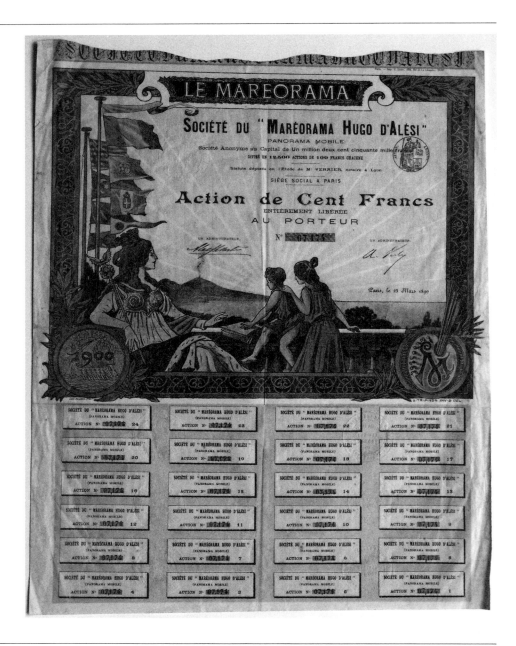

Figure 10.22
Stock certificate for the Maréorama company, c. 1900.
Author's collection.

The Russian person who stood at the entrance an-
nounced that there is a railway inside with a train
and paintings representing the entire landscape
between Beijing and Moscow. I thought it must be
a train running on circular tracks. As I entered,
I realized to my surprise a train with several cars,
but fixed, not moving. The painting on my left did
not seem to move either—to my astonishment I dis-
covered that only the paper-made bushes and hedges
between the train and the picture were moving by
rotation. Someone explained that the picture would
start rotating in a few minutes, creating a feeling
that the train was in motion—as if one was on
a boat shooting down a rapid stream like an arrow,
and the mountains on both side would seem to rush
by at great speed. However, even after 30–40 minutes
the painting still had not started moving. I have
lived in Russia for a long time and know how slow
the Russians are, but this was too much for me.[98]

The Maréorama, or *Illusion d'un Voyage en Mer*
à Bord d'un Paquebot ("illusion of a sea cruise
on an ocean liner") was touted in advance as one
of the highlights of the exposition. It was plan-
ned meticulously, and already patented in 1894.[98]
The majestic palace housing it (designed by the
architects L. C. and A. Lacau) was erected in a central location almost next to
the Eiffel Tower. It was an ambitious speculative venture, an enormous side-
show funded by a stock company. The Compagnie Générale Transatlantique,
whose stationary seaside panorama was, ironically, just behind the Maréorama
(practically in its shade), would no doubt have been more than happy to have
hosted it.

The father of the project was Hugo d'Alési (Frédéric Alexianu, 1849–1906),
a well-known commercial artist, whose handsome railway and shipping com-
pany posters would now entitle him to be called a graphic designer.[100] In a typi-
cal fin-de-siècle fashion that bridged seemingly incompatible opposites, d'Alési
(like his wife) was also known as an ardent spiritualist. He was a drawing me-
dium, who produced automatic portraits of the deceased while in a trance, and
signed them by names received from the spirit-world. It was even claimed that
the autodidact Rumanian-born artist had been taught his skills by the spirits.[101]
However, when his conscious mind took action, it neatly replaced the haunts
of afterlife with the phantasms of capitalism.

Maréorama offered a Mediterranean cruise from Villefranche to Constanti-
nople, with stops at Sousse, Venice, and Naples.[102] One wonders if d'Alési's
esoteric interests had something to do with his determination to produce a true

Figure 10.23
The mechanism of the Maréorama on the cover of *Scientific*
American 83, no. 13 (Sept. 29, 1900). Author's collection.

alternate reality. Two enormous moving panoramas, each 750 meters long and 13 meters high, were rolled by motors on both sides of a simulated steamer's deck (33 meters long and eight meters wide) that served as the viewing platform. The spools floated in huge water tanks. As the weight of the take-up spool increased, it sank deeper and the canvas was caught around the conical top; the other spool ascended at the same time. This solution balanced the weight of the canvases, kept them straight, and protected them from being torn apart.[103]

The steamer-platform rested on an elliptical pivot, supported by four hydraulic pistons, which allowed the boat to pitch and roll. The solution used existing stagecraft technology, but also anticipated the hydraulic simulator platforms still used in training and entertainment.[104] The seven hundred spectators were free to stroll around, sit on deck chairs, and descend to a dining room. They observed the ship's crew in action, sensed the smell of tar, felt the salty sea breeze, witnessed smoke rising from the funnels, and heard the sounds of a steam whistle. Elaborate dioramic effects simulated different times of the day, and a climactic storm broke out between Naples and Constantinople. The spectacle was accompanied by a "descriptive symphony" by the noted salon composer Henri Kowalski, and "local" performers from each port entertained the audience on the deck.[105] Postcards depicting passengers on the cruise completed the illusion; many were sent, and some may even have been written aboard in the manner of real tourists.

Was Maréorama successful? It earned over 588,000 francs, whereas the Panorama Transsibérien made just over 237,000, and Poilpot's Panorama of the Compagnie Transatlantique only 109,000.[106] The calculations on the website exposition-universelle-paris-1900.com show, however, that this was less than half of the total investment; the loss was severe. There are surprisingly few eyewitness reports, which may indicate that the illusion was less powerful than the publicity machinery tried to make one believe. An American journalist bluntly stated that "one does not feel at sea," and criticized d'Alési's paintings for their "bad drawing" and "suggestion of chromo-lithography"—a bad accusation indeed.[107] Recalling the comments made about the Diorama's rotating auditorium,

Figure 10.24
Tradecards depicting the Maréorama building and spectators observing the destination, Constantinople. Chromolithographs by H. Toussaint for the chocolate manufacturer Guérin-Boutron, 1900. Author's collection.

Figure 10.25 + 10.26 (next page)
Postcards depicting "passengers" aboard Hugo d'Alesi's
Maréorama, 1900. These postcards purport to represent the
typical behavior of cruise passengers, and were meant to
be mailed according to the normal rituals of tourism. However,
read symptomatically, they seem to indicate that there was
little of interest in the painted canvases. Author's collection.

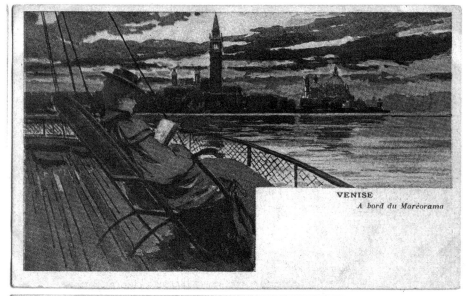

VENISE
À bord du Maréorama

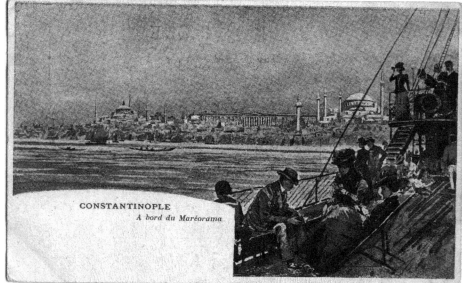

CONSTANTINOPLE
À bord du Maréorama

Figure 10.26

the pitching and rolling of the ship was said to have made some participants seasick, although this may have been just a re-enactment of the old topos.[108]

The scale of Maréorama's multisensory simulation may have been unprecedented, but its ingredients were not. As a synthesis of circular and moving panoramas it was a magnified summary rather than a fresh new start. D'Alési's "noteworthy oddity" (as one article called it), was promoted for the shareholders as an "easily transportable exhibit" that could be installed in other major cities.[109] D'Alési suggested that other cruises could be painted and exhibited with the same system.[110] None of this took place, most likely because of the cost of transporting the cumbersome machinery, and the necessity of erecting a huge building for it. D'Alési died in 1906, which put an end to his painting plans; the company may already have been dissolved by then (although it was established for twelve years).

Raoul Grimoin-Sanson's Cinéorama also drew inspiration from the past while it pointed toward the future. Like Charles A. Chase's Electric Cyclorama, it adopted the form of the circular panorama, but replaced the painted canvas by projected images. The venture was based on a series of patents issued between 1896 and 1899.[111] The idea was to take the audience on a simulated aerial voyage by

Figure 10.27
Cinéorama, from Raoul Grimoin-Sanson, *Le film de ma vie* (Paris: Les Éditions Henry-Parville, 1926), p. 126. The illustration indicates that there were spectators both in the carriage of the "balloon" and in the area around it. The tickets for the carriage cost two francs and one franc for the surrounding area. Curiously, the Cinéorama's façade towards the Seine was La Maison Kammerzell, a simulation of an old house from Strasbourg that functioned as a restaurant (left). The rotunda was also covered by Alsatian galleries — modernity was disguised in tradition. From an autographed copy of the book in author's collection.

means of circular moving pictures shot from a hot-air balloon. The central viewing platform was designed as the carriage of such a balloon. Its scale overshadowed Henry Giffard's famous gigantic captive balloon that had transported 30–40 aerial tourists at a time to the skies above the Tuileries.[112] A circle of ten projectors was installed in a projection booth underneath the platform.

When it came to the films, compromises could not be avoided. The opening scene was shot with radially arranged 70-millimeter film cameras from a hot-air balloon that ascended from the Tuileries in a public event. However, all the other films, including views of the Grand Place in Brussels, the Carnival of Nice, a bullfight arena in Barcelona, and scenes from Tunis, were shot from ground level.[113] The point of view was raised back to the skies only in the closing scene that depicted the balloon's return to the Tuileries. Because shooting the descent had failed, the opening scene was simply repeated—backward. This created a symmetric closure, but one that could not have taken place in real life (unless a captive balloon or a dirigible was used).

The Cinéorama purported to offer a travelogue, but there was no continuity between the films. Grimoin-Sanson was aware of this, and suggested that darkness, canvases with painted clouds, and a "captain's" explanation could be used to disguise the lacunas.[114] Whether this was attempted is not known, because the attraction seems to have been closed as a fire hazard after only four performances.[115] The program was witnessed by only a handful of spectators, who left no testimonies.[116] In his autobiography Grimoin-Sanson blamed the hasty production schedule and a confusing organization for the failure.[117] Even so, Cinéorama was a brave attempt to synthesize moving images and panoramas, and deserves a place in the histories of virtual reality and specialty moving image attractions.

While they apparently endorsed it, all these projects also manifested a certain disbelief in the power of images, for different reasons. Both the Maréorama and the Transsiberian panorama resorted to painting, which was becoming obsolete in media culture. Although it still had some advantages (size, color, fantasy, rich details), the vehicular multisensory experience was used to turn part of the attention away from the canvases. When it comes to the Cinéorama, cinematography itself was an attraction, but it was still in its infancy, and its spectacular possibilities remained underdeveloped (Louis Lumière tried to correct the situation with his Giant Cinématographe projections at the Salle des Fêtes). Cinéorama's simulated balloon environment could have prevented the audience from paying too close attention to the crudest aspects of the film program, such as the lack of color and continuity.

Vehicular amplification was part of a complex play between expectations, trends, promotions, and willing suspension of disbelief. This explains the popularity of *Hale's Tours and Scenes of the World*, which is often said, probably incorrectly, to have been introduced at the midway of the Louisiana Purchase Exposition, St. Louis (1904).[118] The original idea was to transport the audience on a moving railway car into a building, where a second stationary car served as a movie theater. Recalling Maréorama, the films were enhanced by rocking the car, sound effects, and electric fans blowing gusts of air. Although the screen was in

the end of the car, denying the spectators the Transsiberian railway panorama's sidelong panoramic view, nearly all the elements derived from earlier attractions.

Hale's Tours became popular both at amusement parks and city centers, often as stripped-down versions of the patented idea. Sometimes just a stationary railway car (perhaps a simulated one) behind a storefront was used. Connections with earlier panoramic spectacles became evident. Much like Hamilton's Excursions, the promotional strategies touted tours around the world. As in the Maréorama, postcards were used as a promotional medium, disseminating familiar sounding slogans such as "Thousands Travel Daily to the Wonder Places of the Earth," "Trains Every 10 Minutes," and "We can visit the Colonies or any part of the world (without luggage!) and return within fifteen minutes."[119] These playful and persuasive promises built on the strategies of panorama showmen.

Hale's Tours was short-lived (some were converted into cinemas), but patent archives reveal that others cherished similar ideas. The Englishmen Cecil Eustace Hicks and Ernest Wigan focused their attention on "the illusory experience of a sea voyage or water trip."[120] Their rolling and pitching simulation platform recalled Maréorama, but the viewing situation was similar to Hale's Tours: the audience

Figure 10.28
Building housing a *Hale's Tours* ride, side by side with a typical Katzenjammer Castle fun house. Unidentified photograph, c. 1905-10. Author's collection.

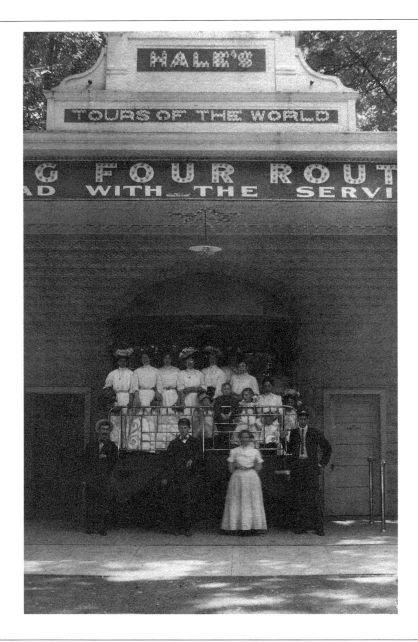

Figure 10.29
A group of ladies and children posing for the camera before
taking a ride on *Hale's Tours of the World*. It seems they are
standing at the back of a movable railway carriage. The four
people in the foreground are probably the staff; the person
on the left may be the manager. Unidentified photograph, c.
1905-10. Author's collection.

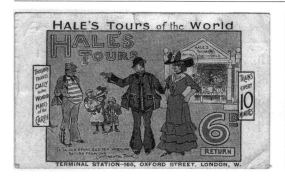

sat in front of a projection screen.[121] Vehicular amplification had come to stay—
Star Tours and *Back to the Future—the Ride* belong to the same lineage. Even painted
canvases reappeared from time to time. The French railways exhibited an attrac-
tion named *Le Diorama Mobile* at the Paris International Exposition of 1937. Lo-
cated at the "Railway Palace" of the Gare des Invalides, it was basically identical
with Jambon and Bailly's Panorama Transsibérien (which was not mentioned),
except that there were *two* trains with three cars in each. A moving panorama and
rows of cutouts rolling as endless loops (six layers of elements) ran between them.[122]

Moving canvases were not forgotten by the culture industry either. A scene
in *Letter from an Unknown Woman* (1948), directed by Max Ophüls, recalls both Le
Panorama Transsibérien and Le Diorama Mobile. The protagonists,
a famous pianist and a woman hopelessly in love with him, take a ride in an
amusement park train simulator (at the Prater in Vienna), "traveling" across
different countries—on panorama rolls moving behind the window. The rolls are
changed by an old man by pulling strings, which evokes both peepshows and
theatrical technology. He animates the rolls by pedaling on a stationary cycle.[123]

The train simulator was again teased out from the cultural memory in an
episode of the British cult television series *The Avengers* (1965), where one was
installed at a rich old eccentric's home, designed to look like a railway station.[124]
The illusion of traveling was produced by an endless canvas rotating between
two cylinders behind the window of the railway car, accompanied by a whole
array of other sensory stimuli, all activated by a toiling manservant.[125] More
recently, media artists like Michael Naimark, and Christa Sommerer & Laurent
Mignonneau have simulated rail travel in their interactive installations.[126] In
Sommerer & Mignonneau's *HAZE Express* (1999), the participants sit in a train
compartment (much like in Ophüls's film). Instead of just watching the passing
scenery, they stroke the interactive window pane and affect the flow of the digi-
tal landscape; the normal coordinates of the situation have been reversed.[127]

Figure 10.30
Hale's Tours of the World. A postcard for the establishment
that operated in London at 165, Oxford Street. Hand-dated
on the back: February 10, [19]08. In the background on the
right we see spectators leaving on a "Trip to Spain" much
like the visitors in the photograph on previous page.
Author's collection.

Figure 10.31
"Train Window Panoramas. New Tokaido Line." The cover of
a leaflet for the Japanese National Railways, announcing
the new Shinkansen bullet train service, 1964. The topos of
the moving panorama seen from the train window has been
recruited to the service of the most advanced train service
of the time. Author's collection.

NOTES

1. *100 Years of Showmanship: Poole's 1837–1937*, [ed. John R. Poole] (Edinburgh: Pillans & Wilson, Printers). (BDC).

2. Charler Brewer, "Chapter V: Charles W. Poole. The Poole Family and Their Myriorama," typewritten script for a BBC radio program featuring John R. Poole and others (copy in EH). According to Powell, the broadcast was on Feb. 14, 1950. Powell, *Poole's Myriorama!*, p. 146.

3. Gompertz and his partner Haswell exhibited this program at the Victoria Rooms, Queen-street, Hull, beginning on May 10, 1841 (broadside in EH). The bombardment of Acre (during the Oriental Crisis of 1840) ended the moving panorama of Turkey and Syria, and may have been a single scene with special effects. The program also contained "dioramas" of the last moments of Lord Nelson and the holy shrine of the nativity in Bethlehem. See also Gompertz's obituary, *Evening Telegraph*, Dec. 30, 1893, where his panoramas are listed. He is thought to have begun his career as a theatrical scene painter in Exeter. Powell, *Poole's Myriorama!*, p. 14.

4. "A Panorama of Mr. Joseph Poole's History," *The Herald of Wales*, Jan. 5, 1895 (in the Poole scrapbook, JWB); ad for Messrs. Poole's *The World* at the Public Hall, Worcester [no date, but because of context in the Poole scrapbook probably 1883, JWB).

5. Another explanation can be found from a broadside for Chas W. Poole's *New Eclipse Myriorama*, Sanger's Amphitheater, London, c. 1890 (EH). It states: "Proprietor and Originator, Mr. Charles William Poole, of the Poole Bros. (Successors to Poole & Young and. M. Gompertz), Established 1837." 1837 was the first year information of Gompertz can be found as a scene painter in Exeter, so the Poole's saw themselves as his descendants.

6. Powell, *Poole's Myriorama!*, pp. 35–36, and passim.

7. For the early career of Poole & Young, see Powell, *Poole's Myriorama!* The next generation showmen Joseph and George Poole also performed as Strange & Wilson, because of family-related arrangements.

8. *Times*, Nov. 21, 1862. The topic of the "diorama" is not mentioned. One wonders if Poole & Young decision to become independent had something to do with this incident? Gompertz's late productions may have been managed by partners and relatives. In a broadside for "M. Gompertz's new entertainment, England and Russia," Good Templars' Hall, Lanark (1870s?), Gompertz lists many of his panoramas and reminds that "in addition to his own labours he secured the assistance of all the greatest London Artists available." (BDC). Gompertz seems to have worked with Charles Marshall on his "Diorama of the Indian Mutiny." *Civil Engineer's and Architect's Journal* (London), 21 (1858): 208.

9. John Henry Pepper, *The True History of Pepper's Ghost* [original title: "A True History of The Ghost and All About Metempsychosis"] (London: The Projection Box, 1996 [orig. 1890]).

10. Even at the Royal Polytechnic Institution the head of a living human had already been projected in giant size by a device called "physioscope." Lester Smith, "Entertainment and Amusement, Education and Instruction: Lectures at the Royal Polytechnic Institution," in *Realms of Light*, p. 139. Living humans had been projected by E.-G. Robertson in his Fantasmagorie, and also by Schirmer and Scholl with their Animated Megascope. The latter claimed that the principle had been invented before Robertson had begun using it. Heard, *Phantasmagoria*, pp. 101–102. In France, the magician Henri Robin contested Dircks's and Pepper's priority, which led to a bitter dispute. Mannoni, *Le grand art de la lumière et de l'ombre*, pp. 235–237.

11. In the competing but essentially identical "Ghost Illusion (King's Patent)" the climax was the "sudden and spiritual appearance of the murdered Amy." In the end of the first act, "the warning spirit of her mother" had already appeared in an "astounding optical climax." A broadside lists the actors, while the Ghost is said to be represented "by itself." (Prince's Theater, Glasgow, September 1863, as part of a two-act play called *Stricken Oak*, EH). In August 1863 the Pepper's Ghost, the "Greatest European Sensation," was introduced to the United States in the romantic play *True to the Last!* at Wallack's Theater, New York. (Broadside in EH).

12. Undated broadside from Holloway Hall, Holloway (probably 1860s) at JJCB. The program included a "musical melange" and a "Laughable Spectral Sketch," but no moving panoramas.

13. The fire took place January 3, 1900, the new opening was January 8. Poole's announcement was published on Saturday, January 6. (Poole scrapbook, JWB).There are several newspaper clippings about the incident in the Poole scrapbook.

14. The latter scene was a staple of Gompertz's shows, and may have been obtained from him.

15. Program booklet in EH. It includes a song book, which probably means that the audience was encouraged to sing along.

16. Jules Verne, *Around the World in Eighty Days*, trans. Geo M. Towle (Boston: James R. Osgood and Co., 1876, orig. 1873). Fogg's adventure started and ended in London, just like Poole's Myrioramas and Hamilton's Excursions.

17. "Joseph Poole's Latest and Greatest Myriorama," no date, p. 2

(GRI). The title may have been adopted from the well-known Myriorama card sets that also emphasized variety (see chapter 2). However, in December 1833 the "nautical drama" *Captain Ross! Or, the Hero of the Arctic Regions* (Queen's Theatre, Tottenham Street, London) included a "Myriorama, or Series of Views, the Departure, Progress, and Fate of the Navigators," painted by Mr. Turner and Mr. W. Turner (playbill in EH).

18. The history of the Hamilton family is poorly known. Powell, *Poole's Myriorama!*, says little. Unlike the Pooles, the Hamiltons did not include much information about themselves in their publications, or give newspaper interviews. Patching together various sources, I suggest that the main showmen were four brothers: Alfred H., Joseph (died Jan. 16, 1895), Harry H., and William (1837–1907 ?) Hamilton (their father seems also Joseph Hamilton). "Messrs. Hamilton" was sometimes used. H. Southern, in "The Centenary of the Panorama," *Theatre Notebook* 5 (1950–1951): 67–69, says "Hamiltons was founded in 1848," but provides no source. Leaflet for *Hamilton's Excursions to the Capitals of Europe* (Corn Exchange, Cupar-Fife, June 27–July 3, [1877]—in JJC) says William commenced his "undertaking" in 1852. Various other family members and partners, such as Overend, and James Anderson, contributed over the years. In 1875, in Hamilton and Overend's Royal Diorama, Mr. A. L. Hamilton was "a pleasant lecturer and guide" and Mr. L. Hamilton sang (*Staffordshire Sentinel*, March 25, 1875, p. 2).William had a son named Willie who died in 1895, aged 22 (the same year as Joseph). The Hamiltons are said to have toured until 1910, but they still gave some panorama performances between 1922–1924. The family moved into the cinema business, managed by Victor Hamilton (a son) and his son Douglas W. Hamilton (Southern, "The Centenary of the Panorama," p. 68). One of their cinemas was the Picturedrome (later Astra) in Bradford, opened in 1910 (www.kingsdr.demon.

co.uk/cinemas/astra.htm last visited April 1, 2012).

19. A leaflet for *Excursions Hamilton. Un voyage autour du monde en deux heures et démie*, shown at Cirque Royal, Brussels, in the Poole scrapbook (JWB).

20. *Harry H. Hamilton's Excursions Passing Events*, broadside, Colston Hall, Bristol, Feb. 21, 1882 (EH). A broadside for *Hamilton's Excursions, At Home and Abroad* (Sanger's Royal Amphitheater, late Astley's, London, 1875, JJCB) promised that "all the Principal Streets, Cities, and Natural Scenery in the World are constantly on view for 20.000 miles." The claim had swelled sixfold in seven years! See also *William Hamilton's Delightful Excursions at Home & Abroad*, broadside, Sanger's Royal Amphitheater, broadside, [1875] (Evanion).

21. *Round the World in Two Hours via Hamilton's Excursions At Home and Abroad*, broadside, Sanger's Royal Amphitheater, late Astley's, Westminster Bridge Road, London [1875] (JJCB). Ironically, on June 6, 1867, the London *Times* reported a serious railway accident involving Hamilton's show. The tall caravan was being transported on a train, when its top hit a low bridge and crashed into the next passenger car. Several people were seriously injured. Hamilton's "Diorama Exhibition" was on its way from Airdrie to Greenock; the train's destination was Glasgow.

22. "A Curious Steam-Ship. The Bessemer Channel Steamer," *New York Times*, Sept. 10, 1874.

23. The tests took place in the spring of 1875, just as Hamilton's panorama was on display. Sir Henry Bessemer told his own version of the steamer project in *An Autobiography* (London: Offices of "Engineering," 1905), ch. 20. According to him the failure had nothing to do with the swinging saloon, although it had been

suspected of serious instability.

24. Unidentified newspaper clipping about the Hamilton exhibition at the Egyptian Hall, Oct 3, 1860 (JJC).

25. "Panoramas and all the other 'ramas: an Interview with Mr. Poole," *Pall Mall Gazette* (Aug. 31, 1889), in the Poole scrapbook (JWB). The article does not specify who was interviewed.

26. *Isle Wight Mercury*, Sept. 27, 1883, clipping in the Poole scrapbook (JWB).

27. *Hamilton's Excursions and the Grand Panstereorama of Passing Events*, broadside, Royal Amphitheater, Holborn, London (Evanion, BL).

28. "Panoramas and all the other 'ramas: an Interview with Mr. Poole."

29. "Panorama of Mr. Joseph Poole's History," *The Herald of Wales* (Jan. 5, 1895), in the Poole scrapbook (JWB). The reporter has interviewed Poole, but does not quote him directly—could the "30 rollers" mean the number of rolls in the entire show?

30. For the Royal Amphitheater in Holborn, a broadside in Evanion, BL (mentioned earlier); for Bristol, broadside for *Harry H. Hamilton's Excursions Passing Events*, Colston Hall, Bristol, Feb. 21, 1882 (EH).

31. Stephen Bottomore, *The Titanic and Silent Cinema* (Hastings, East Sussex: The Projection Box, 2000), pp. 65–68.

32. For information on the late developments, I am indebted to Powell, *Poole's Myriorama!*.

33. "Obituary: Jim Poole," *Independent*, March 31, 1998.

34. Oettermann's *Ankündigungs-Zettel* contains broadsides for such shows, mostly from Germany.

35. I made two research trips to the Musée des Arts Forains in April 2011. This was made possible by the museum's generous owner, Jean-Paul Favand, who helped me in any possible way. The Belgian collector Thomas Weynants from Ghent, who first informed me about the Morieux find, allowed me to consult some key pieces from his own collection, including series of handwritten notebooks. A full excavation of the Théâtre Morieux remains a task for the future.

36. Letter from "Buiron fils" to Jean van Devoorde, Nov. 9, 1869. My discussion is based on the family correspondence. Jean-Henri's son Léon married Charlette Buiron. Léon's name is sometimes given as Vandevoorde-Morieux, perhaps emphasizing a family liaison.

37. In the Favand collection there is a German booklet of a Theater Morieux operated by E. Hensel, and a broadside of another Morieux show operated by Joseph Hensel from Bremen. The broadside dates the origin of the show 1803. One wonders what was the relationship between the Hensels and the Vandevoordes? The Hensel broadside warns against imitators using the Morieux name. Appropriation of a successful "brand" was not uncommon. But who was imitating whom?

38. Léon also exhibited in Germany. He was mentioned in his German broadsides as "frère (brother) Morieux," or "Morieux Frère." His German program booklets from the 1880s only speak about Léon van de Voorde's mechanical theater, without mentioning Morieux. Perhaps he had no right to use the word in the German-speaking territory. Who were Edouard and Eugen(e)? Léon's uncles? "Eugen v. Devoorde" was still exhibiting after 1894, as a broadside for "Grosses Original-Mechanisches Theater Morieux" demonstrates. In: *Theatrum mundi*, ed. Rolf Mäser (Dresden: Staatliche Kunstsammlungen Dresden, 1984), p. 16.

39. The latest date in a broadside I have seen is June 28, 1932 (Jemappes, Place de Jèricho). Late in life Léon operated the "Nieuwe Circus" or "Nouveau Circus" in Ghent. The building still exists (email from Thomas Weynants, May 2011). A key document is a typewritten draft for a flyer addressed to city authorities, dated 1920. The 63-year-old Léon asks for concessions to be able to relaunch his show that had been partly destroyed in World War I. He wants to start over, so that his son Edmond, who had fought as a volunteer, could "entertain our youth still for a long time." (Favand Coll.).

40. Pierre's history deserves to be discussed in detail elsewhere. His real name was Jean-Pierre Claude (1839–1814). For many years he traveled with a show of mechanical pictures and experimented with aeronautics with another Frenchman named Degabriel. The latter died suddenly around 1801, after which Pierre settled down in Paris, and opened his permanent show on May 16, 1802, using ideas he had developed for years with Degabriel. Pierre died in 1814, but his spectacle was continued for years by his former assistants, who also took it on tour. (Synthesized from multiple archival sources).

41. Broadside for M. Thiodon's "Grand Original Mechanical and Picturesque Theatre, Illustrative of the beautiful Effects of ART in Imitation of NATURE," Royal Rooms, Spring Gardens [London], July 1817 (JJC).

42. *Encyclopedia Londinensis, or, Universal Dictionary of Arts . . .*, vol. 18 (1821), p. 484. When Pierre's spectacle was displayed at the Sans Pareil Theater in London, it "did not excite the attention which it merited," perhaps because similar shows had already been seen.

43. The wooden megascope has been preserved at the Musée des Arts Forains and still works perfectly.

44. A piece from an abandoned arctic panorama, showing a ship stuck in ice, has been used sideways as a "header" in the beginning of the roll.

45. A postcard written by Léon from Paris to his wife in Ghent (Sept. 14, 1900), indicates that Léon and their son Edmond were then visiting the exposition, probably taking sketches for the panorama.

46. Several handwritten lecture texts that show signs of wear from heavy use, exist in the collection. The one about the exposition panorama, singles out the Maréorama, among other things, creating a panoramic association.

47. *The Colosseum Handbook, Descriptive of the Cyclorama of "Paris by Night," Now on Exhibition, S. E. Corner Broad and Locust Streets* (Philadelphia: Allen, Lane, and Scott's Printing House, 1876), p. 2 (EH).

48. Hyde, *Panoramania!*, p. 169.

49. *Panorama of the Defense of Paris against the German Armies painted by F. Philippoteaux*, booklet (Paris: Impremerie administrative de Paul Dupont, 1872) (EH). The existence of an English-language explanatory booklet says something about the panorama's success. Also the French version is in EH.

50. It was on display at the Pantheon, 658 Washington Street. Broadside for the grand opening on March 29, 1875 (Boston: Job Print) (EH).

51. The identity of the Pantheon is a mystery. In 1878 Gleason, publisher of *Gleason's Pictorial*, is given the same address. Did Gleason use the Pantheon building, or was it already replaced by a new structure? Boston was undergoing intense building activity at the time because of the great fire that had taken place just a few years earlier. The broadside claimed that Cycloramas of Paris

and London were under preparation. Perhaps the Pearsons planned to exhibit the panoramas brought over from the Regent's Park Colosseum to its namesake in New York?

52. The group was led by R. L. Kennard, who at least nominally made a deal with P. T. Barnum. The venue was even advertised as "Barnum's Colosseum." See "Colosseum," *New York Times*, May 5, 1874.

53. T[homas] Allston Brown, *A History of the New York Stage From the First Performance in 1732 to 1901* (New York: Dodd, Mead and Co., 1903), vol. 3, p. 371.

54. The word may have been adopted from Regent's Park's Cyclorama of the Lisbon earthquake, although it had been a kind of moving panorama (see chapter 6).

55. It had been painted by Philippoteaux with his son Paul, who became a famous panorama painter. The arrival of the painting in the United States was announced in the *New York Times*, Oct. 12, 1875. The notice mentioned that it would be shown at the Colosseum although its "ultimate destination is Philadelphia." On Nov. 7, 1875, the *New York Times* reviewed the painting which had been open to the public at the Colosseum since "last Monday." The structure of the Colosseum and its transfer were discussed in detail in James D. McCabe, *The Illustrated History of the Centennial Exhibition* (Philadelphia: National Publishing Co., [1876]), pp. 77–80; the *Siege of Paris* in New York was mentioned in *Boston to Washington: A Complete Pocket Guide to the Great Eastern Cities and The Centennial Exhibition* (New York: Hurd and Houghton; Cambridge: Riverside Press, 1876), p. 101. The guide does not yet mention the Colosseum in Philadelphia. It was published before the exhibition opened on May 10. The original *Siège de Paris* remained in the rotunda on Champs-Élysées until the turn of the century. David Karel, *Dictionnaire des artistes de langue française en Amérique du Nord* (Montreal: Musée du Québec, Les Presses de l'Université Laval, 1992), p. 634.

56. "The Surrender of Yorktown. A grand panoramic exhibition to be established in this city," *New York Times*, Oct. 6, 1881. The "baron" was the father of the Finnish national hero Carl Gustaf Mannerheim, but he was not a real baron. *The Surrender of Yorktown* was painted by Raoul Arus and assistants in a studio in Nice, and exhibited in New York in a rotunda at the corner of Madison Avenue and Fifty-ninth Street. It was turned into a roller-skating rink when the panorama still hung on the walls. (*New York Sun*, Feb. 16, 1885). The painting was auctioned in 1890 (*Democrat Chronicle*, Rochester, Jan. 20, 1890).

57. Georges Petit, "Exposition Universelle: les Panoramas," *Revue scientifique (Revue Rose)*, 26th year, 1st half (Jan-July 1889), pp. 558–560. Poilpot's two panoramas have been confused in Comment, *The Painted Panoramas*, p. 71. The mistake is translator's.

58. "Le Panorama de la Compagnie Transatlantique a l'Éxposition Universelle de 1889," *La Nature* 17, no. 837 (June 15, 1889): 33–35. Guidebook for this panorama is in EH.

59. Charles D. Linskill, *Travels in Lands Beyond the Sea. Beauty and Glory of Western Europe* (Wilkes-Barre, Pa.: Robt. Baur & Son, 1888), p. 204.

60. *Panorama of the Defense of Paris*, p. 16.

61. Petit, "Exposition Universelle: les Panoramas," p. 558. Petit's description is the most precise I have found. There was also a diorama depicting la Touraine under construction at the dock.

62. Poilpot's poster was re-issued in Les Maitres de l'Affiche (Paris: L'Imprimerie Chaix, 1899), pl. 186 (EH). *Livret explicatif du diorama de Paris à travers les ages. Carré Marigny, aux Champs-Elysées* (Paris: Firmin-Didot, [1886]). (EH). The handbook marketed an illustrated book by Hoffbauer about the same topic (same publisher).

63. "Un coup-d'oeil En Amérique. Diorama au Jardin des Tuileries près du grand bassin." advertising card [1878] (EH). The diorama depicted a view of the docks of New York with the statue as it was supposed to be installed.

64. Wonders, *Habitat Dioramas*, does not discuss dioramas like this, concentrating on natural history museum exhibits where taxidermied animals were displayed behind glass in their natural habitats, surrounded by plants and other props and arranged in front of a carefully lighted "panoramic" backdrop.

65. Frederick Catherwood's New York rotunda (late 1830s) was an exception. Catherwood lectured every evening at half past eight. Hagen, *Frederick Catherwood*, p. 51.

66. Brander Matthews, "On the Battle-Field," *Century: A Popular Quarterly* 36, no. 3 (July 1888): 457–469. Quot. p. 468.

67. *New York Times*, Feb. 16, 1875.

68. Advertisement, *San Francisco Chronicle*, Jan. 5, 1891.

69. Moving panoramic backgrounds were used at Bayreuth. Jeongwon Joe, "Introduction: Why Wagner and Cinema? Tolkien Was Wrong," in *Wagner & Cinema*, ed. Jeongwon Joe and Sander L. Gilman (Bloomington: Indiana University Press, 2010), pp. 2–3. Joe uses the expression "panorama mobile."

70. Charles Arthur Chase, "Stereopticon Panorama Machine,"

U.S. patent no. 545, 423 (Aug. 27, 1895) (copy in EH).

71. The "Electric Cyclorama" was demonstrated in 1894 in the rotunda housing the panorama of the great Chicago fire of 1871. *Scientific American* 74, no. 8 (Feb. 22, 1896): 120; *Cosmos: Revue des sciences et de leurs applications*, vol. 34, no. 588 (May 2, 1896): 142–143. Hyde erroneously says that Chase's Cyclorama was shown at the Chicago World's Fair 1893 (*Panoramania!*, p. 181). Max de Nansouty claimed that Chase had appropriated an idea demonstrated in Paris in 1892 by the inventor Colonel Moessard and the optical instrument maker Alfred Molteni, who projected panoramic lantern slides on a semicircular canvas. Max de Nansouty, *L'année industrielle. Découvertes scientifiques et inventions nouvelles en 1898* (Paris: F. Juven et Cie, 1899), p. 227. Hugo Müller agrees, and mentions that the idea was presented on March 13, 1892, at the Conservatoire national des arts et métiers, in *Photographische Rundschau*, no. 3, 1896, p. 91.

72. Additional panorama-related patents are listed in *British Theatrical Patents 1801–1900*, ed. Terence Rees and David Wilmore (London: Society for Theatre Research, 1996).

73. Vanessa Schwartz mistakes it for a moving panorama in her *Spectacular Realities: Early Mass Culture in Fin-de-Siècle Paris* (Berkeley: University of California Press, 1998), pp. 168–169.

74. Louis Olivier, "Le Microphonographe et ses applications a l'éducation des sourds-muets, a la téléphonie et a la cinématographie," *Revue générale des sciences pures et appliquées* 8, no. 24 (Dec. 30, 1897): 1005–1009.

75. The system was called the "cinémicrophonographe." Paul Charbon, *La machine parlante* (Rosheim: Éditions Jean-Pierre Gyss, 1981), pp. 173–186. The system was patented in 1897 and a company named Phono-

rama founded the same year for its exploitation (pp. 178–180). The patent drawing in Charbon (p. 181) shows that a Cinématographe Lumière was used. Rick Altman erroneously uses the word "cinemacrophonographe" in *Silent Film Sound* (New York: Columbia University Press, 2004), p. 158, and many others have repeated the same mistake.

76. "Le cinémicrophonographe," *Revue des questions scientifiques publiée par la Société scientifique de Bruxelles* (Louvain: Secrétariat de la Société Scientifique, 1898), 2d series, vol. 3 (January 1898): 312. Author's translation.

77. Charbon, *La machine parlante*, p. 180. Mesguich mentions this in his memoirs *Tours de manivelle* (Paris: B. Grasset, 1933).

78. Amplifying the sounds was a problem. Aware of this shortcoming, Dussaud began working on a loudspeaker in 1898, but never came up with a satisfactory solution (Charbon, *La machine parlante*, pp. 182–186). *La Nature* reported that the system was meant to amplify the sound for a crowd of 10000 people! " George-F Jaubert, "Le microphonographe Dussaud," *La Nature* 25, no. 1236 (Feb. 1897), p. 147.

79. Auguste Francovich & Antoine Gadan, "Nouveau Grand Diorama Géographique mouvant, et en relief, avec Panorama interieur," French patent no 249975, August 17, 1895 (copy in EH). The patent is unusually chatty—thirty-five handwritten pages! Francovich and Gadan were both from Bône, Algeria.

80. An interesting rotating cylindrical or octogonal exhibit had been shown at San Francisco's Woodward Gardens around 1880. Created by the taxidermist and naturalist Ferdinand Gruber, it consisted of "scenes of taxidermied animals, props and painted backgrounds in motion." (From an explanatory text on a stereocard titled "The Zoographicon in Woodward's Gardens," San Francisco: Lange & Newth,

EH). More in my "The Diorama Revisited," pp. 213, 217.

81. Henri Motte, "Un panorama – illusion à images distancées et mobiles," French patent no. 205310, August 21, 1890 (copy in EH).

82. Francovich and Gadan explicitly referred to the stereoscope as a comparison in their patent. "Stereorama" had been used as an alternative title for "pansterorama," a three-dimensional miniature model. A Stereorama, a panoramic attraction, was painted by Grieve and Telbin in 1860 and displayed at the Cremorne Gardens in London. Special effects sequences in Poole's Myriorama shows were also called stereoramas.

83. "A Stereorama," *Cassell's Family Magazine* (London: Cassell & Co., 1890), p. 757.

84. It was pictured and explained in "Le Stéréorama de la Tour Eiffel," *La Lumière Èlectrique* 37 (12th year), no 32 (August 9, 1890): 258–259. There were two Kaiser-Panoramas in the "salon." Fuhrmann's device grew into a network of over 250 European cities. Ernst Kieninger and Doris Rauschgatt, *Die Mobilisierung des Blicks* ([Vienna]: PVS Verleger, [1996]), pp. 52–56. Rhonda Garelick presents a truly confused discussion of the Stéréorama and the Panorama Transsibérien, dotted with mistakes, in "Bayadères, Stéréorama, and Vahat-Loukoum: Technological Realism in the Age of Empire," in: *Spectacles of Realism: Body, Gender, Genre*, eds. Margaret Cohen and Christopher Prendercast (Minneapolis: University of Minnesota Press, 1995), pp. 307–308.

86. Oettermann, *The Panorama*, p. 159; *Jean-Charles Langlois 1789–1870*, pp. 64–65.

87. The mechanism was explained in *La Nature* 20, no. 1000 (July 30, 1892): 129–130. The ship was originally agitated by humans, but it proved

too exhausting. The panorama raised
a debate about Poilpot's representa-
tion of the events that led to the
sinking of Le Vengeur in 1794. In the
panorama, it was observed from the
deck of another warship, le Courrier.
The expression "Panorama à Vapeur"
was used by Mercure de France 5
(July 1892): 281. The poster and the
handbook for Le Vengeur are in EH.

88. Oettermann, The Panorama,
pp. 66–67; Edward Sparkhall, "Exhib-
iting Pictorial Representations," British
patent no. 313 (1855). Drawing No 6
illustrates the mobile ship-auditorium.
Copy in EH.

89. Sparkhall's project resembles
a theatrical scene with two moving
panoramas Georges Moynet describes
in Machinerie théatrale (c. 1893). See
chapter 4. Robert W. Paul's project for
a time machine, which was influenced
by H. G. Wells' story, belongs to un-
realized multisensory simulator
attractions. Terry Ramsaye, A Million
and One Nights: A History of the Motion
Picture through 1925 (New York: Simon
& Schuster, 1986, orig. 1926),
pp. 153–158. The text of Paul's British
patent no. 19984, 1895, is reproduced
on pp. 155–157.

90. See Jambon's biography in
Rapports du jury international. Groupe
III.—Instruments et procédés généraux
des lettres, des sciences et des arts.
Classes 11 à 18. Exposition Universelle
Internationale de 1900 à Paris (Paris:
Imprimerie nationale, 1902), p. 587.
Jambon died on Sept. 30, 1908.

91. Stephen Bottomore makes
this mistake in "Dr Pawel Yakolevich
Piasecki," in Who is Who of Victorian
Cinema, A Worldwide Survey, ed.
Stephen Herbert and Luke McKernan
(London: BFI Publishing, 1996),
p. 111. Even the Hermitage News
repeats it (the panorama is in the
Hermitage collection). The existence
of two separate Transsiberian railway
panoramas is clearly stated by Alfred
Picard, Rapport général administratif

et technique. Exposition Universelle
Internationale de 1900, vol. 5 (Paris:
Impremerie nationale, 1903), pp. 79–80.

92. It is divided into nine rolls,
with an overall length of 850 meters.
See "Restoration of Pyasetsky's Great
Siberian Railway Panorama (1894–
1899)," (2007), "The State Hermitage
Museum: Hermitage News," online
www.hermitagemuseum.org (last
visited April 27, 2010). The finished
version of Pyasetsky's panorama is
said to have been shown at the Louis-
iana Purchase Exposition, St. Louis,
1904. Hermitage has many roll pano-
ramas by Pyasetsky, including a 58
meters long panorama of the coronation
of Tsar Nicholas II (1896). Pyasetsky
is said to have been assisted by the
landscape painter Jezzew.

93. This mistake is made in
Sehsucht, p. 248. About the slide
projections, see Picard, Rapport
général administratif et technique, p. 79.
They were organized by the Russian
ministry of roads and communications.

94. "Les panoramas de l'exposi-
tion," La Nature 28, 1er semestre,
no. 1407 (May 12, 1900): 402. Schwartz
claims the train "moved," which is
a mistake (Spectacular Realities, p. 173).

95. Closest was the railway's
track bed that moved in the manner
of a treadmill 300 meters per minute.
Behind it there were two lower cutout
canvases that rotated endlessly 120
and 40 meters per minute. The canvas
itself moved five meters per minute.
"Causerie scientifique," Monde moderne
et la femme d'aujourd'hui, vol. 12 (July–
Dec. 1900), p. 538.

96. No patent seems to exist
for Jambon and Bailly's Transsiberian
panorama.

97. R.S., "Exposition Sideshows,"
New York Times, Sept. 9, 1900.

98. Although he could not
experience the panorama as it should

have been, the Japanese visitor
investigated the train itself, admiring
"how sturdily it has been built, how
clean the beds, bathroom, library
and buffet are." He understood the
promotional value of the exhibit.
Hokkokusei, [pen name] "From Paris,"
Asahi Shimbun (Tokyo), Nov. 5, 1900.
The visitor was a writer, translator
(from Russian) and journalist, who
became the editor in chief of Yomiuri
Shimbun. His pen name was also
written Hokuo Adachi; the real name
was Arahito (or Arato) Adachi (1869–
1945). (Trans. Machiko Kusahara.)
The humorist Gaston Bergeret joked
in Journal d'un Nègre a l'Exposition de
1900 (Paris: L. Conquet, L. Carteret
et Cie, Successors, 1901) that the
most agreeable way to travel from
Moscow to Beijing on the Panorama
Transsibérien is by "eating or even
sleeping" while the canvas is rolling
(pp. 33–34).

99. Hugo d'Alési, "Un système de
panorama à déplacement dit 'Méoro-
rama," French patent no. 240472, 1894
(copy in EH). In his Cinema-bouffe
(Paris: Jacques Melot, [1945], p. 66),
Rodolphe-Maurice Arlaud described
a "Maérorama," an attraction operated
by Louis Regnault in front of the Porte
Saint-Martin in 1898. It is said to have
been as a small-scale multisensory
attraction, where films were projected
for an audience sitting on a boat's
rocking boat's deck, surrounded by
a "crew." It was probably inspired by
news about d'Alési's Maréorama; the
curious name may have been chosen
to avoid patent disputes. No primary
source mentions it. See also Schwartz,
Spectacular Realities, p. 170.

100. Raymond Fielding mistakenly
claims that the Maréorama was by the
Lumière brothers in "Hale's Tours:
Ultrarealism in the Pre-1910 Motion
Picture," in Film Before Griffith, ed.
John L. Fell (Berkeley: University of
California Press, 1983, p. 119. The
mistake is repeated by Friedberg,
Window Shopping (p. 84) and Christian
Hayes, "Phantom carriages:

Reconstructing Hale's Tours and the virtual travel experience," *Early Popular Visual Culture* 7, no. 2 (2009): 195.

101. Jules Bois, *Le Miracle moderne* (Paris: Société d'Editions letteraires et artistiques, 1907), p. 150; Emma Hardinge Britten, *Nineteenth Century Miracles: or, Spirits and their Work in Every Country of the Earth* (New York: William Britten, 1884), p. 87; d'Alési's obituary in *The Annals of Psychical Science*, Second Year, vol. 4 (July–December 1906): 424. Some sources claimed he was Hungarian-born.

102. Comment mistakenly claims that Maréorama's visitors "could see some of the most spectacular land-scapes to be found between Marseilles and Yokohama" (*The Painted Panorama*, p. 74). He may have confused it with Louis Dumoulin's *Panorama du Tour du Monde*. Schwartz (*Spectacular Realities*, pp. 171, 173–176) characterizes the *Tour du Monde* as an "animated panorama-diorama." A "moving diorama" of a sea voyage between Marseille and La Ciotat was shown as a side attraction (on the ground floor). The main attraction was a huge elliptical stationary panorama divided into sections depicting different cultures, with props in the foreground. The painting was "animated" by exhibiting living people in front of the sections. The building also contained five smaller dioramas. Alfred Picard, *Rapport général administratif et technique. Exposition universelle internationale de 1900*, vol. 7 (Paris: Imprimerie nationale, 1903), pp. 225–227. I will discuss the *Tour du Monde* in a forthcoming article.

103. The use of water tanks was not yet described in the patent.

104. Moynet describes several ways of using hydraulic pistons in *La machinerie théatrale*. For motion platform simulators and their history, see my "Encapsulated Bodies in Motion."

105. Kowalski's compositions were adapted for the piano and sold as sheet music. On the reverse of the panoramically opening scores is a chromolithographic representation of the scene in question. The known four versions are in EH.

106. "Détail des recettes brutes des établissements privés situés dans l'enceinte de l'Exposition universelle de 1900," *Annuaire statistique de la ville de Paris* 21 (1900) (Paris: Masson et Cie, 1902), p. 519. The *Stéréorama mouvant* made nearly 220000 francs, which was a good result because it had been realized on a smaller scale. The *Phonorama* that the Compagnie Générale Transatlantique had sponsored made a paltry 6704 francs (!). Dumoulin's *Panorama du Tour du Monde*, initiated by the Compagnie des Messageries Maritimes, was a clear win-ner, making more than 691000 francs, but even that led very likely to a loss for the stockholders.

107. R.S., "Exposition Sideshows," *New York Times*, Sept. 9, 1900. About the questionable reputation of chromo-lithographs, Peter C. Marzio, *Democratic Art, Chromolithography 1840–1900, Pictures for a 19th-Century America* (Boston: David R. Godine, 1979).

108. Bergeret joked that in the Maréorama the spectator could, with-out extra fee, experience a tempest, or at least to become as sick as in a real tempest. While some people are trying to find ways of avoiding seasickness, those who do not have time or money for a real sea cruise, now have an opportunity to experience how it feels to be seasick – "very democratic." (*Journal d'un Nègre*, pp. 34-35).

109. "Le Maréorama Hugo d'Alési. Société anonyme au capital de 1,250,000 Francs," promotional leaflet for investors, c. 1900, four unnumbered pages (EH). An article claimed that "the Maréorama, which is portable [sic], will be shown in the different cities of Europe and

America, and will, it is thought, during the twelve years for which time the company is organized, repay satisfactorily those who go into it." *Parisian* 6, no. 1 (Jan. 1899): 618.

110. D'Alési reportedly said: "It is my intention to change canvases after the Exposition is over, and we shall then, perhaps, make a trip to the North Pole." In: "The Mareorama," *Scientific American* 80, no. 10 (Mar. 11, 1899): 150. The same article claimed that the boat "will be surrounded with genuine boiling and foaming water." Was there such a plan, or is it a misunderstand-ing caused by the water tanks in which the panorama rolls were floating?

111. "Le Projecteur Multiplex 'Sanson' pour prendre et projeter des vues Panoramiques animées," French patent no. 261244, applied Nov. 13, 1896, granted Feb, 17, 1897; "Le Cinécosmorama 'Sanson,' ou Panorama animé en couleurs," French patent no. 2727517, applied Sept. 25, 1897 (granted March 10, 1898); "Cinecosmorama ou panorama à vues animées,"French patent no. 284955, applied Jan. 14, 1899. Grimoin-Sanson's equipment for the Cinéorama have been preserved at the Conservatoire des Arts et Métiers in Paris, where I saw them on display in the 1980s.

112. Gaston Tissandier, *Le grand ballon captif à vapeur de M. Henry Giffard* (Paris: G. Masson, 1878), p. 10. Giffard's balloon first ascended during the 1878 Universal Exposition and was also used during the 1889 Exposition.

113. Fielding's generalization, "films which were shown had been photographed from a real airborne balloon," is incorrect. "Hale's Tours," p. 118.

114. In his patents.

115. The disaster of the Bazar de la Charité in 1897, where an exploding illuminant (Securitas [!] by Alfred

Molteni) caught fire during a film screening and led to a loss of 120 lives, was in everyone's mind. Guerin, *Du soleil au xenon*, p. 39. Curiously, a weekly program booklet of the exposition (October 14–20, 1900) still lists Cinéorama as one of the "permanent attractions." Two ticket prices are given: 1 franc and 2 francs, the latter for the carriage, and the former obviously for the area around it. *La Plate-forme mobile et le chemin de fer électrique. Programme hebdomadaire de l'exposition* (Paris: Figaro, 1900), p. 12.

116. A rare first-hand account of Cinéorama by the Swedish visitor "Gustaf G." has been quoted by Rune Waldekranz, *Så föddes filmen. Ett massmediums uppkomst och genombrott* (Stockholm: Pan/Nordstedts, 1976), p. 401. It is imprecise, which makes one wonder if he experienced it at all.

117. Raoul Grimoin-Sanson, *Le film de ma vie* (Paris: Les Éditions Henry-Parville, 1926), pp. 88–130.

118. Fielding, "Hale's Tours," pp. 120–121. Philippe Gauthier accepts it as a fact in "The movie theater as an institutional space and framework of signification: Hale's Tours and film historiography," *Film History* 21, no. 4 (2009): 326. Tom Gunning's research "does not indicate that it actually appeared at the Exposition," see "The World as Object Lesson: Cinema Audiences, Visual Culture and the St. Louis World's Fair, 1904," *Film History* 6, no. 4 (Winter, 1994): 439.

119. Hayes, "Phantom carriages," p. 191. Hayes does not draw a link with moving panoramas, although he briefly mentions "painted roller-panoramas." (p. 194).

120. C. E. Hicks and E. Wigan, "Illusion Amusement Device," U.S. patent no. 924,068 (June 8, 1909, application filed Mar. 20, 1908). Showing that they know the Hale's Tours patent, they state that "it has been proposed to simulate the

effect and experience of a journey in a railway train but the movements incidental to such a device are of a different order to those pertaining to a sea voyage and therefore the mechanism employed is necessarily of a totally different type." (p. 1, lines 20–26).

121. Hayes mentions (but does not analyze) a patent by William J. Keefe from 1904 ("Amusement Device," U.S. patent no. 767 281). He claims (without evidence) that it was bought by George C. Hale and Fred W. Gifford, the fathers of Hale's Tours ("Phantom's carriages," p. 186). It concerns a rotunda that contains a railway car moving on tracks around its perimeter. Moving images are rear-projected on the outside of cylindrical screen in the center of the building. There is a rear-projection screen in the end of the moving railway car—the spectators would have had both a forward and a sideways view!

122. *l'Illustration*, No 4941 (Nov. 13, 1937). The attraction was introduced in English as "Scenic Diorama Rolls Past Windows of Train," *Popular Mechanics* 69, no. 3 (March 1938): 360. The main canvas was 900 meters long, and presented a railway journey across parts of France.

123. Whether this solution was used in any actual attraction I don't know. The moving panorama scene does not appear in the short story by Stefan Zweig on which the film was based.

124. "Gravediggers," season 4, episode 2 (1965).

125. Schievelbusch compared the experience of watching a moving panorama to the view seen from the window of a railway car. *The Railway Journey*, pp. 61–62.

126. Michael Naimark, VBK—A Moviemap of Karlsruhe (1991), where the user conducts a virtual tram through the streets of Karlsruhe,

Germany; Christa Sommerer & Laurent Mignonneau, *HAZE Express* (1999); *Riding the Net* (2000).

127. *Outoäly—Alien Intelligence*, ed. Erkki Huhtamo (Helsinki: Kiasma Museum of Contemporary Art, 2000), pp. 19, 104–105.

11. IMAGINATION IN MOTION:

THE DISCURSIVE PANORAMA

TOWARD A SHADOW HISTORY OF THE MOVING PANORAMA

When we read history, what does the history tell us? It seems
to be a moving panorama of people and events, but it is really
only a dance of shadows; the people are shadows, not realities,
the kings and statesmen, the ministers and armies; and
the events—the battles and revolutions, the rises and falls
of states—are the most shadowlike dance of all.

—Annie Besant, Introduction to Yoga (1908)[1]

Miles of panoramas have been cranked past the reader's eyes, and the show is
nearing its end. But there is one more topic to be unrolled: the moving panoramas
that were evoked in textual traditions. Charles Dickens, Mark Twain, Nathaniel
Hawthorne, Henry Wadsworth Longfellow, and Jack London wrote about them;
even James Joyce referred to Poole's Myriorama in *Ulysses* (1922).[2] Yet the classics
are only the tip of the iceberg; there are many others. Countless references to
moving panoramas have been embedded in forgotten stories, journal articles,
cartoons, and books that are these days called "nonfiction." Online tools allow
us to look beyond titles, tables of contents and indexes, revealing discursive
panoramas buried in textual streams.

Those who used the words "moving panorama" were often less influenced
by their own experiences than by literary references. Back in 1912, Dr. George
Edgar Vincent, the president of the University of Minnesota, asked a series of re-
levant questions: "How much of that mental imagery have you secured as a result
of your own experience? How much of that mental imagery represents original
thinking? How much of that psychic panorama have you received ready-made

from the society to which you belong?"³ By being evoked over and over again, the moving panorama turned into a topos that expressed many things: perceptual experiences, changes in the space-time continuum, battles between world views, ideas about the human mind. Its intensive discursive life also contributed to the formation of the media-cultural imaginary.

The canvases may have been rough and performances coarse, but their discursive echoes reached almost "angelic" spheres. They will be arranged in this chapter into a kind of shadow history, which is no less real than the technological, economic or social histories of the moving panorama. Because the amount of material is enormous, the discussion is necessarily tentative. We will begin with fiction, and move next to transformations in the perception. This will be followed by a discussion of the metaphysical and transcendental uses of "moving panorama," and its application to the debates about the mind, memory, and consciousness.

THE LITERARY ABSORPTION
OF THE MOVING PANORAMA

Of all the major nineteenth-century writers, no one may have been more aware of the moving panorama than Charles Dickens. Ever since his enthusiastic review of John Banvard's Panorama of the Mississippi was published (days after the giant canvas had begun rolling at the Egyptian Hall), moving panoramas appeared in Dickens's writings numerous times.⁴ Yet as a close friend of Clarkson Stanfield, the master of theatrical moving panoramas, his relationship with the medium must have started earlier. When W. H. Murray's Dickens-adaptation *Scraps from Pickwick* was performed at the Theatre-Royal in Edinburgh in 1837, it already included a moving panorama of "The Lord Mayor's Return by Water from Westminster Hall."⁵

Albert Smith (another close acquaintance) may have coined the word *panoramania*, but it was Dickens who best explained its impact on the "hooked" spectator in "Some Account of an Extraordinary Traveler" (1850).⁶ The protagonist is an elderly gentleman named Mr. Booley, who has been leading a "sedentary and monotonous life." Suddenly everything changes—he develops a passion for traveling extensively around the world. As it happens, his mode of transportation is the "gigantic-moving-panorama or diorama mode of conveyance," which of course refers to his obsessive new habit of attending the shows of London night after night. Mr. Booley is a prototypical portrait of a character addicted by media, evoked countless times in different guises ever since.

With a touch of nostalgia, Dickens looked back upon his experiences in "Moving (Dioramic) Experiences" (1867).⁷ His reminiscences reveal the moving panorama's broad appeal and educational ambitions, without neglecting the

mishaps and unintentionally comic incidents. However, his vision also had a darker side. *The Uncommercial Traveler* contained a somber portrait of Mr. Barlow, a narrow-minded schoolmaster, who had "invested largely in the Moving Panorama trade," and whom the narrator had "on various occasions identified . . . in the dark with a long wand in his hand."[8] Barlow's role as lecturer points to the overly rational, stereotyping, and authoritarian educational system that made the narrator "systematically shun pictorial entertainment on rollers."

Dickens also used the moving panorama as organizing principle in his writings. His travel experiences from Italy were presented as a "Rapid Diorama."[9] Already in *The Old Curiosity Shop* (1841) he used a trope that must have referred to the moving panorama: "The magic reel, which, rolling on before, has led the chronicler thus far, now slackens in its pace, and stops. It lies before the goal; the pursuit is at an end."[10] As the author implies, the reader is supposed to feel as if sitting in front of a moving canvas, while the narrator performs.[11] Scholars have detected other similar occurrences, but they often lack overt verification. Grahame Smith considers works like *Bleak House, Little Dorrit,* and *Our Mutual Friend* as "panoramic representations of Victorian society," because "the panoramic concept returns as a governing metaphor" in their structures.[12]

An influential example of such textual panoramification is Walter Benjamin's notion "panoramic literature."[13] He was referring to a genre of French anthologies that presented "physiologies," or galleries of characters from Parisian life. Benjamin drew a parallel between such works and circular panoramas, because they "consist of individual sketches which, as it were, reproduce the dynamic foreground of those panoramas with their anecdotal form and the sweeping background of the panoramas with their store of information."[14] A media-archaeologist should take such sweeping parallels with caution. Critics' interpretations easily start leading their own lives, and get superimposed on the past; it is often difficult to tell where the subjective interpretation ends and historical reality begins.

Discussing one of these anthologies, *Le Diable à Paris* (1844–1846), Jillian Taylor Lerner suggests that they provided their readers with "optics" and mapping devices to orient them through massive landscapes of data.[15] Some of the texts are supposed to contain indications about the contributor's "panoramic" imagination. In *Le diable boiteaux à Paris, ou, Le livre des cent-et-un* (1832), a contributor associates the *flâneur*, a typical Parisian physiological type of the era, with a "surrounding moving panorama" offering itself to the observer's gaze.[16] Still, as tempting it is, it is problematic to assume, without qualifications, that some "panoramic" principle, identified by the critic but unacknowledged by the writer, was somehow intuitively imposed on the latter's imagination merely by living in a certain cultural context.[17]

Curtis Dahl's study of Mark Twain raises similar issues.[18] Twain was certainly familiar with the medium, as the "Scriptural Panoramist" (1865) demonstrates.[19] Another panorama lecturer appeared in *Life on the Mississippi* (1883).[20] Dahl finds the moving panorama's influence in anything—content, humor, atmospheric effects, and episodic narrative structures. Just like in Twain's writings, in panorama performances, he suggests, the "humorous incident, the local-color anecdote,

the touch of pathos, the dioramic spectacle, the explanatory fact, however well rehearsed, was introduced not according to a preconceived over-all pattern or to elucidate a specific inclusive theme but merely where the locale suggested it."[21] Such parallels are fascinating but hard to prove. Even Dahl has to admit: "There is certainly no evidence that he directly lifted material for his books from the panoramas."[22]

Much the same could be said about Avery's attempt to link Edgar Allan Poe, Henry Longfellow, Walt Whitman, and Hermann Melville with moving panoramas.[23] All used these words but did not discuss the medium or its cultural significance. Longfellow's epic poem "Evangeline" may well have been influenced by Banvard's Mississippi-panorama (which the poet had seen according to his diary), but parallels are vague. By a curious coincidence, Melville embarked on a whaling voyage around the world as a sailor in the same year (1841) as Benjamin Russell, who later produced a moving panorama about the same topic with Caleb Purrington. It is tempting to speculate that this panorama influenced Melville to write *Moby-Dick*, but there is no evidence. Nevertheless, both Melville and Hawthorne were aware of the emerging "mass information society," and its challenges to traditional notions of truth and reality.[24] Beside the penny press, Barnumized entertainment, photography, and news-gathering by telegraphy, panoramas were part of the process.

Nathaniel Hawthorne (1804–1864) developed an unusually active relationship with visual media, including the daguerreotype (in his novel *The House of the Seven Gables*, 1851). This issue has occupied literary scholars, but deserves also media-archaeological attention.[25] Hawthorne's oeuvre contains numerous references to spectacles. As Lease says, his "sketches, tales, and romances absorb and transmute the popular entertainments of the age."[26] Particularly in his "sketches" Hawthorne used his own encounters with media as an inspiration. In "Fancy's Show Box" Memory, Conscience, and Fancy appear as a nightly vision to Mr. Smith, a "venerable gentleman" drinking in his solitude.[27] Fancy is personified as a peepshow exhibitor. "Ethan Brand" describes a peepshow ("diorama") presentation given by "an old German Jew," an itinerant showman.[28] As a medium deeply embedded in popular discourses, the peepshow Hawthorne had experienced firsthand was a suitable token for romance.

Panoramic references permeate "The Toll-Gatherer's Day; A Sketch of Transitory Life" (1837), where an old toll-gatherer spends his days on a bridge, observing the people pass by.[29] Life has been made "to roll its variegated length by the threshold of his own hermitage, and the great globe, as it were, perform its revolutions and shift its thousand scenes before his eyes without whirling him onward in its course." Emphasizing the contrast between the stationary observer and the object, a newlywed couple in a "barouche of the newest style" appears. Its varnished panels "reflect the whole moving panorama of the landscape, and show a picture, likewise, of our friend [the toll-gatherer], with his visage broadened; so that his meditative smile is transformed to grotesque merriment." The panoramic view merges with the observer's own reflection as in a distorting funhouse mirror. As the night falls, the memory of the "procession of mortal

travellers" turns into a "flitting show of phantoms"—perhaps an echo of the phantasmagoria show.

However, Hawthorne's most intricate foray into the realm of spectacles was "Main Street" (1849), a sketch that took the form of a pictorial exhibition in a showroom.[30] The showman's drab interpretation of New England history is visualized by scenes about the evolution of Salem's main street. Figures move in front of painted backgrounds, their "little wheels and springs" operated by a crank. As the presentation unfolds, the spectators question both the reality effect of the jerky pasteboard figures and the accuracy of the scenes, forcing the showman to defend his procedure. The discourse deepens into an ontological reflection on the mechanisms of illusion. Truth does not reside in historical details (the showman apologizes for the inaccuracies); it must be discerned by empathy and imagination rather than by pedantic insistence "to see things just as they are."

The combination of a "shifting panorama" and a puppet show evokes mechanical theaters.[31] Hawthorne referred to them in his notebook on May 14, 1850, writing about an exhibition hall in Boston: "Sometimes, in the evenings, loud music is heard from it; or, if a diorama be exhibiting (that of Bunker Hill, for instance, or the burning of Moscow) an immense racket of imitative cannon and musketry."[32] The observation found its way into *The Blithedale Romance* (1852), enhanced by "the applause of the spectators, with clap of hands, and thumb of sticks, and the energetic pounding of their heels."[33] The "dioramas" (probably *The Mechanical Panorama of the Battle of Bunker Hill* and *The Conflagration of Moscow*), appeared again later in the same book, together with a "moving panorama of the Chinese Wall," as examples of programs seen in a village "lyceum."[34]

The mechanical contrivance of "Main Street" is really a discourse engine churning out narrative motives for the reader to reflect on. The showman is presented as a kind of (failed or pretended) demiurge, who tries to exert control

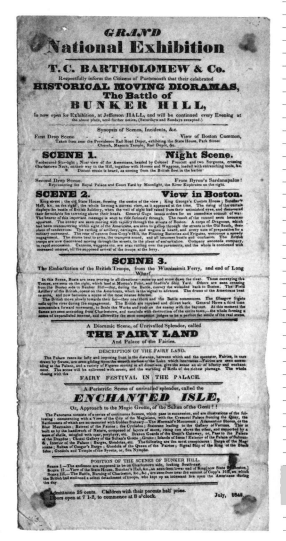

Figure 11.1

Broadside for T. C. Bartholomew & Co.'s *Historical Moving dioramas, the Battle of Bunker Hill*, exhibited at Jefferson Hall, Portsmouth, New Hampshire, July 1842. Nathaniel Hawthorne referred to a show like this, a mech-anical theater with painted backgrounds and various special effects. The "Enchanted Isle" (a "Peristrific Scene") is mentioned as a "series of continuous Scenes, which pass in succession, and may have been a small-scale moving panorama. Author's collection.

over the events and "spectral" figures of his "magic picture." By waving his hand (as a signal to a hidden crank operator who is never mentioned) he gives "time and vicissitude . . . his permission to move forward." When the days in the Puritan settlement become "sluggish," he condenses them "into the space of a few moments." By his "control over light and darkness," he makes "the dusk, and then the starless night, to brood over the street," and causes transforma-tions—"in the twinkling of an eye"—even when the audience's "observation has been fixed upon the scene."[35]

But the media wizardry has its limitations. It cannot restrain the spectators from questioning the representations. The showman's efforts to regain control fail. He even lacks mastery over the machinery: pictures may have been mis-placed, "whereby the people and events of one century might be thrust into the middle of another," or a wire broken, bringing "the course of time to a sudden period." And so, a wire snaps and the panorama gets stuck in the Great Snow of 1717. The audience is denied an opportunity to see happier times, or peek into the future.[36]

The spectacle of "Main Street" was certainly symptomatic of the showmanship of the time but the showman's self-doubt differs from what was customary in public spectacles. Showmen made no public excuses; certainly not before the show had even started.[37] They praised their tricks (Hawthorne's showman also tries to do that), and remained silent about whatever potential problems they may have been aware of (like the showman in Bouton's *Round the Block*). The ending, where the mechanism breaks down, may have been inspired by actual incidents, but Hawthorne may also have resorted to a topos. The idea had appeared already in 1829 in *Blackwood's Edinburgh Magazine*, and possibly elsewhere as well:

> The glory o' the heaven and earth has a' flown by; there's something gane wrang wi' the machinery o' the peristrephic panorama, and it'll no gang roun'—nor is there ony great matter, for the colours hae faded on the canvass, and the spirit that pervaded the picture is dead.[38]

John Greenleaf Whittier also structured his long abolitionist poem "The Pan-orama" (1856) as a panorama performance.[39] He may have been influenced by "Main Street," but Whittier's imaginary show is closer to the spectacles of the panoramania era. We first meet a "half sad, half scornful" showman and his im-patient audience, tapping the floor with feet and canes, and calling for the cur-tain to be rolled up. When it rises, we see a "green land stretching to the evening star," or "the new Canaan of our Israel—The land of promise." The curtain falls, and a "shrewd on-looker" interferes, requesting a view of this promised land "when, with electric nerve, and fiery-brained . . . the twentieth century rounds a new decade." The showman declines; the present as a "mould" for the future will suffice.

One view follows another, always framed by the lifting and lowering of the curtain as music is played. A pastoral society with "homely old-time virtues of the North" gives way to appalling scenes of slavery, revealing how "evil Fate"

has formed a "belt of curses on the New World's zone!" The showman's brow droops in "sorrow's attitude," but he collects himself. As the pictures of the panorama fade away from the discourse, he appeals to the Men of North to take action against "home-bred traitors" who support slavery. The poem ends in a coda, where the "Showman and his show, Themselves but shadows, into shadows go"; the poet may also be forgotten, as long as his call for action will live on.

In both Hawthorne's and Whittier's texts the panorama's "poor trick of paint. . ., incomplete and faint" is overtaken by words.[40] Whether the machinery breaks down or the painted canvas just disappears to the background after fulfilling its demonstrative function, visual imagery succumbs to the power of language.[41] Did both Hawthorne and Whittier belittle pictures because they were literary men, or do their attitudes reflect a more widespread phenomenon? The answer may be: both. Hawthorne had a keen interest in pictures, but the association of popular imagery with Barnum-like humbug was strong, whereas text was the site of truth.[42] In public shows the relationship between the lecture and the visual illustrations was far from settled; it kept shifting case by case.

EXERCISES IN PERCEPTION: FROM STATIONARY TO MOVING PANORAMAS

Et vous, boulevards, lieux chéris de flâneurs, qui pourra vous célébrer dignement, boulevards, panorama toujours nouveau?

—*Musée Français*, vol. 2 (1837)[43]

The circular panorama gave rise to what could be called the "panoramic observer," a "built-in" perceptual model that it imposed on the visitors and that affected their ways of looking and behaving. It was not a straitjacket—within its constraints, each visitor negotiated his or her own experience. The idea of the panoramic observer implies a scopic-ambulatory mastery over an environment, often from an elevated vantage point. Instead of being fixed to a seat, or forced to view the scenery through a peephole or window-like opening (like at the Diorama), the panoramic observer is able to turn and walk around, submitting the surroundings to visual scrutiny. It was related to the perceptual models activated by Alpinism, Montgolfierism, observation towers, and the Panopticon; all came into vogue more or less simultaneously.

There is huge amount of textual evidence purportedly inspired by observing panoramas. It raises questions: Do the sources describe direct observations, or reproduce inherited formulas? Is it possible to detect repeated underlying patterns?

338

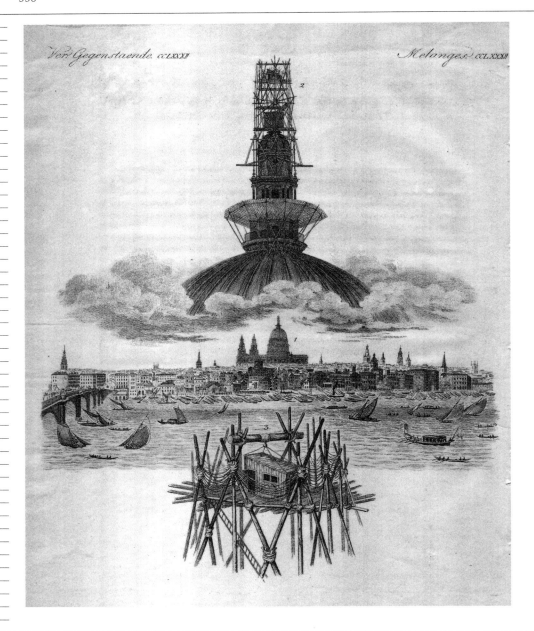

Figure 11.1
Thomas Hornor's scaffolding and hut on top of St. Paul's
Cathedral, London. Hornor used them in 1821–1822 to
produce the sketches for the huge panorama of London,
exhibited at Regent's Park Colosseum. From *Bertuch's
Bilderbuch für Kinder*, vol. 10, no. 95 (Weimar: Verlag des
Landes Industrie Comptoirs, 1821). Author's collection.

It is often difficult to give unequivocal answers. Sensory impressions are processed by the mind, and combined with received ideas. They are made to serve many different purposes. The panoramic observer that appears in literary texts has been "transfigured" from the context of rotundas, stuttering lecturers, and creaking rolls of canvas, and transplanted into great varieties of discursive landscapes.

The panoramic observer was anything but uniform, as the formulations used by the American journalist Nathaniel Hazeltine Carter (1787–1830) demonstrate. In his book of travels across Europe in the 1820s, the panorama appears over and over again as a parable for what he sees.[44] He is aware of its concrete meaning, as a comment about Versailles reveals: "Our countryman [John] Vanderlyn has given such a faithful and perfect representation of the garden [of Versailles], in his splendid panorama, that it would have been instantly recognized by me, had I been conducted blindfold to the place. I sometimes almost fancied myself looking at the picture instead of the reality."[45] Visual representation has become the standard for assessing reality. Still, Carter does not mix up reality and simulation; he knows the difference.

From a hilltop in Marseilles, Carter's "eye is able to survey at a glance the splendid panorama, which occupies the valley," and in Edinburgh a *"coup d'oeil* from the brow of Calton Hill" produces a "superb panorama."[46] In London, he admires "the immense panorama of London and its environs, stretching on all sides below" from the dome of St. Paul's," noting that "objects so far beneath our feet were reduced to a diminutive size; and the belles and beaux looked like puppets, hurrying along side-walks."[47] The "splendid panorama" or "bird's-eye view of Paris and its environs" from the towers of the Notre Dame makes him conclude that this *"coup d'oeil* far surpasses that of London from St. Paul's, though [it is] much inferior in every thing but extent to that of Edinburgh from Salisbury Crag."[48]

A somewhat different perceptual situation appeared when Carter got an opportunity to visit the model prison of Bridewell in Edinburgh:

> *A semicircular tower rises in the centre, through which there are narrow openings, commanding a full view of all the cells of the convicts, ranged in a concentric semicircle. In front are grates and blinds, which prevents the tenants from seeing one another, although their movements may be watched from the observatory in the centre. It is a kind of panorama, where all sorts of mechanical operations are going on. Some are spinning, some weaving, and others sewing, while the males are employed at their several trades. An artist would here find a good subject for a picture.*[49]

This "kind of panorama" is actually a *panopticon*, a disciplinary apparatus conceived by Jeremy Bentham in the 1780–1790s. The panoptic observer observes other humans, who cannot return the gaze, or even be sure they are being watched. Carter interprets the panopticon as a kind of disciplinary spectacle,

a series of animated pictures, that evokes the relationship between laborers, production machines, and scopic power in mechanized factories.[50] The idea of seeing without being seen was also related to another optical device, the camera obscura.[51] Pierce Egan claimed in his *Life in London* (1821) that he had "chosen for his readers a Camera Obscura View of London, not only from its safety, but because it is so *snug*, and also possessing the invaluable advantages of SEEING and not being seen."[52]

Nathaniel Hawthorne's short sketch "Sights from a Steeple" (1830) evokes a situation that resembles Carter's Bridewell experience, but even more his observations from the dome of St. Paul's. Its narrator is hiding in the steeple of a church, and secretly observing what is happening below.[53] In both cases the observer's attention is diverted from the environment to the diminutive human figures below. Carter may even share some of Hawthorne's observer's frustration of being unable to grasp anything beyond their outer shells (even with a spy-glass). Focusing on humans, the panoramic observer has been transformed into the panoptic one.

For Dana Brand, Hawthorne's "steeple-top narrator offers the same illusion" as a panorama, but also evokes the *flâneur*.[54] What is missing is the latter's mobility, street-level perspective, and lack of physical distance between the observer and the observed. The *flâneur* is commonly read through Walter Benjamin's Baudelairean dandy, a bohemian who converts the boulevards and arcades of Paris into his living room.[55] Benjamin's *flâneur* peeps at the surrounding crowd from a café table, enjoying his sense of superior knowledge of art and boulevard gossip. He is both mobile and stationary; the relationship is fluid.

The *flâneur* may have served Benjamin's vision as a token of the time, but was based on facts. It was singled out as a "physiological" type already in the 1820s. A poem called "Le Flâneur" was translated in the *Linguist* in 1825 as "The Spunging Loiterer," to inform British travelers about the "localities and usages of the French metropolis." The opening line condenses the essential: "I am a loiterer; let me be approved or condamned, I am loitering about, I see every thing, I am every where."[56]

The *flâneur* was associated with panoramas early on.[57] He was said to be the perfect guide "to the moving panorama (*panorama mobile*) that surrounds you."[58] Soon after arriving in Paris, a prosaic Englishman began imitating the *flâneur*, "smiling and smirking under the influence of the exhilarating and perpetually-varying panorama at which he is never tired of gazing."[59] Nathaniel Hazeltine Carter provided a comment on the life on the boulevards by saying that a person "might linger whole days about this extensive panorama, where every thing is in motion, in looking at the ten thousand little nothings, which he had never before witnessed, and would never care to see again." [60] The panoramic observer is undergoing a transformation by descending from its vantage point.

Transmuted into a *flâneur*, the panoramic observer became immersed in the crowd, observing the kinetic sight of countless humans hurrying past. As early as 1817, Joseph Mawman characterized the "motley assemblage" of Europeans, Asians and Africans in Marseille as "a sort of moving panorama of people which

is full of curiosity and interest."[61] For Victor Fournel, this constituted a "panorama of democratic art."[62] Another observer remarked that the *flâneur* was a rare sight in New York, where everyone was always rushing ahead toward a goal, but still described Broadway with media metaphors: the "shifting tints" of ladies' dresses, the commodity displays, the signs, and the vehicles driving by suggested the kaleidoscope, while the merchandise, "combined with a fashionable promenade," afforded "the still-life of a variegated moving panorama."[63]

The metropolitan experience suggested a moving panoramic canvas, even if the sight did not match the subject matter of most actual panoramas. Except in miniature form, moving panoramas of city streets were rare (Bullard's *Moving Panorama of New York City* was an exception). A transposition of subject matter had obviously taken place. It was movement, variety, and change that justified the comparison, although habitude may at times have led to the loss of scopic desire, as the contrast between the perceptions of an urban and a country boy in *The Young Explorer* suggested: "Tom Cooper was too familiar with the streets of New York to pay any attention to the moving panorama of which he and Ben formed a part. But everything was new and interesting to Ben, who had passed his life in a quiet country town."[64]

Some distancing, whether forced or deliberate, was needed to maintain an active relationship with the surroundings. The discursive panoramic observer often stayed away from the crowd, observing it from a vantage point that recalls both circular panoramas and Hawthorne's steeple-top narrator, but also evokes the situation of the moving panorama's spectator. In Louisa M. Alcott's *Hospital Sketches* (1863) the narrator watches from a window the moving panorama passing below, "taking notes of the most striking figures in it."[65] Wilkie Collins's and Charles Dickens's "Lazy Tour of Two Idle Apprentices" (1857) offers a kind of rebuttal of this situation.[66] One of its protagonists, Thomas Idle, has sprained his ankle and must be left at a hotel while his travel companion, Francis Goodchild, plans to continue to their destination, a horse race:

> Francis Goodchild, anxious that the hours should pass by his crippled traveling-companion as lightly as possible, suggested that his sofa should be moved to the window, and that he should amuse himself by looking out at the moving panorama of humanity, which the view from it of the principal street presented. Thomas, however, steadily declined profiting by the suggestion.
>
> "The farther I am from the window," he said, "the better, Brother Francis, I shall be pleased. I have nothing in common with the one prevalent idea of all those people who are passing in the street. Why should I care to look at them?"[67]

As the role of the mechanical locomotion became more prominent in the course of the nineteenth century, the discursive panoramic observer stepped into a vehicle. From a train window the protagonist of Harold Frederic's *The Damnation of Theron Ware or Illumination* (1896) sees how "citified streets, with stores and

factories, were alternating in the moving panorama with open fields."[68] In Marie Conway Oemler's *The Purple Heights* (1920), the heroine "gazes fixedly" from an automobile at "the moving panorama of the crowded streets through which [the driver] was skillfully manoeuvering his way."[69] In a kind of negation of this experience, the protagonist of George Gibbs's *Madcap* (1913) takes a walking tour, experiencing "the slowly moving panorama of hill and dell, which was lost upon the touring motorists who continually passed him, filling the air with their evil smells and clouds of dust."[70]

It could be claimed that such discourses misrepresented the actual moving panorama, because its spectator was nearly always immobile. Yet such an accusation would discredit the freedom of imagination. The moving panorama provided only the stepping stone. What happened next depended on the writer, whose choices depended on internalized cultural codes, aesthetic preferences, and ideological leanings. The observer was conceived as mobile, because this option was gaining ground in the culture of modernity, both in concrete forms and in mental formations. But the stationary observer was an alternate model. It persisted as well and had its own cultural justifications.

THE CRANKING GOD:
PANORAMAS AND THE RELIGIOUS IMAGINATION

Turn to the divine record! Unroll those vivid and gorgeous pictures painted with the hues of heaven, whose glories pass before the mind like some splendid moving panorama!

—Professor J. M. Leavitt, 1859[71]

In a story published in 1890, we witness a village school headmaster presenting a biblical "moving panorama" and extolling its virtues.[72] "This pictorial representation . . . fills the minds of the children with imagery that is always retained in the memory," he says.[73] By the late nineteenth century many religious organizations had embraced the ideology of the object lesson. Projections of lantern slides were used to visualize the gospel, and fight against evils like intemperance. Moving panoramas may have been relatively uncommon in churches and congregation halls, but they certainly inspired religious propagandists.

A concrete example of the moving panorama's influence on religious education is the *Royal Scroll* (1896), a portable "teaching machine" invented by the American publisher Levi Walter Yaggy.[74] It was meant for studying the Bible

Figure 11.2
The Royal Scroll. A portable Bible study system. Invented
by L. W. Yaggy. Chicago: Powers, Fowler & Lewis, 1896. The
suitcase-like viewer that folds open into a "desk" contains
two crank-operated moving panoramas seen in different
windows, and a booklet for bible study. Author's collection.

individually by means of rolls of seductive, colorful images. *The Royal Scroll* is a suitcase that forms automatically a kind of desk (or altar) when opened.[75] It contains two crank-operated series of chromolithographs ("Illuminated Life of Christ" and "A Complete Panorama of Sacred Story"), presented in a decorative illusionistic proscenium. A booklet of maps, diagrams, "pen pictures," and study questions has been attached in front of it, encouraging cross-referencing between text and visuals. This device was used in homes, schools, and missionary work.[76] A bishop lauded it as "a picture gallery, a panorama, a guide to sacred geography, a treasury of sacred art, a text-book, an atlas, a lesson-help, all in one."[77]

Visual media inspired religious apologists to paint grandiose "word pictures." To explain the purpose of life within the grand scheme designed by God, they penetrated beyond "the veil of external contingency."[78] Unlike most panorama shows, discursive religious panoramas presented broad visions spanning centuries and millennia, much like a dictionary entry on "revelation" explained: "*History* and revelation are inseparable. The march of events and the development of ideas are but parts of a moving panorama of Divine creation and guidance."[79]

The ideas presented by Reverend Charles Minnigerode, Rector of St. Paul's Church in Richmond, Virginia, had even wider currency:

> Like a vast moving panaroma [sic], the great Architect and Master has cast forth into existence the grand conception of His holy temple, this beauteous creation; and upon the world's canvass [sic] He has painted the history of its immortal inhabitant, placed there to fill the courts of His temple, and learn to worship with a living service their ever-present Lord and God. For six thousand years the great tableau of man's existence and history has been unrolled, and we cannot say how many ages yet may pass before the whole of God's work shall be complete in time. But who that traces back his steps, and casts his eye along the shifting scenes of this world-picture, as in uninterrupted flow they have succeeded each other; and watches their development and marks the causes and effects, as they combine at each period and lead us gradually to the scene which now stands before the eye of the beholder: but must see the golden thread of God's Providence interwoven with it all, and how all turns on the everlasting hinges of His government.[80]

Religious writers depicted God as a showman who kept a "mighty panorama . . . moving and shifting before the eyes of men," varying "the exhibition to suit each particular time."[81] The Revelation of St. John was presented as "a moving panorama of symbolical representations," while Satan unfolded for Jesus his own panorama of "ALL the Kingdoms in the world."[82] An interpreter stressed that John was not summoned to "hear the contents of a book being read; but to see as it were a pictorial representation or vast moving panorama descriptive of events, or 'things which must shortly come to pass.'"[83] Another commentator pointed out a difference between the ways humans and God perceived panoramas: "We

see the universe and its events piecemeal, as in a moving panorama; God sees the whole stretched out at once and for ever before Him."[84] Being outside of time, the almighty God's ability to experience panoramas in motion was, paradoxically, limited.

Discursive panoramas were frequently evoked in debates that contrasted religious worldviews with the findings of geology, biology, paleontology, and the theory of evolution. A widespread discussion concerned "mosaic cosmogony," or the account of the creation presented in Genesis. It was spurred by *Testimony of the Rocks; or, Geology in Its Bearings on the Two Theologies, Natural and Revealed* (1857), a posthumous work by Hugh Miller (1802–1856), the well-known Scottish writer, amateur geologist, and adherent of the evangelical Free Church.[85] Following the teachings of the radical natural theologian Thomas Chalmers (1780–1847), Miller claimed that "the writings of Moses do not fix the antiquity of the globe."[86] Like Chalmers, he suggested that the six days of creation represented longer geological periods; his attempt to reconcile the "Divine Record" with geological discoveries demonstrated that the earth was much more ancient than 6,000 years—the common calculation based on the Bible.

Moving panoramas impressed Miller; references to panoramas and dioramas abound in his writings.[87] An early biographer quoted his description of one of the Messrs. Marshall's peristrephic panoramas, but played down his enthusiasm for it as a "boyish delight."[88] In his theory of "the mosaic vision of creation" Miller suggested that the events of the creation, as recounted in the Bible, had been revealed to Moses "as the successive scenes of a great air-drawn panorama."[89] True to his panoramic analogy, he surmised that "the prophetic vision of creation, if such was its character, consisted of only single representative scenes, embracing each but a point of time; it was, let us suppose, a [moving] diorama, over whose shifting pictures the curtain rose and fell six times in succession."[90]

Miller's elaborate word pictures of the creation included references to dioramic effects or dissolving views: "The appearance and vanishing of each such vision seem to the seer as a morning and an evening, apparently because these were presented to him as an increase and decrease of light, like morning and evening twilight."[91] Such panoramic parallels inspired a well-formulated comment from a critic: "As we peruse his pages, we gaze through the countless ages of time into the vista of the by-gone eternity; and as the wondrous panorama of change stretches out before us, we see the unfolding of the Divine plan."[92] Miller's narrative had been heavily influenced by the "optical appearance" of Milton's *Paradise Lost* (1667), which he quoted as if the poet had kept company with Moses at humankind's first picture show.[93]

Testimony of the Rocks raised much criticism. Marcus M. Kalisch objected to Miller's "soaring flights of fiction," wondering how Moses could possibly have watched the panorama "standing on some elevation above our planet," and known "how many thousand years each 'tableau' comprised."[94] Another commentator found "nothing whatever in the account given us by Moses, which would lead us to suppose that he was recording the description of a vision which he had seen." He recommended that Miller's theory should be relinquished,

Figure 11.3
Denton's Illustrated Scientific Lectures. A broadside for the
naturalist and lecturer William Denton (1823–1883). Color
lithograph designed and printed by his son Sherman Foote
Denton (1856–1937), illustrator and lithographer. United
States, before 1883. Author's collection.

or "at least greatly modified."[95] Even then, a very similar scheme, coated with pseudoscientific rhetoric, surfaced as late as 1908 in David L. Holbrook's *Panorama of Creation*.[96]

Perhaps the most devastating critique was William Denton's *The Irreconcilable Records: Or, Genesis and Geology*. Denton (1823–1883), a radical geologist, naturalist, and explorer, wondered how Moses could possibly obtain his idea about the seventh day: "Did the curtain rise, and show the Creator resting upon a flowery bank after his arduous week's work?"[97] He ridiculed Miller, concluding that "great names lead people to imagine they see wisdom in the most childish and nonsensical things, or Hugh Miller's pretended explanation would have been blown to atoms in the storm of ridicule it would have created. The Gods turning showmen, and to such poor purpose, surpasses even the freedom with which Homer treats the Grecian divinities."[98]

It is somewhat ironic that Denton himself became a showman, or, as one recent commentator called him, a "psychic, sideshow spruiker and lecturer on various topics."[99] A handsome broadside for his "Illustrated Scientific Lectures," designed and color lithographed by his son, the artist and naturalist Sherman Foote Denton (1856–1937), displays attractive scenes of "Silurian Sea," "Coal Forest," "[native] Australian," "Gorilla," "Age of Reptiles," and "Fight with Cave Bear." Central positions have been reserved for the "Destruction of Pompeii" and Denton's own portrait. Of course, references to the Bible and religion are nowhere to be seen.[100]

The panoramas of creation were challenged by panoramas of evolution, inspired by positivism and Darwinism. The phrase *panorama of ages* gave primacy either to natural evolution or human achievements. In the village of Wherstead in Suffolk, England, a writer who was collecting material on local history stated that "it is science that has deciphered the previously unnoticed records of the remote past, and recovered for us, from the grand moving panorama of the ages, another thought-stirring picture of our locality."[101] "The panorama of ages as it unrolls before us is a picture of evolution" became a common formula that was re-enacted almost verbatim by the cultural critic Dolf Sternberger in his *Panorama of the 19th Century* (1938).[102] Predictably, religious writers appropriated it, and used it to characterize God's master plan as "the vast, moving panorama of the ages, worthy of the supreme divine."[103]

348

MIND, MEMORY, AND CONSCIOUSNESS: PANORAMIC PARABLES

"Mortal man is but a drama,

Or a changing panorama,

And made thus by love and hate;

As the body is but motion

Of other lives in Time's ocean,

Held in contact by the soul great."

—*John Ulrick Oberg, The False and the True:*
A Psychic Phantasmagoria of the Resurrection in Epic Verse (1902)[104]

Fin-de-siècle culture was infatuated with psychic phenomena. Telepathic communication and messages from the deceased were debated, and so were the existence of the soul and the individual's relationship to cosmic forces. Dreams, hallucinations, and the mind came under intense scrutiny. But psychology and philosophy were also struggling to free themselves from religious and mythological presuppositions; the age-old epistemological debates about perception and the nature of reality were being cast in new terms. The writings of Sigmund Freud, William James, and Henri Bergson are remembered as classics, but in their own time they were just part of a complex and messy network of crisscrossing discourses, most of which have fallen into oblivion. Yet they did not disappear; digital on-line tools call for their resurrection.

Robert Barker and Peter Marshall would have been surprised to find out how deep into the cultural (un)consciousness their inventions had penetrated. Many discursive panoramas were outright silly, characteristic of an age that was undecided about the relationship between the material and the spiritual. A case in point, Camille Flammarion, the famous French astronomer and popular-scientific writer, served as a writing medium, receiving texts from spirits when in a trance, and signing them "Galileo." The spirit world should feel embarrassed for having sent through him the following blatant truism that extolled *positivism*: "The objective world has unrolled before the eyes of science its splendid panorama and its magnificent wealth of forms."[105]

Moving panoramas were evoked to demonstrate all kinds of outlandish beliefs and theories, such as "traveling clairvoyance." The spirit of the clairvoyant was believed to leave the body and travel to distant locations.[106] To explain how the clairvoyants could describe events and places of the distant past, Newton

Crosland proposed a "spiritual-photographic theory," which suggested that "every significant action of our lives . . . is vitally photographed or depicted in the spirit-world." Under God's direction, the angels unroll "before the spiritual sight of the clairvoyant, a grand panorama of past scenes and events in their order of time and sequence of action." The soul can "discern literally and faithfully, things and persons that have long since disappeared from this world, as well as those that are now actually in existence."[107]

The American self-made psychic philosopher Loren Albert Sherman associated panoramas with "soul projection."[108] He quoted experiments in which hypnotized subjects had been sent to various locations, and back in time. When a test person was asked how he got his information, he claimed to have seen it "as it came around," which was interpreted as "something in the nature of a revolving panorama."[109] This inspired Sherman to liken Eternity "to a vast cyclorama, or the interior of a globe, having no beginning and no end." The events of Eternity are impressed, he suggested, upon "this great cyclorama, and the whole given a slow, revolving motion." The "incarnate and imprisoned soul" is stationary, observing "only the few events coming within the range of its physical perception as they pass."[110] The "projected or decarnate soul," however, is able to fly to any part of the "cyclorama of Eternity" to observe "what is there pictured and recorded."[111]

Although experiences were constantly compared with moving panoramas, there was no consensus about *where* they were rolling: inside the mind, outside in the world, or somewhere in between? Leo Hartley Grindon presented an idealist argument in the thick of the panoramania: "Whatever seems to us to enter or pass through our minds when we 'think,' is the combination into a mental panorama of a series of pictures of material objects or performances, already there. These pictures are the living and moving memories of objects and events which we have at some time or other been informed of by our senses."[112] Along similar lines, the theosophist Jirah Devey Buck characterized thought as "the moving panorama of the brain, reproducing the world to consciousness."[113]

The British philosopher Bernard Bosanquet (1848–1923) presented one of the most original panoramic formulations of the idealist position. In a peculiar way, he switched his attention back to the circular panorama, a medium he had experienced firsthand during his childhood.[114] Anticipating the current imaginary around mobile media, he envisioned humans as walking panoramas carrying their own idiosyncratic worlds around with them as kinds of personal data bodies:

> We all have seen a circular panorama. Each one of us, we must think, is shut up alone inside such a panorama, which is movable and flexible, and follows him wherever he goes. The things and persons depicted in it move and act upon one another; but all this is in the panorama, and not beyond it. The individual cannot get outside this encircling scenery, and no one else can get inside it. Apart from it, prior to it, we have no self; it is indeed the stuff of which oneself is made. Is every one's panorama exactly the same? No, they are

not exactly the same. They are formed round different centres, each person differing from all the others by individual qualities, and by his position towards the points and processes which determine his picture. For—and here is the remarkable point—every one of us has painted for himself the picture within which he is shut up, and he is perpetually painting and re-painting it, not by copying from some original, but by arranging and completing confused images and tints that are always appearing magically on his canvas. Now this magical panorama, from which the individual cannot escape, and the laws of which are the laws of his experience, is simply his own mind regarded as a content or a world.[115]

Another English philosopher, Shadworth H. Hodgson (1832–1912), may have been the first to apply the concept "stream of consciousness" to the subjective human experience (as early as 1865).[116] He emphasized its visual nature, claiming that it consisted not only of presented feelings, "but of represented also; not isolated but in combinations and groups; in fact, a full and varied picture, changing its content from moment to moment."[117] In *The Metaphysic Experience* (1898) he used the phrase "great stream or moving panorama of a Subject's consciousness."[118] Stream of consciousness became well known thanks to William James, who adopted it from Hodgson, and used it profusely in *The Principles of Psychology* (1891).[119] He preferred it to "chain" and "train," because consciousness "does not appear to itself chopped up in bits."[120]

The stream of consciousness and the moving panorama were associated in discourses about near-death experiences.[121] People who had almost drowned were reported to have declared that "when their normal consciousness had left them, in an instant, like a flash, their whole lives passed before them, even in the minutest details, as if it were a panorama."[122] Adding a machinic reference, likely a topos, Jirah Devey Buck compared death to a situation "when the spring is broken, the tension removed and the wheels run down, and as the springs of action slowly unwind the panorama is rehearsed, not this time in parts, but as a whole, before the final tragedy."[123]

The moving panorama sped past the mind's eye before imminent death over and over again until it became a cliché.[124] It was even used in a story written by a man who claimed to have been riding for his life on a bicycle, trying to escape from a ferocious Indian tiger![125] It is not surprising to discover it in texts about communication with the afterlife. E. W. Friend, the former secretary of the American Society for Psychical Research, used the concept "panorama-effect" about cases where the deceased had reported that "everything sweeps before me as in a vast panorama." The spirit of a Dr. Hodgson was said to have reported through a medium that "if he could only have communicated immediately after his death, he could have told everything, because the events of his whole life swept before him."[126]

Henri Bergson's (1859–1941) philosophical ideas about intuition and consciousness became very influential around the turn of the century.[127] Bergson

tackled the experience of imminent death in a lecture he gave at the University of Oxford in 1911, unsurprisingly evoking, like so many of his contemporaries had already done, the moving panorama:

> *In people who see the threat of sudden death unexpectedly before them, in the mountain climber falling down a precipice, in drowning men, in men being hanged, it seems that a sharp conversion of attention can take place—something like a change of orientation of the consciousness which, up until then turned toward the future and absorbed by the necessities of action, suddenly loses all interest in them. That is enough to call to mind a thousand different "forgotten" details and to unroll the whole history of the person before him in a moving panorama.*[128]

Bergson was intrigued by the rapidity with which the impressions followed each other. In *Mind-energy* (1920) he switched his metaphor, comparing dreaming to film projection: "The images . . . rush along with a dizzy rapidity, like a cinematograph film when the speed of the unwinding is not held in check."[129] Bergson's words echoed those of Edgar Rice Burroughs, who made (the year before) Tarzan the ape man struggle on a rope above a pack of bloodthirsty hyenas: "Like a flash of the cinematograph upon the screen, a picture was flashed before his mind's eye from the storehouse of his memory."[130] Elsewhere, a "disappointed man" noted in his diary: "When I feel ill, cinema pictures of the circumstances of my death flit across my mind's eye. I cannot prevent them."[131] The old topos had been filled with new content that corresponded better with changed technological realities.

However, discursive moving panoramas refused to disappear. In the 1960s they even materialized again as "moving panoramic souvenir novelty" pens and letter openers. Their users could relax by turning them in their hands, and watching the changing of the Buckingham Palace guard, or double-decker buses driving past Piccadilly Circus, represented by tiny figures in a cell of liquid inside the stem.[132] Discursive panoramas persisted in cultural memory, as Murray Edelman's *The Symbolic Uses of Politics* (1964) demonstrates: "For most men most of the time politics is a series of pictures in the mind, placed there by television news, newspapers, magazines, and discussions. The pictures create a moving panorama taking place in a world the mass public never quite touches, yet one its members come to fear or cheer, often with passion and sometimes with action."[133] The parallel is accurate in its own anachronistic way, although the writer may not have understood the full implications of his panoramic parable.

More recently, in *Bimbos of the Death Sun* (1988), a murder mystery set in a science fiction convention, Sharyn McCrumb made one of the characters state (ignoring the moving panorama's history): "Late twentieth-century people saw landscapes as a moving panorama, going by at fifty-five miles per hour. Surely this made their thinking different from the rest of humanity, who had seen landscape as a static view, like a painting."[134] Last but not least, panoramas keep

unrolling before the mind's eye at the moment of death, as William Arket's *First Born* (2003) testifies: "As the life began to drain out of him, a moving panorama of his life's events from the present to the past flashed through his mind."[135]

Figure 11.4
"Moving Panoramic Souvenir Novelty" pens. The ones depicting Piccadilly Circus (only box shown) and Buckingham Palace manufactured by H. Seener Ltd., London, 1960s. The one with a superhero (below) was given to the author as a boy, a long time before he had any idea he would one day write this book. Author's collection.

NOTES

1. Annie Besant, *Introduction to Yoga* (Benares City: Theosophical Publishing Society, 1908), p. 1 (emphasis added).

2. "I met do you remember Menton and who else who let me see that big babbyface I saw him and he not long married flirting with a young girl at Pooles Myriorama." James Joyce, *Ulysses* (1922), on-line Planet pdf. edition, p. 1219. (www.planetpdf.com).

3. "Address by Dr. Vincent," *Bulletin of the American Library Association* 6 (Jan.–Nov. 1912): 177. The address was given in a conference of the librarians in Ottawa.

4. Charles Dickens, "The American Panorama," *Examiner*, Dec. 16, 1848. Dickens even wrote a personal letter of congratulations to Banvard (Banvard Family Papers, microfilm roll 1, copy in EH). Dickens had already written three articles about the Colosseum in 1835; John Plunkett, "Optical Recreations and Victorian Literature," in *Literature and Visual Media*, ed. David Seed (Cambridge: D. S. Brewer, 2005), p. 7.

5. Broadside for Dec. 11, 1837 (copy in EH).

6. Charles Dickens, "Some Account of an Extraordinary Traveler," in *Miscellaneous Papers*, vol. 1 (London: Chapman and Hall, 1911), pp. 222–232, addition to the story, "A Card from Mr. Booley," p. 233.

7. Dickens, "Moving (Dioramic) Experiences."

8. Charles Dickens, "Mr Barlow," in *The Uncommercial Traveler and Additional Christmas Stories* (Boston: Houghton, Osgood and Co., 1879), ch. 32, p. 337.

9. Charles Dickens, *Pictures from Italy—American Notes* (London: Chapman & Hall, 1880), p. 156. "A Rapid Diorama" is the title of the book's final chapter that describes a trip from Rome to Naples and on to Florence.

10. Charles Dickens, *The Old Curiosity Shop. Sketches—Part I*, vol. 2 (New York: Hurd and Houghton, 1874), p. 198. Plunkett, "Optical Recreations," p. 8.

11. Which is what Dickens became. See Fitzsimons, *Garish Lights*.

12. Grahame Smith, *Dickens and the Dream of Cinema* (Manchester: Manchester University Press, 2003), p. 34. The idea has been inspired by Walter Benjamin's notion "panoramic literature."

13. Walter Benjamin, "Paris, the Capital of the Nineteenth Century (Exposé of 1935)," in *The Arcades Project*, trans. Howard Eiland and Kevin McLaughlin (Cambridge, Mass.: The Belknap Press of Harvard University Press, 2002), pp. 5–6. Quintin Hoare's translation in Walter Benjamin, *Charles Baudelaire: A Lyric Poet in the Era of High Capitalism* (London: Verso, 1983, p. 35) should be avoided, because both panorama and diorama have been translated as "diorama."

14. Benjamin, "The Flaneur (Part 2 of "The Paris of the Second Empire in Baudelaire)," trans. Harry Zohn, in *Selected Writings*, vol. 4, 1938–1940, ed. Howard Eiland and Michael W. Jennings (Cambridge, Mass.: Belknap Press of Harvard University Press, 2003), p. 18.

15. Jillian Taylor Lerner, "A Devil's-Eye View of Paris: Gavarni's Portrait of the Editor," *Oxford Art Journal* 31, no. 2 (2008): 233–250.

16. "Le panorama mobile qui vous environne!" In "Le flaneur," *Le diable boiteaux à Paris, ou, Le livre des cent-et-un* (Stuttgart: chez La Rédaction de la Collection d'oeuvres choisies de la littérature Française, 1832), pp. 116–117.

17. Smith mentions his move "from the explicit to the implicit use of the panorama in Dickens's work," *Dickens and the Dream of Cinema*, p. 86.

18. Dahl, "Mark Twain and the Moving Panoramas." See also Thomas Ruys Smith, *River of Dreams: Imagining the Mississippi before Mark Twain* (Baton Rouge: Louisiana State University Press, 2007).

19. Twain, "A Scriptural Panoramist."

20. Mark Twain, *Life on the Mississippi* (London: Chatto & Windus, 1883), pp. 514–520. The lecturer is recognized by the steamboat passengers by his speech. There is an illustration of him on p. 519.

21. Dahl, "Mark Twain and the Moving Panoramas," p. 31.

22. Ibid., p. 30.

23. Avery, "The Panorama and Its Manifestation in American Landscape Painting," pp. 219–226.

24. Peter West, *The Arbiters of Reality. Hawthorne, Melville, and the Rise of Mass Information Society* (Columbus: The Ohio State University Press, 2008). West emphasizes Hawthorne's and Melville's clearcut stance against the "culture of lies" of the mass-information society. I do not agree with his polarized vision. Particularly Hawthorne's attitude toward popular media was more nuanced and ambiguous, a love-hate relationship.

25. Dana Brand, "The Panoramic Spectator in America: A Re-reading of Some of Hawthorne's Sketches," *ATQ, The American Transcendental Quarterly: A Journal of New England Writers*, no. 59 (March 1986), pp. 5–17 (especially pp. 13–14); Joseph J. Moldenhauer, "Thoreau, Hawthorne, and the 'Seven-

Mile Panorama,'" *ESQ: A Journal of the American Renaissance* 44, no. 4 (4th quarter 1998): 227–273; Benjamin Lease, "Diorama and Dream: Hawthorne's Cinematic Vision," *Journal of Popular Culture* 5, no. 2 (Fall 1971): 315–323; Benjamin Lease, "Hawthorne and the Archaeology of the Cinema," *Nathaniel Hawthorne Journal 1976*, ed. C. E. Frazer Clark, Jr. (Englewood, Colorado: Information Handling Services, 1978), pp. 133–171; Jeffrey H. Richards, "The Showman as Romancer: Theatrical Presentation in Hawthorne's 'Main Street,'" *Studies in Short Fiction* 21, no. 1 (Winter 1984): 47–55: Bruno Monfort, "Hawthorne et le panorama de l'histoire: 'Main Street," *Transatlantica*, no. 1 (2006), dossier "Beyond the new Deal," on-line at transatlantica.revues.org/793 (last visited July 13, 2010). Moving panoramas were also associated with Hawthorne's writings in John J. Dolis, "Hawthorne's Ontological Models: Daguerreotype and Diorama," Ph.D. dissertation, Loyola University of Chicago, Graduate School, 1978 (unprinted), pp. 256–261 and passim.

26. Lease, "Hawthorne and the Archaeology of the Cinema," p. 136. Lease lists many instances, but offers little analysis.

27. Nathaniel Hawthorne, "Fancy's Show Box," in *Twice-Told Tales* (Boston: American Stationers Co., John B. Russell, 1837), pp. 307–316.

28. Nathaniel Hawthorne, "Ethan Brand: a Chapter from an Abortive Romance," in *The Snow-Image, and Other Twice-Told Tales* (Boston: Ticknor, Reed, and Fields, 1853), pp. 102–124. In some editions the text is titled "Ethan Brand, or the Unpardonable Sin." Hawthorne's original encounter with an itinerant "diorama" showman was noted down on August 31, 1838. Nathaniel Hawthorne, *Passages from the American Notebooks*, vol. 1 (London: Smith, Elder and Co., 1868), p. 231.

29. Nathaniel Hawthorne, "The

Toll-Gatherer's Day; A Sketch of Transitory Life," *United States Magazine and Democratic Review* 1, no. 1 (Oct.– Dec. 1837): 31–35 (later included in *Twice-Told Tales*, first published without it in 1837).

30. Nathaniel Hawthorne, "Main Street," in *The Snow-Image, and Other Twice-Told Tales*, pp. 63–101.

31. For Roberta Weldon, Hawthorne's attraction evokes anachronistically a "Disney-like audioanimatronic version of American history,." *Hawthorne, Gender, and Death: Christianity and its Discontents* (New York: Palgrave Macmillan, 2008), p. 36.

32. Nathaniel Hawthorne, *The American Notebooks* (New Haven: Yale University Press; London: Oxford University Press, [1932]), p. 255. Moldenhauer has tried to prove that Hawthorne saw Burr's *Seven Mile Mirror* during the same trip to Boston. If he did, it did not leave any traces in his writings. Moldenhauer, "Thoreau, Hawthorne, and the 'Seven-Mile Panorama,'" pp. 259–261. The discussion of links between Thoreau and Burr's panorama is more convincing, but superficial.

33. Nathaniel Hawthorne, *The Blithedale Romance. Authorized Edition* (Dessau: Katz Brothers, 1855), p. 135.

34. Ibid., p. 179.

35. In "The Toll-Gatherer's Day" Hawthorne used a schooner, which required the draw-bridge to be opened, as a kind of editing device. It paused the flow of traffic, as if a panoramic canvas had been stopped (p. 35).

36. The tone is similar in William W. Fowler's *Woman on the American Frontier* (Hartford: S. S. Scranton & Co, 1881): " If from the time of the landing we could recall the long procession of the actors and the events of border-

life, and pass them before the eye in one great moving panorama, how somber would be the colors of that picture! All along the grand march what scenes of captivity, suffering, bereavement, sorrow, and in these scenes, woman the most prominent figure, for she was the constant actress in this great drama of woe!" (p. 240).

37. West, in *The Arbiters of Reality*, does not realize that Hawthorne referred to an existing spectacle (p. 82).

38. "Noctes Ambrosianae, No. XLI," *Blackwood's Edinburgh Magazine* 25, no. 150 (March 1829): 390.

39. John G. Whittier, "The Panorama," in *The Panorama, and Other Poems* (Boston: Ticknor and Fields, 1856), pp. 3–26. Ticknor and Fields also published Hawthorne's *The Snow-Image*.

40. Whittier, "The Panorama," p. 12.

41. A critic found "Main Street" "perfectly graphic," suggesting that "if there were an artist of genius enough to transfer it to canvas," it would make a panorama of "inestimable worth." *Evening Traveler* (Boston), 1849, quoted in a letter from Mrs. Peabody to her daughter Sophia (Nathaniel Hawthorne's wife). The reference was made in a review of her other daughter's, Elizabeth Peabody's, book *Aesthetic Papers* (1849), in which "Main Street" first appeared. Julian Hawthorne, *Nathaniel Hawthorne and his Wife: A Biography*, vol. 1, 2d ed. (Boston: James B. Osgood and Co., 1885), p. 332.

42. Rita K. Gollin and John L. Idol, with the assistance of Sterling K. Eisiminger, *Prophetic Pictures. Nathaniel Hawthorne's Knowledge and Uses of the Visual Arts* (New York: Greenwood Press, 1991). The book concentrates on academic art, and has little to say about Hawthorne's interest in popular visual imagery.

43. "A propos de la Grippe et de ma Voisine," in *Musée Français: Choix de littérature, tiré des meilleurs auteurs, tant anciens que modernes*, ed. O. L. B. Wolff & C. Schuetz, Deuxième Année (Bielefeld: Velhagen & Klasing, 1837), p. 231.

44. Carter, *Letters from Europe*.

45. Ibid., vol. 1, p. 466. The visit took place in January 1826. Vanderlyn's circular panorama of Versailles is at the Metropolitan Museum of Art, New York.

46. Ibid., vol. 1, p. 500, 241. The hill in Marseilles now houses the basilica of Notre Dame de la Garde, built after Carter's visit.

47. Ibid., vol. 1, p. 106. Carter visited St. Paul's in August 1825. For an extra shilling he climbed to the top of the dome, close to where Thomas Hornor took in 1821–22 the sketches for the panorama of London, opened to the public in the newly-built Regent's Park's Colosseum in 1829 (Carter does not seem to have been aware of this).

48. Ibid., vol. 1, pp. 399–401. The description may have been influenced by guidebooks or earlier travel accounts. Victor Hugo described a "Bird's eye view of Paris" from the same platform in *Notre Dame de Paris* (1831, trans. Jessie Haynes, New York: P. F. Haynes, 1902, p. 112). Hugo did not mention "panorama," but wrote about "a marvellous picture spread out before you on every side." The coupling of "at a glance" and "coup d'oeil" with "panorama" is interesting, recalling Robert Barker's original name for his invention, *La Nature à Coup d'Oeil*. Is it a coincidence? Carter does not mention the Leicester Square panorama, and refers to the Regent's Park Diorama only indirectly.

49. Carter, *Letters from Europe*, vol 1, p. 255.

50. This brings to mind the famous scene in Jean-Luc Godard's *Tout va bien* (1972), where the simultaneous activities taking place in the apartments of a block of flats are observed by the spectator.

51. It was often associated with surveillance. One of its remarkable qualities was transmitting a "live" view from the outside to the interior of a "dark chamber." John H. Hammond, *Camera Obscura: A Chronicle* (Bristol: Adam Hilger, 1981).

52. Egan, *Life in London*, p. 15. Egan deals with the camera obscura in a manner that mixes up its features with peepshows.

53. Nathaniel Hawthorne, "Sights from a Steeple," in *Twice-Told Tales*, pp. 273–282.

54. Brand, "The Panoramic Spectator in America," p. 13. He uses the "panoramic spectator" about panorama-related links in Hawthorne's work, but does not mention the panopticon. Brand incorporated his essay into *The Spectator and the City in Nineteenth-Century American Literature* (Cambridge: Cambridge University Press, 1991).

55. The notion has suffered a critical inflation that has led to the loss of its historical specificity.

56. *Linguist: or, Weekly Instructions in the French & German* (London), vol. 1, no. 10 (May 28, 1825): 145–148. The original lines (the beginning of the poem) are: "Moi, je flane/Qu'on m'approuve ou me condamne;/Moi, je flane,/Je vois tout,/Je suis partout."

57. The expression *panorama mobile* appeared in French already in 1805, when a journal wrote about "simple spectateur des scènes diverses qui se jouent sur ce vaste théâtre des folies humaines, il soit au milieu du monde, s'il m'est permis d'employer cette comparaison, au centre d'un *panorama* mobile qui tourne autour de lui sans le toucher." *L'ésprit des journaux Français et étrangers* (Bruxelles: Welssenbruch), vol. 3, Premier trimestre (November 1805), p. 21. Original emphasis. One wonders if the comment was inspired by an existing spectacle, or transposed from the circular panorama. A later text characterized the surrounding crowd: "Sous quel aspect inattendu s'offre à vos yeux, avec un pareil démonstrateur, le panorama mobile qui vous environne!" Un Flaneur, "Le flaneur à Paris," *Paris, ou le livre des cent-et-un*, vol. 4 (Frankfurt a/M.: en commission chez Sigismond Schmerber, 1832), p. 63.

58. *Le Diable boiteaux à Paris*, 1832, pp. 116–117.

59. Charles Hervey, "The Habitue's Note-Book," *New Monthly Magazine and Humorist*, ed. W. Harrison Ainsworth (London: Chapman and Hall), vol. 87 (Third part for 1849), p. 490.

60. Carter, *Letters from Europe*, vol. 1, p. 406.

61. Joseph Mawman, *A Picturesque Tour through France, Switzerland, on the banks of the Rhine, and through parts of the Netherlands: in the Year M, DCCCXVI* (London: J. Mawman, 1817), p. 237.

62. Victor Fournel, *Ce qu'on voit dans les rues de Paris*, new edition (Paris: E. Dentu, 1867), p. 58 (author's translation).

63. "Through Broadway," *Atlantic Monthly* 18 (Dec. 1866): 718. The article also uses dissolving views as a metaphor.

64. Horatio Alger, Jr., *The Young Explorer; or, Among the Sierras* (Boston: Loring, 1880), p. 68.

65. Louisa M. Alcott, *Hospital Sketches and Camp and Fireside Stories* (Boston: Roberts Brothers, 1892) p. 71.

356

Many similar examples could easily be mentioned.

66. Collins and Dickens, "Lazy Tour of Two Idle Apprentices," *Household Words* 16, no. 397 (Oct. 31, 1857): 413.

67. Ibid., p. 413.

68. Harold Frederic, *The Damnation of Theron Ware or Illumination* (Chicago: Herbert S. Stone and Co, 1896), p. 456.

69. Marie Conway Oemler, *The Purple Heights* (New York: The Century Co., 1920), p. 225. The car is associated with the moving panorama also in William Perry Brown's *Ralph Granger's Fortunes* (Akron, Ohio: Saalfield Publishing Co., 1902), ch. 5.

70. George Gibbs, *Madcap* (New York: D. Appleton and Co., 1913), p. 101.

71. J. M. Leavitt, "Divine Revelation and Modern Science Based Alike on the Testimony of the Senses," *The Ladies Repository: a Monthly Periodical, Devoted to Literature and Religion*, ed. Rev. D. W. Clark, vol. 19 (Cincinnati: R. P. Thompson, 1859), p. 618.

72. Benjamin George Smith, *From Over the Border, or Light on the Normal Life of Man* (Chicago: Charles H. Kerr & Co., 1890), pp. 98–99. Is it a panorama on canvas or rather a series of educational lantern slides? It is impossible to tell.

73. Ibid., p. 98.

74. Chicago: Powers, Fowler & Lewis, 1896 (EH). Picture rolls were also used in tabletop crucifixes marketed by the Koenig Brothers in the United States. A chromolithographic roll of the Stations of the Cross inside the pedestal was viewed through a square opening by knobs on the side (example in EH).

75. In this sense it resembles

Yaggy's other invention, the pigeon-hole-style Chautauqua (children's) Desk, an environment designed to keep the child occupied for hours.

76. Students sold *Royal Scrolls* door-to-door during their vacations, just like stereoscopic views and Chautauqua Desks. *Northwestern University 1855–1905: A History*, ed. Arthur Herbert Wilde, vol. 3 (New York: University Publishing Society, 1905), p. 142. The Presbyterian *Assembly Herald* (10, no. 1 [January 1904]) told about a student who used it as a pretext to preach in private homes (p. 722).

77. Bishop Vincent, quot. in F[rancis] N[athan] Peloubet, *The Front Line of the Sunday School Movement* (Boston: W. A. Wilde, 1904), pp. 282–283.

78. "Revelation," in *The New International Encyclopedia*, vol. 14 (New York: Dodd, Mead, and Co., 1903), p. 1004.

79. Ibid.

80. Rev. Charles Minnigerode, *Sermons* (Richmond: Woodhouse & Parham, 1880), p. 268.

81. George B. Ide, *Bible Pictures; or, Life-Sketches of Life-Truths* (Boston: Gould and Lincoln, 1867), p. 22.

82. *The Local Preachers' Magazine and Christian Family Record for the Year 1864* [Wesleyan Methodist], vol. 14 (London: Philip Parker, Kent & Co., Simpkin & Co., 1864), p. 39; *The Prophetic News and Israel's Watchman* 6, no. 1 (January 1882): 172.

83. [David Logan Shirres,] *An Exposition of the Apocalypse on a New Principle of a Literal Interpretation* (Aberdeen: A. Brown & Co., John Menzies & Co., Longman & Co., 1871), p. 139.

84. Thomas Solly, *The Will, Divine and Human* (Cambridge: Deighton, Bell and Co., and Bell and Daldy, 1856), p. 250.

85. Hugh Miller, *Testimony of the Rocks, or, Geology in Its Bearings on the Two Theologies, Natural and Revealed* (Boston: Gould and Lincoln, Sheldon, Blakeman & Co., George S. Blanchard, 1857), p. 196. Miller referred to the moving panorama either as "panorama" or "diorama," which reflects the confusing nomenclature on the time.

86. Ibid., p. 143.

87. For example in *Sketch-Book of Popular Geology* (2d ed., Edinburgh: William P. Nimmo, 1869) he writes: "Permit me, however, to present you, in conclusion, not with the formal summary, but a somewhat extended picture, of the whole, exhibited, panorama-like, as a series of scenes." (p. 74) He soon continues: "Let us in like manner attempt calling up the features of our country in one continuous landscape, as they appeared at the commencement of glacial period" (p. 75). For more references, Ralph O'Connor, *The Earth on Show: Fossils and the Poetics of Popular Science, 1802–1856* (Chicago: University of Chicago Press, 2007), ch. 10 (pp. 392–433). O'Connor does not discuss the debate raised by *Testimony of the Rocks*, and does not draw a clear distinction between stationary and moving panoramas and dioramas.

88. Peter Byrne, *The Life and Letters of Hugh Miller,* vol. 1 (Boston: Gould and Lincoln, 1871), p. 150. The description, pp. 147–150.

89. Miller, *Testimony of the Rocks,* p. 196.

90. Ibid., p. 204.

91. Ibid., p. 205. Miller quoted and translated this statement from *Bibel und Astronomie* (2d ed., Berlin: Justus Albert Wohlgemuth, 1849) by J. H. Kurtz, professor of Theology at Dorpat [Tartu, Estonia], which was then part of Russia.

92. *Eclectic Review* 4, new series (London: Judd & Glass, July–December 1860), p. 252.

93. About Milton's influence, Miller, *Testimony of the Rocks*, p. 198.

94. M[arcus] M. Kalisch, *A Historical and Critical Commentary on the Old Testament, with a New Translation. Genesis* (London: Longman, Brown, Green, Longmans, and Roberts, 1858), p. 38. Kalisch concluded that the first chapter of Genesis is not a "creative picture," but a "creative history . . ., a simple prose narrative." Miller wondered, "what would be the aspect of the scene, optically exhibited from some point in space elevated a few hundred yards over the sea?" (*Testimony of the Rocks*, p. 197), admitting that Moses may have been "unacquinted with the extent of the periods represented in the vision." (p. 206.)

95. "Theories of Reconciliation between Geology and the Mosaic Account of Creation," *Macphail's Edinburgh Ecclesiastic Journal and Literary Review* 25, no. 150 (July 1858), p. 354.

96. David L. Holbrook, *Panorama of Creation as Presented in Genesis Considered in its Relation with the Autographic Record as Deciphered by Scientists* (Philadelphia: Sunday School Times Company, 1908).

97. William Denton, *The Irreconcilable Records: Or, Genesis and Geology* (Boston: William Denton, 1872), p. 61.

98. Ibid. Jerome Dean Davis, a missionary in Japan, also pondered how knowledge about the biblical version of the creation had been transmitted: "God could only have given to those first men a very crude knowledge of these things [creation of the universe], and we are not told how he gave that; it may have been in vision, or in moving panorama, before the mind of the observer, of the suggestive stages of the work, in the most simple form, one which his mind could comprehend, and then all was written, which his mind could comprehend and express in the meagre language of that age, and no more." J[erome] D[ean] Davis, *Hand-book of Christian Evidences* (Kyoto: Keiseisha, [1889]), p. 222.

99. *The Birth of Melbourne*, ed. Tim Flannery (Melbourne: The Text Publishing Co., 2002), p. 315. The editor accuses Denton, who died in New Guinea, and his sons for supplementing the family income "by collecting exotic fauna." (p. 315). Denton's four sons, who founded the Denton Brothers Company, gained fame for their butterfly displays, using the Denton Patent Tablet for mounting them.

100. In a flyer for his six lecture course on geology in January 1866 at the Mercantile Hall, Summer Street [Boston], Denton claims that his lectures are illustrated "by splendid Oil Paintings." The list is so extensive that it is more likely lantern slides were used. Online at the Americana Archive, American Broadsides and Ephemera, Series 1.

101. Foster Barham Zincke, *Wherstead: Some Materials forIts History* (London: Simpkin, Marshall, Hamilton, Kent & Co., 1893), p. 188.

102. A. J. McWhirter, "Industrial Development," *Biennial Report of the Commissioner of Agriculture, Statistics and Mines of the State of Tennessee* (Nashville: Marshall & Bruce, 1887), p. 646. Sternberger wrote: "In short, an endless panorama unrolls before us, and its name is: Evolution./One might almost think that this word itself indicated the long, unfolded picture." Sternberger, *Panorama of the 19th Century*, pp. 82–83.

103. Isaac W[inter] Heysinger, *Spirit and Matter before the Bar of Modern Science* (Philadelphia: J. B. Lippincott Co. & T. Werner Lurie, 1910), p. 400. A review of John Henry Newman's *Apologia Pro Sua Vita* (1864), commented on Newman's early doubts about the record of the senses: "Thus we believe it to be not an uncommon speculation in childhood, whether what we see is there, except when we see it; whether this world is not a mere moving panorama, which unfolds itself to spectators, but never displays itself to empty benches." *Christian Remembrancer: A Quarterly* (London: John and Charles Mozley), vol. 48 (July–October 1864), p. 165.

104. Berkeley, Calif: John Ulrick Oberg, 1902, p. 88.

105. Camille Flammarion, *Mysterious Psychic Forces* (Boston: Small, Maynard and Co., 1907), p. 47. According to Flammarion, the sample was from his 1862 notebook.

106. Newton Crosland, *Apparitions. An Essay, Explanatory of Old Facts and a New Theory* (London: Trübner and Co., 1873), p. 88. Originally published in London by Effingham Wilson in 1856.

107. Ibid., pp. 85–88. A related idea was suggested by a cardinal in Marie Corelli's novel *The Master-Christian* (New York: Grosset & Dunlap, 1900): "We accept new marvels of knowledge, as so much practical use to us, and to the little planet we live on,--but we do not see that they are merely reflections of the Truth from which they emanate. The toy called the biograph, which reflects pictures for us in a dazzling and moving continuity, so that we can see scenes of human life in action, is merely a hint to us that every scene of every life is reflected in a ceaseless moving panorama *Somewhere* in the Universe, for the beholding of *Someone*,—yes!— there must be Someone who so elects to look upon everything, or such possibilities of reflected scenes would not be,—inasmuch as nothing exists without a Cause for existence" (p. 105).

108. Loren Albert Sherman,

Science of the Soul (Port Huron, Mich.: Sherman Co., 1895), from the book's long subtitle. About Sherman's life, William Lee Jenks, *St. Clair County Michigan: Its History and Its People,* vol. 2 (Chicago: Lewis Publishing Co., 1912), pp. 495–498. Sherman was not affiliated with any church, in spite of his spiritual interests (p. 498).

109. Sherman, *Science of the Soul*, p. 92. The experimenter was Frank R. Alderman.

110. Ibid., pp. 97–98.

111. Ibid., p. 98.

112. Leo Hartley Grindon, *Figurative Language, its Origin and Constitution* (Manchester: Cave and Sever, 1851), p. 94. Discussing the use of sign-language in the education of the deaf, Isaac Lewis Peet characterized memory "as a moving panorama, beginning with the past and coming down towards the present, or with the present and going back towards the past, or, which is the same thing, as a series of pictures producing the same result." Isaac Lewis Peet, "The Relation of the Sign-Language to the Education of the Deaf," *Proceedings of the Seventh Convention of American Instructors of the Deaf* [Berkeley, California, 1886] (Sacramento: State Office/P. L. Shoaff, 1887), p. 100. Another author wrote that "the moving panorama of the world is devised, painted, set going, and apprehended in terms of mind; . . . we behold not things so much as we behold thoughts that have become things, in order that they may register themselves again as thoughts." Thomas R. Slicer, *The Power and Promise of the Liberal Faith. A Plea for Reality* (Boston: George H. Ellis, 1900), pp. 132–133. The idea was originally presented in the conference paper "Is God Yet Personal and Immediate?" (1897).

113. Jirah Devey Buck, *A Study of Man and the Way to Health* (Cincinnati: Robert Clarke & Co, 1889), p. 49.

Another theosophist, D. Harij, wrote, possibly influenced by Buck: "Memory as a faculty of man is one of the normal functions of the human brain. It is record of the process of events, external objects in relation to sensations and feelings occurring in consciousness, instigated by will or desire, or passively experienced or submitted to. The brain is the organ of memory, the physical basis within or upon which is recorded this moving panorama of events." D. Harij, "Reincarnation and Memory, IV," *Path*, 4, no. 9 (Dec. 1889): 270–271. *The Path* was published by the Theosophical Society.

114. Helen Bosanquet, *Bernard Bosanquet: A Short Account of His Life* (London: Macmillan and Co., 1924). He had seen "the Panorama and Panopticon, 'Wylde's [sic] Globe,' and a lecture by Gordon Cumming the famous lion hunter" (p. 15) The information is from Bosanquet's father's diary.

115. Bernard Bosanquet, *The Essentials of Logic, Being Ten Lectures on Judgment and Inference* (London: Macmillan & Co., 1895), p. 14.

116. It appears already in his first book *Time and Space. A Metaphysical Essay* (London: Longman, Green, Longman, Roberts, and Green, 1865), p. 74.

117. Shadworth H[ollway] Hodgson, *The Relation of Philosophy to Science, Physical and Psychological: an Address* (London: Williams and Norgate, 1884), p. 19.

118. Shadworth H[ollway] Hodgson, *The Metaphysic Experience*, vol. 3 (London: Longmans, Green, and Co. 1898), p. 97. The work uses the concept panorama profusely, developing a complex and rather obscure "total process-Panorama of experience." (p. 34) Hodgson explained elsewhere that ". . .we first analyze the world of common-sense objects into a stream or moving panorama of

consciousness, and then secondly place the analysis of this second world, the stream of consciousness, over against the former one." *The Relation of Philosophy to Science*, p. 16 (n).

119. William James, *The Principles of Psychology* (London: Macmillan and Co., 1891). The concept appears dozens of times. James defines it as "the stream of thought, of consciousness, or of subjective life." (vol. 1, p. 239). Hodgson was the president of London's Aristotelian Society that James joined. James valued Hodgson's analysis of consciousness. H. W. C., "Obituary: Shadworth Hollway Hodgson,"*Proceedings of the Aristotelian Society*, new series, vol. 12 (1911–1912): 328, 330.

120. James, *The Principles of Psychology*, vol. 1, p. 239. James uses the expression, "the panorama of the past, once opened, must unroll itself with fatal literality to the end," on p. 570.

121. More rarely, the static panorama was evoked. A man who had nearly drowned was said to have seen "as if in a wide field, the acts of his own being, from the first dawn of memory until the time he entered the water. They were all grouped and ranged in the order of the succession of their happening, and he read the whole volume of existence at a glance; nay, its incidents and entities were photographed on his mind, illuminated by light, the panorama of the battle of life lay before him." Hudson Tuttle, *Studies in the Out-Lying Fields of Psychic Science* (New York: M. L. Holbrook & Co, 1889), pp. 96. Example is from a book called *Sleep, Memory and Sensation* (p. 43). Hudson also mentions the severely ill Professor Hitchcock, who saw "visions of strange landscapes spread out before him—mountain, lake and forest; vast rocks, strata upon strata piled to the clouds; the panorama of a world shattered and upheaved, disclosing the grim secrets of creation, the unshapely

and monstrous rudiments of organic being." (p. 70).

———————

122. C[harles] G[odlove] Raue, *Psychology as a Natural Science applied to the Solution of Occult Psychic Phenomena* (Philadelphia: Porter & Coates, 1889), pp. 501–502. The kaleidoscope was occasionally evoked for similar purposes. Henry W[illiam] Fischer wrote in *Private Lives of Kaiser William II and His Consort. Secret History of the Court of Berlin*, vol. 2 (New York: Fred de Fau & Co., 1909): "It is said that one's whole life kaleidoscopically passes before the mind at the moment of death." (p. 498). The effects of opium eating were associated by Dr. Fred[erick] Heman Hubbard with the same topos: "Sights rare and pleasing pass kaleidoscopically through the mind, each bringing with it some new delight of the senses." *The Opium Habit and Alcoholism* (New York: A. S. Barnes, 1881), p. 3.

———————

123. Jirah Devey Buck, "Imagination and Will in Health and Disease," in *Transactions of the Thirty-Ninth Session of the American Institute of Homeopathy*, ed. J. G. Burgher (Pittsburgh: Stevenson & Foster, 1886), p. 363.

———————

124. An early occurrence is in Theodore S. Fay's *Norman Leslie; A New York Story* (New York: G. P. Putnam and Son, 1869). The protagonist casts a glance "into that dark cavern, his own heart," foreboding his death: "During these long hours, his past life floated back before him like a moving panorama." (p. 259). Here the "panorama" was slow. Drowning was associated with "the rapidly-moving panorama of of [sic] one's past life passing before the mind's eye" in B. Y. G. A., "Water Gabies," in *Aunt Judy's Christmas Volume For 1879*, ed. H. K. F. Gatty (London: George Bell & Sons, 1879), vol. 17, no. 154, p. 207.

———————

125. "Racing with a Tiger. A Bi-cyclist's Desperate Ride for Life in India," *Ballou's Monthly Magazine*

(Boston: G. W. Studley), vol. 75 (Jan.–June 1892): 192–194. The writer wrote: "I saw long-forgotten events in which I had take part rise up distinctly before me; and while every muscle was racked with my terrible exertion, my mind was clear, and my life seemed to pass before me like one long panorama." (p. 194) The rider was saved when hunters shot the tiger.

———————

126. E. W. Friend, "A Series of Recent 'Non-Evidential Scripts,'" *Journal of the American Society of Psychical Research, Section B* (New York), vol. 9 (1915), p. 129. Dr. Richard Hodgson, who had recently died, had completed Frederic W. H. Myers's posthumous work *Human Personality and It's Survival of Bodily Death*, 2 vols. (New York: Longmans, Green, and Co., 1903). Both Hodgson and Myers were believed to have communicated from beyond, and so was William James. Friend drowned, when a German U-boat sank the *Lusitania* on May 7, 1915. Friend's last article, published after his death, reported about possible post-mortem communications with William James, using his wife as a medium. E. W. Friend, "From William James?" *The Unpopular Review* (New York: Henry Holt and Company), 4, no. 7 (July–September 1915), pp. 172–202.

———————

127. A literary scholar explained Bergson's ideas by connecting them with a peculiar theory of time suggested by Samuel Butler in his Utopian satire *Erewhon* (1872): "[The Erewhonians] asserted in the first place that man, as it chances, is drawn through life backwards with his face to the past, instead of with his face to the future. They conceive of the future and past being, as it were, a panorama on rollers; to them the present exists only as one of the 'minor compromises of which human life is full—for it lives only on sufferance of the past and future.' Possibly this, in more comprehensible language, is what M. Bergson in recent years has been describing as his concept of time, substituting a cinematograph for the

panorama on rollers." John F[rederick] Harris, *Samuel Butler, Author of Erewhon: The Man and his Work* (New York: Dodd, Mead and Co., 1916), p. 82.

———————

128. "The Perception of Change," in *The Creative Mind. A Study in Metaphysics*, trans. Mabelle L. Andison (New York: Philosophical Library, 1946), pp. 152–153.

———————

129. Henri Bergson, *Mind-Energy. Lectures and Essays*, trans. H. Wildon Carr (New York: Henry Holt and Co., 1920), p. 130. Orig. *L'Energie spirituelle*. Bergson wrote about the "rapidity with which some dreams unroll themselves" on p. 128.

———————

130. Edgar Rice Burroughs, *Jungle Tales of Tarzan*, 4th ed. (London: Methuen & Co., 1920, orig. 1919). p. 148.

———————

131. W. N. P. Barbellion, *The Journal of a Disappointed Man* (New York: George Doran Co., 1919), p. 12. Note was from 1907.

———————

132. Some examples, marked as "A Moving Panoramic Souvenir Novelty," manufactured by H. Seener Ltd. [England], in EH. The author's first encounter with "moving panoramas" took place through the moving panoramic Batman pen he received as a boy c. 1965, and still keeps in his collection. In an erotic variant a pinup girl is stripped naked by turning the pen.

———————

133. Murray Edelman, *The Symbolic Uses of Politics*, 2d ed. (Urbana: University of Illinois Press, 1985, orig. 1964), p. 5.

———————

134. Sharyn Mccrumb, *Bimbos of the Death Sun* (New York: Ballantine Books, 1997, orig. 1988), p. 109.

———————

135. William Arket, *The First Born* (Imprint Books, 2003), p. 446. Arket characterizes this scene as "his death panorama." (p. 12).

———————

12. CONCLUSION:

FROM PANORAMAS TO MEDIA CULTURE

FIGURES ON THE SCREEN, OR THINGS LEFT UNSAID

"We are not passive spectators of a panorama of sensations, but are in constant reciprocal commerce with them."

—*J. Forsyth Crawford (1914)*[1]

This book has told a long and detailed story, but one may still wonder who its real protagonists have been—the machines and spectacles that have been so amply described on its pages, or the people who created them, exhibited them, consumed them, and fantasized about them? The answer is an oxymoron: the *clue* of the story was their complex and contentious relationship that led from things material to the figments of the mind, and back again. Moving panorama shows kept exchanging ingredients with other spectacles. They blossomed within a cultural space that was crisscrossed by boundaries, and torn by ideological divisions; economic developments, social changes, political ideas, and cultural trends all had an impact on them. The "identity" of the moving panorama was negotiated in the thick of complex discursive exchanges.

The process was so manifold that things must have been left unsaid here. This book has barely touched upon the economic and legal ramifications of showmanship. Future scholars may want to investigate how much the showmen earned, and how much

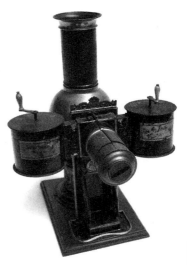

Figure 12.1
A toy magic lantern with a moving panorama–influenced system for projecting a series of pictures from a metal container that houses a transparent picture roll. The system was patented in Germany by J. Bischof (Berlin) in 1879. The patent (no. 7647) suggested flexible gelatin as the material for the rolls. Manufactured by Ernst Plank, Nuremberg, Germany, after 1879. Author's collection.

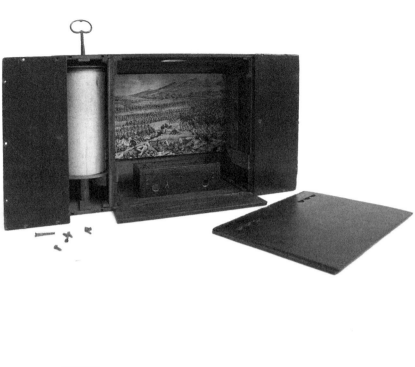

Figure 12.2 + 12.3
Homemade double function moving panorama and
peepshow viewer, discovered from a Connecticut farmhouse,
second half of the nineteenth century. The wooden
presentation box contains a roll of twenty-two chromo-
lithographic views mounted on linen. Turning the box on
its side and peeking in through the hole at the top reveals
another stage for a smaller moving panorama. This feature is
unusual, perhaps unique. Author's collection.

the spectators were ready (and able) to pay. The showmen must have paid taxes, or did they? It would also be worth scrutinizing institutional rules and regulations. There were national and local authorities whose words they had to comply with. How far it would be possible to proceed into these directions I don't know. Although it is fiction, Bouton's *Round the Block* shows how tricky just securing a hall for the panorama show may have been.

One could also have asked why so many moving panoramas dealt with geography and current events instead of fictional narratives. Because of the public's thirst for information about the world? Or because the moving panorama was found unsuitable for telling stories about complex characters, the *forte* of the stage and the novel? Living actors were certainly the theater's advantage, while novels had unique ways to offer intimate encounters with imaginary beings inside the reader's own head. Had they been attempted, panoramic adaptations of Shakespeare's tragedies, or Dickens's or Hawthorne's novels, might have been ridiculed as unintentional travesties—just remember the audience's unsparing comments about the puppets twitching their limbs in front of the panoramic canvas in Hawthorne's "Main Street."

Perhaps the panoramists avoided plays and novels because they believed in the power of visual spectacle over stories and characters. Such a trend already manifested itself in Servandoni's and de Loutherbourg's theatrical productions, and became more pronounced with the Diorama, where optical-mechanical imitation of real world environments was the main attraction. Humans, if included at all, were reduced to tiny stock characters to give the scene local color. True, Barker's, Langlois's, and Philippoteaux's huge battle panoramas contained characters that could be identified with a key diagram and a spyglass, but they were subordinated to the overwhelming alternate reality enveloping the visitors.[2]

The moving panorama resembled these spectacles, but it also differed from them. Already in 1847, Dewey Fay had grasped the difference between the circular and the moving panorama, answering to a polemicist: "He maintains that Mr. Banvard's picture of the Father of Waters, is strictly a panorama, because that designation means literally *all I see*. If we judge the painting of the Mississippi in accordance with his own definition, it cannot be styled a panorama, for it exhibits 'all I see and more too.' . . . Were Mr. Banvard to travel from Boston to New York, he might have seen the road, but did he have a panoramic view of the route? The phrase 'all I see,' as quoted, being in the present tense, refers to the scenery that may be perceived at one time."[3]

The moving panorama was primarily a storytelling medium, and only secondarily an illusionistic and immersive experience. The flesh-and-blood lecturer served as a mediator, and could even become a star; however, human protagonists were mostly lacking from the canvases. Except for the occasional biopic, temperance story, or illustrated classic based on *Pilgrim's Progress*, *Paradise Lost*, or the Bible, fictional narratives were uncommon. They became familiar in magic lantern shows, particularly after photographic "life-model" slides had been introduced. Mark Twain's imaginary "Stereopticon Panorama" sprang from this insight. Narrative slide sets shot with living actors could be produced, copied,

and distributed much more easily than huge rolls of canvas. The step from life models to narrative silent films was short and logical.

Assuming that there was a shift from actualities to fiction in the audience's preferences, and that this was the sole factor that signaled the mediatic change of guards, would be too simplistic. Other factors from the technological, social, and economic to the mental and psychological also contributed. Besides, there were continuities. Actualities and travelogues were also an important part of early cinema. The filmic vocabulary borrowed features from panoramas, as evinced by films shot by rotating the camera 360 degrees, or by continuous scenes cinematographed from the window of a moving train.[4] Last, but not least, film exhibitors continued using lecturers, the staple of both moving panoramas and magic lantern shows. They performed until the evolution of film language, the advent of talking pictures, and an increasing taste for mediated experiences made live explanations superfluous.

The exit of the lecturer left the audience alone in the dark, but not quite alone: scores of human figures were now living shadow lives on the screen. The spectators observed them, but could not attract their attention. These virtual beings became part of their lives, and even their (day)dreams. This is an example of what it means to live in media culture. But so is Charles Dickens's story about Mr. Booley, the "extraordinary traveler," who spent his evenings at moving panorama shows. It makes little difference that Mr. Booley is fictional—he is a token of a cultural condition that was established in the minds of thousands in the heat of panoramania. The moving panorama, and the discursive echoes that surrounded it, contributed to the inception of media culture as a way of being and experiencing.

WHAT IS MEDIA CULTURE?

Media culture is a common term in both scholarly and popular discourses, but few attempts have been made to define it. It could be suggested that it is a cultural condition, where large numbers of people live under the constant influence of media (anything from newspapers to the Internet). Mediated communication has increasingly replaced face-to-face encounters: people relate to each other at a distance by technological devices, and gain much of their information from media channels operated by governments and corporations (and these days by private citizens and groups as well). The accumulation and assimilation of media forms gives rise to an ever-changing zone of discursive exchanges that affect daily experiences at every step.

Media culture is not just an economic and social condition; it is also a shared state of mind, internalized in different degrees by each individual living under its spell. When Lady Florence Dixie wrote that "[a] moving panorama of the past

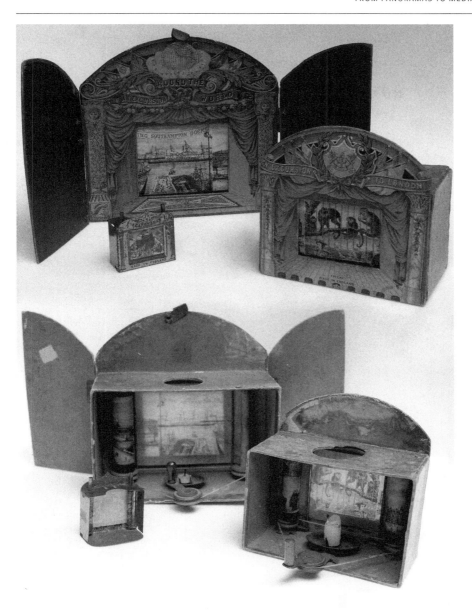

Figure 12.4
Moving panorama toy theatres (front and back views)
produced by Joseph Walker, Birmingham, 1890s. The
iconography and topics of Walker's miniature panoramas—
here an excursion around the world, a trip to London and
the Boer War—were influenced by Poole's Myrioramas
and Hamilton's Excursions. Walker's panoramas can be
recognized from the logo with the letters JWB (Joseph Walker
Birmingham). Author's collection.

nine months revolved its magic-lantern wonder before my eyes" she was unwittingly demonstrating the internalization of media culture. Her mind synthesized media forms that had been distinct, creating a parable to the tendencies in the world outside.[5] Countless similar examples could be quoted. Reverend Josiah Strong could not help bundling media forms even as he was attacking them: "The newspaper habit distorts or destroys our perspective; it fixes attention on the happenings of the hour and passes before the mind a rapidly shifting panorama—a sort of continuous presentation of perpetually dissolving views, which to the average mind is a meaningless jumble of events."[6]

Such accumulation points to the formation of what could be called the media-cultural imaginary—a state of being, where media have come to dominate minds to such an extent that they have replaced other reference points. In a way, they have turned into a second nature, a "panoramic" simulacrum of the world. Anecdotes about characters who fail to draw a distinction between reality and its representation are a token of this. As recycled topoi, they all testify in their own peculiar way to the broadening of this condition. Although an individual's immersion into the media-cultural imaginary can never be total (fortunately, one might add), it can be powerful enough to orient real-world behavior, as evidence about the impact of violent video games on massacres of innocent victims demonstrates.[7]

Media culture came into being at different times in different places. In England, one of the theaters of this story, the 1850s were crucial, and not only because of panoramania. Other media channels were opening at the same time. The rapid dissemination of stereoscopy infected Victorian homes with visual media long before radio and television. The virtual voyages it offered were supported by illustrated magazines. Chromolithographic trade cards and carte-devisite photographs filled scrapbooks and albums, and collages of printed images covered walls and fire screens. In the city streets, bill-posting was all the rage. The dots and dashes of the electrical telegraph, empowered by submarine communication cables, connected continents and disseminated news at speeds that could not be matched by even the fastest means of physical transportation.

Media's grip spread far and wide, both in material practices, and in the imagination. The American Civil War, the Franco-Prussian war, and the World's Fairs, as well as colonialism, mass tourism, temperance, immigration, urbanization, and social movements like suffrage, anarchism, and socialism provided ample topics. The invention of the telephone and the phonograph strengthened the aural dimension, opening up channels for voice communication and recorded sounds. The ruthless stunts of the yellow press, cinematographic moving pictures, and wireless telegraphy were added to the mix at the end of the century; most media channels still remained separate, but paths had been opened for their convergence. Radio, television, the Internet, and mobile telecommunications extended the media's net further, resulting in an integrated media culture.

FROM ILLUSIONS TO INTERACTIONS

The moving panorama's contribution to the emergence of media culture may seem modest, but it should not be underestimated. It reached audiences that lived far away from the highways of progress. Entertaining and informing city dwellers and country cousins alike, it equalized experiences, contributing to the democratization of culture. Besides, it prepared audiences for the sensory over-loads of modern media culture. Did the moving panorama also contribute to the monolithic, oppressive, and one-directional realm of corporate sensory hegemony Guy Debord famously called the "society of the spectacle"? Let us venture to suggest that commercial and ruthless as its underlying motives may often have been, it was more conversational and open than most later public spectacles.

Henry Box Brown, the former slave who exhibited a panorama of American slavery, once gave a benefit performance at Rochdale, a cotton-spinning boom-town near Manchester. Its aim was to help local Polish and Hungarian refugees, who had served as soldiers in Lájos Kossuth's revolutionary army, defeated in the Hungarian Revolution of 1848. Brown explained "the several scenes pre-sented on the canvass [sic], and made appropriate allusions to the case of the Hungarians."[8] Bridging cultures and ideologies in such a sweeping manner may have been unusual, but the underlying curiosity, compassion, and openness were common. To what extent they survive in today's media culture is open to debate.

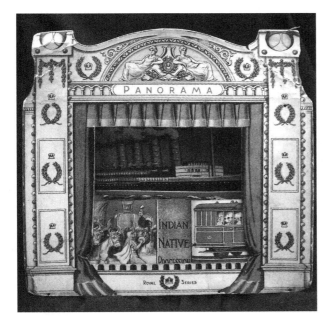

Figure 12.5
This rare toy moving panorama theatre contains two roll panoramas, one partly behind the other. The arrangement makes possible unusual combinations, and may have been influenced by "panstereoramas," where several moving canvases were used. "Royal Series," UK, maker unknown, between 1906-15 (dated by the launch and the sinking of the ocean liner Lusitania, which appears in both rolls). Author's collection.

Without belittling today's public media spectacles, I would like to conclude by reflecting on the other end of the spectrum. As we have seen, miniature panoramas accompanied the history of moving panoramas from the beginning. Especially toward the end of the century, colorful examples were manufactured by printers and toymakers like the industrious Joseph Walker in Birmingham, England.[9] They were also fabricated at homes as a creative pastime. Such Lilliputian devices were not just smaller versions of public shows; the reduction of scale changed their function. Anyone could now become a "crankist" or show(wo)man. Switching roles between the presenter and the spectator became easy. There must have been those who were content to play with prefabricated devices, but others created their own prosceniums and picture rolls, wrote lectures for them, and staged performances with them.[10]

As a side product of such seemingly innocuous play, the mighty world of media began losing its monolithic face. It was no longer necessary to sit passively in an auditorium observing a giant rolling canvas move by as if by itself. By turning the crank of Milton Bradley's *Historiscope*, it was possible to create a conversational relationship with media, and as a consequence with others. In the early twentieth century similar items were disguised as tiny toy movie theaters, operated by knobs; paper rolls were used instead of celluloid film. Such devices brought media to the fingertips. Ephemeral as they may seem, they provided seeds for the growth of personal interactive media—laptop computers, game consoles, iPhones, and all the other gadgets we cannot stop fingering these days. As the device became smaller, the human grew—or at least seemed to grow—bigger.

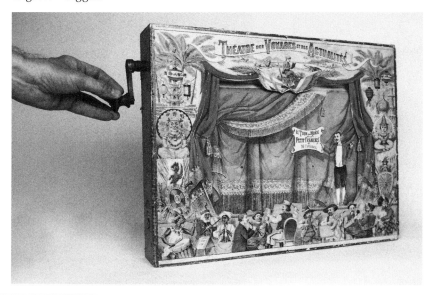

Figure 12.6
Théatre des Voyages et des Actualités. Le Tour du Monde par un Petit Français en 24 Tableux (Theatre of Voyages and Actualities. A boy's trip around the world in twenty-four views), a desktop moving panorama theatre, text by professor C. Gibert, illustrations by professor Ludovic Lion. Publisher unknown, French, c. 1900. Narratives around a central character were rare in moving panoramas, so this was probably influenced by literature, and maybe by early silent film. Author's Collection.

NOTES

1. A book review in *The Philosophical Review*, ed. J. E. Creighton (New York and Lancaster: Longmans, Green, & Co.), vol. 23, no. 4 (1914), p. 467.

2. Exceptionally, at the 1889 Universal Exposition in Paris there were two circular panoramas focused on personalities, Charles Castellani's *Tout Paris* (All of Paris) and Alfred Stevens's and Henri Gervex's *L'Histoire de siècle* (The History of the Century). See the latter's article "The Paris Panorama of the Nineteenth Century," *Century Magazine* 39, New Series 17, no. 38 (Nov. 1889–April 1890): 256–269.

3. Dewey Fay, "Panoramic Paintings," *Home Journal* 46, no. 102 (November 13, 1847): 2.

4. William Uricchio, "Panoramic Visions: stasis, movement, and the redefinition of the panorama," in *La nascita dei generi cinematografici/The Birth of Film Genres*, ed. L. Quaresima, A. Raengo, L. Vichi (Udine: Forum, 1999), pp. 125–133.

5. Lady Florence Dixie, *In the Land of Misfortune* (London: Richard Bentley, 1882), p. 433.

6. Rev. Josiah Strong, *Our World: The New World-Life* (Garden City, N.Y.: Doubleday, Page & Co., 1913), p. 5.

7. The Norwegian mass murderer Anders Behring Breivik wrote in a manifesto that the computer game *Call of Duty: Modern Warfare 2* was "part of my training-simulation." He also admitted his addiction to the online multiplayer game *World of Warcraft*. See Asher Moses, "From fantasy to lethal reality: Breivik trained on Modern Warfare game," *Sydney Morning Herald*, July 25, 2011. Breivik was also a hunter and a Gun Club member, and motivated his murders by his right-wing ideology. Games as such don't make anyone a mass murderer; a combination of factors is required.

8. "Mr. Box Brown and the Hungarians," *The Evangelical Repository*, ed. Joseph T. Cooper, vol. 10 (Philadelphia: William S. Young, 1851), p. 437 (the news was borrowed from a contemporary publication named *Independent*, England).

9. Joseph Walker, "Improvement in Toys," British patent no. 19188, accepted Aug. 11, 1894 (copy in EH). In his trade catalog (discovered by Mike Simkin in the Birmingham Library in 2008) Walker is characterized as "Designer, Modeller, Diesinker, Toolmaker, Stamper, Piercer, etc.— Patentee and Manufacturer—Of Novelties and Fancy Goods in Silver, Electro and Nickel Plate, Copper, Brass, Aluminium, etc." Another maker of great toy moving panoramas was Adolf Sala, Berlin. Dutch version of his panorama of a trip to Africa, "Eene Reis door Afrika. Cyclorama in 22 Beelden" (c. 1890), is in EH.

10. The *Brooklyn Daily Eagle* (New York) published on its "Our Little Folks" page (Feb. 22, 1903) a story called "Tale of Two Panoramas." Inspired by a circular battle panorama, a group of schoolboys creates a moving panorama of the Battle of Santiago. The pictures are cut out from illustrated magazines. The article was written to encourage the young readers to follow the example.

APPENDIX

A LIST OF SURVIVING MOVING PANORAMAS
Compiled with Suzanne Wray and Peter Morelli

This list concentrates on publicly exhibited moving panoramas. Miniature panoramas for private consumption have been left outside. The panoramas have been listed alphabetically by their title. This was the most convenient solution, because much information is missing. It is a compromise, because the titles kept on changing and many variants appeared. We have tried to choose the most representative one as the basis for the classification. Very likely the list is not exhaustive; it is possible that other moving panoramas survive. If you know of any, please contact the author at *erhuhta@ucla.edu.*

PART A: COMPLETE MOVING PANORAMAS

1.

– title:	*Army of the Cumberland*
– year:	c. 1864–1865
– painter:	William DeLaney Travis (1838–1916)
– showmen:	William D. T. Travis and his younger brother James toured the Middle West for seven years with the panorama.
– subject:	The Civil War campaigns fought by the Army of the Cumberland.
– description:	Oil on cotton, 9 x 528 feet. Thirty-two panels make up the panorama. The first shows a young soldier bidding farewell to home and family, and the last the artist himself riding home after the war. The other panels depict battles fought by the Army of the Cumberland.
– location:	National Museum of American History, Smithsonian Institution.
– additional information:	Harold Holzer and Mark E. Neely, Jr., *Mine Eyes Have Seen The Glory, The Civil War in Art* (New York: Orion Books, 1993, chapter five on "Cycloramas and Panoramic Art"); Bruce Catton, "The Army of the Cumberland: A Panorama Show by William D.T. Travis," *American Heritage*, Vol. XIX, No. 1 (Dec. 1967), includes several images. The Web site of the Smithsonian Institution shows all 32 views, with descriptions of each. *http://americanhistory.si.edu/westpoint/discover_travis_print1.html*

2.

– title:	*An Artist's Travels in the Eastern Hemisphere*
– year:	1858
– painters:	Eduard Robyn (1820–1862) and Ferdinand Welcker
– subject:	An artist's travels in the Eastern hemisphere.
– description:	Tempera on two rolls of canvas, each about 350 feet long and 8 feet high.
– location:	Missouri History Museum, St. Louis, Missouri. The museum acquired the panorama in 1940, along with another one by Eduard Robyn. The museum also owns a set of black and white photos of the panorama.

- additional
 information: Walter Schroeder and Howard W. Marshall, *Missouri: the WPA guide to the "Show Me" State* (St. Louis: Missouri Historical Society Press, 1998); Charles van Ravenswaay, *The Arts and Architecture of German Settlements in Missouri: A Survey of a Vanishing Culture* (Columbia: University of Missouri Press, 2006). An image from the panorama is reproduced on p. 491.

3.

- title: ***Battle Scenes of the Rebellion***
- year: The first 12 scenes were completed in 1886; 3 scenes were added later.
- painter: Thomas Clarkson Gordon (1841–1922). He was both the artist and the showman. He had no formal training in art. Born near Spiceland, Indiana, he had served in the Civil War from 1861 to 65, fighting in many battles. After he returned home, he married, and worked as a house painter and hardwood finisher. He began painting the panorama in 1884 or 1885, relying on his memory of the events, and on engravings of war scenes in magazines like *Harpers' Weekly*. The panorama was first shown in December of 1886 in Gordon's hometown, and later throughout eastern Indiana.
- subject: The Civil War, beginning with Fort Sumter and ending with Appomattox; Ironclads, Chattanooga, and the destruction of the Macon railroad were added later.
- description: The individual scenes were painted in oil on unbleached sheeting, sized. Each was 7 feet high by 14 feet wide; these were later joined into a continuous piece of canvas. The artist also constructed the wooden mechanism on which the panorama was wound. It unrolled vertically; most moving panoramas unrolled horizontally.
- location: Henry Ford Museum and Greenfield Village, Dearborn, Michigan. The daughters of the artist donated the panorama, the wooden framework on which it was wound and shown, Gordon's paintbox and related materials to the museum in 1958. The painting had remained in storage after Gordon's death in a building he had purchased to house it.
- additional
 information: *Civil War Panorama, A Moving Panorama Painting Entitled "Battle Scenes of the Rebellion" by Thomas Clarkson Gordon, 1841–1922* (Dearborn, Michigan: Henry Ford Museum and Greenfield Village, 1959) contains an essay by Joseph Earl Arrington and an illustration of each scene of the panorama.

4.

- title: ***The Campaigns of Garibaldi***
- year: 1860, with additional scenes painted through 1862.
- painter: John J. Story, born in 1828, Nottingham, UK.
- showman: John J. Story
- subject: The life and campaigns of Giuseppe Garibaldi, Italian patriot. The first section includes scenes from Garibaldi's childhood, his adventures in South America, his return to Italy and his early Risorgimento battles. The post-intermission portion of

the panorama includes battles in Sicily, some domestic scenes in Sicily, the triumphal entry into Naples, and other scenes from Garibaldi's eventful life.

- description:
4 1/2 feet by 273 feet (1.372 x 83.265 m), painted on both sides, so total length is 546 feet (166.53 m). Some 48 scenes, individually about 10 feet wide, plus transitions to form a continuous image. Tempera on a single roll of heavy paper.

- location:
Brown University Library, Anne S. K. Brown Military Collection, Providence R.I.

- additional information:
The panorama is well documented at the library's web page, at *http://dl.lib.brown.edu/garibaldi/panorama.php*
This includes photography and animation of the panorama, a script for the panorama, and a paper by Ralph Hyde, " 'The Campaigns of Garibaldi': A Look at a Surviving Panorama."

5.

- title: ***Dimick Huntington Panorama***
- year: 1887
- painter(s): C. C. A. Christensen (1831–1912). He was born in Denmark, and moved to the United States in 1857. The first of his four panoramas, two of which are extant. Painted with Danquart Weggeland, a Norwegian immigrant artist. He and Christensen painted ceilings and murals in several Mormon temples.
- showman: Dimick B. Huntington (1808–1879), who commissioned the panorama, planned to use it to preach the gospel to Indians in Utah. Huntington died shortly after the panorama was completed, and it is not known if he exhibited it.
- subject: The history of the world from Adam and Eve to Joseph Smith.
- description: The panorama consists of a series of eleven small paintings.
- location: Brigham Young University's Museum of Art, Salt Lake City, Utah. Christensen's Mormon Panorama is also owned by the Museum, as are photographic prints of the lost Hancock panorama.

- additional information:
Utah History Encyclopedia contains a brief biography of Christensen: *http://www.media.utah.edu/uhe/c/christensen,carl.html*
An article on Christensen and his panoramas is at *www.tfaoi.com/aa/3aa/3aa452.htm*. A Church News (LDS) article has images from the Mormon Panorama and the Dimick Huntington panorama: *http://www.ldschurchnews.com/articles/43312/Mormon-Panorama-makes-return-at-BYU-museum.html*

6.

- title: ***L'Exposition Universelle de Paris 1900***
(1900 Paris Universal Exposition)
- year: c. 1900–1901
- painter: Léon Van de Voorde and helpers, Ghent, Belgium.
- showmen: Le Théâtre Mécanique Morieux de Paris, Ghent, Belgium, Léon Van de Voorde, proprietor.
- subject: A visit to the 1900 Paris Universal Exposition, with exterior views of its most important pavilions. Fifteen scenes, each four meters wide, melt into each other.

– description:	2,31 meters high and 60 meters long. A section of the panorama was shown (as a stationary installation) at the Centre Pompidou, Paris, in the exhibition *Dreamlands* (May–August 2010), with a selection of the Morieux's mechanical marionettes arranged in front of it. A pencil sketch for this panorama is in the collection of Thomas Weynants, Ghent, Belgium.
– location:	Musée des Arts Forains, Paris. Jean Paul Favand Collection. In storage.
– additional information:	Discovered in an abandoned warehouse in Ghent, Belgium, with many other effects of the Théatre Mécanique Morieux, and bought by the Musée des Arts Forains in 2008. Musée des Arts Forains owns four complete Morieux moving panoramas and dozens of stationary background canvases, many of them dioramic.

7.

– title:	*The Grand Caricaturama*
– year:	1867
– painter:	Thomas Nast (1840–1902), a noted *Harper's Weekly* political cartoonist
– showmen:	The narrator in New York was William H. Norton, comic actor, who read a "humorous explanatory text," which has been lost. The narrator in Boston was Charles H. Brainard, a lyceum lecturer; Mrs. Whiting played the piano accompaniment.
– subject:	Giant illustrations of scenes from American history including independence and the Civil War, as well as contemporary politics, with some self-referential parody by the cartoonist.
– description:	Thirty-three paintings, each nine feet high by twelve feet wide, were painted in tempera on cotton muslin. Edwards and Brown, a theatrical machinery company, constructed the apparatus on which they were unrolled before the audience. The paintings were stretched on supports, and a rod, wire, or rope probably fit through the folded margins at the top of the paintings.
– location:	Five panels are at the Library of Congress warehouse, and two panels are hung in Macculloch Hall, a museum across the street from the Nast home in Morristown, N.J. The museum has many Nast drawings, and a photographic set of all thirty-three of the *Grand Caricaturama* paintings. Another panel is displayed in the Periodical Room of the Morristown Public Library.
– additional information:	Nast's scrapbook of news clippings and reviews about the Caricaturama is owned by the New York Public Library. The collection of the Morgan Library in New York contains a sketchbook of Nast's ideas for the *Caricaturama*. The Web site *HarpWeek* contains an excellent summary of the work of Thomas Nast and his *Caricaturama*, written by Alice Caulkins, Nast scholar and former Nast curator for the Macculloch Hall Historical Museum in Morristown, N.J. The HarpWeek Web site also contains photographs of some of the panels from the collection of Macculloch Hall. *The Making of America Project* online contains a review of Caricaturama, *Putnam's Magazine*, Vol. 1, (Feb. 1868), p. 264.

8.

– title:	*Grand Panorama of the Late War*
– year:	The panorama toured Vermont in the late nineteenth century, with a narration added to each scene.
– painter:	Charles Hardin Andrus (1852–1924), Richford, Vt. Born in Enosburg Falls, Vt., Andrus was a painter of murals, theater curtains and scenery, frescoes, trade cards, and signs.
– subject:	Ten scenes from the Civil War, including Surrender at Appomattox and Little Big Horn.
– description:	7 feet x 150 feet. In the original sturdy pine box, with original rollers.
– location:	Vermont Historical Society, Barre, Vt. The panorama was part of the Historical Society's summer 2011 exhibition, *Vermont in the Civil War*. Andrus also painted another Civil War scene, the 17 x 28 foot canvas *Sheridan's Ride*, which now hangs in the Vermont Veterans' Militia Museum and Library. Several theater curtains and backdrops painted by Andrus survive at Opera Houses and town halls in Vermont.
– additional information:	*Vermont History News*, July–August 1989.

9.

– title:	*Grand Voyage autour du Monde* (Great Voyage Around the World)
– year:	1890s
– painter:	Léon Van de Voorde and helpers, Ghent, Belgium.
– showmen:	Le Théatre Mécanique Morieux de Paris, Ghent, Belgium, Léon Vandevoorde, proprietor.
– subject:	Picturesque travelogue that starts from Oostende, and continues to Brussels, London, Constantinople, Moscow, Catania, and other places, reaching finally the Saharan desert, where a great lion hunt takes place. Also referred to in the Morieux publicity as "Un voyage pittoresque autour du monde" and "Le tour du monde."
– description:	2.31 meters high and 90 meters long.
– location:	Musée des Arts Forains, Paris. Jean Paul Favand Collection. In storage.
– additional information:	Discovered in an abandoned warehouse in Ghent, Belgium, with many other effects of the Théatre Mécanique Morieux, and bought by the Musée des Arts Forains in 2008. Musée des Arts Forains own four Morieux moving panoramas and dozens of stationary background canvases, many of them dioramic.

10.

– title:	*The Great Locomotive Chase or Andrews Raid*
– year:	Painted in the late 1870s.
– painter:	Albert Ruger (1828–1899), best known for his bird's-eye views of towns and cities.
– showman:	William J. Knight, a participant in the Andrew's Raid, traveled with the panorama in Indiana and Ohio for more than eighteen years.

– subject:	The panorama depicts a raid by Secret Service Agent James J. Andrews, who led a group of volunteer Union Soldiers on a mission to steal a Confederate locomotive and drive from South to North, destroying railroad tracks, bridges, and telegraph lines along the way. They stole The General, a locomotive, in Marietta, Georgia. Pursued north by Confederate troops on another train, they ran out of fuel after 100 miles. Andrews and seven others were captured and hanged, and other captives were exchanged for Confederate prisoners.
– description:	17 scenes, each 7 by 6 feet, painted on canvas or muslin, joined together. These were unrolled as Knight's lecture was given.
– location:	The Ohio Historical Society. Knight donated the panorama, his lecture notes, advertising, and the original "stage window" and rolling apparatus to the society in 1916. In 2010, the first panel of the panorama, and reproductions of the other 16, too fragile to display, were shown at the Ohio Historical Center in Columbus, Ohio.
– additional information:	*http://ohsweb.ohiohistory.org/ohiopix/Image.cfm?ID=4564* Ohio Historical Society Web site shows each scene of the panorama: *http://ohsweb.ohiohistory.org/ohiopix/events.cfm?start=151* Columbus Dispatch news story about the 2010 exhibition of the first scene, and reproductions of the others: *http://www.dispatch.com/live/content/life/stories/2010/12/02/daring-union-raid-depicted-in-scenes-on-view-at-center.html*

11.

– title:	*"The Great Siberian Route, The Trans-Siberian Railway Panorama"* ("The Great Siberian Railway Panorama")
– year:	1897–1903 (the *Hermitage News* also lists an alternative date 1894–1899, probably referring to the incomplete panorama shown in Paris 1900)
– painter:	Pavel Pyasetsky [Pawel Piasecki, Pavel Piasetsky] (1843–1919), commissioned by the Office for Trans-Siberian Facilities (the Administration of the Siberian railroad), headed by Czar Nicholas II. Said to have been assisted by Jezzew.
– subject:	The route across Siberia from Syzran on the Volga to Vladivostok in the Far East.
– description:	The surviving panorama consists of nine rolls, each in water-color on paper backed by fabric. Each roll is around 48.5 cm high and between 54 and 133 meters long; the total length is around 900 meters. Exhibited at the Siberian section of the Russian Pavilion in an unfinished state at the Paris Universal Exposition of 1900. Often mixed up with the huge simulator attraction *Panorama Transsibérien*, commissioned by the Compagnie Internationale des Wagon-Lits, and also shown at the Paris exposition (painted by the Frenchmen Jambon and Bailly). Not fully completed until 1903. Said to have been shown at the St. Louis Exhibition in 1904.
– location:	State Hermitage Museum Storage Centre in Staraya Derevnia. The panorama was displayed in late 2007 at the Vitebsky Railway Station in St. Petersburg. Restoration had begun

two and a half years earlier. An academic publication showing the entire panorama, and electronic and video versions are planned. The Hermitage owns several miniature roll panoramas by Pyasetsky, created in a similar way and with much the same characteristics. The first two are said to depict China and the life of the Chinese (1874). The "Panorama of Moscow During the Coronation of Nicholas II" (1896–1900) is said to be 58 meters long. Additional Information: G. Printseva has published articles on Pyasetsky's panoramas, most recently "P. Ya. Pyasetsky. Panorama Londona v dni prazdnovaniia 60-letiia tsarstvovaniia korolevy Viktorii," ("The Panorama of London during the celebration of the sixtieth anniversary of Queen Victoria's reign by Pavel Pyasetsky"), in *The Culture and Art of Russia, Transactions of the State Hermitage*, 40 (St. Petersburg: State Hermitage Publishers, 2008), pp. 266–279 (English summary, p. 405); *Sehsucht. Das Panorama als Massenunterhaltung des 19. Jahrhunderts*, ed. Marie-Louise von Plessen, Ulrich Giersch (Basel: Stroemfeld/Roter Stern, 1993), pp. 248–251; Stephen Bottomore, "Dr Pawel Yakolevich Piasecki," in *Who Is Who of Victorian Cinema, A Worldwide Survey*, ed. Stephen Herbert and Luke McKernan (London: BFI Publishing, 1996), p. 111 is informative, but mixes up Pyasetsky's and Jambon & Bailly's panoramas. The State Hermitage Museum's *Hermitage News* on-line (*www.hermitagemuseum.org*) has published articles about the restoration of the panorama.

12.

– title:	*Minnesota Massacre*
– year:	unknown, after 1873.
– painter(s):	unknown. Panorama is probably a copy of John Stevens's panorama of the Sioux Massacre.
– showman:	unknown
– subject:	Scenes of atrocities committed against white settlers in the 1862 Sioux uprising in southern Minnesota, scenes of the Modoc War in 1873.
– description:	The panorama consisted of 45 panels painted in oil on canvas, of which 42 are extant. Each panel is 42 x 42 in. The first 31 scenes illustrate the "Minnesota Massacre" and the last eight the Modoc War; three landscape scenes are inserted in the panorama.
– location:	The Glenbow Museum, Calgary, Canada. It obtained the panorama in 1966. It was too fragile to remain whole, and the scenes were cut and stretched as individual canvases. The script is also extant. Because of their "grossly offensive depiction" of the Sioux, the forty-two canvases are rarely exhibited or researched. The scenes of the panorama were incorporated into a work by Glenn Ligon, "Untitled (Minnesota Massacre)," shown at the Illingworth Kerr Gallery of the Alberta College of Art and Design in 2009. Ligon's work dealt with stereotypes as entertainment.
– additional information:	On-line information describes how the scenes of the panorama were incorporated into the work by Glenn Ligon.

*http://www.thefreelibrary.com/glenn+ligon%3a+death+of+tom+and+
untitled+(minnesota+massacre)%3a...-a0223116810*
*http://www2.canada.com/calgaryherald/news/entertainment/story.
html?id=fa6a6e4e-79e5-41a0-ac87-85a61cc7a11c*

13.

– title:	***Mormon Panorama***
– year:	begun in 1878 and completed over the next several years.
– painter:	C. C. A. Christensen (1831–1912) (See Dimick Huntington Panorama)
– showman:	In the late 1800s, Christensen and his brother Mads Fredrick Theobald Christensen, who financed this panorama, traveled throughout Utah, Idaho, and Wyoming with the panorama, showing it to Church members. A lecture accompanied the panorama, and the audience was invited to sing hymns as part of the performance.
– subject:	The panorama depicts the history of the Latter Day Saints (Mormon) church, from the first vision of Joseph Smith to the pioneers entering the Salt Lake Valley. The first scene of the panorama, showing the First Revelation of the Prophet Joseph Smith in upstate New York, has been lost.
– description:	The 22 individual scenes of the panorama were cut and framed in the 1970s: each is 6 1/2 feet tall by 10 feet wide, painted in tempera on muslin. Originally there were twenty-three scenes, totaling 175 feet long, sewn to a canvas backing and wound on rollers for display.
– location:	Brigham Young University's Museum of Art, Salt Lake City, Utah. One scene Crossing the Mississippi on the Ice, is framed and on display. The panorama Christensen painted for Dimick B. Huntington (1887) is also owned by Brigham Young University. Yet another panorama painted by Christensen and other artists exists only in photographs. The panorama was shown at the Whitney Art Museum in 1970, with the scenes framed and mounted on the walls.
– additional information:	There are two images from Christensen's panorama on line: *http://www.lib.byu.edu/dlib/moa/.* The sources listed under Dimick Huntington panorama also provide information on this one.

14.

– title:	***Moving Panorama of Pilgrim's Progress,*** also called *Bunyan's Tableaux*
– year:	Completed in 1851, based on an earlier version completed in 1850.
– painters:	Joseph Kyle (1809–1863) and Jacob Dallas (1825–1857); earlier version (1850) was painted by Kyle and Edward Harrison May (1824–1887), who studied under Daniel Huntington. All were associates of the National Academy of Design. Designs by Kyle, May, and Dallas, and by Frederick Edwin Church, Jasper Cropsey, Daniel Huntington, Felix Octavious Carr Darley, Henry Courtney Selous, and Peter Duggan.
– showmen:	Robert Greenwood
– subject:	Scenes from John Bunyan's *Pilgrim's Progress*, 1678.

– description:	Distemper on muslin. Eight feet by 800+ feet, in four sections. Conserved in 1999, with additional conservation completed in 2011, the panorama is now in good condition. It originally had 53 scenes, of which 40 remain. Scenes 23 to 35 are missing, and presumed lost. An original roller for the panorama has also been preserved.
– location:	The Saco Museum, Saco, Maine. An exhibition is planned for 2012. The museum is currently creating a full size canvas replica so that the panorama can be performed as well as exhibited.
– additional information:	Peter Morelli and Julia Morelli, "The Moving Panorama of Pilgrim's Progress: The Hudson River School's Moving Exhibition," in *The Panorama in the Old World and the New* (Amberg: Büro Wilhelm. Verlag Koch—Schmidt—Wilhelm GbR and International Panorama Council, 2010), pp. 58–62; Thomas Hardiman, "The Panorama's Progress: The History of Kyle & Dallas's Moving Panorama of Pilgrim's Progress" is at *http://www.tfaoi.com/aa/3aa/3aa70.htm* . Kevin Avery, "Movies for Manifest Destiny: The Moving Panorama Phenomenon in America" is at *http://www.tfaoi.com/aa/3aa/3aa66.htm* . Photographs and a brief description are available online at *http://www.saco museum.org/mus_pilgrims.shtml* .

15.

– title:	*Panorama de la Guerre Russo-Japonaise* (The Russo-Japanese War)
– year:	After 1904–1905.
– painter:	Franz Gruber, Hamburg (signed in the beginning of the roll). Gruber was a theatrical scene painter at the Hamburg Stadttheater (City theater).
– showmen:	Le Théatre Mécanique Morieux de Paris, Léon Van de Voorde, proprietor.
– subject:	The battles of the Russo-Japanese war of 1904–1905.
– description:	2,31 meters high and 30 meters long.
– location:	Musée des Arts Forains, Paris. Jean Paul Favand Collection. In storage.
– additional information:	Discovered in an abandoned warehouse in Ghent, Belgium, with many other effects of the Théatre Mécanique Morieux, and bought by the Musée des Arts Forains in 2008. Musée des Arts Forains owns four complete Morieux moving panoramas and dozens of stationary background canvases, many of them dioramic.

16.

– title:	*Panorama of the Monumental Grandeur of the Mississippi Valley*
– year:	c. 1850
– painter:	John J. Egan, American (born Ireland), 1810–1882.
– showman:	Dr. Montroville Wilson Dickeson (1810–1882) from Philadelphia commissioned the painting, which was based on his own drawings. Dickeson, who considered himself an archeologist, provided the narration as he traveled with the panorama, show-

ing it alongside his artifacts from American Indians in the Mississippi River Valley.

– subject: Scenes along the Mississippi and especially of American Indian life. Scene titles include: "Louisiana Swale Group, with Extensive Wall; Lakes and Sacrificial Monuments," "Natchez Hill by Moonlight; Indian Encampment; Distant View of Louisiana; Indians Preparing Supper," "Indians at Their Games," "Cave in the Rock, Stalagmitic Chamber and Crystal Fountain, Desiccated and Mummied Bodies in Their Burial Places; Magnificent Effect of Crystallization."

– description: Distemper on cotton muslin, 90 in. x 348 ft. (228.6 cm x 106 m and 7 cm). Twenty-five scenes of the original forty-five survive.

– location: Saint Louis Art Museum, St Louis, Missouri. The panorama was exhibited in motion in an exhibition at the City Art Museum of St. Louis in 1950. Recently it has been under conservation and was to be on display (in stationary mode) during the summer of 2011. The complete panorama will be displayed in the museum's American art galleries.

– additional
information: *Mississippi Panorama. The life and landscape of the Father of Waters and its great tributary, the Missouri*, ed. Perry T. Rathbone (St. Louis: City Art Museum of St. Louis, 1950, pp. 13–16, 127–135 (including pictures of its presentation in 1950, pp. 13–14); Lisa Lyons, "Panorama of the Monumental Grandeur of the Mississippi Valley," *Design Quarterly* (Minneapolis: Walker Art Center), no. 101/102 (1976), pp. 32–34 (with color foldout). See also the broadside reproduced in this book from the author's collection.

17.

– title: *Purrington and Russell's Original Panorama of a Whaling Voyage Round the World*

– year: 1848

– painter(s): Benjamin Russell (1804–1885) and and Caleb Purrington (1812–1876). Russell was a native of New Bedford (Mass.), who spent from 1841 nearly four years on the whaling ship Kutusoff of New Bedford (William H. Cox, master) in a whaling voyage to the Pacific Ocean. He later became a marine painter specializing in ship portraiture and whaling scenes. Caleb Pierce Purrington was a Fairhaven, Mass., sign painter.

– subject: Whaling voyage. "The story begins with a whaler leaving New Bedford heading out to sea, meeting ships homeward bound, scenes of the Azores and Cape Verde, the coast of South America, round Cape Horn toward the Pacific Island with scenes of lowering boats, taking whales, cutting in and all aspects of the whaling voyage," according to the museum's Web site.

– description: Water based medium on sewn together canvas sheeting with bolt rope along top edge. The material is Prescott Fine Sheeting (likely cotton). Sections have been cut and are out of sequence. The views are 8 ft. 6 in. tall, and the total length 1275 ft. On four rolls.

– location: In storage at the New Bedford Whaling Museum, New Bedford, Massachusetts. Acquired in 1918 by Old Dartmouth Historical

Society from Benjamin Cummings. Part of the panorama used to hang in the museum's walls. C. 120 ft. was on loan at the Smithsonian Institution 1963–1967, another c. 150 ft. was exhibited at the New York World's Fair, 1964–1965. A film titled *Whaler out of New Bedford* (1961, Francis Thompson, Inc.), documented the panorama with period music.

– additional
 information: Mary Jean Blasdale, *Artists of New Bedford. A Biographical Dictionary* (New Bedford, Mass.: Old Dartmouth Historical Society at the New Bedford Whaling Museum, 1990), pp. 149, 158–160; Samuel Eliot Morison, *Introduction to Whaler out of New Bedford: A Film Based on the Purrington-Russell Panorama of a Whaling Woyage Round the World 1841–1845* (New Bedford, Mass.: Old Dartmouth Historical Society, 1962); Elton W. Hall, *Panoramic Views of Whaling by Benjamin Russell* (New Bedford, Mass.; Old Dartmouth Historical Sketch Number 80, 1981); Kevin Avery, "Whaling Voyage Round the World: Russell and Purrington's Moving Panorama and Herman Melville's 'Mighty Book'," *The American Art Journal* 22, no. 1 (1990): 50–78; Phil F. Purrington, *4 Years A-whaling* (Barre, Mass.: Barre Publishers for the Whaling Museum, New Bedford, Mass., 1972); Michael P. Dyer, "Revisiting the Content and Context of Russell and Purrington's 'Grand Panorama of a Whaling Voyage Round the World," in *The Panorama in the Old World and the New* (Amberg: Büro Wilhelm. Verlag Koch—Schmidt—Wilhelm GbR and International Panorama Council, 2010), pp. 52–57. New Bedford Whaling Museum Web site *http://www.whalingmuseum.org/kendall/library/biblio_ecwill.html*

18.

– title: ***Stevens' great Tableau Paintings Representing the Indian Massacre in Minnesota in 1862 / The Sioux War Panorama / The Panorama of the Indian Massacre of 1862 and the Black Hills***

– year: First version, c. 1863, other versions 1868, 1870, and 1874. The later versions included scenes of current interest, and even some comic scenes.

– painter(s): John Stevens (1819–1879), a sign painter from Rochester, Minnesota. The panoramas were shown in the Midwest until 1878.

– showman: Captain C. E. Sencerbox, "one of the oldest and most popular steamboatmen of the upper river," served as narrator in 1868. In 1870 Stevens himself read the explanation of his painting. In 1873, Merton Eastlick, who had escaped the Sioux with his infant brother, was employed by Stevens to travel with the panorama as manager and lecturer.

– subject: The panoramas illustrated an attack by Sioux Indians on a group of 50 people in Murray County, Minnesota on August 20, 1862. Fifteen of the settlers were killed, others captured by the Sioux, others escaped. Stevens supposedly based his panorama on the recollections of one of the women who escaped the massacre.

– description: Two versions of the panorama are known survive; one at the Minnesota Historical Society, the other in the Gilcrease

Museum at Tulsa, Oklahoma. The panorama in the Gilcrease Museum consists of 36 panels, many signed by Stevens and dated Rochester, 1870. This is a "diaphanous painting," supposedly a form invented by Stevens. The painting was transparent, designed to be lit from behind the scenes, rather than from the front. Scenes include Minnehaha Falls, Washington, with Lafayette, followed by the Sioux War pictures. The Minnesota Historical Society panorama consists of 36 panels, each six feet high and seven feet wide, with an overall length of 220 feet. It includes scenes of Lincoln and his cabinet, scenery from the far West, and some comic scenes which break up the narrative of the Sioux massacre.

– location:
The Minnesota Historical Society owns a version of the panorama, the mechanism to display it, the wooden boxes in which it was transported, two wooden pedestals that were used to hold kerosene lamps on each side of the panorama, an advertising broadside, and a handwritten copy of the lecture given when the panorama was shown, all presented to the Society in 1919 by Burt W. Eaton, of Rochester.

– additional
information:
Bertha L Heilbron, "Documentary Panorama," *Minnesota History* 30 (March 1949): 14–23; John Bell, "The Sioux War Panorama and American Mythic History," *Theater Journal* (Johns Hopkins University Press), vol. 48 (1996): 279–299.

19.

– title:
A Tour of the Eastern and Western Hemispheres

– year:
1855?

– painter:
Eduard [Edward] Robyn (1820–1862)

– subject:
Scenes of Europe.

– description:
C. 10x350 feet. This is one of two moving panoramas painted by Robyn. The other one is *An Artist's Travels in the Eastern Hemisphere*, which he painted with Ferdinand Welcker.

– location:
Missouri History Museum, St. Louis, Missouri; acquired 1940. It also has a set of black and white photos of the panorama.

– additional
information:
Walter A Schroeder and Howard W Marshall, *Missouri: the WPA guide to the "Show Me" State* (St. Louis: Missouri Historical Society Press, 1998); Charles van Ravenswaay, *The Arts and Architecture of German Settlements in Missouri: A Survey of a Vanishing Culture* (Columbia: University of Missouri Press, 2006).

20.

– title:
Vision of St. John on the Island of Patmos
(from the Book of Revelations) and other titles

– year:
Unknown. The painter spent three years creating the paintings, which toured in the 1880s.

– painter:
Arthur L. Butt

– showmen:
Initially Butt narrated the panorama exhibitions. Later Butts's father, John F. Butt, a lay Methodist minister, traveled with the show, and the artist's wife, Mattie Creswell Butt, provided musical accompaniment and sang.

– subject:	One panorama is based on the Book of Revelations while others scenes are from the Old Testament. There are also scenes of social issues such as Temperance.
– description:	six large rolls of painted fabric (plain weave cotton sheeting) on wooden spindles, each image approximately 10 feet by 12 feet. Some images have glued-on foil or glitter, and the Pearly Gates of the New Jerusalem image may have had real pearls sewn to the canvas. It is not clear to the museum whether this is one, two or more panoramas.
– location:	North Carolina Museum of History, Raleigh, N.C. The Museum's Web site gives descriptions of the panoramas in general, and describes some of the individual scenes and its construction.
– additional information:	*http://www.ncmuseumofhistory.org/collateral/articles/F08.mammoth. moving.pictures.pdf . http://collections.ncdcr.gov/dcr/ProficioScript. aspx?IDCFile=PAGE.IDC*

21.

– title:	***Voyage pittoresque d'Alexandrie au pole nord*** (Picturesque Voyage from Alexandria to the North Pole)
– year:	1890s.
– painter:	Léon Van de Voorde and helpers, Ghent, Belgium.
– showmen:	Le Théatre Mécanique Morieux de Paris, Ghent, Belgium, Léon Van de Voorde, proprietor.
– subject:	Depicts a voyage from Alexandria to the North Pole via Naples, San Francisco, and Greenland. This panorama may be identical with ones that were advertised in the Morieux publicity as Nansen's or Wellmann's expeditions to the North Pole.
– description:	2,31 meters high and 91 meters long. The scenes dissolve into each other creating a sense of continuity.
– location:	Musée des Arts Forains, Paris. Jean Paul Favand Collection. In storage.
– additional information:	Discovered in an abandoned warehouse in Ghent, Belgium, with many other effects of the Théatre Mécanique Morieux, and bought by the Musée des Arts Forains in 2008. Musée des Arts Forains own four Morieux moving panoramas and dozens of stationary background canvases, many of them dioramic.

PART B: FRAGMENTS AND VARIANTS

1.

– title:	**"The Bay and Harbor of New York,"** the concluding scene from Samuel B. Waugh's moving panorama of Italy
– year:	between 1849 and 1858
– painter:	Samuel B Waugh (1814–1885), portrait and landscape painter. A native of Mercer (Pa.), he spent eight years in Italy before 1841. After that date he spent most of his time in Philadelphia.
– subject:	Homecoming of passengers to New York Harbor, showing Castle Garden, the Battery, and the Chinese Junk, Keying, which visited the United States in 1847. Brooklyn and Governors Island can be seen in the distance; in the foreground, an emigrant

ship discharges passengers and their property. Waugh's moving panorama The Mirror of Italy was first shown in Philadelphia in 1849 and was being exhibited as late as 1855. A second series, entitled "Italia," was shown from 1854 to 1858. According to the Museum of the City of New York, Waugh painted a dozen additional scenes to his 50-scene panorama, *The Mirror of Italy*, in his studio in Bordentown, NJ. The expanded panorama, Italia, was about 800 feet long,

– description: Watercolor on canvas, 99 1/5 x 198 1/4 inches

– location: The Museum of the City of New York.

– additional
information: See the Web site of the Museum of the City of New York, where it was included in the exhibition *Painting the Town*. The July 31, 1933, issue of *Time Magazine* tells of Waugh's panorama, and the display of the view of New York Harbor in 1933. The handbook is in the Museum of the City of New York's archives: *Waugh's Great Italia & [McDonnells' Voyage to Rome] & A Hand-Book Descriptive of the New Series of Italian Views. Painted by S. B. Waugh, Esq. in 1852, '54, and '55. From Sketches Taken by the Artist During a Residence of Several Years in Italy* (Philadelphia, 1867).

2.

– title: **London to Hong Kong in Two Hours**

– year: c. 1860

– painter(s): John Lamb Primus and John Lamb Secundus

– subject: A trip to the Orient using the Overland Route.

– description: Watercolor 37.5 x 5,338.5 cm Small scale panorama for parlor entertainments. A lecture script exists.

– location: Museum of London (on loan)

– additional
information: Although several images from the panorama appear on the Museum's Web site, there is not much information on the panorama itself. The panorama is described in Ralph Hyde, *Panoramania! The Art and Entertainment of the "All-Embracing" View* (London: Trefoil Publications, 1988), p. 144.

3.

– title: **Panorama einer Reise von Hamburg nach Altona und zuruck**
(Panorama of a Trip from Hamburg to Altona and Back)

– year: 1820s

– painter: Christoph (1771–1842), Cornelius (1781–1857) and/or Peter (1788–1857) Suhr.

– subject: A walking trip or perhaps a coach ride between the two nearby cities, past the various entertainments offered along the route.

– description: Continuous roll painting, colored lithograph, with watercolor and collaged additions. 46,5 cm x 4 meters 92 cm. In the 1820s the Suhrs published a miniature roll panorama depicting the public amusements between Hamburg and the nearby city of Altona. A magnified version was created by pasting the roll on wider paper, and adding elements by watercolor; human figures were cut out and pasted from Suhr's earlier publications. The resulting unique panorama was evidently used for public

entertainment in a hand-cranked view box. It was printed as a hand-colored edition by Hermann Barsdorf Verlag, Berlin, 1909. The original is in the Staatsarchiv, Hamburg. It was exhibited in *Sehsucht*, Kunst. und Austellungshalle der Bundesrepublik Deutschland, Bonn, in 1993. Miniature versions are in Warner Nekes Collection and Getty Research Institute, the extended 1909 edition in the author's collection.

– location:

– additional information:

Dr. J. Heckschler, *Peter Suhrs "Panorama einer Reise von Hamburg nach Altona und zuruck"* (Berlin: Hermann Barsdorf Verlag, 1909); *Sehsucht. Das Panorama als Massenunterhaltung des 19. Jahrhunderts*, ed. Marie-Louise von Plessen, Ulrich Giersch (Basel Main: Stroemfeld/Roter Stern, 1993), p. 211; Barbara Maria Stafford and Frances Terpak, *Devices of Wonder: From the World in a Box to Images on a Screen* (Los Angeles: Getty Research Institute, 2001), pp. 319–321.

4.

– title: ***Mastin's Unparalled Exhibition of Oil Paintings***
– year: 1846
– painter(s): Unknown. The paintings are unsigned, and were probably painted by "folk artists," self-trained decorators, carriage painters, sign painters or tool manufacturers who earned extra money by painting portraits, historical, and religious scenes.
– showman: George J. Mastin (1814–1910), a tailor, storekeeper and farmer from Genoa, New York, who commissioned this group of paintings. He traveled with the exhibition, which, in addition to the lecture given with the paintings, included singing, clog dancing by the Erin Twin Brothers, and phrenological readings.
– subject: In addition to "Landscapes, Historical, Scriptural and Tragical Scenes" (according to a broadside for the exhibition), four of the paintings showed "the Murder of the Van Ness Family by the Negro Freeman, which took place in Cayuga County, N.Y." (The correct spelling of the victims' name was Van Nest.) One of the paintings showed Freeman being hung, although he died in prison before the sentence could be carried out.
– description: Fourteen paintings, oil on canvas (mattress ticking); twelve of the paintings are 8 by 10 feet and the other two 10 by 14 feet. They were not connected, and but were hung on the walls of a tavern or hall.
– location: Farmer's Museum, New York State Historical Association, Cooperstown, New York. The Mastin Collection also includes broadsides for the exhibition, and the original lecture (approximately 1,000 words in length) given when the paintings were shown. An exhibition of Mastin's paintings opened on September 1, 1954.

– additional information:

American Heritage printed a story about Mastin's paintings and the Van Nest murders in vol. 6, no. 5 (August 1955). On line at: *http://www.americanheritage.com/content/crazy-bill-had-down-look*. The Smithsonian American Art Museum's Pre-1877 Art Exhibition Catalogue Index list a painting of "General Washington's Head Quarters at Newburgh": *http://siris-artexhibition.si.edu/ipac20/ipac.jsp?&profile=all&source=~!siaeci&uri=full=3100016~!113456~!0*.

Time Magazine published a story in its Sept. 6, 1954, issue, when the Mastin paintings were exhibited in Cooperstown, N.Y.

5.

– title: ***Panorama of a Whaling Voyage***
– year: c. 1860
– painter: Thomas F. Davidson (?–1921). Davidson was a carriage painter in Salem, Mass., where he is said to have presented his small portable moving panorama publicly outdoors.
– subject: whaling voyage
– description: Miniature panorama, oil on muslin, in its original wooden presentation box. Colorful fabric covers the rollers on both sides of the proscenium.
– location: On display at the Peabody-Essex Museum, Salem, Massachusetts.
– additional
 information: An image from the panorama can be seen on the Museum's Web site.

6.

– title: ***Panorama of a Whaling Voyage in the Ship Niger***
– year: 1878–80
– painter(s): Charles Sidney Raleigh (1830–1925), a British mariner who settled in New Bedford, Massachusetts, after working as a merchant seaman for thirty years. He then worked for the painting contractor William H. Caswell. He set up his own New Bedford commercial painting studio in 1877.
– subject: Whaling voyage of the ship Niger
– description: Not a connected moving panorama, but a series of 22 panels, each 6 ft. 3 in. x 11 ft. 6 in.. These were roped at the top and fitted with grommets, to be hung around the walls of a hall.
– location: Eighteen panels are owned by Old Dartmouth Historical Society. Some are displayed on the walls of the auditorium of the New Bedford Whaling Museum.
– additional
 information: Mary Jean Blasdale, *Artists of New Bedford. A Biographical Dictionary* (New Bedford, Mass.: Old Dartmouth Historical Society at the New Bedford Whaling Museum, 1990), pp. 150–151; Purrington, Philip F., *4 Years A-whaling* (Barre, Mass.: Barre Publishers for the Whaling Museum, New Bedford, Mass., 1972) contains illustrations of seventeen of Raleigh's whaling paintings. A. J. Peluso, Jr., "Charles Sidney Raleigh: His Second Life," *Maine Antique Digest* (on line at *http://www. maineantiquedigest.com/stories/index.html?id=620*).

BIBLIOGRAPHY

This bibliography covers the sources referred to in this study. Many others have been consulted during the research process. To avoid making the list excessively long, most references to short newspaper and magazine comments and reviews, as well as to encyclopedia entries, particularly anonymous ones, have been left out. They can be found from the endnotes.

PRIMARY SOURCES

Institutional Collections (visited)

American Antiquarian Society (Worcester)
Beinecke Library, Yale University (New Haven)
Bill Douglas Centre, University of Exeter (Exeter)
Bodleian Library, John Johnson Collection, Oxford University (Oxford)
British Library (London)
Center for British Art, Yale University (New Haven)
Cinémathèque française, Musée du Cinéma (Paris)
Getty Research Institute (Los Angeles)
Harvard Theater Collection, Houghton Library (Harvard)
Huntington Library (San Marino, CA)
Minnesota Historical Society (St. Paul)
Musée Condé (Chantilly)
New Bedford Whaling Museum (New Bedford)
New York Public Library (New York City)
Saco Museum (Saco, Maine)
Science Museum Library (London)
Torino Film Museum (Torino)
UCLA Young Research Library (Los Angeles)
Victoria & Albert Museum Theater Collection (London)

Private Collections (visited)

American Magic Lantern Theater (Terry and Deborah Borton, East Haddam, Conn.)
Balzer, Richard, Collection (Boston)
Barnes, John and William, Collection (London)
Binetruy, François, Collection (Versailles)
Gestetner, Jacqueline and Jonathan, Collection (London)
Huhtamo, Erkki, Collection (Los Angeles)
Hyde, Ralph, Collection (London)
Judson, Jack, Collection (San Antonio)
Kusahara, Machiko, Collection (Tokyo)
Musée des Arts Forains, Jean Paul Favand Collection (Paris)
Simkin, Mike, Phantasmagoria Museum (Birmingham)
Smith, Lester, Collection (London)
Weynants, Thomas, Collection (Ghent)

Online Resources

This list contains only the most important resources consulted.

ActivePaper Archive, *accessed via http://www.uk.olivesoftware.com/*
American Periodicals Series Online 1740–1900, *accessed via http://proquest.umi.com/*
Archive of Americana. American Broadsides and Ephemera, Series I, accessed through the UCLA Library Web site *www.library.ucla.edu*
Balzer, Richard Collection, *http://www.dickbalzer.com*
Binetruy, François Collection, *http://www.collection-binetruy.com*
Bodleian Library, Oxford, John Johnson Collection Online, *http://johnjohnson.chadwyck.co.uk/marketing/about.jsp*
C19: The Nineteenth Century Index, at *http://c19index.chadwyck.com/home.do*
Early Visual Media, *http://www.visual-media.be*
EdinPhoto Home Page, at *http://www.edinphoto.org.uk* (search for "Edinburgh Dioramas")
Google Books, *http://books.google.com*
Historical Newspapers from New York State, *http://www.fultonhistory.com/*
The Internet Archive, *http://www.archive.org/*
Irish Newspaper Archives, at *http://www.irishnewsarchive.com/*
Leeds Play Bills, at *http://www.leodis.net/playbills/gallery.asp*
Midley History of Photography: R. Derek Wood's articles on the History of early Photography, the Daguerreotype and Diorama, at *www.midley.co.uk*
New York Times Article Archive, *http://www.nytimes.com/ref/membercenter/nytarchive.html*
Periodicals Index Online, *http://pio.chadwyck.com/home.do*
Making of America, *http://quod.lib.umich.edu/m/moagrp/index.html* and *http://moa.cit.cornell.edu/moa/*
The Scotsman Digital Archive, at *http://archive.scotsman.com/*
The Times Digital Archive 1785–1985, accessed via *http://infotrac.galegroup.com/*

Patents

Copies of all the patents listed below are in the author's archive.

Arrowsmith, John. "Diorama, or Method of Exhibiting Pictures. Arrowsmith's Specification." British patent no. 4899, 1824, available on-line at *www.midley.co.uk* (last visited Oct. 21, 2008).
Barker, Robert. "Apparatus for Exhibiting Pictures." British patent no. 1612, granted June 19, 1787. Facsimile in Laurent Mannoni, Donata Pesenti Campagnoni & David Robinson, *Light and Movement. Incunabula of the Motion Picture 1420–1896* (Gemona: La Cineteca del Friuli/Le Giornate del Cinema Muto, 1995), pp. 157–158.
Chase, Charles Arthur. "Improved Stereopticon Panorama Apparatus." Complete Specification, US patent no. 16,070 (Oct. 19, 1895)
Chase, Charles Arthur. "Stereopticon Panorama Machine." US patent no. 545, 423 (Aug. 27, 1895).
d'Alési, Hugo. "Un système de panorama à déplacement dit 'Maréorama.'" French patent no. 240472, 1894.
Francovich, Auguste, and Antoine Gadan. "Nouveau Grand Diorama Géographique mouvant, et en relief, avec Panorama interieur." French patent no. 249975, August 17, 1895.
Fulton, Robert. "Panorama, ou tableau circulaire sans bornes, ou manière de dessiner, peindre, et exhiber un tableau circulaire." French patent no. 150,

applied Feb. 25, 1799, granted 7 Floréal an 7 [April 26, 1799].

Fulton, Robert. "Perfectionnement du Panorama." French patent, no number, 1 Germinal an 9 [March 10, 1801].

Gaucheret, Robert-Michel and Claude-Lambert. "Écrans panoramas." French patent, no number, endorsed by the "Comité Consultatif des arts et manufactures" on Nov. 24, 1819, and granted Feb. 28, 1820.

Giroux, Alphonse. "Mécanisme ajouté à l'instrument d'optique nommé Transfigurateur," ou"Kaléidoscope." French patent application, May 29/June 6, 1818, no patent number.

Grimoin-Sanson, Raoul. "Cinecosmorama ou panorama à vues animées."French patent no. 284955, applied Jan. 14, 1899.

Grimoin-Sanson, Raoul. "Le Cinécosmorama 'Sanson,' ou Panorama animé en couleurs." French patent no. 2727517, applied Sept. 25, 1897 (granted March 10, 1898).

Grimoin-Sanson, Raoul. "Le Projecteur Multiplex 'Sanson' pour prendre et projeter des vues Panoramiques animées." French patent no. 261244, applied Nov. 13, 1896, granted Feb. 17, 1897.

Hicks, Cecil Eustace and Wigan, Ernest. "Illusion Amusement Device." US Patent 924,068 (June 8, 1909, application filed Mar. 20, 1908).

Keefe, William J. "Amusement Device." US Patent no. 767 281, 1904.

Léfort, Pierre Henri Armand. "Perfectionnements apportés dans la construction des appareils d'optique dits Polyorama panoptique." French patent no. 7974, Feb. 21, 1849.

Léfort, Pierre Henri Armand. "Premier Certificat d'Addition pour des perfectionnements apportés dans la construction des appareils d'optique dits Polyorama panoptique." French patent, no number, Oct. 29, 1853.

Motte, Henri. "Un panorama—illusion à images distancées et mobiles." French patent no. 205310, Aug. 21, 1890.

Nepveu, Auguste Nicholas. "Panorama de Salon ou Panorama Portafif à vision extérieure ou intérieure." French patent no. 4300, March 13, 1830.

Nepveu, Auguste Nicholas. "Perfectionnement du Panorama de Salon." French patent no. 5181, March 13, 1833.

Sparkhall, Edward. "Exhibiting Pictorial Representations." British patent no. 313 (1855)

Walker, Joseph. "Improvement in Toys." British patent no. 19188, accepted Aug. 11, 1894.

Published Sources

Abdy, Mrs. "Dissolving Views." *The Metropolitan* (London), 38, no. 149 (Sept. 1843).

An account of the Wonders of Derbyshire, as introduced in the Pantomime Entertainment at the Theatre-Royal, Drury-Lane. London: G. Bigg printer, and sold by W. Ranall, 1779.

Alcott, Louisa M. *Hospital Sketches and Camp and Fireside Stories.* Boston: Roberts Brothers, 1892.

Alger, Horatio, Jr. *The Young Explorer; or, Among the Sierras.* Boston: Loring, 1880.

Allom, Thomas. *The Polyorama of Constantinople, the Bosphorus and Dardanelles.* 3d ed. London: W. S. Johnson, 1850.

Almanach des Spectacles pour 1830, 9th year. Paris: Barba, 1830.

Almanach of the Fine Arts for the Year 1851, ed. R. W. Buss. London: George Rowney & Co., 1851.

Almanach of the Fine Arts for the Year 1852, ed. R. W. Buss. London: George Rowney & Co., 1852.

"An Amusing Incident. . . ." *A Political Observer*. London: William Carpenter, Sat., April 16, 1831.

"An American Gentleman" [John Sanderson], *Sketches of Paris: in Familial Letters to His Friends*. Philadelphia: E. L. Carey & A. Hart, 1838.

"An American" [pseud.]. "Interesting Sights." extract from: [An American], *London in 1838*. New York: Samuel Colman, 1839. In *The Family Magazine, Or Monthly Abstract of General Knowledge*. New York: J.S. Redfield et al., 1840, vol. 7, p. 33.

"Un Archéologue." *Les Grotesques. Fragments de La Vie Nomade*. Paris: P. Baudouin, 1838.

Arnott, Neil. *Elements of Physics, or Natural Philosophy*. London: Longman, Rees, Orme, Brown and Green, 1829.

"Aus einem Briefe vom Windsor, 18. Jun. 1794." *Neue Bibliothek der schönen Wissenschafen und der freyen Künste*, ed. C. F. Weisse. Leipzig: Dyck, 1794, vol. 53, pp. 377–378.

"Avertissement." In Carmontelle, *Nouveaux proverbes dramatiques*, Vol. 1 Paris: Le Normánt & Delaynay, 1811.

[Babcock, John]. *Philosophical Recreations, or Winter Amusements: a Collection of Entertaining & Surprising Experiments . . . Together with the Wonders of the Air Pump, Magic Lanthorn, Camera Obscura, &c. &c. &c. . . .* London: Thomas Hughes, [1830], orig. 1820.

Baker, Sir Samuel W. *Eight Years in Ceylon*. London: Longmans, Green, and Co., 1874.

Bakewell, Frederick C. *Great Facts: A Popular History and Description of the Most Remarkable Inventions During the Present Century*. London: Houlston & Wright, 1859.

Ballantine, James. *The Life of David Roberts, R.A. Compiled from his Journals and Other Sources*. Edinburgh: Adam and Charles Black, 1866.

Balzac, Honoré de. *Old Goriot*, trans. Marion Ayton Crawford. Harmondsworth, Middlesex: Penguin Books, 1985 [1951] [orig. *Le Père Goriot*, 1835].

Banter, Barnaby. "Popular Progress of Recondite Learning." *The Literary panorama*. London: C. Taylor, vol. 1 (1807), p. 834.

[Banvard, John]. *Banvard; or the Adventures of an Artist; A Biographical Sketch*. London: Reed and Pardon, 1851.

[Banvard, John]. *Description of Banvard's Panorama of the Mississippi River, Painted on Three Miles of Canvas: Exhibiting a View of Country 1200 Miles in Length, Extending from the Mouth of the Missouri River to the City of New Orleans; being by far The largest Picture ever Executed by Man*. Boston: John Putnam, 1847.

[Banvard, John]. *Description of Banvard's Pilgrimage to Jerusalem and the Holy Land; Painted from Authentic Drawings made upon the Spot during an Extensive Journey, undertaken expressly for the Work, in Four Immense Volumes; Presenting in Minute Detail the Sacred Localities; the Cities, Mountains, Plains and Rivers; celebrated in Scriptural History. Now Exhibiting at the Georama, 596 Broadway, 1853* [New York: John Banvard, 1853].

"Banvard's Panorama." *Scientific American* 4, no. 13 (New York, Dec. 16, 1848): 100.

Barbellion, W. N. P. *The Journal of a Disappointed Man*. New York: George Doran Co., 1919.

Barnum, P. T. *Struggles and Triumphs, Or, Forty Years' Recollections*. New York: Penguin Books, 1981.

Beale, Willert Beale [Walter Maynard]. *The Light of Other Days Seen through the Wrong End of an Opera Glass*. London: Richard Bentley and Son, 1890.

Bergeret, Gaston. *Journal d'un Nègre a l'Exposition de 1900*. Paris: L. Conquet, L. Carteret et Cie, Successors, 1901.

Bergson, Henri. *The Creative Mind: A Study in Metaphysics*, trans. Mabelle L. Andison. New York: Philosophical Library, 1946.

Bergson, Henri. *Mind-Energy. Lectures and Essays*, trans. H. Wildon Carr. New York: Henry Holt and Co., 1920.

Besant, Annie. *Introduction to Yoga*. Benares City: Theosophical Publishing Society, 1908.

Bessemer, Sir Henry. *An Autobiography*. London: Offices of "Engineering." 1905.

Black, Alexander. *Miss Jerry, with Thirty-Seven Illustrations from Life Photographs by The Author*. New York: Charles Scribner's Sons, 1895.

Börne, Ludwig. *Gesammelte Schriften*. Hamburg: Hoffmann und Camp, 1862.

Bois, Jules. *Le Miracle moderne*. Paris: Société d'Editions letteraires et artistiques, 1907.

Bosanquet, Helen. *Bernard Bosanquet: A Short Account of his Life*. London: Macmillan and Co., 1924.

Bosanquet, Bernard. *The Essentials of Logic, Being Ten Lectures on Judgment and Inference*. London: Macmillan & Co., 1895.

Boston to Washington: A Complete Pocket Guide to the Great Eastern Cities and The Centennial Exhibition. New York: Hurd and Houghton; Cambridge: The Riverside Press, 1876.

Bouton, John Bell. *Round the Block: An American Novel*. New York: D. Appleton & Co, 1864.

The Boy's Own Book of Indoor Games and Recreations. An Instructive Manual of Home Amusements, ed. Morley Adams. London: "The Boy's Own Paper" Office, n.d.

Brees, S. C. *Guide and Description of the Panorama of New Zealand*. London: Savill & Edwards, c. 1850.

Brès, J. P. "Le Diorama." *Le Musée Des Variétés Littéraires* 1, no. 7 (Dec. 1822): 291–294.

Bresnel, M. de. *Dictionnaire de Technologie étymologie et définition*. Petit-Montrouge: J.-P. Migne, 1857.

The British Metropolis in 1851. London: Arthur Hall, Virtue & Co, 1851.

Britten, Emma Hardinge. *Nineteenth Century Miracles: or, Spirits and Their Work in Every Country of the Earth*. New York: William Britten, 1884.

Britton, John. *The Auto-Biography*. London: for the Author, 1850.

Brown, Henry Box. *Narrative of the Life of Henry Box Brown*. Oxford: Oxford University Press, 2002, orig. 1851.

Brown, William Perry. *Ralph Granger's Fortunes*. Akron, Ohio: Saalfield Publishing Co., 1902.

Bryan's Dictionary of Painters and Engravers. New ed., rev. and enl. New York: Macmillan Co.; London: George Bell and Sons, 1904.

Buck, Jirah Devey. "Imagination and Will in Health and Disease." In *Transactions of the Thirty-Ninth Session of the the American Institute of Homeopathy*, ed. J. G. Burgher. Pittsburgh: Stevenson & Foster, 1886.

Buck, Jirah Devey. *A Study of Man and the Way to Health*. Cincinnati: Robert Clarke & Co., 1889.

[Bullard, Otis A.]. *Brief Sketch of the Life of O. A. Bullard, together with Recommendations, and Opinion of the Press in regard to His Panorama of New York City*. Albert Norton, 1851.

[Burr, William]. *Descriptive and Historical View of Burr's Moving Mirror of the Lakes, The Niagara, St. Lawrence, and Saguenay Rivers, embracing the entire range of border scenery of the United States and Canadian shores, from Lake Erie to the Atlantic*. Boston: Dutton & Wentworth, 1850.

Burroughs, Edgar Rice. *Jungle Tales of Tarzan*. 4th ed. London: Methuen & Co., 1920, orig. 1919.

"Burr's Mirror of the St. Lawrence." *The Albion: Journal of News, Politics and Literature* 8, no. 39 (Sept. 29, 1849): 465.

B. Y. G. A. "Water Babies." In *Aunt Judy's Christmas Volume for 1879*, ed. H. K. F. Gatty. London: George Bell & Sons, 1879, vol. 17, no. 144.

Byrne, Peter. *The Life and Letters of Hugh Miller.* Vol. 1. Boston: Gould and Lincoln, 1871.

"The Cannons' Adventures in Boulogne." *Bentley's Miscellany.* Vol. 3. London: Richard Bentley, 1838.

Carlile Campbell, Theophila. *The Battle of the Press: As Told in the Story of the Life of Richard Carlile.* London: A. & H. B. Bonner, 1899.

Carmontelle. *Nouveaux proverbes dramatiques.* Vol. 1. Paris: Le Normánt & Delaynay, 1811.

Carmontel[le]. *Proverbes et comédies posthumes.* Paris: Ladvocat Libraire, 1825.

Carové, Friedrich Wilhelm Carové. *Neorama, Beiträge zur Litteratur, Philosophie und Geschichte.* Leipzig, 1838.

Carpenter, Philip. *Elements of Zoology.* Liverpool: Rushton and Melling, 1823.

Carter, Nathaniel Hazeltine. *Letters from Europe, Comprising the Journal of a Tour Through Ireland, England, Scotland, France, Italy, and Switzerland, in the Years 1825, '26, and '27,* vols. 1–2. New York: G. & C. Carvill, 1827.

Cassidy, G[eorge] W. *Cassidy's Diorama of the Route of the Overland Mail to India, from Southampton to Calcutta.* London: William Stevens, Published for the Proprietor, 1856.

[Cassidy, George W.]. *Geo. W. Cassidy's bewegliches Riesen-Cyclorama des Mississippi und Ohioflusses.* Leipzig, 1850.

Catalogue two hundred and eight. London: Marlborough Rare Books, 2007.

Catherwood, Frederick. *Description of a View of the City of Jerusalem and the Surrounding Country, now Exhibiting at the Panorama, Broadway, Corner of Price and Mercer Streets, New York. Painted by Robert Burford, from Drawings taken in 1834 by F. Catherwood, Architect* [no printer or date].

Chambaud, Lewis. *A Grammar of the French Tongue.* 13th ed. London: A Strahan, 1801.

Chevallier, [Jean]. *Le conservateur de la vue.* 3d ed. Paris: Chez l'Auteur, 1815.

Christian, M. *Description des machines et procédés spécifiés dans les brevets d'invention, de perfectionnément et d'importation.* Vol. 10. Paris: Madame Huzard, 1825.

Clarke, Arthur C. *2001 Space Odyssey.* New York: ROC, 2000, orig. 1968.

Clement, Clara Erskine, and Laurence Hutton. *Artists of the Nineteenth Century and Their Works.* Vol. 2. Boston: Houghton, Osgood and Co. and The Riverside Press, 1879.

Collins, Wilkie, and Charles Dickens. "Lazy Tour of Two Idle Apprentices." *Household Words* 16, no. 397 (Oct. 31, 1857).

The Colosseum Handbook, Descriptive of the Cyclorama of "Paris by Night." Now on Exhibition, S. E. Corner Broad and Locust Streets. Philadelphia: Allen, Lane, and Scott's Printing House, 1876.

A Comprehensive Sketch of the Merrimac and Monitor Naval Battle. 5th ed. New York: New York Panorama Co., 1886.

"Considerations on the Panorama View of Grand Cairo, composed by Mr. Barker from the Drawings of Mr. Salt, who accompanied Lord Valentia, now exhibiting in London." *The Literary Panorama, being a Review of Books, Magazine of Varieties, and Annual Register* [etc.]. Vol. 7. London: Cox, Son, and Beylis for C. Taylor, 1810, p. 448.

Corelli, Marie. *The Master-Christian.* New York: Grosset & Dunlap, 1900.

Corner, G. R. *The Panorama: With Memoirs of Its Inventor, Robert Barker, and His Son, the Late Henry Aston Barker.* London: J & W Robins, 1857.

Croal, Thomas Allan. *A Book about Travelling, Past and Present.* London: William P. Nimmo, 1877.

Crosland, Newton. *Apparitions: An Essay, Explanatory of Old Facts and a New Theory.* London: Trübner and Co., 1873.

Cuisin, P. *Le rideau levé, ou, Petit diorama de Paris.* Paris: Eymery, Delaunay & Martinet, 1823.

Daguerre, L. J. M. *Historique et description des procédés du Daguerréotype et du Diorama*. New ed. Paris: Alphonse Giroux et Cie, 1839.

Daguerre, Louis-Jacques-Mandé. "A M. Le directeur des Annales Françaises [dated April 28, 1821]." *Annales françaises des arts, des sciences et des lettres* (Paris), vol. 8 (2d series, 2d vol.), 1821.

Dalrymple Elliott, Grace. *During the Reign of Terror. Journal of my Life during the French Revolution*, trans. E. Jules Méras. New York: Sturgis & Walton, 1910, orig. 1856.

Davis, J[erome] D[ean]. *Hand-book of Christian Evidences*. Kyoto: Keiseisha, [1889].

Delaborde, Henri. "Notice sur la vie et les travaux de M. le baron Taylor . . . lue dans la séance publique annuelle du 30 ottobre 1880." In Victor Champier, *L'Année Artistique*, troisième année, 1880–1881. Paris: A. Quantin, 1881, p. 605.

Delkeskamp, Friedrich Wilhelm. *Panorama des Rheins und seiner nächsten Umgebungen von Mainz bis Cöln*. Frankfurt: F. Wilmans, 1825.

Denton, William. *The Irreconcilable Records: Or, Genesis and Geology*. Boston: William Denton, 1872.

Description of the field of battle, and disposition of the troops engaged in the action, fought on the 18th of June, 1815, near Waterloo; illustrative of the Representation of that great Event, in the Panorama, Leicester-Square, descriptive booklet with a folding panorama key. London: J. Adlard, 1816.

Description of the historical, peristrephic or revolving dioramic panorama, now exhibiting, In the Rotunda, Great Surrey Street, Blackfriars Road. Illustrative of all the principal events that have occured [sic] during the War between the Turks and Greeks, painted on nearly 20,000 square feet of canvas, In Eleven successive Views, Commencing with the Life and Death of Ali Pacha, the celebrated Tyrant of Epirus, and ending with the ever memorable Battle of Navarino, Fought in the Harbour of Navarino, on the 20th of October, 1827, between the Fleets of England, France & Russia, Under the Command of Admiral Codrington, Combined against those of Turkey and Egypt, when the latter Fleets were nearly annihilated. A minute description is given of each revolving View, accompanied by appropriate Music. London: W. Robarts, 1828.

Description of the Peristrephic Panorama . . . Illustrative of the principal Events that have occurred to Buonaparte, commencing with the Battle of Waterloo, The 18th of June, 1815, and ending with his Funeral Procession at St. Helena. Guernsey: T. Greenslade, 1826.

A Description of The Royal Colosseum, Re-opened in M.DCCC.XLV, Under the Patronage of Her Majesty the Queen, and H.R.H. Prince Albert, Re-embellished in 1848. London: J. Chisman, 1848.

Description of the Royal Cyclorama, or Music Hall: Albany Street, Regent's Park. Opened in MDCCCXLVIII. London: J. Chisman: 1848.

Descriptive catalogue of the Padorama, of the Manchester and Liverpool Rail-Road, Containing 10,000 square feet of Canvass [sic], now exhibiting at Baker Street, Portman Square. London: E. Colyer, 1834.

Le diable boiteaux à Paris, ou, Le livre des cent-et-un. Stuttgart: chez La Rédaction de la Collection d'oeuvres choisies de la littérature Française, 1832.

Dickens, Charles. "The American Panorama." In *To Be Read at Dusk and Other Stories, Sketches and Essays*. London: George Redway, 1898. Orig. *The Examiner*, Dec. 16, 1848.

Dickens, Charles. "Moving (Dioramic) Experiences." *All the Year Round*, March 23, 1867.

Dickens, Charles. "Mr Barlow." In *The Uncommercial Traveller and Additional Christmas Stories*. Boston: Houghton, Osgood and Co., 1879, ch. 32.

Dickens, Charles. *The Old Curiosity Shop: Sketches—Part I*. Vol. 2. New York: Hurd and Houghton, 1874.

Dickens, Charles. *Pictures from Italy — American Notes*. London: Chapman & Hall, 1880.

Dickens, Charles. "Some Account of an Extraordinary Traveler." In *Miscellaneous Papers*. Vol. 1. London: Chapman and Hall, 1911, orig. 1850.

A Dictionary of Music and Musicians. A.D. 1450–1889), ed. Sir George Grove. London: Macmillan and Co., 1890), vol. 3.

Dictionnaire technologique ou nouveau dictionnaire universel des arts et métiers . . . Vol. 7. Paris: Thomine & Fortic, 1825.

The Diorama, 17–19 Park Square East, Regent's Park, London. A Property of the Crown Estate, [booklet for leasing the building]. c. 1983.

Disraeli, Benjamin. *The Voyage of Captain Popanilla*. 1827, in *Popanilla and other Tales*. Freeport, N.Y.: Books for Libraries Press, 1970, orig. ed. 1934.

Dixie, Lady Florence. *In the Land of Misfortune*. London: Richard Bentley, 1882.

Donnet, Alexis. *Architectonographie des Théatres de Paris*. Paris: Didot, 1821.

"D. P. F. M." *Madrid en la Mano ó El amigo del forastero en Madrid y sus cercanías*. Madrid: Gaspar y Roig, Editores, 1850.

Dr. Judd. "Fifty Years Recollections of an old Amusement Manager." *Billboard*, Dec. 5, 1905. Repr. in Joseph Csida and June Bundy Csida, *American Entertainment. A Unique History of Popular Show Business*. New York: Watson-Guptill Publications, 1978, pp. 46-48.

Dr. Judd. "The Old Panorama." *Billboard*, Dec. 3, 1904.

Dunlap, William. *A Trip to Niagara, or Travellers in America. A Farce in Three Acts*. New York: E. B. Clayton, 1830.

Eddy, Daniel C. *The Young Man's Friend*. 2d ed. Ed. Lowell and Boston: Nathaniel L. Dayton; Gould, Kendall and Lincoln, 1850.

Edelman, Murray. *The Symbolic Uses of Politics*. 2d ed. Urbana: University of Illinois Press, 1985, orig. 1964.

"Edina, a Poem in Six Cantos." *Edinburgh Magazine, and Literary Miscellany* (Edinburgh: Archibald Constable), vol. 9 (Sept. 1821).

Egan, Pierce. *Diorama anglais ou promenades pittoresques à Londres*, translation. Paris: Didot, 1823.

Egan, Pierce. *Life in London, or, the Day and Night Scenes of Jerry Hawthorn, Esq. and his Elegant Friend Corinthian Tom*. London: Sherwood, Neely, and Jones, 1821.

"Egyptiana." *The Lady's Monthly Museum, or Polite Repository of Amusement and Instruction*. Vol. 8. London: Vernor & Hood, June 1, 1802.

The Eidophusikon, or Moving Diorama of Venice, displaying, in fourteen views, the principal canals, palaces, churches, shipping, &c. &c. of this gorgeous city. . . . Glasgow: W. and W. Miller, 1841.

Elwick, George. *The Bankrupt Directory: Being a Complete Register of All the Bankrupts . . . from December 1820 to April 1843*. London: Simpkin, Marshall, and Co., 1843.

Fallon, John, Esq. *Six Tours Through Foreign Lands: A Guide to Fallon's Great Work of Art. The World Illustrated. A Complete Mirror of the Universe, From the Earliest Times Down to the Present Day*. Price 10c. Presented Free to Each Purchaser of a Season Ticket. No date or publisher [1860s].

Fay, Dewey. "Panoramic Painting." *Home Journal* 40, no. 91 (Oct. 2, 1847): 3.

Fay, Theodore S. *Norman Leslie; A New York Story*. New York: G. P. Putnam and Son, 1869.

Feller, F[rancois]-X[avier] de. *Dictionnaire historique, ou Histoire Abregée des hommes qui se sont fait un nom par leur génie . . .* Vol. 3. Paris: Méquignon fils Ainé & Périsse Frères, 1821.

Feller, F[rancois]-X[avier] de. *Supplément au Dictionnaire historique, formant la suite de la nouvelle édition . . .* Vol. 2. Paris & Lyon: Méquignon fils Ainé & Guyot Frères, 1819.

Fenn, W[illiam] W[ilthew] Fenn. *Half-Hours of Blind Man's Holiday or Summer and Winter Sketches*. London: Sampson Low, Marston, Searle, & Rivington, 1878.

Fischer, Henry W[illiam]. *Private Lives of Kaiser William II and His Consort. Secret History of the Court of Berlin*. New York: Fred de Fau & Co., 1909.

Flammarion, Camille. *Mysterious Psychic Forces*. Boston: Small, Maynard and Co., 1907.

"Le Flâneur (The Spunging Loiterer)." *The Linguist: or, Weekly Instructions in the French & German* (London), 1, no. 10 (May 28, 1825): 145–148.

Ford, Richard. *A Guide to the Grand National and Historical Diorama of the Campaigns of Wellington*, Gallery of Illustration, 14 Regent Street. London: by the proprietors, 1852.

Fournel, Victor. *Ce qu'on voit dans les rues de Paris*. New ed. Paris: E. Dentu, 1867.

Fowler, William W. *Woman on the American Frontier*. Hartford: S. S. Scranton & Co, 1881.

Fradenburgh, Rev. J. N. *Witnesses from the Dust; or, The Bible Illustrated from the Monuments*. Cincinnati: Cranston & Stowe, 1886.

Frazer, Daniel. *The Story of the Making of Buchanan Street*. Glasgow: James Frazer, 1885.

Frederic, Harold. *The Damnation of Theron Ware or Illumination*. Chicago: Herbert S. Stone and Co, 1896.

Frénilly, François-Auguste Fauveau de. *Souvenirs de Baron de Frénilly*. New ed. Paris: Librairie Plon, 1909.

Friend, E. W. "A Series of Recent 'Non-Evidential Scripts.'" *Journal of the American Society of Psychical Research, Section B* (New York), vol. 9 (1915).

Friend, E. W. "From William James?" *The Unpopular Review* (New York: Henry Holt and Co.), 4, no. 7 (July–Sept. 1915): 172–202.

Furniss, Harry. "Single-Handed Entertainers." *Windsor Magazine* (London: Ward, Lock & Co), 25 (Dec. 1906 to May 1907): 485–492.

Gabet, Ch. *Dictionnaire des artistes de l'école française, au XIXe siècle*. Paris: Madame Vergne, 1831.

Galignani's New Paris Guide. 17th ed. Paris: A. and W. Galignani, July 1830.

Ganthony, Robert. *Bunkum Entertainments*. London: L. Upcott Gill, n.d. [1890s].

Genlis, Madame de. *Mémoires inédits de Madame la Comtesse De Genlis, Sur le dix-huitième siècle et la révolution françoise, debuis 1756 jusqu'a nos jours*. 2d ed. Vol. 3. Paris: Ladvocat, Libraire, 1825.

Genlis, [Stéphanie Félicité] Madame De. "Notice sur Carmontel[le]." In Carmontel[le], *Proverbes et comédies posthumes*. Paris: Ladvocat Libraire, 1825.

Gibbs, George. *Madcap*. New York: D. Appleton and Co., 1913.

Gliddon, Geo. R. *Hand-book to the American Panorama of the Nile, Being the Original Transparent Picture exhibited in London, at Egyptian Hall, Piccadilly. . . .* London: James Madden, 1849.

Goethe, Johann Wolfgang. *Elective Affinities*, trans. David Constantine. Oxford: Oxford University Press, 1994, orig. 1809.

The Good Shepherd and Other Stories. New York: Leavitt & Allen, 1853.

Goodman, Walter. *The Keeleys, on the Stage and at Home*. London: Richard Bentley and Son, 1895.

Goosequill, Jacob [pseud.]. "The Oramas." *London Magazine* 10 (Sept. 1824).

[Green, Jacob]. "Notes of a Traveller." *Christian Advocate*, conducted by Ashbel Green (Philadelphia: A. Finley, 1830), vol. 8, for the year 1830, p. 514.

[Green, Jacob]. *Notes of a Traveller during a Tour Through England, France, and Switzerland in 1828*. New York: G. & C. & H. Carvill, 1831.

Greenwood, Rev. Thomas. *Scripture Sketches; with other Poems and Hymns*. London: J. Hatchard and Son, 1830.

[Grieve, Thomas, and Telbin, William]. *A Guide to the Diorama of the Ocean Mail to India and Australia*. London: Gallery of Illustration], 1853.

[Grieve, Thomas, and Telbin, William]. *The Route of the Overland Mail to India, from Southampton to Calcutta.* 5th ed. London: Gallery of Illustration, no.14 Regent Street, Waterloo Place, 1850.

Grimoin-Sanson, Raoul. *Le film de ma vie.* Paris: Les Éditions Henry-Parville, 1926.

Grindon, Leo Hartley. *Figurative Language, Its Origin and Constitution.* Manchester: Cave and Sever, 1851.

Les Grotesques, Fragments de la Vie Nomade, recueillis par un archéologue. Paris: Chez l'Éditeur, rue de Rivoli no. 50 bis, 1838.

[Hamilton's Excursions]. *Descriptive Programme for this afternoon, Hamilton's Excursions to the Continent and back, in two hours, en route to Italy, France, Austria, Prussia, Switzerland and the Rhine,* program booklet, Egyptian Hall, Piccadilly [1860].

Harij, D. "Reincarnation and Memory, IV." *The Path* 4, no. 9 (Dec. 1889).

Harlequin-Amulet or The Magick of Mona: The songs, chorusses, &c. with a description of the pantomime. First acted at The Theatre Royal, Drury Lane, Monday, December 22, 1800. London: C. Lowndes, [1800 or 1801].

Harlequin Jack Sheppard, or, The Blossom of Tyburn Tress! in 1839. *Harlequin Jack Sheppard, or, The Blossom of Tyburn Tress!* A Comic Pantomime, Produced at the Theatre Royal, Drury Lane, December 26th, 1839, under the sole direction of W. J. Hammond. London: John Duncombe and Co., no date.

Harlequin and the Flying Chest; or, Malek and the Princess Schirine. A new grand comic Christmas Pantomime, comprising the Songs, Chorusses, Recitative, and Dialogue. with A Description of the Business of each Scene, as first performed At the Theatre Royal, Drury Lane, Friday, Dec. 26, 1823. 2d ed. London: John Miller, 1823.

Harris, John F[rederick]. *Samuel Butler, Author of Erewhon: The Man and his Work.* New York: Dodd, Mead and Co., 1916.

Hawthorne, Julian. *Nathaniel Hawthorne and his Wife: A Biography.* Vol. 1. 2d ed. Boston: James B. Osgood and Co., 1885.

Hawthorne, Nathaniel. *The American Notebooks.* New Haven: Yale University Press; London: Oxford University Press, [1932].

Hawthorne, Nathaniel. *The Blithedale Romance.* Authorized ed. Dessau: Katz Brothers, 1855.

Hawthorne, Nathaniel. "Ethan Brand: A Chapter from an Abortive Romance." In *The Snow-Image, and Other Twice-Told Tales.* Boston: Ticknor, Reed, and Fields, 1853, pp. 102–124.

Hawthorne, Nathaniel. "Fancy's Show Box." In *Twice-Told Tales.* Boston: American Stationers Co. & John B. Russell, 1837, pp. 307–316.

Hawthorne, Nathaniel. "Main Street." In *The Snow-Image, and Other Twice-Told Tales.* Boston: Ticknor, Reed, and Fields, 1853, pp. 63–101.

Hawthorne, Nathaniel. *Passages from the American Notebooks.* Vol. 1. London: Smith, Elder and Co., 1868.

Hawthorne, Nathaniel. "Sights from a Steeple." In *Twice-Told Tales.* Boston: American Stationers Co. & John B. Russell, 1837, pp. 273–282.

Hawthorne, Nathaniel. "The Toll-Gatherer's Day; A Sketch of Transitory Life." *United States Magazine and Democratic Review* 1, no. 1 (Oct.–Dec. 1837): 31–35. (Later included in *Twice-Told Tales*, first published without it in 1837).

Hazen, Edward. *The Panorama of Professions and Trades; or Every Man's Book.* Philadelphia: Uriah Hunt, 1838.

Heffner, George H. *The Youthful Wanderer: An Account of a Tour through England, France, Belgium, Holland, Germany.* Orefield, Pa.: A. S. Heffner, 1876.

Hervey, Charles. "The Habitue's Note-Book." *New Monthly Magazine and Humorist,* ed. W. Harrison Ainsworth. London: Chapman and Hall, vol. 87 (Third part for 1849).

Heysinger, Isaac W[inter]. *Spirit and Matter before the Bar of Modern Science.*

Philadelphia: J. B. Lippincott Co. & T. Werner Lurie, 1910.

Hingston, Edward P. *The Genial Showman Being the Reminiscences of the Life of Artemus Ward*. Barre, Mass.: Imprint Society, 1971, orig. 1870.

The History of the Theatre Royal, Dublin, From its Foundation in 1821 to the Present Time. Dublin: Edward Ponsonby, 1870.

Hittorff, J. J. "Origine des panoramas." In Daly, *Revue générale de l'architecture*. Vol. 2 (Paris 1841).

Hodbay, William Armfield. "Memoirs of William Armfield Hobday, Esq.." *Arnold's Magazine of the Fine Arts* (London: M. Arnold), vol. 2 (1831).

Hodgson, Shadworth H[ollway]. *The Metaphysic Experience*. Vol. 3. London: Longmans, Green, and Co. 1898.

Hodgson, Shadworth H[ollway]. *The Relation of Philosophy to Science, Physical and Psychological: An Address*. London: Williams and Norgate, 1884.

Hodgson, Shadworth H[ollway]. *Time and Space: A Metaphysical Essay*. London: Longman, Green, Longman, Roberts, and Green, 1865.

Holbrook, David L. *Panorama of Creation as Presented in Genesis Considered in its Relation with the Autographic Record as Deciphered by Scientists*. Philadelphia: Sunday School Times Co., 1908.

Hood, Thomas. *The Comic Annual*. London: A. H. Baily and Co., 1839.

Hooper, William. *Rational Recreations . . .,*. London: for L. Davis, J. Robinson, B. Law, and G. Robinson, 1774.

Hubbard, Fred[erick] Heman. *The Opium Habit and Alcoholism*. New York: A. S. Barnes, 1881.

Hudson, Thomas. *Comic Songs: Collection the Seventh*. London: Gold and Walton, 1826.

Hugo, A[bel]. "Panoramas. Etc." In Hugo, *France pittoresque ou description pittoresque, topographique et statistique des départements et colonies de la France*. Vol. 3, Paris: Delloye, 1835, p. 120.

Hugo, Victor. *Notre Dame de Paris*. 1831, trans. Jessie Haynes. New York: P. F. Haynes, 1902.

Ide, George B. *Bible Pictures; or, Life-Sketches of Life-Truths*. Boston: Gould and Lincoln, 1867.

"Impromptu on seeing Messrs. Marshall's Peristrephic Panorama." *Freemans Journal* (Dublin), April 8, 1815.

James, William. *The Principles of Psychology*. London: Macmillan and Co., 1891.

Jaubert, George-F. "Le microphonographe Dussaud." *La Nature* 25, no. 1236 (Feb. 1897): 145–147.

Jenks, Edward. *A History of Politics*. London: J. M. Dent & Co, & The Macmillan Co, 1900.

Jeremie, William Henry. *Furlough Reminiscences, Thoughts and Strayings, The Kote Masool, and The Duel*. Calcutta: P. S. D'Rozario and Co., 1849.

"John Banvard's Great Picture.—Life on the Mississippi." *The Living Age* 15, no. 1847 (Dec. 11, 1847): 511–515.

Journal of a Wanderer: Being a Residence of India, and Six Weeks in North America. London: Simpkin, Marshall & Co., 1844.

Joyce, James. *Ulysses* (1922), Planet pdf. ed, on line at www.planetpdf.com.

Kalisch, M[arcus] M. *A Historical and Critical Commentary on the Old Testament, with a New Translation. Genesis*. London: Longman, Brown, Green, Longmans, and Roberts, 1858.

Kenyon, Ellen E. "Teaching Literature." *School Journal: A Weekly Journal of Education* (New York), 51, no. 1 (July 6, 1895). Also in the *Teachers' Institute: A Monthly Magazine of Education* 17, no. 1 (Sept. 1894).

Kingsbury, Alice Eliza. *In Old Waterbury: The Memoirs of Alice E. Kingsbury*. Waterbury, Conn.: Mattatuck Historical Society, 1942.

Knight, Charles, ed. *London*. London: Henry G. Bohn, 1851.

Laidlaw, J[ames] B. *Description of a View of the City of Jerusalem, and the Surrounding Country, now exhibiting at the Panorama in this Town: From Drawings taken in 1834.* Hull: John Hutchinson, 1837.

Laidlaw, J[ames] B. *Description of a view of the City of New York, The Panorama of which is now exhibiting here, and beautifully connected with a pleasure sail for five miles up the bay . . . Painted for the Proprietor, J.B. Laidlaw, from drawings taken on the spot.* Hull: John Hutchinson, 1838.

Leavitt, J. M. "Divine Revelation and Modern Science Based Alike on the Testimony of the Senses." *The Ladies Repository: A Monthly Periodical, Devoted to Literature and Religion,* ed. Rev. D. W. Clark, vol 19. Cincinnati: R. P. Thompson, 1859.

Leigh's New Picture of London; or a View of the Political, Religious, Medical, Literary, Municipal, Commercial, and Moral State of the British Metropolis. . . . London: Samuel Leigh, 1824–1825.

Leslie, Miss, *Miss Leslie's Behaviour Book: A Guide and Manual for Ladies.* Philadelphia: T. B. Peterson and Brothers, 1859.

Lewis, Henry. *Das Illustrierte Mississippithal. . . .* Dusseldorf: Arnz & Co., 1854). in English as *The Valley of the Mississippi Illustrated,* trans. A. Hermina Boatgieter. St. Paul: Minnesota Historical Society, 1967.

Lewis, Henry. *Making a Moving Picture in 1848. Henry Lewis' Journal of a Canoe Voyage from the Falls of St. Anthony to St.Louis,* ed. Martha L. Heilbron. Saint Paul: Minnesota Historical Society, 1936.

Lewis, Henry, and Charles Gaylor. *Lewis' Panorama: A Description of Lewis' Mammoth Panorama of the Mississippi River, from the Falls of St. Anthony to the City of St. Louis . . . by Charles Gaylor, Director of Panorama.* Cincinnati: The Dispatch Office, 1849.

Lewis, J[ohn] D[elaware]. *Our College: Leaves from an Undergraduate's "Scribbling Book."* London: G. Earle, 1857.

Linskill, Charles D. *Travels in Lands Beyond the Sea: Beauty and Glory of Western Europe.* Wilkes-Barre, Pa.: Robt. Baur & Son, 1888.

Livret explicatif du diorama de Paris à travers les ages: Carré Marigny, aux Champs-Elysées. Paris: Firmin-Didot, [1886].

Lockie, John. *Topography of London.* 2d ed. London: Sherwood, Neely, and Jones and J.M. Richardson, 1813.

London As It Is Today: Where to go, and what to see, during the Great Exhibition. London: H.G. Clarke & Co, 1851.

"Ludicrous Incident." *The Albion, A Journal of New, Politics and Literature,* March 11, 1843.

Malcolm, E. H. "The Pantomimes." *New Monthly Belle Assemblée* (London: Robertson and Tuxford), vol. 72 (Jan. to June 1870): 106–107.

Marshall, Charles. *Delhi: Notices of the Great Indian Rebellion: more particularly in relation to Mr. Charles Marshall's Great Picture of Delhi. The Descriptive and Explanatory Lecture, every half-hour, By Mr. Gregory.* London: Published at the Delhi Exhibition, 1857.

Marshall, Charles. *Description of Mr. Charles Marshall's Kineorama; with Keys: Constituting Turkey, Syria, & Egypt.* London: W. S. Johnson, 1841.

Mathews, Mrs. [Anne Jackson]. *A Continuation of the Memoirs of Charles Mathews, Comedian.* Vol. 1. Philadelphia: Lea & Blanhard, 1839.

Matthews, Brander. "On the Battle-Field." *The Century: A Popular Quarterly* 36, no. 3 (July 1888): 457–469.

Mawman, Joseph. *A Picturesque Tour through France, Swizerland, on the banks of the Rhine, and through parts of the Nethelands: in the Year M, DCCCXVI.* London: J. Mawman, 1817.

Mayhew, Henry. "In the Clouds." *The Albion, A Journal of News, Politics, and Literature* 11, no. 41 (Oct. 9, 1852).

McCabe, James D. *The Illustrated History of the Centennial Exhibition.* Philadelphia: The National Publishing Co., [1876].

McCann, Mary Agnes. *The History of Mother Seton's Daughters: The Sisters of Charity of Cincinnati Ohio, 1809–17.* Vol. 1. New York: Longmans, Green and Co., 1917.

McCrumb, Sharyn. *Bimbos of the Death Sun.* New York: Ballantine Books, 1997, orig. 1988.

M'Dowall's New Guide in Edinburgh. Edinburgh: Thomas and William M'Dowell, 1842.

Mesonero Romanos, D. Ramón de. *Manual histórico-topográfico, administrativo y artistico de Madrid.* Madrid: D. Antonio Yenes, 1844.

[Messrs. Marshall]. *A Description of Marshall's grand historical peristrephic panorama of the ever-memorable Battles of Ligny, Les Quarte Bras, Waterloo . . .* 19th ed. Bristol: T. J. Manchee, c. 1821.

[Messsrs Marshall]. *Description of Marshall's grand peristrephic panoramas: Battle of Genappe, St. Helena, and the most interesting events that have occurred to Bonaparte, from his defeat At the Battle of Waterloo, Until the Termination of his Earthly Career at St. Helena; and the memorable Battle of Trafalcar.* London: J. Whiting, 1825.

[Messsrs Marshall]. *Battles of Ligny and Waterloo. Description of Messrs. Marshall's grand historical peristrephic painting of the ever-memorable Battles of Ligny, and Waterloo, etc.* Dublin: W.H. Tyrrell, 1816.

[Messrs. Marshall]. *British valour displayed in the cause of humanity: being a description of Messrs. Marshall's Grand Marine Peristrephic Panorama of the Bombardment of Algiers. . . .* Hull: R. Wells & Co., 1819.

[Messsrs Marshall]. *Description of Messrs. Marshall's grand historical peristrephic panorama. . . of the ever memorable Battles of Ligny and Waterloo. . . .* London: M. Wilson, 1818.

[Messrs Marshall]. *Description of Messrs. MARSHALL's Grand Peristrephic Panorama of the Polar Regions; which displays the North Coast of Spitzbergen, Baffin's Bay, Arctic Highlands, &c. &c. Now exhibiting in Marshal's [sic] Pavilion, Lower Abbey-Street, Dublin, Painted from Drawings taken by Lieut. BEECHY [Beechey], who accompanied the polar expedition in 1818, And Messrs. Ross and Saccheuse, who accompanied The Expedition to discover a north-west passage,* 1820 [no printer or place of printing mentioned].

[Messrs. Marshall]. *Grand Peristrephic Panorama of the Polar regions: which displays the north coast of Spitzbergen, Baffin's Bay, Arctic highlands, &c.* Leith, Scotland: William Heriod, 1821.

Miller, Henry. *Tropic of Capricorn.* Grove Press, 1994, orig. 1961.

Miller, Hugh. *Sketch-Book of Popular Geology.* 2d ed. Edinburgh: William P. Nimmo, 1869.

Miller, Hugh. *Testimony of the Rocks, or, Geology in its Bearings on the Two Theologies, Natural and Revealed.* Boston: Gould and Lincoln, Sheldon, Blakeman & Co., George S. Blanchard, 1857.

Millin, A. L. *Dictionnaire des Beaux-Arts.* Vol. 3. Paris: Desray, Libraire, 1806.

Minnigerode, Rev. Charles. *Sermons.* Richmond: Woodhouse & Parham, 1880.

Monck Mason, Thomas. *Aeronautica; or, Sketches Illustrative of the Theory and Practice of Aerostation: Comprising an Enlarged Account of the Late Aerial Expedition to Germany.* London: F.C. Westley, 1838.

"Monster Panorama Manias." *Punch* 17 (July—Dec. 1849).

Morgan, Lady. *France in 1829–30.* London: Saunders and Otley, 1830.

[Morris, Peter]. *Peter's Letters to his Kinsfolk.* Vol. 2. Edinburgh: William Blackwood and London: T. Cadell and W. Davies, 1819.

"Moving Diorama." *Knickerbocker: New-York Monthly Magazine* (New York: Clark & Edson), vol. 6 (July 1835).

"Mr. Box Brown and the Hungarians." *The Evangelical Repository*, ed. Joseph T. Cooper, vol. 10. Philadelphia: William S. Young, 1851.

"Munchausen Ride through Edinburgh." *Mirror of Literature, Amusement and Instruction* 10, no. 286 (Dec. 8, 1827): 387–388.

Myers, Frederic W. H. *Human Personality and Its Survival of Bodily Death*. 2 vols. New York: Longmans, Green, and Co., 1903.

"My Ghosts." *Household Words* 15, no. 360 (Feb. 14, 1857).

Nagler, Georg Kaspar. *Neues allgemeines Künstler-Lexicon*. Munich: E. A. Fleischmann, 1847, vol. 17.

"New French Peristrephic Panorama." *New Monthly Magazine and Literary Journal*, vol. 12 (London: Henry Colburn, 1824), Jan. 1824.

New Oriental Diorama: Life and Scenes in India—Illustrated in an Imaginary Tour. Designed, and for the most part painted, by W. Wallace Scott, Esq. Willis's Rooms, King Street, St. James's, 1850.

New Paris Guide, or, Stranger's Companion through the French Metropolis. Paris: A. and W. Galignani, May 1827.

Nodier, Charles. *Histoire du Roi de Bohème et de ses sept chateaux*. Paris: Delangle Frères, 1830.

Northwestern University 1855–1905: A History, ed. Arthur Herbert Wilde, vol. 3. New York: University Publishing Society, 1905.

Norton, Albert. *Norton's Hand Book of New York City*. [New York:] Albert Norton, 1859.

"Notice sur Carmontelle." In *Fin du Repertoire du Théâtre Francais*. Vol. 1, ed. Lepeintre. Paris: Mme Veuve Dabo, 1824.

Novello, Vincent, and Mary Sabila Hehl Novello. *A Mozart Pilgrimage: being the travel diaries of Vincent & Mary Novello in the year 1829*, ed. Rosemary Hughes. London: Novello and Co., 1955.

Nowrojee, Jehangeer, and Hirjeebhoy Merwanjee. *Journal of a Residence of Two Years and a Half in Great Britain*. London: Wm H. Allen and Co, 1841.

Oberg, John Ulrick. *The False and the True: A Psychic Phantasmagoria of the Resurrection in Epic Verse*. Berkeley, Calif.: John Ulrick Oberg, 1902.

"Odds and Ends. From the Port-Folio of a Penny-a-Liner." *The Knickerbocker: Or, New-York Monthly Magazine* (New York: Clark and Edson), vol. 8 (Dec. 1836), pp. 710–711.

Oemler, Marie Conway. *The Purple Heights*. New York: Century Co., 1920.

Old "Miscellany" Days: A Selection of Stories from "Bentley's Miscellany." London: Richard Bentley and Son, 1885.

Olivier, Louis. "Le Microphonographe et ses applications a l'éducation des sourds-muets, a la téléphonie et a la cinématgraphie." *Revue générale des sciences pures et appliquées* 8, no. 24 (Dec. 30, 1897): 1005–1009.

100 Years of Showmanship. Poole's 1837–1937 [ed. John R. Poole]. Edinburgh: Pillans & Wilson, Printers.

"168. Panorama Voyageur. Vue de Paris." *Bulletin des sciences technologiques*, red. M. Dubrunfaut. Paris: Bureau central du bulletin & M. Carillan-Goeury, 1829, vol. 11, p. 186.

"One Tom" [pseud.]. "Sights of London, Etc. no. 2." *The Literary Gazette: A Weekly Journal of Literature, Science, and the Fine Arts*, March 20, 1824, p. 18.

Orpen, Charles Edw. Herbert. *The Contrast, between Atheism, Paganism and Christianity, Illustrated; or, the Uneducated Deaf and Dumb as Heathens, compared with those, who have been instructed Language and Revelation, and Taught by the Holy Spirit, as Christians*. Dublin: M. Goodwin, 1827 [8 corrected as 7 by ink].

Ossorio y Bernard, Manuel. *Galería biográfica de artists españoles del siglo xix*. Madrid: Moreno y Rojas, 1883–84.

Oulton, A. N. *Life in Dublin, and weekly theatrical review: being a peristrephic*

panorama of all the public entertainments which enlivened the Irish Metropolis.... Dublin, 1826.

Paine, Albert Bigelow, *Mark Twain, a Biography: The Personal and Literary Life of Samuel Langhorne Clemens.* New York: Harper & Brothers, 1912.

Panckoucke, Charles-Joseph, *Encyclopédie méthodique, ou par ordre de matières; par une société de gens de lettres, de savans et d'artistes* (Paris: chez Panckoucke, 1782ff).

"Das Panorama." *Jahrbücher der Preussischen Monarchie under der Regierung Friedrich Wilhelms des Dritten.* Berlin: Johann Friedrich Unger, 1800, vol. 2. *Panorama of London 1749.* London: Sidgwick & Jackson, 1972.

"Panorama of the Nile." *New Monthly Magazine and Humorist* 87, third part for 1849 (London: Chapman and hall, 1849), p. 130.

The Panorama of Wit: Exhibiting at one view the choiceset epigrams in the English language. London: J. Sharpe, 1809.

Paris guide, par les principaux écrivains et artistes de la France. Paris: Librarie Internationale, 1867.

Parry, Sir William Edward. *Journal of a Third Voyage for the Discovery of a Northwest Passage, from the Atlantic to the Pacific, Performed in the Years 1824–25, in His Majesty's Ships Hecla and Fury, Under the orders of Captain William E. Parry.* Philadelphia: H. C. Carey and I. Lee, 1826.

Parsons, Mrs. Clement. *Garrick and His Circle.* New York: G.P. Putnam's Sons and London: Methuen & Co., 1906.

Paton, Andrew Archibald. *Servia, Youngest Member of the European Family or, A Residence in Belgrade and Travels in the Highlands and Woodlands of the Interior, during the years 1843 and 1844.* London: Longman, Brown, Green, and Longmans, 1845.

Peet, Isaac Lewis. "The Relation of the Sign-Language to the Education of the Deaf." *Proceedings of the Seventh Convention of American Instructors of the Deaf* [Berkeley, Calif. 1886] (Sacramentio: State Office/P. L. Shoaff, 1887).

Peloubet, F[rancis] N[athan]. *The Front Line of the Sunday School Movement.* Boston: W. A. Wilde, 1904.

Pepper, John Henry. *The True History of Pepper's Ghost* [original title: "A True History of the Ghost and All About Metempsychosis"]. London: The Projection Box, 1996 [orig. 1890].

Petit, Georges. "Exposition Universelle: les Panoramas." *Revue scientifique (Revue Rose)*, 26, no. 1 (Jan.–July 1889).

Philippoteaux, Félix-Emmanuel-Henri. *Panorama of the Defence of Paris against the German Armies painted by F. Philippoteaux,* booklet. Paris: Impremerie administrative de Paul Dupont, 1872.

Pigault-Lebrun, Charles. *My Uncle Thomas: A Romance,* from the French. Vol. 2. New York: John Brennan, 1810.

Pike, Benjamin. *Pike's Illustrated Descriptive Catalogue or Optical, Mathematical and Philosophical Instruments.* Vol. 2. New York: By the Author, c. 1848–49.

Planché, J. R. *The Extravaganzas of J. R. Planché, Esq.,. Somerset Herald) 1825–1871,* ed. T. F. Dillon Croker and Stephen Tucker, vol. 4. London: Samuel French, 1879.

Planché, J. R. "Mr. Buckstone's Ascent of Mount Parnassus. A Panoramic Extravaganza." In *The Extravaganzas of J. R. Planché, Esq. (Somerset Herald) 1825–1871,* ed. T. F. Dillon Croker and Stephen Tucker, vol. 4. London: Samuel French, 1879, pp. 258–292.

La Plate-forme mobile et le chemin de fer électrique: Programme hebdomadaire de l'exposition. Paris: Figaro, 1900.

Polehampton, Henry S. *A Memoir, Letters, and Diary of Rev. Henry S. Polehampton, M.A.,* ed. Rev. Edward Polehampton and the Rev. Thomas Stedman Polehampton. London: Richard Bentley, 1858.

Pomarede, Leon. *A Guide to Pomarede's Original Panorama of the Mississippi River, from Mouth of the Ohio River, to the Falls of St. Anthony. By T.E. Courtenay.* New York: Printed and Published for the Author by George E. Leefe, 1849.

[Poole, Charles W.]. *Charles W. Poole's Royal Jubilee Myriorama; Picturesques trips around the World; All Over the World. Guide Book and Songs, Price Twopence.* Booklet, 16 pp., hand-dated "1886."

Portrait and Biographical Record of Seneca and Schuyler Counties New York. New York: Chapman Publishing Co., 1893.

Pougin, Arthur. *The Dictionnaire historique et pittoresque du théâtre et des arts qui s'y rattachent.* Paris: Librairie de Firmin-Didot et Cie, 1885.

P. P. C. R. "Balloon-ways versus Railways." *Mechanics Magazine, Museum, Register, Journal, and Gazette* 27 (April 8–Sept. 30, 1837).

Promenades pittoresques sur le continent, ou Panorama portatif du voyageur sur toutes les routes de l'Europe. London: Black et Armstrong, 1836.

[P. T. W.]. "Recent Balloon Ascent." Letter to the Editor, *The Mirror of Literature, Amusement, and Instruction* 13, no. 376 (June 20, 1829).

Pückler-Muskau, Hermann von. *Reisebriefe aus Irland.* Berlin: Rütten & Loening, n.d.

[Pückler-Muskau, Hermann von]. *Tour in England, Ireland, and France in the Years 1828 & 1829; with Remarks on the Manners and Customs of the Inhabitants, and Anecdotes of Distinguished Public Characters. In a Series of Letter. By A German Prince.* London: Effingham Wilson, Royal Exchange, 1832.

Pulleyn, William. *The Etymological Compendium, Or, Portfolio of Origins and Inventions.* 2d ed. London: Thomas Tegg, 1830.

[Purcell, Mrs.]. *The Orientalist, or, Electioneering in Ireland; a Tale, by Myself.* London: Baldwin, Cradock, and Joy, 1820.

Pyne, William Henry [Ephraim Hardcastle]. *Wine and Walnuts; or, After Dinner Chit-Chat.* 2d ed. London: Longman, Hurst, Rees, Orme, Brown, and Green, 1824.

"Q. Q. Q." "The Praise of the Past." *The Inspector, Literary Magazine and Review* (London: Effingham Wilson, 1827), vol. 2, pp. 34–35.

"Racing with a Tiger. A Bicyclist's Desperate Ride for Life in India." *Ballou's Monthly Magazine* (Boston: G. W. Studley), 75 (Jan.–June 1892), pp. 192–194.

Raue, C[harles] G[odlove]. *Psychology as a Natural Science applied to the Solution of Occult Psychic Phenomena.* Philadelphia: Porter & Coates, 1889.

Rice, Charles. *The London Theatre in the Eighteen-Thirties,* ed. Arthur Colby Sprague and Bertram Shuttleworth. London: Society for Theatre Research, 1950.

Risley, Professor [Richard Risley Carlisle], and John Rowson Smith. *Professor Risley and Mr. J. R. Smith's Original Gigantic Moving Panorama of the Mississippi River, extending from the Falls of St. Anthony to the Gulf of Mexico, painted by John R. Smith, Esq. [. . .] Being one-third longer than any other pictorial work in existence: four miles in length.* London: John K. Chapham and Co., 1849.

Risley, Professor [Richard Risley Carlisle], and John Rowson Smith. *Risley's aus America: Grosses bewegliches Original-Panorama des Mississippi-Flusses, von dem St. Anthony Wasserfalle bis zu dem Meerbusen von Mexico, Gemalt von John R. Smith, Esq.* Berlin: Ferdinand Reichardt u. Comp, 1851.

Ritchie, Leitch. *Travelling Sketches on the Rhine, and in Belgium and Holland. With Twenty-Six Beautifully Finished Engravings, from Drawings by Clarkson Stanfield,* Esq. London: Longman, Rees, Orme, Brown, Green, and Longman, 1833, orig. 1832.

Roberts, Randall Howland. *Modern war: or The campaigns of the first Prussian army, 1870–71.* London: Chapman & Hall, 1871.

Robertson, Étienne-Gaspard. *Mémoires récreatifs, scientifiques et anecdotiques d'un physicien-aéronaute.* Paris: chez l'auteur, 1831–1833.

Rose, A. *The Boy Showman and Entertainer.* London: George Routledge & Sons and E.P. Dutton & Co., n.d.

[Rose, A. W. H.]. *The Emigrant Churchman in Canada*, ed. Rev. Henry Christmas. London: Richard Bentley, 1849.

"The Roxbys and Beverleys." *Monthly Chronicle of North-Country Lore and Legend* 3, no. 29 (July 1889): 327–328.

Russell, Henry. *Cheer! Boys, Cheer!, Memories of Men & Music*. London: John Macqueen, 1895.

[Russell, Henry]. *Songs in Henry Russell's Vocal and Pictorial Entertainment, Entitled The Far West; or, the Emigrants' Progress From the Old World to the New: and Negro Life, in Freedom and in Slavery*, booklet. London: John K. Chapman and Co., [1851].

Russell, W[illiam] Clark. *Representative Actors*. London: Frederick Warne and Co., 1888.

[Sachsen-Weimar-Eisenach, Herzog Bernhard zu]. *Reise Sr. Hoheit des Herzogs Bernhard zu Sachsen-Weimar-Eisenach durch Nord-Amerika in den Jahren 1825 und 1826*, ed. Heinrich Luden. Weimar: Wilhelm Hoffmann, 1828), I Theil.

[Sala, George]. "Since this old cap was new." *All Year Around* 2, no. 30 (Nov. 19, 1859).

Santayana, George. *Winds of Doctrine. Studies in Contemporary Opinion*. New York: Charles Scribner's Sons, 1913.

"Sarsfield Young's Panorama." *Punchinello*, Nov. 26, 1870, p. 135; Dec. 3, 1870, p. 158; Dec. 17, 1870, p. 190; Dec. 24, 1870, p. 204.

"Scenic Diorama Rolls Past Windows of Train." *Popular Mechanics* 69, no. 3 (March 1938).

Scott, William B. "Barker and Burford's Panoramas." *Notes and Queries*, June 22, 1872.

Shaw, Eyre M[assey]. *Fires in Theatres*. London: E. and F.N. Spon, 1876.

Shea, James J., and Charles Mercer. *It's All in the Game*. New York: G. P. Putnam's Sons, 1960.

Seidel, C. "Über Panoramen, Dioramen und Neoramen." *Berliner Kunstblatt* 1 (1828).

Shepherd, Ettrick. "Noctes Bengerianae no. II." *Edinburgh Literary Journal: Or, Weekly Register of Criticism and Belles Lettres* (Edinburgh: Constable & Co.), no. 19, (March 21, 1829).

Shepherd, Tho[ma]s H. *Metropolitan Improvements or London in the Nineteenth Century*. London: Jones & Co., 1827.

Sherman, Loren Albert. *Science of the Soul*. Port Huron, Mich.: Sherman Co., 1895.

[Shirres, David Logan]. *An Exposition of the Apocalypse on a New Principle of a Literal Interpretation*. Aberdeen: A. Brown & Co., John Menzies & Co., Longman & Co., 1871.

"Sketches of the Irish Bar.—no. 5: The Solicitor-general, Mr. Joy." *New Monthly Magazine, and Literary Journal* 5, no. 30 (1823).

Slicer, Thomas R. *The Power and Promise of the Liberal Faith. A Plea for Reality*. Boston: George H. Ellis, 1900.

Smith, Albert. "A Go-a-Head Day with Barnum." *Bentley's Miscellany*, 21 (1847), pp. 522–527, 623–628.

Smith, Albert. "Composite Columns, no. V: Panoramania." *Illustrated London News*, Aug. 5, 1850.

Smith, Albert. *A Hand-Book of Mr. Albert Smith's Ascent of Mont Blanc: Illustrated by Mr. William Beverley: With Sixteen Outline Engravings of the Views. First Represented at The Egyptian Hall, Piccadilly, Monday Evening, March 15, 1852*. London: Savill and Edwards [1852].

Smith, Albert. *A Hand-Book to Mr. Albert Smith's Entertainment entitled the Over-land Mail*. London: Savill & Edwards, Published for the Author, 1850.

[Smith, Albert]. *Handbook to Mont Blanc. A Handbook of Mr. Albert Smith's Ascent of Mont Blanc . . . First Represented at the Egyptian Hall, Piccadilly* [hand-written: 2d ed.]. London: Published for the Author, 1852.

Smith, Albert. *Hand-Book to the Grand Moving Diorama of Constantinople, including The Dardanelles, and The Bosporus, up to the entrance of the Black Sea, which is now open, in the New Room, at The Egyptian Hall.* London: W.S. Johnson, [1854].

Smith, Albert. *A Month at Constantinople.* London: David Bogue, 1850.

Smith, Albert. "Sketches of Paris: Musard's." *The Mirror of Literature, Amusement, and Instruction* (London: J. Limbird), vol. 33 (1839).

Smith, Albert. *The Story of Mont Blanc.* London: David Bogue, 1853.

Smith, Albert. *To China and Back being a Diary kept out and home.* Hong Kong: Hong Kong University Press, 1974, orig. 1859.

Smith, Albert, and John Leech. *A Month: A View of Passing Subjects and Manners.* London: "Month" Office, 1851.

Smith, Benjamin George. *From Over the Border, or Light on the Normal Life of Man.* Chicago: Charles H. Kerr & Co., 1890.

Smith, James. *The Panorama of Science and Art.* Liverpool: Nuttal, Fisher and Co., 1815.

Smith, J[ohn] R[owson]. *Descriptive Book of The Tour of Europe, The Largest Moving Panorama in the World,* Linwood Gallery, Leicester Square, London, Sept. 1853. Frankfort o/M: C. Horstmann, 1853.

Smith, Thomas. *A Topographical and Historical Account of the Parish of St. Mary-le-Bone.* London: John Smith, 1833.

Solly, Thomas. *The Will, Divine and Human.* Cambridge: Deighton, Bell and Co., and Bell and Daldy, 1856.

Songs, choruses and dialogue, in the grand, romantic, legendary, burlesque and comic Christmas pantomime, entitled the Castle of Otranto, or, Harlequin and the Giant Helmet. Performed for the first time at the Theatre Royal, Covent Garden, on Saturday, December 26th, 1840. London: S. G. Fairbrother, [1840].

The Songs, Chorusses, Dialogue, &c. in the New Grand Historical, comic Christmas pantomime, called Harlequin and George Barnwell, or the London 'Prentice. London: W. Kenneth, [1836 or 1837].

Songs, glees, &c. in the Thespian panorama; or, Three hours heart's ease: As performed at the Theatre-Royal, Hay-Market. London: J. Barker, at the Dramatic Repository, 1795.

Spicer, W. A. *Our Day in the Light of Prophecy.* Washington, D.C.: Review and Herald Publishing Assn., 1917.

Stearns, Jess, with Larry Geller. *Elvis' Search for God.* Murfreesboro, Tenn.: Greenleaf Publications, 1998.

[Sterndale, Mary R.]. *The Panorama of Youth, in Two Volumes.* London: J. Carpenter, 1807.

Stevens, Alfred, and Henri Gervexi. "The Paris Panorama of the Nineteenth Century." *Century Magazine* 39, new series vol. 17, no. 38 (Nov. 1889–April 1890): 256–269.

Stirling, James. *Letters from the Slave States.* London: John W. Parker and Son, 1857.

Stocqueler, Joachim Hayward. *The Memoirs of a Journalist,* Enlarged, Revised and Corrected by the Author. Bombay: Offices of the Times of India, 1873.

Stoe van Dyk, Harry. *Theatrical Portraits; with Other Poems.* London: John Miller, Simpkin and Marshall, Chappell and Son, 1822.

Strong, Rev. Josiah. *Our World: The New World-Life.* Garden City New York: Doubleday, Page & Co., 1913.

"Summer Novelties in Balloons." *Punch* 19 (July–Dec. 1850).

Swanquill, Sylvanus. "January." *New Sporting Magazine* (London: Baldwin & Cradock), 2, no. 9 (Jan. 1831).

Taylor, Jefferys. *A Month in London; or, Some of its Modern Wonders Described.* London: Harvey and Darton, 1832.

Taylor, Tom. *Leicester Square; Its Associations and its Worthies*. London: Bickers and Son, 1874.

Telbin, William. *The Panorama and Diorama of the Isle of Wight with the Interior of Senlis Cathedral*. Cheltenham: J. Hadley, [post-1844].

Théaulon, Mrs. Ferdinand et Bisset, *Le Zodiaque de Paris: Vaudeville-épisodique en un acte*. Paris: Duvernois & Sédille, 1822.

Thiery, L. V. *Guide des amateurs et des étrangers voyageurs à Paris*. Paris: Hardouin et Gattey, 1787.

Thornbury, Walter. *The Life of J. M. W. Turner, R. A.: Founded on Letters and Papers Furnished by His Friends and Fellow-Academicians*. New revised ed. London: Chatto & Windus, 1897.

Thornton, B. [auctioneer]. "The Splendid and Far-famed Panorama (recently known as Laidlaw's Panorama . . .)." *Manchester Guardian*, Sept. 24, 1842.

"Three Trips in the Air." *Chambers's Edinburgh Journal*, new series 15, nos. 366–391 (Jan.–June 1851): 302.

Timbs, John. *Curiosities of London: Exhibiting the most Rare and Remarkable Objects of Interest of the Metropolis*, etc. London: David Bogue, 1855.

Timbs, John. *Knowledge for the People, Or, The Plain Why and Because*. Boston: Lilly & Wait and Carter & Hendee, etc., 1832.

Tissandier, Gaston. *Le grand ballon captif à vapeur de M. Henry Giffard*. Paris: G. Masson, 1878.

Turnor, Hatton. *Astra Castra: Experiments and Adventures in the Atmosphere*. London: Chapman and Hall, 1865.

Tuttle, Hudson. *Studies in the Out-Lying Fields of Psychic Science*. New York: M. L. Holbrook & Co, 1889.

Twain, Mark. "The Launch of the Steamer Capital [includes "The Entertaining History of the Scriptural Panoramist." pp. 146–151], in Mark Twain, *The Celebrated Jumping Frog of Calaveras County, and Other Sketches*. London: George Routledge and Sons, 1867.

Twain, Mark. *Life on the Mississippi*. London: Chatto & Windus, 1883.

Twain, Mark. "A Travelling Show [Scriptural Panoramist]." In Mark Twain, *Screamers*. London: J. C. Hotten, 1871, pp. 146–150.

Twain, Mark. "What Is Man?" In *What Is Man? and Other Essays*. New York: Harper & Brothers, 1917.

The Universal Songster: Or, Museum of Mirth. London: Jones and Co., 1834.

Verne, Jules. *Around the World in Eighty Days*, trans. Geo M. Towle. Boston: James R. Osgood and Co., 1876.

Verne, Jules. *Michael Strogoff. The Courier of the Czar*, translation. New York: Charles Schribner's Sons, 1895.

Viollet-le-Duc, Eugène. *Lettres d'Italie: 1836–37*. Paris: L. Laget, 1971.

Vizetelly, Henry, *Glances Back Through Seventy Years: Autobiographical and Other Reminiscences*. Vol. 1. London: Kegan Paul, Trench, Trübner & Co., 1893.

Walsh, William Shepard. *A Handy Book of Curious Information: Comprising Strange Happenings in the Life of Men*. Philadelphia: J.B. Lippincott, 1913.

Ward, Artemus. *Artemus Ward's Panorama: As exhibited at the Egyptian Hall, London.)*, ed. T. W. Robertson & E. P. Hingston. New York: G.W. Carleton, 1869.

Ward, Artemus. *His Travels: Part1—Miscellaneous, Part II—Among the Mormons*. New York: Carleton, 1865.

Ward, Mrs. Humphry. *Robert Elsmere*. London: Smith, Elder & Co., 1901.

Webster's International Dictionary of the English Language. New Edition with supplement of new words, ed. Noah Porter. Springfield, Mass.: G. & C. Merriam Co., 1902.

Welch, A[donijah] S[trong] Welch. *Object Lessons: Prepared for Teachers of Primary Schools and Primary Classes*. New York: A. S. Barnes & Burr, 1862.

Wellbeloved, Horace. *London lions for country cousins and friends about town, being all the new buildings, improvements and amusements in the British Metropolis. . . .* London, Edinburgh and Dublin: William Charlton Wright, J.Robertson and Co., Westley and Tyrrell, 1826.

Wellington Anecdotes. A Collection of Sayings and Doings of the Great Duke. London: Addey and Co., 1852.

Wheaton, Nathaniel S. *A Journal of a Residence During Several Months in London; including Excursions through Various Parts of England; and a Short Tour in France and Scotland; in the Years 1823 and 1824.* Hartford: H & F. J. Huntington et al., 1830.

W. H. R. "Letter from London." *Home Journal* 9, no. 211 (Feb. 23, 1850): 2.

Whittier, John G. "The Panorama." In *The Panorama, and Other Poems.* Boston: Ticknor and Fields, 1856, pp. 3–26.

Wilcox, John. *Guide to the Edinburgh and Glasgow Railway.* Edinburgh: John Johnstone, and W. and A. K. Johnston, et al., 1842.

Wilkie, Andrew. *The Diorama of Life; or, the Macrocosm and Microcosm Displayed: Characteristic Sketches and Anecdotes of Men and Things.* London: Edward Barrett, 1824.

[Williams, Insco J.]. *A Short History of J. Insco Williams' Panorama of the Bible, containing a scriptural account of each scene: to which is appended a few practical notes, taken from various authors of distinction, by Rev. S. H. Chase, M.D.* Cincinnati: Printed by the Gazette Co., 1857.

Willigen, A. van der. *Aanteekeningen op een togtje door een gedeelte van Engeland, in het jaar 1823.* Haarlem: Wed. A. I. Oostjes Pz., 1824.

[Wines, Enoch Cobb]. "The Author of *Two and a Half Years in the Navy,* "Hanington's Dioramas." *Gentleman's Magazine,* ed. William E. Burton. Philadelphia: Charles Alexander, 1838, vol. 3 (July–Dec. 1838), pp. 291–292.

Winks, Tiddledy [Albert Smith]. "Transactions and Yearly Report of the Hookham-cum-Snivey Literary, Scientific, and Mechanics' Institution." *Punch, or the London Charivari. Vol. 1.* Sept. 12, 1841.

Woodin, W. S. *Mr. W. S. Woodin's Olio of Oddities, an Entirely New and Original Mimical, Musical, Pictorial, Polygraphic, and Panoramic Entertainment,* Polygraphic Hall, King William Street, Charing Cross, prgoram booklet. London: John K. Chapman and Co. [1855].

Yates, Edmund. "Bygone Shows." *Fortnightly Review,* ed. T. H. S. Escott. London: Chapman & Hall, vol. 39, new series (Jan. 1 to June 1, 1886).

Yates, Edmund. *Memoirs of a Man of the World: Fifty Years of London Life.* New York: Harper & Brothers, 1885.

Zincke, Foster Barham. *Wherstead. Some Materials for its History.* London: Simpkin, Marshall, Hamilton, Kent & Co., 1893.

Zoroaster, or, the Spirit of the Star, a Grand Melo-dramatic tale of Enchantment, in two acts, as performed at the New Theatre Royal, Drury Lane, with Universal Approbation, First produced Easter Monday, April 19, 1824, by W. T. Moncrieff, Esq. London: J. Limbird, 1824.

SECONDARY SOURCES

Unpublished Sources

Avery, Kevin. "The Panorama and Its Manifestation in American Landscape Painting, 1795-1870." Ph. D. dissertation, Columbia University, 1995.

Baillais, Jean. "Carmontelle" (unprinted, no date, six typewritten pages, Músee Condé MS 12–96–38–70).

Barber, Xenophon Theodore. "Evenings of Wonders: A History of the Magic

Lantern Show in America." Ph. D. dissertation, Department of Performance Studies, New York University 1993.

Blake, Erin C. "Zograscopes, Perspective Prints, and the Mapping of Polite Space in Mid-Eighteenth-Century England." Ph. D. dissertation, Stanford University, 2000.

Borton, Terry and Deborah. "Before the Movies: American Magic-Lantern Entertainment and The Nation's First Great Screen Artist, Joseph Boggs Beale." Book manuscript draft, dated May 1, 2008.

Dolis, John J., Jr. "Hawthorne's Ontological Models: Daguerreotype and Diorama." Ph.D. dissertation, Loyola University of Chicago, Jan. 1978.

Hanners, John. "John Banvard (1815–1891) and His Mississippi Panorama." Ph.D. dissertation, Michigan State University, Depertment of Theatre, 1979 (unprinted).

Hedgbeth, Llewellyn Hubbard. "Extant American Panoramas: Moving Entertainments of the Nineteenth Century." Ph.D. dissertation, New York University (Theater Department), 1977.

McGinnis, Karin Hertel. "Moving Right Along: Nineteenth Century Panorama Painting in the United States." Ph. D. dissertation, University of Minnesota, June 1983.

Pinson, Stephen C. "Speculating Daguerre." Ph. D. dissertation, History of Art and Architecture, Harvard University, 2002.

Wickman, Richard Carl. "An Evaluation of the Employment of Panoramic Scenery in the Nineteenth-Century Theatre." Ph.D. dissertation, Graduate School of The Ohio State University, 1961.

Wilcox, Scott B. "The Panorama and Related Exhibitions in London." M. Litt Thesis, University of Edinburgh, 1976.

Published Sources

Abrahams, Aleck. "The Egyptian Hall, Piccadilly, 1813-1873." *The Antiquary* (London: Elliott Stock), vol. 42 (Jan.–Dec. 1906).

Abrahamsson, Åke. "Panoramats skenvärld - 1800-talets bildteatrar." In *Stadsvandringar*, 15, ed. Britt Olstrup, Irene Sigurdson, et al. Stockholm: Stockholms Stadmuseum, 1992.

Adorno, Theodor, and Max Horkheimer. Max, *Dialectic of Enlightenment*, trans. John Cumming. London: Verso, 1979, orig. 1944.

Agle, Nan Hayden, and Frances Atchinson Bacon. *Ingenious John Banvard.* New York: Seabury Press, 1966.

Allen, Ralph G. Allen. "The Eidophusikon." *Theatre Design and Technology*, December 1966. Reprinted in Stephen Herbert, *A History of Pre-Cinema*. London: Routledge, 2000, vol. 2, pp. 82–88.

Allevy, Marie-Antoinette (Akakia Viala), *La mise en scène en France dans la première moitié du dix-neuvième siècle.* Paris: Librarie E. Droz, 1938.

Altick, Richard D. *The Shows of London.* Cambridge, Mass.: The Belknap Press of Harvard University Press, 1978.

Altman, Rick. *Silent Film Sound.* New York: Columbia University Press, 2004.

Altmann, Aleana Andrea, ed. *Les Quatre Saisons de Carmontelle: Divertissement et illusions au siècle des Lumières.* Paris: Somogy éditions d'art & Musée de l'Île-de-France, 2008.

Auerbach, Alfred. *Panorama und Diorama: Ein Abriss ueber Geschichte und Wesen volkstuemlicher Wirklichkeitskunst.* Grimmen: Verlag Alfred Waberg, 1942.

Anderson, John D. "The Bayeux Tapestry: A 900-Year-Old Latin Cartoon." *Classical Journal* 81, no. 3 (Feb.–March 1986), pp. 253–257.

Aronson, Arnold. "Theatres of the Future." *Theatre Journal* 33, no. 4 (Dec. 1981): 496–498.

Arrington, Joseph Earl. "Henry Lewis' Moving Panorama of The Mississippi River." *Louisiana History* 6, no. 3 (Summer 1965): 239–272.

Arrington, Joseph Earl. "John Banvard's Moving Panorama of the Mississippi, Missouri, and Ohio Rivers." *Filson Club Historical Quarterly* 32 (July 1958): 207–240.

Arrington, Joseph Earl. "John Maelzel, Master Showman of Automata and Panoramas." *Pennsylvania Magazine of History and Biography* 84, no. 1 (Jan. 1960): 56–92.

Arrington, Joseph Earl. "Leon D. Pomarede's Original Panorama of the Mississippi River." *Bulletin of the Missouri Historical Society* 9, no. 3 (April 1953): 261–273.

Arrington, Joseph Earl. "Lewis and Bartholomew's Mechanical Panorama of the Battle of Bunker Hill." *Old-Time New England* (Fall–Winter 1951–52), pp. 1–17.

Arrington, Joseph Earl. "Otis A. Bullard's Moving Panorama of New York City." *New York Historical Society Quarterly* 44, no. 3 (July 1960): 308–355.

Arrington, Joseph Earl. "Samuel A. Hudson's Panorama Of the Ohio and Mississippi Rivers." *Ohio Historical Quarterly* 66, no. 4 (Oct. 1957): 355–374.

Arrington, Joseph Earl. "Skirving's Moving Panorama: Colonel Fremont's Western Expeditions Pictorialized." *Oregon Historical Quarterly* 65, no. 2 (June 1964): 132–172.

Arrington, Joseph Earl. "The Story of Stockwell's Panorama." *Minnesota History* 33 (Autumn 1952): 284–290.

Arrington, Joseph, Earl. "Thomas Clarkson Gordon's Moving Panorama of the Civil War: Battle Scenes of the Rebellion." In *Civil War Panorama: A Moving Panorama Painting Entitled "Battle Scenes of the Rebellion" by Thomas Clarkson Gordon, 1841–1922* (Dearborn, Michigan: Henry Ford Museum and Greenfield Village, 1959), 6 pp., unpaginated.

Arrington, Joseph Earl. "William Burr's Moving Panorama of the Great Lakes, The Niagara, St. Lawrence and Saguenay Rivers." *Ontorio History* 51, no. 3 (1959), unpaginated.

Augustin-Thierry, A. *Trois Amuseurs d'Autrefois: Paradis de Moncrif, Carmontelle, Charles Collé*. Paris: Librairie Plon, [1924].

Avery, Kevin J. "Dioramas in New York, 1826–1849." *Panorama Newsletter*, Spring 1990, pp. 5–11.

Avery, Kevin J. "Movies for Manifest Destiny." In *The Grand Moving Panorama of Pilgrim's Progress*. Montclair, N.J.: The Montclair Art Museum, 1999, pp. 1–12.

Bachelard, Gaston. *Poetics of Space*, trans. Maria Jolas. Boston: Beacon Press, 1969, orig. 1958.

Balzer, Richard. *Peepshows: A Visual History*. New York: Harry N. Abrams, 1998.

Bann, Stephen. *Parallel Lines: Printmakers, Painters and Photographers in Nineteenth-Century France*. New Haven: Yale University Press, 2001.

Bapst, Germain. *Essai sur l'histoire des panoramas et des dioramas*. Paris: Imprimerie nationale & Librairie G.Masson, 1891.

Barthes, Roland. "The Reality Effect." In *The Rustle of Language*, trans. Richard Howard. Berkeley: University of California Press, 1989, pp. 141–148.

Battchen, Geoffrey. "Seeing Things. Vision and Modernity." *Afterimage* 19, no. 2 (Sept. 1991): 5–7.

Baudry, Jean-Louis. "Ideological Effects of the Basic Cinematographic Apparatus." In *Narrative, Apparatus, Ideology: A Film Theory Reader*, ed. Philip Rosen (New York: Columbia University Press, 1986), pp. 286–298.

Baudry, Jean-Louis. "The Apparatus: Metaphychological Approaches to the Impression of Reality in Cinema." In *Narrative, Apparatus, Ideology: A Film Theory Reader*, ed. Philip Rosen (New York: Columbia University Press, 1986), pp. 299–318.

Baugh, Christopher. *Garrick and Loutherbourg*. Cambridge: Chadwyck-Healy, 1990.

Bell, John. *American Puppet Modernism*. New York: Palgrave, Macmillan, 2008.

Benjamin, Walter. *The Arcades Project*, trans. Howard Eiland and Kevin McLaughlin. Cambridge, Mass.: The Belknap Press of Harvard University Press, 2002.

Benjamin, Walter. *Charles Baudelaire: A Lyric Poet in the Era of High Capitalism*. London: Verso, 1983.

Benjamin, Walter. "The Flaneur [Part 2 of "The Paris of the Second Empire in Baudelaire]." trans. Harry Zohn, in *Selected Writings*. Vol. 4: *1938–1940*, ed. Howard Eiland and Michael W. Jennings. Cambridge, Mass.: Belknap Press of Harvard University Press, 2003.

Benjamin, Walter. "Paris, the Capital of the Nineteenth Century (Exposé of 1935)." In Benjamin, *The Arcades Project*, trans. Howard Eiland and Kevin McLaughlin. Cambridge, Mass.: The Belknap Press of Harvard University Press, 2002, pp. 3–13.

Benjamin, Walter. "The Work of Art in the Age of Mechanical Reproduction," trans. Harry Zohn, in *Illuminations*. Glasgow: Fontana/Collins, 1979, pp. 219–253.

Bermingham, Ann, ed. *Sensation & Sensibility: Viewing Gainsborough's Cottage Door*. New Haven: Yale Center for British Art and the Huntington Library, 2005.

Berrouet, Laurence, and Gilles Laurendon. *Magiciens des Boulevards: Bateleurs, Artistes et Bonimenteurs d'Autrefois*. Paris: Parigramme, 1995.

Bertetto, Paolo, and Donata Pesenti Campagnoni, eds. *Macchine e spettacoli prima dei Lumière nelle collezioni del Museo Nazionale del Cinema*. Milan: Electa, 1996.

Bluehm, Andreas, and Louise Lippincott. *Light! The Industrial Age 1750–1900: Art & Science, Technology & Society*. New York: Thames & Hudson, 2001.

Bogdan, Robert. *Freak Show: Presenting Human Oddies for Amusement and Profit*. Chicago: University of Chicago Press, 1988.

Booth, Michael R. *Victorian Spectacular Theatre 1850–1910*. Boston: Routledge & Kegan Paul, 1981.

Bordini, Silvia. *Storia del panorama: la visione totale nella pittura del XIX secolo*. Rome: Officina Edizioni, 1984.

Born, Wolfgang. *American Landscape Painting*. Westport, Conn.: Greenwood Press, 1970, orig. 1948.

Borton, Terry and Deborah Borton. *Before the Movies: American Magic-Lantern Entertainment and the Nation's First Great Screen Artist, Joseph Boggs Beale*. forthcoming.

Bottomore, Stephen. *I Want to See This Annie Mattygraph: A Cartoon History of the Movies*. Pordenone: Le giornate del cinema muto, 1995.

Bottomore, Stephen. "The Panicking Audience? Early cinema and the train effect." *Historical Journal of Film Radio and Television* 19, no. 2 (June 1999): 177–216.

Bottomore, Stephen. *The Titanic and Silent Cinema*. Hastings, East Sussex: The Projection Box, 2000.

Bouhours, Jean-Michel, ed. *Lumière, transparence, opacité: Acte 2 du Nouveau Musée National de Monaco*. Milan: Skira, 2006.

Bourgeron, Jean-Pierre. *Les Masques d'Eros: Les objets érotiques de collection à système*. Paris: Les Editions de l'Amateur, 1985.

Brand, Dana. "The Panoramic Spectator in America: A Re-reading of Some of Hawthorne's Sketches." *ATQ, The American Transscendental Quarterly: A Journal of New England Writers*, no. 59 (March 1986), pp. 5–17.

Brand, Dana. *The Spectator and the City in Nineteenth-Century American Literature*. Cambridge: Cambridge University Press, 1991.

Brown, T[homas] Allston. *A History of the New York Stage from the First Performance in 1732 to 1901*. New York: Dodd, Mead and Co., 1903.

Brunetta, Gian Piero. *Il viaggio dell'icononauta dalla camera oscura di Leonardo alla luce dei Lumière*. Venezia: Marsilio Editori, 1997.

Bruno, Giuliana. *Atlas of Emotion: Journeys in Art, Architecture, and Film*. New York: Verso, 2002.

Brydall, Robert. *Art in Scotland: Its Origin and Progress*. Edinburgh: William Blackwood and Sons, 1889.

Buddemeier, Heinz. *Panorama, Diorama, Photographie; Entstehung und Wirkung neuer Medien im 19. Jahrhundert*. Munich: Wilhelm Fink Verlag, 1970.

Burch, Noel. "How we got into Pictures: notes accompanying Correction Please." *Afterimage*, nos. 8–9 (Spring 1981), pp. 22–48.

Burian, Jarka. *The Scenography of Josef Svoboda*. Middletown, Conn.: Wesleyan University Press, 1971.

Burke, Peter. *Popular Culture in Early Modern Europe*. New York: New York University Press, 1978.

Cahn, Iris. "The Changing Landscape of Modernity: Early Film and America's 'Great Picture' Tradition." *Wide Angle* 18, no. 3 (July 1996): 85–94.

Cameron, A[lexander] D[urand]. *The Man Who Loved to Draw Horses: James Howe 1780–1836*. Aberdeen: Aberdeen University Press, 1986.

Campagnoni, Donata Pesenti, ed. *Vedute del "Mondo Novo." Vues d'optiques settecentesche nella collezione del Museo Nazionale del Cinema di Torino*. Torino: Umberto Allemandi & C./Museo Nazionale del Cinema, 2000.

Carnegy, Patrick. *Wagner and the Art of the Theatre*. New Haven: Yale University Press, 2006.

Carson, William G. *Managers in Distress: The St. Louis Stage, 1840–1844*. St. Louis: St. Louis Historical Documents Foundation, 1949.

Ceram, C. W. *Archaeology of the Cinema*. New York: Harcourt, Brace & World, [1965].

Charbon, Paul. *La machine parlante*. Rosheim: Éditions Jean-Pierre Gyss, 1981.

Chatel de Brancion, Laurence. *Carmontelle au jardín des illusions*. Château de Saint-Rémy-en-l'Eau: Éditions Monelle Hayot, 2003.

Chatel de Brancion, Laurence. *Carmontelle's Landscape Transparencies: Cinema of the Enlightenment*, trans. Sharon Grevet. Los Angeles: The J. Paul Getty Museum, 2008.

Chatel de Brancion, Laurence. *Le cinéma au Siècle des lumières*. Château de Saint-Rémy-en-l'Eau: Éditions Monelle Hayot, 2007.

Clayton, Ellen, C. *English Female Artists*. London: Tinsley Brothers, 1876.

Clement, Clara Erskine, and Laurence Hutton. *Artists of the Nineteenth Century and Their Works*. Vol. 2. Boston: Houghton, Osgood and Co. and The Riverside Press, 1879.

Colligan, Mimi. *Canvas Documentaries: Panoramic Entertainments in Nineteenth-Century Australia and New Zealand*. Melbourne: Melbourne University Press, 2002.

Collins, Paul. *Banvard's Folly: Thirteen Tales of Renowned Obscurity, Famous Anonymity, and Rotten Luck*. New York: Picador, 2001.

Comment, Bernard. *Le XIXe siècle des panoramas*. Paris: Adam Biro, 1993.

Comment, Bernard. *The Painted Panorama*, trans. Anne-Marie Glasheen. New York: Harry N. Abrams, 1999, orig. 1993.

Conan, Michael, ed. *Landscape Design and the Experience of Motion*. Washington, D.C.: Dumbarton Oaks Research Library and Collection, 2003.

Cook, Olive. *Movement in Two Dimensions*. London: Hutchinson & Co, 1963.

Crafton, Donald. *Emile Cohl, Caricature, and Film*. Princeton: Princeton University Press, 1990.

Crangle, Richard, Mervyn Hand, and Ine van Dooren, eds. *Realms of Light: Uses and Perceptions of the Magic Lantern from the 17th to the 21st Century*. London: Magic Lantern Society, 2005.

Crary, Jonathan. "Géricault, the Panorama, and Sites of Reality in the Early Nineteenth Century." *Grey Room*, 09 (Fall 2002), pp. 5–25.

Crary, Jonathan. *Techniques of the Observer: On Vision and Modernity in the Nineteenth Century*. Cambridge, Mass: MIT Press, 1989.

Curtius, Ernst Robert. *European Literature and the Latin Middle Ages*, trans. Willard R. Trask. London and Henley: Routledge & Kegan Paul, 1979, orig. 1948.

Dahl, Curtis. "Mark Twain and the Moving Panoramas." *American Quarterly* 13, no. 1 (Spring 1961): 20–32.

Dawes, Edwin and Heard, Mervyn. "M. Henry's Dissolving Views." In *Realms of Light. Uses and Perceptions of the Magic Lantern from the 17th to the 21st Century*, ed. Richard Crangle, Mervyn Heard and Ine van Dooren (London: Magic Lantern Society, 2005), pp. 159–161.

de Bourgoing, Catherine, ed. *Jardins romantiques français: Du jardin des Lumières au parc romantique 1770–1840*. Paris: Les musées de la Ville de Pars, 2011.

de Lauretis, Teresa, and Stephen Heath, eds. *The Cinematic Apparatus*. London and Basingbroke: Macmillan, 1980.

Djajasoebrata, Alit. *Shadow Theatre in Java: The Puppets, Performance and repertoire*. Amsterdam: Pepin Press, 1999.

Dobson, Austin. *At Prior Park and Other Papers*. London: Chatto & Windus, 1912.

Dorikens, Maurice. *Joseph Plateau 1801–1883 Leven r'tussen Kunst en Wetenschap/ Vivre entre l'Art et la Science/Living between Art and Science*. Ghent: Provincie Oost-Vlaanderen, 2001.

Ernouf, Baron [Alfred Auguste]. *Les inventeurs du gaz et de la photographie*. Paris: Hachette, 1877.

Fell, John L. *Film and the Narrative Tradition*. Berkeley: University of California Press, 1986 [1974].

Fielding, Raymond. "Hale's Tours: Ultrarealism in the Pre-1910 Motion Picture." In *Film Before Griffith*, ed. John L. Fell (Berkeley: University of California Press, 1983).

Finck, Heinz Dieter, and Michael T. Ganz. *Bourbaki Panorama*. Zurich: Werd Verlag, 2000.

Five Paintings from Th. Nast's Grand Caricaturama. New York: The Swann Collection of Caricature and Cartoon, 1970.

Fitzsimons, Raymund. *Garish Lights: The Public Readings of Charles Dickens*. Philadelphia: J. B. Lippicott, 1970.

Fitzsimons, Raymund. *The Baron of Piccadilly: The Travels and Entertainments of Albert Smith 1816–1860*. London: Geoffrey Bles, 1967.

Flannery, Tim, ed. *The Birth of Melbourne*. Melbourne: The Text Publishing Co., 2002.

Flichy, Patrice. *Une histoire de la communication moderne: espace public et vie privée*. Paris: Editions la découverte, 1991.

Francastel, Pierre. "Les transparents de Carmontelle." *L'Illustration*, no. 4511 (August 17, 1929), p. 159.

Friedberg, Anne. *Window Shopping. Cinema and the Postmodern*. Berkeley: University of California Press, 1993.

Friedell, Egon. *Kulturgeschichte der Neuzeit*. Munich: C.H. Beck, 1827–32.

Fritze, Sointu, Claire Gould, Sanna Juntunen, and Erja Pusa, eds. *India Express: Sacred and Popular*. Helsinki: Helsinki City Art Museum's Publications no. 90, 2006.

Fruitema, Evelyn J., and Paul A. Zoetmulder, eds. *The Panorama Phenomenon: Mesdag Panorama 1881–1981*. The Hague: Foundation for the Preservation of the Centenarian Mesdag Panorama, 1981.

Fullerton, John, and Jan Olsson, eds. *Allegories of Communication: Intermedial Concerns from Cinema to the Digital*. Rome: John Libbey, 2004.

Fung, Stanislaus. "Movement and Stillness in Ming Writings on Gardens." In *Landscape Design and the Experience of Motion*, pp. 243–262.

Füsslin, Georg; Werner Nekes, Wolfgang Seitz, Karl-Heinz W. Steckelings, and Birgit Verwiebe. *Der Guckkasten: Einblick—Durchblick—Ausblick.* Stuttgart: Füsslin Verlag, 1995.

Gaa, Karin, and Bernd Krueger, eds. *Das Kaiserpanorama: Bilder aus dem Berlin der Jahrhundertwende.* Berlin: Berliner Festspiele, 1984.

Galperin, William H. *The Return of the Visible in British Romanticism.* Baltimore: Johns Hopkins University Press, 1993.

Garelick, Rhonda. "Bayadères, Stéréorama, and Vahat-Loukoum: Technological Realism in the Age of Empire." In *Spectacles of Realism: Body, Gender, Genre,* ed. Margaret Cohen and Christopher Prendercast (Minneapolis: University of Minnesota Press, 1995).

Garnier-Pelle, Nicole. *Paysages: Chefs-d'oeuvre du Cabinet des dessins du musée Condé à Chantilly.* Paris and Chantilly: Somogy éditions d'art and Musée Condé, 2001.

Gauthier, Philippe. "The movie theater as an institutional space and framework of signification: Hale's Tours and film historiography." *Film History* 21, no. 4 (2009).

Gernsheim, Helmut and Alison Gernsheim. *L. J. M. Daguerre: The History of the Diorama and the Daguerreotype.* 2d rev. ed. New York: Dover, 1968, orig. 1956.

Ghosh, Pika. "Unrolling a Narrative Scroll: Artistic Practice and Identity in Late-Nineteenth-Century Bengal." *Journal of Asian Studies* 62, no. 3 (August 2003): 835–871.

Gitelman, Lisa. *Always Already New: Media, History, and the Data of Culture.* Cambridge, Mass.: MIT Press, 2006.

Gollin, Rita K., and John L. Idol, with Sterling K. Eisiminger. *Prophetic Pictures. Nathaniel Hawthorne's Knowledge and Uses of the Visual Arts.* New York: Greenwood Press, 1991.

Goodman, Matthew. *The Sun and the Moon: The Remarkable True Account of Hoaxers, Showmen, Dueling Journalists, and Lunar Man-Bats in Nineteenth-Century New York.* New York: Basic Books, 2008.

The Grand Moving Panorama of Pilgrim's Progress. Montclair, N.J.: The Montclair Art Museum, 1999.

Grau, Oliver. *Virtual Art: From Illusion to Immersion,* trans. Gloria Custance. Cambridge, Mass.: MIT Press, 2003.

Gravelaine, Frédérique de, *Le Futuroscope: Le Parc européen de l'image, un lieu pour apprivoiser le futur,* ed. René Monory. Paris: Editions du Moniteur, 1992.

Griffiths, Alison. *Shivers Down your Spine: Cinema, Museums, and the Immersive View.* New York: Columbia University Press, 2008.

Groce, George C., and David H. Wallace. *The New-York Historical Society's Dictionary of Artists in America 1584–1860.* New Haven: Yale University Press, 1966.

Grossklaus, Götz. *Natur—Raum: Von der Utopie zur Simulation.* Munich: iudicium, 1993.

Guerin, Patrice. *Du soleil au xenon: Les techniques d'éclairage à travers deux siècles de projection.* Paris: Editions Prodiex, 1995.

Hall, Elton W. *Panoramic Views of Whaling by Benjamin Russell.* New Bedford, Mass.: Old Dartmouth Historical Society, Sketch no. 80, 1981.

Hammond, John H. *Camera Obscura: A Chronicle.* Bristol: Adam Hilger, 1981.

Hanley, Keith, and John K. Walton. *Constructing Cultural Tourism: John Ruskin and the Tourist Gaze.* Bristol: Channel View Publications, 2010.

Hannavy, John, ed. *Encyclopedia of Nineteenth-Century Photography.* Vol. 1. New York: Routledge, 2007.

Hanners, John. "The Great Wizard of the North: John Banvard and His Floating Theaters." *Traces of Indiana and Midwestern History* 2, no. 2 (Spring 1990): 26-35.

Hanners, John. *"It Was Play or Starve": Acting in the Nineteenth Century American Popular Theatre*. Bowling Green, Ohio: Bowling Green State University Popular Press, 1993.

Hanners, John. "John Banvard's Mississippi Panorama." *American History Illustrated* 17, no. 7 (1982): 30–32, 36–39.

Hardiman, Tom. "The Panorama's Progress: The History of Kyle & Dallas's Moving Panorama of Pilgrim's Progress." In *The Grand Moving Panorama of Pilgrim's Progress* (Montclair, N.J.: The Montclair Art Museum, 1999), pp. 13–24.

Hauser, Beatrix. "From Oral Tradition to 'Folk Art': Reevaluating Bengali Scroll Paintings." *Asian Folklore Studies* 61, no. 1 (2002): 105–122.

Haverstock, Mary Sayre, Jeannette Mahoney Vance, Brian L. Meggitt, and Jeffrey Weidmarkt. *Artists in Ohio, 1787–1900: A Biographical Dictionary.*. Kent, Ohio: The Kent State University Press, 2000.

Hayes, Christian. "Phantom carriages: Reconstructing Hale's Tours and the virtual travel experience." *Early Popular Visual Culture* 7, no. 2 (2009): 185–198.

Hays, David. "Carmontelle's Design for the Jardin de Monceau: a Freemasonic Garden in Late-Eighteenth-Century France." *Eighteenth-Century Studies* 32, no. 4 (1999): 447–462.

Heard, Mervyn. *Phantasmagoria: The Secret Life of the Magic Lantern*. Hastings, East Sussex: The Projection Box, 2006.

Hecht, Hermann. *Pre-Cinema History: An Encyclopaedia and Annotated Bibliography of the Moving Image Before 1896*, ed. Ann Hecht. London: Bowker-Saur with British Film Institute, 1993.

Hecht, Hermann. "Some English Magic Lantern Patents." *The New Magic Lantern Journal* 2, no. 2 (Jan. 1982): 2–3.

Heckschler, Dr. J. *Peter Suhrs "Panorama einer Reise von Hamburg nach Altona und zuruck."* Berlin: Hermann Barsdorf Verlag, 1909.

Herbert, Stephen. *A History of Pre-Cinema*, vols. 1–3. London: Routledge, 2000.

Herbert, Stephen, and Luke McKernan, eds. *Who Is Who of Victorian Cinema, A Worldwide Survey*. London: BFI Publishing, 1996.

Heskett, John. *Industrial Design*. London: Thames & Hudson, 2001, orig. 1980.

Hick, Ulrike. *Geschichte der optischen Medien*. Munich: Wilhelm Fink Verlag, 1999.

Huhtamo, Erkki. *Virtuaalisuuden arkeologia. Virtuaalimatkailijan uusi käsikirja.* "An Archaeology of Virtuality. The New Handbook of the Virtual Voyager"). Rovaniemi: University of Lapland, Faculty of the Arts, 1995.

Huhtamo, Erkki. "A Dioramic Discovery." *Magic Lantern Gazette* (The Magic Lantern Society of the United States and Canada), vol. 19, no. 1 (Spring 2007): 25–26.

Huhtamo, Erkki. "The Diorama Revisited." In *Sonic Acts XIII—The Poetics of Space, Spatial Explorations in Art, Science, Music & Technology*, ed. Arie Altena & Sonic Acts (Amsterdam: Sonic Acts Press/Paradiso), 2010, pp. 207–228.

Huhtamo, Erkki. "Dismantling the Fairy Engine: Media Archaeology as Topos Study." In *Media Archaeology: Approaches, Applications, and Implications*, ed. Erkki Huhtamo and Jussi Parikka (Berkeley: University of California Press, 2011), pp. 27–47.

Huhtamo, Erkki. "Encapsulated Bodies in Motion. Simulators and the Quest for Total Immersion." In *Critical Issues in Electronic Media*, ed. Simon Penny (Albany: State University of New York Press, 1995), pp. 159–186.

Huhtamo, Erkki. "From Kaleidoscomaniac to Cybernerd. Towards an Archeology of the Media." In *Electronic Culture*, ed. Timothy Druckrey (New York: Aperture 1996), pp. 296–303, 425–427.

Huhtamo, Erkki. "Ghost Notes: Reading Mervyn Heard's *Phantasmagoria. The Secret Life of the Magic Lantern*." *Magic Lantern Gazette* 18, no. 4 (Winter 2006): 10–20.

Huhtamo, Erkki. "Global Glimpses for Local Realities: The Moving Panorama, a Forgotten Mass Medium of the 19th Century." *Art Inquiry* 4, no. 13 (2002), special issue: "Globalization in Art and Culture," pp. 193–223.

Huhtamo, Erkki. "Penetrating the Peristrephic: An unwritten chapter in the history of the panorama." *Early Popular Visual Culture* 6, no. 3 (Nov. 2008): 219–238.

Huhtamo, Erkki. "Peristrephic Pleasures, or The Origins of the Moving Panorama." In *Allegories of Communication. Intermedial Concerns from Cinema to the Digital*, ed. John Fullerton and Jan Olsson (Rome: John Libbey, 2004), pp. 237–238.

Huhtamo, Erkki. "The Pleasures of the Peephole: An Archaeological Exploration of Peep Media." In *Book of Imaginary Media: Excavating the Dream of the Ultimate Communication Medium*, ed. Eric Kluitenberg. Rotterdam: NAi Publishers, 2006, pp. 74–155.

Huhtamo, Erkki. "Toward a History of Peep Practice." In *A Companion to Early Cinema*, ed. André Gaudreault, Nicolas Dulac, and Santiago Hidalgo. Oxford: John Wiley & Sons, forthcoming.

Huhtamo, Erkki, ed. *Outoäly—Alien Intelligence*. Helsinki: Kiasma Museum of Contemporary Art, 2000.

Huhtamo, Erkki, ed. *Virtuaalimatkailijan käsikirja*. "The handbook of the Virtual Voyager"), a special issue of *Lähikuva*. Turku: The Finnish Society of Cinema Studies), no. 2–3, 1991.

Huhtamo, Erkki, and Parikka, Jussi. "An Archaeology of Media Archaeology." In *Media Archaeology: Approaches, Applications and Implications*, ed. Erkki Huhtamo and Jussi Parikka. Berkeley: University of California Press, 2011, pp. 1–21.

Huhtamo, Erkki, and Jussi Parikka, eds. *Media Archaeology: Approaches, Applications, and Implications*. Berkeley: University of California Press, 2011.

Hrbas, Jiri, ed. *Nearly all about the magic lantern: A collection of articles*. Prague: The Czechoslovak Film Institute, 1968.

Hung, Wu. *The Double Screen: Medium and Representation in Chinese Painting*. London: Reaktion Books, 1996.

Hunt, Lynn, ed. *The New Cultural History*. Lynn Hunt. Berkeley: University of California Press, 1989.

Hunt, John Dixon. "'Lordship of the Feet': Toward a Poetics of Movement in the Garden." In *Landscape Design and the Experience of Motion*, pp. 187–213.

Hunt, John Dixon. *The Picturesque Garden in Europe*. London: Thames & Hudson, 2003.

Hutt, Julia. *Understanding Far Eastern Art*. New York: E.P. Dutton, 1987.

Hyde, Ralph. "Das Moving Panorama zwichen Kunst und Schaustellung." In *Sehsucht. Das Panorama als Massenunterhaltung des 19. Jahrhunderts*, ed. Marie-Louise von Plessen and Ulrich Giersch. Basel: Stroemfeld / Roter Stern, 1993, pp. 84–93.

Hyde, Ralph. "Myrioramas, Endless Landscapes. The Story of a Craze." *Print Quarterly* 21, no. 4 (2004): 403–421.

Hyde, Ralph. *Panoramania! The Art and Entertainment of the 'All-Embracing' View*. London: Trefoil Publications in Association with Barbican Art Gallery, 1988.

Hyde, Ralph. "Thomas Allom and His Panorama of Constantinople: The Visual Evidence of a Recently Discovered Peepshow." In *Panorama: Virtuality and Realities: 11. International Panorama Conference in Altötting 2003*, ed. Gebhard Streicher. Altötting: SPA Stiftung Panorama Altötting & Verlag Koch—Schmidt—Wilhelm, 2005, pp. 76–83.

Imamura, Taihei. "Japanese Art and the Animated Cartoon." *Quarterly of Film Radio and Television* 7, no. 3 (Spring 1953): 217–222.

Jacob, Georg. *Geschichte des Schattentheaters im Morgen- und Abendland*. Hannover: Orient- Buchhandlung Heinz Lafaire, 1925, orig. 1907.

Jean-Charles Langlois (1789–1870): Le spectacle de l'Histoire. Paris: Somogy, 2005.

Jennings, Humphrey. *Pandemonium 1660–1886": The Coming of the Machine as Seen by Contemporary Observers,* ed. Mary-Lou Jennings and Charles Madge. London: Picador, 1987.

Joe, Jeongwon. "Introduction: Why Wagner and Cinema? Tolkien Was Wrong." In *Wagner and Cinema,* ed. Jeongwon Joe and Sander L. Gilman. Bloomington: Indiana University Press, 2010, pp. 1–25.

Johnson, Lee. "The 'Raft of the Medusa' in Great Britain." *Burlington Magazine* 96, no. 617 (August 1954): 249–254.

Jones, John. "The Magic Lantern and Paul Sandby." *New Magic Lantern Journal* 3, no. 3 (Oct. 1985): 18–20.

Jones, John. "Trying to date some long slides." *The Ten Year Book (The New Magic Lantern Journal,* volume 4) (London: The Magic Lantern Society, 1986), pp. 74–79.

Jullien, Philippe. "Les talents de société de Carmontelle." *Connoisseur des Arts* (Janvier 1965), pp. 80–86.

Kämpfen-Klapproth, Brigid. *Das Bourbaki-Panorama von Edouard Castres.* Lucerne: Stadt Luzern, 1980.

Kant-Achilles, Mallay, Friedrich Seltmann, and Rüdiger Schumacher. *Wayang Beber: Das wiederentdeckte Bildrollen-Drama Zentral-Javas.* Stuttgart: Franz Steiner Verlag, 1990.

Kapcia, Antoni. *Havana: The Making of Cuban Culture.* Oxford: Berg Publishers, 2005.

Karel, David. *Dictionnaire des artistes de langue Française en Amérique du Nord.* Quebec City: Presses de l'Université Laval, 1992.

Keeler, Ward. *Javanese Shadow Plays, Javanese Selves.* Princeton: Princeton University Press, 1987.

Kieninger, Ernst, and Doris Rauschgatt. *Die Mobilisierung des Blicks. Eine Ausstellung zur Vor- und Frühgeschichte des Kinos.* Vienna: PVS Verleger, [1995].

Kirby, Lynne. *Parallel Tracks. The Railroad and Silent Cinema.* Durham: Duke University Press, 1997.

Kittler, Friedrich. *Aufschreibesysteme 1800/1900.* Munich: Wilhelm Fink Verlag, 1985), in English as *Discourse Networks 1800/1900,* trans. Michael Metteer with Chris Cullens. Palo Alto, Calif.: Stanford University Press, 1990.

Kittler, Friedrich. *Optical Media: Berlin Lectures 1999,* trans. Anthony Enns. Cambridge: Polity Press, 2010.

Klein, Norman M. *The Vatican to Vegas: A History of Special Effects.* New York: New Press, 2004.

Koller, Gabriele, ed. *The Panorama in the Old World and the New.* Amberg: Buero Wilhelm, Verlag Koch—Schmidt—Wilhelm GbR, 2010.

Komatsu, Hiroshi; Loden, Frances. "Mastering the Mute Image: The Role of the Benshi in Japanese Cinema." *Iris. A Journal of Theory on Image and Sound,* no. 22 (Autumn 1996), pp. 33–52 (special issue on The Moving Picture Lecturer).

Krauss, Rolf H. *Die Fotografie in der Karikatur.* Seebruck am Chiemsee: Heering-Verlag, 1978.

Kunhardt, Philip B., Jr., Philip B. Kunhardt III, and Peter W. Kunhardt. *P. T. Barnum: America's Greatest Showman—An Illustrated Biography.* New York: Alfred A. Knopf, 1995.

Kusahara, Machiko. "Panoramas in Japan." In *The Panorama Phenomenon,* ed. Tom Rombout. The Hague: Panorama Mesdag, 2006, pp. 81–88.

Lacy, Robin Thurslow. *A Biographical Dictionary of Scenographers 500 B.C. to 1900 A.D.* New York: Greenwood Press, 1990.

Lamb, Andrew. *A Life on the Ocean Wave: The Story of Henry Russell.* Croyton, UK: Fullers Wood Press, 2007.

Laub, Peter, ed. *Kosmoramen von Hubert Sattler*. Vol.1: *Metropolen*. Salzburg: Salzburger Museum Carolino Augusteum, 2006, Salzburger Museumshefte 8.

Lavit, Jean-Georget. "Les Quatres Saisons." In *Jardins en Ile-de-France dessins d'Oudry à Carmontelle* (Sceaux: Musée de l'Ile-de-France, 1990), pp. 24–29.

Lawrence, W. J. "Water in Dramatic Art." *Gentleman's Magazine*, ed. Sylvanus Urban (London: Chatto & Windus), vol. 262 (Jan.–June 1887).

Layne, George S. "Kirkbride-Langenheim Collaboration: Early Use of Photography in Psychiatric Treatment in Philadelphia." *Pennsylvania Magazine of History and Biography* 105, no. 2 (April 1981): 182–202.

Lease, Benjamin. "Diorama and Dream: Hawthorne's Cinematic Vision." *Journal of Popular Culture* 5, no. 2 (Fall 1971): 315–323.

Lease, Benjamin. "Hawthorne and the Archaeology of the Cinema." *The Nathaniel Hawthorne Journal 1976*, ed. C. E. Frazer Clark, Jr. (Englewood, Colorado: Information Handling Services, 1978), pp. 133–171.

Levie, Françoise. *Étienne-Gaspard Robertson. La vie d'un fantasmagore*. Longueil and Brussels: Éditions du Préambule and Sofidoc, 1990.

Levie, Pierre. *Montreurs et vues d'optiques*. Brussels: Editions Sofidoc, 2006.

Lewis, Robert M., ed. *From Traveling Show to Vaudeville: Theatrical Spectacle in America, 1830–1910*. Baltimore: Johns Hopkins University Press, 2003.

Lyons, Lisa. "Panorama of the Monumental Grandeur of the Mississippi Valley." *Design Quarterly* (Minneapolis: Walker Art Center), no. 101/102 (1976), pp. 32–34.

Mair, Victor H. *Painting and Performance: Chinese Picture Recitation and Its Indian Genesis*. Honolulu: University of Hawaii Press, 1988.

Malthête, Jacques, and Laurent Mannoni, eds. *Méliès: Magie et Cinéma*. Paris: Paris-Musées, 2002.

Mannoni, Laurent. *Le Grand art de la lumière et de l'ombre: Archéologie du cinéma*. Paris: Nathan, 1994). In English: *The Great Art of Light and Shadow*, trans. Richard Crangle. Exeter: University of Exeter Press, 2000.

Mannoni, Laurent, Donata Pesenti Campagnoni, and David Robinson. *Light and Movement: Incunabula of the Motion Picture 1420–1896*. Gemona: La Cineteca del Friuli/Le Giornate del Cinema Muto, 1995.

Mannoni, Laurent, and Donata Pesenti Campagnoni. *Lanterne magique et film peint: 400 ans de cinéma*. Paris: Éditions de la Martinière & La Cinématheque française, 2009.

Mannoni, Laurent. *Trois siècles de cinéma de la lanterne magique au Cinématographe*. Paris: Éditions de la Réunion des musées nationaux, 1995.

March, John L. "Captain E. C. Williams and the Panoramic School of Acting." *Educational Theatre Journal* 23, no. 3 (Oct. 1971): 289–297.

Markel, Stephen, with Tushara Bindu Gude. *India's Fabled City: The Art of Courtly Lucknow*. Los Angeles: LACMA, Del Monico Books, and Prestel, 2010.

Marshall, Philip. *Charles Marshall R. A.: His Origins, Life, and Career as a Panorama, Diorama, Landscape and Scenic Artist*. Truro: Cornwall: Aston Publishers, 2000.

Marten, James. *The Children's Civil War*. Chapel Hill: University of North Carolina Press, 1998.

Marten, James. "History in a Box: Milton Bradley's Myriopticon." *Journal of the History of Childhood and Youth* 2, no. 1 (2009): 5–7.

Marten, James, ed. *Lessons of War: The Civil War in Children's Magazines*. Wilmington, Del.: Scholarly Resources, 1999.

Marvin, Carolyn. *When Old Technologies Were New: Thinking About Electric Communication in the Late Nineteenth Century*. New York: Oxford University Press, 1988.

Marx, Erich, and Peter Laub, eds. *Das Salzburg-Panorama von Johann Michael Sattler. Vol. 1, Das Werk und sein Schöpfer*. Salzburg: Salzburger Museum Carolino Augusteum, 2005.

Marx, Leo. *The Machine in the Garden: Technology and the Pastoral Ideal in America.* London: Oxford University Press, 1964.

Mäser, Rolf, ed. *Theatrum mundi.* Dresden: Staatliche Kunstsammlungen Dresden, 1984.

Mayer, David, III. *Harlequin in His Element: The English Pantomime, 1806–1836.* Cambridge, Mass.: Harvard University Press, 1969.

Marzio, Peter C. *Democratic Art, Chromolithography 1840–1900, Pictures for a 19th-Century America.* Boston: David R. Godine, 1979.

McCalman, Iain. "Magic, Spectacle, and the Art of de Loutherbourg's Eidophusikon." In *Sensation & Sensibility: Viewing Gainsborough's Cottage Door,* ed. Ann Bermingham (Yale: Yale Center for British Art and the Huntington Library, 2005), pp. 180–197.

McCauley, Elizabeth Anne. *Industrial Madness: Commercial Photography in Paris 1848–1871.* New Haven: Yale University Press, 1994.

McDermott, John. *The Lost Panoramas of the Mississippi.* Chicago: University of Chicago Press, 1958.

McDonald, Robert. "The Route of the Overland Mail to India." *New Magic Lantern Journal* 9, no. 6 (Summer 2004): 83–87.

Michaux, Emmanuelle. *Du panorama pictural au cinéma circulaire: Origines et histoire d'un autre cinema 1785–1998.* Paris: L´Harmattan, 1999.

Mierral-Guérault, Mme. "L'oeuvre picturale de Carmontelle." *Bulletin des Musées de France,* Oct. 1949, pp. 226–229.

Mihara, Aya. "Little 'All Right' Took the Stage: A Tour of the Japanese Acrobats in Western Europe." *Ohtani Women's University Studies in English Language and Literature* (Japan), vol. 23 (March 1996): 99–114.

Mihara, Aya, and Thayer, Stuart. "Richard Risley Carlisle: Man in Motion." *Bandwagon: The Journal of the Circus Historical Society* 41, no. 1 (Jan.–Feb. 1997): 12–14.

Milano, Alberto, ed. *Viaggio in Europa attraverso le vues d'optique.* Milan: Mazzotta, 1990.

Miller, Angela. "The Panorama, the Cinema, and the Emergence of the Spectacular," *Wide Angle* 18, no. 2 (April 1996): 34–69.

Minici, Carlo Alberto Zottti, ed. *Il Mondo nuovo: Le meraviglie della visione dal '700 alla nascita del cinema.* Milan: Mazzotta, 1988.

Moldenhauer, Joseph J. "Thoreau, Hawthorne, and the 'Seven-Mile Panorama'." *ESQ: A Journal of the American Renaissance* 44, no. 4 (4th Quarter 1998): 227–273.

Monfort, Bruno. "Hawthorne et le panorama de l'histoire: 'Main Street." *Transatlantica,* no. 1 (2006), dossier "Beyond the new Deal." on-line at trans-atlantica.revues.org/793 .

Morelli, Peter, and Morelli, Julia. "The Moving Panorama of Pilgrim's Progress: The Hudson River School's Moving Exhibition." In *The Panorama in the Old World and the New* (Amberg: Büro Wilhelm. Verlag Koch—Schmidt—Wilhelm GbR and International Panorama Council, 2010), pp. 58–62.

Morison, Samuel Eliot. Introduction to *Whaler out of New Bedford: A Film Based on the Purrington-Russell Panorama of a Whaling Voyage Round the World 1841–1845.* New Bedford, Mass.: Old Dartmouth Historical Society, 1962.

Mosser, Monique. "*Rapporter le tableau sur le terrain*: Fabrique et poétique du jardin pittoresque." In *Jardins romantiques français: Du jardin des Lumières au parc romantique 1770–1840,* ed. Catherine de Bourgoing (Paris: Les musées de la Ville de Pars, 2011), pp. 32–42.

Mosser, Monique. "The Roving Eye: Panoramic Décors and Landscape Theory." In Odile Nouvel-Kammerer, *French Scenic Wallpaper 1795–1865* (Paris: Musée des Arts Décoratifs/Flammarion, 2000), pp. 194–209.

Moynet, Georges. *La machinerie théatrale: Trucs et décors. Explication raisonnée de*

tous les moyens employés pour produire les illusions théatrales. Paris: A la Librairie Illustrée, n.d. [1893].

Mungen, Anno. *"BilderMusik." Panoramen, Tableaux vivants und Lichtbilder als multimediale Darstellungsformen in Theater- und Musikaufführungen vom 19. bis zum frühen 20. Jahrhundert*. Remscheid: Gardez! Verlag, 2006.

Murase, Miyeko. *Emaki: Narrative Scrolls from Japan*. Japan: The Asia Society, 1983.

Musser, Charles. *Before the Nickelodeon: Edwin S. Porter and the Edison Manufacturing Company*. Berkeley: University of California Press, 1991.

Musser, Charles. *Edison Motion Pictures: 1890–1900: An Annotated Filmography*. Gemona: Le Giornate del Cinema Muto & Smithsonian Institution Press, 1997.

Musser, Charles. *Emergence of Cinema: The American Screen to 1907, History of the American Cinema. Vol. 1*. Berkeley: University of California Press, 1994.

Musser, Charles. "Toward a History of Screen Practice." *Quarterly Review of Film Studies* 9, no. 1 (Winter 1984): 59–69.

Musser, Charles, with Carol Nelson. *High-Class Entertainment: Lyman H. Howe and the Forgotten Era of Traveling Exhibition, 1880–1920*. Princeton, N.J.: Princeton University Press, 1991.

Neite, W. "The Cologne Diorama." *History of Photography* 3, no. 2 (April 1979): 105–109.

Nicoll, Allardyce. *The Development of the Theatre: A Study of Theatrical Art from the Beginnings to the Present Day*. 5th ed. London: George G. Harrap & Co., 1966, orig. 1927.

Nicoll, Allardyce. *The Garrick Stage: Theatres and Audience in the Eighteenth Century*. Manchester: Manchester University Press, 1980.

Nouvel-Kammerer, Odile. *French Scenic Wallpaper 1795–1865*, translation. Paris: Musée des Ars Décoratifs/Flammarion, 2000.

O'Brien, Patricia. "Michel Foucault's History of Culture." In *The New Cultural History*, ed. Lynn Hunt. Berkeley: University of California Press, 1989, pp. 25–46.

O'Connor, Ralph. *The Earth on Show: Fossils and the Poetics of Popular Science, 1802–1856*. Chicago: University of Chicago Press, 2007.

Odell, George Clinton Densmore. *Annals of the New York Stage*. New York: Columbia University Press, 1927–1949.

Oettermann, Stephan. *Ankündigungs-Zettel von Kunstreitern, Akrobaten, Tänzern, Taschenspielern, Feuerwerkern, Luftballons und dergleichen*, 6 volumes + Register & Katalog. Gerolzhofen: Spiegel & Co Verlag, 2003.

Oettermann, Stephan. *The Panorama: History of a Mass Medium*, trans. Deborah Lucas Schneider. New York: Zone Books, 1997, orig. 1980.

Okudaira, Hideo. *Emaki: Japanese Picture Scrolls*. Rutland, Vt.: Charles E. Tuttle Co., 1962.

Olivier, Marc. "Jean-Nicolas Servandoni's Spectacles of Nature and Technology." *French Forum* 30, no. 2 (Spring 2005): 31–47.

Palmquist, Peter E, and Tomas R. Kailbourn. *Pioneer Photographers from the Mississippi to the Continental Divide: A Biographical Dictionary, 1839–1865*. Stanford: Stanford University Press, 2000.

Parry, Lee. "Landscape Theater in America." *Art in America* 59, no. 6 (Nov.–Dec. 1971), pp. 52–61.

Peters, John Durham. "Introduction: Friedrich Kittler's Light Shows." In Kittler, *Optical Media: Berlin Lectures 1999*, trans. Anthony Enns. Cambridge: Polity Press, 2010.

Petersen, William J. *Mississippi River Panorama: The Henry Lewis Great National Work*. Iowa City, Iowa: Clio Press, 1979.

Philippe Jacques de Loutherbourg, R. A. (1740–1812). London: Greater London Council, n.d.

A Picturesque Guide to The Regent's Park; with Accurate Descriptions of The Colosseum, the Diorama, and the Zoological Gardens. London: John Limbird, 1829.

Pinson, Stephen C. *Speculating Daguerre: Art and Enterprise in the Work of LJM Daguerre.* Chicago: University of Chicago Press, forthcoming 2012.

"A Pioneer of the Wilderness" [A. W. H. Rose], *The Emigrant Churchman in Canada,* ed. Rev. Henry Christmas. London: Richard Bentley, 1849), vol. 1.

Plunkett, John. "Optical Recreations and Victorian Literature." In *Literature and Visual Media,* ed. David Seed. Cambridge: D. S. Brewer, 2005.

Poisson, Georges. "Un transparent de Carmontelle." *Bulletin de la Société de l'Histoire de l'Art francais,* Année 1984 (publ. 1986), pp. 169–175.

Poniatowski, Jan. *Panorama Raclawicka przewodnik.* Wroclaw: Krajowa Agencja Wydawnicza, 1990.

Potonniée, Georges. *Daguerre, peintre et décorateur.* Paris: P. Montel, 1935.

Potter, Russell A. *Arctic Spectacles: The Frozen North in Visual Culture, 1818–1875.* Seattle: University of Washington Press, 2007.

Powell, Hudson John. *Poole's Myriorama! A story of travelling showmen.* Bradford on Avon: ELSP, 2002.

Printseva, G. "P. Ya. Pyasetsky. Panorama Londona v dni prazdnovaniia 60-letiia tsarstvovaniia korolevy Viktorii." ("The Panorama of London during the celebration of the sixtieth anniversary of Queen Victoria's reign by Pavel Pyasetsky"), in *The Culture and Art of Russia, Transactions of the State Hermitage,* 40. St Petersburg: The State Hermitage Publishers, 2008, pp. 266–279 (English summary, p. 405).

Quinn, Stephen. *Windows on Nature: The Great Habitat Dioramas of the American Museum of Natural History.* New York: Harry N. Abrams, 2006.

Quinxi, Lou. *Chinese Gardens,* trans. Zhang Iei and Yu Hong. China Intercultural Press, 2003.

Ramsaye, Terry. *A Million and One Nights: A History of the Motion Picture through 1925.* New York: Simon & Schuster, 1986, orig. 1926.

Randl, Chad. *Revolving Architecture: A History of Buildings that Rotate, Swivel and Pivot.* New York: Princeton Architectural Press, 2008.

Rathbone, Perry T., ed. *Mississippi Panorama: The life and landscape of the Father of Waters and Its Great Tributary, the Missouri.* St. Louis: City Art Museum of St. Louis, 1950.

Rees, A. L. and F. Borzello, eds. *The New Art History.* London: Camden Press, 1986.

Rees, Terence. *Theatre Lighting in the Age of Gas.* London: Society for Theatre Research, 1978.

Rees, Terence, and David Wilmore, eds. *British Theatrical Patents 1801–1900.* London: The Society for Theatre Research, 1996.

Remise, Jac, Pascale Remise, and Regis van de Walle. *Magie lumineuse du théâtre d'ombres à la lanterne magique.* Tours: Balland, 1979.

Richards, Jeffrey H. "The Showman as Romancer: Theatrical Presentation in Hawthorne's 'Main Street.'" *Studies in Short Fiction* 21, no. 1 (Winter 1984): 47–55.

Richardson, Dorothy B. *Moving Diorama in Play: William Dunlap's Comedy* A Trip to Niagara *(1828).* Youngstown, N.Y.: Teneo Press, 2010.

Richmond, Ian. *Trajan's Army on Trajan's Column.* London: British School at Rome, 1982.

Robinson, David. "Further Adventures of the Flying Dutchman." *New Magic Lantern Journal* 9, no. 4 (Summer 2003): 59–60.

Robinson, David. "Magic Lantern Sensations of 1827." *New Magic Lantern Journal* 8, no. 4 (Dec. 1999): 14–15.

Robinson, David. *Masterpieces of Animation 1833–1908. Griffithiana,* no. 43. Dec. 1991), Special Issue.

Rockett, Kevin, and Emer Rockett. *Magic Lantern, Panorama and Moving Picture Shows in Ireland, 1786-1909* (Dublin: Four Courts Press, 2011).

Rolle, Andrew. *John Charles Fremont: Character As Destiny*. Norman: University of Oklahoma Press, 1991.

Rombous, Tom, ed. *The Panorama Phenomenon*. The Hague: Panorama Mesdag, 2006.

Rosenfeld, Sybil. "The *Eidophusikon* Illustrated." *Theatre Notebook*, 1963/4. Reprinted in Stephen Herbert, *A History of Pre-Cinema*. London: Routledge, 2000, vol. 2, pp. 79–82.

Rosenfeld, Sybil. *Georgian Scene Painters and Scene Painting*. Cambridge: Cambridge University Press, 1981.

Rossell, Deac. *Laterna Magica—Magic Lantern*. Vol. 1. Stuttgart: Füsslin Verlag, 2008.

Ruggles, Jeffrey. *The Unboxing of Henry Brown*. Richmond: The Library of Virginia, 2003.

Ryan, William M. "A Plethorama." *American Speech* 36, no. 3 (Oct. 1961): 230–233.

Sandweiss, Martha A. *Print the Legend: Photography and the American West*. New Haven: Yale University Press, 2002.

Saxon, A. H. *P. T. Barnum: The Legend and the Man*. New York: Columbia University Press, 1989.

Sayre, Henry M. "Surveying the Vast Profound. The Panoramic Landscape in American Consciousness." *Massachusetts Review* 24 (Winter 1983): 723–42.

Schaffer, Nikolaus. "Vier Salzburger in einem Boot. Ein ungewöhnliches Familienbild also wichtige Ergänzung zum Sattler-Panorama." In *Das Kunstwerk des Monats*. Salzburg: Salzburger Museum Carolino Augusteum, 15. Jahrgang, p 168 (April 2002), unpaginated.

Schivelbusch, Wolfgang. *Disenchanted Night: The Industrialization of Light in the Nineteenth Century*, trans. Angela Davies. Berkeley: University of California Press, 1995, orig. 1983.

Schivelbusch, Wolfgang. *The Railway Journey: The Industrialization of Time and Space in the 19th Century*, translation. Berkeley: University of California Press, 1986, orig. 1977.

Schwartz, Vanessa R. *Spectacular Realities: Early Mass Culture in Fin-de-Siècle Paris*. Berkeley: University of California Press, 1998.

Sebastien, Thomas. "Technology Romanticized: Friedrich Kittler's Discourse Networks 1800/1900." *MLN* 105, no. 3, German Issue (April 1990): 585–595.

Sharma, Shiv Kumar. "The Art of Scroll Painting in India—Some Aspects." In *Indian Art & Culture*, ed. Govind Chandra Pande et al. Allahabad: Raka Prakashan, 1994, pp. 145–150.

Shegreen, Sean. "From broadside to book: pen and pencil in the *Cries* of London." *Word & Image* 18, no. 1 (Jan.–March 2002): 57–86.

Shegreen, Sean. "'The manner of Crying Things in London': Style, Authorship, Chalcography, and History." *Huntington Library Quarterly* 59, no. 4 (1996): 405–463.

A Short Account of the New Pantomime Called Omai, or, A Trip round the World; performed at the Theatre-Royal in Covent-Garden. With the recitatives, airs, duetts, trios and chorusses; and a description of the PROCESSION. The Pantomime, and the Whole of the Scenery, designed and invented by Mr. Loutherbourg. The Words written by Mr. O'Keeffe; And the Musick composed by Mr. Shields. London: T. Cadell, 1785.

Silbergeld, Jerome. *Chinese Painting Style: Media, Methods, and Principles of Form*. Seattle: University of Washington Press, 1982.

Simkin, Mike. "Albert Smith: Entrepreneur and Showman." *Living Pictures* 1, no. 1 (2001): 18–28.

Smiles, Sam. "Panoramas in Exeter 1816-1864." *Newsletter of the International*

Panorama and Diorama Society, vol. 5 (New Series), no. 2 (Autumn 1989).

Smith, Grahame. *Dickens and the Dream of Cinema.* Manchester: Manchester University Press, 2003.

Smith, Lester. "Entertainment and Amusement, Education and Instruction: Lectures at the Royal Polytechnic Institution." In *Realms of Light. Uses and Perceptions of the Magic Lantern from the 17th to the 21st Century,* ed. Richard Crangle, Mervyn Heard, and Ine van Dooren. London: The Magic Lantern Society, 2005.

Smith, Thomas Ruys. *River of Dreams: Imagining the Mississippi before Mark Twain.* Baton Rouge: Louisiana State University Press, 2007.

Southern, H. "The Centenary of the Panorama." *Theatre Notebook* 5 (1950–1951): 67–69.

Southern, Richard. *Changing Scenery: Its Origin and Development in the British Theatre.* London: Faber & Faber, 1952.

Southern, Richard. *The Georgian Playhouse.* London: Pleiades Books, 1848.

The Spectacular Career of Clarkson Stanfield 1793–1867: Seaman, Scene-Painter Royal Academician. Newcastle, UK: Tyne and Wear County Council Museums, 1979.

Stafford, Barbara Maria, and Francis Terpak. *Devices of Wonder: From the World in a Box to Images on a Screen.* Los Angeles: Getty Research Institute, 2001.

Stenger, Erich. *Daguerres Diorama in Berlin: Ein Beitrag zur Vorgeschichte der Photographie.* Berlin: Union Deutsche Verlagsgesellschaft, 1925.

Stenger, Erich. "Das Pleorama." *Technikgeschichte* 28 (1939).

Sternberger, Dolf. *Panorama oder Ansichten vom 19. Jahrhundert.* Suhrkamp Taschenbuch 179, 1974, orig. 1938.

Sternberger, Dolf. *Panorama of the 19th Century,* trans. Joachim Neugroschel. New York: Urizen Books & Mole Editions, 1977.

Stewart, Susan. *On Longing: Narratives of the Miniature, the Gigantic, the Souvenir, the Collection.* Durham: Duke University Press, 1993.

Stulman Dennett, Andrea. *Weird and Wonderful: The Dime Museum in America.* New York: New York University Press, 1997.

Sturken, Marita Sturken, and Lisa Cartwright. *Practices of Looking. An Introduction to Visual Culture.* Oxford: Oxford University Press, 2001.

Takahata, Isao. *Juniseikki-no Animation* ("Animation in the 12th century"). Tokyo: Studio Ghibli Co., A Division of Tokuma Shoten Co., 1999.

Thomas, Russell. "Contemporary Taste in the Stage Decorations of London Theatres, 1770-1800." *Modern Philology* 42, no. 2 (Nov. 1944): 65–78.

Thorington, J. Monroe. *Mont Blanc Sideshow: The Life and Times of Albert Smith.* Philadelphia: John C. Winston Co., 1934.

Toulet, Emmanuelle. *Cinématographe, invention du siècle.* Paris: Gallimard / Réunion des Musées nationaux, 1988.

Tsivian, Yuri. *Early Cinema in Russia and Its Cultural Reception,* trans. Alan Bodger. Chicago: University of Chicago Press, 1998, orig. 1994, Russian orig. 1991.

Tsuji, Nobuo. "Early Medieval Picture Scrolls as Ancestors of Anime and Manga." In *Births and Rebirths in Japanese Art,* ed. Nicole Coolidge Rousmaniere. Leiden: Hotei Publishing, 2001, pp. 53–82.

Turner, E. S. *The Shocking History of Advertising.* New York: Ballantine Books, 1953.

Turnor, Hatton. *Astra Castra: Experiments and Adventures in the Atmosphere.* London: Chapman and Hall, 1865.

Uricchio, William. "Panoramic Visions: stasis, movement, and the redefinition of the panorama." In *La nascita dei generi cinematografici/The Birth of Film Genres,* ed. L. Quaresima, A. Raengo, L. Vichi. Udine: Forum, 1999, pp. 125–133.

van Eekelen, Yvonne, ed. *The Magical Panorama: The Mesdag Panorama, an Experience in Space and Time.* The Hague: Waanders Uitgevers / Panorama Mesdag, 1996.

Vardac, A. Nicholas. *Stage to Screen: Theatrical Origins of Early Film: David Garrick to D. W. Griffith*. New York: Da Capo Press, 1987 [1949].

Verwiebe, Birgit. *Lichtspiele: Vom Mondscheintransparent zum Diorama*. Stuttgart: Füsslin Verlag, 1997.

Visser, Colin. "Scenery and Technical Design." In *The London Theatre World, 1660–1800*. Carbondale: Southern Illinois University Press, 1980, pp. 101–104.

von Dewitz, Bodo, and Werner Nekes, eds. *Ich sehe was, was du nicht siehst! Die Sammlung Werner Nekes*. Göttingen: Steidl & Museum Ludwig, 2002.

von Hagen, Victor Wolfgang. *Frederick Catherwood Archt*. New York: Oxford University Press, 1950.

von Plessen, Marie Louise, and Ulrich, eds. Giersch *Sehsucht: Das Panorama als Massenunterhaltung des 19. Jahrhunderts*. Basel: Stroemfeld/Roter Stern, 1993.

Waddington, Damer. *Panoramas, Magic Lanterns and Cinemas: A Century of 'Light' Entertainment in Jersey 1814–1914*. St. Lawrence, Jersey: Tocan Books, 2003.

Waldekranz, Rune. *Så föddes filmen: Ett massmediums uppkomst och genombrott*. Stockholm: Pan/Nordstedts, 1976.

Waltz, Gwendolyn. "Filmed Scenery on the Live Stage." *Theatre Journal* 58, no. 4 (Dec. 2006): 556–558.

Watson, Ernest Bradlee. *Sheridan to Robertson: A Study of the Nineteenth-Century London Stage*. Cambridge: Harvard University Press, 1926.

Weeden, Brenda. *The Education of the Eye: History of the Royal Polytechnic Institution 1838–1881*. Cambridge: Granta Editions, 2008.

Weldon, Roberta. *Hawthorne, Gender, and Death: Christianity and Its Discontents*. New York: Palgrave Macmillan, 2008.

Welling, William. *Photography in America: The Formative Years 1839–1900*. New York: Thomas Y. Crowell, 1978.

Wells, Kentwood D. "The Stereopticon Men: On the Road with John Fallon's Stereopticon, 1860–1870." *Magic Lantern Gazette* 23, no. 3 (Fall 2011): 3–34.

West, Peter. *The Arbiters of Reality: Hawthorne, Melville, and the Rise of Mass Information Society*. Columbus: Ohio State University Press, 2008.

Wijs, Hugo de. "Saving a Kaiser Panorama." *Stereo World* 33, no. 3 (Nov.–Dec. 2007: 8–13, 36–37.

Wilcox, Scott B. "Erfindung und Entwicklung des Panoramas in Grossbritannien." In *Sehsucht: Das Panorama als Massenunterhaltung des 19. Jahrhunderts*, ed. Marie-Louise von Plessen and Ulrich Giersch. Basel and Frankfurt am Main: Stroemfeld/Roter Stern, 1993, pp. 28–35.

Wilcox, Scott B. "Unlimiting the Bounds of painting." In Ralph Hyde, *Panoramania! The Art and Entertainment of the "All-Embracing" View*. London: Trefoil Publications in Association with Barbican Art Gallery, 1988, pp. 13–44.

Windschuttle, Keith. *The Killing of History*. San Francisco: Encounter Books, 1996.

Winterer, Caroline. *The Culture of Classicism: Ancient Greece and Rom in American Intellectual Life 1790–1910*. Baltimore: Johns Hopkins University Press, 2002.

Wonders, Karen. *Habitat Dioramas: Illusions of Wilderness in Museums of Natural History*. Uppsala, 1993, Acta Universitatis Upsaliensis, Figura Nova Series 25.

Wood, R. Derek. "Daguerre and His Diorama in the 1830s: Some financial announcements." *Photoresearcher* (European Society for the History of Photography, Croyton, UK,), no. 6 (1994/95/96), pp. 35–40. Available on-line at www.midley.co.uk .

Wood, R. Derek. "The Diorama in Great Britain in the 1820s." *History of Photography* 17, no. 3 (Autumn 1993): 284–295. Available on-line at www.midley.co.uk .

Wray, Suzanne. "In the Style of Daguerre: Two 19th-Century American Showmen and Travelling Exhibitions of Chemical Dioramas." Paper read at the

International Panorama Conference, Plymouth, UK, 2007 (unpublished).

Wray, Suzanne. "R. Winter's Unrivalled Exhibition of Chemical Dioramas, Chrystalline Views, Chromatropes, &c. The Traveling Exhibitions of Robert Winter." *Magic Lantern Gazette* 19, no. 4 (Winter 2007): 8–19.

Wright, Richardson. *Hawkers & Walkers in Early America*. Philadelphia: J.B. Lippincott, 1927.

Ziter, Edward. *The Orient on the Victorian Stage*. Cambridge: Cambridge University Press, 2003.

INDEX